D1066857

Errant Modernism

A JOHN HOPE FRANKLIN CENTER BOOK

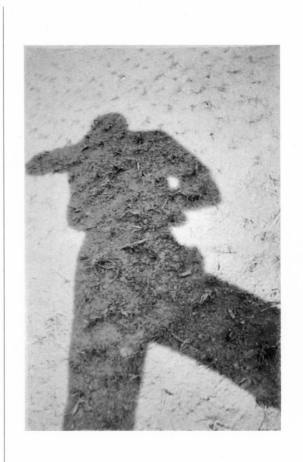

ESTHER GABARA

Errant Modernism

THE ETHOS OF
PHOTOGRAPHY
IN MEXICO
AND BRAZIL

DUKE UNIVERSITY PRESS DURHAM AND LONDON 2008

Printed in the United States of America
on acid-free paper ∞
Designed by C. H. Westmoreland
Typeset in Bembo with Magma Compact
display by Tseng Information Systems, Inc.
Library of Congress Cataloging-in-
Publication Data appear on the last
printed page of this book.

Portions of chapter 2 previously
appeared in "Facing Brazil: The Problem
of Portraiture and a Modernist Sublime,"
CR: The New Centennial Review 4
(2004): 33–76.

Earlier versions of portions of chapters 3
and 4 appeared in "Modernist Ethics:
Really Engaging Popular Culture" in
*The Ethics of Latin American Literary
Criticism: Reading Otherwise,*
ed. Erin Graff Zivin (New York:
Palgrave, 2007) and "Engendering
Nation: Las bellas artes públicas and the
Mexican Photo-Essay, 1920–1940," in
the *Yearbook of Comparative and General
Literature* 49 (2001): 139–54.

facing the title page: Mário de Andrade,
"Sombra minha / Sta. Tereza do Alto /
1-1-28." *Fundo Mário de Andrade, Arquivo
do Instituto de Estudos Brasileiros,* USP

Contents

List of Illustrations . . . vii

Acknowledgments . . . xi

Introduction . . . 1

1 LANDSCAPE
Errant Modernist Aesthetics in Brazil . . . 36

2 PORTRAITURE
Facing Brazilian Primitivism . . . 75

3 MEDIATION
Mass Culture, Popular Culture, Modernism . . . 120

4 ESSAY
Las Bellas Artes Públicas, *Photography, and Gender in Mexico* . . . 143

5 FICTION
Photographic Fictions, Fictional Photographs . . . 196

EPILOGUE . . . 240

Notes . . . 261
Bibliography . . . 319
Index . . . 345

Illustrations

Plates (between pages 148 and 149)

1 James Casebere, "Monticello #3, 2001"
2 Don Carlos Balmori represented on the tomb he shared with Conchita Jurado
3 Don Carlos Balmori with several bataclanas
4 Gerardo Suter, "Tollan 14"
5 Silvia Gruner, "Don't Fuck with the Past, You Might Get Pregnant"
6 Arthur Omar, "The Angled Beach"
7 Arthur Omar, "A Boy, All White"

Figures

1 José de Olivares, *Our Islands and Their People* . . . 5
2 Manuel Álvarez Bravo, "Sand and Little Pines" . . . 23
3 Hugo Brehme, "Peak of Orizaba" . . . 24
4 Giovanni Stradano, "Vespucci Discovering America" . . . 39
5 Title page, *The Apprentice Tourist* . . . 39
6 Mário de Andrade, "Accidental *desvairismo* / question of a boat and / of *lunch*/ 6/7/1927" . . . 43
7 Mário de Andrade, "Entry of an inlet [paraná] or inlet [paranã]/ Madeira River/ July 5, 1927/ Island of Manicoré!" . . . 44

8 Mário de Andrade, "Alagoas—Maceió / Boy throwing himself/ from the Manaos into the water / 12/9/28" . . . 51

9 Mário de Andrade, "Mogi-Guassú July 1930" . . . 53

10 Mário de Andrade, "Mogi-Guassú (with wind) July 1930" . . . 53

11 Mário de Andrade, "Alvarengas / 25 of May 1927 (cargo ships)" . . . 54

12 Mário de Andrade, "Mahogony Rafts / banking at San Salvador / to embark / Nanay, June 23, 1927 / Peru / Future victrolas" . . . 54

13 Mário de Andrade, "Reefs, May 13, 1927" . . . 58

14 Mário de Andrade, "Dolur in the vista of Marajoara / 7/31/1927 / sun 3, diaph. 3 / Trombeta" . . . 61

15 Mário de Andrade, "Dolur in Sta. Tereza do Alto / 10/12/27" . . . 64

16 Mário de Andrade, "My shadow, Sta. Tereza do Alto / 1/1/28" . . . 76

17 Mário de Andrade, "Madeira River / Portrait of my shadow cast from the deck of the Victoria, July 1927 / What happened to the poet?" . . . 77

18 Mário de Andrade, "Bom Passar" . . . 86

19 Mário de Andrade, "Tapuio from Parintins" . . . 89

20 Anonymous ethnographic photograph . . . 92

21 Mário de Andrade, "Ridiculous bet in Tefé, June 12, 1927" . . . 94

22 Charlie Chaplin . . . 96

23 Buster Keaton . . . 97

24 Portrait of Mário de Andrade with his music students . . . 104

25 Mário de Andrade, "Futurist photograph of Mag and Dolur superimposed on the banks of the Amazon, June 1927, Obsession" . . . 114

26 Mário de Andrade, "Freudian clothes, Fortaleza 8/5/27, Sun 1, diaf. 1, Repressed photograph, Repression" . . . 116

27 Mário de Andrade, "Lake Ararí, Marajó, 7/30/27" . . . 117

28 Mário de Andrade, "Toada" . . . 121

29 "The Paulista Sense of Brazilian Life Means . . ." . . . 122

30 *S. Paulo*, September–October 1936 . . . 125

31 "Take Photographs, It is Recreation, Instruction, and very Easy" . . . 152

32 "Weston, the Artifice of the Lens" . . . 154

33 Waldemar George, "Photography, Modern Magic" . . . 156

34 María Becerra González, "Women, Fashion, and the Fashionista" . . . 156

35 "A Masculine Haircut, and Also . . . Everything Else" . . . 158

36 Arqueles Vela, "A Frightening Story" . . . 161

37 Luis de Hoz, "The Art of Photography" . . . 163

38 "Photo-Tricks" . . . 165

39 "Trips/Tourism" . . . 167

40 "Our Capital" and "East and West" . . . 170

41 "The City of Palaces" . . . 170

42 "Modern Lady Gulliver in Lilliput" . . . 171

43 Arqueles Vela, "The Art of Showing Off Your Calves" . . . 175

44 "The Feminine Art of Showing Off Your Legs" . . . 175

45 "Raceway Graphics" . . . 176

46 "La India Bonita" . . . 179

47 María Bibiana Uribe as "La India Bonita" . . . 179

48 Silvestre Bonnard, "The India Bonita in Theater and Film" . . . 181

49 "The Spirit of the Jarabe" . . . 182

50 El Caballero Puck, "Masks" . . . 184

51 El Caballero sin Nombre, "Our Artists in Masks" . . . 184

52 Xavier Villaurrutia, "The Mask" . . . 185

53 Adolfo Best Maugard, *Método de dibujo* . . . 187

54 Ortega, "A Good Friday with Lupe the Girl" . . . 188

55 Arqueles Vela, "The Film That Does Not Exist" . . . 190

56 Detail, "The Spirit of Cinema" . . . 215

57 Manuel Álvarez Bravo, "Striking Worker Murdered" . . . 222

58 Manuel Álvarez Bravo, "Historic Plot" . . . 223

59 Manuel Álvarez Bravo, "The Washerwomen Implied" . . . 225

60 Edward Weston, "Excusado" . . . 226

61 Manuel Álvarez Bravo, "Boy Urinating" . . . 227

62 Conchita Jurado as Don Carlos Balmori, receiving a kiss from another conquest . . . 241

63 Don Carlos Balmori enjoys a balmoreada with several bataclán dancers . . . 243

64 Maris Bustamante, "EL CORAZON COMO CEREBRO LATINOAMERICANO" . . . 249

65 Gerardo Suter, "Coatlicue" . . . 250

66 Tunga, "Description of an Experience of Fine and Subtle Physics" . . . 255

67 Tunga, "Capillary Siamese Among Us" . . . 256

Acknowledgments

The heart of this project lies in the archival materials that were made generously available to me by a large number of people and institutions in Mexico City and São Paulo. I would like to thank the entire staff at the Fondo Mário de Andrade and the library at the Instituto de Estudos Brasileiros, Universidade de São Paulo, and in particular, Telê Ancona Lopez. In Mexico, the staff of the Hemeroteca Nacional and the Fondo Reservado of the Biblioteca Nacional of Mexico, the Biblioteca Miguel Lerdo de Tejada, and the Instituto de Investigaciones Estéticas at Universidad Nacional Autónoma de México, were very helpful. In New York, the holdings of the New York Public Library were indispensable, especially its collection of *El Universal Ilustrado*. My deep gratitude also to the artists whose work appears in the epilogue, for granting me permission to reproduce their work and for helping me to understand why the questions I explore here are still relevant. I especially thank Maris Bustamante, Arthur Omar, and Tunga for long conversations about their work.

A comparative study of countries as complex and vast as Mexico and Brazil requires years of support for archival re-

search, and I thank the Fulbright–García Robles Foundation; the Center for Latin American and Caribbean Studies, the Center for North American Studies, the Arts and Sciences Research Council, and the Deans of Arts and Sciences at Duke University; and the Tinker Foundation and the Center for Latin American Studies at Stanford University for making my research possible. Additionally, I received support from the Whiting Foundation, the Virginia Museum of Fine Arts, and as a Helena Rubenstein fellow in Critical Studies at the Whitney Museum of American Art, in the Independent Study Program. The New Beginnings faculty seminar at the John Hope Franklin Center at Duke provided both time for writing and the opportunity to discuss ethics with colleagues from across the university.

Mary Louise Pratt, Claire F. Fox, Lúcia de Sá, and Edward Sullivan first guided me through my dissertation, and I continue to count on their insight and counsel. In Mexico City, Gabriela Cano, Alejandro Castellanos, Alfonso Colorado, Mónica Mayer, Renato González Mello, and Pablo Ortiz Monasterio, were very generous with their time and their knowledge. In São Paulo and Rio de Janeiro, Marcos Moraes shared his extensive knowledge of everything Mário de Andrade, and Tânia Dias shared her expertise in Brazilian literature, critical theory, and even her home. Thanks too to Willi Bolle, who first read my work on Mário de Andrade, and to Paulo Herkenhoff for wide-ranging conversations. At Duke, I thank my colleagues in Romance studies and art, art history, and visual studies for truly supporting both the spirit and pragmatics of interdisciplinary inquiry. Special thanks to Roberto Dainotto, Margaret Greer, Francisco-J. Hernández Adrián, Patricia Leighten, Walter Mignolo, Diane Nelson, Kristine Stiles, Antonio Viego, and Priscilla Wald. Marc Schachter, Roberto Tejada, and Jocelyn Olcott read portions of this book with great care. Ken Wissoker at Duke University Press provided crucial support for this project, as did Mandy Earley.

Laura Carton, Soledad Galvez, Alia Hasan-Khan, Anna Indych-López, Susan Kelly, Hilary Czarda, Stephen Morton, Orit Raff, and Allison Rouse have inspired and sustained me in innumerable ways. Thanks to the Lasches for a new home in Mexico City. My family, Vlodek, Uliana, and Rachel Gabara, laid the foundation for it all. This book is dedicated to Pedro Lasch, with dreams of past, present, and future collaborations.

Introduction

Let us begin with an image that repeats throughout this book: the Latin American modernist intellectual grasps hold of the camera and asks: "What now? How do I capture an accurate image of this modernity? Who is the subject and who is the object of this photographic encounter?" The modernist looks through the lens or at a photograph and doubts the modern subject and the place captured within, the history it frames, the veracity of the technology of representation itself. In the decades of modernist experimentation of the 1920s and 1930s, photography played a crucial role in eliciting questions about the forms of ethical responsibility and the promises of innovative aesthetics. Once the camera changed hands, from foreigner to native (we will continue to circle around both of these terms), modernists retook photography's naturalized function as a privileged medium of modern representation and used it to alter the very image of modernity.[1] The act of taking this tool into one's hands became both a triumphant gesture of acquisition and created a deep trauma of representation. In Brazil and Mexico, two widely influential and iconic sites of modernism in the region, photographs and the idea of

the photographic led artists and writers to produce works that fuse meditations on ethics with experimental aesthetics in what I call the ethos of modernism.

Since its invention in the nineteenth century, photography has been bound up with modern fantasies and fears as much as it has defined artistic, scientific, and even political projects. In the 1920s, greater access to cameras and the widespread reproduction of all kinds of photographs created a broad association between the medium and key characteristics of modernity. Photography captured the increasing circulation of products, ideas, and people, contributed to an epistemology that associated seeing with knowing, and represented subjects marked by race and gender who were gaining visibility as participants in modern societies. These decades saw an explosion of photographs globally: improved rotogravure technology filled newspapers and weeklies with photographs; with smaller and lighter cameras in hand, tourists and social scientists voyaged to the frontier between the modern and its others by train, plane, and automobile; and artists moved between the continents and within nations, experimenting with new technologies and theories of representation.

The modernist avant-garde across Latin America emerged on the scene during the late teens and early 1920s: the Week of Modern Art in São Paulo (1922) featured readings, concerts, and exhibitions, Estridentistas (Stridentists) posted manifestos in the streets and published experimental visual poetry in Xalapa (1921), and odes to the urban such as *Twenty Poems to Be Read on the Tram* (1922) by Argentine Oliverio Girondo peppered the literary landscape.[2] During the 1930s the number of manifestos diminished but experiments with prose fiction and visuality still flourished, laying the groundwork for the international importance of the Latin American novel throughout the rest of the century. Brazilian anthropophagy, which proclaimed a nation of cultural cannibals who consumed African, indigenous, and European cultures, recurs in novels, theory, films, and fine arts throughout the twentieth and into the twenty-first century. The Estridentistas and the Contemporáneos, the two leading modernist avant-garde movements in Mexico, were publicly at odds over the character of modern art and of modernity itself. Nevertheless, they shared a focus on linguistic innovation, temporal discontinuity, and interdisciplinary collaborations across the arts. These authors, who are now canonical figures in

the national literary traditions of Mexico and Brazil, looked at modern life through the camera in a variety of ways: Mário de Andrade, known as the pope of Brazilian modernism, took and collected hundreds of photographs, and Salvador Novo, who remained a dominant presence in Mexican letters from the 1920s until the 1970s, meditated on the medium's aesthetic potential as "the prodigal daughter of the fine arts." Major writers from both countries' modernist movements published in photographically illustrated magazines, an early form of mass media that included their reflections on the relationship between image and word contained within. Commonplace rhetoric about the contemporary experience of visual overload—through advertisements, the Internet, and video—echo proclamations about radical and disorienting changes in technologies of seeing and representation from this earlier period.

This book examines the varied functions of photography in the major modernist movements in Mexico and Brazil in the twenties and thirties, working toward a theory of modernism contained in the contact—material and conceptual—between image and word. The place commonly referred to as Latin America offers a story about modernism in which the variety of photographic discourses in circulation are as important as those few later designated as art. It poses the challenge of seeing such images as important practices of modernism even as they require a redefinition of modernist photographic aesthetics. The images that follow may be surprising to readers accustomed to looking at European and U.S. works from the same period: strangely rural for the urban New Vision, diminutive compared to Constructivism's monumentalism, more populated than the stark New Objectivity, melodramatically kitsch as much as avant-garde, and documentary without satisfying the progressivist desires of that reformist mode.[3] Even writing those comparisons, however, works against the broad project of this book, which seeks to substantially decenter modernism from those centers of economic modernization. Looking at these photographs and reading the texts that engage them entails a formalism that does not impose aesthetic expectations from other modernist sites, and an ethics that understands the histories of modernity and photography embedded in that of colonialism.

Photography provides a special opportunity to theorize modernism in Latin America, for it bore both the promise of modernity as

technological advancement and the stain of late-nineteenth and early-twentieth-century projects of imperial expansion. In the groundbreaking first colloquium on Latin American photography held in Mexico in 1978, Héctor Schmucler explained that the truism that "the camera doesn't look from nowhere" signifies more than just a general concept of the photographer's limited "point of view." The lack of neutrality of photographs results as much from the stance of the photographer as the camera's design, which reproduces the perspectival illusion canonized in Renaissance painting. The Argentine scholar adds a twentieth-century challenge to this history of pictures, for "the Kodak, along with Coca-Cola and the starred flag, constitutes one of the most broadcast symbols of the North American presence in the world."[4] Just two decades before the modernist movements took shape, J. C. Hemment wrote in *Cannon and Camera: Sea and Land Battles of the Spanish-American War in Cuba, Camp Life, and the Return of the Soldiers* (1898): "The camera is like the gun of the war ship: while the gun can do the deadly execution, while shot and shell are brought to a state of perfection by our skilled artisans, the man must be behind the gun. So it is with the camera."[5] As the dramatically illustrated, two-volume set *Our Islands and Their People* (1899) makes clear—especially in figure 1, an altered image with the U.S. flag drawn in to imagine a warm welcome in Cuba—photography arrived burdened with the baggage of military intervention and commercial expansion, as well as touristic curiosity and ethnographic desire.[6] It also carried with it a way of seeing, which embeds ethical issues in even the most formal analyses. Literary expression shared these tensions: as much as photographers sought to make the camera see differently, writers attempted to make the colonizer's languages of Spanish and Portuguese achieve national expression, even as millions of people around them spoke indigenous languages.

Despite the often violent history of photographic capture, there was no resisting the temptation of the camera in the vibrant cultural atmosphere of the 1920s and 1930s. Mário de Andrade fondly referred to his camera as his *codaquinha*, a nickname that fused the name of the pervasive U.S. brand with the diminutive typical of Brazilian Portuguese. The literary and artistic modernist movements in Mexico and Brazil were deeply engaged with photography and exhibited a fascination with the medium as a means to represent modern life as well as a rich mine of words and concepts. Through the examination of

1 José de Olivares, *Our Islands and Their People*, N. D. Publishing Co., 1899

extensive archival materials, I show how photography pervaded the experimental and popular literature of the period, and how captions, graphic design, and other texts altered the meaning of photographs. The ethical self-questioning provoked by the photographic encounter was part and parcel of aesthetic experiments with light, line, and frame, surprisingly the very themes germane to the formalism of mainstream modernist studies.[7] By making explicit the challenges of making art do more than just represent the world realistically, photography augured exciting new possibilities for formal experimentation and an ethics that challenged antiquated social mores rather than dictated morality. The resulting modernism participated in what Mário de Andrade termed "critical nationalism," a politics that critiqued the colonial history of the Americas and its twentieth-century formation, yet did not obediently serve the interests of the increasingly centralized and homogenizing modern states in Mexico and Brazil.

I introduce the concept of ethos as a way to theorize a set of modernist practices, both photographs themselves and photographic concepts and language in literature, that simultaneously engage ethics and aesthetics. The word itself is not new to the scholarship on modernism; in fact, it appears with great frequency among theorists of modernity and modernism from Latin America. Adrián Gorelik, for instance, refers to modernity as "the most general cultural ethos of the era, as the modes of life and social organization."[8] Perhaps the word's popularity stems from its indefinite quality, so that it avoids the traps of regional or national essentialism, technological determinism, and the appearance of a causal relationship between economic modernization and aesthetic modernism. By developing a more defined architecture of ethos as the intersection of ethics and aesthetics, however, I am able to articulate the interventions and innovations of this generation of intellectuals and writers: their formulation of modernist aesthetics as a practice of formal intervention into the forms of everyday life, rather than formalism only as artistic purity, and their constitution of ethics as a social bond that nonetheless resists conservative moralism. Drawing out this ethos elucidates the continued relevance of these movements to artists in the region, who again are facing the challenges of new visual technologies and globalization.

The *Oxford English Dictionary* lists two definitions of ethos. The first cites Aristotle and refers to "the characteristic spirit, prevalent tone or sentiment of a people or community;" the second places the term "in reference to ancient aesthetic criticism and rhetoric . . . Some modern writers have taken ethos to mean 'ideal excellence.'"[9] The first definition helps to imagine ethics as the social location of the work and the artist, rather than simply as morality. Ethos frames ethics as a way of dwelling together, building community, being responsible to the others with whom one shares space. A central concern of Latin American modernism was to determine the places of this ethical responsibility by carefully considering the frontiers of the local. We will see that the space pictured by ethos is the actual space of lands (and nations) represented by photographs and texts, as well as the space constituted by representation itself, the framed space of the photograph and the left-to-right space of text. This ethics binds these spaces and the people who occupy them, such that concepts of locale and subjectivity become

mutually constitutive. While philosophers such as Hegel have meditated on the relationship between place and population, de Andrade offers a biting ethical critique of mistaking this mutual relationship for one in which the land founds a national race. He, Jaime Torres Bodet, and Xavier Villaurrutia picture a displaced intellectual, split in two, strangely running into himself as he tries to orient himself in relation to the modern nation and his fellow citizens.[10] The ethos of modernism is embodied as much as it is located: it pictures the ethics of inhabiting a place. These two concepts—locale and subjectivity—have been at the center of discourses of modernity, in claims of cosmopolitanism and regionalism as well as civilization and primitivism, and are radically reimagined in the photographic works examined here.

The second definition of ethos designates its less expected, aesthetic sense. While the dictionary warns that this was likely not its classical meaning, common usage deploys the term to gesture toward an aesthetics that is not a formal mandate but rather a "way of life," either of an individual or a society. The ethos of these works, to use Michel de Certeau's language, combines a tactics of survival as a practice of everyday life with an aesthetic mode.[11] Mari Carmen Ramírez uses this word precisely when she wishes to describe these artistic movements' mixture of art, experience, and life: this is Latin America's "vanguardist ethos."[12] Formal strategies including abstraction, lyricism, and montage create a modernist sublime that does not require moral or aesthetic purity but rather breaks down the hermetic distance of the literary text or art work from the social. The aesthetic quality of many of the photographic works, both literary and visual, is open, unfinished, tense, and contradictory, with reflections and repetitions that formulate the doubts of modernist intellectuals. The "excellent character" of works and people constitutes an aesthetic ethos but does not dictate their content; this quality materializes from contact with rather than distance from the social world.

Modernism in Latin America cannot be named by a style or charted as a historical progression toward abstraction. It is not characterized by a particular attitude toward cosmopolitanism or nationalism, nor does it faithfully reject or celebrate modern technologies. Alfredo Bosi argues that the single unifying characteristic that spans the diverse and even contradictory "mosaic of paradoxes" of these movements is their "colonial sense."[13] Theorizing ethos formalizes this "sense" and presents Latin American modernism as a philosophy of art situated in a real space

between representation and action. Bolívar Echevarría, who offers the most elaborated theory of a modern (not modernist) ethos, explains its work as "a mediating concept," a "strategy of construction of the 'world of life.'"[14] His theory of ethos focuses on baroque art and literature, the "style" that accompanied the imposition of European colonialism in the Americas.[15] This baroque ethos shows modernity unfolding in multiple modalities across history, everyday life, and aesthetics, and provides a mode of defense against its imposition; it is an ethical response without a determinate content, and it offers the radical promise of employing the deep structures of culture to reveal the "the possibility and the urgency of an alternate modernity."[16] The ethos of modernism developed here also bridges ethics and aesthetics, "those deep structures" of language and expression with social responsibility and critique, now however located in the artistic experiments of vanguardism rather than baroque art. It takes on the challenges of twentieth-century modernity, framed both by the history of European colonialism and the growing presence of the United States as the hegemonic power in the Western hemisphere.

The ethos of modernism performs a mediatory function between ethics and aesthetics, popular and elite, form and content. For Echevarría, this ethos is germane to the Americas' defining *mestizaje*, a way of thinking mixture that is grounded in race, and which occupies a dominant place in theories of modernity.[17] Yet theorists of coloniality have argued that the very idea of race was created by colonialism itself. Aníbal Quijano writes that race is "a mental construction that expresses the basic experience of colonial domination and pervades the more important dimensions of global power, including its specific rationality: Eurocentrism. The racial axis has a colonial origin and character, but it has proven to be more durable and stable than the colonialism in whose matrix it was established."[18] I propose, therefore, that ethos opens up a process of mediation, rather than hybridization or mestizaje, and thus makes possible critiques of race (and racism), as well as of damaging myths of virility and femininity.[19] One strategy of mediating art and life frequently deployed by modernists was self-conscious posing for the camera: de Andrade posed as a ridiculous version of "the primitive" by holding props such as a spear and a palm frond, and Arqueles Vela created a protagonist who rehearses the different poses of femininity she could use to defend herself against an unnamed threat. The pose is one

of many survival tactics that shape the ethics as much as the aesthetics of modernism.

Popular culture played a crucial role in establishing the mediatory function of the ethos of modernism. In addition to the shared colonial sense of modernism, Bosi finds an "ethical impulse" in the linguistic innovations of modernists who engage seemingly "high art" values of truth and beauty. Playing with the linguistic diversity surrounding them—formal Spanish and slang, as well as indigenous languages—they discover what he terms a "popular ethos" and respond to the oppressive social conditions of modernity in the Americas.[20] Rather than a singular "popular" ethos, I examine two broad and varied spheres that constituted popular culture during these decades: a folkloric or ethnographic popular, and mass media, "pop" culture. From Mexican Estridentistas eating "hotcakes"—a word still used in Mexican Spanish today—and talking in slang about movie stars, to de Andrade's ethnographic collections that include himself as an object of study, the modernist avant-gardes simultaneously represented and participated in popular cultures. Photography was a crucial tool in their activities, due to its common use in both ethnography and mass media. The active participation of modernists in these popular cultures fashions a modernist aesthetics and an ethics, rather than the sort of distanced mining of popular cultures for the renovation of lagging civilization seen, for example, in European primitivism. The ethos of (popular) modernism reveals a sense of ethical responsibility to sectors of society that were increasingly defining modernity in these countries, and an aesthetic that reflects its formulation through disciplines and discourses not proper to high art.

Modernist Genres

I present ethos through Mexican and Brazilian innovations in the same genres that have been crucial to modernism internationally: landscape, portraiture, the (photo-)essay, and prose fiction. Here genre operates as more than just a formal designation. One looks at a portrait, for example, and recognizes both the person and the genre. But where does the recognition of the face end and the recognition of the genre begin? Is it not possible that the force of genre is so strong that it permits the recognition of the person? Jesús Martín Barbero offers a flexible

answer to these questions: "Genres mediate between the logic of the system of production and the logics of use . . . In the sense that we are working with genre, it is not something that happens *to the text*, but rather something that passes *through* the text."[21] He stresses that genres are not "purely literary," for they bring up questions of communicability. That is, the uses to which texts and images are put create genres as much as literary and artistic traditions do. Elaborating both the aesthetic function of genre and its operation as this form of this communication, I show how these modernist genres fuse ethics and aesthetics to frame modernity in Latin America. The portraits examined in chapter 2 simultaneously represent the subjects they contain and redefine modernist portraiture; as a result, they alter the very concept of modern subjectivity.

These experimental genres employ a sophisticated interdisciplinarity, spanning the literary and the photographic to imagine key characteristics of modernity in Latin America: locale, subjectivity, morality, and truth. In the following chapters, I analyze these genres to show how they formulate an aesthetics and an ethics that are of Latin America and also important to modernism internationally. The first genre, landscape, maps a paradoxical idea of locale in a practice of "erring." Simultaneously signifying both "to make an error" and "to wander," I present *erring* as a form of modernist abstraction that pictures place itself in new terms. These landscapes both locate Brazil and hide it from inquisitive and greedy eyes; they remap the presumed opposition between the local and the international long associated with modernist vanguardism. Once the place of modernism is plotted, I examine how the genre of portraiture envisages the modern subjects who inhabit these locales. Modernist portraiture faces the construction of race in modernity as an aesthetic as much as an ethical practice; these portraits exist not so much in the photographs themselves, but in the process of two subjects staring at one another that created them. The resulting modernist sublime alters the definitions of both individual and national character. As much as landscape begins the process of defining the meaning of locale in Latin American modernism, the space of representation requires further exploration. I return to the idea of space and movement through the genre of the photo-essay, which emphasizes the modern circulation of ideas within a work, as well as of bodies and goods in markets and streets. These essays—feminized through their contact with photographs and mass media—alter the trajectory of the (presumed

male) Creole intellectual by immersing him in popular culture. They place his word at the mercy of photographic images that take over the page, causing profound aesthetic and moral disruptions. This immoral aesthetic pervades modernist prose fiction, the final genre explored in this study. It leads to the creation of photographic documentary fictions, which are simultaneously indexical and illusory, embodied and abstract, hermetic and ethical. The ethos of modernist fiction frees ethics from the requirement of truth and replaces it with an ethics of photographic fiction.

These reformulated genres repeatedly constitute modernist objects that cannot be contained. Throughout the following chapters, photographic modernism turns the eye of the reader to the photographic frame and the written text themselves, but also to the margins between these spheres and some "outside." I find that these movements used photography to frame this contradiction of a formally constituted and yet adulterated object, one that is simultaneously open and closed. Manuel Álvarez Bravo's photographs, like the prose fiction by his contemporaries, simultaneously compose an internal drama within the photograph out of light and form, and gesture to the tensions of modernity outside the photograph. René Jara associates this character of objects with the experience of modernity in Latin America as a "closeness to everyday life," which leads to an aesthetic philosophy in which "objects [are] there, beyond good and evil, in their naked materialness, depriving themselves of qualifiers such as beauty or ugliness, in their triumphal opacity."[22] Like Echevarría, Jara maintains that this quality results from the spectacular "ethics and a politics" that the modernist movements share with baroque art of the colonial period. Clement Greenberg's classic theory of (mainstream) modernism imagines quite different objects, which dwell only in themselves: paintings that refer to the painterly surface, photography to the operation of light, and so on.[23] This formulation of medium specificity has been crucial to the proclaimed and assumed universality of what must be named as a European and North American modernist aesthetics. However, the medium of photography itself is not defined the same way everywhere: in Latin America, modernist photography can refer to itself in the interests of ethics and history. The ethos of these simultaneously self-referential and externally referential works also affects what Fernando Rosenberg calls the geopolitics of modernism, for they operate simultaneously as local and universal. The differences in the very definition of the medium of

photography mean that these adulterated and expansive modernist objects produce a vision of modernity that reaches from São Paulo to the Amazon, as well as to Paris and New York.

This theory of ethos intentionally, admittedly, contains the tensions and problems of thinking modernism and modernity in Latin America. Its reference to "a people" and echo of "*ethnos*" frame modernism's troubled deployment of race as primitivism and indigenism. Its anachronistic, old-fashioned sound captures the paradoxical sense of futurity and classicism found in so many modernist photographs and texts, which Gorelik calls the construction of a future for its own tradition. Images of flappers and traditional masks filled the pages of modernist literature and photography, as feminized and racialized bodies were asked to bear the weight of this modern tradition in both Brazil and Mexico. Modern women were alternately vilified, praised, and desired for being both the carriers of tradition and traitors to it, and indigenous peoples were excluded from the benefits of the modern nation even as they became the symbol of its independent identity. As much as the ongoing influence of modernism is clearly visible today, the discomfort caused by ethos is fitting for the analysis of modernist artists and writers criticized both immediately after their heyday and by a new generation of scholars in Latin America. Mário de Andrade's much-cited denunciation of himself and fellow modernists in "The Modernist Movement" (1942) has provided the terms for many of the movement's recent critics: modernism was remote from the political urgency of the time and ultimately unproductive. Recent critiques have argued that modernist indigenism in fact precluded demands by indigenous peoples for their rights as citizens, and that the modern woman was vilified precisely when she sought suffrage and the broader rights promised by the revolutionary projects causing major social change. These tensions are crucial to the structure of ethos because they are the nodes that lead us to analyze what Roberto Schwarz might call the "ideas out of place" of modernism, modernity, and Latin America. They also indicate the relevance of these movements to a contemporary generation of photographers and writers, who face related challenges of globalization, an image-saturated modern world, and new technologies of imaging race and gender.

Errant Ideas: Modernism, Modernity, and "Latin America"

I bring ethos into focus through a comparative map of Mexican and Brazilian photographic modernism, not as parallel examples nor as models of influence within Latin America, but rather as a means of tracking how key ideas of modernism, modernity, and Latin America accrued meaning against the desire of their hegemonic articulation. Theories of Latin American modernism can be (polemically) divided into two extremes: one makes constant comparisons to its European counterparts, either as influence or as difference but always measured by these metropolitan versions; its mirror image rejects any such contact, imagining a utopic postcolonial sphere, miraculously free from the burden of a colonial past. Schwarz reveals the inadequacy of thinking both extremes of influence and originality in the Americas and proposes instead a theory of "ideas out of place." He reasons that the flow of ideas from powerful center to periphery is unavoidable, but that this weaker partner uses these ideas against the dominant power's intent. Thus the very examples of the "imitation" of European ideas in Brazilian arts and letters perform a crucial conversion, which produces the modernist avant-gardes that Bosi describes as simultaneously too original and too derivative. The titular concept of *errancy* thus begins by tracking the movement and disruptions of these key ideas out of place, rather than by judging their originality or condemning their submission to influence. Errancy, explained fully in chapter 1, is first a question of wandering, but also implies an error, which in the case of Latin American modernism is often an intentional one. This trajectory produces a recalibration of theories of modernism and postmodernism, and even of the nationalism long considered the defining political project of these modernist movements.

Photography provides an ideal opportunity to track these errant ideas and the form of modernism they made possible. The camera arrived throughout much of the Americas almost simultaneously with its proclaimed invention in France: the successful design of the daguerreotype was publicized in Rio de Janeiro on May 1, 1839, in the *Xornal do Comercio*, in Lima on September 25, 1839, in *El Comercio*, and in Mexico on February 26, 1840, in *El Cosmopolita*. Brazilian versions of this history contest the originality of the French daguerreotype, asserting that a photograph-like image was produced in a *camara obscura* in 1833 by Antoine Hercules Florence. Florence, a French émigré to Brazil, even

used the word "photography" five years before John Herschel but receives little acknowledgment outside the country.[24] This debate over the most basic facts about the history of photography reveals the heated contest for control over the medium as a major carrier of the ideas and the image of modernity. Given the French origins of this Brazilian inventor of photography, the story itself frustrates any desire for Brazilian "originality" even as it operates as a demand for equal recognition of histories located elsewhere. As an "idea out of place," photography's origins mean far less than the camera's movement internationally, and the circulation of photographs in the press, art galleries, and social scientific studies.

Like photography, each time the words *modernism* and *avant-garde* appear, they seem errant in some fashion, for these basic aesthetic terms do not translate between English, Spanish, and Portuguese. In Spanish America, the word used to designate these experimental artistic and literary movements is *vanguardia* (avant-garde), while the parallel and contemporaneous movement in Brazil is called *modernismo* (modernism). Spanish *modernismo* refers to late-nineteenth-century poetry movements—the very generation against which the *vanguardia* proclaimed its rebellion—which are known for an "art for art's sake" aesthetic philosophy. Yet when Carlos Blanco Aguinaga takes on the task of naming the "sense" of modernity on the periphery, he observes that with the increasing presence of the terminology and theoretical apparatus of *postmodernismo* (postmodernism) in both Spanish and Portuguese, it is more and more common to find *modernismo* changing its meaning.[25] This new use of *modernismo* expands to include the vanguardias. When Mexican art historian Rita Eder describes "el *modernismo* latinoamericano," "Latin American *modernism*, from the twenties and thirties, [which] had among the fine arts the strong support of poets,"[26] her use of the word to stress the visual arts' connection with literary movements effectively broadens modernism's reach, allowing greater diversity and eclecticism within the concept. While "modernismo" used in this fashion appears more frequently in the visual arts than in literature, Eder's application of it to the literary is part of an important disciplinary and theoretical shift. I repeat the errancy of this revised meaning of "modernism" throughout the book, for it both demands entry of these movements into the "universal" and "international" theories of modernism that have generally excluded them, and underwrites recent returns to the period by artists, curators, and scholars.[27]

The renaming of modernism via postmodernism is one of the key uses to which scholars in Latin America have put postmodern theory; it is a means to critique Eurocentric versions of modernity and to theorize alternative modernities. Mempo Giardinelli and José Joaquin Brunner, for instance, agree that postmodernism is the form that modernity takes in Latin America. These studies create temporal as much as spatial ideas out of place, converting postmodernism from the achievement, overcoming, or end of modernity into an opportunity to define global modernity in their own terms. Errant modernism therefore pictures a broad and varied set of practices that continue to circulate among artists at the beginning of the twenty-first century. No longer contained by objects, these practices actively engage popular culture, decenter the authorial subject, undermine scientific truth, and interrupt the forward motion of progress—social, individual, and even narrative. Read thus, they do not obey classic divisions between modernism and postmodernism. Román de la Campa, for instance, attributes Angel Rama's return to a theory of transculturation proposed by Fernando Ortiz in 1940 to the intertextuality typical of the modernist avant-garde, rather than to postmodern pastiche.[28] Silviano Santiago has charted the path for this sort of "rigorous yet personal rereading[s] of Modernism from the perspective of renewal rather than canonicity."[29] Theorizing the ethos of modernism contributes to this process and suggests how and why contemporary artists using photography enact this return with the same goal in mind. The errant modernism pictured here has a contemporary urgency rather than a nostalgic longing.

Despite this reframing of modern and postmodern, it would be impossible not to address discourses of modernization and modernity when looking at modernist art and literature. The ethos of modernism contains the contradictions and violence of the global project of modernity, and functions as both a critique and a blueprint of the form it takes in the Americas. The works that follow certainly reference the historical period characterized by increased urbanization, faster transportation in trains, planes, and automobiles, and new technologies contributing to the development of mass media such as radio, cinema, and photographically illustrated newspapers and magazines. Interdisciplinary combinations of music, text, and image employing these technologies appeared in "mainstream modernism" as much as the places that experienced what Beatriz Sarlo calls "peripheral modernity." The importance for modernist aesthetics of collage, photomontage, and

printing experiments with literature, which referenced the technologies of representation listed above, is as apparent in Latin America as in Europe and North America.[30] However, to state that the meaning of these formal combinations depends on the particular histories of media and disciplines in each place is not quite sufficient. While we can say, for example, that the invention of radio had a tremendous impact on the perceived function and place of music and poetry, that impact was formed in the presence of already existing music halls, conservatories, and musical traditions. These differences are not simply a question of describing the historical context; rather, they call for an examination of the structure of artistic discourses in the region.

At stake here is the danger of collapsing modernism into modernity, of assuming a causal relationship in which modernity is a logical, historical context in which modernism emerges. This logic works no better for "alternative" or "peripheral" modernity than for its dominant examples. Even though I argue that the ethos of modernism contains a theory of the local, this locale should not be confused with Latin American modernity as a context. Contexts can be produced unendingly, such that each drawing of one context only poses the question of the context of that context.[31] The basis for this logic of modernity as context paradoxically has been a view of it as a deterritorializing phenomenon, which produces a universalist modernism. Griselda Pollock, for instance, argues that the long modernism beginning in the late nineteenth century "effaces local particularism in pursuit of ways to deal with its topic and resource, modernity. Modernity can be understood in part as the very process by which local differences were erased and a general culture began to colonize and homogenize the world brought into varieties of contact through colonization, trade, commerce, political power, and tourism."[32] While critical of direct links between modernism and ideologies of modernization as progress, this analysis still presumes that both projects successfully erased local differences. Photographic modernism from Brazil and Mexico shows instead that these very endeavors—colonization, trade, and tourism—in fact constituted difference rather than homogeneity. This does not mean that modernism founds an identity based in difference, but rather that it represents modernity as a violence that erases the very differences of access, wealth, and rights that it creates.

One challenge for any theory of Latin American modernism is to locate its production in the face of this imagined deterritorialization,

while at the same time recognizing the local impact of global projects of modernism and modernization. While it may be tempting to assign peripheral modernism the role of rejecting modernity, not only would this oversimplify the dilemmas faced by these intellectuals, it also would not achieve the kind of defiance of current and former colonial powers they so desired. In fact, many European modernist movements defined themselves through such a rejection of modernity, in order to combat the general despair produced by a metropolitan modernity they perceived as emptied of cultural promise. If Latin American modernists at least to some degree wished to present themselves as doing something *other than* obediently following the hegemonic aesthetic movements, the mere rejection of the modern would fruitlessly repeat their gesture. At a more practical level, it is much easier to disavow modernization if one already enjoys the broader social and economic benefits it brings to some. Tace Hendrick stresses that, for very understandable reasons, the periphery strove to modernize during this period. Anticolonialism in its nationalist form did not simply reject "the modern," nor did it exclude utopian visions of modernization as urban growth, technological invention, and the rapid circulation of ideas and people. Carlos Alonso describes this paradoxical longing and rejection as the strange temporality of modernity, which he finds in both aesthetic production and the socioeconomic situation in Spanish America. He calls this the "somewhere else" of modernity in the region; the very definition of modernity in the region is its out-of-placeness. So while Latin American modernism emerged within the discursive site of modernity, it was neither its opponent nor its henchman.[33]

Brazilian and Mexican modernists self-consciously created their own photographic practices with the same tools credited with the expansion of European modernity, altering them such that the images produced were curiously wrong. This is the second meaning of errancy that I set forth: a way of getting photography wrong, of making the camera take a bad picture. De Andrade called his practice "apprentice tourism," a form of travel and exploration that was both touristic and critical of its own acquisitive gaze. These uses of photography do not locate modernism in the "context" of modernity, but rather represent an intervention into its discursive formation in Latin America. The paths of modernity's expansion characteristic of these decades were not only cleared by foreigners or in foreign lands, but also were topics and practices *within* Latin American modernism. Travel writing and photographs by

major figures including de Andrade and Novo engaged in debates about the relationship between nationalism and touristic propaganda, combining anticolonial rejections of European influence with demands to be taken seriously by the "international" art world. Sérgio Luiz Prado Bellei and Nestor García Canclini name travel to Europe as the formative experience of Latin American artists and writers, and the upheaval of these decades as a focus on Europe rather than the nation. According to García Canclini, Mexican artists became nationalist vanguardists by "discovering" their native land in Paris. Even as they also looked elsewhere for the imagined modern, I find that these movements seriously examined and engaged modernity's inscription on the bodies and lands that they sought to designate as "here." Travel abroad was important to modernist aesthetics, but so was travel within these countries, especially "apprentice tourism" and a related practice of domestic tourism in Mexico. These Brazilian and Mexican journeys share strange and defining effects on modernist aesthetics: a contradictory exoticism of the familiar, distinct threats to embodied explorers, and women travelers who threaten to alter the practice of travel entirely. If Rosalind Krauss's foundational theory of (Euro-American) modernism relies upon John Ruskin's description of travel as "contemplative abstraction from the world," the travels examined here lead instead to aesthetic as well as ethical decisions about a world of colonial and national expansion.

This book itself errs as it strives to produce a Latin Americanism out of place through a comparative study of Mexico and Brazil. The debate over Latin America is contemporary but also very much of the period, when the idea of Americanness appeared in fiction, poetry, and visual culture.[34] During these decades, both countries sought to elevate their regional political influence, simultaneously employing nationalist and Americanist rhetoric against the increasing presence of the United States in the region. As Mexico struggled to show that the country had survived and moved past the Revolution and could be included more fully in the international sphere, Brazil sought a foothold in Spanish America.[35] Though not extensive, cultural and artistic exchange between the two reflected their shared projects of political, economic, and cultural integration into the region, most visibly in the form of José Vasconcelos's journey to Brazil in 1922 to celebrate the centenary of its independence, Alfonso Reyes's long residence there as ambassador in the 1930s, and Cândido Portinari's murals influenced by the

Mexican school. Yet even as Mexico and Brazil played and continue to play major roles in Latin American economies, politics, and culture, each is set at a distance from Latin America. Brazil stands apart, an enormous, Portuguese-speaking land mass; Mexico is the lone Latin American country in North America. For these differences and many more, Mexicans and Brazilians often do not consider their countries to be part of Latin America. While their dominance in the region may invite an assumption of their representative quality, I propose to imagine Mexico and Brazil as the receding point of the idea of Latin America, dominating any definition of the region yet productively, errantly never quite fitting into it.

Traditional structures of Latin Americanism reduce the differences among the countries in the region, glossing over the conceptual disruptions caused by Portuguese-speaking Brazil, North American Mexico, and the multilingual Caribbean in order to impose a smooth surface of unity. Yet comparative studies can also reveal the modern sense of colonial histories in the region, particularly as a means of critique of the foundational national myths that paradoxically built upon them. Errant Latin Americanism is located on the margins, in the postcolonial space, even as the borders of that space by definition are constantly penetrated by colonial power. The history of the idea of Latin America itself contains this movement and makes the identities of natives and foreigners difficult to determine. While the term has been rejected of late as the invention of nineteenth-century French intellectuals, its oft-proclaimed foreignness is not entirely clear-cut. Citing Colombian José María Torres Caicedo's *Unión Latinoamericana*, Arturo Ardao argues, "This baptism [as Latin America], although it took place in Europe, was to be the work of Hispanic Americans, not of Europeans . . . the idea of the Latinity of our America appears for the first time in the pen of native inhabitants of it."[36] Even these displaced origins, however, are only ever the myths and desires of history. Ardao's "native inhabitants" were Creole elites, not Native Americans, whose naming defined an "independent" Latinity only insofar as it served their controlling interests. However, he continues that the power of naming "Latin America" came to function as a counterpoint to Anglo-Saxon North America; it was an anticolonial gesture that relied upon new articulations of regional identity.[37] The colonial condition that connects the divergent artistic and cultural experiments of the twenties and thirties is thus

doubled in the employ of *Latin America*, a term born in the period of the region's independence from Spain and fully defined in opposition to the new power of the hemisphere, the United States.[38]

The Latin America that appears in this study is anticolonial and yet not nationalist, for the comparison of Mexico and Brazil reveals a critical nationalism that is substantially muted when we remain within their national borders and national myths. Salvador Novo's "Return Ticket" may best represent this Latin Americanism, despite the Mexican author's famous rejection of regionalism. As I argue in chapter 5, Novo's fictionalized memoir combines a denunciation of U.S. expansionism with a critique of Mexican nationalism, bizarrely mixing American English phrases with colorful details about popular culture in Mexico. Errant Latin Americanism contests European and U.S. influence, but it nonetheless admits the irrevocable impact of their colonial and interventionist projects. The qualified nativity of the modernists themselves will be central to the debates over the place of modernity, and the ethics and aesthetics of modernism.

Ethics and Photography: Knowledge, Science, and Modernity

Paul Strand wrote in the international journal *Broome* that the photographer "has taken to himself to love a dead thing unwittingly contributed by the scientist, and through its conscious use, is revealing a new and living act of vision." These "seekers of knowledge, be it intuitive and aesthetic or conceptual and scientific" are "disinterestedly experimenting."[39] During these decades, photographs circulated as art and science, amateur and professional. Artists and authors debated whether photography mechanically inscribed reality or was itself a creative act, an issue reflected in the fact that the standards of defining authorship and protecting the copyright of photographs were not yet fixed. In Latin America, the intimate contact between the artistic and the scientific led photographic modernism to challenge a defining characteristic of modernity as a "rationalist culture in which . . . a scientific world-view . . . claims privileged access to truth."[40] Despite Strand's assertion, Latin American photographers made it clear that they had a vested interest in the epistemology and aesthetics that their medium formulated. Mário de Andrade's photographs were part of his lifelong experiments with documentary practices, and Manuel Álvarez Bravo's

oeuvre plays with reflections, reversals, and cropping, to disorient the eye of the viewer and make her doubt the image she sees. At the same time that the major institutions of knowledge production in the region were being reinvented, modernist intellectuals used photography to rethink the very concepts of knowledge, truth, and representation.

The implicit relationship between seeing and knowing—the scientific process that asserts the facticity of observed experiments—is at the core of modern conceptions of truth. While the scientific truth of the visible ought to be universally accessible, Idelber Avelar points to the unequal global division of intellectual labor produced by this form of knowledge: certain sites are valued for their production of knowledge and others simply are not. Avelar proposes that ethics itself be defined as the concern for this inequity, as "the very relationship between ethos and episteme," and that it can in turn assign value (and truth) to other forms of knowledge.[41] Avelar formulates this definition of ethics through an analysis of Jorge Luis Borges's short story, "The Ethnographer" (1969), which tells of a student of ethnography from the United States who discovers the carefully guarded secret of an indigenous group. When he returns from the field to the university, however, the student violates the very premise of the discipline: "He walked up to the professor's office and told him that he knew the secret and had resolved not to publish it."[42] Avelar concludes that the story's ambiguous ending rejects the limitation of the other to the status of object of study and denies that the knowledge produced by this exploitative process could ever belong to the foreign social scientist. Indeed, Borges shows that recognition of the relationship between knowledge and ethics is the only means of achieving understanding across difference; real knowledge was achieved by the student, who learned the secret and learned to keep it. This understanding does not imply complete or scientific knowledge; in fact, achieving that form of knowledge would be less than ethical. Borges leads us to wonder if the necessity of secrecy is the secret itself.

What remains to be defined in this exploration of ethics, however, is the place of the Latin American intellectual, as well as the foreigner, in the global map of knowledge and power. To put the question in terms of Borges's story, we must ask: what happens to the Brazilian or Mexican ethnographer? Which role belongs to the Latin American modernist: that of the ethnographer or of the "native"? I find that Borges's generation of modernists goes even further in the challenge of ethos and

episteme. Photography's simultaneous distancing and approximation and the doubled location of the displaced intellectual bring modernist aesthetics and its profound relation to ethics into focus.

In Brazil and Mexico in the 1920s and 1930s, the paradox of photographic veracity offered opportunities for ethical and aesthetic interventions into this contested terrain. Photographs functioned as evidence even as they were employed to violate viewers' belief in what they saw. Roland Barthes explains that the structural paradox of photography as both analogue and code is also its ethical paradox: "When one wants to be 'neutral,' 'objective,' one strives to copy reality meticulously, as though the analogical were a factor of resistance against the investment of values."[43] This "as though" is at the crux of thinking ethics and photography, not because it was erased by Latin American modernists, but to the contrary because they underlined the tension as an ethical bind. The very indexicality of photography, its analogical ability to trace each object in its purview onto the sensitized paper, appears counterintuitively as its ability to invent and deceive. In what de Andrade called "epidermic portraits," as well as photographic short fictions by Mexican modernists, the very characteristic of photography most associated with its ability to tell the truth in fact makes it deceive. Modernists invented in order to reveal the (imperial) history of representation contained in any photographic capture; they deployed this technology to create alternate visions of the very modernity that photography always already references.

The rejection of the truth of modernity, though not its power, occured in representational practices that obscured as much as they revealed. As much as photography participated in modernity's fundamental association between knowing and seeing, in Latin America it offered a fascinating opportunity for Borgesian sorts of hidden and even deceitful presentations of knowledge. Since the advent of "postmodern" photography in the 1970s, the medium's unreliability has received a great deal of attention. From posed film stills to invented ethnographies, artists such as Cindy Sherman, Jeff Wall, and James Casebere have produced faked and staged photographs, inventing characters, settings, and events. In his "Monticello" series (2001), Casebere flooded architectural models of buildings that he then photographed from close up, so that they appear almost as if they were real buildings (see plate 1). Yet we will see that the mimetic accuracy of photography was teased, questioned, and joked about since its invention, especially during the

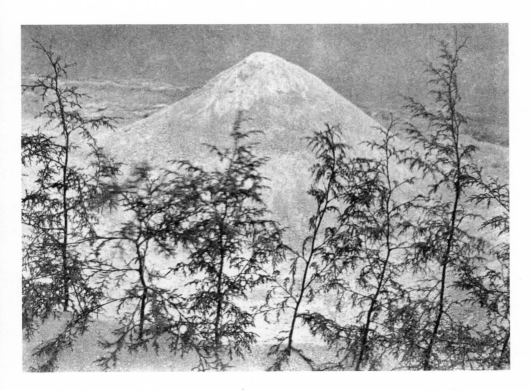

2 Manuel Álvarez Bravo, "Arena y pinitos" ("Sand and Little Pines"), circa 1920s.

© Colette Urbajtel

period of modernist production. In "Arena y pinitos" ("Sand and Little Pines"), Álvarez Bravo photographed a mock-up of the kind of pictorialist landscape of Mexico that made German photographer Hugo Brehme famous (figs. 2 and 3).[44] Casebere's flooded building and Álvarez Bravo's title include just enough distortion for their photographs to be simultaneously grandiose and a little ridiculous at the same time. They take the viewer in and soon let her know that she has been duped. The photographers considered the progenitors of art photography in Mexico and the writers whose work inspired the internationally renowned generation of the Boom created a photographic modernism that took on the crucial dynamic of truth and seeing.

During this same period, the institutions responsible for the production of knowledge in Latin America, from universities to literature to newspapers, were undergoing profound changes. These changes contributed to the critique of Western modernity's epistemological

promise and emphasized the relationship between ethics and knowledge. While still governed by dominant classes, the *ciudad letrada* (lettered city)—Angel Rama's denomination of the urban, Creole intellectuals who wrote the literature and the laws of the Americas—was being transformed in both its real and metaphoric senses. The "real" city experienced massive demographic shifts from rural to urban, as well as changes in the gendered expectations of public and private spaces. Industrializing São Paulo grew from 64,935 inhabitants in 1890 to 579,033 in 1920, a population composed of new immigrants from Europe and Japan as well as migrants from the interior of Brazil.[45] The rate of change for Mexico City was equally radical: in 1900, Mexico City had a population of 344,721, which rose to 615,367 in 1921, and then skyrocketed to 1,029,068 in 1930 and to 1,802,679 in 1940.[46] Thousands of rural Mexicans and Brazilians were arriving in the cities, populations who were perceived to be racially distinct from the established

3 Hugo Brehme, "Peak of Orizaba," *México pintoresco*, 1923. *Courtesy Dennis Brehme*

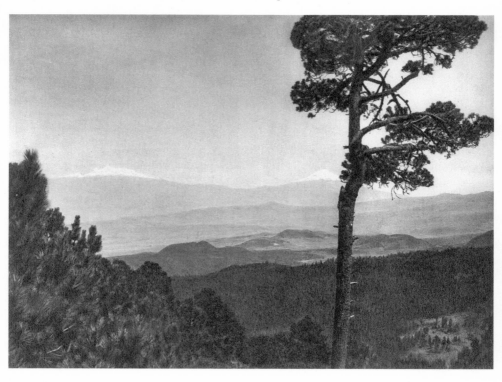

urban populations. More and more women began to work outside the house, gaining visible presence in public spheres not traditionally open to them. The *letrados* created new ideas about knowledge, about truth and seeing, as they sought to respond to these changes in the definition of the city itself.

The institutional structures underlying literature and the arts, the ciudad letrada, were also undergoing deep transformations. University reforms of the late 1910s meant that the traditional degrees in law and medicine held by the aristocratic elite no longer guaranteed the same role in society and politics, and the antioligarchic project of these reforms clamored for the rights of the underprivileged classes. García Canclini points to the contradictions faced even by the reformed universities: "Confronted with the illiteracy of half of the population and with pre-modern economic structures and political habits . . . literary practices are conditioned by questions about what it means to make literature in societies that *lack a sufficiently developed market for an autonomous cultural field to exist.*"[47] Latin American modernisms—though hardly successful in their utopic goals of a shared nation, and still characterized by the vast divide of class and race that split the elite from the masses— created "new aesthetic trends within the incipient cultural field and novel links that artists were creating with the administrators of official education, unions, and movements from below."[48] Darryl Williams even calls the Week of Modern Art in São Paulo the beginning of the erosion of the ivory tower, which pulled "the medieval image of the scholar-in-the-turret" down into the flow of people. These changes led to a new kind of professional class of writer/intellectual, who began almost to scratch out a living by writing, addressing, and participating in varied forms of popular culture. Williams describes new cultural practices put to use by this new generation, including popular literature, cinema, sports, and even *automobilismo*, in which driving cars bridged tourism, art, literature, and the newly formed mass media.[49] I show that these cultural practices—all of which employed photography—played an important role in the articulation of modernist aesthetics in both Brazil and Mexico and made race and gender crucial formal and philosophical categories. The transformations of the ciudad letrada were translated into ethical and aesthetic demands, which profoundly altered the status of knowledge in Latin American modernity.

These changes in the lettered city have been associated more with Latin American modernism's political, nationalist charge than with ethics as such. Internationally and regionally, Mexican muralism and Brazilian anthropophagy long have been emblematic of nationalist modernism, including large murals in public space, educational projects, and essays of identity. Muralism in particular—paid for by state funds invested in promoting national culture following the violence and social chaos of the Mexican Revolution (ca. 1910–20)—repeatedly appears as the dominant example of what Latin American modernism looks like and certainly has had a major influence on political art throughout North, South, and Central America. Yet these decades of energetic cultural production reveal a range of experimental practices in literature, media, and the arts in addition to muralism (in Mexico and beyond), all of which engage ethics as well as politics. Thinking errant modernism draws our eye to these practices, which alter the classic division between political avant-garde and high modernism: the former defined by its social engagement, the latter by a definition of modern art exclusively referencing the artistic, either art institutions or the materiality of the artwork.[50] Critical responses in the burgeoning field of comparative and non-Western modernist studies are producing exciting new possibilities to replace this dyad, but there is still an emphasis, especially in studies of what we might call "strong" modernist movements such as the Mexican and Brazilian examples, on the political and the state.[51] I find that sophisticated critiques of modernity and formulations of modernism in both countries have been overdetermined by attention to these nationalist projects. Two presumably opposing options, hermetic poeticism and political manifesto, were combined through a photographic practice grounded in ethics and aesthetics, and produced critical rather than cultural nationalism. Critical nationalism emerged in response to the push and pull of anticolonial and nationalist discourses, especially as they faced the idea of modernity as economic modernization and the rhetoric of modernization as progress.

Jorge Schwartz writes that attempts to differentiate "political vanguardia" from "artistic vanguardia" in Latin America ultimately fail.[52] Not only did individual artists belong to both types of movements at different moments in their careers, but the very same works appeared in different contexts as alternately political and artistic avant-garde.

Nonetheless, most studies of the most influential modernist groups in Mexico, the Estridentistas and the Contemporáneos, separate them on the basis of the quarrels over art and nationalism that divided them during their short lives as constituted groups, a battle that maps easily onto the conceptual divide between political avant-garde and formalist modernism.[53] The Estridentistas (active ca. 1921–27) were considered more "political," even if their vision of art and politics suffered from accusations of Italian futurist influences. The Contemporáneos (active ca. 1928–32), were characterized as producing pure poetry (although also suffering from European influence). These groups were more similar than the bibliography admits; many of the most influential figures are included in the membership lists of both groups, among them Diego Rivera and Salvador Novo.[54] Similarly in Brazil, despite Eduardo Jardim's classic division of two phases of modernism—the "heroic" phase (1917–24), which focused primarily on aesthetics, and a phase of nationalist didacticism (1924–42)—both critical nationalism and experimental aesthetics appeared consistently across the two decades.[55] Indeed, Aracy Amaral characterizes Brazilian modernism as a middle ground between politicized nationalism and aestheticized cosmopolitanism. Mário de Andrade collaborated in a heteroclite variety of journals and modernist groups, including *Estética* in Rio de Janeiro and the Grupo Estrela in Belo Horizonte. This book reunites the two sides of these dyads, and elucidates the groups' sophisticated combinations of art, ethics, and politics as the ethos of modernism.

Recent ethical theory, especially in the U.S. academy, admires the mixture of politics and art associated with the avant-garde and calls for a return to these decades. "Peripheral" literature and racialized and feminized subjects are central to this field of inquiry. However, while providing a sophisticated critique of modernity, this theory suffers from its neglect of aesthetics outside of modernism's classic centers. Lawrence Buell proposes that ethical criticism revisit the modernist avant-garde's celebratory combination of criticism, art, and politics, but in practice he solely recuperates European and North American avant-gardes.[56] It may be easy to agree that one must think about ethics when studying non-Western cultures from within the U.S. academy, but I argue that assuming a "naturally" ethical, simply moral art from the periphery threatens to vacate the aesthetic and critical content produced by these different places. Such a presumption risks once again delimiting the space of the non-Western artist or critic to a (post)modern version of

the "noble savage": innocent of the guilt of colonial exploitation, but also excluded from an active role in analyzing global systems of modernization and modernism.[57] It paradoxically reproduces the peripheral status of Latin American modernisms ad infinitum, limiting these artists to the presumed ethical place of the ethnographic other; the West ultimately maintains ownership not only of the telos of modernization but of modernism's critique of the modern as well. The ethos of modernism, in contrast, offers a form of ethical criticism based in Latin American modernist approaches to art and life, politics and ethics.

Even some alternative modernist studies, which have done important work in geographically diversifying the field, diminish the aesthetic concerns of these movements in favor of a propagandistic or didactic political function. They do so by equating the difference of Latin American modernism with the countries' statist nationalism, and by dividing the art object or literary text into a European form and Latin American content. Brazilian modernism thus asserts its difference by inserting a "typically Brazilian" object into an imported composition.[58] Mexican modernist photography is perhaps the best known among Latin American countries, and yet even its most recognized artist, Manuel Álvarez Bravo, is too often read in relation to the aesthetic goals set by U.S. modernist Edward Weston during his brief residence in Mexico between 1923 and 1926. Erika Billeter writes: "Although [Álvarez Bravo's work] *formally* inclined toward the *international* tendencies, his vision evolved from the roots of his country."[59] Aesthetics in this mode of thinking remains always European, while the periphery produces only the objects to be represented. These objects can be exploited in the same fashion as the natural resources in the Americas, for they seemingly take no work to produce and contain no philosophy of art of their own.[60]

Mainstream modernist studies established the groundwork for the seeming aesthetic vacuity of places outside of Europe and the United States by presuming that artistic influence always follows economic and political power. Even sophisticated readers of modernist photography such as Molly Nesbit fall into this trap, producing texts that I view to be symptomatic of this geopolitics of aesthetics. Nesbit, for instance, paradoxically makes Edward Weston's formalist photographs decidedly nationalist when she addresses his years in Mexico: "[Weston] prized . . . realism, meaning by this a denatured, aestheticized realism. It was never the social realism of his Mexican colleagues. Weston's avant-

garde position was an American one, based on the significant forms of the straight document and formulated long distance in Mexico, on a tangent from Steiglitz."[61] All of Mexican modernism is encapsulated in a reductive vision of muralism, and in this reduced fashion can present no possible impact on the famous U.S. photographer, despite the fact that he produced some of his best-known work in Mexico.

We shall see that Mário de Andrade and Álvarez Bravo created photographs that comment on this geopolitics of aesthetic value. The Mexican artist's "Urinating Boy" parodies the version of formalism Weston represents for Nesbit, and de Andrade's "Victrolas" literally turns the image of the modern circulation of goods and images on its side (see figures 12, 60, and 61). These works use humor and critique as part of the formal complexity of modernist objects characterized by internal and external references. The ethos of Latin American modernism engages aesthetic concerns that have long been considered central to modernism internationally: abstraction, medium specificity and the purity of the art object, opticality versus narrativity, and the long-debated relationship between "high" and "low" culture.[62] However, the recognition of certain familiar concerns of mainstream modernism does not ultimately negate the urgent need to theorize these other sites. The ethos of modernism reveals the simultaneous location in and distancing of Latin America from hegemonic discourses of modernism and modernity; it points to the necessity of critique and the impossibility of remaining free from these dominant political, literary, economic, and artistic modes.

Brazilian anthropophagy famously provides a graphic answer to this structure of cultural influence: the digestion of foreign and local content alike in the production of modernist aesthetics. The São Paulo Anthropophagists, led by writers Mário de Andrade and Oswald de Andrade (no relation) and painter Tarsila do Amaral, took center stage with the Week of Modern Art and maintained their dominance in the decades that followed. Oswald's "Anthropophagist Manifesto" (1928) did more than just parody Shakespeare when he proclaimed: "Tupi or not tupi, that is the question." By inhabiting the famous playwright's English with the name of one of the major indigenous groups in Brazil, Oswald does not destroy either. Rather, he eats them up in a sentence that transforms the most ontological of verbs, "to be," into a joke that asks the pressing question of whether indigenous people will survive modernity in the Americas. The Paulistas maintained their dominance

throughout the century, but as we shall see, Mário de Andrade's active engagement with writers and artists in distant parts of Brazil contributed greatly to his theory and practice of modernism. His broad investigations into the vast terrain and the heterogeneity of cultures of Brazil, especially through his practice of photography, contributed to what Amaral considers the main contribution of Paulista modernism: the presentation of the idea of national culture as a *problem*.

The ethos of modernism maintains a distinction between ethics and politics but does not exclude the defining debates over politics within and about these movements. Throughout the book, the ethics formulated by these groups is shown to be linked to the production of a critical nationalism, rather than the cultural nationalism that was the tool of the centralizing and modernizing states. Paul Gilroy's influential map of the Black Atlantic (to which Brazil and Mexico would certainly belong) contains critical and artistic practices that resemble ethos as I define it: "Not simply a succession of literary tropes and genres but a philosophical discourse which refuses the modern, occidental separation of ethics and aesthetics, culture and politics."[63] While Gilroy's parallel sentence structure sets up a relationship of equivalence between "ethics and aesthetics, culture and politics," I focus on the first pair of reconciled oppositions. The simultaneous engagement of the aesthetic and ethical in photographs and literary texts, as well as critical writings from the period, produces a modernist ethos that is more important to rethinking modernism and more relevant to the contemporary moment than the second pair of "culture and politics." These two pairs of concepts usually are subsumed in discussions of the nationalist tenor of many Latin American modernist movements, which often use Brazil and Mexico as prime examples and include influential groups in Cuba and Peru. Gilroy's "culture and politics" was an important dyad in the period, but more than the *problem* of national culture, it describes the nationalism promoted by the cultural missions of postrevolutionary Mexico and the work of Brazilian modernists for governmental cultural and educational programs, especially in the years following the Estado Novo revolution (1930).

The decades of greatest modernist experimentation, however, preceded the consolidation of power as revolutionary governments became authoritarian regimes. Darryl Williams calls the productive chaos before the consolidation of culture and politics the "culture wars" of Brazil, a term Anne Rubenstein uses to describe the same years in Mexico.[64]

While modernism was made to work for the interests of the centralized governments by the end of the 1930s, the articulation of nationalism by artists and writers in the preceding two decades was not so monolithic. Despite the centralization that characterized both governments' plans for modernization, these movements were not born in their respective country's capital cities.[65] The famous Week of Modern Art (1922) in São Paulo stood explicitly in contrast to the International Exhibition in the capital of Rio de Janeiro the same year, which celebrated the Centenary of Independence and promoted the official state discourse of order and progress.[66] The canonization of the São Paulo–based modernist group certainly has to do with the city's increasing economic power as the industrial capital of Brazil, but its displacement from the administrative center of the federal government is nevertheless significant. In highly centralized Mexico, the Estridentistas first mobilized in the small city of Xalapa, Veracruz, which has an important intellectual history but was by no means a political center of the postrevolutionary government. The members of the Mexico City–based Contemporáneos were originally from different places across the vast country: Xavier Villaurrutia was born in Mérida, in the south, Salvador Novo lived his early years in northern Torreón, Gilberto Owen was from Toluca, Jorge Cuesta from Córdoba, and José Gorostiza from Aguascalientes.[67] The horizon of modern Mexico and Brazil drawn by the writers and photographers addressed here was not limited to their centers of administrative control, and their vision of critical nationalism reflects it. In his classic essay on anthropophagy, Haroldo de Campos argues that a reborn baroque character of Americanness exploded in the Brazilian movement of the 1920s, which plots "nationalism as a dialogical movement of difference."[68] This critical nationalism with no origin repeats in distinct constellations, or movements, from the historical avant-garde to Concrete Poetry, and functions as the very condition of possibility for a modernist avant-garde in the aftermath of colonial violence.

Ethos underlines the existence of a modernist aesthetics in Mexico and Brazil and seeks to free it from a theoretical enclosure that locks works of art into an instrumental understanding of what expressive culture does in the social or political sphere. It reveals that the impact of these movements cannot be judged by the successful delivery of a message or the iconic utility of a single or set of works of art, nor can it be limited to state-funded nationalist projects. By joining ethics and aesthetics in this word, this book overcomes the entwined theoretical

structures that oppose political avant-garde to hermetic modernism and an always foreign aesthetic to merely local objects. The ethos of modernism in Mexico and Brazil is neither obsessed only with form nor can it be reduced to a didactic, political message. These movements developed theories and practices that reflect a concern with the medium of representation—an aesthetic of radical presence focused on the object itself—while always already producing that object in dialogue with the social tensions of being in a particular place. As a result, modernism contributed a critical nationalism, which pictured Mexico and Brazil including groups who inhabited a marginal form of citizenship: Afro- and indigenous populations, women, and homosexuals. We will see how de Andrade and Novo's sexuality framed their articulation of both the ethos of modernism and a critical nationalism, adding another level of intensity and complexity to photographic modernism's practices of revealing and hiding, documenting and inventing. These modernist groups were certainly anxious about the political implications of this image of nation, and at times even turned to reject it themselves. Nevertheless, their intimate and active engagement with photography locked them into an errant modernism defined by a fusion of ethics and aesthetics.

The Ethos of Modernism

The two main parts of this book follow a parallel structure, the first half dedicated to Brazilian modernism, in particular Mário de Andrade's photography, and the second to Mexican modernism's interaction with photography in the pages of illustrated magazines. Chapters 1 and 4 deal with ethos as place and a broader social locale, while chapters 2 and 5 address subjectivity and a more individuated inhabitation of those places. They are joined by a theoretical interchapter whose topic and function is mediation: it makes the transition from Brazil to Mexico, from the photograph itself to the circulation of photographs, and from ethnographic or folkloric popular culture to mass culture. The images in the two parts look very different, both because the ethos of modernism did not impose a particular style, and because photographic modernism actively engaged very different forms of popular culture to compose an ethics and aesthetics.

Chapter 1 examines the ethos of modernism in the photographic

landscapes that appear in de Andrade's literary, theoretical, and folk-loric work.[69] Ethos here demarcates a shared space, the aesthetics of a particular place. In addition to the definition of ethos as home, however, a less familiar sense exists that stems from the word's Greek root, meaning "to wander."[70] The dual meaning of ethos appears in Mário's fascination with the idea of *erring*, meaning both to move and to be full of errors, a repeated trope in his mixed-media manuscript *O turista aprendiz* (*The Apprentice Tourist*), as well as the canonical works of poetry and fiction that have dominated Brazilian literature through the twentieth century. Simultaneously travel diary, ethnographic text, folkloric collection, poetry, and fiction, *O turista aprendiz* includes photographic and literary landscapes that show Mário's struggles to find his place. Like modernist landscapes in general, this errant ethos engages abstraction, but his abstracted landscapes foreground the ethical dilemma of the Latin American modernist intellectual. In contrast to the purity so often ascribed to this dual entity of abstraction/landscape, Mário configures the place of Brazil as always partially deferred or inaccessible, and nevertheless a locale crucial to any theory of modernism.

Chapter 2 presents Mário's photographic and literary portraits as a form of Brazilian primitivism, which creates an image of national and individual character that overturns Freudian narratives of modern subjectivity. This primitivism develops in photographs that show Mário to be the object of representation even when he is the photographer, an experience that he proclaims to be the basis of a modernist sublime. Pushing the mimetic habit of photography to its limits, Mário presents a racialized, modern subject—and himself as such a subject—via strange poses and obscure language, which he insists can bridge the hermetic and the political. Read alongside these photographic portraits, his foundational novel *Macunaíma: O héroi sem nenhum caráter* (*Macunaíma: A Hero with No Character*, 1928) prepares us for a radical repositioning of portraiture, ethics, and aesthetics. This hero is ethical in a different sense: he both reflects the painful inheritance of colonialism and resists its influence. The ethos of modernism creates a blurry yet accurate portrait of a reconfigured subject, creates a sublime based on being the object of a gaze, and sets out ethical and political proposals for the character and rights of modern citizens.

Chapter 3 shifts from Brazil to Mexico through a return to the question of the great divide between elite and mass culture, and the idea of the popular.[71] Photography carried elite culture into the popular and

back again, blurring the boundaries between artistic and ethnographic photography and illustrating experimental literature in mass-media publications. Mexican and Brazilian modernists did not simply mine the popular for exotic and scandalous images but rather actively located themselves within it, as producers and consumers of mass and popular culture. Expanding on Martín Barbero's theory of mediations, I propose that the modernist avant-garde's active participation in photographic mass culture recasts the relationship between race and modernism examined in the first two chapters, and I add to recent critiques of mestizaje, the long-dominant discourse grounding Latin American identity in racial mixture. The gender of modernity is crucial to this critique, as femininity operates as a tense and conflictive means of mediating between the modernist ciudad letrada and the modern city.[72]

Chapter 4 presents extensive archival evidence of this strange mixture of popular and modernist avant-garde: photo-essays, poems, and stories by Estridentistas and Contemporáneos that filled the pages of the new mass media in Mexico. Unlike a traditional view of the visual as an obedient and docile feminine, photography offered a distinctive modernist aesthetic that I term the *bellas artes públicas* (public fine arts). Salvador Novo calls the medium "the prodigal daughter of the fine arts"; a rowdy and active femininity in circulation through the city, she is popular, mobile, energetic, mass-produced, curious, and mechanical. The ethos of modernism pictured by this photographic feminine produces an ethics that both appears in stark contrast to the traditional morality associated with women's prescribed domesticity and formulates aesthetic ideals far from the formal concepts of light and line associated with artists such as Weston and Strand. The public sphere of *El Universal Ilustrado* and other similar illustrated magazines, in dramatic contrast to the masculinist space of the murals, repeatedly printed photographs of modern women in photo-essays that redefine the classic genre of the Latin American essay of identity. These popular photo-essays restructure the path of the essay, causing the critical eye of the elite "man of letters" who traditionally served as its narrator to err. Rejecting the moralisms of both Catholic femininity and the secular Revolutionary *caudillos*, they present a radically different image of the socially engaged artist. In this modernist ethos, varied and uncontrollable performances of femininity are perversely constitutive of the artist as ethical critic.

The bellas artes públicas that filled the journals described above also

invaded the poetic and extremely aestheticized novels by Mexican modernists examined in chapter 5. As much as these short novels have been studied and anthologized, their successive reprints have erased their connection to the illustrated journals and the photographs that pervaded them. This chapter details the theoretical debates over photography's evidentiary force that appear in modernist fiction and relates them to the work of Manuel Álvarez Bravo, whose images play with invented documentation and invisible forces. Mexican modernist prose, incorporating photography as a trope, creates an ethos of modernism based in imagined evidence and documentary fictions. Jaime Torres Bodet, Arqueles Vela, and Salvador Novo created a visual and literary genre of fiction that has little to do with the determination of its truth or lies but rather uses images and concepts learned from photography to reconstitute the status of evidence so central to the discourse of modernity.

The book closes with an epilogue on the contemporary art practices that continue to engage the ethos of modernism. In 1996 Mexican performance artist Maris Bustamante proclaimed that contemporary non-object art in Mexico is the heir of a set of practices that first emerged in 1922 with Estridentismo. She explains: "It has seemed more interesting to me to try to find the roots of these forms of contemporary visual thought of the end of the century in Mexican culture itself."[73] Bustamante's national specificity and anachronistic return to the 1920s throw into question an entire set of assumptions that underwrite the idea of contemporary international art, as well as the relevance of a similarly globalized postmodern theory to her generation's body of work. This revision of the trajectory leading to contemporary art practices does not just refer to Estridentismo, it also reenacts the group's critical and artistic procedures of manifesto and critical nationalism. Similarly, in the renowned 1998 São Paulo Biennial, head curator Paulo Herkenhoff challenged the participating foreign curators to respond to Oswald de Andrade's famous "Anthropophagist Manifesto" in their galleries. Like Bustamante, Herkenhoff does not simply position modernism as a historical movement that contemporary art must surpass, he anachronistically locates it as a contemporary theoretical and artistic challenge. Neither of these leading figures in the Latin American and international art world treats the modernist avant-garde with nostalgia; instead, they find that strategies used in criticism and art production in the second and third decades of the twentieth century are critically relevant in the beginning of the twenty-first.

1

He lived all this right around
here and he lived it for real.

MÁRIO DE ANDRADE

Landscape

ERRANT MODERNIST AESTHETICS IN BRAZIL

Setting off on a monthlong journey that will take him from bustling São Paulo to the farthest internal border of Brazil with Peru and Bolivia, his small Kodak camera in hand, Mário de Andrade panics: "My impression is that everything is wrong [*errado*]. I had an urge to fling all those people in the wagon, to stay on that eternally *Paulistana* platform, and to cry contently to my departing friends: "'Bye folks! Bon voyage! Have a lot of fun . . . Bon voyage!'"[1] Although Mário was one of the few modernists who never went to Europe, he was also one of the few who traveled throughout Brazil, complaining bitterly all the while. His two major journeys were the source for the manuscript *O turista aprendiz*, which includes the trips as separate sections subtitled "Viagens pelo Amazonas até o Peru, pelo Madeira até a Bolívia por Marajó até dizer chega—1927" ("Journeys through the Amazon until Peru, up the Madeira until Bolivia through Marajó until saying enough—1927") and "Viagem etnográfica" ("Ethnographic Journey" [1928–29]). The manuscripts include detailed trajectories as the modernist writer and photographer from São Paulo discovers the vast regions

of the country that were so crucial to its self-definition, as well as its image internationally. The impressive Amazonian trip, covering thousands of kilometers, began in São Paulo on the steam ship the *Pedro I*, stopped shortly in Rio de Janeiro and headed up the Atlantic coast to Recife, São Luis, and Belém, then up the Amazon through Santarém, Parintins, Manaus, Tefé, Remate de Males, and Iquitos in Peru. On the return, Mário went by train to Bolivia, later returning to Marajó and eventually arriving home in São Paulo. The "Ethnographic Journey," also lasting approximately three months, went into the famous northeastern region, taking Mário to Pernambuco, Alagoas, Rio Grande do Norte, Paraíba, Natal, Maceió, and Recife. The two journeys are related in a parodic and inventive manuscript that combines tourist diary, ethnographic and folkloric collection, poetry, photographs, drawings, and fictions.

The crucial word in the opening passage of Mário's manuscript is *errado*, meaning both errant and erroneous, lost and mistaken. Each time the word *errar* appears, we must simultaneously picture a movement and an intentional mistake. Mário is not simply weary of the burden of the educated, civilized traveler setting off into the wilderness. He is certain that he is the wrong man for the job, or as we shall see, that he is the right man to do the job wrong. Mário even differentiates the serious and organized results of his "Portuguese error" from Oswald de Andrade's linguistic jokes, which he finds to be merely comic.[2] In a Brazilian modernist ethos everything must be "errado," which means that it is both local and out of place, ethically engaged but judged to be wrong, and, finally, abstract but referential.[3] Mário composes this errant modernism in literary and photographic landscapes, simultaneously reproducing and parodying the genre natural to colonizers, naturalist explorers, and even members of the international avant-garde who visited Brazil, such as Blaise Cendrars and Filippo Marinetti.

Like any genre, landscape has its rules of conduct and a history in both the visual and literary arts. In the eighteenth century, cultured domestic landscapes showed smooth fields and shapely bushes, revealing no trace of the work done to create their views.[4] Scientist-artists of the period followed global explorer Alexander von Humboldt's insistence upon the primacy of landscape in humanity's sense of place in the world, and thus the naturalized appearance of order in these images were "the expression of control and of command."[5] In the nineteenth century, colonial images benefited from the self-evidence of dominion

and place in landscape, and they subtly offered up lands for acquisi-
tion behind this veil of the apparent right to behold and obtain them.
Landscape's naturalized conventions made it "an international, global
phenomenon, intimately bound up with the discourses of imperial-
ism. . . . Landscape might be seen more profitably as something like
the 'dreamwork' of imperialism . . . disclos[ing] both utopian fantasies
of the perfected imperial prospect and fractured images of unresolved
ambivalence and unsuppressed resistance."[6] Colonial landscapes served
a very practical function in addition to their more subtle contribu-
tion to the colonial imagination: that of surveying the contents of the
new possessions. Tellingly, in an analysis of Renaissance landscapes E. H.
Gombrich denies any such utility; according to him, they are "works
of art [prized] for the sake of their artistic achievement rather than for
their function and subject matter." He even ties the emergence of the
genre in sixteenth-century painting to "the idea of art as an autono-
mous sphere of human activity."[7] Mário's photographs and texts contest
this history and theory of the genre, foreground rather than erase the
power relations implicit in the view, and insert modernist landscapes
directly into the field of human life, politics, and ethics.

The title page of O turista aprendiz features a cartoonishly drawn par-
ody of America with a tiny clownlike crown tipped on the side of her
head, which mocks colonial engravings of America receiving European
conquerors with a combination of seduction and deception (figs. 4
and 5). The subtitle, "Journeys through the Amazon until Peru, up the
Madeira until Bolivia through Marajó until saying enough," sends up
the lengthy titles of colonial and independence period travel narra-
tives.[8] Yet Mário worries immediately about his complicity in a similar
capture of lands and peoples. He lays bare his invention of America and
admits his dependence on myths about Brazil learned in foreigners's
travel diaries: "Memories of reading impelled me more than truth, sav-
age tribes, alligators, and ants. And my sacred little soul imagined: can-
non, revolver, walking stick, knife. And it chose the walking stick."[9]
Despite opting for the relatively harmless walking stick over the can-
non, Mário's preface expresses his fascination and difficulties with this
inherited genre of the travel narrative:

> More a warning than a preface. During this journey through Amazonia,
> very resolved to write a modernist book, probably more resolved to write
> than to travel, I took a lot of notes, as you will see. Rapid notes, tele-

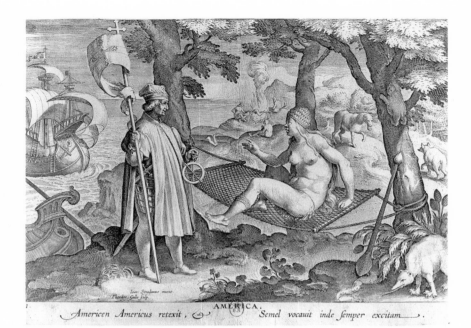

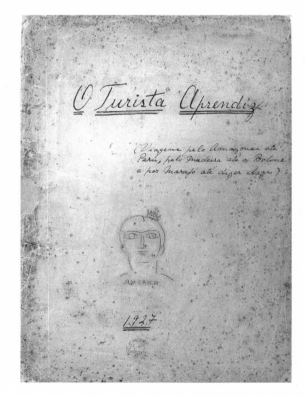

(above)

4 Giovanni Stradano, "Vespucci
Discovering America," 1589.
*Photo: Bridgeman-Giraudon/
Art Resource, N.Y.*

5 Title page,
The Apprentice Tourist.
*Fundo Mário de Andrade,
Arquivo do Instituto de
Estudos Brasileiros,* USP

graphic many times. . . . But almost everything noted still without any intention of a work of art, reserved for future elaborations, *without the slightest intention to let others know about the land traveled*. And I never completed the definitive elaboration. I made a few attempts, I did. But I stopped right at the beginning, I don't know why, displeased.[10]

Mário's aborted travel narrative was never meant to represent Brazil to an uninitiated reader, and the knowledge refused blocks the easy acquisition of the natural resources contained in the vast interior of Brazil, as much as it interrupts the unifying, foundational promise of travel writing. His prefatory refusal to feed the appetite for an exotic Brazil is an early sign of the ethics of place contained in the landscapes that follow.

Yet apprentice tourism is based upon a paradox. While it would be tactically imprudent and unethical to reveal the riches contained in Brazil, Mário also reveals an urgent political need to locate the country accurately for all of its inhabitants. Nationalist sentiment — the desire to both promote and protect the nation — is thus at odds with itself when it comes to the creation and diffusion of knowledge in the postcolonial context. How is Mário to assert Brazil's place in the international sphere without revealing its secrets? This order of paradox operates powerfully in Schwarz's theory of ideas out of place, for he explains that the strongest assertions of an autochthonous Brazilian culture ultimately reassert its peripheral status. A singular, rooted Brazil allows the European center to maintain its hegemony over culture and knowledge. In response to this dilemma, we shall see that rather than attempt to capture the real, authentic place of Brazil, Mário created photographic landscapes that *err*. They paradoxically locate the nation and set the borders that define it into motion.[11]

In the early decades of the twentieth century, landscape became a key genre for experiments with abstraction in mainstream modernism, and Mário's practice of errar produces a kind of abstraction that alters crucial aesthetic, ethical, and political characteristics generally associated with the genre.[12] In the more familiar places of modernism such as Paris and Berlin, abstraction reinvented landscape in order to create a universal modernist aesthetic, such that the place these landscapes represented was the space of the two-dimensional representation itself. Effectively, the horizon of figurative landscapes is converted into an abstract line whose function is to divide the flat space of the canvas or print. The de-

clared self-referentiality of this kind of modernist abstraction is paired with its ability "to efface local particularism."[13] Once translated into abstraction, the horizon line no longer bears any relationship to the idea of a place contained in the original horizon. Modernist landscapes effectively lose their place in their achievement of this new aesthetic. However, when the landscape that the modernist artist reconfigures is a colonial landscape seen from within, the form and meaning of the resulting abstraction changes. Mário created landscapes that counter the trajectory of modernism, and of the genre itself, as the "progressive movement toward purification of the visual field."[14] Instead, these errant landscapes frame a photographic space that is always productively adulterated by the place of Brazil. This chapter examines how Mário used photography to alter the genre of landscape and thus created a modernist ethos that is simultaneously abstract and located in Brazil's colonial experience.

Modernist erring contains two movements: the first judgment locates an original error, which must be corrected by an intervening act; the second finds the first intervention to be already wrong and proclaims an aesthetic result of error itself.[15] Mário emboldens the familiar avant-garde strategy of creating abstraction through formal distortion with his practice of errar. Distortion in mainstream modernism does not include the double ethical and aesthetic judgment inherent in errar. Piet Mondrian, for example, finds a faulty vision of nature in figurative landscapes, which he proposes to correct through their abstraction. In his dialogical explication of the new "plastic vision," which proceeds through an analysis of the relationship between the horizon and the moon, Mondrian writes: "We need not look past the natural, but we should in a sense look *through* it: we must look deeper, we must perceive *abstractly* and especially *universally*. Then we will perceive the natural as pure relationship. Then external reality will become for us what it actually is: the reflection of truth."[16] Mondrian is confident that the truth of nature can be uncovered through abstraction's correct distortion and reduction of the natural world. Even surrealism, which sought to shock the viewer with unusual combinations and even perverse images, similarly strove to access a truer reality. The genre of landscape that provides mainstream modernism with the opportunity for abstract and universal truth contains something very different for Mário. The aesthetic pictured in landscapes on the periphery includes an ethical judgment about *how to live* in this particular, invented, and

never quite representable place. Errant abstraction maintains the place of figurative landscape, even as it distorts its content and appearance.

It is important to note that photography presents a special challenge to the link between abstraction, landscape, and modernism. Clement Greenberg even argues that unlike painting, for photography to achieve the proclaimed goal of modernist medium-specificity it must be "outwardly referential and 'anecdotal.'"[17] The problem, then, is that the same medium-based abstraction that makes paintings modernist, and therefore isolated from the social, appears to defy photography's "natural" function of anecdotal mimeticism, its automatic figuration. While Euro-American modernists nevertheless are known for making photography produce a kind of abstraction in response to this dilemma, Mário instead focused on its resistance to these purer images.[18] Rather than make photography present abstract concepts of light and object, he made it *err*. Photography's special relationship to mimetic representation in fact reveals the intentional formal and conceptual errors that Mário made in his Brazilian landscapes. Due to the medium's ease of figurative representation, intentional errors are more obvious in photographs than in painting; while an error in a painting, especially a figurative one, may simply be taken as the sign of a bad painter, a "bad photograph" is rarely judged as such because it tried to reproduce a scene and failed. Mário made photographs look wrong, precisely because of their presumed mimetic function. "Accidental *desvairismo* / question of a boat [*lancha*] and / of *lunch* [English original] / June 7, 1927" shows a seated man and girl and does everything possible wrong: it decapitates both subjects, includes high-contrast blotches of light and shadow, turns the pictorial space at a forty-five-degree angle, and provides no context (no background) of the place in which the photograph was taken (fig. 6). These errors are the accidental encounter with "desvairismo," the titular concept of Mário's breakthrough poetry collection *Paulicéia desvairada* (*Hallucinated City*, 1922). This ode to modern São Paulo contains as its preface his first theory of modernism, which he read as a manifesto during the Week of Modern Art. So sought after in poetry, *desvairismo* is accidentally found in this photograph, as if by mistake. The landscapes included in *O turista aprendiz* constitute an ethos of modernist abstraction in photographs that references and exceeds the framing act of photography itself. They picture photography's invasive act of seeing and insistently populate even abstract landscapes by including figures as well as a corporealized photographer within the frame.

6 Mário de Andrade, "Desvairismo por acaso / questão de lancha e / de *lunch* / 7-VI-27" ("Accidental *desvairismo* / question of a boat and / of *lunch*/ 6/7/1927"). *Fundo Mário de Andrade, Arquivo do Instituto de Estudos Brasileiros, USP*

The ethical importance of this error lies precisely in its configuration of place, of the locale that remains inscribed in these photographs. The technical language and mechanics of photography reveal its intimate relationship to the determination of place: focal length, a basic setting of any standard single lens reflex camera of the kind that Mário was already using, is the distance from the lens of the camera to its point of focus. It is a measure of the space between the photographic machine (and generally the photographer) and the desired image. Focalize is defined as: "1. To adjust or come into focus. 2. To bring or be brought into focus. 3. *To localize.*"[19] Photographic language easily has entered common parlance and literary analysis, both of which link the focus of the camera with the position of the photographer in relation to his or her subject. Their proximity and the shared place it designates contribute to the conceptualization of the ethos of modernism, but as we shall see ultimately are not sufficient for its ethics. The errant photographs that Mário produced present neither strictly figurative nor entirely abstract images of the landscape of Brazil as they enact the ethical value of place in modernist aesthetics.

Mário began to photograph in earnest during the two journeys that make up the parodic and yet ethnographically detailed travel narratives of *O turista aprendiz*. During the first journey in 1927, Mário took 540

7 Mário de Andrade, "Entrada dum paraná ou paranã / rio Madeira / 5-VII-27 / Ilha de Manicoré!"
("Entry of an inlet [paraná] or inlet [paranã]/ Madeira River/ July 5, 1927/ Island of Manicoré!").
Fundo Mário de Andrade, Arquivo do Instituto de Estudos Brasileiros, USP

photographs; during the second, between 1928 and 1929, he took 260.[20] A very careful and interested photographer, Mário experimented with double-exposed images and frequently documented technical information about the images, noting the aperture and position of the sun in multiple photographs of the same subject. Nevertheless, his photographs are literally humble: printed small (most just 2 × 2 inches) and not exhibited publicly, they are like the tiny face of the cartoonish America seen above, who refuses to exaggerate her status. Kept with the unpublished manuscript, these modest photographs nonetheless prove to play a critical role in Mário's theory of modernism, which, as we shall see in chapter 2, is framed as a surprisingly humble sublime. Certain photographs, however, appeared to fascinate Mário; these he enlarged several times over, up to 8 × 11 inches. A photograph from the first trip, "Entry of an inlet [*paraná*] or inlet [*paranã*] / Madeira River / July 5, 1927 Island of Manicoré!" (fig. 7) hints at the aesthetic possibilities and the ethical dilemmas Mário will elaborate during this extended

journey of investigation. It shows an island dividing the brightness of the overexposed sky from similarly bright water; the island merges with its own dark reflection in a black oblong form. The horizon line of the landscape almost disappears into the reflection of island and sky, and the river that should lead into the heart of Brazil becomes a confusing mirror. The apprentice tourist's inviting path is confounded by the trompe l'oeil of horizon and river, yet the exclamation point ending the title reveals that Mário's enthusiasm is not dampened. The photograph shows what a landscape looks like when the foreign explorer of Brazil is replaced with a (disoriented) Brazilian modernist writer and photographer, who proclaims himself an apprentice but who has much to teach about the meaning of that disappearing horizon, of mirrors, and of place itself.

Ethos as Locale

The first and most colloquial definition of ethos connotes a habit or way of life. Embedded in this habit of living is the idea of living a particular way in a certain place. The word's etymological root in *ethêa*, meaning "haunts" or "hang outs," links ethos with a strange sort of home.[21] There is more to this ethereal place of ethos, however, as Tracy McNulty points out in her analysis of Lacan's ethics of psychoanalysis. While in Aristotle the "etymological connotation of 'dwelling' suggests [that] ethos traditionally seeks to describe man there where he is at home, in his place, possessed of an essential autonomy," a less familiar notion of ethos stems from its Greek root meaning "to repeat," or to wander.[22] McNulty follows this meaning of ethos in Lacan's tracing of an Other, feminine jouissance, which poses a challenge to the ethics that had heretofore excluded feminine experience.[23] I will return to this excessive, feminine, and "gay *sçavior*," but for our purposes here this configuration of an errant and located ethos helps to map the ethics of locale composed in Mário's modernist landscapes. The particular knowledge of this ethos—between wandering and dwelling, subject and other—appears in Mário's configuration of the place of Brazil and the landscapes that compose it. The double meaning of ethos as a mobile home works through this modernist aesthetics and sets forth an ethical mode of living in the world.

This wandering locale appears in Mário's practice of errar, which

makes possible a unique theory of the local that combines nationalism, far-ranging Americanism, and cosmopolitanism. Reshaping the form and content of the modern nation, it also connects Brazil with Spanish America. Mário develops a modernist aesthetics through the reconfiguration of the diverse geographical spaces of Brazil: from urban to rural, from the coastal areas to the border with Peru. In order to understand modernity's place, we find that we have to cover a great deal of territory, from city to interior, across the contested border with Peru and back to the city of São Paulo. The camera accompanies us to all of these places. In the early 1920s, Mário's representation of life in increasingly industrial São Paulo presents an ecstatic model of poetic production as a kind of modern machine, a type of lyrical camera. In the second half of the decade, Mário's journey north to Rio de Janeiro and west along the Amazon and Madeira rivers into the interior of the country led him to a careful examination of photographic technology and to a more complex view of modernist artistic production. During this second phase, Mário was most actively producing photographs himself, and the effects of this practice appear clearly in changes in his modernist poetics. Not satisfied with nineteenth-century, utopian nationalist representations of Brazilian natural phenomena nor convinced by Futurism's hyperbolic proclamations about the city, Mário combined experimental lyrics with photographic vision to create a modernist ethos. His concept of the local nature of modernism works through the tradition of landscape—in both image and word—and its relationship to forms of abstraction.

Errar, Part 1: Writing Brazilian

From his early writings until his death, Mário phonetically transcribed the colloquialisms of Brazilian Portuguese in texts replete with orthographic and grammatical "mistakes." He even worked on a kind of textbook of "Brazilian" grammar that formalized these errors.[24] While he carried out research into indigenous cultures throughout his life, unlike the comic hero of Lima Barreto's *The Sad End of Policarpo Quaresma* (1911), Mário does not dream of a Brazil in which the national language would revert to the major indigenous-language group, Tupi. Instead, his vision of national expression takes the form of an incorrect Portuguese reinvented in Brazil. Mário reconfigures a modernist lyric

voice as part of a broader epistemological claim that emerges out of the traumatic legacy of colonialism in Brazil, revealed in the pressure to write in Portuguese even though he speaks Brazilian. He conceives of a language that is flawed, disfigured, by its place of inscription as much as utterance.[25] Modernist lyricism becomes not simply a question of poetic stylistic conventions, but also an epistemological proposal for writing and speaking "Brazilian": a poetically self-conscious, abstract metalanguage that articulates an ethics and an aesthetics.

The journeys in O turista aprendiz are literally the source of linguistic error—both erring and wandering—at the core of this modernist ethos. When in Belém, Mário tries to produce a literary landscape, a written description of the countryside and of the stars. He meditates on the nature of Brazilian language: "I believe that there is a Brazilian tendency to toss the qualifier in after the noun. At least among the common people. Note the difference of a Brazilian flavor and the Portuguese, between 'the uselessness of the shine of the stars' and the 'useless shine of the stars.' The example is no good. Brazilian: 'it was a countryside that was vast' . . . Portuguese: 'It was a vast countryside.'"[26] His orthographic and grammatical "errors" represent both the inescapable legacy of colonialism and the metropolis's inability to perfectly reproduce its language in the space and voice of the colonized. As much as Tupi was devastated, proper Portuguese never took root. Mário creates layers of errors, here showing that even in the explanation of the defining error of Brazilian Portuguese he has mistakenly chosen a bad example. The literary landscape that is the source of his metalinguistic detour can only be visualized through this series of mistaken descriptions. Of course, the example is perfect in its error: the errant landscape "that was vast" is precisely the place of Brazil. As we shall see, photography provided a unique opportunity for Mário to develop this ethos of error, as he forced one of the prototypically modern technologies of representation to act against its own design.

Errar, Part 2: Cities out of Place

Adrián Gorelik writes that "to debate the modern in Latin America is to debate the city."[27] The explosive urbanization and changes in the ciudad letrada made the city central to the representation of modernity in modernist art and literature. Yet as much as Mário sought to liberate

Brazilian aesthetics from its colonial past, he was also painfully aware of a similar dynamic between center and periphery that governed the city of São Paulo's relationship with its rural populations. In the early 1920s, the city was the site of contact between its longtime inhabitants, Afro-Brazilian and indigenous rural populations arriving in search of relief from poverty, and a variety of European (especially Italian and Polish) and Japanese immigrants. Mário's vision of this contact was less celebratory than Oswald de Andrade's famous "Anthropophagist Manifesto," and the tension between the imagination of the modern nation as urban and the overwhelming historical and literary associations of Brazilian identity with its rural interior permeates his theory of modernism. The beginnings of Brazilian modernism are located in major shifts in the landscape of the city, but loyal to the ethos of erring, it immediately begins to wander through Brazil.[28]

Paulicéia desvairada, the poetic ode to São Paulo whose phantasmagoric character is captured "accidentally" in "Desvairismo por acaso," alters the locale of the city, both nationally and internationally, and shows that modernism and modernity in Brazil do not exclude the rural.[29] The collection maps out the landmarks of the city, producing a kind of cityscape of poems that locate the city at the crossroads of a global market, errant urbanism, and an increasingly abandoned countryside. The collection includes four numbered poems titled "Landscape." "Landscape no. 1" calls the city "My London of the fine mist," which despite apparent similarities to the foggy city is immediately defiant:

> High summer. The ten thousand million roses of São Paulo.
> There is a snow of perfumes in the air.
> It is cold, very cold . . .[30]

The cold of a São Paulo summer makes the speaker of this poem happy, and he makes its latitude a poetic geopolitical reversal of the metropolitan center's order of seasons. The final "Landscape no. 4" also reveals the ongoing financial and political control of Brazil by European countries:

> And the grand golden chorus of sacks of coffee!
> At the intersection the English cry of the São Paulo Railway . . .
> But the windstorms of disillusionment! the drop in coffee prices! . . .[31]

São Paulo suffers its dependence on the foreign coffee market, for the industrial capital of South America is described as a junction to which

trains bring worthless coffee from the countryside. Like Joaquín Torres García's famous inverted map of the Americas, in which north becomes south, these poetic landscapes perform a reversal in time and space. Yet the real critique of this modernity falls on the city's treatment of the source of that coffee, which Mário describes as: "Very far away, Brazil, with its arms crossed."[32] This rural interior, upon which São Paulo depends for its wealth, has turned its back in disgust, refusing to participate in Paulicéia's madness. The city that is so central to Mário's early modernist aesthetics risks existing as a no man's land between the global market and its agricultural regions, if it does not turn to face Brazil.

Concern for that rural Brazil led Mário to make the two journeys into the interior between 1927 and 1929, traveling with his camera in hand.[33] These trips are the source for much of his writing during the next decade: his important collection of poems *The Clan of Jaboti* (1927); many chronicles that were first published as part of a series titled "The Apprentice Tourist" in the newspaper *Diário Nacional* and later collected in *The Children of Candinha* (1942); and the posthumously published *Music and Witchcraft in Brazil* (1963) and *Dramatic Dances of Brazil* (1959). Immediately following these journeys in 1929, Mário explains his concern with incorporating the rural into his nationalist modernism: "A concern for cities is dominant. They seek to synthesize a civilization and progress that do not correspond to the national reality. There is established therefore, a disequilibrium between these centers and the rest of the country. . . . And when we remember that the fascination with the cities is at the cost of that immense mass of Brazilians . . . we find a point for profound meditations."[34] He finds that he must represent a modern Brazil that is simultaneously made up of this "massa immensa," the settled *paulistas*, and the increasing movement of these groups from one place to another.

Mário pictures a tense and errant place of the modern Latin American intellectual: rooted in São Paulo, looking both at Paris and toward the interior of Brazil, he creates an aesthetics self-consciously located at the intersection of West and non-West. Thus, despite his loathing of travel, Mário must set off on a journey, producing landscapes that reflect on the awkward relationship of proximity and distance between city and country. Travel brings him closer to the rural space that he named "Brazil with its arms crossed," yet he will also struggle against the history of representing these places. He experiments with photo-

graphs and text in order to reconfigure the genre of landscape and to create a Brazilian modernist ethos in which the aesthetic and ethical concerns of picturing place are equally urgent and intertwined. This ethos ultimately makes possible what Mário terms "critical national-ism," a bridge between this ethical and aesthetic union and its political promise.

Shifting Horizons: Vertical and Horizontal

During his journeys to respond to the demand of Brazil with her arms crossed, Mário repeatedly photographs horizons—the contact point between land, sea, and sky. The horizon is responsible for the delinea-tion of pictorial space in both figurative and abstract art, for it creates both the picture plane itself and organizes the representational illusions projected upon it.[35] In abstract images, the horizon line has no other function than to divide the space of the canvas and thus create pictorial space. In figurative images, the horizon line may allow for the illusion of perspective, so that an object appears to be closer or farther from the viewer. These two aspects of the picture are independent entities: it is possible to create pictorial space with no pictorial illusion, no attempt at figuration or mimesis. Mário experiments with both functions in photographs of two kinds of horizons of Brazil: those marked by water (rivers and the sea), and by land, the *sertão* of the interior. These images range from heavy touches of abstraction, images empty of recognizable objects, to landscapes that show classic images of the Brazilian sertão. All draw attention to the aesthetic, ethical, and political functions of horizons and configure Brazil's national borders as shifting boundaries at the edges of the country's territory. His treatment of horizons re-turns again and again to the image of the photograph itself as an addi-tional horizon, albeit a finite one, such that the image balances on the photographic paper as if on the surface of the sea.

"Alagoas—Maceió / Boy throwing himself / from the Manaos into the water / 12/9/28" (fig. 8) presents the horizon between sea and sky as Mário captures a boy leaping off the boat into the water below. The view is taken from directly above the flat surface of the water, an un-usual perspective that forces the viewer to alter her expectation of a seascape, in which the horizon normally appears at a vertical distance. Rather than see the horizon as a line in the distance, this photograph

presents it as a flat plane; the vertical and horizontal planes shift places and disorient the viewer in time and space. The water parallels the flat surface of the photograph; the expanse of semireflective liquid mirrors the sensitized surface of film and shows a glimmer of reflection of light on its surface, making it look almost solid. This view of the river adulterates the purity of photographic modernism often pictured in the sea, which Rosalind Krauss calls "a special kind of medium for modernism, because of its perfect isolation, its detachment from the social, its sense of self-enclosure, and, above all, its opening onto a visual plenitude that is somehow heightened and pure, both a limitless expanse and a sameness."[36] While fascinated with the reflective surface of the river, Mário reveals the illusion of sameness by capturing the precise moment that the boy's body breaks through its solid surface. The boy is off-center, a blip in the corner of the photograph, a flash of movement in an almost entirely black sea that causes a rupture in the reflective plane. "Boy throwing himself / from the Manaos into the water" captures the expansive surface of the sea, but also the rupture of its hermetic enclosure.

8 Mário de Andrade, "Alagoas—Maceió / Menino se atirando / do "Manaos" nagua / 9-XII-28" ("Alagoas—Maceió / Boy throwing himself/ from the Manaos into the water / 12/9/28").
Fundo Mário de Andrade, Arquivo do Instituto de Estudos Brasileiros, USP

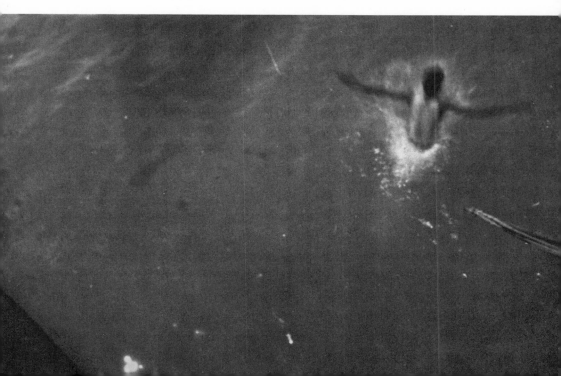

The instability of these reflective surfaces—of the sea, mirrors, and photographs—appears in many of Mário's photographic horizons. In "Mogi-Guassú / July 1930" (fig. 9) and "Mogi-Guassú (with wind), July 1930" (fig. 10), he photographs the bow of the boat in which he is traveling as it cuts through the water. In the first, the water is a precise, undisturbed mirror; here the perfect modernist sea hides the horizon that marks the destination of the traveler in reflections of land and water. Yet as their titles make clear, these photographs form a series. In the second photograph, "with wind," the water becomes a darkened mirror, its reflected image erased by the invisible presence of wind. The mirror of the water, stunning in its mimetic accuracy like a photograph, dissolves into incomprehensibility even as the horizon comes more into focus. While the potential perfection of the sea appears in its flatness, in its seeming remove, its contact with the wind is just as defining a characteristic as its "visual plenitude." The sea's ruined mirror of difference (not sameness) is critical to errant modernism in Brazil, for it refuses a vision of modernist opticality untouched by the disturbing presence of the social, and asks the viewer to consider the photograph as a similarly unstable reflection of the world. The kind of abstraction produced as a result is errant, ruining both the purity of medium specificity and the stable, localizing function of the horizon.

The horizon of difference, the social that comes into focus as the sea ceases its infinite regress of mirrors, is an especially significant space in Mário's photographs. He inserts these formal horizons into global politics by means of a subtle intervention: the repeated inclusion of transitional objects just at this line between sea and sky. The modernist sea further loses its solidity in photographs that show spaces of reflections and ruptures—points where there is never a clear separation between land and water, water and sky. A low horizon line divides "Alvarengas / 25 of May 1927 (cargo ships)" (fig. 11) and dark, flattened ships are lightly mirrored by clouds in the sky. The dispersion of the low-lying ships and clouds emphasizes the flatness of the sea and sky, making the composition of the photograph heavily horizontal. The small ships appear to hover between these two horizontal planes, balanced on the surface tension of the water as much as on the surface of the paper. Mário returns to the image of the photograph itself as a horizon in "Mahogany Rafts / banking at San Salvador / to embark / Nanay June 23, 1927 / Peru / Future victrolas" (fig. 12). He printed this image of floating mahogany three times with different sizes and exposures, experimenting with manipulations of the photographic image.

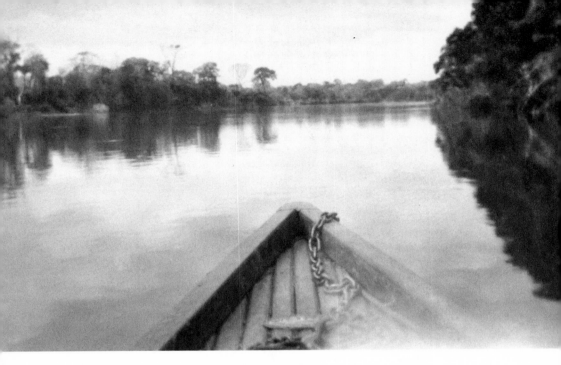

9 Mário de Andrade, "Mogi-Guassú VII-930" ("Mogi-Guassú July 1930"). *Fundo Mário de Andrade, Arquivo do Instituto de Estudos Brasileiros,* USP

10 Mário de Andrade, "Mogi-Guassú (com vento) VII-930" ("Mogi-Guassú [with wind] July 1930"). *Fundo Mário de Andrade, Arquivo do Instituto de Estudos Brasileiros,* USP

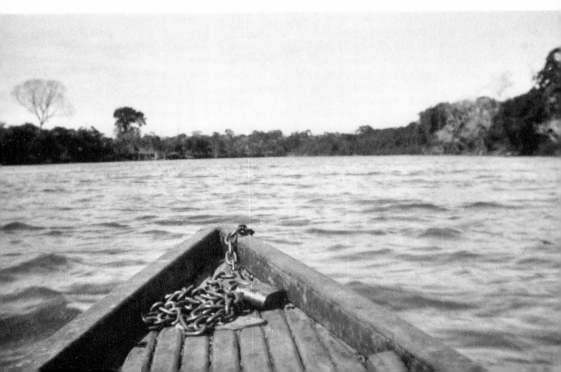

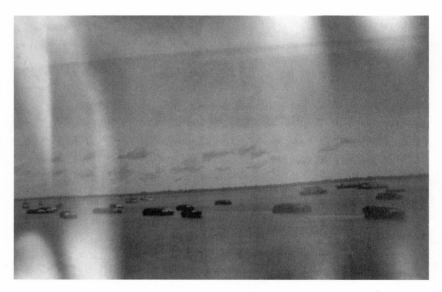

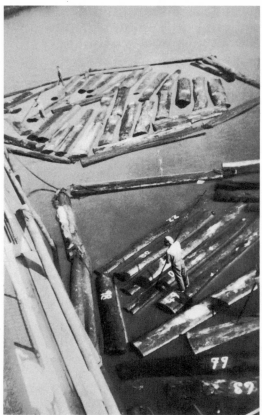

11 Mário de Andrade, "Alvarengas / 25 de maio 1927 (barcos de carga)" ("Alvarengas / 25 of May 1927 [cargo ships]"). *Fundo Mário de Andrade, Arquivo do Instituto de Estudos Brasileiros,* USP

12 Mário de Andrade, "Jangadas de mogno / encostando no S. Salvador / pra embarcar / Nanay 23-Junho-1927 / Peru / Vitrolas futuras" ["Mahogony Rafts / banking at San Salvador / to embark / Nanay, June 23, 1927 / Peru / Future victrolas"]. *Fundo Mário de Andrade, Arquivo do Instituto de Estudos Brasileiros,* USP

Rather than a "limitless expanse and sameness," Mário's enigmatic horizons create a floating, unstable, pictorial space that implies a possible, even required, transition to a place outside its frame, as he uses these transitional objects to bridge the expanse of the water and the sky. The perfection of the infinite is marred by a point of reference that limits the horizon and implies a transition to a place outside the frame of the photograph. The cargo ships, while formally mirroring the clouds in the sky, are named for their function of transporting goods down the river. In "Mahogany Rafts," these transitional objects are "future victrolas," already part of a market that takes raw material from Latin America to be fashioned into modern music machines. The ruining of the perfect sea creates horizons that compose a distinct pictorial space, a neocolonial landscape that is always already inserted in the global trade of raw materials.[37]

These errant horizons are part of an ongoing formulation of the relationship of modernist art to an extra-artistic sphere, which Mário articulates in photographic terms as early as *A escrava que não é Isaura* (*The Slave Who Is Not Isaura*, 1925). Mário makes the gesture toward an outside of the work of art crucial to modernist poetics, for both the reader and the poet. New visual technologies provide a model of poetic production as a mechanistic process of internalization and externalization of modern stimuli: "What really exists is the subconscious sending the intellect more and more telegrams. . . . The intelligence of the poet—which no longer resides in an ivory tower—receives a telegram in the trolley. . . . Thus virgin, synthetic, energetic, the telegram gives him great commotions, divinational exaltations, sublimations, poetry. Reproduce them! . . . and the poet casts the word free onto the paper."[38] Born from the "profound I," the unconscious "takes" the poetic image, which is "telegraphed" like light onto the critical mind of the poet. He then prints it onto paper in an altered but recognizable form. Like Mário's affectionately named *codaquinha* (little Kodak), the poet focalizes the modern as he moves through the city. In a footnote, Mário further clarifies what this means: "Perhaps it would be more accurate to say: the necessity of exteriorizing."[39] Any modernist work by definition, here, cannot be contained. Unlike a modernist aesthetic based upon the purity of the picture plane or the integrity of linguistic invention, this aesthetic sets the work of art loose in the modern world. The aims of this externalization are not the exact reproduction of the poet's emotional experience, but rather "to recreate in the spectator an

analogous commotion to what the person first felt."[40] Analogy is a relationship of proportion, where similarity in function is accompanied by difference in origin and structure. The aim of modernist poetry is not the exact reproduction of the commotion of modern sensations, but the creation of something that itself produces an analogous sensation *outside* the work itself, something mistakenly (errantly) not like the original. The error in reproduction allows the modernist work to produce this received sensation.

As much as modernist aesthetics explode photographically from world to poem to world, unstable horizons cause the world to press into the frame of modernist photographs and break their hermetic remove. Mário composes a literary landscape about the same day pictured in "Entry of a paraná or paranã / Madeira River / 7/5/27" as a trompe l'oeil. The photographed sunrise again obscures as much as it enlightens: "It seems that it will get lighter but then an instant of intense darkness hits. Before any sign of light in the sky, it is the river that begins the dawn and rouses itself in a first desire for color."[41] The source of light in the scene is reversed as the water burns more brightly than the sun. This literary reversal makes the photograph yet more difficult to read: not only is the horizon's division between sky, land, and water invisible, but the source of light, which is the source of the photograph itself, tricks the eye as well. Mário, the narrator of this passage about discovering Maricoré, gets lost in the series of reflections between sky and water as "the day comes on slowly, watery itself . . . more indecisive light than defined color."[42] The written description of this moment presents the confusion between the viewer and what is seen, as the confused horizon between sky and river makes the day itself liquid, and the uncertain source of light blurs the boundaries between objects. What is more, while I (logically) translated *aguado* above as "watery," it also means "frustrated" and "failed." Thus the sentence also reads, "The day comes on slowly, frustrated." This failed, errant landscape, which is both illuminated and darkened, envelops the narrating modernist poet and blurs the edges of the photograph.

Mário can no more maintain a safe distance from the scene he observes than the river is able to avoid its reflection of the sunrise. Later in the same journey, Mário writes of another view: "The sky is white and reflects in water that is totally white, a fierce white, desperate, luminous, absurd, that penetrates through the eyes, nose, pores, one cannot resist, I feel that I am going to die, mercy!"[43] Mário opens himself up

so that these landscapes seem to gaze at him, his corporeal presence in conflict with the bright light of the photographic landscape. He describes the very experience of travel as one of being inscribed by the light that enters through the windows of the train: "At times it stops, the landscapes will be 'kodaked.' . . . What is the reason for all of these international dead who are reborn in the din of a locomotive and who see with their little eyes of weak light, which spy me through the little windows of the train car?"[44] Landscape's entrenchment in the history of colonialism pretends a natural visual truth and appeals to "deeply instinctual roots of visual pleasure associated with scopophilia, voyeurism, and *the desire to see without being seen*."[45] Travel narratives from John Ruskin's contemplative abstraction to "Victorian verbal painting" present discovery as a visual capture, but a passive one, which constitutes the colonizer as the natural master of all he sees.[46] In Mário's landscapes, not only can the apprentice tourist literally not distinguish (visually) the horizons of the landscape he views, nor extricate himself from the blurred objects that fill it, he himself is conquered by the view. Despite his ownership of the Kodak, it manages to transform the landscape and change the train in which he travels into a jail made of "little eyes of light." The "international dead" whose eyes penetrate the poet are the workers of varied origins that he lists—Chinese, Bolivians, Barbadoans, Italians, Arabs, Greeks—who along with Afro-Brazilians built the railroad upon which Mário and his companions traveled. The pain of these gazes interrupts their pleasure, Mário notes, as they drink cold guarana under the hot sun and stop to photograph the landscape. Rather than reproduce the image of the landscape from the perspective of an all-powerful gaze, inured to the effects of the colonial space that he sees, Mário represents landscapes that pierce the eye of the viewer, entering through every possible path, ruining his pleasure, and changing him in the process. In *O turista aprendiz*, Mário focuses on the activity of seeing in order to undermine his own place of mastery, and to reveal the epistemological and ethical significance of these altered modernist landscapes.

In this unveiling of visual power, Mário confesses the limitations and dangers of his scopophilic participation in the tradition of travel writing. "Reefs, May 13, 1927" (fig. 13) provides a glimpse of water and land through the porthole of a ship; the round window imprints the eye of the traveler on the photographic paper, providing it with almost telescopic power to see into the interior of the land it approaches.

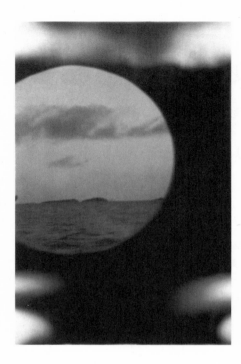

13 Mário de Andrade, "Abrolhos, 13 de maio 1927" ("Reefs, May 13, 1927"). *Fundo Mário de Andrade, Arquivo do Instituto de Estudos Brasileiros*, USP

The blackness surrounding the circular image mirrors the shape of the camera lens, showing the photograph to be merely the cutout of a wider, three-dimensional space, dependent on a mechanics of lens and light that is always incomplete in its purview. The familiar modernist strategy of a frame within a frame in "Reefs" recalls here the trope of conquest, the arrival by sea to new lands and the acquisitive gaze of the traveler. In his journal entry for this day, Mário writes:

> City of Salvador. Oh what a marvel, I am tired. But the devil of it all is that it doesn't improve things to say, "marvel," "admirable morning," "adorable architectural invention," "pretty girl." It doesn't do any good, doesn't describe. These qualificative words exist only because man is a fundamentally envious individual: we say that a thing is "admirable" and we not only believe but even augment in our imagination what we felt. But if one were able to describe without adding qualifiers . . . oh, well, that wouldn't be me.[47]

Mário shows the entire process of the production of literary land-scapes—the description of new lands and their consumption—as an

act of jealous adjectival acquisition. He admits that his own desire to describe without qualification or designation is a utopian dream; there is no possibility of representation without an act of linguistic and photographic capture. The ethical dilemma inscribed within the familiar modernist focus on medium—the revelation of the frame within a frame—is also a crucial gesture of the ethos of modernism. Yet here the framing refuses both "pure immediacy" and "complete self-enclosure," as the photograph gestures inside and outside the frame in the same motion.[48] The ethos of Brazilian modernism implicates the artist in the very histories he condemns, such that the acquisition of knowledge even in such abstract photographs maintains an ethical dimension. The avarice of this genre that Mário highlights on May 13, 1927, refuses the manner in which landscape becomes a "social hieroglyph that conceals the actual basis of its value . . . by naturalizing its conventions and conventionalizing nature."[49] He uses his camera instead to make nature appear strange, constructed, and even inhabited. The next section examines how Mário further defies the self-enclosure of the photograph by repopulating landscapes, with the body of the photographer and others, and by destabilizing the figure/ground relationship within them.

Errant Ground and Figure

During the later "Ethnographic Journey," Mário laments the failure of Brazilian photography to represent the country's landscapes and cityscapes. Arriving at the Convento de São Francisco in Paraíba, he is struck by its beauty and only somewhat surprised that, despite having seen photographs of the convent already, he almost does not recognize it:

> However it was a terrible photo, awful like all that the photographers of Brazil take. In fact: photographers more brutish than those that appear in this land are difficult to find. "Plaza Sé" in São Paulo. What people see at the base is a church with scaffolding, beside some skyscrapered houses that are nonsense, and on the ground 200 cars lined up on purpose, one perceives, for them to photograph the Plaza. And people? No one. São Paulo has many people, and Rio also, but the photographs, I don't know what time these photographers choose, a desert without even a dry caatinga plant.[50]

While he goes on to say that photographs of this church also ignore its architectural beauty and the quality of its paintings and tiles, what is truly striking about Mário's critique of the state of photography in Brazil is the primacy of his complaint that it empties all people from its view. Decades before Raymond Williams criticized the erasure of workers from landscapes of the English countryside, Mário recognizes the tradition of "pure landscape" "as something like the 'dreamwork' of imperialism."[51] In this critique, Mário also makes fun of what can be recognized as stereotypical European and North American modernist photography, which carefully lays out the symbols of the modern: scaffolding, skyscrapers, and a symmetrical line of automobiles. The motionless formalism of these photographs appears ridiculous and invented to Mário. In his own photography, he insists upon a wandering version of Brazilianness and reverses the emptying of photographic spaces. He recodes the syntax of the landscape tradition by repopulating images of rural and urban Brazil, using the familiar modernist strategy of collage as a practice of experimental ethnography.[52] The juxtaposition of land and person in Mário's photographs creates a false analogy between landscape and nation; just as he forced the language of the Portuguese colonizer to write a national literature, Mário made the camera defy its own mechanism that creates the illusion of depth and perspective necessary for a harmonious effect.

The introduction of figures into the unique pictorial spaces of Mário's landscapes is a complicated step in the creation of an ethical modernist aesthetics. When figures appear in colonial landscapes, they create an ordered relationship that protects the figure of the colonial viewer from the place, establishing an illusion of ideological harmony.[53] The careful placement or erasure of figures in relationship to a perceived ground erases the signs of discord and violence caused by colonialism even for the colonizer himself. The relationship between figure and ground in Mário's photographs instead makes the same kind of intentional error that he makes by transcribing colloquial Brazilian Portuguese. "Dolur in the vista of Marajoara / 7/31/1927 / sun 3, diaph. 3 / Trombeta" (fig. 14) distorts photography's most natural ordering mechanism, the illusion of depth of field, which ought to locate the figure of Dolur in front of the landscape of Marajó. By focusing equally on both the portrait of Dolur's face and the picturesque scene behind, her profile appears as if it were a montage photographed on top of the background. The high-contrast collapse of the perspectival rules that establish figure and

14 Mário de Andrade, "Dolur na vista Marajoara / 31-VII-27 / sol 3 diaf. 3 / Trombeta" ("Dolur in the vista of Marajoara / 7/31/1927 / sun 3, diaph. 3 / Trombeta"). *Fundo Mário de Andrade, Arquivo do Instituto de Estudos Brasileiros,* USP

ground in photography and the doubling of the familiar trope of colonial landscapes refuse the illusion of harmonious order in landscape. There is a paucity of technical information available about Mário's photography, but careful examination of the images does not suggest that he produced photomontages. Instead, this photograph of Dolur creates the effect of montage in a straight photograph. In Dada and Constructivism, photography and photomontage were employed as means to escape the limitations of abstraction without returning to figurative painting.[54] Mário's image pushes this relationship to reality yet further, for it is not actually a photomontage, but rather a photograph made to *err.* The exaggerated importance of blown-up images in the foreground of modernist montages, as in the landscape including Dolur, alters the hierarchy between these elements and operates as a formal intervention into the deployment of ideology and power.[55]

Collage and montage are important formal and political strategies in much of Mário's literary production, especially his most influential novel, *Macunaíma* (1928). Telê Ancona Lopez notes its layering of references to nineteenth-century Romantic novels, sixteenth-century chronicles, and contemporary journalism, and Lúcia de Sá reveals that collaged intertextuality with indigenous narratives "proves to be [its]

strongest ideological achievement."[56] While the relationship between this important novel and *O turista aprendiz* is the focus of the following chapter, at this point it is important to emphasize that the beginning of Mário's greatest experimentation with photography in 1927 fell precisely between his first draft of *Macunaíma* in 1926 and its publication in 1928. The technique of collage that appears in both texts is profoundly bound up with Mário's photographic practice and is a form of erring that constitutes an ethically and aesthetically engaged abstraction.

Mário deploys something like collage to undermine the concept of the perfect work of art, and as the source of a modernist sublime that counters what he considered to be outdated and irrelevant designations of beauty. The disordering of the relationship between ground and figure, landscape and inhabitant in these photographs references the art historical tradition already discussed, as well as new fields in the social sciences. James Clifford looks to collage as a potentially liberatory practice that emerges from modern ethnography's task of representing cultures, which he finds in the "ethnographic surrealism" of Mário's Parisian contemporaries in the school of Marcel Mauss. André Breton and Georges Bataille, as well as the "Third World modernism and nascent anticolonial discourse" of Caribbean artists and writers Aimé Césaire and Wifredo Lam, also experimented with this kind of collage.[57] Mário participated actively in the conceptualization of ethnography in Brazil, and in its establishment as a department in the University of São Paulo. He even spent afternoons practicing ethnography with Claude and Dina Lévi-Strauss during their stay in São Paulo between 1934 and 1939. In Mário's "Ethnographic Journey," he uses the tools of ethnographic collection of stories, music, and religious practices, and nevertheless considers himself neither a folklorist nor an ethnographer: "I already affirmed that I am not a folklorist. Folklore today is a science, they say. . . . I am interested in science but yet I have no ability to be a scientist. My intention is to provide documentation for a musician and not to spend twenty years writing three volumes about the physiognomic expression of a lizard."[58] Mário values the act and results of collection, even as he doubts the results of the social sciences.

The word *errar* appears once again when Mário faces his misgivings about these fields of study. He describes a dream he has during his apprentice journey, in which he is giving a lecture to a group of Indians in Tupi. Throughout the presentation, the Indians look at each other

and laugh, and Mário imagines that they are planning to eat him and his traveling companions, the classic trope of cannibalism found in European travel narratives of Brazil. When he finishes, Mário discovers that cannibalism is not their plan at all, for all of the Indians begin to scream at him: "Tá errado! Tá errado!" ["He's wrong! He's wrong!"].[59] Even in his dreams the Brazilian modernist cannot achieve the position of expert ethnographer, for he is reminded of his own displacement—being errado—within Brazil. This inauthenticity of the modernist artist will be discussed at length in chapter 2, but for now let us be assured that the truth of ethnography was undermined by Mário even as he dedicated his life to the accurate documentation of the diverse cultures of Brazil.

The errant collages of image and text in O turista aprendiz defy earlier formulations of Brazilian national identity, in particular diffusionism, a branch of ethnographic theory popular in Europe as well as among the previous generation of Brazilian cultural theorists. As with ethnographic surrealism, the possibility of liberatory documentary practices is at stake here. Diffusionism proclaimed a direct connection between a nation's geographical formations and the racial and ethnic characteristics of its citizens.[60] It operated as the very organizing structure of Euclides da Cunha's foundational Os sertões (1902), in which descriptions of the land prepare the reader for the nature of the people who inhabit it: part 1 is titled "Land," and part 2 "Man." Da Cunha explains that his philosophy of national determination is also an addendum to Hegel, who: "Outlined three geographical categories as comprising the basic elements, which along with others, react upon man, creating ethnic differentiations: the steppes, or vast arid plains, with their stunted vegetation; the fertile valleys, abundantly irrigated; and the coastlands and islands. . . . As for our northern backlands, which may at first sight appear to resemble other regions, a place is lacking in the German thinker's scheme. . . . Barbarically sterile; marvelously exuberant."[61] Not opposed to Hegel's basic formula of land and the ethnicities it produces, da Cunha only seeks to insert the sertões into the equation; he goes on to detail the characteristics of racial categories belonging to the distinct landscapes of Brazil. Mário explicitly rejects da Cunha's philosophy of identity grounded in these landscapes, and writes a scathing condemnation of this foundational text of Brazilian national identity. His fury is directed at its oppressive operation that enchains people to land:

15 Mário de Andrade, "Dolur na Sta. Tereza do Alto / 12/X/27" ("Dolur in Sta. Tereza do Alto / 10/12/27"). *Fundo Mário de Andrade, Arquivo do Instituto de Estudos Brasileiros, USP*

I guarantee you that *Os sertões* is a false book. The climactic disgrace of the Northeast is indescribable. It is necessary to see what it is. It is frightful. Euclides da Cunha's book is a genial pleasantry, but it is nevertheless a hideous falsification. Repugnant. But it seems that we Brazilians prefer to be proud of a beautiful literature than to give up literature all at once for the first time to do our work as men. Euclides da Cunha transformed the unbearable blindness of that sun into the brightness of a musical phrase and chic images. . . . God save me from denying the resistance of that resistant northeasterner. But to call this heroism is to not recognize a simple phenomenon of adaptation. The strongest are taking off.[62]

Not only does Mário denounce this fundamental text, he insists that a key protagonist in Brazilian history—the hardy *nordestino*—proves his characteristic resilience by leaving the very land that da Cunha claims to have defined him. Dolur's profile against the landscape of Brazil pictures a much more tenuous relationship between the two. Mário reveals that the ethos of error has clear ethical limits: while it does not claim scientific accuracy, neither does it give license to lies and falsehoods.

By altering the relationship between figure and ground in his landscapes, Mário creates an image of nation based upon the painful inhabitation and abandonment of the very spaces that were to have formed a national race. He again uses an extended depth of field in "Dolur in Sta. Tereza do Alto / 10/12/27" (fig. 15), so that all elements in the picture are equally in focus, producing the effect of collage in the space of a single photograph.[63] This effect collapses background onto foreground, exaggerating the two-dimensionality of the photograph and calling attention to its surface. In "Dolur in Sta. Tereza do Alto," Mário adds a new twist, having Dolur face the camera and look directly into its lens, to confront the viewer with her stare. This turn of the figure breaks the enclosure of the photographic surface, drawing the viewer into it through Dolur's gaze. Mário's photographs explore the "apparent paradox of modern landscape": the manner in which it references a deep space while undermining the relationship between figure and ground that establishes that depth.[64] The result is a real place—Brazil—that cannot be seen synthetically. These errors, a form of photographic abstraction, foreground the ineffability of Brazil, the tenuous nature of photographic representation, and the political promise of the ethos of modernism.

Word, Image, and Other Truths

Regardless of their intentional errors, Mário's photographs rarely surrender their documentary function entirely. The errar that characterizes them may disorient, disrupt, or undermine the image contained, but they permit a degree of recognition of forms. Their utility as documents has led, in part, to their dismissal as important works of art. Rather than recuperate these images as art, a gesture that would go against the grain of the hybridity and multimedia experimentation of *O turista aprendiz*, I propose that the tenuous relationship with the real imagined through photography is crucial to the ethics and aesthetics of modernism. As much as his musical, dance, and story collections are useful documents and yet not part of an organized practice of folklore, Mário casts doubt on the "accuracy" of the photograph as mirror of an exterior world, even as he celebrates its ethical relationship to reality. The production of photographs, their reproduction and circulation,

and their entry into language through captions, literary images, and modernist theory, frame an ethics and aesthetics of modernism with epistemological and formal ramifications.

Throughout *O turista aprendiz*, Mário makes his own experience fictional, undermining what Lopez calls the "European optic" of rationality in order to present the real colonial experience of South America.[65] He invents fictional names and characters for his fellow travelers, coffee baroness Olívia Guedes Penteado, her niece Margarida Guedes Nogueira (Mag), and Dulce do Amaral Pinto (Dolur). The photograph of Dolur therefore is both a portrait of Dulce and the invention of a character based upon her, whom Mário also calls Trombeta; the tiny landscape behind her resembles a stage set more than a snapshot showing the tourist in her destination. The unstable truth of photographic representation—a theme that will appear throughout this book—appears most clearly in the combination of image and word in *O turista aprendiz*. In his journal entry for August 11, 1927, Mário writes, "August 11—There was no August 11, 1927."[66] Here Mário plays with the impossibility of naming something that does not exist: the day exists only because he writes that it does not. This entry, as if not self-contradictory enough by itself, is accompanied by a photograph of Oswald de Andrade and Tarsila do Amaral captioned: "On board the Baependi—August 11, 1927." The photograph further contradicts Mário's written denial, "proving" the existence of the day. Yet the photograph forces one more double (quadruple?) move that undermines the certainty of the existence of the eleventh of August, for there is no visible evidence of that day, of that date, inscribed in the photographic image. It is only the eleventh of August because the caption tells us so. Telê Ancona Lopez points to the connection between the hybridity of *O turista aprendiz* and its aesthetic and ethical claims; here the idea of the photograph as document, and the pairing of image with written narrative, create what Lopez calls the "elasticity" of truth.[67]

On the eleventh of August, the combination of image and text stretches perception and representation to their limits but never reaches the point of proclaiming the nonexistence of truth or experience. The written and photographic denials and assertions of the existence of the eleventh of August show just how crucial the recording of these histories was for Mário. In a review of an exhibit of photographs by Jorge de Castro published in 1940, he precisely explains his view of photography's relationship to the real:

That which elevates artistic photography above the purely documentary resides not in the machine nor in the light, as manipulators of photographic tricks confusedly imagine . . . but in the human creation of the artist. Indeed, there has to be that special quality of grasping the "poetry of the real." . . . Fundamentally realist, loving the visions of life, he interprets them, even so capturing the moment and rich angle, or composing the ambience in which reality capitulates before light and is converted into suggestive and beautiful expression.[68]

Photography refines the analogical truth described as a photomechanical process in *A escrava que não é Isaura*, as de Castro's camera "converts" the light into a photographic reality.

The mixture of photography and text in *O turista aprendiz* does not insist upon the particular hermeneutics of each medium in order to argue for a singularity of meaning. Instead, the repetition of the same scene in each, as seen in the sunrise represented in word and image, creates a multiplicity of meanings: neither photograph nor text alone is sufficient to present the journey, yet the two media do not perfectly reinforce one another.[69] The contradictions between caption and photograph in "August 11" in fact elaborate a theory of modernist aesthetic heterogeneity that Mário first imagined in *A escrava que não é Isaura*. He proclaims multimedia, poetic "simultaneity" to be a crucial modernist tool:

> Thus, in modernist poetry, in most instances the concatenation of ideas doesn't happen, but rather an association of images, and principally:
> THE SUPERIMPOSITION OF IDEAS AND IMAGES.
> With no perspective nor intellectual logic.[70]

While his description of modernist painting as "colors, lines, volumes on a surface" sounds terribly close to Greenberg's vision of the purity of medium, Mário does not limit the different media to these specific functions.[71] He immediately establishes experimental mixture as a corrective to the divisions between them: "It is true that the branches [of the arts] interlace at times. The tree of the arts like that of the sciences is not split but has an interwoven branch. The trunk from which the branches separate—that later will freely develop—is one: life. Various branches intertwine in what is generally called SIMULTANEITY."[72] Thus simultaneity creates a multimedia aesthetic of modernist expression that is both focused on the particularity of different media and

thrives on their intertwining. The result is an adulterated modernist aesthetics and an ethics that can invent but that must always maintain a relationship to life.

The Abstract Place of South America

Mário was wary of abstraction, a suspicion voiced in his warning to Tarsila do Amaral not to abandon the Brazilian modernism he called *matavirgismo* in favor of the "isms" she would find in Europe.[73] This wariness has been ascribed to modernism's search for a defined image of patria and the common presumption that figuration provides a clearer image of nation than does abstraction. The modernist movements in Mexico and Brazil often operate as proof of this logic, for in both countries the dominant artistic movements maintained a dedication to figuration. However, understanding figurative art as a window onto the Brazilian nation does not accurately present the form of nationalism Mário promoted, or his theorization of modernist aesthetics. As we have seen, his experiments with landscape do not erase the referent point of the horizon, even as they abstract the vistas by distorting the dominant (imperial) discourse of the genre. The ethical impulse of errar provides an alternative to "pure" abstraction without rejecting it entirely. Errar is a kind of abstraction practiced on the periphery, which carries with it the ethical urgency of place.

There are two major practices of creating abstract works: abstraction can begin with an object in the world, from which the artist reduces, expands, or exaggerates certain perceived elements, or it may begin within the mind or emotions of the artist, who produces a nonfigurative work that embodies, expresses, or represents an idea or sentiment from within. Luis Pérez Oramas points to two major trends in Latin American abstraction in the 1920s: the first led by the Uruguayan Joaquín Torres García, the second represented by the work of Venezuelan Armando Reverón. The first process of abstraction can be seen in Reverón's paintings, where "structure is melded with the pictorial field and proceeds from sensation, arising as a trace of what is perceived."[74] In contrast, Torres García's "School of the South" produced simultaneously constructivist and nativist paintings and sculptures, in which the origin of the abstraction lies within the imagination of the artist. Yet Pérez Oramas collapses these two seemingly incompatible

strands of modernism in Latin America precisely in their engagement with landscape and locale: "the 'abstract function' of twentieth-century Latin American art has been, among others, that of rediscovering for ourselves the experience of location. On a continent where cultural tensions have been marked from time immemorial by the difficulty—both symbolic and topological—of taking hold of a place of one's own, this is no small achievement."[75] The genre of landscape in Latin America creates a powerful site of abstraction, which is both place defined anew and the space of representation reimagined.

Mário's photographs break several of the cardinal rules of abstraction. First, they defy the divide between landscape as a stepping stone toward abstraction and the full achievement of abstraction. That is, the actual landscape *still exists* in Mário's move to the abstract. This practice of abstraction is errant in its rejection of purity, in its "figuration," which I use to mean both the representation of recognizable objects and the literal inclusion of human figures in the picture plane. When Mário lamented the poor quality of Brazilian photography for erasing human inhabitants, it certainly was for its lack of social responsibility, but also because it did not produce a sufficiently errant modernist aesthetic. The inscription of the body of the artist and the materiality of these landscapes (like the light that painfully penetrates Mário's entire being) is "a kind of 'ruining' of the landscape."[76] This defiance of landscape matched with its very inescapability is crucial to Latin American modernist aesthetics. Mário's errant landscapes create an ethos based in place, which pictures place in new terms.

Once again, colonialism, its history and continued ramifications, is the ground for this place. In *O turista aprendiz*, Mário explains the connection between error, civilization, and ethics in an "Amazonic letter" he wrote to a "French Jewish woman." This letter, in fact written to Dina Lévi-Strauss, was written in a terrible combination of French and Portuguese: "E se a Senhora não sente senão liens muito frágeis com esta América em que a Senhora desviveu três anos, é que lhe falta a puissance des valeurs éternelles . . . Je ne peux pas avoir pitié de vous, parce que vous êtes la plus forte" [And if Madame does not feel at least very fragile ties with this America in which She mislived for three years, what is lacking is [shifting to French] the strength of eternal values . . . I cannot feel sorry for you, because you are the stronger one].[77] The linguistic errors of Mário's "Brazilian" language create both a national language and a generalized, anticolonial lyric voice, which is character-

ized by what he calls "this South American 'pain' of the individual."[78] This passage insists that the landscape of Brazil is not only a question of place, but of *living the colonial experience of the place* from the perspective of the colonized. It is a particular experience of pain that expands, Mário goes on to suggest, to the rest of South America, which shares the history of colonial exploitation. This knowledge, located in Brazil and the Americas, is explicitly denied to any traveler who has too much access to power.[79]

Returning now to the dual meanings of ethos as both wandering and home, we see that Mário imagines a modernist ethos that develops in the moving place of a lived colonial history. It is important to emphasize that simply wandering through the colonized place does not produce the ethos that Mário designs for Brazil. Mere proximity, the sharing of space, is necessary but not sufficient for the ethics he imagines. The Frenchwoman "desviveu" (mislived) her time in Brazil; she lived in close proximity to Brazil, but due to her position of power it turned its back on her and crossed its arms. Her failure is diametrically opposed to the success of Jorge Fernandes, a poet Mário met in Natal during his travels. Mário writes that Fernandes, "*lived all this right around here and he lived it for real*, it remained imprinted in his flesh, which is more life-like memory and less literary."[80] Fernandes's *Livro de poemas* (*Book of Poems*) "is just that: a memory captured in the muscles, nerves, stomach, eyes, of the things that he lived."[81] Like Reverón's monochromatic paintings, which still contain a trace of the body of the artist, and Mário's own photographic landscapes punctured by light, really living Brazil means that these experiences are incarnate in the ethos of modernism. Brazilian landscapes must present this relationship to the body of the artist as much as the artist represents his or her place in landscapes. This modernist abstraction is not purely optical, but rather reminds us that even the modern photographic eye is attached to a body. The camera is not the reproduction of the human gaze, yet it is always held in front of a real eye.

The experience of location, the living for real as opposed to misliving, is a profoundly ethical decision. Through the mixture of photography and text, Mário details the daily difficulties of writing and living in Brazil, providing a view of locale suggested nearly sixty years later by Sara Facio during the second Latin American Colloquium on Photography: "I insist, one can write about Buenos Aires from Rome, compose *bagualas* in Paris, paint the Pampa in Los Angeles, but, how could

one take pictures of Uruguayans in Lake Leman?"[82] In *A escrava que não é Isaura*, Mário mocks the debate about an overwhelming European influence on Modernist poetry, accusations of a national betrayal:

"Anti-Brazilian!"

"Not at all. I am Brazilian. But *more than being Brazilian*, I am a living, impassioned being to whom the telegraph communicates an elegy of blood-soaked peoples. . . . I am Brazilian. Proof? I could live in Germany or Austria. But I live patched together in Brazil."[83]

Critical Nationalism: Ethics and Politics

The image of place pictured in these abstracted landscapes forms the basis of Mário's sophisticated vision of nationalist modernism. The modernist ethos composed in this Brazil, defined as a place of wandering and erring, relies equally on an aesthetics not characterized by beauty or even formal coherence or purity. After watching a performance by a group of dancers in Natal, Mário writes: "It is clear that it doesn't have to do with a technically perfect work of art, still for a long time I have perceived perfection to be ridiculous and vacuous. Put a bit more in focus, through the monotony and vulgarity of the troupe, things of a sublime value appear that move me to exaltation."[84] The collage of dances creates an imperfect, adulterated aesthetic, from which "bursts out a damaged [*danado*] Brazilianism."[85] The word *danado*—which Mário uses to describe the hybrid dance forms of northeastern Brazil—contains an equally hybrid list of meanings: from "impaired" or "damaged" to "damned, condemned," to a particularly Brazilian usage meaning "smart, keen, clever." *Danado* signifies "valiant" or "courageous" and its opposite "wicked."[86] "Brazilianism" is itself errant—as damaged and productive as the word *danado*. Mário's collaged photographic landscapes reveal the error of picturing the horizon of Brazil as if it marked the boundaries of Brazilian identity, and still deny a view of the country to an uninitiated audience. They instead compose an ethics and aesthetics of really living in Brazil.

Benedict Anderson describes the importance of bilingual intellectuals like Mário in the colonial territories during the "last wave" of nationalisms in the early twentieth century: "Bilingualism meant access, through the European language-of-state, to modern Western cul-

ture in the broadest sense, and, in particular, to the models of nation-alism, nation-ness, and nation-state produced elsewhere in the course of the nineteenth century."[87] Mário fits this description in many ways, yet his bilingualism configures nationalism as "a half ironic smile di-rected at the city of Paris."[88] The pun of *lancha* and *lunch* in the title of the photograph "Accidental *desvairismo*" creates a false analogy to ac-company the errant photograph. The bilingual explanation in French and "Brazilian" that he writes to Dina Lévi-Strauss does not represent access to a French configuration of nationalism but instead reveals the insufficiency of that understanding of what it means to live in a place. As much as Mário does not reclaim Tupi as the national language of Brazil, instead writing in an errant Brazilian, he does not simply refuse the French intellectual influence that the Lévi-Strausses represent in a francophone nationalism. Instead, to patch together a life in Brazil, he perverts French into a bilingual critique of the foreigner's misliving of place.

Here we can begin to differentiate critical nationalism from the cultural nationalism that has dominated studies of both Brazilian and Mexican modernism. Mário locates the source of critical nationalism in the legacy of the colonial experience, which is central to the national ethos of Brazil as well as a pan-American, anticolonial civilization, aes-thetics, and epistemology. He seeks to locate "a new *country of America*, a civilization that they keep calling barbarous because it contrasts with European civilization."[89] Mário vents his frustration with limited defi-nitions of the national as necessarily opposed to the regional: "I don't understand either those from Pernambuco, nor Paulistas nor anyone like that. Moreover, I don't even understand patriots, that is already known. Tristão de Athayde the other day said that despite the fact that I arrived at a certain expression of the national being, I had a singular po-litical incomprehension of Brazil. I think he was wrong. I already had a political understanding of the country [*pátria*] but I surpassed it. Thank God."[90] The new meaning of pátria is not apolitical but rather includes a range of other considerations that he considers to be more important. This nationalism is at core an opposition to the history of European colonialism, and it contributes to what Gorelik calls the constructive rather than destructive project of Latin American modernism.

In a letter to Oneyda Alvarenga in 1934, Mário repeats this idea of a more complex construction of pátria: "And you are in Minas, you are living in Minas, eating, sleeping and suffering in Minas . . . Your pátria

now is Minas. Not in the vulgar, bourgeois and sentimental sense of pátria . . . Your pátria ends up being at the moment 100 percent Minas, and you will make a very useful book that through the expansion of Minas will maintain a value and utility for all of Brazil. And even universally."[91] The ethos of modernism produces an image of the local that can layer microcultural and universal claims on top of each other. As Eliana Bastos indicates, the national, the local, and the universal emerge complementarily here. Mário's critical nationalism is simultaneously of Minas and of Brazil, of Brazil and the Americas, local and cosmopolitan. Mário himself writes: "Now the countries with an imported civilization, the colonial-countries, are by definition international countries."[92] What colony or former colony, he forces us to ask, has the luxury of *not* being global? For this ethnography to be truly local in a colonial place like Brazil, it is must be simultaneously regional, national, and universal. It cannot simply employ the folkloric methods of collection that Mário described with such disdain earlier. The composition of a Brazilian landscape must combine image and word (often at odds with one another), fiction and collection, place and practices, and as we shall see more in the next chapter, humor and severity. The ethos constituted here is not apolitical, but in these passages Mário views a cultural nationalist understanding of pátria as exhausted and, in his terms, useful neither for Brazil nor for the rest of the continent. Indeed, the increasing repressiveness of Getúlio Vargas's government, which often employed the more heroic images of Brazilian modernism, shows that Mário was wise to be wary of calls to pátria. The thirties in Brazil, perhaps not as much as in fascist Europe but certainly to a degree, was a decade in which populist appeals to ethnic identity and national pride had clear political goals. The philosophy of history linking land and race—put to use by fascism—that Mário rejected in favor of ideas of polyphony and "living truly" are clearly political. His form of apprentice tourism, Mário seems to warn with the same ironic smile directed at Paris, has a universal value and influence that Europe must take into account. Modernismo operated politically through the composition of an ethos that simultaneously counteracted a history of colonial oppression and the contemporary ideas that threatened to reproduce its effects of racism and poverty.

Mário's reinvented genre of landscape contains a seemingly contradictory picturesque of the familiar, the image of a known, lived place: "The picturesque of Natal is an honest enchantment, a familiar delight

for us, an air of a country home that renders it so Brazilianly human and quotidian like no other Brazilian capital . . . oh, winds, winds of Natal, criss-crossing me as if I were a veil. I am a veil. I don't obstruct the landscape, I don't have the obligation to see exotic things . . . I am living the life of my country."[93] In this utopic moment, Mário—like Jorge Fernandes and unlike Dina Lévi-Strauss—lives the place of Brazil. The same winds that obscure the reflection of the horizon of Brazil in "Mogí-Guassu (with Wind) July 1930" allow the modernist artist to act as a veil for Brazil: he lives the place but does not resolve its contradictions. This veiled picturesque is founded in the ethics of modernism: the artist is located in the community, protecting it from the exoticizing and acquisitive eyes of foreigners, and not perverting the image of everyday life.

Defying the unidirectional "move toward abstraction" and the purity of the painterly landscape, Mário locates modernism in Brazil and then reveals the ruptures and inconsistencies within this nation. These landscapes mess up the photographic frame so vital to protecting the purported purity of modernist photographic aesthetics. Their errant modernist aesthetics based in place actually pictures place in new terms. The movement of Brazilian modernism is not toward the perfection of the pictorial sphere, but rather what Haroldo de Campos might call a baroque gesture that points simultaneously to the surface and frame of the photograph and to its outside.[94] Through its mistakes, modernismo insists on the place of its enunciation and refuses to be left out of the "international" avant-gardes; it reveals the internal contradictions of the global project of modernity and demonstrates nevertheless that modernization was (and continues to be) an ongoing goal in peripheral countries. This is a painful process for an apprentice tourist, especially with his codaquinha in hand. His photographs remind the viewer that like the wooden planks floating on the horizon and destined to be victrolas, the photographs themselves will not remain within their frames but will also enter a global market of goods and ideas.

Portraiture

FACING BRAZILIAN PRIMITIVISM

Two very different self-portraits of Mário appear in *O tu-rista aprendiz*. Separated by just six months, both show his shadow cast onto the framed space of the photograph and function as meditations on the medium itself. In "My shadow, Sta. Tereza do Alto / 1/1/28" (fig. 16), Mário's shadow dominates the pictorial space and spills over the margins of the image, while it is almost lost in the river in "Madeira River / Portrait of my shadow cast from the deck of the Victoria, July 1927 / What happened to the poet?" (fig. 17), which reduces the poet to the size of a doll. If in the first photograph Mário's shadow explodes across the paper in a surge of excitement about stealing the foreigner's tool, in the second he is overcome by the photographic act, such that his barely visible shadow displays the struggle to represent himself in this untrustworthy medium. The tense relationship he reveals with his Kodak—which he describes as an "obsession"—becomes the site for his theory of a mod-ernist sublime. For modernist intellectuals like Mário, the act of taking the camera into their hands becomes both a triumphant gesture of acquisition and a source of anxiety

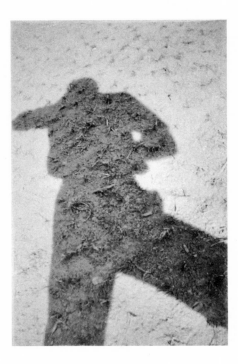

16 Mário de Andrade, "Sombra minha / Sta. Tereza do Alto / 1-I-28" ("My shadow, Sta. Tereza do Alto / 1/1/28"). *Fundo Mário de Andrade, Arquivo do Instituto de Estudos Brasileiros,* USP

about representation, a kind of embodiment of what Silviano Santiago famously called the "entre-lugar" [between-place] of Latin American discourse.[1] Mário is neither European enough to be the cosmopolitan photographer of exotic others nor "primitive" enough to be authentically one of them, and his resulting position as simultaneously subject and object of photographs leads him to a brilliant rewriting of modernist portraiture and modern subjectivity. If these photographs read as familiar "portraits of the artist," their contradictory images of the photographer and cloaking of the artist as his shadow are the starting point for a more profound investigation into how portraiture operates outside mainstream modernism.

As much as the shifting landscapes in the previous chapter pictured the sites of demographic shifts, as rural populations arrived in the city and as modernist artists traveled into the country, we see the resulting face-to-face encounters in deeply racialized portraits. What is the relationship of these representations of race and modernity to European primitivism, which mined images of racialized bodies and faces for the renovation of a declaredly exhausted culture? What do Mário's shadowy self-portraits reveal about Brazilian modernism's own practice

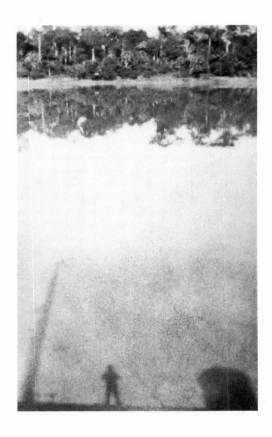

17 Mário de Andrade, "Rio Madeira / Retrato da minha sombra trepada na tolda do Victoria, julho 1927 / Que-dê poeta?" ("Madeira River / Portrait of my shadow cast from the deck of the Victoria, July 1927 / What happened to the poet?"). *Fundo Mário de Andrade, Arquivo do Instituto de Estudos Brasileiros, USP*

of primitivism? Mário named both indigenous and Afro-Brazilian cultures as the source of regional and national identity, and he composed a photographic modernism that pictured a nuanced and tense vision of this act of representation in the midst of an ethnically diverse society. We have seen already that mere proximity to other people did not satisfy Mário's demands; Dina Lévi-Strauss lived in São Paulo for several years, and he denied that she had any access to the real Brazil. The shared terrain that proximity presupposes eluded even the apprentice tourist himself, as the land constantly receded into reflective horizons.[2] The ethics of living Brazil demand more than just immediacy, and this demand carries over into Mário's articulation of Brazilian primitivism. The difficulty is that proximity imagines race and difference as if they were concrete, definable, and containable, and most importantly, translatable into artistic modernism: a discernible object easily inserted into an artistic form. Instead, in Mário's photographs racial and cultural

heterogeneity operate as aesthetic and ethical tensions at the core of Brazilian modernism and are not readily available for the energizing of a modern culture in need of fuel.

Brazilian anthropophagy sought to create a heterogeneous, racialized national identity by polemically recasting cannibalism as a positive cultural practice. At the same time, in a founding text of modernism, Mário disparages primitivist fads in European modernism — "In sculpture Rodin is horrendous: imaginary Africans are good"— and several years later mocks Oswald's knowledge of his own country: "Oswald comes from Europe and Brazilwoods-himself."[3] Mário rejects the discovery of primitive Brazil, by the French and Portuguese as much as by Brazilians themselves. He parodies the adoption of the role of the traveler by Brazilian modernists—the form of modernist indigenism that García Canclini argues arrived in the Americas as a result of journeys to Europe—even as he enacts his apprentice tourism and investigates the art, music, and knowledge of non-European Brazilians. As discussed above, Mário takes the project of modern ethnography very seriously, creating his own collections of indigenous and Afro-Brazilian stories, religious beliefs, music, and photographs of these communities in São Paulo and in the northeast.[4] Mário undermines the accuracy of his own collections—remember the dream in which the Tupi Indians berate him for getting their story wrong—but he does not create images of some abstract or imaginary indigenous other. Instead he delves into the cultural, linguistic, and ethnic diversity of Brazil in search of serious alternatives to an imported vision of modernity.[5] To follow how Mário avoids such a superficial "pau-Brazilianism," we must look carefully at his representations of racially marked subjects and himself as such a subject. How do they (and he) appear in portraits, and what implications do these interventions have for the genre, for photographic theory, and for modernist aesthetics?

In literary, theoretical, and visual experiments with photography, Mário configures an ethos of modernism that remains productive and challenging to contemporary cultural producers and theorists due to its fusion of ethics and aesthetics. Through portraiture he faces the representation of racially and ethnically heterogeneous populations in Brazil: he examines how race is lived without confirming its self-evidence. Raul Antelo calls this "Brazilian primitivism," and while the repetition of the word may engender some confusion, it also generates an appropriate feeling of discomfort. Mário's Brazilian primitivism did

not fundamentally change the social, political, or economic position of the communities with which he was engaged any more than Picasso's ended French colonialism in Africa. Mário describes the ideal modernist poet as a veil for the nation's landscape, emphasizing his or her doubled position between center and periphery, between the interior of Brazil and Europe. The negotiation of this position by the urban modernist artist, who seeks to create accurate representations of Brazil while protecting it from the acquisitive eyes of foreigners, takes place throughout Mário's poetic, fictional, and theoretical writing and belongs to a long tradition of portraits of national identity. His ongoing practice of portraiture in both photography and writing sets forth a new definition of the sublime from the perspective of the object of the gaze—the sublime as photogenicity—which proves crucial to the ethos of modernism.[6] Mário's portraits frame modernism as a "lyrical true deceit," which combines ethics and aesthetics in a mixture of art, truth, and lies.

Ethos as Character

The key text for any exploration of the portrait in Brazilian modernism is Mário's landmark novel *Macunaíma* (1928). Throughout the twentieth century and into the twenty-first, it has been made into films and plays, reconfigured in art installations, and remained a constant point of reference for artists and writers from across the Americas. Based on a character contained in the collections of German folklorist Theodor Koch-Grünberg, the novel follows its eponymous hero from his birth in the heart of the jungle in northern Brazil, in an Indian community but with "skin black as calcined ivory," to the heart of an industrializing São Paulo full of machines.[7] Traveling with his two brothers, Maanape and Jiguê, Macunaíma undergoes remarkable changes, and Mário creates a language and mythology of modern Brazil.

Mário dedicated *Macunaíma* to the influential essayist Paulo Prado, but its bawdy humor provides a striking contrast to Prado's somber *Retrato do Brasil: Ensaio sobre a tristeza brasileira* (*Portrait of Brazil: Essay about Brazilian Sadness*), published the same year. Most importantly, the subtitle of *Macunaíma* marks a dramatic break with how Prado's essay paints the Brazilian national character. The dedication begs a comparison between his *Portrait of Brazil* and the emptied space of portraiture created

in Mário's subtitle, which names Macunaíma as *O herói sem nenhum cará-ter* (*A Hero with No Character*). Prado argues that the sadness and weakness of Brazilian national character is the result of the mixture of races that make it up, a *mestiçagem* that causes the persistent defect of "a lack of energy, brought to an extreme of profound indolence."[8] Brazilian character, he continues, is excessively sensual as a result of the rampant desire of the colonizers for indigenous and African women, which produced "our primitive, mestizo populations" in animalistic matings.[9] In contrast, Macunaíma's embodiment of multiple races—Afro-Brazilian, Indian, and European—makes him the hero of a bizarre American modernity. The composition of the hero of Brazil without any character will be fundamental to modernism's combination of ethics and aesthetics. K. David Jackson reads the emptiness of Macunaíma's character as the reproduction of colonial tropes of the emptiness of Indian culture: "Modernist primitivism asserts that indigenous societies lack a history or a blueprint for the future, and occupy a space that is vacant of organized culture, save what repeats or replies to the West."[10] Considering Mário's study of music and stories, fictionalized but also detailed in their presentation of particular, living cultures, I find that it is not Indian culture that is vacant, but rather the modern subject. That vacuity represents not a negative value, but rather a fundamental revaluation of subjectivity and character.

How can a modernist movement founded on a hero with no character be concerned at all with ethics? Mário himself described *Macunaíma* as "the most immoral book in the world."[11] Ethos and the ethics it imagines do not obey the demands of morality, but rather explode the very structure of character in the modern subject. In his seminar on the ethics of psychoanalysis, Lacan states that ethos, from Aristotle to Freud, has been a "science of character";[12] it refers to mental character traits (smart, funny, mean), and to how people physically inhabit the world and express emotions. Those individual characteristics come into being, however, through the actions of a person in the world as part of a praxis. For Aristotle, ethos is a "habitus or habit, in other words, a kind of second nature that we acquire in the course of our socialization by continual practice."[13] Ethos therefore has to do with "living Brazil for real," as defined above, and also with the innate character of the person who lives it. The scholarship on ethos contains the language of drama and performance as much as social interaction, as "a playing out of customary roles."[14] Modernist portraits of a Brazilian character,

both individual and national, formulate ethos as the ethical participation of the individual in this social sphere, and as the aesthetic that this performance enacts. That Macunaíma is a hero "sem *nenhum* caráter" is a meaningful linguistic trick: as a modern Brazilian subject, he has no moral character at all, and he has not one but many social habits. More than just linguistic play, the playful language of *Macunaíma* suggests a portrait of Brazil with no character but with an ethical way of being nonetheless.

Mário's ongoing engagement with Freudian structures of the psyche reveals the importance of character in a modernist sublime, for he reads Freud's theory of the subject as a theory of history and a theory of aesthetics. He debates Freud precisely on the terrain of character: on the character of "primitives" and on the character of civilization. Mário theorizes an "epidermic" subjectivity, which takes on pathologizing modern discourses of race and sexuality. Haunted by anxiety about whether or not he is Brazilian, Mário's photographic portraits present a national character that is simultaneously empty and multiple, a modern subject that transforms the dominant psychoanalytic theories of the day, and a modernist sublime that is simultaneously hermetic and social.

Portraiture

Despite its conservative reputation, portraiture is at the center of modernist experiments with aesthetics. Portraits by definition bridge mimetic representation (of a person's face) with the inaccessible, even hermetic, space of interiority. Wendy Steiner describes literary portraiture as a paradoxically mimetic realm for modernist experimentation: "The portrait pushes outward to refer to reality . . . The portrait is drawn, then, toward both an art for art's sake aesthetics and a call for documentary reference in art." This doubled gesture to interiority and to documentation makes the portrait "an exhibit of *both modernist hermeticism and primitivist realism*."[15] Yet Steiner implies that portraiture unites two realms that ought to be incompatible: modernism should limit its reference to the work of art itself and thus preclude any concrete reference to race, and any art that smacks of realism for its representation of racialized bodies ought not be considered modernist. Even so, canonical figures such as Pablo Picasso and Gertrude Stein reveal that

"in painting and in literature, the step away from conventional veri-similitude into abstraction is accomplished by a figurative change of race."[16] Indeed, if abstraction often was conceived as landscape reduced to horizons and planes, the other major gateway to the abstract was primitivism. The representation of race—especially in portraiture—is crucial to modernist abstraction and functions as an aesthetic convention as much as a social one.

Macunaíma also undergoes a "figurative change of race" as he makes his way from the interior of Brazil to São Paulo, albeit in the opposite direction than do Stein's and Picasso's protagonists. While the ladies of *Les Demoiselles d'Avignon* put African masks on pink bodies, our hero changes from "preto retinto" (deep black) to "branco louro" (white blond).[17] What, then, is the difference between these two masks of race? What does the reversal of the direction of racial transformation mean for modernist aesthetics? Macunaíma's transformation could be read as a comic reference to Mário's own change from being a "primitive intellectual" in relation to Paris to being an urban ethnographer during his ethnographic journeys in Brazil.[18] By becoming an apprentice tourist, Mário experiences a transformation much like Macunaíma's, from racialized peripheral modernist looking toward Europe into "white" city dweller in the interior of Brazil. Perhaps because of his occupation of multiple racial categories—a point of debate to which I will return below—Mário creates a genre of Brazilian primitivist portraiture in which he includes himself as both subject and object.

Photography is particularly important to these experiments with portraiture, for it seems to necessarily produce a faithful document of the face in front of the camera. The medium gained popularity in the nineteenth century because of its easy production of portraits, making them accessible to the middle and lower classes, for whom painted portraits had been out of reach. Walter Benjamin argues that photography profoundly changed portraiture, for while the authenticity of painted portraits resides in the identity of the painter, that of photographs never varies from the identity of the person pictured. Despite his condemnation of the bourgeois indulgence in photographic portraits, Benjamin argues that "photography cannot do without people," the presence of whom—in their particularity—defines the medium's impact on art. The subject of the photographic portrait "will never yield herself up entirely into art" but instead always remains partially in the world.[19] Photography thus captures the spirit of Goethe's poetic "form of the

empirical which identifies itself so intimately with its object that it thereby becomes theory."[20] Photographic portraits can be understood as theory themselves in their stubborn loyalty to the "empirical" subject they picture; they are a theory of art in the modern age.

While the intimate relationship between object and theory holds on in Latin America, Mário undermines the mimetic function of photography in portraits and thus transforms the theory these objects produce. The clearest use of photography's ability to document people's faces, common in the late nineteenth and through the twentieth century, were phenotypes of "primitives" and criminals. These images, however, are generally not included in genre definitions of portraiture.[21] Ethnographic images generally refuse what Benjamin marks as the founding question of portrait photography, the name of the person portrayed, replacing it with "empirical evidence" about race and criminal pathology. A theory of this kind of modernist object, the impossible photographic portrait of a racialized subject, presents character, subjectivity, and modernist aesthetics in completely different terms.

Telê Ancona Lopez points out that Mário made important revisions to *Macunaíma* during the two years that passed between the six consecutive days during which he famously wrote it in 1926 and the novel's publication in 1928. These revisions were made during his travels and the initial production of *O turista aprendiz*. During the two years between the first writing and subsequent publication of *Macunaíma*, Mário produced the hundreds of photographs contained in his archive and in the manuscript. These photographic portraits—their formal composition, titles, and insertion into *O turista aprendiz*—expand portraiture's role as a bridge between abstract hermeticism and figurative representation in Brazilian modernism. Mário creates a photographic portraiture based in images of masking and doubling that bridges the hermetic and the referential, and which creates a Brazilian modernist ethos founded in a distinctly ethical subject.

Sublimation and the Sublime

Mário's practice of portraiture and the ethos of modernism to which it contributes propose a structure of subjectivity that reverses the Freudian map of the modern subject. This modernist aesthetics participated in the larger discussion about subjectivity and representation that was

taking place at the crossroads of literature, ethnography, and psychology. The composition of the hero with no character that appears in *Macunaíma* and *O turista aprendiz* and Mário's fascination with the development of human subjectivity were profoundly influenced by the international dissemination and translation of Freud's writings.[22] He read *Totem and Taboo* before writing *Macunaíma*, in which he takes on some of its central concepts, including repression, narcissism, a "bricolage of discourses," and the Oedipal complex.[23] Mário departs from many of Freud's proclamations about the development of modern subjectivity, especially from his hypothesis about its relationship to the development of the arts in human civilization.

In the preface to *Totem and Taboo*, Freud states that unlike the totem, taboo still exists in modern civilization: "It is negatively conceived and directed to different contents, but according to its psychological nature, it is still nothing less than Kant's 'Categorical Imperative,' which tends to act compulsively and rejects all conscious motivations. On the other hand, totemism is a religio-social institution which is alien to our present feelings."[24] Civilized groups are so distanced from the concept of totemism that it no longer governs the social impulses of modern human beings. In direct contrast to this historical progress toward civilization, Mário structures the narrative progression of *Macunaíma* around the hero's pursuit of his goddess lover Ci's lost amulet, the totemic *muiraquitã*. In the classic novel of Brazilian modernism, totem rather than taboo is the governing force in what the author calls "the only great (grand?) civilized, tropical country."[25] This favoring of totem over taboo also alters the development of the individual psyche, for Freud states that taboo is the earliest form of individual conscience. Macunaíma's bawdy language and raunchy sexual behavior defies all of the prohibitions that Freud describes as governing even "savage" cultures. Although the hero with no character is not a serious representation of individual subjectivity, every stage of his development is askew: he does not speak until he is six years old, he demonstrates an immediate and precocious sexuality, and he magically transforms himself from child to adult and back again. The modern subject embodied in Macunaíma fundamentally transforms the status of "the primitive," as both a historical and a psychic figure.

These differences established with the Freudian story of development have ramifications not only for Mário's representation of Brazilian subjects, but also for his concept of a modernist aesthetics. In his essay

"The Uncanny" (1919), Freud "feels impelled to investigate the subject of aesthetics . . . when aesthetics is understood to mean not merely the theory of beauty, but the theory of feeling."[26] Aesthetics for Freud contributes to a theory of subjectivity, for he considers aesthetic production to be an expression of intimate feelings. Of course, the modern subject does not have access to all of these intimate feelings, especially not the libidinous drives at their core. In *Civilization and Its Discontents*, he explains:

> At this point we cannot fail to be struck by the similarity between the process of civilization and the libidinal development of the individual. Other instincts [besides anal eroticism] are induced to displace the conditions for their satisfaction, to lead them into other paths. In most cases this process coincides with that of the *sublimation* (of instinctual aims) with which we are familiar, but in some it can be differentiated from it. *Sublimation of instinct is an especially conspicuous feature of cultural development; it is what makes it possible for higher psychical activities, scientific, artistic, or ideological, to play such an important part in civilized life.*[27]

According to Freud, individual psychic development from infancy to adulthood and social history from savagery to civilization rely on a process of sublimation. In both, sublimation makes possible the pursuit and achievement of the sublime.[28]

Mário sets forth a modernist sublime achieved instead by an accretion of historical moments, an additive process that allows the coexistence of multiple past times in the present. Macunaíma enters São Paulo literally bearing the values of the primitives, carrying with him "no less than the value of forty times forty million cocoa beans, the traditional currency in these parts."[29] Unfortunately for our hero: "They were entering the country of the river Tietê, where boodle regulates everything and the traditional money is no longer cocoa beans but what is described at various times as cash, coin of the realm, gold, dollars, pelf, lucre, dough, jack, brass, bullion, tin, sterling, boodle, farthings, joeys, tiddlers, tanners, bobs, florins, half-crowns, pence, quids, fivers, ponies, monkeys, dimes, quarters, fins, greenbacks, frogskins, bucks, iron men and zacs."[30] Although the bags of *cacau* are no longer the currency used in São Paulo, they still function in the system of exchange and continue to bear a certain value. The semantic explosion caused by the exchange of *cacau* into *contos*—just one of many such lists of synonymous words—implies that the symbolic and spo-

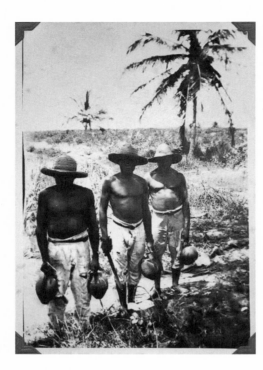

18 Mário de Andrade, "Bom Passar." *Fundo Mário de Andrade, Arquivo do Instituto de Estudos Brasileiros,* USP

ken languages of modern Brazil are the result of an additive mixture of words and values. Mário's sublime defies the sublimation of instinct that Freud argues permits development through the deferral or substitution of earlier historical moments by the conscious mind. Each of the repeated synonyms is redundant, in a sense, yet each marks the excessive, simultaneous existence of "primitive" and "modern" symbolic systems in São Paulo.

Mário's photograph "Bom Passar" (fig. 18) both critiques and lauds the photographic process as such an aggregate composition of the modern Brazilian subject. The title is both a place called Bom Passar and means "to have a good time," a coincidence that Mário exploits in this complex image. The photograph presents a challenge to his own, oft-cited formulation of the modern subject as a "ser-multiplicado" (multiplied being) in *A escrava que não é Isaura*:

The peoples are confused.
The sub-races abound.
The sub-races conquer the races.
Will they prevail perhaps for a moment?

The contemporary man is a multiplied being . . . three
races meld in my skin . . .
Three?[31]

Unlike Prado's portrait of *mestiçagem* as the source of a national malaise, in this early theory of modernism Mário suggests that the conflicts between these groups are continuing to be fought within each subject. The races exist individually at the same time that they fuse in the poet's skin and create a mixture. Questioning the "three" of the common refrain about the "three races of Brazil," Mário conceives of a manifold, shadowy Brazilian subject whose identity is never permanently resolved as the desired subject of *indigenismo, negrismo,* or *mestiçagem*. In "Bom Passar," the replicated subject of the photographically reproduced image is the very subject of the photograph: the high light contrast creates multiplied bodies without faces and transforms the men into objects rather than people, which serve only a compositional function in this picture of Brazil. The photographer's excessive power alters the relationship between artist and subject, and transforms the men's faces into the kind of landscapes surveyed by colonial travelers.[32] The faces in "Bom Passar," darkened into invisibility by their photographic reproduction, threaten that the "ser-multiplicado" might not fulfill the modernist goal of multiplicity as heterogeneity.

Strategies for Representing a "Hero with No Character"

The question raised by Mário's "Bom Passar," then, is *how* to produce portraits of people who are frequently the subject of ethnographic study. In European histories and theories of portraiture, the representation of indigenous peoples is a generic impossibility. In his recent, far-ranging meditation on portraiture in the European tradition, Richard Brilliant dedicates just one paragraph of the book to this problem, worth quoting at length:

> So-called "ethnographic portraits" seem to cause some critical difficulty in assessing their worth as portraits because the subjects are so often ignored as subjects of portraiture or they are strongly subordinated to other agendas of representation. . . . From a present perspective the portraits exhibit a very narrow range of physiognomic variation; they conform to a limited repertoire of types, particularized by details of ethnographic costume

and hair treatment, even though each person represented is named. If we mean by the term "ethnographic portrait" the portrayal of exotic non-Westerners by Western artists for Western audiences, in which the exoticism of the person portrayed is intentionally represented as the principal subject, and that exoticism is manifested through careful attention to details of costume, personal appearance, and "race," then such ethnographic portraiture is both anthropologically defined and culturally biased. But if ethnography, as a social science, involves the scientific description of men and women, their customs, habits and differences, then most portraits would qualify for ethnographic analysis, and most would be exotic to some ethnographers. *Of course, portrait artists working in their own culture rarely think like ethnographers, nor is it customary to apply anthropological techniques to the portrait of those with whom one shares a common culture.*[33]

Despite Brilliant's critique of exoticism, his definition of portraiture ultimately serves to exclude all "non-Western" people. Even naming the ethnographic subject does not allow her to appear in portraiture. How could one include the details of face, dress, and social status (Western or not) that create portraits, yet not transform clothes into costume and face into the "race" that Brilliant sets off with quotation marks? As Brilliant suspects, one could easily argue that Velázquez's portraits of the family members of the Hapsburg dynasty in Spain "exhibit a very narrow range of physiognomic variation . . . [and] conform to a limited repertoire of types, particularized by details of [ethnographic] costume and hair treatment." Why are these portraits not evidence of Hapsburgian exoticism or submitted to "ethnographic analysis"? Even though Brilliant accepts the possibility that Western portraits may be treated as ethnographic by some other group of viewers, his effective exclusion of non-Western populations from the genre of portraiture for their "limited repertoire of types" must be contested.

In fact, Mário's photographic portraits attempt to "think like [an] ethnographer" about Brazil, without denying the status of these representations as modernist portraits. "Tapuio from Parintins" (fig. 19) serves as a prime example of this form of photographic portraiture. Mário visibly reproduces the inquiring, even invasive, gaze of ethnography, and denies the young boy pictured a name. At the same time, he makes the status of the image as a portrait the pressing subject of the photograph. This is not a snapshot (there is no touristic context that proclaims "I was there"), nor does it function as ethnographic evidence (it contains no

19 Mário de Andrade, "Tapuio de Parintins" ("Tapuio from Parintins"). *Fundo Mário de Andrade, Arquivo do Instituto de Estudos Brasileiros,* USP

specific social scientific data). This image also does not work as a "type," due to the distortion of the characteristics of the face it contains. The boy's face is literally too close to the camera: it exceeds the framed space captured by the lens and cannot be kept in focus. Instead of the details of a child's face, the camera blurs his facial characteristics so that all we see are the shadow of an eye, half of a nose and mouth, and the rim of a hat. Although the subject remains recognizably a person, "Tapuio from Parintins" is not fully a portrait, for we cannot clearly make out his face. The effect of the photograph is close and intimate, his humanity pressing close to the cold lens of the camera, yet no viewer could recognize the identity of the person contained within its frame. The photograph proclaims only that Mário and this boy were in one another's presence, without allowing the camera to capture an essential indigenous subject for a nationalist, modern art. Mário's proximity to the boy permits him

a certain intimacy and demands an ethical response to his presence, and in so doing denies him clarity of vision.[34]

One could consider such portraiture, and the self-portraits that began this chapter, a form of what Mary Louise Pratt calls "autoethnography," a practice that Brilliant does not include within portraiture even though it resolves his dilemma over the representation of non-Westerners. Pratt identifies autoethnographic expressions as "instances in which colonized subjects undertake to represent themselves in ways that engage with the colonizer's own terms. If ethnographic texts are a means by which Europeans represent to themselves their (usually subjugated) others, autoethnographic texts are those the others construct in response to or in dialogue with those metropolitan representations."[35] Autoethnography is heterogeneous in its engagement with metropolitan representations; such works do not claim to be authentic or pure, but rather tend toward a mixture of signifying practices and bilingualism that registers differently among both the colonial and metropolitan readership. Unlike Brilliant's complete separation of the native and foreign viewers of portraits, the heterogeneity of autoethnographic texts speaks to varied audiences even as they elicit quite different responses from them. The simultaneous appropriation and explicit parody in *O turista aprendiz* of the travel narratives and ethnographic practices that Pratt examines make the relevance of autoethnography quite clear. If Brilliant thinks it is rare for portrait artists to think of their own culture as ethnographers, Mário's portraits suggest that for Latin American modernism this practice is urgent and central.

Mário uses another intimate encounter—cited in the epigraph to this chapter—to reveal how these experiences of photographic portraiture lay the foundation for a Brazilian modernist sublime. He narrates an encounter with a North American girl during his travels, in which his inability to speak English leads to an exchange of stares that takes place through his camera lens. She is: "a little American girl, very sweet and photogenic at once. Make believe that I don't know any English, I take pictures. It was enchanting to converse only through eyes and gestures. *I never stared so stared-at in my life, and it is sublime.*"[36] Here photographic representation occurs on both sides of the lens. Mário must be as photogenic as the American girl, as constituted by her stare as she is represented by his. He performs this new photographic act—the creation of an image that is only visible to the object of a stare—in photographs of himself as simultaneously the ethnographer and the racialized object

of study. While the landscape turned its eyes on Mário and pierced him through the windows of the train, in portraits this return gaze is even sharper; it imagines the photographic act itself as an exchange of gazes between two profoundly interdependent subjects, who nevertheless struggle to communicate. The sublime of "being photogenic," of being a good subject of photographic portraits, is crucial to Mário's definition of Brazilian modernist aesthetics.[37] It creates the ethos of modernism as the ethical coexistence and mutual constitution of subject and object.

These two photographic encounters offer a response to the critique of photographic reproduction contained in "Bom Passar." First, they create intimate interactions between photographer and subject that elude the objectification caused by an all-powerful photographer. At the heart of this intimacy is a redefinition of the sublime, a concept central to aesthetics since Kant, which Romanticism framed as the awesome experience of the landscape "rising up" to meet the heroic artist-viewer. Throughout O turista aprendiz, Mário references Kant's canonical image of man's encounter with nature but slyly provides another way to read it. The sublime encountered in a timid exchange of looks with a small girl, or the bewildering and intimate encounter with a young Tapuio, bears little resemblance to the grandeur of the Romantic sublime.[38] It is tiny in scale and does not promise the freedom imagined by Kant. The strangely humble autoethnographic sublime produces a frisson, but it is a contingent experience rather than the result of a majestic domination of the natural view.[39]

These tenuous encounters return to the contradictions of photographic portraiture that appeared in Mário's shadowy self-portraits at the start of this chapter. His archive holds another photograph of shadows (fig. 20), which he clearly did not take himself. It has no title, and is printed and shot entirely differently from all of his photographs. The shadow of the ethnographer stands beside the indigenous man who is the object of study, the two clearly separated even though they briefly inhabit the same pictorial space. This photograph can be read as the image of proximity as experienced by Dina Lévi-Strauss, rather than the modernist sublime Mário describes as "staring so stared-at." In the photographs of Mário's shadow, in contrast, he pictures the pain of the colonial encounter in his doubled position both in front of and behind the camera, as both the authorial subject and the powerless object. There is no other subject of his photographic investigation in these images, no projection of otherness on a racialized body. His shadow

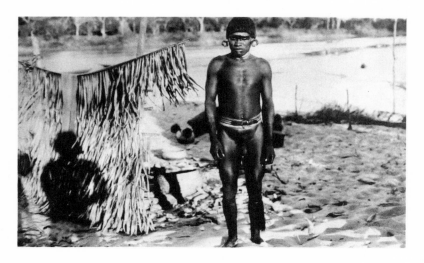

20 Anonymous ethnographic photograph. *Fundo Mário de Andrade, Arquivo do Instituto de Estudos Brasileiros,* USP

portraits present the simple and profound difference between Europe and the Americas, which Mário described in the letter to Levi-Strauss cited earlier: "I remembered having written her an Amazonic letter, telling about this South American pain of the individual. Yes they have a theoretical pain, social, but no one ever imagines what this precise pain is, of the effective incapacity of the moral being, which amazes and affects me . . . They don't suffer, no, they theorize about suffering. Pain, the immense and sacred pain of the irreconcilable human, I always imagined that it traveled on Columbus's first ship and lives here."[40] As a result of the Conquest, and the subsequent history of representation of Brazilianness by foreigners, the modernist artist always sees himself as the object of representation, even when he is the author of that representation. This is the intimate pain of the modern Brazilian subject, codaquinha in hand.

"Quá! quá! quá quaquá!" (Ha! Ha! Ha haha!), or Why It Is
Necessary to Be Funny and Photogenic When Being Modern
in Latin America

While this pain appears in portraits that create a sublime accessible only to the object of a stare, not everything is quite so bleak in Brazilian

modernism. Or better said, this pain appears with a concomitant grin. Freud's *Jokes and Their Relation to the Unconscious* (1905) marks a major shift in the theory of humor for the twentieth century, conceiving of jokes as a mode of defense against suffering.[41] In aesthetics and psychoanalysis, as in jokes, form plays a crucial function in the achievement of their desired effect: one cannot describe a joke, one has to tell it *well* in order for it to be funny. Mário makes full use of this Freudian conception of humor and aesthetics to create Brazilian primitivism, and to explore the colonial pain he defines as its source.

Throughout *Macunaíma*, Mário's great sense of humor explodes in the cursing, jokes, and sexual trickery of the hero without any character. The hero's laugh punctuates his adventures in grotesque laughter and bawdy humor:

> Then Macunaíma observed a maid with a dress of yellow linen painted with the extract of tatajuba. She was already crossing the stream on the tree trunk. After she passed the hero screamed to the tree trunk:
> "Did you see anything, tree?
> "I saw her privates!"
> "Ha ha ha haha!"
> Macunaíma let out a huge guffaw.[42]

This laughter is simultaneously self-directed and at the expense of others. *Macunaíma* laughs both at modernism and its outdated predecessors, at Brazil and its European colonizers, at the absurdity of the literary text itself. Like so many modernist texts and manifestos, the novel uses humor to activate the reader's participation. Much as manifestos call forth participatory and adversarial audiences, the jokes contribute to a "historically and culturally complex" Brazilian primitivism, for they alter the constitution of community and belonging.[43] Unlike Prado's somber, sad Brazilian character, the laughter inspired by these texts unites the readers in a community of diverse laughers, one composed of multiple individual subjects whose faces are ravaged by laughter. Getting the joke here means that the audience understands both its formal and ethical implications.

Mário's autoethnography culminates in a hysterical pose for the self-portrait, "Ridiculous Bet in Tefé, June 12, 1927" (fig. 21), in which he holds the cane and hat of the European naturalist, the banana of Afro-Brazilian and indigenous "savages," and the fan of the mistress of a plantation. This ridiculous bet and the pose mock European representa-

21 Mário de Andrade, "Aposta do ridículo em Tefé, 12 de junho de 1927" ("Ridiculous bet in Tefé, June 12, 1927"). *Fundơ Mário de Andrade, Arquivo do Instituto de Estudos Brasileiros,* USP

tions of Brazilian savagery, while simultaneously marking Mário's own distance as an inhabitant of industrial São Paulo from the rural spaces where he travels. The icons of the primitive are shown to be performances of otherness for the benefit of the camera, and the symbols of the so-called three races of Brazil are layered comically one on top of the other, refusing the portrait of a single, unified national body. In "Neptuno," a similarly posed photograph holding a spear and decorative palms as props, Mário again places himself at the center of a satirical ethnography. In these portraits, Mário's body performs and gestures each race, while his scholar's glasses brightly reflect back at the viewer. The round glass of the lenses doubles the mirror of the single lens reflex camera, and suggests the viewer's capture as much as Mário's own.

In the years following his most active engagement with photography, Mário continued to explore the power of humor and the aesthetic theory of being "photogenic," examining two of the early twentieth century's best-known funny men. His modernist humor leads to fascinating conclusions about the ethics of photographic portrai-

ture, modernist aesthetics, and, quite literally, representations of face. Mário wrote about cinema in the early years of the famous modernist journal *Klaxon* and later in a journal that was inspired in part by the French magazine *L'Esprit nouveau*, producing texts about film that reveal a fascination with modernist portraiture and the ongoing influence of still photography. In the first issue of *Espirito Novo*, Mário wrote an essay titled simply "Caras" ("Faces" [1934]), in which he discusses the faces that were synonymous internationally with modernity in those years: Buster Keaton and Charlie Chaplin.[44] As early as *A escrava que não é Isaura*, Mário treats Chaplin—whom he fondly calls Carlito—as a philosopher of the modern era: "No one passes safe and sound through Schopenhauer's emptiness, through Freud's scalpel, through ingenious Carlito's irony."[45] In the later text, he uses a comparison between the two cinematic figures as, in a sense, portraits in action, Benjaminian object-theories of what it means to be "photogenic."

Mário's theory of photography once again originates from the object of photographic capture. He dwells on what it means to be photogenic, not what it means to take a beautiful or avant-garde photograph. Coming down firmly on the side of Chaplin in what he stages as a competition with Keaton, he states that "the most admirable thing about the creation of Carlito's face is that the entire effect of it is produced directly by the photographic machine. Carlito manages to give it an anticinegraphic quality, enormously lacking in shadows and principally planes. And it is for this reason really that his face is comic in itself, violently contrasting with the other visages on the screen, and which we perceive as visages from real life."[46] Mário admires the absolute artistry that makes Charlie Chaplin, the man, indistinguishable from the invented character of Carlito (fig. 22). This invented figure is possible only in the medium of photography: "I am not saying that the face composed by Carlito isn't photogenic, on the contrary, it is extremely photogenic. Even so it is anticinegraphic, and this is why it gives the sensation of a real man with a designed face."[47] The photogenic is not an aesthetic determination based upon attractiveness of Carlito's face, but rather a result of the comic distortion of the "real man" who acts the part.

Mário creates a precise vocabulary to explain Chaplin's photographic superiority to Keaton. He differentiates between *a cara*—the "face"—of Chaplin, and *o rosto*—the "visage"—of Keaton: "The inferiority of Buster Keaton begins already in the creation of his face. He utilizes a

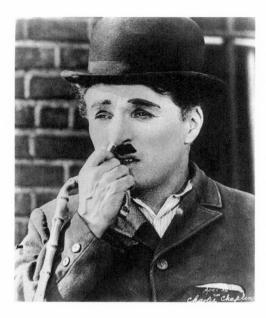

face *d'après-nature*, which seems to me to be a grave defect" (fig. 23).[48] The complex function of Carlito's pure *faciality*, as we might call it, is worth quoting at length:

> We cannot get interested, that is, don't feel intimately, that behind the character of Carlito is the man Charles Chaplin who plays Carlito. The perceived truth is of a single entity—Carlito or Charles Chaplin is of little importance—which has a designed face. And the designed face on the body of a man is what causes the comic (it would be absurd) that is so extraordinarily funny and intimate. And at the same time profoundly tragic, because of the notion of abnormality that it carries with it. And the proof that the comic of Carlito's face is not absurd is that we identify the face of the man Charles Chaplin intimately with it. The real portrait of Chaplin, as much as we sympathize with it (because we love Carlito), causes us a certain foreboding. We feel robbed or mystified, because for us the visage of Chaplin is the face of Carlito.[49]

The *cara* of Carlito is an honest fake; it is purely about the face as an exterior that is deeply meaningful, and yet is only ever superficial. The limitations of Keaton's *rosto* are those of traditional portraiture, which proclaims a truth of identity through the creation of a naturalistic visage. Carlito's face reconceptualizes modern character itself: it is a super-

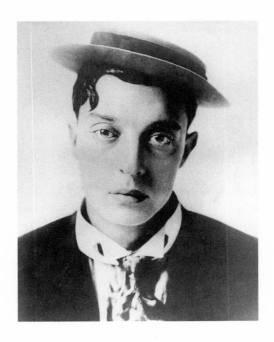

23 Buster Keaton.
*Courtesy of the Douris
Corporation*

ficial design that is intimately connected to the person who "wears" it.
The image here is not unfamiliar: a mask behind which there is no face.
Macunaíma wears such a mask of heroism even as he has no character.
The combination does not deny his heroism but instead alters the defi-
nition of character.

Surprisingly, the photogenic in Mário's modernist aesthetics results
from the *dissolution* of the indexical function of photography and film,
for it erases the actual being represented in the image. Photography
and cinema have been proclaimed "indexical"—an adaptation of C. S.
Peirce's differentiation between indexical and iconic signification—for
their "actual contiguity or connection in the world," for tracing the
light of the world onto the sensitive surface of film.[50] In Mário's view,
though, the photogenic does not provide a trace of a past or present
"real," but rather presents an impossible mixture of the "real" with the
"designed." A subject is photogenic when his or her face is always already
a photograph, already the object of a gaze, and therefore not altered by
photographic capture. This reverses the meaning and direction of the
photographic sublime; since the design is primary, the photograph is
not valued for its accurate, indexical capture of a face. Its primary sig-
nification is not, as Barthes has famously written, "this has been," but

rather "this has been designed." This reversal rejects the imbalance of power between photographer and subject, the objectifying violence of the medium, for the photographer does not control her own photographic image. The photogenic sublime preexists the photograph itself and is the property of the photogenic object, the designed subject of photographic capture. The counterintuitive paradox Mário establishes, in which the fictional truth in portraiture signified by "face" is superior to the more naturalistic yet aesthetically less powerful "visage," changes the terms of the old debate over the medium's documentary status. Altering the value of photography's indexical function means questions of truth and lies are no longer at the core of the ethical or aesthetic definition of photography. Instead, the quality of a mutual exchange of stares pictures the two people involved in the production of the portrait in an ethical bind and defines the sublimity of the photograph in terms of this form of "photogenicity."

As in *Macunaíma*, the rejection of indexicality depends on a sophisticated form of laughter, which is both philosophical like Chaplin and active at the same time. Unlike a clown, this photographic face is funny without being absurd, permitting a sympathetic response to the character portrayed. Humor stimulates "aesthetic contemplation," which (rather than beauty) differentiates artistic from commercial cinema and photography. Aesthetic contemplation for Mário, however, is not the same as what Rosalind Krauss calls "contemplative abstraction" in mainstream modernism, which enfolds the viewer and the artist in a hermetic enclosure.[51] Here again Mário creates a precise vocabulary for the effects of Carlito's humor: it attains *o cômico*, the comic, rather than merely *o engraçado*, the funny. Unlike the funny, the comic in his modernist aesthetics necessarily includes a move to the tragic. This representation of the comic portrait returns us once more to *Macunaíma*, where the literary portrait of the protagonist's lack of character is part and parcel of the novel's bawdy humor. Jokes are a defensive gesture against pain; as much as they seek to avoid it, pain is also their source. The novel concludes with the loss of the hero: Macunaíma, weary of life and still mourning the death of his lover, tells his story to a parrot, dies, and rises to the heavens to become a constellation of stars. In these last pages, the reader discovers that the story she has just read had been related to the narrator of the novel by this parrot. Like Carlito's pure faciality, the major novel of Brazilian modernism is told by a being

with no consciousness; it is purely superficial and yet a truthful figure of modernity. The lack of character and superficiality (super-faciality?) of the portrait is inextricably tied to the pain of colonial history and makes modernist portraiture possible on the periphery. Like these faces, the ethics and aesthetics Mário outlines in this ethos are conceptually empty; they do not prescribe ethical actions or the image of formal excellence but rather present a modernist portraiture composed at the intersection of the two.

Mirrors: The Exteriority of the Subject

Mário grants Buster Keaton just one artistic triumph in the composition of his cinematic character: the immobility of his face. This immobility, which emphasizes the still photograph behind all moving images, contributes a truly comic element to Keaton's work: "It is an exterior element, added. It is not part of the structure of the face, it does not come from the skeleton, it doesn't come from the flesh, from the skin. And it doesn't come — even less so — from the photographic machine. It is not a plastic phenomenon. It is an element of a psychological order, added to the structure of the face, to make it interesting. It makes it interesting and produces the comic. But it is always an excess."[52] The paradox of the "face" versus the "visage" creates a counterintuitive configuration of the relationship between psychology and identity, such that psychology resides outside the individual subject as a supplement or a remainder. This vision of subjectivity is key to the modernist aesthetics of portraiture that Mário devises, for although the face is still literally at the center of the portrait, it is a strangely vacant surface. An immobile, masklike face appears as an anticolonial revision of Freudian psychology, putting into question "the actuality of the portrait subject" that Steiner placed at the very center of the paradox of modernist portraiture. This ethos constitutes character as truly exterior and therefore emphasizes its function as a praxis. The remaindered subjectivity presents the (non)character of Brazil, with important ramifications for the cultural and political project of Brazilian primitivism.

In "Espelho, Pirineus, Caiçaras" ("Mirror, Pyrenees, Fences"), written in December 1941, Mário discovers the exteriority of the modern subject that appears throughout his own aesthetic production. He medi-

tates on "Eu sou trezentos" ("I Am Three Hundred"), the first poem of the collection *Remate de males* (1930), which generally has been read as a nationalist celebration of racial heterogeneity in Brazil:

> I am 300 I am 350,
> Sensations are reborn from themselves without rest,
> Oh mirrors! O Pyrenees!
> . . .
> I am 300 I am 350,
> But one day I will finally run into myself.[53]

This trope of "running into oneself" repeats throughout his literary and photographic production, and also in the work of the Mexican modernists examined in the following chapters. Yet in the 1941 manuscript, Mário admits that he himself has never understood "the exact meaning of those words, but they always remained for me as a refrain of the intimate meaning of my being."[54] Only later, contemplating his own reflection in a mirror and thinking about donating his possessions for the greater good of humanity, "I had such a blinding realization that I trembled. The thing finally became conscious, the meaning of mirrors in my verse!"[55]

Mário's shocking revelation recasts mirrors through a visual and logical pun on the word *posse* as both *posar* (to pose) and *possuir* (to possess). In portraiture, the subject's pose almost always includes possessions that mark his or her social position, profession, or class. Possessions are a pose, both truthful and fictive. The double reference to poses and possessions evokes Mário's earlier poses in front of the camera lens as primitive, *dona* (plantation mistress), and dandy. Mário makes these discoveries about the nature of portraits by drawing connections between the seemingly unrelated terms *mirror*, *Pyrenees*, and *caiçara*:

> If the other two terms [Pyrenees and *caiçara*] seem (I am not sure) to express values of my collective being, an Iberian Brazilianism and a Franco-international culture, "mirror" reflected a simply individualistic attitude, an *epidermic* instinct, faithfully coordinated and organized. The "mirror" stared at indicated to me the posture of a portrait that I want to adopt. If it is true that I never studied attitudes in the mirror, it is no less certain that many times I surprised myself contemplating myself, observing myself in the mirror, and I turned away embarrassed. . . .
>
> "Mirrors" in the verse . . . is the exteriority of my whimsical "attitudes,"

are my adventures and experiences—aesthetic, artistic, vital. It is the being seen in the mirror. *I am not wholly myself, but rather my "I" visible in mirrors. Even by me. . . .*

Which is where I perceive now that this verse is terribly painful. I didn't 'suffer' particularly with it, nor is it that I found it pretty or beautiful: it surprised me by being a definition.[56]

The poses in the mirror are the portrait of the artist, but only and essentially a portrait of a pose. This is a theoretical lesson learned from photography, for it incorporates Mário's photogenic sublime of staring so stared-at. Even the seemingly individualistic mirror reflects the poet's social function, for the exteriority engendered by mirrors stretches from the meaning of *caiçara* as a fence surrounding an Indian encampment to include the border between Spain and France.

A fascinating shift in the meaning of the word *epidermic* takes place in this epiphany about mirrors, showing this vision of the modern subject to be inseparable from Brazilian primitivism. In the first lines, *epidermic* signifies a superficial and vain attitude. By the end, an "epidermic" vision of subjectivity makes possible an altogether different, Buster Keaton–inspired definition of modernist aesthetics. I have argued that this external subjectivity creates a distinctive modern subject on the periphery. The reminder of this external face *as skin* is not coincidental; it echoes Franz Fanon's concept of "epidermalization" published just over a decade later in *Black Skins, White Masks* (1952). The two are radical critiques of the Eurocentrism of psychoanalytic theory, insisting that any theory of the subject must address the racism contained within the discipline's history.[57]

The definition of a self visible in mirrors unites the South American pain explained to Dina Lévi-Strauss with humor, and both with the concept of a photogenic sublime. It reveals the true character of a designed, exterior, masklike face. Finally, it emphasizes the profound contradiction between Mário's conclusions about the condition of the modern subject and Freud's basic proposition, summed up simply by Lacan: "Freud's experience begins with the search for the reality that is somewhere *inside himself.*"[58] Like Carlito, Mário turns out to be a real man with a designed face that he sees only in mirrors; like Keaton, his character is configured outside this body. The mirror signifies an exchange of gazes and a being so stared-at, or better said, being as his reflection. The mirror, with nothing behind it, is the image of a hero

with no character, a portrait that does not contain or capture even the reflection of a person. The mutual dependence between the person and his or her reflection, however, ethically binds Mário in a photographic sublime. The exteriority of the modern subject defines the urban, industrial everyman performed by Charlie Chaplin, the Tapuio from Parintins, and the shadowy poet himself, and it makes them not only coexist but even depend on one another. Even today, putting the faces of Carlito and the Tapuio youth side by side causes a jolt of surprise; it forces a profound recalibration of how primitivism functions in modernist aesthetics. The visible exteriority contained in the word *mirrors*, discovered through Mário's ongoing engagement with photography, is the definition of a modernism that is both aesthetic and ethical: a reconfigured modernist sublime as an ethos (character) formed through an exchange of gazes.

Sexuality and Primitivism, Vanity and Narcissism, Hermeticism and Politics

The portrait of a self that exists only in mirrors is fundamental to Mário's conclusions about the relevance of the modernist movement to Brazilian culture and politics. Although most critics refer to "O Movimento Modernista" ("The Modernist Movement," 1941) as the culminating condemnation of modernism, this essay provides only a partial view of his thinking in the last years of his life. In fact, the unpublished "Ensaio de interpretação de *O carro da miséria*" ("Interpretive Essay of *The Car of Misery*") of the same year and "Espelho, Pirineus, Caiçaras" address many of the same concerns. Written in the waning days of modernism, these essays come to profoundly different conclusions about the aesthetic and sociopolitical legacy of modernismo. Almost obsessively, they frame the debate over modernism's ultimate social responsibility in terms of the "vanity" of the participants and their work. Mário's discovery of the meaning of mirrors shades the meaning of vanity, but it only begins to explain his contradictory conclusions about modernism. Once again, Mário revises Freud, this time in a critique of narcissism and its relationship to primitivism and sexual "inversion"; and this time, Mário's complaint is even more personal.

In "The Modernist Movement," Mário contrasts vanity with virility, disparaging the unproductive first term for its failure to fulfill the so-

cial responsibilities of the modernist artist. The essay concludes with "a quite cruel confession, to have perceived in almost all of my work, an insufficient *abstencionismo*," meaning to abstain from voting, but reminiscent of *absistência*, abstinence more broadly.[59] He imagines the masculine virility of socially aware art in opposition to vain aesthetic excess. Mário writes: "In our research and creations, we, the participants in the period best called 'modernist,' were, with a few unconvincing exceptions, victims of our own pleasures in life and of the festivity in which we *devirilized* ourselves."[60] This devirilization is, paradoxically, the result of an overly sensual artistic movement; he uses expressions such as "the very sensual arrogance of individuality," "vanity, all vanity," and even calls the movement "our 'orgy.'"[61] Strangely, excessive sensuality appears to diminish these men's virility rather than exaggerate it. Vanity and a socially proscribed sensuality are repeatedly collapsed, a formulation that returns with a vengeance in the following chapters on postrevolutionary Mexican modernism.

The language throughout Mário's condemnation of his own poetic production, and his critique of the modernist movement in general, is filled with descriptions of sensuality and hidden desires. Mário's homosexuality is effectively an open secret in Brazil. It is said that he split with his friend and collaborator, Oswald de Andrade, because he called Mário "our Miss São Paulo translated into the masculine" in the *Revista de Antropofagia*.[62] This caricature of Mário as if he were always in drag is often quoted, but a more nuanced portrait of him as a gay intellectual has not appeared in the literary scholarship. In many portraits, Mário poses as an effeminate dandy (see fig. 24), but given his complex vision of the pose, we must ask what these poses really signify for his photographic and literary aesthetics. His dual performances of closeting and posing in his writing and photographs are a refined strategy of modernist portraiture, a play of mirrors that demonstrates that a discussion of his sexuality is not a type of historical outing but rather is necessary to understand the seemingly contradictory, hermetically social ethos of modernism. Mário's sexuality even leads back—once more through Freud—to the question of primitivism with which this chapter began.

The short story "Frederico Paciência," one of Mário's few explicitly homoerotic texts, helps to unravel his condemnation of modernism's devirilization. Telling of a passionate relationship between two adolescent boys, it was written and revised multiple times between 1924

24 Portrait of Mário de Andrade with his music students. *Fundo Mário de Andrade, Arquivo do Instituto de Estudos Brasileiros,* USP

and 1942 and published only after the author's death. The story wavers between explicitly sexual moments of unbridled passion, kisses, embraces, and "entwined bodies," and repentance and regret.[63] Early in the story, the narrator, Juco, cannot control himself and plants a kiss on Frederico:

[Frederico] advanced, embraced me anxiously, kissed me bitterly, he kissed me full in the face painfully. But then the sensation of condemnation that exploded frightened us, and we separated ourselves consciously. We looked at each other in the eye and a laugh came out that calmed us. We were true and sufficiently active in the truth we chose. We loved each other as friends once again, we desired each other, exultant in our ardor, but we were decided, strong, wholesome.

"We should be more careful."

Who said that? I don't know if it was he or I, I hear the sentence that spurted out of us. I was never so grown up in my life.[64]

The boys' repentance for their loss of control does not last long, though, and this is only one of multiple self-condemnations for many such lapses. Juco finds that when their intellectual arguments grow heated, "it excited us too much physically" and the mental image of the kiss returns.[65] The narrative order of the story similarly undoes the undoing of their passion, for in the two moments when the narrator directly addresses the reader, he admits that he is trying to diminish the real reason for the ending of their relationship. The two separate only when Frederico's father dies and he moves to Rio de Janeiro to study. Juco remains in São Paulo only because he does not have enough money to follow Frederico, not because he has won the struggle to repress the strong desire he feels for him. It is remarkable, given the internal battle fought throughout the story and its presentation of a homosexual relationship that was sensual, intellectual, and even somewhat accepted by the boys' families, that Mário believed that this story was ready to be published.[66]

The story ends, however, with a less rosy conclusion. In the last paragraphs, Juco recalls Frederico Paciência complaining that a girl was holding him too closely at a dance. The narrator advises him, "Paciência," to which Frederico explodes, "My name is Patience!"[67] He is the embodiment of a relationship always postponed, which is nevertheless a passionate desire that speaks itself clearly. The last line of the story reads: "That confusion with the word *patience* always pained me un-

easily. It burns me, made a mockery, an allegory, an unsatisfied terror."[68] The story ends with the word *unsatisfied*, that is to say, with Juco (perhaps as a veil for Mário) still clearly desiring Frederico's passionate love as much as he fears it.

"Frederico Paciência" is a rare exception in Mário's voluminous writings. More often he obscures the nature of his desire in love poems by carefully avoiding adjectives that would have to be modified according to the gender of the object of his desire. A poem from *Losango Cáqui ou Afetos militares de mistura com os porquês de eu saber alemão* (*Khaki Rhombus, or Military Friendships Mixed with the Why's of My Knowing German*, 1926) both thematizes and exemplifies how he hides the object of his desire:

As always, I hid my passion.
No one knew of the first kiss I gave you.
No one no is the entire truth

. . .

But I dream that you walk *holding on* [*agarradinha*] to my arm
In a street full of friends, of soldiers, of acquaintances.[69]

The only word in this poem about forbidden love that reflects the gender of the poet's lover is *agarradinha*—holding on—which is feminine. This is the pattern in Mário's love poems: long verses without any noun modified by the gender of the loved, and then one thrown in as if haphazardly. The poem also imagines the city, like the photographic portraits seen above, to provide a degree of anonymity to hide away forbidden love while parading it in full view.

Mário theorizes this double move of revelation and obfuscation not only as a personal experience of his own sexuality, but also as a crucial element of modernist literature. The difficult language for which he is well known and of which he was quite proud operates as a veil and a marker of the communal, ethical function of modernism. In "Da obscuridade" ("On Obscurity"), Mário praises the difficulty of Surrealist and other avant-garde poetry for requiring the reader to become a truly active participant in the creation of meaning.[70] The "Interpretive Essay of *The Car of Misery*" goes on to offer the following explanation of how hermetic language actually makes modernist art *more* rather than less socially relevant:

But let's leave beauty aside now. *What interests me greatly in this poem is that, in it, I have hidden myself as perhaps in no other of my poems.* "Interested" poem,

"poem of circumstance" even, derived directly from political, social, and national concern of immediate value . . . [it] is, nevertheless, the most obscure (and unnecessary), most apparently purely poetic, most hermetic poem that I ever wrote. But this . . . to my eye constitutes a *lyrical true deceit*. I hid myself a thousand ways. And the most ingenuous was that false, unnecessary hermeticism. Which was perhaps at times forced. That is to say: if the poem is pretty clear in its interpretation to me, I threw in things that I am convinced had absolutely no possible interpretation . . . no interpretable sense. Only to *disguise*.[71]

The complex language of the poem obscures or masks the face of the artist and foregrounds the instance of the poem. Mário disguises himself in hermeticism—a disguise that must be understood in relation to the revelation and hiding of his homosexuality—in order to produce a poem that is entirely located in the social and political issues of Brazil. The portrait that results is like that of the young Tapuio. It is too close to be in focus, and thus it reveals and protects him from the violence of the inquisitive gaze of the viewer.

"The Modernist Movement" links this difficult language to vanity, associating both with a proscribed sexuality and condemning them as the root of the movement's ultimate failure. In "Interpretive Essay of *The Car of Misery*," Mário addresses the same concern about modernism's dedication to a social function, and again the terminology of "vanity" appears. His confession, however, is quite different: "All of my life I had an impaired [*danada*] preoccupation with combating vanity: which I consider epidermic and wretched, and convert it into pride which is fertile, virile, capable. Which doesn't keep me from having my vanities, clearly, although they were combated and disparaged."[72] His concern with vanity and the perception of its antisocial nature turns out to be again *danada*, the same word that we saw earlier contained a string of hybrid and contradictory meanings to define his nationalist Brazilianism. Mário never determines the morality of his preoccupation with vanity, saying only that it is a source of ethical meditations for him throughout his life; in this essay he recognizes that his battle against vanity obscured the important meaning of mirrors and the defining exteriority of subjectivity.

Mário's discovery of the social meaning of vanity and (as) poetic hermeticism performs a sophisticated critique of Freud's influential theory of narcissism. I find that he translates, rather than collapses,

narcissism into vanity, by correcting the meaning of three central elements of Freud's theory: a passionate dedication to the mind, homosexuality (which he calls "inversion"), and racialized primitivism. The very basis for Freudian narcissism as an extension of libido theory "receives reinforcement," as he writes, from his studies of the "mental life of children and primitive peoples," and leads to a conclusion that "large amounts of libido of an essentially homosexual kind are drawn into the formation of the narcissistic ego ideal."[73] In *Totem and Taboo* Freud again joins these two groups, arguing that while homosexuality existed in Western antiquity, it continues to be "remarkably widespread among many savage and primitive races, whereas the concept of degeneracy is usually restricted to states of high civilization; and, even amongst the civilized peoples of Europe, climate and race exercise the most powerful influence of the prevalence of inversion and upon the attitude adopted towards it."[74] Even had Mário cared to do the delicate analytical work that Freud himself only vaguely gestured toward, of distinguishing sublimation from repression and narcissism from other kinds of autoeroticism, he still would have been indelibly marked by his primitive psyche. The mark of "climate and race" (despite da Cunha's best efforts) places the civilizing benefits of sublimation out of reach, and condemns the primitive intellectual to a necessary sexual state of inversion. According to Freud, Mário would be primitive even if he performed the sublimation necessary to achieve the sublime and would be gay even if he put himself through the repression necessary to control his homosexual desire.

The extensive, even obsessive interdisciplinary research for which Mário is so famous produced an impressive archive of information about langauge, music, and dance, and also replaces Freud's concept of narcissism with his newly discovered vanity. In the same text in which he discovers the meaning of mirrors and vanity, the "Interpretive Essay of *The Car of Misery*," Mário writes that he finally understands his uncontrollable compulsion for research:

> It seems to me that there is visible antithesis there: violent research about Brazil, exacerbated, gratuitous, spontaneous, exploding in a Brazilianism violently "caiçara," my mania to study, to cultivate myself, that made me so free, so far away from Brazil, shining in the word Pyrenees. That denationalizing anguish of culture nevertheless gave me a whole poem, the "Improvisation of the Ills of America." . . . I adore the value found un-

willingly in the word "Pyrenees." It is between the Iberian peninsula and France, with the rest of Europe. . . . So that the word Pyrenees, the only one whose meaning I don't have doubts about (nevertheless not sought, nor understood, when it exploded), pleases me a lot. *It is the trampoline of the Brazilian leap*—and that I saw in my folkloric studies—when it was Iberian (not just Portuguese, but Iberian—the blackness, the redness of the being in the cited "Improvisation") they were the same Pyrenees that agitated me toward other cultures and that made my spirit and the individualist sense of my being.[75]

If Freud finds the source of narcissism in "the omnipotence of thought," or an overly passionate dedication to the power of the mind that appears as animism in primitive culture, by using the word *caiçara* in his description of his own research into national characteristics as violent and uncontrolled, Mário references the "primitives" whose knowledge Freud dismisses under the name of animism.[76] Mário redeems as a socially engaged modernist art practice precisely what Freud calls the "high estimation of psychic acts among primitives and neurotics, which we deem to be an overestimation, [and which] may now be brought into relation to narcism [*sic*], and interpreted as an essential part of it."[77] He defines this as the same kind of danado Brazilianism seen above. Brazilian primitivism thus rescues narcissism as a form of socially responsible vanity, which passionately investigates the cultures of Brazil even as it hides itself in hermeticism. This vanity converts narcissism's pathology into the (non)character of the Brazilian modern subject. The vanity of "inverts" and "primitives" denationalizes and renationalizes Brazilianism as the high bounce on a trampoline between multiple geographical references, a primitive intellectual's Brazilian leap.

Critical Nationalism, or "It is still necessary to distinguish between primitivism and primitivism"

One cannot, however, directly translate Mário into Freud's sexualized primitive.[78] Mário himself refused to do so, not only in his shifting between closeting and coming out, but also in his emphasis on his position between Paris (or Vienna) and the Amazon. In his ethnographic journeys, Mário holds the camera, and so subjects other people to the same photographic incarceration he described as "little eyes of light."

He is the creole city-dweller, the metropolitan using photographic technology to represent the local, to write the rural as primitive and use it as the mark of his own national identity.[79] Scholars have taken this generation of writers and artists to task for their participation in a nationalist ideology that depended upon primitivist attitudes toward indigenous and black populations in the Americas. Mário's generation of thinkers produced theories of transculturation and *mestizaje*, as well as *indigenismo*, from the position of the same social elites who had controlled power and wealth in the region since independence. According to these critiques, the strategy of picturing the indigenous as the source of an autochthonous national identity parallels European primitivism's desire for cultural renewal through the integration of exotic artifacts. Prado Bellei concludes that modernism ultimately offers little "emancipatory potential."[80]

Natalia Majluf explains the underlying rationale for this critique: the Latin American avant-garde *indigenistas* based a personal identity on a collectivity that was not theirs. Unlike earlier representations of indigenous peoples in the service of nationalism, this indigenism "is neither a simple exaltation of the local nor a simple exoticism. It is rather an autochthonism filled with anguish."[81] This anxiety nags at Mário as well, and in one of several unpublished prefaces for *Macunaíma*, he writes: "One of my interests was to legendarily disrespect the geography and geographical fauna. Thus I deregionalized the creation as much as possible, at the same time that I achieved the merit of literarily conceiving of Brazil as a homogenous entity, a national, ethnic harmony, as much as geographical. (This is to say also that I am not convinced . . . of having made a Brazilian work. *I don't know if I am Brazilian*)."[82] Even in his description of a goal of a "homogeneous" Brazil, however, Mário's choice of the word *concerto* suggests that many distinct individual instruments contribute to the overall rhapsody of nation that he declares *Macunaíma* to be.

The anxiety of not being Brazilian was a profoundly ethical and aesthetic one, a face-to-face encounter with representation—hermetically political—as a strategy of participation in a changing Brazilian society. In his own poem, "Improviso do mal da América," the lyric voice suffers the fact that despite echoes of Black and Indian cultures in the air: "I feel white, fatally a being of worlds / I have never seen."[83] Mário never traveled to Europe, a fact whose lethal importance is made clear by this verse. The epidermic subjectivity that Mário so admired in Keaton's

face reveals his own whiteness as much as the differences among other Brazilians. Unable to represent members of "his own culture" as independent from the colonial cultures that compose Brazil, nor to separate himself from the perpetrators of colonial violence, Mário's portraits rely on a series of strategies for representing the exteriority of modern Brazilian subjectivity.

The performances of race in "Ridiculous bet in Tefé" and "Neptuno" reveal that epidermic portraits do not follow nineteenth-century racist models of skin color as fixing identity, nor does the "figurative change of race" that his primitivism performs permit a move to a pure field of abstraction. Using the verb *retratar*, which contains the word *retrato* [portrait], Majluf states that "indigenism tried to freeze the Indian in order to portray him [*retratarlo*]," concluding that it was ultimately a strategy of "homogenization that facilitates domination."[84] Yet Brazilian primitivism necessarily includes Mário, as well as a series of other modern Brazilian subjects, as both photographer and photographic object. It creates unstable and mobile portraits, not fixed ones. In a letter to Manuel Bandeira, Mário explains: "Macunaíma is not the symbol of the Brazilian just as Piaimã is not the symbol of the Italian. They evoke ethnic values 'without continuity,' or purely the circumstances of race."[85] This brief sentence conveys an image of race as solely coincidental, and even so as a form of particularity those marked by race cannot disavow. His photographs foreground race as a visual sign whose history is that of colonial oppression, while they focus on the instability and superficiality of the identity it contains. Mário's attempts to "retratar" diverse urban and rural ethnic communities in Brazil reflect the historical particularity of their differences, as well as the contingency of racial discourse itself.

Mário thus designs "critical nationalism" in the bouncing back and forth between multiple cultural referents.[86] He does not reject the concept of national portraiture entirely, but rather empties the space of character in order to have an additive, combinatory, and even contradictory portrait of nation. In his classic essay on anthropophagy, Haroldo de Campos contrasts the "modal, differential nationalism" of Brazilian modernism with an "ontological nationalism . . . [which] when it comes time to describe this entified substance—the 'national character'—one is reduced to a 'half-portrait,' watered down and conventional, where nothing is characteristic."[87] The humor and exteriority introduced by Macunaíma as a hero with no character continue to be a

source for literary, artistic, and filmic representations of a changing and critical national character.[88] It is difficult to imagine such an evasion of an "essential" national character without the theory of the exteriority provided by Mário's meditations on and experiments with photography. The ethos of modernism makes possible a critical nationalism with space for a variety of citizens who occupy circumstances of race (and racial diversity) and sexuality generally not considered part of homogenizing nationalist discourse.

Photographic Cities, Photographic Subjects, Photographic History

We must now return to the questions posed to Steiner's definition of modernist portraiture as caught between "modernist hermeticism and primitivist realism." What is the difference between Mário's wearing of the mask of race and Gertrude Stein's? What is the ethos of modernism it creates? Mário's mask of race might better be termed primitivist hermeticism. Rather than finding primitivist masks etched onto his admittedly white face, he finds modern history itself written on his portrait. Mário confirms the connection between photography and this formulation of a Brazilian primitivist sublime in the journal *Rotogravura* in 1939, in which he writes that photographs function as a special kind of collectible object: "The objects, the designs, the photographs that belonged to my existence from some day in the past, for me always retain an enormous force for the reconstitution of life. Seeing them, I don't simply remember, but relive with the same sensation and same old state, the day that I already lived."[89] Photographs exhibit a kind of intellectualized expressiveness similar to what he called "simultaneity" in 1925, for they create the necessary connection between critical intellect and personal inspiration. Mário points to this result as the unique power of photographs as objects, for they permit the inscription of the real and the later decoding of it:

> I am sending you the portrait that I like best . . . because it marks the "roads of suffering" on my face, you'll notice, a creased face, still not wrinkles, but streets, roads, plazas, like a city. At times, when I spy this portrait, I forgive myself and a vague sign of tears even comes to me. Of pain. Because it announces all of the suffering of a happy man . . . [the de-

feats] were for me motives for so much, not happiness, but a dynamic of being and an almost physical transcendence, that I forgot that I suffered. Until they took this picture of me. And I was horrified by all that I had suffered.[90]

The paradoxical distance and proximity made possible by the exteriority of the photographic act permits Mário to "run into" himself in this portrait, surprising himself with the contradiction between his own happiness and the city of pain he finds drawn on his face. Photography permits a record of the pain that differentiates South America from Europe, and Mário names this pain as the source of the frenetic and passionate creativity that redefined narcissism as a form of artistically and socially productive vanity. Colonial pain provides the necessary distance and proximity to create the hybrid practice of (auto)ethnography, apprentice tourism, and modernist art that has established Mário's continued relevance in Latin American art and letters. Not surprisingly for the medium or for modernism, this vision of history returns us to the city. However, the city drawn on Mário's face does not resemble the Parisian flâneur's photographic city, but rather a peripheral one. This image of the city returns us one final time to Mário's creation of a modernist ethos through the revision of the Freudian psychoanalytic subject.

Freud begins *Civilization and Its Discontents* with an extended metaphor of Rome, the Eternal City, which serves as a model for the individual psyche and is strikingly similar to the city of pain that Mário finds on his face:

> Now let us, by a flight of imagination, suppose that Rome is not a human habitation but a psychical entity with a similarly long and copious past — an entity, that is to say, in which nothing that has once come into existence will have passed away and all the earlier phases of development continue to exist alongside the latest one. This would mean that in Rome the palaces of the Caesars and the Septizonium of Septimus Severus would still be rising to their old height on the Palatine and that the castle of S. Angelo would still be carrying on its battlements the beautiful statues which graced it until the siege by the Goths and so on.[91]

However tempted by the beauty of his own rhetoric, Freud must immediately reject this image in order to protect the broader parallel structure he proposes between civilization and individual maturation:

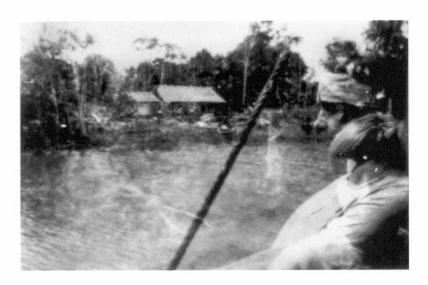

25 Mário de Andrade, "Foto futurista de Mag e Dolur sobrepostas às margens do Amazonas, Junho de 1927, Obcessão" ("Futurist photograph of Mag and Dolur superimposed on the banks of the Amazon, June 1927, Obsession"). *Fundo Mário de Andrade, Arquivo do Instituto de Estudos Brasileiros,* USP

"There is clearly no point in spinning our phantasy any further, for it leads to things that are unimaginable and even absurd. If we want to represent historical sequence in spatial terms we can only do it by juxtaposition in space: the same space cannot have two different contents. Our attempt seems to be an idle game. It has only one justification. It shows us how far we are from mastering the characteristics of mental life by representing them in pictorial terms."[92] Mário's revised theory of simultaneity and the sublime created through the practice of photographic (self-)portraiture pictures this very unimaginable fantasy. This modernist theory imagines the simultaneous occupation of a single space, that of Brazilian modernity, not just by two or three but by a series of subjects and historical moments.

Mário made several photographs with double-exposed negatives, picturing precisely the simultaneous occupation of a single space in pictorial representation that Freud finds impossible. "Futurist photograph of Mag and Dolur superimposed on the banks of the Amazon, June 1927, Obsession" (fig. 25) is another version of the starkly conflictive relationship between landscape and portrait discussed above.

Rather than a tension between inhabitant and landscape, here Mário produces a ghostly, haunted photograph of his two fellow travelers. Although it has been impossible to determine how or where he developed and printed his photographs, the enlargement of this photograph and the title calling it his "obsession" indicate that he was quite pleased and interested by the results. As a result of the double exposure of the negative, the traces of photographs of the two girls appear as shadows on an image taken from the boat in which the group was traveling. The portraits contain the hint of earlier photographic moments, one piled on top of another to produce a "futurist photograph." The image forces the viewer to collapse multiple times, multiple moments of the taking, onto the flat surface of the photograph. By thus layering the portraits, Mário again disallows Freud's narrative of the sublimation of desires as what permits progress from savage to civilized societies, and from childhood to adulthood. Freud must discard his brief "fantasy" of a simultaneously archaic and contemporary city of Rome in order to chart this development. In contrast, Mário provides us with "simultaneity": the impossible pictorial image of the psyche that appears in Macunaíma, our hero with no character, or rather an additive surfeit of multiple characters among which he never chooses.

Freud's beautiful image of a modern city composed of ruins could be seen as the (im)possible image of peripheral modernity. Mário jokingly presents this prospect as a photographic challenge to Freud in "Freudian clothes, Fortaleza 8/5/27, Sun 1, diaf. 1, Repressed photograph, Repression" (fig. 26). The underclothes drying on the line are Freudian because they cover up, and thus metonymically represent, what Macunaíma calls "a graça" (privates) in Macunaíma. Freudian sublimation here is also subject to Mário's humor, as this caption of course is partially a joke: in his apprentice journey to see Brazil he finds this version of Freudian sublimation and airs intimate secrets for all to see. Of course, like all jokes, this one about repression itself references a real trauma, that of exposing Brazil's pain in the same photographs that seek to capture its portrait.

This photograph of white clothes and sheets fits into a repeated fascination with picturing the invisible in Mário's photography: the image of what he called a lyrical true deceit. Like "Mogi Guassú / July 1930" and "Mogi-Guassú (with wind) July 1930," this Freudian photograph shows traces of the wind that gives the drying laundry the illusion of form. As in his superimposed images, the simultaneously empty and

26 Mário de Andrade, "Roupas freudianas / Fortaleza 5-VIII-27 / Sol 1 diaf. 1 / Fotografia refoulenta / Refoulement" ("Freudian clothes, Fortaleza 8/5/27, Sun 1, diaf. 1, Repressed photograph, Repression"). *Fundo Mário de Andrade, Arquivo do Instituto de Estudos Brasileiros,* USP

full clothing makes the camera able to capture the image of an unseen, nonexistent time or object. More than an indexical document of something "that has been," through these bodiless underclothes Mário reveals that photography is always partially a fake. The repressed truth of this photograph, which will appear again in Manuel Álvarez Bravo's photographs of the invisible, is that the visual evidence of invisible subjects is not to be trusted. The empty forms of bodies that the clothing contains and whose absence it emphasizes is the same vacant and additive space of character in *Macunaíma*. It is also the image of the exteriority of subjectivity that Mário discovers in his own work, for the subjects of this portrait exist only because the wind fills the clothing and gives the illusion of a being inside it. As much as the subject pictured in "Freudian clothes" has no body, no physical or psychic urges to repress, the modernist sublime on the periphery is a product not of sublimation but rather of a layering of history, multiple subjectivities, and numerous races that exceed the interiority considered necessary even to modernist portraiture.

Contemporary debates over the ideological nature of portraiture, especially photographic portraits, continue to rely on the genre's re-

lationship to primitivism and abstraction. Benjamin Buchloh argues that all photographic portraits compensate for the loss of mimetic representation associated with the (European) avant-gardes by "restoring physiognomic likeness in traditional single-frame imagery . . . and [thus] reassur[ing] the spectator of the continued validity of essentialist and biologistic concepts of identity."[93] Following this logic, every facial representation that is not abstract makes an ideological claim to the real and produces an essentialist image of identity. What is more, Buchloh assumes that race as biology is readily recognizable and collapses all representations of faces into the reaffirmation of biologistic identity. In contrast to these physiognomic likenesses, here abstraction implicitly appears untainted by the influences of racism and essentialism. Even as Buchloh seeks an ethical critique of portraiture, this ethics limited to the theory of (mainstream) modernism allows no space for different constitutions of race and modern subjectivity, or the ethos they make possible. While the previous chapter dealt at greater length with abstraction in Brazilian modernism, it is important to note here that another pathway to abstraction, that of primitivism, is radically reconstructed in Mário's photographic practice and theory.

In "Lake Ararí, Marajó, July 30, 1927" (fig. 27), the face of the man

27 Mário de Andrade, "Lago Ararí, Marajó, 30-VII-27" ("Lake Ararí, Marajó, July 30, 1927").
Fundo Mário de Andrade, Arquivo do Instituto de Estudos Brasileiros, USP

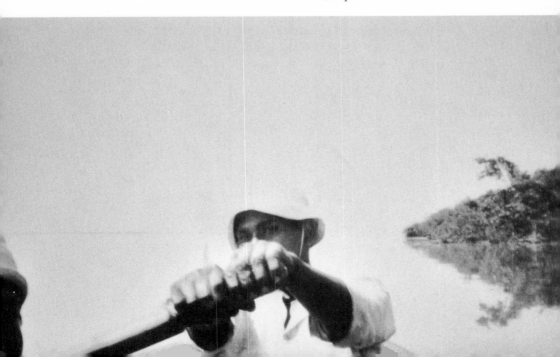

rowing the boat is hidden by the action of his hands on the oar. His hands, arms, and the oar form a triangle, repeated by the triangular shape of the bank of the river and its reflection on the right border of the image. The triangles focus the viewer's eye on the rower's fist as the compositional center of the photograph, which takes the place of his face. This portrait from *O turista aprendiz* is not static, nor does it contain a promise of the easy integration of indigenous and Afro-Brazilian bodies into nationalist discourse. We might understand the fist in the eye of the camera in "Lake Araří" as a rejection of Buchloh's assumptions about photographic portraiture. The logic of the "biologistic" promise of photographic portraiture is turned on its head by Mário's funny, tragic, and now violent poses, yet he portrays subjects who demand their place in a genre that signifies not their racial identity but their humanity. Photographic portraits can critique the history of colonialism and its accompanying discourse of racism in faces that are both legible and an act of disguise.

The changes of race that take place in *Macunaíma*—from black to white instead of the reverse—do not offer the promise of cultural renovation in the abstract mode of European primitivism, nor the promise of authentic identity sought by cultural nationalism.[94] They present an "epidermic" Brazilian primitivism based in photographic images that are themselves a theory of the ethos of modernism. Brazilian primitivism designs a structure of history in which the artist discovers himself in the eyes of others, and through that photographic exchange is primitivized himself. It creates a dynamic ethics and aesthetics, which are made possible by the discomfort with the camera seen in the two shadow portraits that opened this chapter. These photographic portraits mock the exoticism of European primitivism's imaginary Africans, revealing it to be a powerful force in narratives of the progress toward civilization as much as in the development of modernist abstraction. Neither this kind of primitivism nor its concomitant abstraction offers useful solutions to the problems of representation on the periphery. Mário instead revises the empirical function of photography, still using it as part of a practice of engaging cultural diversity yet constantly undermining its scientific weight. Brazilian primitivism diminishes the force of the real by composing weakly indexical photographs that nonetheless frenetically seek to learn more about the people they picture. This other primitivism relies upon hermeticism as a means of social engagement, a "lyrical true deceit" that reveals a Brazilian national leap off a tram-

poline rather than a grounded Brazilian national identity. The hetero-geneity of modernism is thus not the result of an automatic or direct translation of racial characteristics of a population into aesthetic prac-tice, but rather an anticolonial gesture that radically reconceptualizes the function of race in the development of human subjectivity, in aes-thetics, and in social interactions. The practice of portraiture produces a character of modern Brazil through a "staring so stared-at," exchanged gazes marked by their knowledge of pain, to which the best response are guffaws of laughter that crease the face of the portrait. The epider-mic portraits of a hero with no character are like a map of the urban industrial capital of Brazil. Criss-crossed and shifting, they contest the ongoing pain of a colonial history but do not found a homogeneous *ethnos* of nation.

Mário's poem "Toada" (1932)—the name of a dance from Parintins, which could also be translated as "rumor" or "sound"—presents this photographic experience of the city of São Paulo:

> I looked for São Paulo on the map,
> But everything, with a new face,
> Of a sadness of travel.
> I took photographs
>
> . . .
>
> I remained so poor, so sad,
> That even my gaze closed up.
> On the other side of the city
> The wind scattered me.[95]

The consolatory practice of photography results in the simultaneous location and dispersion of the poetic self, as his home city produces the sadness and discomfort of traveling seen in Mário's landscapes. The poet can be shown only in the kind of portraiture outlined in this chapter, and the modernist ethos of this dispersed and empty character contains at once an ethical bind and a modernist sublime.

3

Mediation

The portrait of a dispersed modernist poet contained in
Mário's poem "Toada" was first published in 1932 and re-
printed in August 1936 in the large format publication
S. Paulo. The pages in which the poem is reprinted flip out
and unfold, so that the placement of the poem appears to
change. Like all of the pages of the journal, they are filled
with dramatic photographs, photomontages, and experi-
mental graphic design. A portion of this folded page offers
"A trip around São Paulo" and presents a photographic mon-
tage showing sailboats and a futuristic building in the back-
ground (fig. 28). The bottom half of the extended page is
divided between Mário's evocative poem and cartoonish
drawings of the diverse touristic attractions of the city,
from the Horto Florestal to the modern urban vista of Ypi-
ranga. Viewed with the other page unfolded, the same sail-
boats meet a dynamic montage of men loading and carry-
ing coffee beans. In both configurations, Mário's evocative
poem meets images of the modern circulation of goods and
people.

From more efficient agricultural production to building

28 Mário de Andrade, "Toada," *S. Paulo*, August 1936. *Biblioteca, Instituto de Estudos Brasileiros,* USP

construction, railroads, public health, tourism, and the very publication of journals and newspapers, *S. Paulo* displays the city's triumphant entry into modernity in photographs. Employing the popular new technology of rotogravure, its pages are overrun by photo-essays and photomontages that portray the rapid industrialization and growth of the city and seek to demonstrate its investment potential to both domestic and international business readerships. The journal celebrates a "renaissance" of commerce, industry, and culture; it proclaims a new generation of Paulista Bandeirantes, unapologetically reviving the image of the rapacious explorers who claimed the mine-rich lands in the interior of Brazil in the seventeenth and eighteenth centuries. The editors write: "This monthly, documentary organ of Paulista achievements, is born of the very logic of the moment, like a mirror necessary to fix our powerful vitality. Its value will reside not only in the images that are reflected in it, even though everything may appear small in order to reproduce the action and thought of a 'race of giants.'"[1] The first issue of the journal reflects on its own function in this process, enlarging a photograph of a young boy selling newspapers so that he seems to dominate the fast-moving street traffic (fig. 29). The growth

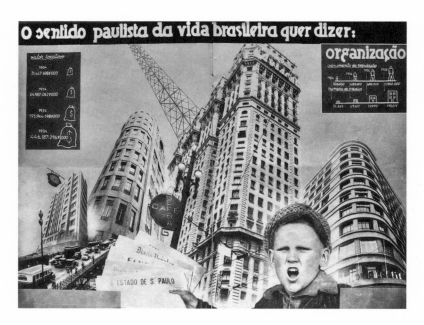

O sentido paulista da vida brasileira quer dizer: organização

29 "The Paulista Sense of Brazilian Life Means . . . ," *S. Paulo*, January 1936. *Biblioteca, Instituto de Estudos Brasileiros,* USP

of a national mass media was a point of pride in Brazil's modern status, and journals both popular and experimental emphasized the crucial connection between print and modernity. *Base: Arte tecnica e pensamento*, a journal contained in Mário's archive, proudly proclaimed that Rio de Janeiro with only 2 million inhabitants, and São Paulo with 1 million, produced more journals and magazines than New York, with a population of 13 million people. While these numbers are clearly inaccurate, the claim reveals an excitement about a new generation of readers and writers. The author explains that throngs of Brazilians were so eager to publish their own literary production that periodicals were cropping up "like mushrooms."[2]

What is Mário's melancholy poem doing in a magazine like *S. Paulo*? Was the pope of Brazilian modernism just one more of these innumerable people with an affinity for literature? He himself wrote in *A escrava que não é Isaura*, "Through the journal we are omnipresent."[3] Many scholars treat this as a reference to journals such as *Klaxon* and *Verde e Amarelo*, the short-lived, limited circulation "little magazines" that appear commonly in modernist studies. Yet the editors of the eclectic

pages of *S. Paulo* were well-known modernist collaborators Cassiano Ricardo and Menotti del Picchia, as well as Leven Vampré.[4] *S. Paulo* is just one example of an explosion of illustrated publications in Latin America during these two decades. In places as diverse as Argentina, Chile, Mexico, and Puerto Rico, the rapid growth of a national mass media opened up an important new cultural space whose character was largely defined by the inclusion of experiments with photography and graphic design.[5]

Modernist engagement with photography was part of a broader process by which artists and writers addressed the ideologically contradictory yet inescapable notion of "the popular." Examining this term is critical to understanding the bind of ethics and aesthetics in Latin American modernism, for it was at the center of these groups' engagement with nation, modernity, and the role of art. The best-known modernist movements participated in educational programs and university reform, placed art in public spaces through murals and journalistic publications, and wrote extensively on the question of how to bridge the vast distance between intellectuals and the masses who were to become the modern citizens of both countries. The ethos of modernism includes both an ethnographic popular, which in Spanish is termed "cultura popular," *and* the commercialized mass media that emerged during these decades, or "cultura de masas." So far Brazilian modernism's ethics has taken shape through Mário's photographs and writings about "cultura popular," and the shift from the intimate space of his photographic diary to the dynamic urban masses reproduced in *S. Paulo* is doubtless visually shocking. In order to follow errant modernism through Latin America, we must survive this bumpy transition. The confusion caused by finding the poem "Toada" in *S. Paulo* can be cleared up only by examining how and why modernist writers and photographers located themselves in relation to both forms of the popular.

Mexican contemporary artist Felipe Ehrenberg has called photography "the popular medium par excellence."[6] Photography played a central role in the production of both images of popular culture — the folkloric and the masses — welding together these two faces of the popular and revealing their powerful influence on the formulation of modernist literature, art, and theory. In his groundbreaking "Manifesto Pau Brasil" (1924), Oswald de Andrade writes of "stars made familiar through photographic negatives. The correspondent of physical surprise in art . . . *See with open eyes* . . . , Barbarous, credulous, picturesque

and tender. Readers of newspapers. The forest and the school. The National Museum. Cuisine, ore and dance. Vegetation. Pau-Brazil."[7] In this list with photography at its center, Oswald intersperses both images of the popular, joining jungle with school and readers of journals with barbarians. The medium contributed to modernism's active engagement with popular culture, in part due to its mass reproducibility and increasing circulation during these decades. In photographically illustrated journals similar to S. Paulo, the "popular" appeared as a mass-media audience, a population defined by its participation in a rapidly expanding circulation of images, ideas, people, and goods.

The montaged photographs and the interplay of images and text in S. Paulo create pages that underline the importance of analyzing both the cooperation and the battles between the major forces that sought to picture modernity in Brazil during these decades. The editorial voice that addresses S. Paulo's readers is only one of the multiple voices contained within it. Despite its celebration of the cooperation between industry, state, and culture (especially the media), the contributions by modernist writers and the images with which they engage reveal a contradictory vision of São Paulo's modernity. S. Paulo itself did not present a flawlessly progressivist ideological stance. Recall that our first reading of Mário's poem "Toada" at the end of chapter 2 contributed to the understanding of a critical, danado nationalism. Ricardo, later branded as an apologist for the Vargas regime, published a poem titled "Girl Drinking Coffee" in the illustrated journal, which presents a strong critique of the very systems of modernization and global capital celebrated in the editorial essay.[8] The poem leads the reader from the image of a happy young girl in Paris drinking her coffee, across the ocean, through a Brazilian port, on a train to the sertão, to a laborer covered with dirt who works the land to produce the coffee. The laborer dreams richly at night but awakens poor everyday, and he "destroyed all by himself the brutal jungle."[9] The riches of the coffee plantation in Brazil are described as a promise never meant to be kept, a burned wedding veil, a dream torn from the hands of the laborer. Ricardo's poem concludes with the same, hopeless repetitive structure of its opening lines:

What of the laborer?
He is planting coffee.
What of the coffee?
The girl drank it.

And the girl, where is she?
She is in Paris.
Happy girl.[10]

Thick with irony, the poem contradicts the celebratory claims of the
editors—of Ricardo himself—and reveals the sinister edge of the jour-
nal's photomontage of a bright-eyed girl of European descent drink-
ing coffee, surrounded by a backdrop of a burgeoning urban landscape
(fig. 30).

Is the melancholy "Girl Drinking Coffee" a critique of the exploita-
tion of workers and of natural resources that Mário presented as Bra-
zil "crossing its arms" to the city, or is it a rejection of agriculture as
a fruitless past to be replaced by an idealized industrial future? What
happened to the powerful class of coffee plantation owners as the city
underwent such dramatic change? As much as the image of industrial
São Paulo was crucial to the concept of Brazilian modernity and the
rate of urban growth surged incredibly during this period, the owners
of the land that cruelly awoke the worker from his dreams of riches

continued to exercise economic and political power. We cannot forget that the woman who made Mário's journey possible (although he did have to pay some of his own way) was the coffee heiress Olívia Guedes Penteado. The contradictory nature of modernity on the periphery occupies the space between text and image in this photographically illustrated journal, despite the elaborate rhetoric of the editorial address.[11]

Mário, "apprentice tourist" and touristic curiosity, actively participated in the expanding mass media in Brazil and considered it an important component of critical nationalism. His journalistic writing was included in a wide variety of publications: chronicles, which were predecessors to the poetry collection *Paulicéia desvairada*, appeared in 1920 and 1921 in a section of *Ilustração Brasileira*, "About São Paulo," and he went on to publish in *América Brasileira* in 1923 and 1924, and *A Manhã*, a large circulation periodical, in 1926.[12] Beginning on August 30, 1927, Mário wrote almost daily art criticism for the *Diário Nacional*, the opposition journal of the Partido Democrático, work he stated that he enjoyed. The newspaper initially supported the Revolution of 1930 but later opposed Vargas's increasingly oppressive government and was forced to close in 1932. *Diário Nacional* published 771 texts by Mário, respecting his syntax, experimental orthography, and neologisms.[13] The photographic theorization of an ethics and aesthetics of modernism depended upon his participation in this broad range of publications. By directing focus on this other content of "the popular," the publication of "Toada" in the newly born mass media in Brazil expands the discussion of the ethics of modernism, the articulation of critical nationalism, and theories of politically engaged modernist art.

If mestizaje has been the reigning conceptualization of the mixture of elite and popular, as much as of European and indigenous populations, I argue that by now it operates as a limitation for understanding modernity in Latin America. It is constrained by both its grounding in racial discourses of the nineteenth century and its successful integration into the homogenizing force of the modern state. Instead, I build upon Jesús Martín Barbero's concept of mediation to theorize a conflictive cultural field of modernist aesthetics and ethics. Photography is an ideal mechanism for mediation, since it makes the broad circulation of images possible, comes in contact with printed words in graphic design of the period, and alters the cultural status of visual objects, artistic and otherwise.

The interdependence of these two images of the popular in modernism—*cultura popular* and *cultura de masas*—figured "the popular" as both raced and gendered. As much as Mário converted his anxiety about artistic practice into critical nationalism in the face of the ethical demands he encountered in his work with indigenous and Afro-Brazilian cultures and peoples, his Mexican counterparts created an alternative to the dominant cultural nationalism of the postrevolutionary era in the strange and conflictive pages of popular, illustrated women's magazines. While these two faces of the popular look confusingly different—the Tapuio meets the flapper—the practice of and meditation on photographing these people constitutes the ethics and aesthetics of modernism. Miriam Hansen prefers the term *vernacular* to *popular* in analyzing how modernism exceeded the limits of elite culture, "because the term vernacular combines the dimension of the quotidian, of everyday usage, with connotations of discourse, idiom, and dialect, with circulation, promiscuity, and translatability."[14] However, the deployment of "the popular" among the modernist movements in Latin America reveals that this concept was imagined as both folkloric and mass. Before getting too far ahead in proposals about photographic modernism in early Mexican mass media, we must understand how the popular becomes the masses at this crucial juncture in the twentieth century, what role photography played in the process, and why the modernist avant-garde would have been interested in the first place.

Mediations

Jesús Martín Barbero's landmark book, *De los medios a las mediaciones* (1987), represented a major shift in studies of popular culture in Latin America away from a more rural focus to an urban one.[15] Studies of popular culture as "folkloric" may seem outdated, having given way to contemporary studies of cities and mass culture. However, Martín Barbero defines urbanism as Mário did, as always already in contact with the rural. His central proposal, still relevant and generative, is that "the popular" continues to exist within and outside of "the masses": they exist in a relationship of mutual dependence and conflict. The very groups that had been enclosed in folkloric images of the popular, which were therefore forced outside the unfolding of political, economic, and cultural history, make up "the masses." Martín Barbero refers to Mário's

studies of Afro-Brazilian music as an approach that conjoins the aes-
thetic avant-garde with the urban popular: "the black gesture is made
mass-popular."[16] These transitional years in the development of mass
media permitted greater openness in the conflictive negotiation be-
tween popular and elite cultures, and between masses and nation.

Martín Barbero argues for a modified, culturalist approach to theo-
rizing the popular and the masses. This method takes into account rec-
ognizable hegemons such as the state, as well as the influence and power
deployed by mass media. Mediation operates as follows: the hegemon
seeks to cover up differences and reconcile tastes through the manu-
factured consent and deformation of the "old popular culture," and the
integration of the new popular class into the market of the masses.[17]
The masses are not mere receptors of these ideas but instead participate
in the process of mediation. Mass culture does not exactly parallel mass
market, and the mixtures of modernity on the periphery are not always
resolved in the reconciliation of the massive into the interests of the
hegemon.[18] While the Frankfurt School philosophers Max Horkheimer
and Theodor Adorno help Martín Barbero to analyze the systematic
production of (consumer) desire in mass media—we want what we
see reproduced over and over again—he argues that Walter Benjamin's
analysis of the process is more relevant to the structure of modernity in
Latin America. Martín Barbero appreciates that the systematic culture
industry that Adorno theorizes makes impossible a purely culturalist
position and its concomitant division of high and low; the danger he
detects, though, is that it reproduces the same reading of every cultural
text or object it encounters. The result is "*the atrophy of the activity of the
spectator*" and a "cultural pessimism."[19] Martín Barbero argues that this
is an error based in the confusion between a mode of historical use and
a technological rationality, which produces a form of cultural elitism
that still denies the possibility of a plurality of uses of culture and a
multiplicity of aesthetic experiences. In contrast, Benjamin addresses
the conflictive nature of mass culture, finding the popular to be not the
negation of culture but rather its production.

While "aesthetic experience" runs as a rather subtle current within
Martín Barbero's broader argument, it is crucial for our study of culture
as a conflictive site of mediation. His goal of an anarchist aesthetics,
which seeks to erase the division between art and life, asserts culture
as a site not only of the manipulation of the masses, but of conflict,
heterogeneous practices, and experience.[20] This experiential aesthetics

intersects with the concept of (re)production in a series, particularly Benjamin's vision of how photography transforms the reception and function of art. Criticism in the age of mechanical reproduction shifts from a conception of the work of art as total to a theory of multiple works, practices, and most of all, experiences of those works. Whereas Adorno thinks of aesthetics as one person losing himself in the work, Benjamin pictures a mass of people in which the work is immersed. If Adorno still relies on the individual reading or viewing the work, Benjamin imagines a collective experience that makes the circulation and reception of the work(s) — henceforth always plural in their hermeneutics — as or more important than their made objectness. Following Benjamin, then, we will look at photographs in their plurality: in their reproduction, circulation, and even misappropriation.

Martín Barbero argues that in its fully developed form, mass media became the "spokesman" of the process of interpellation that converted the masses into a *pueblo*, and the pueblo into nation. This interpellation relied upon the self-recognition of the masses in the media they viewed: an encounter with their most basic demands and certain forms of popular expression. Recognition is the facet of mediation that transforms the idea of nation into "experience, in sentiment and daily life."[21] Photographically illustrated magazines like *S. Paulo* were not necessarily alphabetically *read* by massive popular audiences, given the dismally high rates of illiteracy in Brazil, Mexico, and most Latin American countries in the first decades of the twentieth century. However, their expanded and plural hermeneutics, and the altered use of their visual content by populations with varying degrees of literacy, make them crucial sites for composing the modernist ethos' popularity. Benjamin's theory in fact develops out of his interest in the "minor" arts: caricature, pornography, photography, and so forth. These very arts were reproduced in the same illustrated journals in which modernist avant-garde writers published.

Picturing the Lettered City

Mário's early theory of poetic simultaneity has at its center the poet's reintegration into the world, an escape from the "ivory tower" that thrusts him (codaquinha in hand) into a world of cinema, buses, telegrams, and newspapers. This image of the modern intellectual reflects

major changes in the institutions of culture and education in much of Latin America during the early 1920s, when academic and artistic disciplines were in a state of flux. The explosion of modernismo in São Paulo rather than in Rio de Janeiro has been explained in part by the city's industrialization, but it also must be considered in contrast to the presence of already established institutions of art and literature in the capital city. While the capital served as the center of art in the service of the governing forces first during the Portuguese Empire and later during the early Republic, in São Paulo there was no formal art school and Mário felt himself the inventor of entire fields of critical practice.[22] By the time that the Escola Paulista de Belas-Artes was founded in 1925, most of the modernist writers and artists had already completed their studies. In his study of the ciudad letrada in Latin America, Angel Rama describes these intellectuals of the early twentieth century as a generation of autodidacts: "Either for economic or intellectual reasons, the university stopped being the mandatory path of the letrado that it was entirely in the nineteenth century and even during modernization. With unknown dignity appears the category of the autodidact."[23] The traditional degrees of law and medicine no longer guaranteed the same role in society and politics that they had before, and so the very idea of the intellectual had to change. Rama describes this transition as part of the professionalization of the ciudad letrada, during which the writer entered into a market economy of journals and newspapers. Paid for their work like other white-collar workers, albeit poorly, writers entered into a new cultural market.[24]

Viewed as a broad shift in the professional and disciplinary structures throughout the twentieth century, Rama's analysis is precise and accurate. However, looking more closely, this transitional generation of the modernist avant-garde contained internal differences among the artists' and writers' professional opportunities and their aesthetic theories. Mário was one of the few participants who had little choice but to operate in this professional capacity if he was to be active in the modernist movement. Unlike Oswald de Andrade and Paulo Prado, whom Sérgio Miceli characterizes as "men without a profession" and who still operated much as the nineteenth-century intellectual did, Mário could not rely on family wealth to support him and pay for his publications.[25] Although his mother came from a socially prominent family, his father was a journalist and small businessman. While criticizing Oswald's "Anthropophagist Manifesto" for its European formal

characteristics, Mário complains that because of a lack of funds he cannot publish books with the rapidity that Oswald can, and so he appears to be left behind.[26] He did not receive his degree in law, instead studying at the Conservatório Dramático e Musical in São Paulo. He made a living writing for newspapers and teaching music classes to the daughters of the established oligarchy and new bourgeois families.[27] The wide-ranging, experimental interdisciplinarity of Mário's writing, photography, and research can therefore be understood to some degree as the result of the financial necessity of his being a jack-of-all-trades. He himself believed that this class difference led to different aesthetic values. Mexican chronicler, poet, and public figure Salvador Novo felt similarly excluded from the upper-class privilege of fellow Contemporános Jaime Torres Bodet and Xavier Villaurrutia.[28] In his biography of Novo, Monsiváis quotes him asking in 1925, "Is it possible in our time, in Mexico, to make a living from writing?"[29] Novo's father was an aspiring businessman, and while his family was somewhat established, Salvador was also a professional writer and intellectual. He worked at the Summer School established for foreigners in Mexico City, served as chief of the Ministry of Education's editorial wing, and published texts in everything from the popular *El Universal Ilustrado* to *Forma*, the "little magazine" of the Contemporános, to *El Chafirete*, a periodical for Mexico City truck drivers.[30] While these writers were somewhat unique among their cohorts, Rama would insist that they are the model of the letrado of the twentieth century. The criticisms leveled at modernism in recent years for its ongoing connection to oligarchic political and economic privilege should not be dismissed. The professionalization of Mário and some of his Mexican contemporaries, however, contributed to their theorization of an ethos of modernism lodged in the popular that would continue to be relevant throughout the century.

Writers and artists thus increasingly participated in the expanding economic sector of mass media, as well as in the centralizing state in both Brazil and Mexico. The relationship between culture and the state in Brazil has clear relevance to the relationship between avant-garde and postrevolutionary government in Mexico. While it did not experience the same degree of radical social change that characterized postrevolutionary Mexico, Brazil proclaimed a New Republic following the (more moderate) Revolution of 1930. Similar increases in state funding for education and culture are found in both countries, and in addition to his educational and media jobs, Mário also held several positions in

the early years of the Vargas regime. Mário served as director of the Department of Culture and Recreation for the city of São Paulo in 1936, and he was later asked by Gustavo Capanema, Vargas's infamous minister of press and propaganda, to draft a proposal for a Serviço de Patrimonio Artístico Nacional.[31] In order for Mário's critical nationalism to be truly relevant to the kind of engagement with the popular that Martín Barbero imagined above, it must hold up even through his employment by the Vargas regime.

In his state-sponsored draft of a design for cultural patrimony, Mário attempts to put into practice the theory of critical nationalism seen in his creative work, clarifying the multiple meanings of "the popular" at its core. He defines national artistic patrimony broadly as "all works of pure and applied arts; popular or erudite art; art produced by nationals and foreigners; and, art owned by public entities, independent organizations, private individuals, and foreigners residing in Brazil."[32] In addition to the more ethnographic engagement with popular culture that was the focus of the first two chapters, Mário includes a broad range of popular cultural practices in this plan for a national patrimony, including gardening, regional dress or costume (*indumentaria*), and fashion (*moda*). Most relevant to the theory of popular cultural expression is the logic by which Mário links "regional costume," specifically "the horseman, the cowboy, the Bahian woman," with upper- and middle-class fashion. He writes: "Yet another process, and very useful, to put into practice this mobile part of the social program, would be the founding of a Magazine of National Fashion, or the creation of a section directed by Society, in a magazine already founded (*Vanitas, Cigarra*), in accordance with its directors."[33] Here the "ethnographic" collection of regional uses of skins (one example he gives) would operate parallel to and within the photographically illustrated women's magazines that show the newest styles from Rio de Janeiro, London, and Paris. Mário himself published in *Cigarra*, which included photographic collages and was directed at a female readership. The national popular expressed through clothing is both the ethnography and apprentice tourism seen in Mário's photographic practice, and the fashion photography published in popular women's magazines.

Mário's expansive definition of national patrimony was substantially altered after the outline was submitted to Vargas's propaganda minister, Capanema. It became instead a proposal for a Serviço do Patrimônio *Histórico* e Artístico Nacional, and the insertion of this single word re-

sulted in a crucial shift from contemporary popular culture to a historical definition of patrimony.[34] These changes made to Mário's vision have led to conclusions that during the first Vargas regime "cultural patrimony would be synonymous with high art."[35] Mário's experimental ethnography and apprentice tourism were erased from the SPAHN's structure, as was the concept of an equally important and contemporary urban popular culture.

The proposal that fashion magazines be a central location for the creation of a national patrimony stands out as a bizarre combination of indigenous skins and Parisian furs. The variety publications that Mário describes were explicitly designed for a female audience, and they addressed the many interests and concerns of their public, even as they were crucial to the careers of many modernist writers and artists. Emiliano di Cavalcanti, likely the creator of the Week of Modern Art in São Paulo, got his start in the women's magazine *Fon-Fon* in 1914, and he contributed artwork for the covers of the widely popular *O Cruzeiro*.[36] This magazine was a leader among illustrated publications, with news as well as "sport, politics, art and spectacles, consumption, ways of life."[37] Kaz describes how mass-media publications "were 'feminized'" as women left the privacy and intimacy of the home to enter into the public sphere of the economy and politics.[38] *Revista Feminina*, founded in São Paulo in 1914, began publishing photographs in 1916 and sold more than 20,000 copies per month.[39] Despite the clear address to their women readers, the politics of such journals cannot be termed feminist. While a section of the *Revista Feminina*, titled "Feminine Life" ("Vida Feminina"), reported on women's movements around the world and defended women's right to vote, it condemned foreign suffragettes and contained a conservative, moralistic tone that expounded on the importance of women as mothers.

These journals played a crucial function in mediating the popular, the mass, and the modernist avant-garde, specifically through images of modern femininity. The explosion of a mass-media sphere in Mexico and Brazil was dominated by photographically illustrated magazines for women, in which the contradictory nature of modernity was drawn onto the figure of the modern woman. Even Mário's poems in *Paulicéia desvairada* figure the city as:

A woman taller
than the hallucinated awe

of the towers of São Bento!
Woman made of asphalt and marsh mud,
all insults in the eyes,
all invitations on that mouth mad with blushes!
. . .
half lady, half whore,
the crucifying hallucinations
of all the dawns of my garden![40]

The conjoined images of marsh mud and asphalt, lady and whore, pic-
ture the two faces of the popular that are so crucial to the ethos of mod-
ernism. The "transmutation," as Martín Barbero terms it, of popular
into mass takes place in specifically gendered spaces, and the resulting
modernism acquires an ethical and an aesthetic definition. The pages of
the popular illustrated magazines, filled with variety pieces and photo-
graphs of Hollywood stars as well as experimental poetry and photo-
montage, present us with a striking and conflictive vision of modern
Mexico, and reveal an ethos of modernism that exceeds and challenges
the state's projects of cultural nationalism.

The Case of Mexico

One can hardly imagine a moment in history at which the state was in
greater need of such a consolidation of the national imaginary than the
period following the Mexican Revolution. After a decade of violent
civil war, the tenuous political structures sought to instill the "lived-
ness" of the state. What is more, it was precisely the state's representa-
tion of itself as the will of the popular classes—urban factory workers
and rural *campesinos* alike—upon which it staked its claims of authority.
Nonetheless, as Martín Barbero himself points out, during these de-
cades the mass media was in as conflictive a process of formation as
the postrevolutionary government. Mexico functions as an impor-
tant case for understanding the urban popular across Latin America,
for its vision of revolution, of popular struggle, "el pueblo" and mass
social movements; it is a complex, fascinating, and contradictory site
for the study of the relationship between the popular, the masses, and
the nation.

José Vasconcelos's cultural missions, which included a national lit-

eracy campaign, have become a primary reference point in studies of nationalism during the so-called Mexican Renaissance. His canonical *La raza cósmica* (*The Cosmic Race*, 1925) provides the underlying philosophy governing these projects, in which the future of Latin America lies in the mestizaje of indigenous and Hispanic (Europeans) that would miraculously create the "fifth race." Vasconcelos was not just the financer but also the visionary behind the explosion of muralism as the ultimate fusion of nationalism and modern art. He called Diego Rivera back from his long residence in Paris in 1921 to participate in his cultural missions, even sending him to Yucatán to see the Maya ruins in Chichén Itza and Uxmal in order to learn about Mexico. Yet Mauricio Tenorio provides a much-needed corrective to the more idealistic visions of what mestizaje meant to Vasconceles, writing that his "combination of pro-Hispanism (linked to creole patriotism) and (so to speak) 'scientific racist anti-racism' allowed Vasconcelos to defend the universal task of the new *mestizo* nations. . . . But it also led him to expand the nineteenth century racist theories into the twentieth-century post-Revolutionary era."[41] During his 1922 trip to Brazil for its centennial of independence, the minister of education strongly opposed the choice of gift given by Mexico: a statue of Cuauhtémoc, the last prince of Tenochtitlan, which matched the one still standing today on the Paseo de la Reforma in Mexico City. Vasconcelos explained in his speech given upon its presentation that "the veneration of this hero suggested neither the rejection of progress nor the ambition of going back to Aztec times," nor a turning away from Europe.[42] Vasconcelos's model of nationalism as mestizaje in fact concludes with the successful hispanization of the indigenous and mestizo communities.

Mediation can be employed to frame mestizaje historically, as a concept germane to the analysis of Latin American modernity because of its successful deployment by the state to consolidate its power.[43] Martín Barbero's basic theoretical premise almost, but not quite, replaces mestizaje with this new figure of modernity:

> The cultural truth of these countries: of a mestizaje that is not only that racial fact from which we come but today's story of modernity and cultural discontinuities, of social formations and structures of feeling, of memories and imaginaries that mix up the indigenous with the rural, the rural with the urban, the folkloric with the popular, and the popular with the massive. It was thus that communication became for us a question of

mediations as well as media, a question of culture, and therefore not only knowledges [conocimientos] but also re-cognition [re-conocimiento].[44]

As seen in the earlier discussion of Brazilian primitivism, race itself is a discourse lodged in colonial history, made factual by the violence it rationalized. Its structures still often generate the terms for representing modernity in Latin America, but it cannot be accepted as fact.[45] Despite his treatment of race as a "fact," here Martín Barbero begins to think mediation rather than mestizaje, establishing culture as a strategic space for negotiation between the unfairly matched pair of the hegemon and the popular.

Mediation does more than simply shift the understanding of modernity from race to the globalization of mass media. Mestizaje, even as defined by Vasconcelos, included mass media, for he proclaimed that the universal tendency toward racial mixture appears as "modern communications tend to overcome geographic boundaries . . . the obstacles to the accelerated fusion of the races will slowly continue to disappear."[46] The ideal (hispanized) mestizo state would use communication and mass-media networks to spread a homogeneous culture. A study framed through mediation focuses instead on points of tension in the hegemonic representation of mass culture, on the breaks and disruptions that indicate by what paths popular culture circulates and interrupts elite culture.

Despite radically different histories of press and graphic design, mass media began to emerge at about the same time in Mexico and Brazil. In both countries, the press combined a nationalist tone with cosmopolitan content, and the "feminization" of periodicals that described the press in Brazil was a central topic in the definition of mass media and modernist avant-garde in Mexico. While the best-known manifestation of Mexican modernism's populist nationalism is the muralist movement, known for its massive conversion of public spaces into revolutionary history lessons and for what has been termed its masculinist and even heterosexist rhetoric, these decades also saw an explosion of photographically illustrated journals like *S. Paulo*. In what now seems like a contradiction between "high" and "low" art, many of the most canonical vanguardistas, both Estridentistas and Contemporáneos, contributed to this early form of mass media in Mexico. *El Universal Ilustrado* will function as the prime example of this phenomenon, but it extended throughout the weekly supplement of *Excélsior*,

Revista de Revistas, and others. As troubling as we may find some of the images of modern femininity contained within the pages of illustrated magazines, they are a space in which mediation brings the ethos of modernism into focus.

The media participated both in the state's centralization of bureaucratic power through revolutionary rhetoric and in its reaffirmation of private capital. A growing bourgeois class took control of radio and the press out of the hands of foreign owners, as much as they operated under the watchful eyes of the revolutionary caudillos who successively passed through the presidential seat of power.[47] The twenties and thirties saw both conflict and a strange cooperation between a supposedly revolutionary government and this bourgeois class; both the birth of consumer culture in Mexico and a widespread rhetoric of revolutionary ideals; and the intersection of middle-class and "popular" interests. The postrevolutionary state paradoxically depended upon this new media and upon a nationalist discourse grounded in the image of a populist revolution, and the media served both to communicate political messages and to create an internal market.[48] The illustrated journals that were owned and run by this bourgeoisie displayed their resistance to the populist discourse of the revolutionary government but also sought to diversify the political sphere and to create some version of civil society in the aftermath of a decade of militarization. This emerging class and the state, with mutually intertwined but not identical interests, staked their claims to the definition of Mexican modernity in the media.

The popular sectors were new social actors in this contest for power, beginning with the new rights granted (if not actually given) in the Constitution of 1917, and continuing as the working classes and campesinos gained force through the Revolution. As readers and consumers of a nascent mass media, the middle and popular classes shared increased buying power and formulated a new social presence as they participated in discussions about the use of public space and the role of the postrevolutionary government. Ortiz Gaitán marks the radically new social attitude sparked by the media as a portent of contemporary consumer culture.[49] These were real struggles about a core set of issues: transformations of the household and workplace, masculinity and femininity, and religion. Anne Rubenstein insists that these groups "used mass media . . . as the best available space for dissent, negotiation, and accommodation. As surprising as students of Antonio Gramsci may

find it, the interpretive communities gathered around popular culture *were* Mexican civil society in this era."[50] Rather than suffering only the alienation of the culture industry and the erasure of resistance, these popular social groups were impure, conflicted, urban. The state certainly operated as mediator and instigator to manipulate cultural conflict to its advantage, even as national media sources sought to gain ground by turning the state's resources against its interests.

The weekly illustrated magazines to which both Estridentistas and Contemporáneos contributed were affiliates of daily newspapers founded in the late teens, including *El Universal*, which was established in 1916. All of these newspapers and weeklies loudly pronounced themselves to be independently owned and operated. There is tremendous debate about *El Universal* in particular, as accusations of complete obedience to President Venustiano Carranza, whose support launched the paper, are countered by its own proclamations of total financial independence.[51] Some scholars have criticized *El Universal* as the instrument of the middle and upper classes, financed by advertising and too critical of the revolutionary government, while others deny the claims of founder Félix Palavicini about its independence from governmental support.[52] The Secretaría de Hacienda y Crédito Públio did pay for the cost of paper, and control over access to paper was for many years the government's best means of control over the press.[53] However, governmental support was not ongoing, and while the newspaper survived dramatic political shifts, individual editors were fired and exiled (including Palavicini himself from 1927 to 1929), and the newspaper was even shut down temporarily.

Palavicini's politics mixed progress-minded industrialist ideals with a proclaimed concern for true social equality, and he expressed profound doubts about the power of the state to achieve social change. He is not, however, entirely honest when he writes in his melodramatic autobiography: "I dedicated myself to the organization of a private business to publish a daily paper. . . . my intention was to dedicate myself to political journalism, creating a great business to make an independent, revolutionary daily paper. . . . It is opportune to declare here that the government of Mr. Carranza did not provide a single peso for the foundation of this periodical."[54] In fact, Carranza put Palavicini in charge of the newspapers of the Revolution, and he was responsible for the creation of the publications department within the Ministry of Public Instruction.[55] Notwithstanding, Palavicini warns: "The purely po-

litical state is weakening during our era. . . . Industrialism, in turn, is the owner of the modern world: it spreads well-being, it consolidates democracy."[56] He adds that laws and taxes are not sufficient to resolve real social problems, and instead Mexico must distribute "the media of action" to alleviate immense social inequalities.

Due to the competing interests of the revolutionary state and the growing bourgeois class, *El Universal Ilustrado* and *S. Paulo* resist a simple "culture industry" analysis. Juan Manuel Aurrecoechea and Armando Bartra ascribe the era's cultural boom to the support of both the state and the entertainment industry and note that illustrated magazines reached "from the *more or less elitist avant-gardes* to the still unredeemed popular masses."[57] These weeklies sought to broaden their readership, to integrate the entire family as a "reading public" through the inclusion of the colorful illustrations and a section of *historietas*. While it has proven impossible to confirm the figures about the numbers of Mexican journals and newspapers that circulated at the time and their readership, in the 1920s, the web of distributors and the number of street sellers of periodicals increased notably, and the Union of Vendors, Criers, and Distributors of Press was founded. When the vast open market at La Lagunilla began in the 1930s, the weekly illustrated supplements were sold alongside secondhand books. While Aurreccoechea and Barta stress the "precarious autonomy" of the press, calling it Mexico's "doubtful fourth power," the idea of a more or less elite avant-garde sharing the loot of the postrevolutionary government and the commercial gains of a new consumer culture with the popular masses must give theorists of modernism pause.

Carlos Noriega Hope was the director of *El Universal Ilustrado* during the height of its engagement with the modernist avant-gardes, from March 4, 1920, until his death in 1934. In his director's commentary in the journal, which was subtitled a *Popular Artistic Weekly*, Noriega Hope states:

> The ideal of this journal is to be a [forum of] . . . the frivolous and the modern, where transcendent things are hidden under an agreeable superficiality. Because it is doubtless that all periodicals have their physiognomy and their spirit, exactly like men. . . . There are those that are frivolous and apparently vacuous, but that hold, at their base, original ideas and a human perception of life. Perhaps this weekly, within its frivolous spirit, contains the scent [perfume] of an idea.[58]

This description of the mixture of frivolity and innovative thought is expressed in mixed codes of silly femininity and modernist avant-garde. The director of publication immediately preceding Noriega Hope was, in fact, a woman: María Luisa Ross. J. M. Gonzáles de Mendoza bemoans that she "wanted to make *El Universal Ilustrado* a publication for the home and inserted portraits of ladies and children, established sections of useful recipes, advice to mothers, embroidery lessons; she published articles about tea time, fans, wrinkles, and their triumphant adversary, plastic surgery."[59] These sections and the like continued, however, under Noriega Hope's leadership. In the history of *El Universal* published recently by the newspaper itself, the ideological and aesthetic confusion still had not been resolved. The film page of the newspaper, which Noriega Hope coordinated before becoming director of the weekly supplement, "was an anarchical illustrative page of different artistic currents; in reality it had no coherence whatsoever since its themes were so dissimilar that one sheet was insufficient to give them any order."[60] *El Universal Ilustrado*, under Noriega Hope's leadership, served as a fascinating and contradictory meeting ground for the discourses of nation articulated by the state, the increasingly powerful bourgeoisie, and avant-garde artists and writers. It reported on the educational programs of Vasconcelos, included fiction and poetry by both of the major groups of the vanguardias, and even reflected a conservative Catholic voice frequently associated with middle-class women of the time. At the core of the mixture of frivolity and avant-garde originality are photographs, which over and over picture modernity in the figures of modern women. The mediation that takes place in this mass media contributes to the ethos of modernism in the form of a nondogmatic ethics and a strangely mass-cultural aesthetic.

Mass Modernisms

Important interventions have challenged the defining separation between high and low culture in mainstream as much as "alternative" modernist studies. Since the much debated exhibit at the New York Museum of Modern Art, "High and Low: Modern Art and Popular Culture" (1990–91), even these titular terms have been rejected. In Euro-American modernist studies, Thomas Crow convincingly establishes the "continuing involvement between modernist art and the ma-

terials of low or mass culture."[61] "Involvement," however, makes the terms of exchange between these realms of culture too vague to pin down. What is more, Crow describes the relationship as a moment of scandal and disturbance that does not last. Modernism has a quick and notorious fling with mass culture, and then retreats energized into its protected walls. Modernist artists are "mock conspirators"[62] with mass culture, and only so when they are unable to produce a sense of novelty within the realm of high culture. High culture makes raids into the terrain of the popular in times of desperation, "to displace and estrange the deadening givens of accepted practice."[63] Even though Crow praises select artists for not being "tourists" in the popular class, mass culture effectively plays the role of the primitive in primitivism, imbuing an exhausted cultural practice of the (European) elite with new life.

García Canclini proposes that unlike the European context of avant-garde art, the university reforms in Mexico and the rest of Latin America of the late teens created a situation in which connections between elite and popular art served a defining function. Indeed, we have at our disposal, thanks to Mário, a very different view of what it can mean to be a tourist. Rather than condemning the "tourist" avant-garde for passing through mass culture and giving the "authentically" lower class artist a free pass, I propose a different understanding of the relationship between modernism and mass culture, which further explores the "tourism in one's own land" that comes of always already being both native and foreign to the place (or class) represented. The promotion of domestic tourism, similar to Mário's apprentice tourism, was part of a broader phenomenon in which the modernist literary avant-garde *actively participated* in the early forms of mass media in Mexico, and the representation of an urban and national mass culture. These writers did not just mine the popular for inspiration, picking out a newspaper clipping as if for a Cubist collage, but rather were editors and regular contributors to the popular publications introduced above. It is difficult to overstate the now strange and varied participation of the Mexican modernist avant-garde in popular media. One fascinating example is the series of monthly publications sponsored by a beer company, *Boletín Mensual Carta Blanca*, which ran for six years between 1933 and 1938. Edited by Salvador Novo, it included short essays by Jorge Cuesta, Villaurrutia, Jaime Torres Bodet, Novo, Manuel Toussaint, and Samuel Ramos. These contributors wrote about contemporary and historical works of art from Mexico and Europe, and also contained

tourist recommendations ("Places That Should Be Visited") courtesy of the magazine *El Mapa*. It included high-quality, colored photographic reproductions of art works, as well as recipes that included Carta Blanca beer. The artist as (apprentice) tourist is at the heart of this modernist aesthetics rather than exiled from it; it is the activity of tourism that functions differently. Engaging the simultaneous distancing and approximation of photographic focus, the "involvement" of modernism with popular culture does not emerge from an authenticity or closeness, nor from the distanced desire of exoticism. Through active participation in the production of popular culture, modernism *mediates* ethics and aesthetics. In the following chapter, the ethos of modernism emerges by tracing the circulation of images, ideas, and people that happens during this conflictive process. It maps a libertine rather than a moralizing ethics, and it imagines a modernist aesthetic that is not autonomous but rather adulterated by popular culture.

In the office where Maples Arce and Arqueles Vela wrote their books, one found amorous pages, stained by the gazes of literary women. GERMÁN LIST ARZUBIDE

4

Our poor photography is relegated to the furthest corner of artistic value. Like a dirty suit, she humbly takes up the mission that painting has left her and puts it on. But, new creature, she marches happily through the streets, she goes on excursions, she exercises, she *curiouses*. She is the prodigal daughter of art. SALVADOR NOVO

Essay

LAS BELLAS ARTES PÚBLICAS, PHOTOGRAPHY,

AND GENDER IN MEXICO

German List Arzubide's short book, *El movimiento estridentista*, includes poetry, essays, and artwork by and about the Estridentistas and is full of references to these "literary women." Reading it for the first time, I puzzled over them and was intrigued by their repeated appearance in texts not only by the Estridentistas, but also by their proclaimed rivals, the Contemporáneos. Who were these women? How did their very looks stain the pages of both canonical literary movements? While only traces of them appear in the scholarship, the simple answer is that many of the writers from both groups published essays, fiction, and poetry in the photographically illustrated mass media.[1] Their writings appeared alongside, and even addressed, beauty tips, advice on how to care for your husband, and fashion. The "feminization" of journals and magazines appears in the very subjects of the photographs that flooded their pages: the vast majority of photographic images in the illustrated journals were of women, published just beside and within Estridentista and Contemporáneos texts. Photography itself, and

the photographic image translated into literary concept, came to embody the so-called femininity that characterized these media.

This material history is only the beginning of an analysis of the "feminization" of mass media and literature that caused such widespread distress among certain literary men, and that had a major impact on modernist aesthetics. These illustrated journals did more than picture women, they also addressed them, simultaneously revealing and constructing an audience of women who were demanding readers and viewers, posers and takers of photographs. Femininity is not just the subject of these pages, it also has a formative role in their composition as the terms in which mediation was taking place. Feminization complicates Martín Barbero's theory of mediation as a negotiation between popular and hegemonic groups in postrevolutionary Mexico: radical changes in this period cast women as new social actors with divergent political and social interests, whom the intellectuals involved in defining modern Mexico were at pains to fit into reigning discourses of modernity, nationalism, and popular culture. The photographically illustrated journals included debates over femininity and heated arguments about the relative "virility" or "effeminacy" of modern literature. The coding of modernist avant-garde movements as gendered determined the value and meaning—the ethical and aesthetic force—of their literary and artistic production. The mediatic feminine and the feminized media represent an alternative site for the articulation of modern Mexican culture, one that contests the vision of mestizaje presented in the state's cultural nationalism (in murals, essays, and public education) while actively engaging the popular.

Among this generation of writers and cultural figures, the battle over the definition of modern literature and its future came to be a fight between an aesthetics that was "virile" and one that was "effeminate." Like Mário's "vanity," this division was explained in terms of social responsibility: virile literature contributed to the institutionalization of the revolutionary project and the peaceful continuation of revolutionary ideals, while effeminate literature undermined the social and political goals for a new Mexico in favor of foreign influences.[2] Francisco Monterde wrote in El Universal that virile literature was needed because "what is lacking is someone who might elaborate the sentences that consecrate that which the public—the masses—take up to repeat, thus creating popularity, since they are not educated to formulate by themselves a definite opinion about new works [of art]."[3] The formulation of

revolutionary popular culture had to be masculine and had to be taught to the uneducated masses. Important new scholarship has treated this anxiety about virility as a homophobic response to the sexuality of the writers who were accused of creating "effeminate" literature.[4] Authors Salvador Novo, Xavier Villaurrutia, and Carlos Pellicer, and artists Roberto Montenegro, Manuel Rodríguez Lozano, and Abraham Ángel made up what Carlos Monsiváis calls "El Ambiente" of gay intellectuals in the period. Homophobia was certainly part of the reason for the severity of the attacks, but only partially explains the broad strokes by which some work was termed *effeminate*.

Víctor Díaz Arciriega explains that while these terms — virile and effeminate — were assigned an aesthetic value, they were in fact empty categories. Nevertheless, even his critical study uses bizarrely gendered terms to describe the early mass-media publications in which the literary avant-garde published: "There *cohabitate, promiscuously*, a very extensive show of themes that reveals an editorial direction that has difficulties *discriminating*."[5] Díaz Arciriega continues to associate unethical, "promiscuous" sexual behaviour with a lack of discrimination, with the inability (or refusal) to differentiate between good and bad literature, elite and popular culture. A simultaneously aesthetic and ethical judgment framed in the determination of the gender of mass-media publications began in the 1920s and continues to work today. This verdict condemns aesthetic indiscriminacy through a moralizing evaluation of sexual practices.

The undiscerning licentiousness of mass media appears at the intersection between text and photograph in the pages of these illustrated journals. As we shall see, photographic theory at the time classified the medium itself as "feminine," and its contribution to the arts as the creation of a profligate mixed-media aesthetic. The "promiscuous" jumble of modernist avant-garde and popular magazine contributes to a modernist ethos that I call *las bellas artes públicas*, public fine arts. The bizarre sound of the phrase in Spanish is proper to the collapse of the assumed contradiction between fine art and popular culture ("discrimination"), and to the gender of the public sphere. Debra Castillo explains: "On analogy with men who dedicate their efforts to governmental and public-service functions (*hombres públicos*), logically, such women would be *mujeres públicas* [prostitutes]. The impossibility of such an appellation points to the historical problem."[6] The feminized public sphere that appears in photo-essays presents an image of nation that has

been erased from studies of Mexican modernism. It pictures mediation in the movement of women into public spaces, a vision that redefines modernity in Mexico as more than only men's nationalistic move into the postrevolutionary political sphere. The bellas artes públicas contain an ethics and aesthetics of modernism in Mexico and lead to a vision of the national not usually found in a country credited with the composition of a durable and monolithic cultural nationalism.

To define the bellas artes públicas as a crucial element of the ethos of modernism, I first examine the tradition of ethics placed in the hands of women, and the radical changes in ethics that took place in the postrevolutionary period. Second, I present how this gendered ethics is intimately linked to a Mexican photographic aesthetic, which cannot be forced to fit within an imported theory of modernist photography from Europe and the United States. Armed with this "feminine" ethical aesthetics, one can make sense of the mixed media photo-essays that appear in the illustrated mass media. Their intervention in the influential genre of the essay in Latin American letters reveals circulation itself at the crux of this errant modernism.

Circulation here again presents the double meaning of errancy, referring to the movement of bodies and goods in modernizing Mexico, to the distribution of the journals, and to the order and design of ideas and images within the illustrated journals. Like Mário, Mexican modernist writers and photographers were fascinated with the idea of being tourists in their own land; domestic (rather than foreign) tourism was actively promoted in the bellas artes públicas, and many photo-essays represent such journeys as crucial to the achievement of modernity. This form of modern circulation takes a particular shape in the travels of women, and during these decades the New Woman fascinated the readers of illustrated mass media. The tourist-protagonists of the photo-essays map a defining movement between the city and the country and compose a modernist aesthetic that organizes the circulation of ideas and images in photo-essays in a "feminized" media. This final point leads to the political promise of this ethos of modernism, for it shows the photo-essay to be a significant intervention in the essay of identity in Latin America. The excessive and uncontrolled aesthetic and ethics of these wandering feminine photo-essays contain the seeds of an alternative, if not critical, nationalism. The photo-essay's promiscuity—as it fools around with image and word, elite art and Hollywood screen stars—pressures the limits of the genre of the essay and presents

an errant modernism that radically redefines the meaning of ethics and our expectations of modernist aesthetics. In the bellas artes públicas, promiscuity can be ethical, and modernist aesthetics bridges mass culture and experimental art. The photo-essays that appeared in mass media and the corresponding graphic-arts industry show a far more variegated and contradictory image of nation than the ontological one that has governed studies of this period.

Essays

The genre of the essay in Spanish contains a fascinating if contradictory history of literature's relationship to critique. The translator of Montaigne's *Essais* into Spanish (1636) warns that the text instructs its readers in the principles of heresy and places the essay definitively outside the Catholic tradition.[7] Though the word *ensayo* itself was not used to reference "a light, didactic and provisional literary work" until 1892, this sort of text maintained a critical, outsider status.[8] The birth of the ensayo we know today coincided with the era of independence in Latin America, and it was the site of a simultaneously heretical and foundational articulation of national identity.[9] The essays of the twenties and thirties continued this divided tradition: they depend on the letrado as a present authorial figure, one who is able and even required to cast a critical eye on the current state of affairs. He is simultaneously inside and outside the society he essayistically engages. The force of this form of essayistic critique is such that in the late 1980s García Canclini still argued that the genre permits the freedom of movement necessary to write his theory of hybridity.[10] He writes that his essay creates a real, a textual, and a theoretical hybrid city, "which one enters via the path of the cultured, of the popular, or of the massified. On the inside, everything gets mixed together; every chapter refers to all the others and thus it is not important to know the approach by which one arrived."[11] Modern Latin American hybridity itself, like the essay, is constituted by circulation: of culture, people, and words.

The essay requires further examination of the approach by which one arrives, however, rather than the erasure of this path.[12] Especially in these early decades of exploding global and national circulation, we must examine how the conflicts between hegemonic and emerging popular classes were mediated. There were indeed limitations to move-

ment into and from the (textual) city: who was allowed to be heretical in this fashion, who could speak in an essayistic voice, which bodies were permitted to move through the streets of the city, and most importantly the form this circulation took, were central to the resulting image of modernity. Rama points out that the Mexican Revolution was the first in a series of "violent ruptures" that fundamentally altered the role of the letrado. His new voice, not just energized by its proximity to "cultura popular" but actively participating in it, is audible and visible in a different kind of essay that exploded onto the scene in the twenties and thirties.

Photo-essays were an integral part of a larger process of organizing representation following the Revolution, which included vast educational reforms from the elementary to the university level and the development of mass media from commercial magazines to cinema. The modernist avant-garde's engagement of photography and text offers a distinctive organization of the essayistic circulation of ideas and diverts the genre long treated as the critical eye of the intellectual, essential to national identity yet always remaining outside the center of bureaucratic power.[13] W. J. T. Mitchell names the relationship between image and word in photo-essays "a principal site of struggle for value and power . . . where images and words find and lose their conscience, their aesthetic and ethical identity."[14] Mitchell decides that the relationship between words and what Barthes calls the ethically paradoxical medium of photography becomes "a site of resistance."[15] Yet this theory of the photo-essay paradoxically places it well *within* canonical definitions of the Latin American essay as a hybrid, heretical genre. The history of this canon of essays of national and regional identity begs the question: how resistant can a (photo-)essay of national identity really be? Bearing in mind both the danger of assuming that art from the periphery is ethical, as well as the androcentric legacy of the essay in the region, I examine the photo-essay as a primary site of mediation.[16] The conflicting codes of photograph and text that intrigue Mitchell as a form of resistance create an aesthetic of excess that appears in the graphic design of these photo-essays: highly irregular, collagelike pages disrupt straightforward narrative and graphical expectations. Rather than "resistance" in general, these effeminate essays contain meaningful interruptions and reconfigurations of discourses of modernity and nationalism.

PLATE 1 James Casebere, "Monticello #3, 2001," digital chromogenic print, 48 × 60 in. *Courtesy Sean Kelly Gallery, New York*

PINTURA A GRAN FUEGO

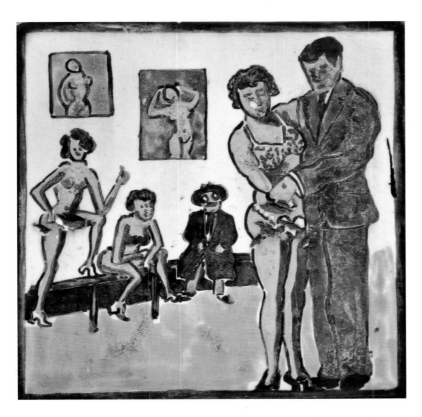

PLATE **3** The photograph of Don Carlos Balmori with several bataclanas, reproduced as a tile on the tomb he shared with Conchita Jurado in the Panteón de Dolores, Mexico City. *Photo: Esther Gabara*

(opposite page) PLATE **2** Don Carlos Balmori represented on the tomb he shared with Conchita Jurado in the Panteón de Dolores, Mexico City. *Photo: Esther Gabara*

PLATE 4 Gerardo Suter, "Tollan 14," from "The Photographic Archive of Professor Retus" ("El archivo fotográfico del profesor Retus"), 1984, 15 × 15 cm. *Courtesy of the artist*

PLATE **6** Arthur Omar, "A praia em ângulo" ("The Angled Beach")
from the series "O esplendor dos contrários" ("The Splendor of Opposites"),
2000. *Courtesy of the artist*

PLATE **7** Arthur Omar, "Um rapaz todo branco" ("A Boy, All White") from the series "Antropologia suprematista" ("Suprematist Anthropology"), 2001. *Courtesy of the artist*

Thus far, the ethics of ethos has been framed as a response to the inequalities and injustices of modernity as lived in Latin America, a familiar way of framing the demands of ethics. However, the artists and writers who engaged photography as both a medium and a theory of modernism also took on the definition of ethics. Their radical questioning took place through a debate over the content of *lo femenino*, "the feminine," which filled the pages of photographically illustrated journals. As in much of Latin America, in Mexico *lo femenino* and women themselves have long been the repository for social ideals and protectors of tradition. In her maternal capacity and care of the home, Woman (conceived singularly) was to occupy a protected sphere, and was good because she was unsullied by the corrupting touch of paid work, governmental politics, and the sexualized temptation of public spaces. Postindependence literary women in the nineteenth century offered moral resistance and a national ground, in contrast even to a potentially corrupt modern state. Lo femenino, and the women who were required to embody this unified ideal, functioned as the symbol of a Mexican ethics. In the chaotic early decades of the twentieth century, literary women continued to play key roles, but the threat represented by new cadres of working women led to a variety of campaigns meant to regulate these bodies out of place. Francine Masiello notes the Argentine state's response to an equation of "the feminine . . . with the unmanageable,"[17] which has clear parallels to the contemporaneous unstable period of state formation following the Revolution in Mexico. The occupation of public spaces by women became particularly disconcerting in the context of vast displacements of populations from country to city, and the rapid turnover of power as competing factions sought to gain political control.[18]

The bad behavior of modern women and their threat to tradition frames the broad attempt of Latin American modernist avant-gardes to bridge seemingly competing values of tradition and novelty. The artists, writers, and politicians in Mexico charged with the shaping of cultural nationalism after the Revolution sought to promote certain characteristics of modernization—urban renewal, secular education and literacy, and industrial development—even as they distanced themselves from the version of progress promoted by Porfirio Díaz and his *cientí-*

ficos. Generally speaking, these movements did not define themselves through a strict rejection of all art and culture that came before them. While they certainly wished to mark their differences from certain earlier schools of art, Adrián Gorelik's denomination of them as "constructive" rather than "destructive" projects is accurate and important. They endeavored to recapture the idea of a traditional Mexico—often represented by indigenous cultures—while they imagined a modern Mexico filled with trains, factories, and automobiles. Modernist aesthetics reflect a similar relationship to artistic innovation and tradition, exemplified by a radical Estridentista manifesto that simultaneously proclaims Charlie Chaplin as "the possibility of a new art, youthful enthusiastic and palpitating," and ends with the famous cry, "Viva el mole de guajolote [*sic*]!" [Long live turkey mole!].[19] By naming mole, the sauce made of chile and chocolate, and employing the hispanicized version of the Náhuatl word *guajalote* rather than the Castillian *pavo*, the Estridentistas produced a cinematic, international modernity that existed simultaneously with the idea of traditional culture belonging to the nationalist rhetoric of indigenismo. The group published their studies of pre-Columbian cultures in the industrialized graphic press, creating the same strange intersection of cosmopolitan fashion and skins imagined by Mário. This mediatic sphere brought them face to face with women as the other major representative of "tradition" in Mexico.[20]

Women's entry into the public spheres of paid labor, city streets, and mass-media magazines signified that they would no longer protect that sanctified space of tradition. While both were imagined to bridge tradition and novelty, women could not be ghettoized in the way indigenous peoples were; men had to live with them.[21] This necessary intimacy made women's bridging of modernity and tradition a tantalizing and disconcerting option for both Estridentistas and Contemporáneos. The anxiety about modern women and the correspondent attempts to regulate femininity appear in the obsessive categorization of types of modern women in postrevolutionary Mexico. These categories were invented not only by the state, but also by publications dedicated to varied political allegiances. The first issue of *El Machete*, the publication of the Communist Party in Mexico, reveals how tradition was figured as both indigenous and feminine. The national character of modern Mexico appears in Silveria Sierra's fascinating and virulent codification of the ethical role of women in four distinct classes: "the woman

of means" ("La mujer bien"), "the Old Bag" ("La Cacatua") "[from] the family of revolutionary apostates and thieves," "the middle-class woman," and "the Indian woman."[22] Each class has a function that is specifically based in her performance of femininity: as a mother, as beauty, as a national ethics.

The "middle-class woman," who would be the primary reader of illustrated magazines, reflects the tensions of race, gender, and tradition and of the photo-essay, as well as her damaging impact on the letrado:

> Although degraded for her subservience to the bourgeoisie and to the bureaucracy, she conserves innate qualities that do not achieve social transcendence because of *the hybridity of her class*. . . . In the case of foreign war, she would brandish the tricolor flag in accordance with the national anthem, but, in social battles, she has to be on the side of the boss who feeds her. She patiently receives what the rich spit out and at the same time is lost in thought in the face of the poor. 90 percent of suicides, prostitutes and literary intellectuals belong to [this group].[23]

One of the new social actors of the postrevolutionary era, the middle-class woman exhibits some "innate qualities": she is neither part of the aristocratic hegemony of the two upper classes of women described, nor does she accept the subjugation of the "abnegated" Indian woman (who is, incredibly, both chaste and fertile). *El Machete* does not quite know what to do with these women who do not embody the "family values" of the good Catholic mother and are caught between state bureaucracy ("revolutionary apostates") and the bourgeoisie. The emergence of this class in the 1920s and 1930s and its relationship to popular sectors, consumer culture, and mass media, and surprisingly to the modernist avant-gardes represent a crucial "class hybridity" not taken into account in most studies of hybridity and mestizaje. In fact, the only clear and totalizing racial determination is of the Indian woman, whose utter abjection allows for a kind of retroactive contrast with the creoles and mestizas presumably contained in the other classifications. The relationship between racial hybridity and what Sierra calls "class hybridity" is deeply embedded in the perception of femininity in the postrevolutionary period. As I will show, the illustrated journals were filled with images of these women as both photographic subjects and viewers, where they provide a vision of bizarrely ethical, not properly mestiza, New Women.

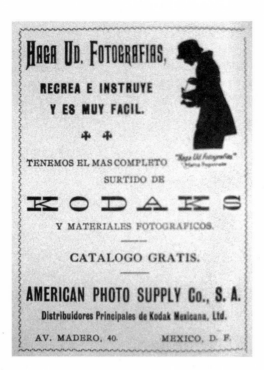

31 "Take Photographs, It is Recreation, Instruction, and very Easy," Kodak advertisement in *CROM*, July 2, 1926. *Hemeroteca Nacional de México*

Photography: The Prodigal Daughter

Photography itself was marked by what Rita Felski calls the "gender of modernity." The periodical *El Mundo* stated in 1899: "In effect, if there is a job for woman, it is photography."[24] The connection between photography and women continued in the *revistas ilustradas*—in which she is photographer as much as subject—as seen in figure 31, a frequently reproduced advertisement for Kodak from the twenties. Salvador Novo's "The Art of Photography" (1931) figures the medium as an out-of-control, effeminate, and modern tool. He describes photography as popular and mobile, urban, mass-produced, and mechanical:

> Our poor photography is relegated to the furthest corner of artistic value. Like a dirty suit, she humbly takes up the mission that painting has left her and puts it on. But, new creature, she marches happily through the streets, she goes on excursions, she exercises, she *curiouses*. She is the prodigal daughter of art: she has been born and developed, a machine herself, in the age of mechanical instruments. But, exiled and all, she follows with her own resources the steps that her cruel mother gives her. And if

painting has ceased copying, can't photography attempt creation on its own account? Can't it manage to produce a meeting of lines, of meaningful, related forms in such a manner that at the same time that they don't remind us of anything seen they call forth in us, nevertheless, aesthetic emotion?[25]

Photographic aesthetics itself is modern and machinistic, an exile from the world of art and painting but still dressed up in their old clothes. Still formally significant, creative, and productive of "aesthetic emotion," photography reappraises the denigrated "effeminate literature" described earlier. In contrast to traditional aesthetics, which represents the visual as an obedient and docile feminine, photography is a rowdy, uncontrollable, and threatening feminine in circulation through the city.

Novo's prodigal daughter does not at all resemble the formalist remove so often ascribed to photographic modernism. Her circulation in the streets refuses "an absolute opposition between the artistic and the useful,"[26] and she leaps gladly into the very masses that were described earlier as in dire need of direction. Novo proclaims: "In the hands of millions of young people, the humble Kodak is sport and expression . . . How many small pieces of pure art!"[27] He defends photography's position within the bellas artes at the same time that he insists on its nature as popular expression. This enthusiasm for photography as the medium in which to compose a modernist ethos is based precisely in its feminized ability to bridge the distance between fine and popular arts. Although examples of more recognizable "art photography" began to appear in exhibitions of the now well known work of Edward Weston, Tina Modotti, and Manuel Álvarez Bravo, theories of modernist photographic aesthetics were still profoundly tied to the other uses of the medium that pleased Novo so much. The fluid boundaries between types of photographic practice appear in the constant crossover between press and art photography, including the presentation of Manuel Álvarez Bravo's photographs simultaneously in political magazines such as *Frente a Frente* and in New York's Museum of Modern Art. Rather than retroactively assign artistic status to certain photographs in the design of a Mexican photographic canon, I find that the photographs that circulated in mass culture, anthropology, journalism, and art spaces such as museums and galleries constitute the material for thinking the ethos of modernism.[28]

32 "Weston, the Artifice of the Lens," *El Universal Ilustrado*, September 27, 1923.
Hemeroteca Nacional de México

Despite early exhibitions of "art" photography—or *fotografía de autor*—
in galleries such as the Sala de Arte in the 1920s, it was common to see
the same photographs shown in these exhibitions reproduced in illus-
trated journals. Paradoxically, even the early canonization of Edward
Weston as the epitome of modernist photography occurs in the pages of
El Universal Ilustrado (fig. 32). The anonymous author of "Artifice of the
Lens" defines modern, artistic photography through images of three
women, who embody the differences between photographic genres.
The captions, which now would be termed "titles," in the two-page
layout reveal their function: "Ruth" is a portrait, a woman of European
descent who is named and individual; "Profile" is an art photograph,
representing only an abstract concept; and "A Tehuana" is an unnamed
ethnic type, reproducing an ethnographic view. In all three cases, the
racial identity of the woman works with the title to direct the viewer's
aesthetic judgment of the photographs. While categorized like the
classes of women in *El Machete*, these three photographs still share the
same page in the popular *revista ilustrada*; they have not yet been sepa-
rated into separate spheres of circulation. The accompanying text refers
to all of them as "artistic" photographs, even though they are repro-
duced on the page in the same manner as photographs of Hollywood

and stage stars and are framed with art nouveau decorative designs. The manner of inclusion of these photographs in *El Universal Ilustrado* and their "cohabitation" with photographs of street scenes, news, and film stills shows that photography bridged high and low so confidently that even an article about its arrival as an art mixed the two. A theory of modernist photography in Mexico—even one that includes Weston's powerful influence—thus cannot retroactively select a canon based solely upon the aesthetics of the New Vision. It must take form though the structure of circulation imagined in this early photographic mass media and, especially, the circulation of women and images of women through postrevolutionary Mexico.

The journal *Imagen* defined itself as just such a hybrid space. In its first issue, the editors proclaim it to be an "informative journal" of "modern journalism" and list the diverse images it contains: "Reproductions of paintings by Orozco, Rivera, and Siqueiros, Photos by Carlos Tinoco, Manuel Álvarez Bravo, Rafael Carrillo, Paramount, Metro-Goldwyn, United Artists, Acme Newspapers, International News Photos and Archivo IMAGEN." Despite ranging from works by the icon of Mexican modernist photography, Álvarez Bravo, to Hollywood studio photographs, the editors nevertheless make an argument about the meaning of the medium of photography and its centrality to their editorial project: "It will be the camara, the mirror or the antenna, which in its mechanical condition will project the image or the word, the gesture or the voice, just as they are in the model, without anyone altering the vision or the accent or damaging the truth that is owed to the public."[29] The second issue of the magazine explains different aspects of modern photography, including photograms—images produced by placing objects on photosensitive paper and exposing them to light—and photographic abstraction. In an article illustrated by Álvarez Bravo's "Four Little Horses" and titled "Photography, Modern Magic" (fig. 33) Waldemar George celebrates the photogram as "translation, interpretation, free, arbitrary of an existing spectacle. It is a creation that utilizes the properties of the [photographic] plate, receptacle of light, for an end that is not a copy but a fantastic arrangement of shadows and light." Abstract photographs are similarly about light and shadow but: "attack [form's] corporeal essence. Objects are made unfamiliar . . . Transgression, violation of the laws of seeing."[30] Yet just as serious is another article illustrated by Álvarez Bravo, titled "Woman, Fashion, and the Fashionista" (fig. 34). Using the same language as George, María Be-

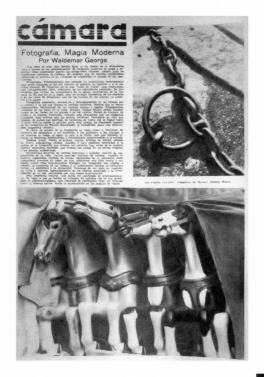

33　Waldemar George, "Photography,
Modern Magic," *Imagen*, June 30, 1933.
Hemeroteca Nacional de México

34　María Becerra González,
"Women, Fashion, and the
Fashionista," *Imagen*, August 4, 1933.
Hemeroteca Nacional de México

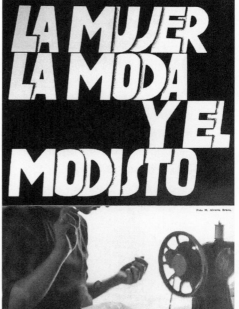

cerra González writes, "Let's see now how the *magic* of the dress is developed, its conception, its metamorphosis, its realization and its success as a finished *work*."[31] Like photographs, dresses contain a magic, and both function as works of art [*obras*]. Feminized modern culture contributes as much to photography's magic and its aptitude for modernist abstraction as do experiments with the technology.

A regular column in *Imagen* written by "Psique Hadaly," "My Chat for Them [feminine]" ("Mi charla para ellas"), reveals the aesthetic and ethical interventions this mixture of mass and elite culture produces. Hadaly addresses her audience as "my dear little readers" ("querid*as* lectorcit*as* [feminine])" and promises to discuss "exquisite and delicious frivolities" in a column subtitled "As You Desire Me," which she admits she borrowed from the Italian playwright Luigi Pirandello.[32] Having constituted her women readers as owners of their own desire, Hadaly instructs them that all men have an ideal image of a beautiful woman in their minds. The goal of the modern woman should be "precisely, to know this image and to appropriate it for herself," creating a new version of it that does not destroy her personality.[33] As much as the explosion of photographs of movie stars in journals (including *Imagen*) contributed to the impossible ideal of woman, Hadaly perceives these images to be vulnerable to concerted interventions by desirous women. Mixing Pirandello with a type of "Dear Abby" advice column, "delicious frivolities" with a critique of conservative gender stereotypes, Hadaly imagines the potential of using images for effeminate mediation between popular culture and avant-garde literature.

La Hija Pródiga and the New Woman

The illustrated press repeatedly reproduced photographs that show unruly modern women who have broken out of the domestic sphere. Photographic practice at the time similarly was leaving the enclosed studio, as smaller, lighter, handheld cameras and faster film placed street photography within the reach of more people. Many of the photographs in these journals focus on the new styles of the modern woman, which included diverse figures such as the flapper, *pelona* (referring to women with short hair), *marimacha*, *garçonne* (a boyish girl), and the proponent of "hombrunismo" [male-ism] pictured in *Rotográfico* (fig. 35). She has "a masculine haircut . . . *and something more*; the little ladies

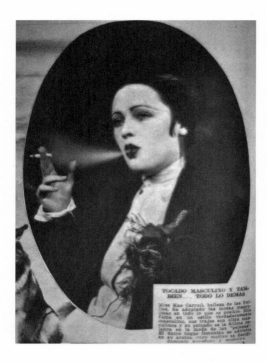

35 "A Masculine Haircut, and Also . . . Everything Else," *Rotográfico*, September 22, 1926 (detail). *Biblioteca Miguel Lerdo de Tejada*

who smoke Murads and want to be men."[34] Even poet José Juan Tablada wrote a dramatic essay about "Flappers" in *El Universal*:

> With hair so short that it shows the nape . . . she is something more than a "tomboy" girl or *marimacha*, the exception that scandalized our grandmothers. The "flapper" is so voluntarily, deliberately, and nakedly, her manners and her special *caló* exteriorize a deeply rooted and lamentable philosophy that goes from the nefarious crime by the one who killed her own mother because she prevented her from going to dance in a cabaret night after night, to those that contract galloping consumption by passing evenings dancing and days working the dictaphone and in front of the typewriter.[35]

Flappers work outside the home and listen to jazz, are sexually charged and yet cold, greedy and yet have no respect for the value of money. All of these traits describe women whose financial independence and defiance of normative sexual behavior threaten men's social control.

Carlos Monsiváis explains the powerful disturbance contained in images of the new stars of theater and film whose photographs were frequently reproduced in *Revista de Revistas*, *El Universal Ilustrado*, and

Jueves de Excélsior. Film starlet Celia Montalván, the archetypical *vedette* of the twenties, embodied the disruption of the Revolution, the roaring twenties of the United States, and the cultural programs spearheaded by Vasconcelos.[36] Monsiváis includes Lupe Vélez and Chela Padilla among these vedettes, as well as familiar artistic and literary figures such as actress Lupe Marín, photographers Tina Modotti and Lola Álvarez Bravo, painters Frida Kahlo and María Izquierdo, and arts patron Antonieta Rivas Mercado. Again, there are a variety of types of women: the divas who claim masculine attention, "the vamp, the girl who vampirizes with her eccentric beauty," muscular, liberated, overtly sexual women, suffragists, and flappers, "whose cultural stratus mixes with the Scott Fitzgeralds, Freud, and the European avant-gardes."[37] Their independence and sexuality were too great a threat to the traditional mores of the era, so they were relegated to the "'untranscendent' frivolous theater."[38] A range of intellectuals, government officials, and bourgeois families nonetheless frequented these popular reviews, and the women performers grew in importance through what Monsiváis calls "a shock of mass media diffusion in a city still dominated by oral culture."[39]

Despite his attention to the images of these women and their important place in postrevolutionary political and cultural spheres, Monsiváis keeps them separate from the modernist avant-garde. Granting their importance to mass-media studies, he maintains a split between high and low culture at this point: "The avant-garde go by without a major public register, the Estridentistas sing to the machine without provoking commotion outside of literary circles, and Tablada, Pellicer, and Novo are barely noticed."[40] Yet the interaction of these very authors in the pages of *El Universal Ilustrado* signified their presence in this popular sphere. In 1926, Arqueles Vela (using the pseudonym Silvestre Paradox) published an article titled "El café de nadie," which played on his novella of the same name published earlier as the Weekly Novel of *El Universal Ilustrado*. He describes an important shift in the literary world:

> Now one has to look for writers, poets, painters, and musicians in the café closest to the busy and tumultuous life. . . . writers, painters and poets invade automated restaurants, to sit alongside that perennial banquet that are the "Quick-Lunches" and chat rapidly, synthesizing concepts to be up to date with the synchronic emotions that suggest the accelera-

tion of life. . . . Every night they meet around some "hotcakes," Salvador Novo, Xavier Villaurrutia, José Gorostiza, Bernardo Ortiz de Montellano, Roberto Montenegro and they serve themselves their emotions rapidly, subjecting them to the slogan of coffee. . . . They synthesize the scenes of life and visualize them for a future scene.[41]

Vela presents the entry of the letrado to the fast-moving public sphere, a participation in popular culture as he lunches with the very men who published and authored *El Universal Ilustrado*. Recognized figures of the Contemporáneos occupy the same spaces as these editors and illustrators of the publication generally associated with the Estridentistas. Although this is a humorous look at the modernist avant-garde and the popular publication, these writers nonetheless appear "without the fiction of bohemia."[42] They can no longer rely on even the typical myth of an artistic realm at a distance from the modern circulation of goods and people.

As much as the vedette, the pelona, and the marimacha represent stereotyped images of modern women, writers who participated in the mass-media journals encountered in these images the same potential that Psique Hadaly encouraged her readers to access in *Imagen*: the power of the woman who capitalizes on the very projections of sexuality with which others seek to control her. The semiotic power of the female characters, photographic New Women, appears in a photoessay by Vela, "A Frightening Story" (fig. 36).[43] In the layout of the pages, posed photographs play with a melodramatic story in which the heroine wonders out loud which performance of femininity she should deliver for this particular story:

When she had put out all of her thoughts, submerging herself in overwhelming worry, she began to review the innumerable names that she used during the few years that she had been an elegant woman, without deciding on any one of them.

Betty Reynolds.

Stenilda Steinberg.

Charlotte Ellis.

Varenka Karinec.

Asunción González.

Etc.

Etc.

She hid her identification card, discarding them alphabetically, con-

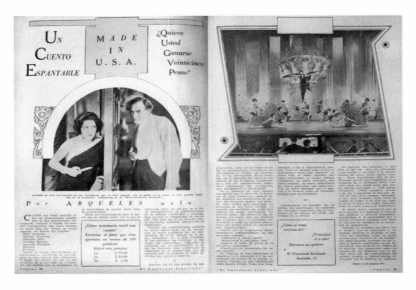

36 Arqueles Vela, "A Frightening Story," *El Universal Ilustrado*, March 11, 1926. *General Research Division, the New York Public Library, Astor, Lenox, and Tilden Foundations*

vinced that none of them would serve to interpret the part of the woman that she would have to be in this adventure, in which everything was going to depend on the name that she might present in the sumptuousness of that party full of presumptions.

She had to characterize herself as a woman who doesn't know anyone, with whom everyone is confused. This way she would be seen disturbing the prestidigitation of mirrors, sharpening and arching her eyebrows, as if to give her looks a certain malevolent deviation, leading one astray from her ingenuity.[44]

The female narrator of this frightening story manipulates a differentiated and multiple series of codes of femininity in order to extract the most power for the character she plays.[45] Photographs of famous women circulate both as objects of desire and representations of a feminine sexuality heretofore only meant to serve the pleasure of men. In "A Frightening Story," the weapon held by our heroine is not so much the knife we see in the photograph, but the unexpected list of feminine possibilities she comprises.

The performative reproduction of images of modern women in Vela's photo-essay draws out the difference between *las bellas artes públicas* and what Monsiváis calls "'verbal transvestism' . . . *a contagious feminine iden-*

tity" performed by the gay men of the avant-gardes.[46] In fact, reading feminization as the result of queer adaptations of a style operates as a limit, for it presents femininity as singular—as *an identity* that is not only accessible to gay men but is also infectious. Rita Felski critiques this problem in the dandy of the late nineteenth century, who adopted an effeminate style even as he despised women as products of mechanized mass culture, as crass desire and pure irrationality. These men split women from the feminine, so that "women can function only as the Other of a male subject, a stimulus to his own pursuit of the ideal."[47] As we shall see, however, the photographic reproduction and circulation of innumerable images of modern femininities do not permit such an easy conversion into either a utopian or dystopian idealized feminine. The medium simultaneously dismembers and references a recognizeable visible world; it disallows the ready contagion of femininity at the same time that it permits women to "perform" it like Vela's vedette.

In *El Universal Ilustrado*, Luis de Hoz attempts but fails to demonstrate that the medium's complex relationship to reality allows photographs to reveal a particularly Mexican modernity and femininity, even in the image of a flapper. He asks:

> Do all "modern" women have to be precisely a flapper in the sense, a little sinful, that is given this English word in Latin America? . . . *No*, we respond. . . . The outward appearance of these two feminine modalities is, nevertheless, exactly equal. The same elongated and frail silhouette . . . the same ten scarlet fingernails like so many threats of scratches and blood . . . the identical manly hair cuts . . . the same blue touches, red and black on their faces that give a certain Lucerphine expression.[48]

De Hoz makes a great exception: "many of *our* little modernized ladies have, behind that continent of vampires, all the scruples of the provinces." This dream of the scrupulous provincial woman recalls the most foundational associations between women, tradition, and ethics. He reasons that since "las damitas mexicanas" are at heart not like these devils with fingernails, it is morally acceptable to publish photographs of them in flapper costume. Against all odds, the internal character of the good Mexican girl can appear photographically, despite her external similarities to the foreign flapper.

Yet the representation of this traditional Mexican morality through the medium of photography soon presents a dilemma. In an article published just one month later, "Art in Photography," de Hoz again

37 Luis de Hoz, "The Art of Photography," *Rotográfico*, November 10, 1926. *Biblioteca Miguel Lerdo de Tejada*

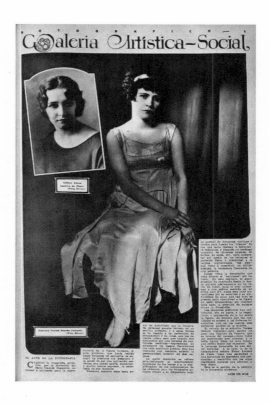

addresses the ability of the photograph to reveal that "internal" truth of the Mexican woman (fig. 37). Illustrated by soft-focus, pictorialist photographs of modestly dressed, middle-class women of European descent, he strangely concludes that these traditional values do not reside in the accuracy of straight photography. Rather, "contemporary photographers have at their disposition an entire arsenal of lights, curtains, and backdrops to look for the 'effects' of light, that so enhance feminine beauty, and then a complete catalog of papers, acids, salts, etc. to complement through retouching the physical appearance and communicate to the printed card 'that something' that comes to constitute, in the final analysis, the true physiognomy of a person."[49] Paradoxically, the truth of a Mexican woman's character appears through the falsification, the touching up, of photographs of her. Such a portrait "has the serenity and harmony of expression that concur marvelously with the high morals that adorn the lady. This is the secret of the aesthetic of modern photography."[50] In the same publication that introduced photographs by Tina Modotti, Agustín Jiménez, and Edward Weston,

la hija pródiga of the fine arts takes her modern form in an ethics and aesthetics that is neither purely the New Vision nor entirely pictorialist. Most important for understanding the resulting modernist ethos, then, is that despite the calming effect of the traditional portraits accompanying de Hoz's article, "that something" at the very heart of a Mexican ethics and photographic aesthetics is created by alterations to the image added by the photomechanical process, rather than visibly inhering in the subject of the photograph herself. This process *creates* a true image rather than capturing something that shows on the face. The essence of a modern, feminine ethics is effectively nonessential: it is an image created by new illusionistic advances in the very technology of representation that ought not to invent.

Despite de Hoz's original optimism, the illustrated journals reveal their own inability to control the reproduction of these artificial, photographic femininities. While certainly exploitative and often misogynist, even stereotyped photographic images of women in the public sphere operate as powerful ethical and aesthetic disruptions. Here it is important to stress that photography has never been simply the capture of the image of the woman for the easy enjoyment of the (male) viewer.[51] Even for the male photographer it always entails a risk: although it marks the distance between photographer as subject and that which is taken as object, it also places the two in very intimate contact, threatening the eye and the person of the photographer with a contamination by his subject. The image of such a capture of the photographer appears in the "Photo-Tricks" published in *Rotográfico* (fig. 38). We laugh at the distortion of the "camera experts" looking through the lens unaware, says the article, of their disfiguration as they become victims of their own instruments. The photograph exceeds the power of the photographer; the machine turns on the man, making the power of the gaze accessible to modern women.[52]

This shift of meaning and power, of subject and object (of desire) through the camera, does not mean that there was a free play of signification and gender. Instead, it requires an examination of how gender, representation, and power circulated between the different agents involved in photography. Martín Barbero's definition of mediation invites an analysis of the circulation implicit in photography and the circulation of photographs, opening a more precise understanding of how they contributed to the formation of modernist aesthetics. Photo-essays — composed solely of photographs, or of photographs and text —

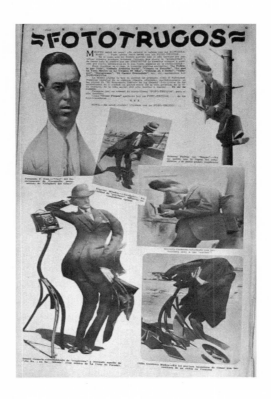

38 "Photo-Tricks," *Rotográfico*, December 29, 1926. *Biblioteca Miguel Lerdo de Tejada*

present the mediation of modernity through images of circulation: the circulation of tourists and tourist artifacts, the circulation of bodies in cars, and the circulation of mass media.

Circulation, Part 1: Domestic Tourism

The vulnerability of the photographers in the "Foto-trucos" and the exteriority of de Hoz's photographic beauty resemble Mário's concept of photogenicity. What is more, Mexican photography similarly locates the modernist artist as a vulnerable tourist in his own land and constitutes a modernist aesthetics from the position of the object's photogenicity rather than the photographer's skill. A similar fascination with tourism spans the illustrated publications to which Mexican writers and photographers contributed, representing a crucial path for the mediation of modernity. In addition to well-known examples such as *Mexican Folkways* and Anita Brenner's *Idols behind Altars* (1929),

almost all of the weekly illustrated supplements contained a section dedicated to tourism in Mexico for Mexicans.[53] *Revista de Revistas*, *El Universal Ilustrado*, and *Jueves de Excélsior* had similar "Places You Should Know" sections, directed at a new middle class that gained status as well as national identity through travel. These publications seduced "apprentice tourists" with images of picturesque landscapes, historic ruins, and rural people. Precise instruction informed them that photography was an integral part of the experience of tourism; they could get to know the "real" Mexico by taking pictures. These sections also enjoyed the contributions of Estridentistas and Contemporáneos including Villaurrutia, Vela, and Novo, painters Diego Rivera and Dr. Atl (Gerardo Murrillo), and photographers Tina Modotti, Manuel Álvarez Bravo, and Hugo Brehme. The twenties and thirties saw rapid growth of the tourist industry, as well as the legal and political infrastructures to support it. After the Revolution, the hotel industry was reborn, the first buses began to provide urban transportation, and the Asociación Mexicana de Turismo was founded. Air travel began between cities in Mexico, increasing rapidly in the following years, and the automotive industry was born in 1925 with the opening of Ford Motor Company and Chrysler Corporation plants. In 1926, the first laws that included the designation of "tourist" were included in the Ley General de la Población. By 1940, there were 100,000 cars, 40,000 trucks, and 10,000 buses in the country.[54] As we shall see, the gender of the bellas artes públicas ultimately directed the circulation of ideas about modernity in Mexican domestic tourism.[55]

El Mapa: Revista de Turismo, launched in 1934, followed the general format of the earlier travel sections in the weekly illustrated journals, including photographs and photomontages, travel logs, and folkloric essays. The founding premise of *El Mapa* was the preservation and propagandizing of Mexican culture, especially popular culture, for middle- and upper-class residents of Mexico City. In a stunning statement of purpose, the editors write:

> It is necessary that we defend our artistic truth, our "national reality" (*to employ the phrase in vogue*). . . . We believe, therefore, that national tourism, that is to say, making Mexico known to Mexicans, should be created and fomented with all support, without by doing so neglecting the foreign vision that is, at this time, a reality beyond discussion. *Teaching ourselves to be tourists in our own country* is the first step toward an approachment that

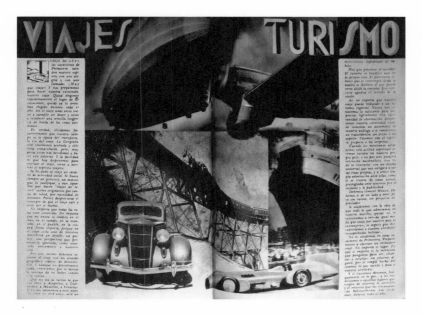

39 "Trips/Tourism," *El Mapa*, May 1935. *Biblioteca Justino Fernández, Instituto de Investigaciones Estéticas,* UNAM

only tourism can effectively achieve; it is the first step, also, to be able to understand, value, and respect our riches of all types, our tradition, and our nationality, values that, jealously guarded, will also be the greatest attraction for foreign tourism.[56]

These comments on the vogue of nationalist rhetoric demonstrate that there was already a sense of irony about the cultural nationalism promoted by the state, even in the decades when it was first being invented. *El Mapa* proposes that their concept of domestic tourism differs from the state's project: tourism contributes to educational reforms promoting Mexican national identity, but like *El Universal Ilustrado*, the editors proclaim their independence from governmental politics and funding. Domestic tourism thus offered the modernist avant-garde a distinct space to imagine nationalism and the popular.

El Mapa makes clear the importance of circulation to this vision of modernity, dedicating many pages to the demand for and celebration of new roads and train routes, and using photography and photomontage to elaborate the proposed function of domestic tourism. The dramatic photomontage "Viajes /Turismo" ("Trips/Tourism," fig. 39) overlaps

dynamic photographs of a car, ship, race car, airplane, a train on elevated tracks, and even a zeppelin. The editors proclaim: "Our time is the era of transportation."[57] The experience of modern transportation and tourism is credited with the creation of a particular *visual* knowledge, for learning to be a tourist in one's own land teaches a new way of seeing the country: "Tourism must be practiced. Tourism is beneficial even in one's own home. The urban panorama that one contemplates from the roof is different from that which one sees from the window. This exercise sharpens the sense of vision."[58] The editors explain that learning to read the disorienting and contrasting elements in photomontage sharpens the reader's sense of sight and expands into a broader "spiritual attitude" that is both nationalist and universal. *El Mapa* also included a series of articles that instruct its readers how to properly compose a photograph, how to create a modern, touristic image of Mexico. Tourist photography was simultaneously an artistic and amateurish practice: "It is no longer enough for the amateur to dedicate himself to taking documentary photographs; now he wants animated scenes, light effects, still lifes; in sum, he tries to produce matter that awakens an aesthetic emotion."[59] Novo's prodigal daughter again offers an unexpected aesthetic sublime appropriate to modern Mexico.

Domestic tourism competed with the state over the configuration of modernity through tradition. *El Mapa* deployed images of femininity and indigeneity, and employed modernist artists and writers to present *artesanía* alongside the conduits through which the New Woman circulated. Dr. Atl published a series titled "Artes Populares," including articles on "Retablos," a popular painting tradition that gives thanks or asks for miraculous interventions, and an "Index of Sarapes," which listed the kinds of textiles woven in different states in Mexico. Contemporáneos poet Villaurrutia wrote on "Picturesque Cities: San Miguel Allende." These modernists were fully integrated into the mass cultural as well as folkloric popular, as photographs by Luis León and Luís Márquez, whose work is now considered kitschy, shared the page with "founders" of the Mexican tradition, Manuel Álvarez Bravo and Hugo Brehme. *El Mapa* even included photographic reproductions and explanatory essays of Diego Rivera's murals as touristic attractions, rather than sacred images of revolutionary history. Villaurrutia writes, "We begin to publish with this article what one could call in touristic terms, 'The Diego Rivera Circuit.'"[60] While recent studies of Rivera critique his touristic representations of indigenous Mexicans, *El Mapa*

celebrated precisely that element, in competition with the state's use of Rivera's murals. The publication shows domestic tourism to be at the margins of the state's cultural project, a site for Mexican nationalist discourse not before considered in studies of the modernist avant-garde's articulation of aesthetics. This opposition to the state, like Palavicini's, did not diminish the racism of the publication, which also included racial "types" for the viewing pleasure of its readers.

The mediation that took place in *El Mapa* composed a vision of modern hybridity that did not fit exactly into the homogenizing project of state mestizaje. This image comes into focus in its presentation of Mexican cities as containing both the (racialized) mark of the rural *and* the "something more" of the flapper. The modern woman introduced a disruptive, if exciting, reversal of the geopolitical, cultural, and historical place of Mexico City. "Our Capital," with photographs by Manuel Álvarez Bravo and Luis León, informs that Russian ballerina Ana Pavlova visited the markets in Mexico and exclaimed: "Orient! This is the Orient!" The article explains: "To pass through the center of Mexico is to make the strangest of travel itineraries. . . . *The West is in the center of Mexico, and Mexico, our capital, is disseminated, through strange allusions, in the entire Western world*" (fig. 40).[61] "Architectural Anarchy in Mexico" at first appears to support this triumphant national and universal urbanist victory, describing the capital city as belonging both to Europe and to America, due to its unique urban hybridity. However, the editors worry that Mexico City is committing stylistic and cultural suicide by giving in to bad influences that "convert this city, that was unique, into a horrible mosaic of all styles."[62] Despite the promise of domestic tourism, Pavlova's city threatens to become *promiscuous*; her proclamation leads to deep concern about how to manage this hybridity of East and West, urban and rural, popular and elite, which is most disconcertingly embodied in the femininities set loose by postrevolutionary freedoms, and which has clear ramifications for modernist aesthetics. The illustrated journals showed the New Woman entering urban spaces, at times comically, such as in the photomontages of gargantuan women taking over "The City of Palaces" and dominating it as a graphic "Modern Lady Gulliver" (figs. 41 and 42). "Lady Guliver" is so carefully composed that her reflection appears clearly in the water below, and the women wrap themselves around the buildings housing state power and national identity. These women exaggerate the threat

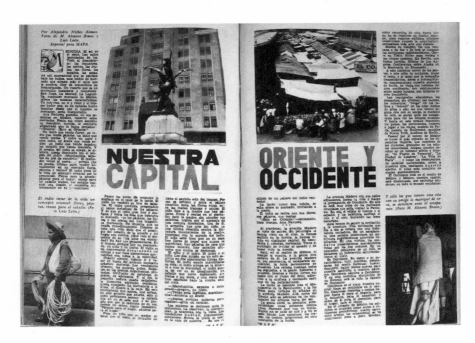

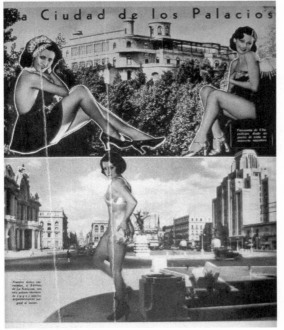

(above)

40 "Our Capital" and "East and West," *El Mapa*, August 1934. *Biblioteca Justino Fernández, Instituto de Investigaciones Estéticas, UNAM*

41 "The City of Palaces," *Vea*, November 9, 1934. *Hemeroteca Nacional de México*

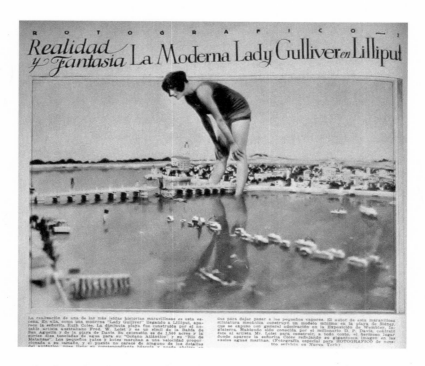

La realización de una de las más leídas historias maravillosas es esta escena. En ella, como una moderna "Lady Gulliver" llegando a Lilliput, aparece la señorita Ruth Coles. La diminuta playa fue construida por el notable artista australiano Fred. W. Loist y es un símil de la Bahía de San Agustín y de la playa de Davis. Su extensión es de 1,500 acres y la cierran diez toneladas de agua para su "Océano Atlántico" y su "Río de Matanzas". Los pequeños yates y botes marchan a una velocidad proporcionada a su tamaño, y el puente no parece de ninguno de los detalles del exterior, pues llena su correspondiente báscula y puede abrirse ó cerrarse para dejar pasar a los pequeños vapores. El autor de esta maravillosa miniatura mecánica construyó un modelo mínimo en la playa de Sidney, que se expuso con general admiración en la Exposición de Wembley, Inglaterra. Habiendo sido conocida por el millonario D. P. Davis, contrató éste al artista Mr. Loist para construir, a todo costo, el hermoso lugar donde aparece la señorita Coles reflejando su gigantesca imagen en las suaves aguas marinas. (Fotografía especial para ROTOGRÁFICO de nuestro servicio en Nueva York)

42 "Modern Lady Gulliver in Lilliput," *Rotográfico*, April 14, 1926 (detail). *Biblioteca Miguel Lerdo de Tejada*

implied by Novo's *hija pródiga*, and by the distortion of the cameramen in "Foto-trucos." The image of modern circulation fully takes shape in these bodies.

Circulation, Part 2: "The Woman Who Travels Alone" and *Automovilismo*

Domestic tourism and amateur photography in Mexico and Brazil were coupled with *automovilismo*, the car and excursion clubs made up of growing middle and bourgeois classes in both countries. *El Mapa* eventually became the official publication of the Mexican Automobile Association (AMA), and in Brazil, most amateur photography competitions were organized by the Brazilian Auto Club.[63] Popular photography and cars fused together in the imaginary of modern circulation, and the circulation of modern vehicles as photographs had an important role in defining modernist aesthetics. Writers and photographers envisioned

cars and trucks literally tranforming the bodies—and minds—of the men and women traveling within them. The touristic invention of modern Mexico becomes dangerous when promiscuous women take hold of the steering wheel; the movement of fast cars and fast women shapes the errancy of modernism.[64]

Modernist avant-garde writers meditated on the impact of new modes of circulation—from automobiles to mass media—in the pages of El Universal Ilustrado, their texts interspersed with photographs of the increasing number of cars in Mexico. Novo explains that, like other migrants from small towns to Mexico City, he "see[s] in the automobile the most complete summary of their ambition and the perfect realization of progress."[65] He relates these means of circulation to the form and content of modern expression: "Beyond what they mean in relation to progress, considered as things in themselves, it is gratifying to observe that in their aspect they increasingly approximate *the perfect realization of the pure line, clean and synthetic,* that we want to express . . . and beyond any doubt, a 'ponjola girl' seems more at home in a Paige, in a Packard, in a Buick."[66] The modernist ideals of form and line appear in imported cars and popular photographs of "girls." As in "El arte de la fotografía," modernist aesthetics is produced at the intersection of modern technology, mass culture, and the prodigal daughter who wanders the streets and roads.

Pavlova's disruption revealed that women's participation was central to the development of domestic tourism, yet it had an unpredictable and uncontrollable impact on the space of modern nation and the ethos of modernism. Margarita Abella Caprile writes about "The Woman Who Travels Alone" in El Mapa, beginning her essay not with travel itself but with a discussion of the woman artist's need for solitary time to produce work.[67] Abella Caprile cites Virginia Woolf to describe women's need for "the seclusion of the private and silent atelier, the right to have nothing distract one during many hours of the day, to not interrupt her captious wandering through the paths of the country or the city streets."[68] The defining freedom of modern movement is a necessary prerequisite for artistic production, as much as the hermetic quiet of the studio. Her quiet place to work is described as a right, language that coincided with the demands for women's suffrage of that period.[69] Gabriela Medina also writes about the liberation of women through driving in suffragist language. "Woman and the Car," published in a special issue of El Mapa dedicated to automobiles, ex-

plains that women live modernity differently than men: "The car has created a mental attitude, that is to say, in the modern man, but while for him automobilism has resulted in the mechanization of his spirit, for the woman it has resulted in a liberation and a conquest. . . . Why is automobilism a conquest for the woman if it is an intellectual waste for the man?"[70] Abella Caprile answers Medina's question by turning to the question of ethics:

> Now things have begun to improve significantly, principally in the countries of the other hemisphere. Among us, who still conserve that primitive suspicion of "liveliness," there still has not been established a difference between the noble concept of "liberty" [libertad] and the inferior idea of "licentiousness" [libertinaje]. And referring to women, worse and worse. She is not conceived of as seeking her independence, but with the malicious intent of employing it in an inappropriate manner. . . . She who has the sense of her own responsibility, traveling or not, will always be balanced and formal; she who is irresponsible will commit errors *even if she doesn't emerge from the four walls of her house*.[71]

This clever conclusion pretends to assure the constancy of women's protection of Mexican ethics, even as it undermines the presumed security of the woman in the domestic sphere. Licentiousness is possible inside the house as much as in the streets. Both women essayists conclude with sly warnings that indicate that women circulating in cars, as a metaphor for freedom, contained a shift in ethical norms. They point precisely to the radical ethical and aesthetic potential of the *mujer pública*: even as any move toward freedom is necessarily interpreted as one toward sexual promiscuity, artists can use this very fear to inhabit the house of a Mexican national ethos, opening it up to aesthetic and ethical interventions by *mujeres libres y libertinajes*.

The form of circulation shaped by women, cars, and photographs appears throughout modernist texts. In "Luminescent Rockets," Estridentista Vela describes the emotion of "the headlights of cars that present us with calves as if in 'close-up.' It seems that these lights have become the fashion, precisely now that short skirts triumph over commentaries . . . hallucinatory lights . . . Those that turn off and on, automatically, identical to the wink of certain women whom we encounter in forbidden streets. Lights that distort the direction of the streets, that change our direction, as if having moved a 'switch' of perspectives."[72] Like domestic tourism, this encounter with public women creates an altered

way of seeing, a visual aesthetic that is photographic like the close-up and leads the modernist writer down unknown streets. Vela's use of the word *switch* makes the impact on modernist literature explicit, for it echoes the First Declaration of the Estridentistas signed by Germán List Arzubide in February 1923. The lights of cars, like the beckoning wink of a prostitute, bring the modernist artist into close proximity to the aesthetics of unethical women in the modern city.

In the pages of *El Universal Ilustrado*, Vela and Novo seriously take on how changes in car design make possible the reconfiguration of flirting in the modern age, and celebrate the immoral, cut-up images of modern feminine desire they cause. Vela states that he prefers driving as a sport for women since: "In automobilism, women can practice their coquetry and all the 'flirts,'"[73] and in "The Art of Showing Off Your Calves" (fig. 43), he enjoys the scandal of seeing more (of) women's bodies in the streets: climbing into automobiles, walking and reaching and showing more and more leg. The graphic design of the page shows enlarged photographs of legs pasted beside smaller ones, reflecting a sense of shifting perspective (a "switch") that matches the combination of appeal and threat that the combination of cars and the new fashion signified. Vela repeats a theme common in the illustrated journals — it appears in an even more elaborate photomontage published one month later, "The Feminine Art of Showing Off Your Legs" (fig. 44). An enormous leg forms the background of cutout images of women revealing their legs; at the center of the page, a pelona sits on the lap of another woman as they gaze into one another's eyes. Even a rather matronly woman looks threateningly over her shoulder as she climbs into a car and shows off the small bow on her stockinged leg. Like Abela Caprile, Vela and Novo share a vision of a modernist ethos in which the feminine circulation of the hija pródiga alters both the ethics and the aesthetics of modern artistic and literary production. The bellas artes públicas are indeed, as Díaz Arciriega put it, "promiscuous," precisely because this libertine ethic and aesthetic of modern circulation contains the promise (or threat) of a concommitant freedom.

Medina's question about the different impact of automobiles on women and men has an ugly, misogynist side, also framed by photography. Novo explains that his own fascination with automobiles and other new advances in technology is not about an abstract notion of modernization, but rather about how these objects literally shape modern bodies: "If man made machines, they made him a driver, like bi-

43 Arqueles Vela, "The Art of Showing Off Your Calves," *El Universal Ilustrado*. June 10, 1926. *General Research Division, the New York Public Library, Astor, Lenox, and Tilden Foundations*

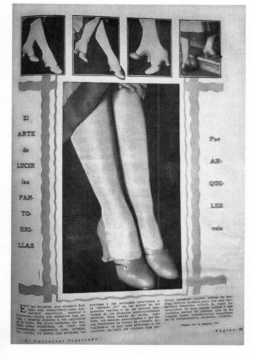

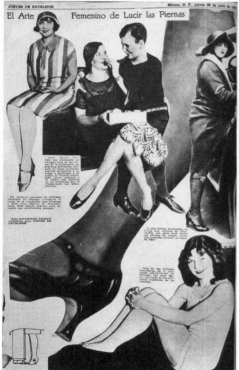

44 "The Feminine Art of Showing Off Your Legs," *Jueves de Excélsior*, July 29, 1926. *Hemeroteca Nacional de México*

45 "Raceway
Graphics," *El Universal
Ilustrado*, April 19, 1923.
*Hemeroteca Nacional
de México*

cycles developed his legs, like fast trains that those brakemen had to
climb have given them a peculiar form of hat against the winds and a
nodding manner of walking."[74] Similarly, the editors of *El Mapa* point
out that "generally no one realizes that the automobile is changing
human thought and even bodies."[75] Yet women's bodies more often
suffer the physical effects of modernization and are a site for the pro-
jection of a disturbing image of modernity. In the photo-essay "Autos
and Artists," the circulation of cars parallels the circulation of images
of the "artists" of film and stage "empassioned by the steering wheel."[76]
"Raceway Graphics" shows "the most exciting moment of the car race
piloted by women. The cars were surprised in full run in this admirable
photograph." Praise for the ability of this perfect snapshot to capture
an astonishing moment of the modern woman in motion is accom-
panied by a threatening text (fig. 45), which informs the reader that
the photograph captures: "Georgina Henderson and her mechanic, mo-
ments before starting the race that would cost the life of the latter. Miss

Henderson will be terribly disfigured."[77] She will not be simply injured, she will be *disfigured*, the impact of modern circulation permanently imprinted on her body. The photograph shows the moment when the modern woman driver careened forward in full flight, while the text employs a complex structure of verb tenses: the past perfect describes the innocent photograph before the race, the past subjunctive describes the death of the mechanic, and a straightforward future the certain fate of the woman driver.

The threat of women taking control of the vehicle that represents their sexuality is that they might be able to *manejar* (drive) their own desires in the open streets. The association between sex, women, and cars should come as no surprise, since it continues in advertising and popular culture into the twenty-first century. The circulation of women in photo-essays presents an eroticized *ethos* that contains this violence, as well as the potential to change the direction of the (photo-)essay of national identity. Grabbing hold of the steering wheel, these photographic women drive straight into the myths of tradition, morality, and stability that enclose them.

Circulation, Part 3: Race, Beauty, and Graphic Design

The woman tourist suffers this violent, photographic promise of disfigurement because of her role in the struggles over race, tradition, and modern culture. In the 1920s, official discourse sought to translate Mexican national identity as mestizaje from racial terms into cultural ones, and the resulting ambiguity of the category fell more on women than on men, as they were considered "more malleable."[78] Yet this projection appeared as a failed mestizaje, and ultimately an excessive hybridity, in photo-essays that reproduced images of the New Woman alongside the woman who was named La India Bonita. If race was supposed to circulate freely from indigenous to European bodies in order to constitute modern Mexico, when the bodies marked as feminine and as indigenous met in the pages of modern media, rather than contribute to the successful unification of the nation as mestizo, they mediated the violence and discord this nationalist discourse sought to mask. The photo-essays that place the two images in intimate contact ultimately point to the limits of modern circulation by tracing exactly how certain bodies travel.

The postrevolutionary project that sought to make indigeneity acces-ible as cultural mestizaje appears in *El Universal Ilustrado* in the form of a beauty contest for indigenous women to select La India Bonita (1921, fig. 46). Photographs of the contestants and related cultural activities present the pageant, which was sponsored by the journal in celebration of the centenary of Mexican independence, as a popular entertain-ment phenomenon. The jury who selected the winner was made up of anthropologist Manuel Gamio, indigenist artist Jorge Enciso, writer Aurelio González Carrasco, theater critic Carlos M. Ortega, and film critic Rafael Pérez Taylor. This esteemed group of men chose María Bibiana Uribe from San Andrés Tenango, Puebla, because she had "all of the characteristics of the race: brown color, black and straight hair, etcetera. She belongs from a racial point of view to the Aztec race, that is spread through the diverse parts of the Republic; her language is Mexican."[79] This praise did not include indigenous men and women as full citizens of Mexico, but it did make nationalist discourse de-pendent upon them. The nationalism configured in Bibiana Uribe's image, however, immediately required the transformation of La India Bonita from Aztec into a mestiza.[80] Her name sounds Spanish more than Nahuatl, and while the caption to the first photographic portrait of Bibiana Uribe stated that she was "a pure-race Mexica Indian who doesn't speak Spanish,"[81] the following week's issue showed her "in a delightful chat with the gentle ladies of our highest society, in the house of the Secretario de Relaciones Exteriores, Mr. Alberto J. Pani" (fig. 47).[82] No mention is made of the language in which they chat-ted, but it is safe to assume that these society ladies were not fluent in any indigenous language. A week later, an interview with María men-tions a few lapses in her Spanish, and her use of a word with a great many *j*s and *h*s, but apparently required no translator. Over the course of publicizing the contest, Bibiana Uribe was literally "hispanicized." Ruiz Martínez concludes that La India Bonita represented the success of the state's rhetoric of revolution, which needed a mestiza woman as a bridge between the traditional and modern.

The celebration of Bibiana Uribe's beauty, even after she was made mestiza, nevertheless stimulated a tense debate about race and modern aesthetics. Gamio himself asks in "The Indian Venus": "Is she truly a beautiful woman, Bibiana Uribe, 'The Beautiful Indian'? Is she repre-sentative of a type of feminine beauty? These apparently simple ques-tions ensnarl, nevertheless, complex problems of aesthetics that are very

46 "La India Bonita," *El Universal Ilustrado*, August 4, 1921. *Hemeroteca Nacional de México*

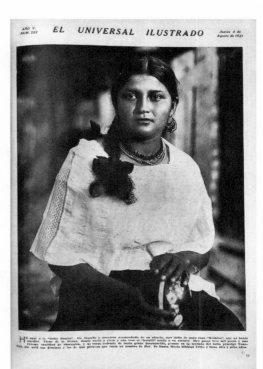

47 María Bibiana Uribe as "La India Bonita" *El Universal Ilustrado*, August 11, 1921. *Hemeroteca Nacional de México*

difficult to resolve."[83] Gamio does not differentiate between the perceived beauty of María herself and the history of art, which he calls "that aesthetic tyranny" that the unequal power between nations produces. He writes that María's beauty, like the art of the Americas, was devalued by powerful minorities of Spanish descent. Gamio's collapse of the beauty of pageants and the history of aesthetics is the logical result of the fusion of mass and elite in *El Universal Ilustrado* and reveals a conflict over national ethics and aesthetics that appears in many articles thereafter. "Women Do Not Want to Be Brown-Skinned" expresses the author's dismay that women tell her they want to lighten their skin, and counters their wishes with examples of "mestiza" beauties such as Malinche and Xóchitl. Even so, she writes: "I am with you, little readers, in that it cannot be very comfortable to have toasted brown skin."[84] The article reveals, intentionally or not, the distance between the celebrated mestiza aesthetic and the people living in those bodies. Finally, one male author mourns that "EL UNIVERSAL *nationalized*" Bibiana Uribe's beauty, and that her newly found sophistication and wealth — her new mestiza identity — would prevent her return to the rural space of tradition.[85] For men like this author, the creation of a mestiza aesthetic in the bellas artes públicas operates as an irrecuperable loss rather than the constitution of a national identity: it destroys the basis of traditional ethics and creates an unresolvable aesthetic dilemma.

The illustrated journal in which the India Bonita phenomenon was produced and reproduced reveals the ideological conflict generated as this process of mestizaje takes place simultaneously on the (photographed) bodies of women of both indigenous and European descent. During this period, the *traje de charro* and the *china poblana* became commonplace dress at parties held by the middle and upper classes, and advertising from the period alternated flappers with women dressed in traditional clothing from different regions.[86] The iconic image of the *tehuana*, surrounded by a white veil and bearing the imagination of a matriarchal society, came to be a "national" figure.[87] The India Bonita and the Mujer Nueva met in the pages of *El Universal Ilustrado*: photographs of beautiful indigenous women were reproduced alongside images of flappers, marimachas, and vedettes. Elsa Muñiz writes that the pelona and the India Bonita were two representations of femininity that worked together rather than in opposition, precisely because they "condensed not only modernity and tradition, but also the Vasconcelian dream of the Cosmic Race and the perfect conjunction between

48 Silvestre
Bonnard, "The
India Bonita in
Theater and
Film," *El Universal
Ilustrado*, August 17,
1921. *Hemeroteca
Nacional de México*

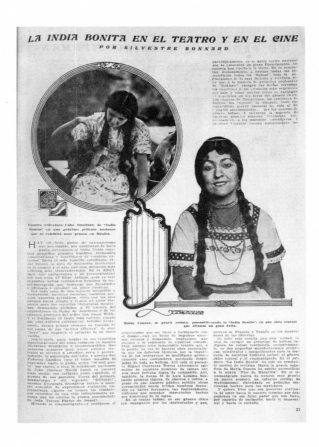

the New Woman and the good mother."[88] The issues of *El Universal Ilustrado* that announced the winner of the beauty contest also reproduced images of theatrical and cinematic productions about a character named La India Bonita (fig. 48). Cube Bonifant, an actress and later a regular contributor to *El Universal Ilustrado*, played La India Bonita in the film, and María Conesa took the role in the play.[89] As Ortiz Gaitán notes, the transformation of traditional clothing into a kind of costume for the middle and upper classes was a means of deethnicizing the indigenous, but it is important to recall now that the hybridity of class of the middle-class woman attacked in *El Machete* makes this performance somehow *too* hybrid.[90]

The graphic design of the illustrated journals reveals an unresolved mediation of aesthetic tensions and ethical debates, and composes the ethos of modernism in the reorganization of images and words. A two-page spread in the issue of *El Universal Ilustrado* celebrating María Bibi-

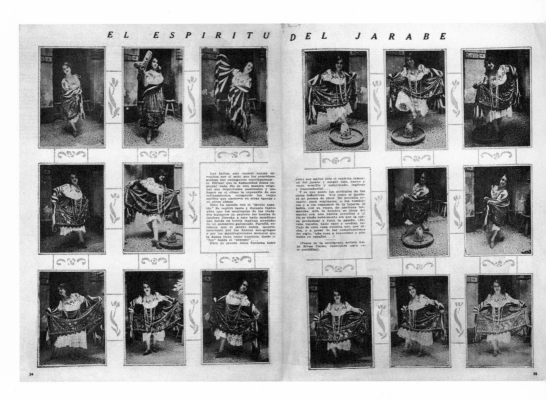

49 "The Spirit of the Jarabe," *El Universal Ilustrado*, August 4, 1921. *Hemeroteca Nacional de México*

ana shows vedette Lupe Rivas Cacho dancing the *jarabe tapatío* (fig. 49). The text explains the dance's perfection: it shows the woman's resistance to the "macho" ending in surrender but does not allow her to feel desire herself. Looking quickly at the page, the carefully ordered grid of images appears to contain Lupe as the pure object of the photographic gaze. The graphic design gives the impression that the series of photographs, which show the different steps of the dance, would allow the woman reader to imitate Lupe. Given all the other advice for women contained in these pages, about how to care for their skin, their husbands, their children, such instructions would be expected. However, careful examination of the individual photographs and their order on the page provides no means of reproducing the dance. Each photograph is an individual pass, but does not "read" narratively into the movement of the jarabe. The typical sombrero that is an important part of the dance appears on the floor in one photograph and is absent

from the following one—if the reader wanted to reproduce the dance, she would not know how the hat got from one place to the other. The image of an easy integration of a mestiza Lupe operates as an illusion; any dedicated woman reader who sought to activate her own mestizaje by performing the jarabe would find herself unable to complete the dance, and any man reading it would have his desire for a conciliatory mestizaje frustrated by this unreadable narrative.

The modernist avant-garde made the most of the failure of this form of nationalist mestizaje. If masks are familiar terrain for experiments with race and aesthetics in modernism, from Pablo Picasso to Hannah Höch, the deployment of this trope in the bellas artes públicas reveals their mediation of aesthetics, ethics, and citizenship. One issue of *El Universal Ilustrado* contains two photo-essays about masks, printed one after another, as well as the essay "The Mask" by Xavier Villaurrutia. The first photo-essay, "Masks" (fig. 50) shows a variety of examples of masks as ancient art; it is followed directly by "Our Artists in Masks" (fig. 51), which presents the covered faces of screen and stage stars.[91] In the first, "El Caballero Puck" praises Estridentista artist Germán Cueto's colorful terra-cotta mask of List Arzubide for its radical mixture of "the prehistoric memory of carnival" and the modern art of caricature. The second, "Our Artists in Masks," examines each of the numbered photographs of the women, describing their characters and citing poems by Estridentistas about them. The author states that the pictured women are "artists. Women who have the passing celebrity of success, who exhibit their beauty in the frivolous stage of farse. *Mysterious souls that make graphic the symbol of the 'Señorita Etcetera.'* ONE, TWO, THREE, FOUR, FIVE, SIX, SEVEN, EIGHT."[92] The mixture of frivolity, popular masks, and public women are the photographic image of the Estridentista's modernist aesthetics. The similar, circular graphic designs of "Masks" and "Our Artists in Masks" present them as mirrored faces of the same modern city, which mediate between the mass and the popular. This Señorita Etcetera makes graphic the force of a popular modernist aesthetics, but as we shall see below, this form of gendered mediation does not provide the basis for the state's vision of nationalism.

Rather than serving a renovatory aesthetic function, Villaurrutia's theory of masks in this issue of *El Universal Ilustrado* argues for their status as both artistic and functional objects. If primitivism's basic operation is the extraction of an object from its (religious or secular) function and its insertion in an artistic sphere, in "Masks" Villaurrutia writes that

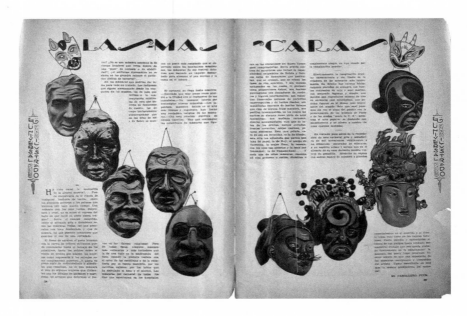

50 El Caballero Puck, "Masks,"
El Universal Ilustrado, March 4, 1926. *Hemeroteca Nacional de México*

51 El Caballero sin Nombre, "Our Artists in Masks,"
El Universal Ilustrado, March 4, 1926. *Hemeroteca Nacional de México*

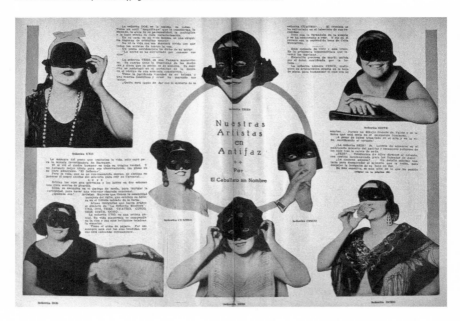

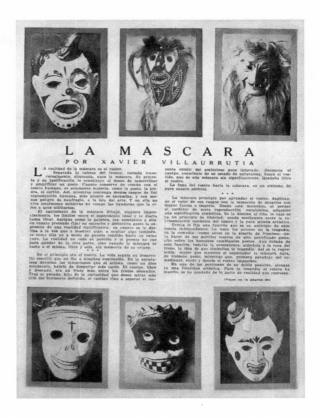

masks are the connection between the quotidian and the significant, the artistic and the utilitarian (fig. 52). The mask operates like language, which can be used either to communicate a simple message or to write poetry: "So similar to [the word] . . . it is destined at the same time that it shows something, that it hide something also, it [the word] is like a kind of bridge stretched toward a pure realm."[93] Neither quotidian nor sublime, the mask is a bridge belonging to neither side. When it functions simply as sculpture (art) or only hides a face (use), the mask loses its unique means of creating meaning. As if explaining the connection between Puck's essay and the modern "artistas," Villaurrutia describes the mask as "a mediating path between the mechanical representation of the face and pure artistic mission."[94] Masks and photographs create faces that are not quite faces, portraits that gesture (like Mário's) to another sublime: a strangely functional modernist aesthetics. The bellas artes públicas, like the mujer pública, are defined by their work rather than by their pure form or beauty.

By taking the women pictured in these photographs as the "graphic symbol" of his modernist aesthetics, the professionalized modernist writer acknowledges that his texts have entered into circulation in the new consumer culture in Mexico. They followed the lead of New Women as they literally went to work, and the "effeminate" aesthetic that results is both functional and modernist. Even as the works published in the illustrated journals share key characteristics with mainstream modernism—linguistic experimentation, collage, and play with the visual character of printed words—the utility of this popular aesthetics embeds them within mass culture. These photo-essays maintain the communicative function of language at the same time that they experiment with the printed word, and they deploy photography's "special relation to reality" as they cut and paste photographs into montages not seen in the real world. Like the fast-moving cars of automovilismo, these photographic women reveal the potential perils of picturing modern hybridity in their image. The eclecticism, hybridity, and promiscuity that results ultimately define the political impact of the bellas artes públicas.

Essays: Word and Image in the Design of the Nation

Like Lupe's stilting and interrupted jarabe tapatío, the photo-essays that fill the illustrated journal create an altered narrative path for the articulation of nationalism. Unlike the apparent order of the photographs of Lupe, however, most of the photographs in the illustrated journals join into a cacophonous and often confusing graphic relationship with the text alongside them. The disruptive force of photography as the prodigal daughter of the fine arts is evident in these photo-essays; the combination of word and image shows the circulation of the feminine disrupting the traditional movement of essayistic writing. Although Mitchell states that the photo-essay combines the "incomplete" nature of both photography and the literary essay, I find that rather than a lack of expressiveness, these photo-essays present an *excess* that is coded feminine.

Graphic design played a central role in postrevolutionary educational programs, which imagined a national citizenry that would be visually as well as verbally literate.[95] In the Estridentista journal *Horizonte*, Genaro Estrada points to the graphic arts as a potential site for

53 Adolfo Best Maugard, *Método de dibujo: Tradición, resurgimiento y evolución del arte mexicano.* Mexico, 1923

the development of "a new concept of our nation." Painter Adolfo Best Maugard provided the visual art counterpart to Vasconcelos's national literacy campaign, a method of drawing introduced nationwide in the Escuelas Superiores de Artes y Oficios in 1918.[96] Not as well known as Vasconcelos's essays, Best Maugard's *Method of Design* summarized what visual literacy meant to the postrevolutionary state, employing drawing in the service of national unity: "Place the figures where their shapes blend most harmoniously with each other and with the whole design. . . . Note that the effect of movement is dependent on a ruling line. This main line of the composition is called the *dominant,* and the supplementary parts are *subordinate.* The subordinate lines must never obtrude, and they must support and be in complete harmony with the main line or lines" (fig. 53).[97] The visually literate citizen is taught to see the logic of harmony through hierarchy.

In marked contrast to this ordered design, in *El Universal Ilustrado* the image of a potential female citizen explodes onto photographic pages; these photo-essays present an alternative form and content to the essay of cultural nationalism that excluded her. Photography was critical to this revolution in graphic design, perhaps due in part to the lessening

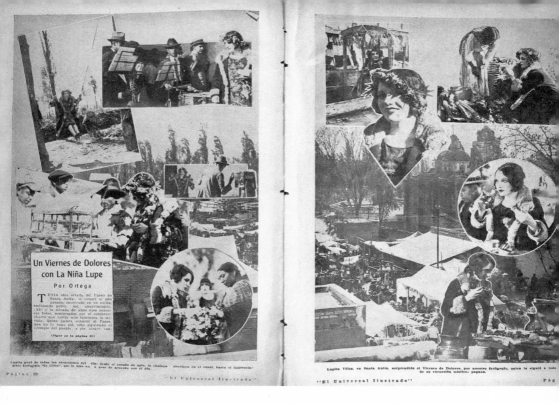

54 Ortega, "A Good Friday with Lupe the Girl," *El Universal Ilustrado*, April 1, 1926. *General Research Division, the New York Public Library, Astor, Lenox, and Tilden Foundations*

of government control of press photographers following Porfirio Díaz's dictatorship.[98] The troubled photo-essayistic path appears in "A Good Friday with Lupe the Girl" (fig. 54), in which the real Lupe Vélez plays herself in a fictionalized melodrama involving a male journalist and the photographer Casasola. Lupe wanders the streets freely through crowds of men, enjoying the traditional festivities and market. The resulting photo-essay is literally hard to follow. The order of the photographs makes no narrative sense, neither moving left to right like writing, nor clockwise. The close-up images of Lupe are printed and cut out on top of a background photograph of the crowds of the market. The perspectival rules that generally indicate narrative time in painting are broken by the startling collage of photographs, making this essay of the modern nation difficult to read. In addition to its disordered graphic design, there are two kinds of written texts in this photo-essay: one text encapsulated in a box, and the other in the form of captions beneath the photographs. Since neither one is privileged in the graphic

design of the page, the reader cannot know which version to believe. The continuation of the boxed text describes the time of the fictional photo-essay, including the reader as an actor in the essay: "We didn't feel the flow of time: unretainable water, Lupe Vélez seduces, enchants, dominates." The caption on the right, however, distances the reader from the essay, reporting the content of the photograph: "Lupita Vélez in Santa Anita was surprised on a Good Friday by our photographer, who followed her all along her mystical-pagan excursion."[99] In this text, the mystery and enchantment of the photo-essay belongs entirely to Lupe, who is trailed by the reporter-photographer. The question of the distance separating photographer from subject — narrator from photo-essay, image from word, letrado from the popular culture he observes — is unresolved when it comes to control over the time and space of the photo-essay.

The ethos of modernism appears in the motivation of the contact between image and word as an excess that results in enchantment. The enthralling aura of the women protaganists in "A Frightening Story" and "A Good Friday with Lupe the Girl" is typical of descriptions of mass media and the graphic arts at the time, and this excess itself is the topic of "The Enclosed Lady . . . Un-written and un-directed by Arqueles Vela . . . the film that does not exist" (fig. 55).[100] Although the photo-essay resembles the many film stills that accompanied reviews of new Hollywood and Mexican cinema in these publications, this film itself is a fiction. Vela uses the combination of still photography and fictional text to "un-narrate and un-formulate" the ordered time of cinema. The hero of the essay remembers "the look of that woman whom he never could identify, so seen by everyone . . . She comes from faraway lands inaugurating all the cities and conquering them."[101] The vast circulation of her image gives her, like Novo's hija pródiga, a visible and yet unnamable power. In Vela's photo-essay, photographs of Douglas Fairbanks and John Barrymore contrast with one of an unidentified woman, suggesting her intangibility.[102] The half-painterly edges of her photograph reveal its documentary unreliability, the visual mark of the manner in which the photo-essay as a whole simultaneously creates and destroys a nonexistent film. The written text describes a film that it later denies exists, and its photographs reproduce the image of a woman who is supremely known yet unidentifiable. Vela presents the woman who can be found everywhere but does not exist, clearly a reference to the images of women flooding the pages of the illustrated journals. Like the

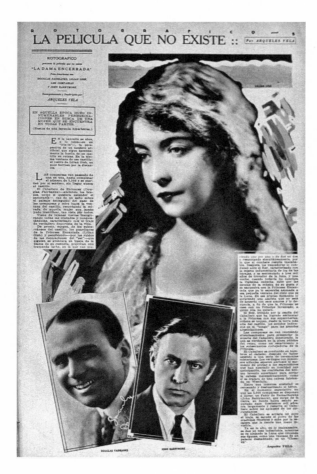

55 Arqueles Vela, "The Film That Does Not Exist," *Rotográfico*, March 3, 1926. *Biblioteca Miguel Lerdo de Tejada*

Señorita Etc., she is the absent yet driving force of the photo-essay, of these "pilgrimages" that suggest an altered trajectory for the essay and furnish an image of nation that is too heretical even for this genre.

In addition to the contact between image and word, the excessive aesthetic of photo-essays is produced by their often melodramatic style, apparent in the florid prose and extravagant imagery of "The Enclosed Lady" and "A Frightening Story." Illustrated journals like *El Universal Ilustrado* and *Rotográfico* were part of an increasingly widespread sensational press and included tabloidlike photographic reconstructions of crimes, street scenes, and popular customs. Many of the photo-essays show scenes of marital deception and violence played by photographed actors, some of which were reconstructions of real crimes and others fantasies of photographic licentiousness and the modern woman. Mar-

tín Barbero argues that such sensational stories represented the interests of populations left out of "traditional political discourses," including women, and were "traces" of popular culture in the press.[103] Melodrama for him becomes the most dialogical form of narrative, including the voices of these women and working-class men—and, as we will add in chapter 5, queer modernists. This dialogical (if seemingly frivolous) form shows yet another way in which the ethos of modernism creates continuity between ethics and aesthetics, a popular aesthetic imbrication of life and art.

The widespread impact of the melodramatic revistas ilustradas in both elite and popular culture created a profound displacement of Rama's ciudad letrada. Their aesthetic of excess was celebrated, as seen in the many photo-essays and articles cited above, and also considered a threat to virile aesthetics. An editorial in the Estridentista journal *Horizonte*, of which List Arzubide was director and to which Vela contributed, describes its surprise at receiving letters from women: "Because the ambience that journals have created in Mexico . . . is one of laziness of concepts and cowardice in manifestations, that has been poorly called eclecticism, a chaos that satisfies the undulating taste of women."[104] Paradoxically, the "undulating" movement of feminine desires and fashions represented in the photo-essays was considered distasteful to the publication whose own members participated in its creation. The editors of *Horizonte* approve that "the Mexican woman be incorporated into the phalanxes that are going to start the battle for new thought," but they conclude by pigeonholing her as the "cement of humanity" and mother of all.[105] Reflecting on the foundation of the journal itself in "Thus Was Made *Horizonte*," List Arzubide complains: "The weekly journals of Mexico are so tacky and so futile, so silly and so frivolous, obliged to publish whatever there is, whenever there is something." His disdain for popular journals is expressed in gendered terms, their only purpose being to "[emotionally] move spoiled nice girls."[106]

El Universal Ilustrado also reflected on its own circulation, the power of its women readers, and the impact they had on mediating hybridity. In the similarly titled "How *El Universal Ilustrado* Is Made," the editors exult in its quick creation from scratch each week, and its creative use of new technologies in design and content.[107] The article proclaims eclecticism to be its greatest virtue; the frivolous mixture condemned by List Arzubide is the source of its popularity and the innovative aes-

thetic of the publication. As evidence of this success, they published the responses of advertisers to the question "Why Do You Advertise in *El Universal Ilustrado*?" The answers given demonstrate the unique forum that the journal provided at the time. Dr. Holden, the inventor of "ideal pills," responds: "Because it is a serious periodical and has wide circulation. Thanks to its choice of literary material, it reaches homes, women read it and the advertisement for beauty products . . . not only in the capital of the Republic but also in various states."[108] The eclectic texts reach men and women, rural as well as urban audiences. Advertiser Ana Gómez Mayorga also affirms that it "is the weekly with the greatest circulation in the country," stressing its female readership.[109] These same women readers ultimately wrench control of Vela's "A Frightening Story" out of the author's hands: the journal advertises a competition to complete the story, with three prizes for the best endings proposed by readers. What is more, all the self-analyses of media insist that while women readers were in the forefront of publishers' concerns about keeping circulation high, they were not the only readers. Those letrados who wished to keep up with the newest prose and poetry by both groups of modernist avant-gardes also had to peruse its pages. The denigration of this popular press thus stemmed from a desire to protect the traditional domain of the ciudad letrada from the changing path of the photo-essay. The Estridentistas' and Contemporáneos' participation in these publications, despite their own denigration of them, was key to the development of a modernist aesthetics. As seen in the "Foto-trucos," the gazes of these "literary women" shaped the ethos of modernism of both groups of artists.

El Universal Ilustrado's experimental graphics generated particularly glowing responses from their readers, the very consumers that most theories of modernism insist would have been alienated and thwarted by them. Dr. Holden explains that she advertises in the illustrated journal because of its innovative design, which she implies is made possible by its economic and political status: "EL UNIVERSAL ILUSTRADO is independent and has no political ties and can attend carefully to the graphic part, publishing beautiful ads that are etched in the minds of its readers."[110] Surprising for those who associate experimentation in the graphic arts in Mexico only with state-sponsored education and arts programs, the commercial status of the publication is credited with its excellent and unique graphic arts. While this argument for the novelty of commercial graphic design fits well within studies that

present this period as the early form of consumer culture in Mexico, this does not necessarily preclude its participation in both modernist aesthetics and popular culture. In his foundational book on modernity, Arjun Appadurai reminds us that "consumption in the contemporary world is often a form of drudgery, part of the capitalist civilizing process. Nevertheless, where there is consumption there is pleasure, and where there is pleasure there is agency. Freedom, on the other hand, is a rather more elusive commodity."[111] The aesthetic of excess, found even in the rebelliously libertine women within their homes, also reveals the possibility of pleasure. These active women readers placed aesthetic and ethical demands on even the most misogynist Estridentista. Freedom however, as Abella Caprile so clearly pointed out, was the limit of women's participation in modern circulation; it was the point at which the bellas artes públicas represented a threat to the state's program of cultural nationalism, for women were not meant to be included fully as citizens in postrevolutionary politics.

La Cosa Pública / That Public Thing

The altered patterns of circulation that appeared in the revistas ilustradas—of images, women, and essays—played a crucial role in the debates about national identity following the Revolution. The circulation of women in these photo-essays represented a crisis: a historical problem that had to do not only with representation, but also with the concept of the gender of the modern citizen, with engendering a modern citizen.

In his 1926 report from Los Angeles for *El Universal Ilustrado*, titled "Men-Women," Luis G. Pinal warns in a state of panic that the phenomenon of women acting as men is even more common in "Yanquilandia" than it is in Mexico. This transgressive behavior does not just appear in flapper fashion and short haircuts; it is explicitly about citizenship. As Pinal himself puts it, the question is whether "woman should figure in the **'Public Thing.'**" He warns that in the United States, "There are already three WOMEN who now occupy public posts, which were created for MEN."[112] The creation of mujeres públicas in Yanquilandia is presented as a direct political threat, as much as a threat to a traditional ethos. Women were not granted full political citizenship in Mexico—the right to vote in national elections—until 1953. While deeply sus-

pect after seven decades of P.R.I. manipulation of the electoral process, the 1920s and 1930s saw active suffragist movements that clearly considered voting an important recognition of a citizen's rights. The revistas ilustradas recreated the public sphere as a performative theater in which feminine desire was the ruling passion, and photo-essays the journey by which Mexico arrived at this modern society. The aesthetic of excess of the photo-essay delineates the trajectory of women taking over the "public thing" of politics, as well as dictating the letrados' novels and poetry in the bellas artes públicas.

Beginning with the earliest manifestos in 1922 through the closing years of the 1930s, the Estridentistas and Contemporáneos debated their relationship to the postrevolutionary state. Maples Arce wrote of the failure of intellectuals to truly participate in the social revolution in Mexico and explained that a main goal of Estridentismo was to create a reading public that would form a new intellectual movement.[113] Oscar LeBlanc asked Dr. Atl, Manuel Rodríguez Lozano, Jorge Enciso, Roberto Montenegro, and Adolfo Best Maugard: "What should be the source of a national visual arts?"[114] The debate over the relative nationalism of the Contemporáneos and the Estridentistas has continued since their active years, with scholars going so far as to count the number of texts and art works reproduced in their journals by Mexican artists compared to those by foreigners.[115] The vision of Mexican modernity as circulation that appeared in the early mass media, however, requires a definition of nationalism more aligned with Mário de Andrade's concept of erring than with a singular, grounded, or quantifiable nation. In the photo-essays that so frequently pictured this modernity, the multiple images of femininity performed their nationalism as tourists and as citizens, modern and traditional, ethical yet certainly not moral.

The proclaimed hybridity and critical stance of the canonical essay of identity were manageable because of their articulation by hombres públicos, firmly lodged within Rama's lettered city. Photography, "the prodigal daughter," exceeds the bounds of the lettered city, circulating in a public sphere not yet charted for occupation. The photographically illustrated journals reflect a radical shift as the modernist avant-garde participated in las bellas artes públicas, and they represent an interruption in foundational narratives of national identity. The modernist aesthetic that appears in the photo-essay engenders the narrative voice of the essay; it marks the path by which it arrives as one specifically traced by a reproduction of modern femininities that go where they ought

not. Given her functional aesthetic and active character, the prodigal daughter does not remain safely contained as a projected image of desire or shame, but rather fills the public spaces of mass media and even politics. The feminized, multiple, and mass circulation configured in and by these photo-essays permits a vision of a conflicted terrain of mediation not often associated with this period of didactic Mexican literature and art. Marked by a promiscuous ethics and a frivolous and tacky aesthetic, the ethos of modernism is excessive and popular. As will become clear in chapter 5, many modernist fictions show letrados reproducing the varied performances of modern femininity in their literary texts. This performance of femininity by men within the (governmental) public sphere—hombres públicos acting like mujeres públicas—is doubly threatening to a "virile" model of nation and makes something like a critical nationalism possible.

5

Manuel Álvarez Bravo makes it possible that, standing before his best photographs, we find ourselves facing true representations of the unrepresentable, facing true evidence of the invisible.

XAVIER VILLAURRUTIA

Fiction

PHOTOGRAPHIC FICTIONS, FICTIONAL PHOTOGRAPHS

Writing about an exhibition of photographs by Álvarez Bravo, Contemporáneos poet and novelist Villaurrutia begins by suggesting that photography is best employed for its documentary potential: "In the service of science, the contemporary, fashion or journalism."[1] Almost immediately thereafter, though, he has a change of heart and declares it "one of the mediums that most incites a lack of confidence."[2] Villaurrutia ultimately praises Álvarez Bravo for dwelling precisely in this contradictory space between proof and doubt, and for producing photographs that invent (in)visible truths.

Western modernity defines itself through assertions of the necessary relationship between seeing and knowing, through "a scientific world-view which claims privileged access to truth."[3] This visual epistemological promise instituted the genealogy of "artist-scientists" of the seventeenth and eighteenth centuries to which photography is heir. The first ethical question still asked of photography is whether photographs, at some basic level, are truthful representations of the visible world. Yet theorists of photography in

Europe and the Americas have debated the truth of the medium as long as photographers have altered the images produced by their cameras—since the very invention of the camera. This photographic tradition of invention matched with the critique of modernity we have seen in the preceding chapters reveals that this question is better split in two: Do photographs mimetically reproduce the visible world, and if they do not, are they necessarily unethical? Mário de Andrade's alternation between revealing and obscuring the truth of Brazil indicated that the ethical decision in some circumstances may be to make the camera lie. In this chapter, I suggest that Mexican modernist prose fiction goes even further by composing an ethics and aesthetics of photographic truth and lies out of the bellas artes públicas.

Fiction by both the Contemporáneos and Estridentistas deploys a surprising combination of mass-cultural photography and avant-garde prose and thus reconstitutes the status of evidence such that it corresponds to the experience of peripheral modernity. Photographic images of New Women populate Villaurrutia's prose fiction, as well as works by Jaime Torres Bodet, Novo, Vela, and List Arzubide.[4] Their repeated references to photography imagine a modernist artwork characterized by blurry boundaries that only partially set it off from the "real" world. While certainly not realist novels, these photographic documentary fictions create an ethos of modernism that plants one foot in a quite pragmatic ethics and the other in a very ethereal aesthetic. First-person novels dominate this modernist prose, creating a version of documentary fiction that bridges the biographical with the invented. They stand in stark contrast to the dominant "novel of the Revolution," the great cultural nationalist achievement of the postrevolutionary period, which followed straightforward, realist narrative structures.[5] While publicly they rejected the novel of the Revolution for being too folkloric, touristic, and photographic, both groups of modernists built on the bellas artes públicas—especially domestic tourism and experimental photography—to reimagine fiction, and to promote a critical and even queer nationalism.[6] These lyrical and abstract narratives detach truth from ethics and free fiction from the necessity of a narrative form; they constitute an adulterated sphere of modernist fiction that corresponds to the intellectual's messy new role in modern Mexico.

These fictions are most frequently described in the same airy, dreamlike language that the texts themselves employed. The novels create "a foggy eroticism . . . Between these two waters the narrator of the texts

wanders and sinks. In the end nothing remains in one's hands, more than the sensation that where there are ashes there was once smoke."[7] Repeating the haziness of the fiction, this critic equates the women characters who populate these novels with an ephemeral feminine and a "pure" aesthetic that he defines as crucial to their intangibility. Generally, these women characters have been treated as if they were complete invention, empty shells serving only a formal function as the opportunity for the male author's play with abstract poetic prose. Yet a precise historical referent exists for the women who float in front of the eyes of the narrators of the avant-garde novel: Arqueles Vela's "Enclosed Woman," and all the other photographed New Women who are found everywhere but do not exist. If mainstream modernist fiction and photography rejected both femininity (however it was framed) and realism in the attempt to make the transition from popular to high art, Mexican modernists' active participation in popular culture composed a different relationship between fiction, photography, and aesthetics.[8] The bellas artes públicas reveal that photographic modern women were too politically and ethically powerful and publicly present to slip through our fingers like ashes. As they take form in modernist prose fiction, they are both concrete references to the Señorita Etcétera and lead to fictional experiments with the kind of performativity seen in the illustrated journals. Photographic modernist fiction, in literature and in photographs, creates a bind between that which exists within the frame and the social world outside it. It is an adulterated sphere in which ethics and aesthetics are edgily interdependent and mutually disruptive.

The enchantment of the photo-essays and the fogginess of novels disordered by these women produce a melodramatic aesthetic that is not foreign to documentary photography. John Tagg describes it as documentary's melodramatic mode, which "transformed the flat rhetoric of evidence into an emotionalized drama of experience that worked to effect an imaginary identification of viewer and image, reader and representation, which would suppress difference and seal them into the paternalistic relations of domination and subordination on which documentary's truth effects depended."[9] While this trenchant critique of its affective address provides a crucial interruption in documentary photography's facticity, Tagg does not consider other possible uses of these images. He does not consider melodrama as a potentially dialogical form of popular culture, which can be used, as Martín Barbero

suggests, by women, workers, and other politically excluded groups; it is only a tool that destroys difference. Let us instead imagine the kind of mixture that Tagg hints about, in which soap opera meets Works Progress Administration photograph, but without forsaking any chance of dialogism.[10] The melodramatic document can then reveal the tensions of modernity on the periphery rather than act only as a bitter contradiction in terms. Still able to realize Tagg's critical goal of destabilizing the truth effect of documentary, it does so through the suspicious (and entertained) eyes of the multitude of active viewers that Martín Barbero theorizes. By manipulating the visual evidence of photography and referencing the bellas artes públicas, prose fiction by Estridentistas and Contemporáneos in Mexico creates an ethos of modernism in the tense balance between melodramatic document and documentary fiction.

The debated truth of photography that accompanies the "prodigal daughter" into modernist fiction engendered experimental short novels, which have influenced Latin American literature from the boom generation to the present. Gustavo Pérez Firmat argues that the contrast between their novelistic form and poetic lyricism maroons these works: "Vanguard fiction is degenerate literature, in both senses; without genre and thus without gender."[11] Given their intertextuality with the bellas artes públicas, I argue that these works in fact have a gender, feminine, and a genre, fiction. These texts span the literary and the photographic, the documentary and the fictional, ethics and aesthetics, and thus contribute the final component to the ethos of modernism. Whereas earlier ethos took form through an altered narrative order, the disordered path of the photo-essay, here we will be concerned with how errant modernism takes shape in invented photographic fictions.

Ethos as the Non-Tautology of Fiction and Ethics

Recent theory about fiction still seeks to protect it from accusations of an unethical lack of truthfulness by characterizing it as a type of philosophical tautology. Doritt Cohn states that her goal is "to show that fictional narrative is unique in its potential for crafting a *self-enclosed universe ruled by formal patterns* that are ruled out in all other orders of discourse."[12] The "distinction of fiction" is this nonreferentiality, and while Cohn acknowledges that fiction can make reference to the world, she

insists that it need not do so. The fictional text is defined by this tauto-logical operation: "A work of fiction itself creates the world to which it refers by referring to it."[13] No ethical demands from outside the work can then be brought to bear on it *as fiction*. Aníbal González defines ethics as similarly tautological: "It is impossible to verify it with refer-ence to any rule or example outside itself. In this, it resembles fiction, since it can be argued that the 'falsehood' of any work of fiction can always be recovered as a 'truth' on another level."[14] Cohn's argument rightly counters judgments of fiction as true or false, and González re-jects any simplistic understanding of ethics as a moralist designation of good or bad, yet both theoretical proposals do so through a distancing from the social world.

To insist on this divide because of a desire to give fiction its own kind of truthfulness ultimately limits its scope and imaginative possi-bilities. Cohn's defense of fiction resembles a version of Greenbergian modernism, in which the ideal modernist object refers only to the realm of its own artistic making, the painting to the layer of paint on a square canvas. Fiction conceived thus obeys a strictly formalist logic, and often is thought through a particular (Euro-American) body of texts.[15] The ethos of Mexican modernist fictions does not compose such a completely untethered formulation of fiction's ethics or aesthetics. These works use photographic images to interrupt the fictional and to adulterate it with traces of the nonfictional, releasing fiction from its fidelity to truth and composing an ethics grounded in Mexican moder-nity. The photographic in-between of fiction and document creates the final connection to be explored between aesthetics and ethics in Latin American modernism. The adulterated space seen in photographs and photographic prose conceives of a modernist object that does not establish its authenticity through its separation from the world, but rather pictures the ethos of modernism in the tense and intimate inter-action between life and fiction.

In classical terms, ethos signified the correspondence between the honest nature of a speaker and the veracity of his or her words: the "identification of the speaker with/in his or her speech."[16] The diffi-culty of judging this correspondence appears in the continuing debate over the ethics of rhetorical mastery. Excessive facility with words as easily characterizes a false as a true representation. Rather than truth-fulness, James and Tita Baumlin offer an almost spatial analysis of Aris-totelian ethos in which "the rhetorical situation renders the speaker an

element of the discourse itself, no longer simply its origin (and thus a consciousness standing outside the text) but rather a signifier standing *inside* an expanded text."[17] As much as the rhetor is one of a number of signifiers at the level of discourse, this physical description of presence marks this figure as a special kind of signifier: neither safely outside the text nor entirely indistinguishable from it. The work's ethos thus depends on the relationship between a text (or image) and some perceived (even if only perceived) outside. Not to be judged for containing true or false information, the ethos of these fictions does not sustain self-referentiality as their overriding characteristic. The texts are rather set into motion by a negotiation of this position at the intersection between "properly" aesthetic and ethical realms. In this process, neither remains pure; neither the fiction nor the ethics produced relies upon tautological self-referentiality to protect itself from denigrating accusations of falsehood.

The word *fiction*, however, is rarely used in its nominal form to speak about visual art. That is, one may contrast historical painting to an image with fictional subject matter, but one rarely describes a work of art as a fiction.[18] My (perhaps awkward) appellation of photographic fiction lodges the study of these works squarely within the theoretical quandary about photography's relationship to narrative, which is crucial to analyses of avant-garde experimental, or "imagistic," fiction. In the nineteenth century, amateur and professional texts described the reception of photography as a form of reading, and photographs ideally had a narrative structure that conveyed one main idea to the viewer. The photographer was instructed to control the excessive detail captured by the camera, which could make its thesis difficult to read, and even given permission to mechanically alter the print in order to protect its narrative logic.[19] Long before Barthes described the pen hovering over every photograph, Lady Eastlake, the first president of the Royal Photographic Society of England, explained that photography fell into "neither the province of art, nor description, but of that new form of communication between man and man—neither letter, message nor picture—which now happily fills the space between them."[20] Many contemporary theorists employ narrative theory and semiotics for the study of photography more than visual theory.[21] As much as photographic theorists have reached into narrative theory to explain the medium, narrative theorists employ photographic concepts to analyze fiction. Shlomith Rimmon-Kenan defines narration as a "succes-

sion of events," even if unimportant or seemingly unrelated; discrete instances placed in a stream of words become narrative. Not only can this model of narrative embrace photographs in an essay, in a book, or in an exhibition, the very language that underwrites Rimmon-Kenan's analysis of textuality is based in photography.

The most photographic language and concepts appear in Rimmon-Kenan's analysis of Text (Genette's *récit*), the material of the narrative itself, as the element of fiction created through its focalization, time, and characterization. Estridentistas and Contemporáneos experimented most actively with the textual (and thus most photographic) level of prose fiction, to the effective exclusion of the other aspects of narrative. Very little happens in these avant-garde prose fictions; their prose leaves behind description, discursive elaboration, and the concept in order to "surrender to the image."[22] While Paúl Arranz concludes that these experimental novels' linguistic play refers only to writing itself, I propose that the photographic nature of their imagism creates an ethics grounded outside the text, as much as a highly aestheticized realm considered internal to fiction. Imagistic fiction, specifically photographic for its relationship to the photo-essays seen earlier and for the narrative techniques to be examined in the following pages, contains the final concept for theorizing the ethos of modernism. These textual terms—focalization, time, and characterization—therefore guide my discussion of the photographic fictions of the Mexican avant-gardes. While this relationship between photography and narrative is an important theoretical issue explored in these fictions, the ethos they compose ultimately exceeds the limits of narrative. The new letrados who occupy these imagistic fictions, as both characters and the node of their focalization, themselves are written into an alternative story of postrevolutionary aesthetics and ethics.

Characterization: The Creation of Celebrity

Rimmon-Kenan describes the function of character as a kind of trail of hints that the reader compiles in her passage through the text. Rejecting a psychological understanding of characters as people, instead they are inextricable from the design (at the textual level) of narrative fiction. This investigative vision is exaggerated in prose fictions by both Estridentistas and Contemporáneos, as many are structured around the

narrator's pursuit of elusive and mysterious female characters. No really satisfactory explanation has been offered for these women who drive the narrative fiction of both avant-garde movements; not only has their resemblance to the Mujer Nueva been ignored, but they have been marked as utterly abstruse. Even Juan Coronado's suggestive description of these texts as a kind of literary transvestism fails to locate them within the highly charged discussion of gender and politics that was taking place in the literary world during this period: "The novel, the cloud, and the woman are the ungraspable par excellence."[23] In spite of his observation that the texts may parody the historical monumentalism of the revolutionary novel, in the end Coronado exiles them from the graspable world. Paradoxically, these images from popular culture became the source of the highbrow quality of avant-garde fiction.

These fictions rely on two kinds of characterization: *direct* presentation by an authoritative narrator, "explicit and supratemporal," and *indirect* characterization via action, speech, environment, analogy with names, landscape, or other characters.[24] Through direct characterization, modernist writers create women characters who embody the images of New Women in illustrated magazines, women who function to some degree as celebrities. They are the projected images of desire, utopic and dystopic ideals. Yet these photographic women take hold of the fictions they inhabit, threatening to take the power of imagination and narration into their own hands. The novels show that this reversal already has begun to take place, as the first person narratives subtly incorporate the language and style of popular culture in the narrators' own words: the texts themselves indirectly take on the character of these photographic women.

Direct Characterization: Women in Magazines

Arqueles Vela's "La señorita etcétera" (1922) begins as the narrator descends from a train bound for the capital in a provincial town that is "vulgar" and "unknown." One cannot quite say that the story is driven by the presence of the many unnamed *ellas* (shes) that he encounters, as nothing really happens. However, from the beginning the narrator explains: "In order to grab hold of the absurd reality of my fantasy, I went back to see her from time to time. . . . It was inevitable and even indispensable that we continue together."[25] The images filling the novella are

dreamlike yet precise, and they are sewn together through the narrator's pursuit of a series of characters called "ella." These characters' only defining trait is that they are feminine objects of the male narrator's mistaken desire.[26] This absurd reality creates a distinctive fictive realm through the composition of these characters. Like the photographed vedettes to whom Vela refers in "The Enclosed Woman," these women are simultaneously pure invention and in wide circulation. They are concrete images of an imagined Mujer Nueva. Based upon her photographic image, they are not individually "real" but rather the real invention of the mass media that shaped the experience of modernity both locally and globally.

The characters who inhabit these novels further complicate the ethics of the modern woman. If at first it seems the narrator will face a choice between a traditional and a modern object of desire, none of these characters fully resembles the ethical Mexican woman; she is not an option. Torres Bodet's *Margarita de niebla* (*Margarita of Mist*, 1927) tells of narrator Carlos Borja's simultaneous courting of Margarita Millers and Paloma. Each fulfills in part the description of the New Woman: Margarita physically resembles a flapper, with "the firmness of her calves . . . and the solidity of her shoulders"; and Paloma, "contrary to what was expected, is taller than Margarita. Her hair, cut in a bob, doesn't have that sentimental ease that undoes . . . the braids of her friend."[27] The narrator faces not a simple contrast between the Mujer Nueva and the traditional Mexican woman, but a confusing explosion of modern femininities. Similarly, in Villaurrutia's "Dama de corazones" ("Queen of Hearts," 1928), Julio returns home to a provincial city in Mexico to consider marrying one of his two cousins. At first he distinguishes between the sisters: Susana is the flighty, flirty one who "reads novels, poetry," and who "lies naturally, as if she weren't lying. . . . She would write quickly, without any orthography, in interminable paragraphs that would have to be full of periods and commas, if she were to pay attention to punctuation."[28] Aurora, in contrast, "belongs to that flora a little less than extinct, of women who write slowly, in long paragraphs, repainting the letter two or three times, paying attention to orthography."[29] Susana seems to be the modern writer, producing telegraphic avant-garde texts in contrast to Aurora's nineteenth-century script. Yet Julio observes: "I am decidedly wrong. Susana is not so different from Aurora. . . . Thus Susana in Aurora, thus Aurora in Susana. . . . *Now they overlap in my memory like two films destined to form just one photograph.*

Diverse, they seem united in the same body, like a queen of hearts in a deck of cards."[30] The sisters are traditional and modern, influenced by the urban and yet recognizably from a rural town. The most precise image of this female character is that of a double-exposed photograph, resembling Mário's "Futurist photograph of Mag and Dolur superimposed on the banks of the Amazon," which combines and confuses the traces of the different moments it records. This image echoes the photomontages that appeared in *El Universal Ilustrado*, combining overlapping fragments of modern, feminine characters.

The photographic character of vedettes equally permeates works by the Estridentistas, filling them with a violent, modern (ir)reality. In Vela's "El café de nadie" ("The Café of Nobody," 1926), named after the group's famous coffee shop hangout, the narrator-journalist makes his fascination with such women very clear: "My sensuality . . . is purely intellectual. Women don't interest me, except those that I glance at in magazines. Underwear in magazines gets me worked up more than on a woman."[31] The woman that this narrator pursues, Mabelina, is painted solely out of the scandalous makeup for which she is named, and which repeatedly appears in descriptions of the vedettes.[32] Her appearance in the café creates a photographic "retrospective irreality," a motionless place "under the fog of time" set off from the frenetic movement of the city outside its door.[33] The narrator insists that women are mere vessels to be filled with whatever tensions and ideas men conceive, and Mabelina becomes increasingly disjointed throughout the story, like the photomontages of legs in *Rotográfico*. "El café de nadie" includes a list of names of the Estridentista writers, whom Mabelina reads like texts:

> With each one of them she had felt like a different woman, according to his psychology, his manner, his likes, his passions, and now she was barely a sketch of herself. It seemed that she had been falsified, that they had molded her. . . . They had gone on grabbing a look, a kiss, a smile, a caress until they left her exhausted, extinguished, languid, defeated, huddled, sleepless. From feeling so much she found herself insensible. . . . After being all women she was no longer anyone.[34]

The violent reproduction and undoing of Mabelina, evocative of a rape, reflects the same anger expressed about women and the "Cosa Pública." Even so, Mabelina's decomposition takes place simultaneously with the narrator's. While she appears to be his creation, she invades his control over the situations he narrates: "[Mabelina] stutters that which he told

her that night that they met and smiles, parenthesizing her thoughts with that interior murmur that emulsifies after a laugh, enumerating the subterfuges in which she shielded herself, dissembling her timidity, disguising it in a series of sentences and situations that almost always made him appear like an unworried man, insolent, intrepid, and even cynical."[35] The truth of Mabelina's deception unfolds in the vocabulary of photographic development: her appearance of feminine reticence is shown to be a superficial guise, while the truth of the young man's character is revealed in a laugh that operates like the process of photographic emulsion. The narrator of "El café de nadie" ultimately finds himself as undone as Mabelina herself, "wanting to adapt to the irreality that the woman evoked."[36]

The bravado of the Estridentista text tries to stage a competition over the modern with the Contemporáneos, whom it terms "fifíes" (poofs), as a battle over virility. The real threat, however, emerges from the multiple and mass-produced series of images of femininity that inhabit the city. In *El movimiento estridentista*, List Arzubide lays claim to these "women of the Estridentistas . . . cinematic girls, *super-pelonas* . . . the lovers of everyone, the unanimous girlfriends, hung on our tastes, in the face of the sterile protests of the poofs." He states: "With these women Arqueles Vela represents the dramas and novels that then appear in the newspapers."[37] The homophobic author seeks to maintain control over the bellas artes públicas, to claim the uncontrollable feminine as the terrain of a "virile" literature rather than the effeminate writing of the Contemporáneos. These modern women, whom List Arzubide describes as 5,000 dolls with whom Vela lives, are nevertheless the source of profound anxiety, for "these women . . . are those who dictate his novels to him . . . The Señorita Etcetera is the most real of his dolls, at times we even believe that she is going to end in disaster, turning into a flapper."[38] She threatens to seize control of his aesthetic production rather than serve as its subservient muse. Like the "Fototrucos," the capture of the feminine by the male avant-gardes is imperfect. These characters are able to "dictate" the novels because they are the most "real" of the fictional dolls; they change the form of avant-garde expression as much as the representation of the feminine itself and are subject to a violent misogyny in response. *El movimiento estridentista* ends with the image of "the avenue littered with pieces of all of the women," the collaged legs and bodies embued with the same violence called upon to limit the political representation of women in the Public Thing.[39]

The ethos of the bellas artes públicas appears profoundly yet more subtly through the indirect characterization of the male narrators—themselves often writers—as they adopt a descriptive style that verges on the effeminate, *cursi* (tacky), and indiscriminate character of the bellas artes públicas. Torres Bodet in particular experiments with this aesthetic; in *Margarita de niebla* the narrator confesses: "If it weren't for the angle of the orange sky that floats in the crystal of her liquid eyes, I would wish to say farewell, but there is in her attitude one of the gestures that recall, in typography, the trace that opens a parenthesis."[40] The sentence slips between the described image of the vedette and the narrator's language, which adopts her melodramatic voice. Both character and sentence remain open, unfinished, a series of reflections. The airy, indefinite aesthetic of these prose fictions stems from this characterization—both direct and indirect—of a consciously invented and widely reproduced femininity.

The translation of the mass-media image of the vedette into these women characters creates a radical uncertainty in the voice of the male narrator; their entrance into these fictions unsettles the narrator's privileged status and breaks the remove of the ciudad letrada. Torres Bodet's "Estrella de día" ("Daytime Star," 1933) presents a studious narrator, Enrique, who becomes obsessed with a young Mexican film star, Piedad Santelmo. Piedad had been discovered at age seventeen by a Hollywood film director who came to Mexico to organize "the greatest competition of eyebrows in the Republic," and was soon cast as a "vedette of the screen."[41] The narrator's obsession with the vedette leads him out of the ciudad letrada: "In the hermetic world of culture that Enrique himself had forged, like an incandescent breeze—who knows through what door, through what window—life was entering."[42] Enrique stops his academic writing and map-making and begins to make photo collages in the style of the illustrated journals: "To cut out a woman, to disarticulate her fragments. Then, piece by piece, on a blank page, to paste them on with glue."[43] The narrator as avant-garde artist is not only shaped by mass culture, he even dedicates himself to the making and remaking of the New Woman. He leaves behind high culture and begins to produce photocollages.

"Primero de enero" ("First of January," 1935) is a similar story about the entry of a previously enclosed letrado into the modern city and his

introduction to popular culture, in which both experiences are framed by photographic encounters. The opening pages of Torres Bodet's novella are an extended meditation on a photograph of the protagonist's dead wife, and the closing chapters relate his experience of having his mug shot taken and the ensuing relationship with the police photographer. Gonzalo Castillo, a respected intellectual and a banker, has a wild first day of the year, during which he rejects his upper class habits: he walks through the city rather than drives, resigns from a powerful bureaucratic position, intentionally gets arrested, and invites the photographer who takes his mug shot to dine with him. A widower, Gonzalo casts himself into the city, remembering that before he was married he liked to follow an unknown woman randomly as if she were his guide. This search is the mechanism that drives his general quest to escape his own class privilege and to discover the lower and middle classes of the modern city. The resulting series of unrelated events, joined only by Gonzalo's vicarious desire for the popular class's experience of city life, presents the impact of photographic modernity on the character of the lettered man and in the process articulates a theory of photography.

A long introduction precedes Gonzalo's entry into the city, as he stares at a photographic portrait of his wife and wonders about the contradiction between his memory of her as paranoid and deceptive, and the photograph he holds in his hands: "Impeccable Sara! There she was, at fourteen years old, at fourteen centimeters of distance, with that mute semblance that the photographer had to correct, thinning out the more personal features—the dedication of the mouth, of the nose, the date of the eyes—all that is not written in ink, that is not erased, but in whose paragraphs without words the most optimistic husband discovers, like in the postscript of a posthumous letter, a dramatic confession."[44] The photograph collapses time into space, years into centimeters, and is a narrative "without words" that Gonzalo reads as the admission of his wife's infidelity. Yet the message revealed through the discreet object held at this short distance utterly confounds him. Gonzalo first thinks that the photograph offers an objective view of the lifelike truth about his wife. He then breaks the photograph into a complex code of poses and lighting used by photographer and model alike to represent a desired (but perhaps inaccurate) image of the subject. As much as Gonzalo claims that his dead wife's beauty was hers in life, this truth is shown to be the effect of the photograph's composition. Its *image* of veracity

emerges, he determines, not from Sara's fidelity itself but rather from the face-on pose and the carefully placed lights of the photographer.

Throughout the novella Gonzalo repeats the word *impeccable*, although "he could not explain even to himself the origin of that adjective. But it was enough for him to look at the portrait of his consort, to touch it, to understand that he was right."[45] This adjective embodies an idea of perfection, of being "im-pecable," without sin, that is paradoxically the sign of deception in a photograph. While Gonzalo states that the portrait of his wife absolves her entirely, the analysis of the photograph that he enacts defies this conclusion:

> Everything in the photograph of a guilty wife agrees with her. Everything absolves her: her eyes, the furniture, the size of her mouth, the lazy curve of her curls. Everything, on the contrary, in the photograph of Sara, proof of innocence, was coldly against her. . . . A wife who betrays . . . chooses her accomplices better. But those pearls, those eyebrows, those disobedient slippers . . . Only a woman beyond reproach could permit herself the luxury of a portrait like that.[46]

The imperfection of the photograph supports Sara's fidelity, since portraits of deceiving women appear untroubled, ordered, "impeccable," while the photograph of his wife is awkward, "disobedient," and flawed. Gonzalo's conclusions about photographic truth are entirely circular. The photograph is evidence of a truth about his wife, yet when the photograph achieves the perfect incarnation of his wife, it proves her falseness. Her falseness means that the perfect photograph is not perfect, for it presents a perfect image of a corrupt woman. When women are "impecables," they are clearly guilty of adultery; it is only in their flaws, when they are "pecables," that they can occupy an ethical position. Feminized photographic space and time represents a philosophical dilemma for the letrado's formulation of ethics and aesthetics. Like Mário's erring, the ethics Torres Bodet formulates goes beyond the truth and lies of fiction to a theory of modernism as an ethical demand produced through photographic aesthetics.

The radical ethical readjustment demanded of Gonzalo as he leaves the lettered city appears in the form of a fascination with criminality, which he again accesses through photography. After fruitlessly pursuing a woman through the city, Gonzalo intentionally gets himself arrested. Facing the police photographer's camera as if it were a guillotine, he

thrills: "It had been a long time since anyone had managed to get such a perfect pose from him."[47] The police photograph is so accurate that Gonzalo calls it "microscopic biography" and even compares the camera to Proust's eye. The perfection of this photograph is the result of the photographer's interest in the subject's face itself and is produced by a total lack of special effects of light. While he earlier praised the truth of his wife's character revealed in lights and special effects, he fantasizes that his mug-shot portrait shows him as a man of the popular classes. Despite his immense pleasure with the experience and the resulting photograph, Torres Bodet makes it clear that once again Gonzalo has none of the necessary tools to understand it: in the end he escapes arrest, precisely because of his bureaucratic position, and so his mug shot becomes a superficial pose of popularity.

Gonzalo's ridiculous pose ties "Primero de enero" to a broader critique of the revolutionary novel, ironically undermining his rebirth as an intellectual's phony pretense of popularity. Searching for further intimacy with the popular classes, Gonzalo pursues a friendship with Robles, the police photographer. Their relationship is solidified in a shared fascination with a photograph of Fernando Snickers, an anarchist and working-class murderer of the (fictional) conservative President Lindarte (whose name sounds like *lindo arte*, beautiful art). Robles informs the narrator that Snickers had promised that he would soon marry, "to have children, friend, many children. The country needs them."[48] Here, a perverse connection between virility and nationalism produces a pathological family descending from a murderous father. Gonzalo immediately sets out to meet Rosa, the adult daughter of Snickers, who had become a loose woman, carousing with sailors and musicians, and pregnant by an unknown man. She spans the gambit of the modern woman: literally a mujer pública when she sells her body to sailors, figuratively so as the goddaughter of Robles, the photographer, and later, the repentant vision of humble maternity with her illegitimate son, whom she gently calls Fernandito. Gonzalo impulsively decides to adopt the grandson of the murderer, the progeny whose face contains the same future-past promise for the nation contained in the dark portrait of Snickers. Like all of his previous attempts to ally himself with the popular classes, however, Gonzalo does not follow through. His criminality resembles the impeccable nature of his dead wife: false, for he never really surrenders his class privilege nor risks true punishment, yet true in what Torres Bodet reveals as the white

collar crimes of his postrevolutionary bureaucratic class. His character is indirectly formed by the photographic modernity and the pursuit of women embodied in the illustrated journals, even as he himself is unable to decipher their meaning. The narrative that traces his steps behind different women undermines revolutionary novels and photographs, begetting impeccable sons and daughters like Rosa and Gonzalo rather than virile, revolutionary sons. These characters contain the character of modernist fiction: the airy, effeminate invention of popular photography that reveals a paradoxical, documentary truth about revolutionary bureaucrats and the criminalization of popular classes. The ethics of these fictions emerges as the linguistic and photographic tension of being impeccable, rather than any specific moral content in the character of Gonzalo, his dead wife, or the reader herself.

Focalization: Photographic Embodiment

Focalization, while related to the characterization of the narrators, deals specifically with the reader's point of access to the fictional space of the text. The most photographic term Rimmon-Kenan employs in her discussion of textuality, focalization is "the angle of vision through which the story is filtered in the text, and . . . is verbally formatted by the narrator."[49] It is created by the narrator's "position relative to the story," either internal or external, and by the degree of persistence of this position. Focalization actually makes the common visual metaphor of "point of view" far more photographic, and it suggests specific conclusions about the ethical dimension of fiction in photographic modernism. The position of the narrator returns to the references within avant-garde fictions to textual and extratextual spheres; focalization recalls the conceptualization of ethos as the rhetor's position in an extended textual sphere. The first- and third-person fictions examined thus far would seem to support a designation of these modernist novels as hermetically formalist, since both employ a character within the represented world rather than some omniscient or external function to focalize the text. However, the close proximity of the first- and third-person focalizer to the represented "object" can operate like a camera too close to its subject, creating intimacy while preventing clarity of vision. Like Mário's "Tapuio de Parintins," the proximity of the photographer or narrator to his subject blurs the resulting portrait,

obscuring the face of the studied subject but accurately capturing the anxious, ethical position of the photographer. Gonzalo's confusion about the portrait of his wife, held just 14 centimeters from his eyes, is then doubly photographic: in addition to the theory of photographic analysis he enacts in the narrative, the focalization of the scene reduces the view of her deception to his perspective while making it concrete, tangible. While no other narrative point of view can confirm or reject his doubts about her fidelity, the tangibility of the photograph—its objectness—makes it the incarnation of a memory. The simultaneously intimate and impersonal examination of the object reveals a modernist photographic ethos that is both fictional and documentary.

Perhaps counterintuitively, these internalized first-person narratives create fictional worlds that simultaneously gesture outward. That is, they create nontautological fictions and ethics. While modernist prose explores the interior worlds of fictional narrators, it also encourages the expectation of a connection between this internal narrative and some notion of "real" experience. Even as Latin American avant-garde fiction "antimimetically displays its own artifice, each one also evokes a temporally and site-specific 'real-world' urban reference"[50] through autobiographical markers and sociopolitical clues. These works repeatedly break the separation of fictional from actual world. Torres Bodet's "Proserpina rescatada" ("Persephone Redeemed," 1926) returns to the intimate relationship between male narrator and a series of desired modern women. Like *Margarita de niebla* and Villaurrutia's "Dama de corazones," this short novel incorporates photography to picture the narrator's role in the fiction, using it to bend the relationship between the first-person narrator and the fictive status of the text, and ultimately between fictional text and national truth. Despite their atmosphere of dreams and mist, their hermetic language and interiority, these works always include an interruption of first-person consciousness by a point outside the fiction.

These first-person narrators cannot be contained within the character function they perform, and their focalization of the novels is always either insufficient or excessive. "Proserpina rescatada" follows medical student Delfino through his affairs with different women, revealing the special obsession he has with a woman nicknamed Persephone; Delfino is yet another intellectual confused by the multiple feminine faces of photographic modernity. As he ponders his different love affairs, he reflects: "Something of mine always remained outside of me: a foot, an

arm, a desire, a lump of sugar, my heart. . . . I envy Janus. I sympathize with him. Two semblances are worth less than one when both should smile or cry for a fixed time."[51] Janus is the god of looking, also called the god of doorways and passages, whose split face looks in opposite directions and contains both the tragic and the comic. His bidirectional gaze is like a camera that takes the photographer as much as the subject, and Delfino's split gaze never manages to see an integrated image of himself. *Margarita de niebla* similarly concludes with the disastrous end of Carlos Borja's affair with Margarita, and his return to the school where he first met her: "I have the strange sensation that, upon getting out of the car, I will find the silhouette of my body from that time beside the door, awaiting my return. Will it run into me?"[52] Carlos is broken into two like Delfino, and the physicality of his expectation that he might run into the early shadow of himself employs almost exactly the same terms as Mário's poem, "I Am Three Hundred." These photographically disarticulated narrators directly address their readers. Carlos interrupts his meditative narrative to speak directly: "Let me explain my attitude to you."[53] This disruption has no other function than to break the interiority of the first-person narrative. These fictions employ the same interior voice, the same first-person focalization, that would seem to distance the text from any reference to the outside world. However, this photographic point of view makes them the object and subject of the camera, splintering the gaze and rupturing fiction's hermetic remove.

Narrated glimpses from a sphere "outside" the text show the power of objects to overwhelm the focalizer-narrator and reveal that photography's indexicality can counterintuitively produce both literary and visual fictions.[54] The excess of the bellas artes públicas pervades both the photographic character of the fictions and their metatexual reflections on how language works. Torres Bodet's Persephone is "always thinking about that theory that cannot contain a single sentence. . . . *Owner of a look that is bigger than her eyes*."[55] She is a narrative that exceeds the sentence, a photographic gaze that overwhelms the eye. Persephone's excess offers a crucial insight into how the nontautological ethos of modernist fiction bridges the aesthetic and the ethical. For Cohn, historical narrative requires a process of selection from among an infinite number of possible facts while fiction is the result of concise and total invention. She argues that the self-referential world of fiction springs fully formed, like Athena from the author's mind, and includes only

what is necessary. In contrast, Norman Bryson observes that realist fictions—novels as much as paintings—require an excess of details that he compares specifically to photography.[56] If realist fictions depend on such an excess of details, even as they seek to produce an experience of narrative logic and continuity in the reader, the experimental fiction of the modernist avant-garde, with its reliance upon narrative strategies of collage, dissociative language, and stream of consciousness, produces an even greater excess of detail. The precision of photography's seemingly automatic mimeticism thus does not exclude Persephone's melodramatically excessive vision, and the process by which photographers weed out an infinite number of possible frames to select the desired image can therefore be understood as fictional. By emphasizing this photographic process of selection from excess—and the challenge to modern characters' eyes—these fictions bridge the interior focalization of the novels with an ethical set of decisions by the narrators, as well as the readers they address directly from time to time. In this formal strategy of photographic focalization, the writing of history meets the writing of fiction.

Torres Bodet emphasizes Persephone's association with photography, in marked contrast to other women characters who are described as painterly and cinematic. Like Novo's "prodigal daughter," Persephone is curious and urban: "the city visibly attracted her" and she frequently upsets her professors by asking too many questions and demonstrating a "lucid curiosity."[57] She further reveals her affinity with photography through her fascination with death masks and spiritism, both of which employed the camera. While spirit photography was very popular at the end of the nineteenth century, supposedly the revelation of latent images of the other world, by the 1920s it was widely accepted as fakery.[58] Stills from the "spirit film" *A Glorious Day* (fig. 56) are playful examples of this phenomenon, in which the author explains the photographer's trick.[59] Photographic Persephone exaggerates photography as a fiction tied to modern technologies of representation, and thus explodes the one-way capture typical of ethnographic and tourist photography. When Delfino struggles to name his obsession with her, he considers a number of mythological characters associated with the power of looking: Argos, the man cursed with one hundred eyes; Janus, the god of gates and portals who looks both forward and backward; and Narcissus, who falls victim to his own self-adoring gaze. Persephone constitutes a photographic look even more aggressive than the

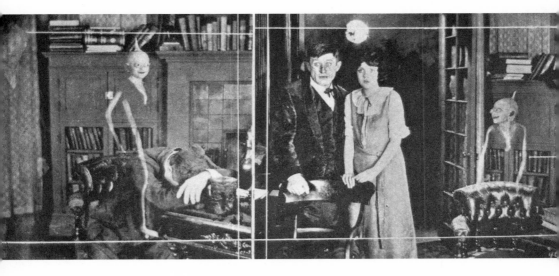

56 Detail, "The Spirit of Cinema," *Revista de Revistas*, June 18, 1922.

Biblioteca Miguel Lerdo de Tejada

split looks that these characters suffer: "For other women, memory is brought back to us in grades, the snapshot of a certain silent image, the foreshortening of a certain friendly attitude, the pressure of a delicate, warm hand. . . . With Persephone, on the other hand, memory assaults me on all sides, it encompasses me, it covers me, it pierces me with imperceptible arrows that destroy me like a plague."[60] The arrows of this photographic memory pierce the narrator, eerily resembling Barthes's later formulation of the *punctum* as the most important element of his favorite photographs, which "rises from the [photographed] scene, shoots out of it like an arrow, and pierces me."[61]

Barthes laments that this favored component—which provides the ontology of Photography—is nevertheless what most viewers fear as its potential madness and so seek to control. Yet he himself separates the subjective, personal punctum from the objective, historical component of the photograph, the *studium*. This separation of the historical and social knowledge from the meaningful and productive madness of the photograph also operates as a control on this madness. It privileges an imagined interiority of the photograph that Barthes locates not within the image but within the viewer: "Ultimately—or at the limit—in order to see a photograph well, it is best to look away or close your eyes."[62] He too fears the excessive visibility of the photograph,

the inscription on his eyes that Mário experienced, and which appears again later in this chapter as the experience of modernity in Mexico. Barthes theorizes an ideal viewer who is able to insulate himself from the very assault that Delfino experiences in the face of Persephone's photographic memory. His response to this threat is to attempt to break off contact with the "actual world," to seal up the narrator's point of view into an entirely subjective one. In Mexican modernism, in contrast, the photographic indexicality of these female characters alters the focalization of these fictions by penetrating their narrators with sharp traces of the real.

"Proserpina rescatada" shares a great deal with André Breton's *Nadja* (1927), a foundational reference for Barthes's thinking about photography, yet the two novels part ways precisely when they come to the ethics and aesthetics of the medium. Both are framed by male narrators who relate their experience of modern urban life through a by-now familiar photographic projection of desire onto a female character. Written within one year of one another, the novels formulate a modernist aesthetic through a fragmented, collagelike narrative. At the end of Torres Bodet's book, Delfino is unable to make order out of the photographic modernity he experiences through Persephone. Her photographic duality overwhelms him so much so that it remains always incommensurable with and yet ever present in the narrative of his life. On his return train journey from seeing her, Delfino confesses that "from each small window a countenance became visible that said aloud: 'Don't forget.'"[63] He remains trapped in a type of madness, caught in the simultaneous past-ness and present-ness of photographic Persephone, endlessly trying to "unite the fragments" of himself and of his story. Breton's narrator also encounters Nadja in the city and becomes obsessed with her, so much so that a similar transformative threat changes his first question, "Who am I?" into "Who is she?" However, Breton limits the photographic to a descriptive function: "The abundant photographic illustration has as its goal the elimination of all description."[64] This restriction profoundly affects the resulting fiction: despite experiments with narrative voice, photography, and surrealism, at the end of the novel it is not the narrator but Nadja who has gone mad and is locked away in an asylum. Although the narrator states that all confinements are arbitrary, his voice alone persists, ultimately protected from the presence of an uncontrolled photographic feminine. The focalization of the novel through the narrator's view of the mod-

ern world is never really threatened. He is impervious to the threat of a modernity embodied in the photographic femininity that was so graphically pictured in the "Fototrucos," and which threatens to break apart the narrators of Mexican modernist fiction.

In his review of *Nadja*, Torres Bodet attacks Breton precisely for his use of photographs: "He has interspersed, in the pages of *Nadja*, various photographs of his friends . . . and various postcards that represent the places in Paris in which develop that which, with certain benevolence of the imagination, we could call his plot."[65] Torres Bodet translates *Nadja* from a shocking, avant-garde narrative into a banal tourist album and argues that Breton's text lacks any *liberatory* artistic force. Breton imposes his own control on the hija pródiga, in contrast to the mujeres libres y libertinajes who populate the Contemporáneos' fictions.[66] Two different fictional worlds grow out of the opposite effects of photographic focalization on these narrators: Breton's narrator remains safely protected from what Barthes terms the madness of photographic looking, while Torres Bodet's is overwhelmed by Persephone's photographic femininity. The focalization of Mexican modernist fiction combines the interiority of the first-person and third-person narratives—and the questionable images they produce—with an indexicality that inscribes the looker as much as the object viewed. In them there is no looking, no photograph, that does not simultaneously alter the perceiving eye.

Focalization through such vulnerable narrators alters the status of the modernist work of art; these narrators address an extratextual sphere that writes upon them. The letrados are pierced, confused, and unraveled by their repeated pursuit of modern women. What is more, they are made into objects: like photography's basic mechanism, by which light reflects off objects and inscribes sensitive film, these narrators indexically record the tensions of the changing postrevolutionary world. The result is the foggy, imaginary world of modernist fiction; as within the camera, the picture of the world is reversed, altered, often blurred, and collapsed from three to two dimensions. The ethos of photographic modernism in Mexico is defined not by its abstract or mimetic character, but rather by this evident impossibility to contain the modernist object. These fictions reach outside themselves like the essays of the previous chapter, but more than through a winding narrative path, their very focalization and characterization exceed the limits of the "purely" aesthetic or exclusively fictional.

Photography, Narrative, and Time;
or, What Is Congealed Movement?

If a similar process of selection from detail structures the focalization of history and realist fiction, and photography maintains its documentary touch even as it invents, what do these photographic, modernist fictions do to history? What do they do in particular to the ponderous weight of revolutionary history that was the inevitable center for debates about culture during these decades?[67] While the overlaps between narrative fiction and photography have guided this discussion until now, we shall see that through the deployment of photographic time in these novels, Mexican modernists disentangle fiction from narrative.[68] Photography's narrativity dominates cautionary warnings about the use of the medium in Latin America and discussions about its potential for political resistance. Whereas some theorists favor narrative photography as a means of creating pluralistic histories, others characterize it as a repressive mode of Western metaphysics.[69] While neither narrative nor nonnarrative photography in itself can be celebrated as the proper political response to a history of colonialism, the temporality of photography in these modernist fictions composes a reversibility and a freedom of movement that lead to ethical critique and aesthetic experimentation.

Comparisons of the visual and the literary arts, especially those that address photography and film, often name temporality as the key characteristic that separates the two. Seymour Chatman states that for any work to be considered narrative, it must "*temporally control* [sic] its receptions by the audience. Thus, texts differ from communicative objects such as (non-narrative) paintings and sculptures, which do not regulate the temporal flow or spatial direction of the audience's perception." Painting and sculpture — and photography — require readings that present themselves "all at once," ascribing the temporality of the picture only to the "spectator's work in perceiving the painting . . . it is not part of the painting itself."[70] According to Chatman, true narratives require a filling in when interrupted, a reader's explanation of what has happened in the interim; there is a logical temporal contingency inherent to narrative that results from a collaboration between reader and narrative structure. Rimmon-Kenan opens up the idea of textual time in narrative slightly more, describing "time as the textual arrangement of the event component of the story . . . strictly speaking,

it is a spatial, not a temporal, dimension. The narrative text as text has no other temporality than the one it metonymically derives from the process of its reading."[71] Rather than grant literature a dominant role in theorizing narrative, we can say that the spatiality of the written text shares at least an equal partner in the structuring of the visual image. Whether learned or instinctive, the recognition of three-dimensional spaces in two-dimensional photographs requires a process of interpretation—nonnarrative "reading"—based upon clues such as focus, size, and lighting.

Nonnarrative reading of visual materials does not follow the spatial temporality of textual reading: its most simple and unrelenting demand of moving from left to right (in Spanish, Portuguese, and English). This textual movement shares rather more with film than with photography, and in fact, scholarship about the impact of new visual technologies on avant-garde literature often refers to the fictions as "cinematic."[72] Even so, when describing the filmic nature of the Contemporáneos' fiction, Coronado writes: "[Gilberto] Owen sows a visual discourse instead of following the traversal of a true narrative time. *Novela como nube* is modern cinema, that which denies its essence of movement and freezes in the composition of images."[73] This strange construction begs the question: what is the difference between "frozen" cinema and still photography, especially when represented in literary texts? Which incursions of the visual arts can be understood as cinematic and which as photographic?[74] The answers to these questions ground the historical and ethical location of photographic fiction, and once again the gender of modernity (and modern temporality) is feminine.

The sophisticated visual tropes in these works require a more precise determination of what constitutes a "moving image." One of the major arguments for a cinematic reading of the strongly visual component of these fictions is Russian avant-garde filmmaker Sergei Eisenstein's presence in Mexico from 1930 to 1931. The making of his film *¡Que Viva México!* was featured frequently in *El Universal Ilustrado* and *Revista de Revistas*. However, Eisenstein never completed the film, so it was only ever seen as stills in these illustrated journals. The fact that these images never flickered on screens in these years does not mean that they remained still. As we saw, Novo's "El arte de la fotografía" emphasizes the movement of photography: the prodigal daughter "marches happily through the streets, goes on excursions, exercises, 'curiouses.'"[75] Indeed, in comparison to painting and cinema, by the late 1920s the camera was

portable and quick. Moreover, the photo viewer is encouraged to wander through an exhibit or flip through a book out of order. In contrast, the film audience is immobilized, seated, and experiences a controlled narrative time. Torres Bodet might say that cinema is "less liberatory" than a series of photographs. After leaving Persephone, Delfino despairs: "I still cannot unite the fragments, all the loose pages of the unbound book, of the almanac in disorder that scatters over my memory of our life in New York."[76] Vela writes in "La señorita etcétera," that despite spending many days wandering the city, the narrator still does not retain any coherent knowledge of it. The employment of photographic time in these novels does not permit a smooth succession from scene to scene; each still denies any cumulative ordering of memory and history. The movement of photographic fictions composes a nonnarrative temporality that is historical, an inscription of a moment in time, but that cannot be ordered.

In "Proserpina rescatada," Delfino celebrates the liberation of narrative time from the (un)necessary linkage between the metonymic sequence of words and the logic of narrative linearity. To make himself feel sure of the destiny of his forebears, he does some gymnastics around his room: "I am like a perfect sentence, a succession of syllables of which no one could change the order. For example: *Dábale arroz a la zorra el abad*. I read myself, several times, in one and another meaning of the line. I am pleased not to have a forward or backward."[77] Delfino does not deny the spatial relationship between neighboring words on the page, but using a classic palindrome he insists that their meaning be legible in both directions. Narrative time as such order does not create the real meaning of the text. Despite the absence of traditional novelistic time, a metonymic reading of all of the sections creates a meaningful text. These fictions are like photographic negatives, which contain the same elements even when viewed backward as the inverse of the positive print. Cinema denies precisely this reversibility of a series of still photographs: photographs can be collected, stacked, flipped through in whatever order the viewer pleases, while cinema, even Eisenstein's experimental montage, must obey the inexorable "forward motion" of film.

In Torres Bodet's "Primero de enero," as the first light of the first day of the year enters his window, Gonzalo remarks that some years are "varones" (masculine) and others are "hembras" (feminine). On the titular January 1, he proclaims the entry into a femininized, popular epoch: "The one that had just penetrated the room, through the park

window, silent Fantômas, not even bissextile, had the most feminine style of breaking with tradition. It masked apparent temerity with the audacity of a man, a subterranean tenacity, passive, the resignation of a woman."[78] The popular French comic book villain Fantômas, who was even given the honor of a Mexican reincarnation in the 1960s, was a crucial crossover point between avant-garde and popular culture on both sides of the Atlantic. Here, Torres Bodet connects the comic book to the idea of an "año hembra" and shows that the mass popular femininities set loose in the city shape even the time of modernity. The dawn of this girlish year creates a kind of photograph of the narrator's room: "The room was inundated with mist, with incrustations of mother-of-pearl, of pale silver. Nothing black nor white. Gray on top of gray."[79] Many of the modernist authors created fictions composed of a series of similarly stilled black and white spaces. Like "Dama de corazones" and "Primero de enero," Vela's "La señorita etcétera" is divided into a series of short sections; it does not develop a plot but rather charts out a series of different spaces for fictional inhabitation, each one becoming a frozen "home" for the first-person narrator. As seen earlier, the relationship between the different sections of the story is not one of cause and effect. Instead, it is comprised of collages that do not lead the reader to a deeper understanding of the character's inner development. The fictional time of avant-garde prose is photographic and feminine, with all of the contradictions that these terms will signify for a cohesive narrative of the modern nation.

Visible Photographs of Invisible Bodies

The fictions by Estridentista and Contemporáneos authors employed photography to reimagine the space of fiction and alternatives to the logic and temporality of narrative. Photographs by Manuel Álvarez Bravo were similarly both fictive and documentary, at times narrative and yet rarely just illustrative. Álvarez Bravo's photographs appeared in illustrated journals and art galleries and were of interest to members of both modernist groups. While he occasionally made use of narrative strategies in his photographs, as in the journalistic "Striking Worker Murdered" (fig. 57), more often he created fictionalized situations within the composition of photographs without a clear development of a story. The catalog for the exhibition of Álvarez Bravo's photographs

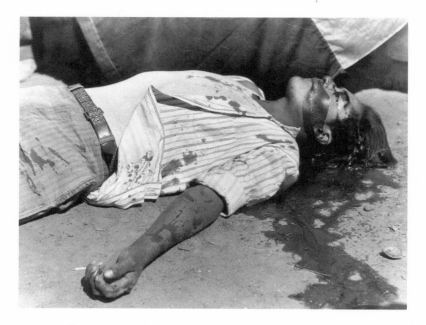

57 Manuel Álvarez Bravo, "Striking Worker Murdered" ("Obrero en huelga asesinado"), 1934, gelatin silver, 19.1 × 24.1 cm. *J. Paul Getty Museum, Los Angeles.* © *Asociación Manuel Álvarez Bravo AC*

at the Sociedad de Arte Moderno in Mexico City in 1945 presents their ephemeral, otherworldly character, as well as their ability to bridge this hermetic world with the modern one in which the photographer lived. His work is "an expression of the worries and progress of man and of the current world, as contemporary language that has achieved a rich vocabulary and great literature."[80] Much of the criticism about Álvarez Bravo's photography, however, employs airy language similar to that surrounding the prose by the Contemporáneos and stresses the same kind of removed aesthetic.[81] While this accurately describes one vein of Álvarez Bravo's work, he himself described the poetic and the documentary as complementary rather than opposing aesthetics.[82] The combination of the two, even in a single photograph, creates documentary fictions that invent and tell the truth, mimetically capture and abstract the subjects they contain.

Photographs can function similarly to literary and filmic narratives, but their fictive quality is not dependent upon this ability. The fictive potential of photography in "Sand and Little Pines" becomes explicit

in "Historic Plot" (fig. 58). Shot from above like an evidentiary crime photograph, the image reveals the traces of a familiar story, including a crown of thorns and a bouquet of white flowers dropped on the ground; the vertical line of a rope implies an ascension. The props in this photographic drama motivate a questioning of belief and truth: the word *trama*, like its English equivalent *plot*, conjures up not only a story but a deception as well. The frayed strands of the rope make it appear as much like the tool of an escape artist as the metaphorical representation of Christ's ascension. This photograph is a particularly apt one to separate the idea of fiction in photography from its narrative capacity. Although there is no narrative action in "Historic Plot"—no implied movement nor any precise event implied—some fiction is pictured. The fiction refers to what is outside the frame of the photograph: the ascension is *toward and beyond* the frame of the image. This movement interrupts the fiction of photography's mimeticism by drawing

58 Manuel Álvarez Bravo, "Historic Plot" ("Trama de la historia"), 1930s, gelatin silver print, 24 × 16.7 cm. *The J. Paul Getty Museum, Los Angeles. © Asociación Manuel Álvarez Bravo AC*

attention to the cutting action by which the photographer selects what should fit within the image. Leading the viewer's eye beyond the image frontier brings the space outside of the photograph into the visual experience. "Historic Plot" thus produces visually the double meaning of the titular "historia" in Spanish, as both history and invented story. It moves the eye and the imagination back and forth between document and fiction, real and invented.

These fictions emerge in part from Álvarez Bravo's emphasis on the estrangement produced by the very framing act of photography.[83] In 1933, Waldemar George wrote that photography presents "still lives of dispersed or isolated objects, objects of use, accessories of life . . . *separated from their locale* . . . these companions of ours of everyday aquire a new life and lay the ground for interminable dialogues among themselves."[84] These photographed objects take on a dynamic, invented life of their own. Fernando Leal compares Álvarez Bravo with Henri Cartier Bresson, whose exhibition opened on March 11, 1935, in the Galería de Exposiciones del Palacio de Bellas Artes. Both artists, he wrote, attempt to make photography more expressive through experiments with light, development chemicals, and perspective. Cartier Bresson uses the camera as "a revelatory document of the most extraordinary reality," in order to make dramatic photographs of brutal and coarse "obscenities." The contrast between the stillness of the photograph and the drama of the event makes reality itself appear absurd. Yet he adds that if "Cartier Bresson interrupts life, Álvarez Bravo animates still lives."[85] Despite the disruption of estrangement, the primary referent of Cartier Bresson's work remains the "real" world. Álvarez Bravo's photography creates new worlds without manipulating the negative or the print; he creates fictions as he animates objects.

Photographic theory and modernist fiction from the period share a fascination with the meaning and power of objects. Francisco Miguel, another contemporary of Álvarez Bravo's, finds his photographs to be indexical and poetic, abstract and documentary. They share more with the New Objectivity, a German realist movement, than Weston's North American abstraction: "It is the precise form of things, their mimic [*sic*] details, their linear contour, closed mass and tactile sensation. . . . in Álvarez Bravo's photographs we find all that, also combined with a slight, vague abstraction which endows his experiments with an imprecise but intensely poetic aroma."[86] The creation of fictional photographs thus returns to earlier questions about abstraction and modernist represen-

59 Manuel
Álvarez Bravo,
"The Washerwomen
Implied" ("Las
lavanderas
sobreentendidas"),
1932, gelatin silver
print, 24.3 × 16.5 cm.
*The J. Paul Getty
Museum, Los Angeles.
© Asociación Manuel
Álvarez Bravo AC*

tation in Latin America. More recently, Olivier Debroise also contrasts Álvarez Bravo with Weston's formalism, for "Manuel photographed inhabited space."[87] Debroise productively differentiates between the ideal of pure abstraction of North American photography — its emptied frame — and the aesthetic of Mexican modernist photography.

Many of the spaces shown in Álvarez Bravo's photographs, however, only *appear* to be inhabited. Villaurrutia describes the illusion in the epigraph to this chapter: "Manuel Álvarez Bravo makes it possible that before his best photographs we find ourselves facing true representations of the unrepresentable, facing true evidence of the invisible."[88] Álvarez Bravo's oeuvre reveals a fascination with creating photographs of the invisible, a preoccupation that closely resembles Mário de Andrade's repeated photographs of wind. "Absent Portrait" ("Retrato Ausente," 1945) pictures an empty dress draped upright on a chair; it reminds

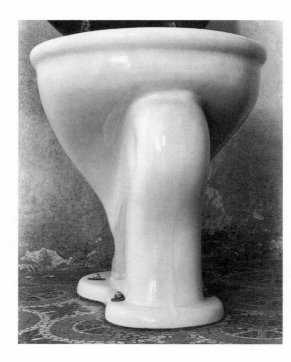

60 Edward Weston,
"Excusado," 1925.
*Collection Center for
Creative Photography.*
© *1981 Arizona Board
of Regents*

the viewer that despite the figurative precision of photographic por-
traits, they always indicate the physical absence of the person pictured.
"The Washerwomen Implied" (fig. 59) reveals that this meditation on
photographic presence and absence has a parallel in society's erasure of
certain types of labor; the washerwomen are understood (*sobreenten-
didas*) to exist, for the drying sheets signify that work has been done,
but the women's bodies that do the work are erased. These images of
the invisible are fictions that invent while obscuring their subject, yet
they reveal a truth about the erasure of certain forms of labor. Álvarez
Bravo's photographic fictions thus present a distinctive form of abstrac-
tion, as Debroise suggests, but one that maintains the work's location in
the social (ethos).

Álvarez Bravo actually pokes fun at the pure, abstracted representa-
tion of everyday objects by Weston. He puts Weston's highly formalist
"Excusado" (1925, fig. 60) to use by the "Urinating Boy" (fig. 61). Here
there is no doubt about the function of the same sort of object that
Weston describes as: "that glossy enameled receptacle of extraordinary
beauty . . . Here was every sensuous curve of the 'human figure divine'
but minus the imperfections. Never did the Greeks reach a more sig-

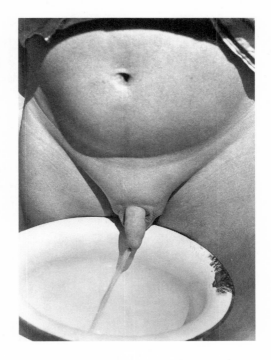

61 Manuel Álvarez Bravo, "Niño orinando" ("Boy Urinating"), 1927, gelatin silver print, 24.6 × 17.4 cm. *The Metropolitan Museum of Art. Ford Motor Company Collection, Gift of Ford Motor Company and John C. Waddell, 1987 (1987.1100.500) Copy Image* © *The Metropolitan Museum of Art.* © *Colette Urbajtel*

nificant consummation to their culture, and it somehow reminded me, forward movement of finely progressing contours, of the Victory of Samothrace."[89] While Weston may not have been entirely serious in this ode to the toilet (he did write to Álvarez Bravo that he particularly liked his "Urinating Boy"), his photograph is generally reproduced in English-language publications with its Spanish title, *Excusado*, as if the translation into English might make the real function of the photographed object too obvious and so undermine its formal purity. Álvarez Bravo's photograph does not lack formal interest: the same rounded shape and smooth ceramic of the improvised toilet provides the important white reference point in the black and white photograph. The close-up of the child's penis as he urinates repeats the photographer's interests in the folded shapes seen in the sheet of "Absent Portrait." The folded skin of the body works as another investigation into photography's eye for surfaces, its imperfect ability to arrive at a representation of subjectivity that is only ever skin deep. Álvarez Bravo reveals that this focus on form in no way requires the abnegation of the use value, the life, of this most useful object.

While a theory of modernist photography that combines the inven-

tion of fiction with the exaggeratedly quotidian use of Weston's toilet may seem a contradiction in terms, the mixture is precisely the intersection of ethics and aesthetics I have been calling ethos. Like the narrators of the novellas, who presented the intimate and mutual inscription of their "point of view" by and upon the objects that surround them, this photographic aesthetics of form and use, fiction and document forms the basis for the ethos of modernism. Modernist photography in Mexico combines the stillness and resulting "objectness" of the image with the promise of some kind of a plot. This kind of modernist object maintains a relation to social reality and promises a fictional alternative to documentary truth.

Documentary Fictions as National Literature

The utility of art and culture was at the center of discussions over postrevolutionary aesthetics, though the modernist fictions discussed here are rarely if ever included on the "useful" side of the debate. Even so, core issues of the urban subject, modern circulation, and the place of Mexico in the changing geopolitical landscape do appear in these novels. They range from fictional stories to semifictional memoirs to travel diaries and deploy photography's broad range of social locations and artistic possibilities, as well as its ambivalent relationship to the truth. Biographical and autobiographical details about the authors and their friends, often unnecessary to the plot of the story, occupy even the purest fictions with a documentary push.[90] Rather than drag the texts into the realm of truth, they balance like photographic fictions on the edge between the two. These narratives present an ethos of modernism as documentary fiction and articulate a heretofore unrecognized formulation of nationalism in postrevolutionary Mexico. While this is not literature in the service of nationalism, the nation nonetheless appears as a site important to the ethics and aesthetics of modernism.

At the end of "Dama de corazones," having failed to marry either of his cousins, Julio prepares to leave the rural town to return to the city. He fantasizes about how to capture the experiences narrated in the novel, using precise, photographic terms:

> I pack my luggage slowly, seeking to pull out of each thing the painful pleasure *of an index*, although it may be small, that would help me to fix

a moment of my stay in this house. Now each thing is like one of those photographs that we keep without wanting to, and that with time, upon finding them casually some day, surprise us because they have acquired a precise value, historical, that causes damage. Within me is beginning to be born, even today, the past that I didn't want, that I didn't ever think about having.[91]

The indexicality of the photograph—and here Villaurrutia writes contemporary photographic theory *avant la lettre*—pervades each object that Julio packs. Each is a document of a particular memory that acquires a weight that overwhelms the narrator. Yet even these indexical recordings do not maintain a perfect documentary function. The transformation of the indexical inscription into fiction is particularly poignant as Julio packs his mirror: "I take the small mirror and I enclose it quickly in the suitcase with the hope that in another place, upon seeing it again, it may still conserve the last image, the piece of cloth the color of tobacco that it has copied daily for three months."[92] Employing the classic description of photography as a mirror with a memory, the sepia tones of the imagined reflection underline the constantly changing nature of even that memory contained in the photographic image. Avoiding the oversimplification of photography into a moment frozen in time, Villaurrutia points to the gradual fading of the photographic object from the stark contrasts of a new print to the blurred lines of an old photograph, from black and white to tobacco-colored sepia. Even as they become memories that are painful in their precision, photographs always border on the invented or the fictive. Julio remarks: "Now I also have something to tell my friends with the same words that sound like a lie, something that will not be the anecdote that took longer to invent than to forget."[93] The embedded truth and lies of photographic memory are composed out of the negation of falsehood rather than the assertion of truth. In photographic documentary fictions, objects and places gain the ability to inscribe their presence on the narrator himself, yet neither the objects nor the memory remains faithful to a stable representation.

The shifting reflections of these photographic inscriptions operate as instruments of writing future desire as much as memory. At the train station, Julio sees people "with eyes wide open that already contain, now, the landscape of the place of destination. This one contains the sea of Veracruz in her eyes; that one, the wooden houses of Laredo."[94] We

must assume that the narrator of "Dama de corazones" also carries his destination imprinted on his eyes, as much as he carries objects engraved with indices of the past. The focalization through Julio's eyes inscribes the past and the future, equally imaginary realms that remain simultaneously within and outside fiction. The social location—Mexico as both Julio's imagined past and anticipated future—burns a photographic image into his eyes that begins to fade as soon as light strikes it.

These invented memories and desires gain the status of fiction rather than of lies, creating a modernist ethos without the tautological self-evidence that Aníbal González finds in ethics and fiction. "Dama de corazones" begins with a description not simply of deceived senses but of fictional ones. The first words of the novel are: "I have been awake for a while. I don't dare any movement. I am afraid to open my senses to an almost forgotten life, almost new for me. I have my eyes open, but the darkness of the room is bent on demonstrating to me that it is completely useless; on the contrary, closing them, pressing them, little lamps are lit, sprinkling, humid, small colored flutes that revive in me the lights of a distant port, at night, on board."[95] Julio experiences the sense of vision without object and without light. By squeezing his eyes open and closed, he sees fictional images that are a vision of nothing in the darkness, but that nevertheless produce a memory (of travel) and a real visual experience. If photography is "writing with light," as its etymology and technical mechanics affirm, in "Dama de corazones" we see photography as the seeing eye, inventing and inscribed by the objects it sees and its unseen desires.

Familiar Picturesque, Pretend Desire

In "Return Ticket" (1928), "El joven" ("The Youth," 1928), and *Continente vacío* (*Empty Continent*, 1935), Novo's autobiographical narrators are similarly inscribed by travel and desire. These short novels frame travel writing as the genuine expression of experiences of self-discovery, as a crucial genre in postcolonial places, and as the opportunity to experiment with the very notion of truth and lies in fiction.[96] Many of the characteristics of apprentice tourism appear in "Return Ticket," which tells of Novo's trip through California to Hawaii and also explores his sexuality. Like Mário, Novo complains about travel and longs for his familiar routines; flipping through his diary, he wonders, "Perhaps out

of this a book could be made, my first book."[97] Again the narrator of the travel diary draws attention to the awkward position of the Latin American modernist, trapped between West and non-West, in Mexico City looking both toward Paris and toward Querétero: "The train goes along the very well known [*conocida*] route of San Juan del Río, Querétero, Irapuato. . . . I already know [*conozco*] all of these people. These unfamiliar [*desconocidos*] types, dark, picturesque, good for easel painting, are the most vulgar that one can find. There really isn't anything to write in my diary."[98] The humdrum familiarity of the exotic operates here as a writer's block. The paradox is clear in Spanish, for Novo uses the verb *conocer*, meaning "to know a person," to describe his simultaneous familiarity with and estrangement from these "dark types." Novo's racist description cannot be ignored; it even augments the discomfort of his position. Nonetheless, later in the same journey he draws comparisons between Hawaii and Mexico: their relationship to the United States's economic and political power, and their own injustices against the original occupants of the land. He satirically repeats facile comparisons of the "tropics," while at the same time making convincing parallels between the two as semicolonial possessions of the United States: "There are also papayas here like in Mexico! And, like in the House of Tiles, one lunches on them with lemon and a spoon. . . . They also offer mangos on the menu, which seems quite natural."[99] Immediately after this silly observation Novo gives detailed information about the political, economic, and social structure of Hawaii, and its implications for understanding Mexico's social inequalities. The familiar picturesque of the travelogue reveals the discordant knowledge held by the Latin American modernist, which both repeats and contests the discursive inheritance of colonialism.

Torres Bodet reflects further on this now familiar anxiety about the "exotic" desires that are constitutive of travel writing and pervade modernist prose. "Estrella de día" parodies both Hollywood's gaze toward Mexico and the European habits of the Mexican elite. The young Mexican film star Piedad Santelmo suffers this misguided touristic desire:

> Anxious to submerge her in that bath of "local color"—100 percent Mexican—they deprived her of all the delights, of all of the customs that had constituted patriotism for her: her own environment, the religiosity of her mother, the climate of her discrete province, the song of her indescribable Mexico. They gave her a *rebozo* [shawl], a *jícara* [gourd]. To her! Who had

always ordered the most European hats in stores! To her! Who always served fruits—while they may have been pineapples, mangos, oranges—in anonymous trays made of crystal!"[100]

He marvels that U.S. Americans looked at Piedad as Montesquieu saw the Persians, and like the English saw Madame Butterfly. Yet Torres Bodet does not deny the possibility of some genuine national identity: "Her Mexican vein ran in other places, subtle, where the North Americans didn't look for it."[101] He pairs a critique of exoticism with Eurocentrism as twin concepts, ultimately in order to maintain the possibility of a genuine relationship with a place. This vision of the local is captured only unintentionally within the frame of film stills of Piedad wearing a rebozo, and is the same subtle site from which Torres Bodet critiques representations of exotic Mexico by foreigners and by Mexicans themselves.

Photography—as mass media, tourist tool, and art—allows the capture of this doubled image of self as exotic other, with a disguised, subtle index of place. Crucially, it does so without promising the truth of its own representation. Novo's fictionalized memoir, "Return Ticket," builds on the photographic power of the vedettes, the performance of a scandalous and widely disseminated image of desire and sexuality, to create fictions that exist in the fold between ethics and aesthetics. His may be the most extreme and successful example of a modernist fictional ethos that bridges these realms. Along with fellow modernist participants in the gay "Ambiente," Novo uses "specific 'real-world'" references in experiments with avant-garde fiction to create documents that reveal and obscure his sexual identity. In this memoir, Novo changes names and alters and invents events because of the prohibition against publishing a memoir about his homosexuality.[102] Nonetheless, Novo was never shy about his sexuality, and created a truly incredible public persona of an engaged, public, gay intellectual. He posed in photographs and in texts with plucked eyebrows, eye makeup, and an affected voice that Monsiváis would call "rarito," or queer. The performance of his sexuality operates as a nexus between fiction and documentary, exhibition and secret, and it pervades Novo's varied literary practices. Novo's performance of queerness was much more public than Mário's, though he did hold his tongue to some degree about being "entendido" ["understood"], specifically the unspoken understanding of one's homosexuality.[103] More than just participating

in eye-catching behavior, Novo makes his queerness an intellectual difference from contemporary formulations of nation, aesthetics, and politics, and thus helps to understand the relationship between critical nationalism and sexuality. These memoirs and Novo's other homoerotic writings are part of a carefully constructed public persona that allowed him to compose a hybrid and complex nationalist modernism. Novo pretended desire in both senses of the word: his presentation of sexuality was highly performative, and yet he struggled to have this form of knowledge recognized as a defining element of his profile as a letrado.

La estatua de sal (The Statue of Salt), the memoir that Novo always wanted to publish but that only appeared posthumously in 1998, is full of stories about queerness. It narrates the invention of obscene nicknames, extravagant characters, and public interactions in which el Ambiente deployed their sexuality as what Monsiváis calls the catalyst for social revolution on a small scale. Novo draws explicit connections between his most crucial intellectual and aesthetic stances and his sexuality. His split with his prominent mentor, the Dominican writer Pedro Henríquez Ureña, which has been ascribed to philosophical differences about a pan-American identity, instead is the result of forbidden and repressed desires. One afternoon, he recalls, Henríquez Ureña uncertainly tried to seduce him but retreated in fear. That same day, he had received a "treatment" for "hemorrhoids and other posterior ailments," and upon leaving Henríquez Ureña's office after the failed seduction: "To my disgrace, I failed to notice as I left that the roll of cotton which Dr. Voiers had deposited in my ass a few hours before had slipped out and worked its way down my pants leg to the floor. There I unknowingly left it as concrete evidence of my wrongdoings. It must have infuriated poor Pedro, for the favors he once showered upon me gave way to a furiously belligerent enmity."[104] While his intellectual differences with Henríquez Ureña were very real, his memoir also links their intellectual divide to his homosexuality.

In so doing, Novo allied himself with the disturbing hybridity of the bellas artes públicas. The participation of the Mexican avant-gardes in mass media, as we have seen, was quite different from the mining of mass culture for the production of an aesthetic practice itself distanced from that culture, and it challenged the moralism of the postrevolutionary state. Novo proudly admits the pleasure he derived from his lifelong participation in popular publications, and in so doing collapses the two moral extremes of effeminacy: "I don't deny the fact that be-

fore me, and after, writers have shared the slow, hidden, and heroic elaboration of their true work with journalism: clandestine *maternity* with public *prostitution*. I simply confess, relatively apologetically, that the prostitution grabbed hold of me, a circumstance about which the hope to have ennobled it a little bit consoles me."[105] If a feminine ethics here configures the divide between high and low culture—the legitimate birth of elite art versus the licentious, bastardized popular—Novo places himself alongside the mujeres públicas and the prodigal daughter of fine arts.

How did this visually effeminate, declaredly prostituted man dominate the cultural scene during and after the postrevolutionary period? The popularity and state support he enjoyed make his story even more noteworthy. The biography of Novo that appears today on the Web site of the Secretaría de Educación Pública (SEP) for use in primary and secondary schools lists his governmental jobs: head of the editorial department of the SEP (1925), director of the Department of Theater of the Instituto Nacional de Bellas Artes (INBA, 1946–52), and head of the Department of Public Relations of the Secretaría de Relaciones Exteriores. He was inducted into the prestigious Academia Mexicana in 1952, won the Premio Nacional de Literatura (1967), the Premio de la Ciudad de México, and was named the Cronista de la Ciudad de México (1961). Even in this official narrative for school children, the radical aesthetic and ethical interventions of Novo's autobiography sneak in. The Web site states: "He was frequently inspired by autobiographical themes and showed the author's emotions through the use of irony, and the employment of varied expressive forms."[106] While there is no mention of Novo's life—which for him was always remembered *as* his homosexuality—the paradoxical description of irony as emotion rather than critical distance is accurate. However, classic definitions of the emotional excess of melodrama preclude ironic self-detachment, even as they admit that it reveals the preoccupations and aesthetic decisions central to (Western) modernity. The modernist as much as the "sophisticated" postmodernist may experience some pleasure in the emotion evoked by melodrama but is unable to surrender to it fully.[107] The SEP's public school lesson about ironic detachment and emotion, precisely during the period when Mexico's modernity was being debated by the state, the media, and the modernist avant-garde movements, brings us once again to the role of melodrama as a site for mass-cultural dialogism.

For Novo, the ethos of modernism is dialogic and melodramatic, ironic and enjoyable. He exults in melodrama as he describes his pleasant encounters with the beach boys who work at his hotel in Hawaii:

> Oh, my first contact with the ocean! I advanced, holding the hand of my instructor. Slowly it swallows me, sweet tongue of temperate fire. I am already entirely yours. It enters in my mouth, it squeezes my head, fills my ear with profound rumors. It lifts me in its multiple hands and my arms look in vain to grasp it. I abandon myself either to float or sink. I am not swimming! I am not here for everyone else, nor want to show off, nor have any purpose, not the desire to learn to swim, nor anything else. In vain you tell me, oh wise instructor, that I move my arms. I don't want to go anywhere. . . . He quits teaching me and we chat in the water, pieces of conversation, while I float like a bottle he does pirouettes in the water. . . . He is toasted by the sun, but when he takes off his blue bathing suit, he has another white bathing suit of his own flesh.[108]

If Novo rejects the colonial conclusions typical of travel writing, his autobiographical texts do take advantage of the self-discovery typical of it to relate obliquely the story of his own sexual awakening. The melodramatic tone and style of this "true story" exist alongside bitterly ironic observations about the power of the United States and his own role as a functionary of the Mexican government. Immediately before this passage, Novo drily relates his exchange with the U.S. governor, Wallace Rider Farrington, and mocks his own recitation of the achievements of the revolutionary government, especially in public education. Just after this passage, returning to his room in the hotel elevator, Novo admits that he will not swim in the sea again, but instead will put on his bathing suit, climb into the bath tub, and move his arms around in the water: "I have always preferred imagination to reality. In the elevator that descends to the beach there are warnings: UNDER NO CIRCUMSTANCES WHATSOEVER WILL BEACH BOYS BE ALLOWED INTO GUESTROOMS."[109] Novo's melodramatic memoir displays his ironic preference for fantasy, which like a photograph of desire is imprinted in the text and on his eyes.

The representation of homosexual desire in Mexican modernist avant-garde fiction is not limited to Novo's work; it emerges in two clearly photographic moments in Villaurrutia's "Dama de corazones." In the first, a simultaneously documentary and fictional technique breaks the novella's modernist haze of "fogginess," and for the first time a pre-

cise date is given: May 1. At this moment Julio remarks: "In an instant I remember, for the first time, in a sudden illumination from childhood, the strange manner [Dr. Batista] had of caressing me when I was a boy."[110] It makes sense to read this as an early homosexual awakening rather than a memory of abuse, both because of the narrator's comical description of Dr. Batista "consuming more than smoking an enormous cigar," and since the doctor appears to be more fearful of himself (and his desire) than the narrator is of him. This startling memory leaps to Julio's mind during Madame Girard's funeral, reminding him of a dream he had about his own funeral. He pictures a service in which his friend Jaime—a reference to the real-world Torres Bodet—gives a eulogy: "He remembers our chats about literature, and the sentences of the modern novel that we played at inventing with an art close to vice, with a perfect art . . . and ends with a sentence perfect for its brevity, offered in slow motion as if his intelligence had obtained it by photographing it with a high speed camera."[111] The eulogy itself becomes a theory of the modernist novel: as a perfect exemplar of an ideal text, it employs the slow motion of a camera to create both a photographic document and an imagined phrase. Reviving the medium's association with death, these two funerals trigger photographic moments in the fictional texts: the clear memory of an early homosexual encounter, and the brief interjection of a real-world referent into the novel. The documentary fiction is double, for it exists both within Jaime's eulogy and in the reference to the real author within Villaurrutia's novel. The two funerals present a definition of modernist fiction as the perfect imperfection of photography, framed in tales of the narrators' (forbidden) sexual awakening.

Like Álvarez Bravo's photographs, these texts enjoy the invention of fiction, which allows modernist art to gesture toward and beyond its limits. The visible and trampy melodrama that Novo cultivates in his prose fiction and mass-media publications creates a particular formulation of the bridge that ethos represents between ethics and aesthetics. While he includes himself as "rhetor" in the self-referentiality of these writings, an important part of this "I" is always deferred. He cannot explicitly name the sexual desire that drives the narratives, so that, as Delfino explains, "something of mine remains outside of me: a foot, an arm, a desire, a pot of sugar, a heart."[112] Like many of the narrators of these short novels, Novo resolves this dilemma by performing—as self-consciously as the vedettes themselves—the images of modern

femininity. In these poses, he refuses a facile understanding of the role of the arts in mediating the ethical and the aesthetic and manages to keep one foot in each world. Frequently deploying an ironic melodramatic mode, Novo establishes a connection between fictional and actual worlds.

Critics of the literary avant-garde have noted the novelty and influence of what Hugo Verani calls Novo's "hybrid" prose, even if they have not linked it directly to his display of sexuality. Verani argues that "Return Ticket" "brings a radical change in perspective: he tries to be an objective chronicler who applies resources from the social sciences, he cites his sources of information and accumulates data . . . but the facts that he observes stimulate a displacement of documented reality to interiority and self-reflection. . . . [He creates] a new literary form, narrative without fiction, an intermediary genre between the novel and the document that constitutes a central line in contemporary Latin American narrative."[113] Verani recognizes the paradoxical displacement of reality that the documentary turn of Novo's prose produces. To be clear, this fiction is not the pretense of heterosexuality, but rather a fiction made possible by the explicit and unstated performance of homosexuality. This narrative aspect is less important than the fiction itself, one composed in the poses and fantasies that Novo found and produced in the photographically illustrated magazines and mass culture in general. We might imagine "Return Ticket" as one of Novo's many photographic poses, like Álvarez Bravo's serious portrait that is reproduced on the cover of *La estatua de sal*: eyebrows plucked, face lightly powdered, eyes with a hint of makeup. The writer's thumb hooks into the waistband of his pants, and his hand extends downward so that it both gestures toward and covers up his groin; his other hand is placed dramatically on his hip, so that his pose is simultaneously effeminate and masculine. Novo's self-presentation and Álvarez Bravo's portrait challenge us to admit what we see, as Monsiváis would say, while at the same time denying the necessary truth of this evidence.

National Popular Ethics

This "gesture" beyond the frame of fiction, or better, the composition of a genre of fiction that is defined by such a gesture, reveals Mexican modernism's ethical investment in the popular and formulates a differ-

ent definition of nationalism as a result. Novo was hostile to the nationalist "master plans" of postrevolutionary figures such as Vasconcelos and Henríquez Ureña, who viewed artists as their tools to create modern Mexico.[114] He was suspicious of their faith that literature and the arts would mold a better world, and he rejected any demand that creative work mimetically reflect reality. As seen in *Return Ticket*, though, he never surrendered the possibility of nationalism entirely. His nationalism, like Mário's desire to write in "Brazilian," sought a vision of "the popular" in modernist literature. Novo introduced popular language into the literary realm, even curses like "hijo de puta" (son of a bitch), which he used to refer to Diego Rivera.[115] Modernist art and literature, he stressed, could be popular both in their production and theory, not dictated either by the new revolutionary elite or the upper class. In "El joven" he asks: "Does there exist in Mexico a literature that synthesizes the popular spirit? Is there slang, argot? . . . When will it be that there may be Mexican literature, theater, novel, music? . . . When should the daughters of Europe have begun to flee from their home?"[116] His demand for a national literary language takes a very strange form in the context of postrevolutionary Mexico, for Novo goes so far as to present the United States as a potential model for such a practice. He contrasts the small editions of books intended for the "pequeños eruditos" [little erudite ones] in Mexico with the broad availability of cheap books in the United States. Novo's modernist ethos therefore includes the anticolonialist critique of U.S. global intervention seen in "Return Ticket," as well as a demand for a mass-produced, specifically Mexican literature based upon an idea of popular literature he identifies with the United States.[117] Novo rejects the state's vision of popular art, replacing it with a mass popular whose ethical status as a prostitute he hopes to have ennobled without seriously altering its form.

Rather than primarily focus on racial determinations of "the popular," Novo incorporated the popular he saw in the city and in a growing mass media. That does not mean that Novo denied the presence of indigenous cultures in Mexico; instead, he mocked Best Maugard's *Method of Drawing* for inventing a vision of the popular, rather than elaborating the cultural practices already in use in popular communities. In a review of one of the many exhibitions of children's art based in Best Maugard's program, Novo argues that these "artificial symbols" must be tossed out. Instead, he lauds Manuel Rodríguez Lozano's interest in *retablos*, the popular, small paintings with written messages thank-

ing the Virgin Mary for a miracle or seeking her help: "Their figures are perfect and significantly deformed. They satisfy the postulates of the most recent aesthetic without knowing them: through colors and lines combined in a significant manner, they set the tune of music that doesn't tell stories nor reproduce recognizable physiognomies; that only connects the artist who 'creates' with the artist who admires."[118] For Novo, a popular modernist aesthetic is errant: it is both perfect and deformed. What is more, in errant modernism both the viewer and the creator are artists. The work itself is made and remade in its social life, rather than only in the moment of its fabrication.

The form of nationalist modernism made possible by verbal transvestism, viewers of popular art, and photographic poses is quite unlike the triumphant historical narratives seen in muralism. Novo, as much as he occasionally pondered the possibility of leaving the heterosexist and masculinist oppression of Mexico behind, like Mário remained where he was. He became, as Monsiváis titled him, "the marginal in the center." Like the ironic tone of melodrama, Novo's critical nationalism exists as a central, if certainly not dominant voice in the cacaphony debating the terms modern, national, and culture in the 1920s and 1930s.

The photographic documentary fictions produced by Estridentistas and Contemporáneos create a modernist ethos that bridges the hermeticism of the interior, first-person narrative and the nationalist art that exclusively characterized the era for so long. Novo's reflections in "El arte de la fotografía" include a clear articulation of this stance on modernist aesthetics. He argues against "an absolute opposition between the artistic and the useful" and concludes by stating: "I have said at the beginning that we are disposed to deceit; to reality distorting itself to take advantage of our highest sentiments; let's say it already: we want the artist to illustrate Goethe's phrase: that he use *the opposite of reality to give the apogee of truth.*"[119] Through photography, Novo finds that truth and fiction are not mutually exclusive, and that fiction does not require hermetic purity—nor tautology—in order to coexist with truth. The modernist ethos that results crosses between documentary and fiction, popular and elite, aesthetics and ethics, and produces a form of nationalism that includes a gay, effeminate, and somewhat extravagant citizen.

Epilogue

On December 4, 1931, Carlos Noriega Hope, the director of *El Universal Ilustrado*, wrote an obituary for a remarkable person. Titled "The Man Who Stripped Souls Bare," he mysteriously mourns the death of "one of the most humble and intelligent little women in Mexico."[1] Our confusion is only somewhat dispelled by Noriega Hope's description of the "sensational experiment" carried out by Concepción Jurado, known as Conchita. Born in 1865, at the age of fifty-six she became a cultish phenomenon in the cultural and media circles of Mexico City. Jurado and a team of accomplices organized events known as *balmoreadas*, in which she starred as Don Carlos Balmori. Dressed entirely in drag, with a hat, spectacles, and a mustache (fig. 62), Jurado as Balmori was a fabulously rich Spaniard who traveled the world looking for new partnerships, both financial and sexual.[2]

Through her network of journalist friends, Jurado set up a party with the premise that the rich Balmori would be there. She and her "Band of Jokesters"[3] designated a *puerquito* (little pig), the victim of their prank, whom they invited to the party. Jurado entered dressed as Balmori and pretended to be interested in the puerquito for some kind

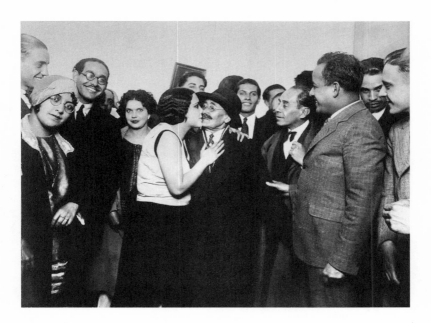

62 Conchita Jurado as Don Carlos Balmori, receiving a kiss from another conquest.
Anonymous, Fondo Reservado, Biblioteca Nacional de México

of commercial venture—an investment, a job, a gift—or commonly, offered himself as a wealthy husband for a single—or even engaged—woman. This final scenario was particularly popular and often repeated, and it culminated with a staged wedding and a passionate kiss between Balmori/Jurado and the duped woman. In all of the variations on the balmoreada, Balmori seduced his victims with the promise of large sums of money until they relinquished their most dearly held values of friendship, loyalty, honor, and so on. Following the public marriage ceremony, complete with a fake priest, a kiss, and the total acquiescence of the puerquito, Conchita revealed her identity and thus the greed to which the generally middle-class victim had surrendered.

Jurado was literally not of her time. She was an older woman surrounded by young journalists, a performance artist *avant la lettre*. As much as she was the extreme embodiment of defining elements of the ethos of modernism—a reinvented ethics and a truly avant-garde aesthetics—she was part of an underground, secret group that left few concrete traces. Photographs captured glimpses of this ephemeral practice, but as we shall see, they obscured as much as they represented

what was going on in these events. Unlike canonical figures like Mário de Andrade and Salvador Novo, Jurado never made her way into the historical archive of the avant-garde. Jurado/Balmori thus belongs here in the epilogue, outside the core chapters about the modernist avant-garde, and as a fascinating bridge to experimental aesthetics in play today. She opens the door to contemporary artists who use photography as part of interdisciplinary practices that echo the errancy of photographic modernism outlined in the previous chapters. Maris Bustamante's feminist performances and installations and Silvia Gruner's mixed-media confrontations with the history of violence continue the history of critical nationalism in Mexico. While Bustamante continues the line of mediatic engagement of the bellas artes públicas, Gruner, along with Gerardo Suter, uses photography against its history of racial categorization and exoticism. Tunga and Arthur Omar also play out anew the trope of the urban Brazilian traveler with camera in hand, creating books that combine photographs with fictionalized texts. While Omar's *O esplendor dos contrários: Aventuras da cor caminhando sobre as águas do rio Amazonas* (*Splendor of Opposites: Adventures of Color Walking on the Waters of the Amazon River*) formally resembles Mário's literary and photographic portraits and landscapes, Tunga's *Barroco de lírios* (*Baroque of Lilies*) returns again and again to the ethics of living in particular places and among other human beings. We shall see that these artists do not nostalgically return to modernism but rather take up the challenge of the ethics and aesthetics that these varied practices of photography threw into relief. Using the balmoreadas as a kind of portal—rather than nostalgia, or a historical progression from modernism to postmodernism—this epilogue gestures toward the contemporaneity of the ethos of photographic modernism.

Casos de la vida real (Real Life Cases):
Balmoreadas, Performance, Photography

The balmoreadas were more than just individual performances directed by Jurado, for a crucial component of these events was that they served as a kind of initiation into the group of players. The crowd that surrounded her, and which planned and paid for the events, was made up of previous puerquitos (fig. 63). They became something of a cult, sworn to secrecy about Balmori's identity and eager to trap the next victim.

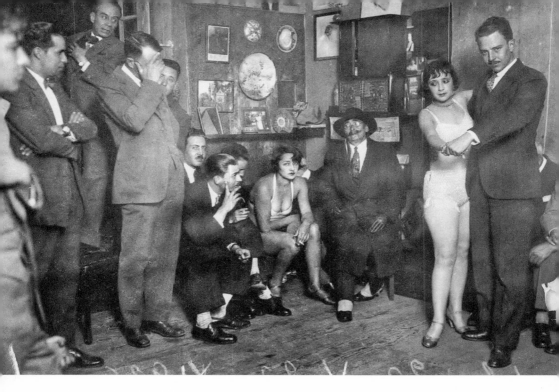

63 Don Carlos Balmori enjoys a balmoreada with several bataclán dancers.

Anonymous, Fondo Reservado, Biblioteca Nacional de México

What is more, while the posthumous biographies written about Jurado were likely exaggerations, they claim that over 3,000 people were victims and participants in the plays. According to Luis Cervantes Morales, her victims (and later balmoristas) included Gerardo Toledo (the director of the city government of Mexico City), the editorial director of *El Universal*, a Venezuelan general, Valenti Quintana (the police inspector for President Emilio Portes Gil), Ernesto García Cabral (a caricature artist popular in the revistas ilustradas), and even forty-four surgeons from the Cruz Verde. The balmoreadas founded a secret society made up of public figures including journalists, revolutionaries, politicians, artists, policemen, and writers. The most concrete remaining evidence of the social impact of the balmoreadas is an impressive monument placed on Jurado's grave in the Panteón de Dolores in Mexico City. Covered with hand-painted tiles, the tall tombstone is split in half like the person him/herself. While one side of the tomb has been vandalized, historical photographs reveal that one side of the large memorial was dedicated to Conchita and the other to Carlos Balmori, and both

contained painted tiles that told the story of the person named. Erected by the "Promonument Committee" composed of Rafael Heliodoro Valle, Carlos Noriega Hope, José Pérez Moreno, Fernando E. Sosa, and Dr. Luis Cervantes, the tomb compares Balmori favorably to Vanderbilt, Morgan, Rockefeller, and Ford, describing Jurado as an "artistic genius" who authored a "subtle philosophy."

It is difficult to describe these events without resorting to language that seems anachronistic. "Performance" or "acciones" [actions] may be the only words still in use today that accurately describe these events, which were unscripted yet fictive, and ephemeral except for photographs and newspaper articles published after Jurado's death. Perhaps this is why the word *balmoreada* entered common parlance in Mexico for several decades after Jurado's death, used to refer to an elaborate dupe or trick of some kind. Eduardo Delhumeau, Jurado's agent and a close friend of the family, calls the events "farces" and "extraordinary occurrences," and proclaims that in them "the real and the false are confused."[4] The group's self-appointed historians describe the balmoreadas as a means to reveal the ongoing deception perpetrated by all three sectors of postrevolutionary society described in the preceding chapters: the corrupt revolutionary government, the consumerist middle class, and the Catholic Church. In addition to their clear social intervention, the articles and memoirs about this strange band of tricksters almost always read their impact on the puerquitos through the lens of Freudian psychology, and explain that the extreme humiliation of the victims functioned as a kind of catharsis. Like contemporary performance art, the catharsis they inspired had both an individual, psychological force and a communal, social function.

Photography was used to document the balmoreadas, much as it is used in contemporary art actions. In his memoir, Cervantes Morales includes many of these photographs, as well as photographs of marriage certificates, checks written by Balmori, and one image of his eyeglasses, mustache, watch, and large jeweled pin as a kind of memento mori. As in performance, the status of these photographs is difficult to determine, for the memoirs of the participants repeatedly stress that the most important aspect of the balmoreadas was the intense personal and communal experience of deception and revelation the events inspired.

Recently Jurado has received attention from the same two cultural groups that filled the balmoreadas seventy years ago: the mass media

and avant-garde artists. Two very different women, both prominent in their own fields, have rediscovered Conchita Jurado/Carlos Balmori: feminist performance artist Maris Bustamante, and actress, mass-media phenomenon, and P.R.I. party senator Silvia Pinal. Pinal tells a version of Balmori's story in an episode of her popular Televisa television series, *Mujer: Casos de la vida real* (*Woman: Cases from Real Life*), in which she plays the lead role of Balmori.[5] Pinal herself embodies the mixture of mass media and avant-garde of the bellas artes públicas; early in her career she starred in important films by Spanish director Luis Buñuel, including *Viridiana* (1961), *El ángel exterminador* (1962), and *Simón del desierto* (1964). She went on to star in popular films and soap operas. In the late 1980s, *Woman: Cases from Real Life* began to appear in the form of a serial *fotonovela* titled "Silvia Pinal Presents Stories of Women" ["Silvia Pinal presenta Historias de mujer"]. Fotonovelas, popular in Mexico since the 1940s, are inexpensively printed, at times semipornographic soap operas composed of photographs in a series, and they can be viewed as an outgrowth of the photo-essays examined in chapter 4, repeating many of the plots and aesthetic characteristics. Pinal's television program about Jurado is composed of a series of skits based upon the balmoreadas, all of which reveal the corrupting influence both of Balmori's money and of the power gained by revolutionary caudillos as the new governmental bureaucrats of the 1920s and 1930s. Pinal frames the balmoreadas, however, in such a manner as to transform their ethos into the very moralizing ethics that they called into question. Her version of Balmori's story creates a narrative arc that begins with Jurado's invention of Balmori as the clever act of a desperate, upright woman defending herself from a corrupt bureaucrat, and concludes with a balmoreada in which Jurado herself becomes the victim of the trick. While the program moves through a series of quite risqué skits, in which Jurado's cross-dressing reveals racial, class, and gender inequities in Mexican society, she is ultimately punished (by Pinal) for her radical critique of gender normativity and of middle-class moralism. In her introduction to the show, Pinal describes Jurado's true genius as her ability to reveal the "fragility of morality." For Pinal's moralizing of Jurado to work, she must downplay the sexual experimentation and critique of marriage that was glaringly present in every faked wedding between Jurado and another woman.

In contrast, Bustamante stresses this aspect of the balmoreadas: "It all began when she [Jurado] disguised herself as a man and courted young

society girls in order to make fun of them."[6] In the Fondo Reservado of the Biblioteca Nacional in Mexico City, I found an envelope of photographs that the staff did not know about, lodged inside *Grand Deception: The World's Most Spectacular and Successful Hoaxes, Impostures, Ruses and Frauds*, a book donated along with the collection of Rafael Heliodoro Valle, a prominent journalist and participant in the Band of Jokesters. One of the photographs (fig. 63) shows Balmori with several men and two almost naked women; Jurado is dressed as Balmori, and the women are wearing the outfits of the famous *bataclanas*, or dancing revue girls, who scandalized and filled the theaters of Mexico City in these years.[7] The photograph was later memorialized in one of the many small tiles on his/her tomb, which pictured Balmori's triumphs (see plates 2 and 3). In contrast to Pinal's framing of the balmoreadas, the eroticism of these photographs and the kisses that ended the weddings between two women is evident, and the underground ambience of the image emphasizes that these faked unions undermined the morality founded in the heterosexual family.

Conchita's powerful virility was central to the group's total dismissal of morality. Luis Cervantes Morales, Jurado's personal secretary, recalls the balmoreadas as "the golden age of 'DIZZINESS' . . . when the manly figure of 'DON CARLOS BALMORI' shone in Mexico City, embossing the era of marvelous bohemia."[8] He records the last words of Jurado on her deathbed, as she pretends to confess the sins of Balmori. Her confession, however, sounds more like a triumphal list of conquests than pious repentance: "[he/she] seduced beautiful young girls and married them; several times [he/she] joined in holy matrimony with respectable matrons, marrying them at the same time that [he/she] married their daughters; [he/she] was a polygamist par excellence and caressed the pretty girls and kissed them on the mouth, perhaps giving them tuberculosis; [he/she] embodied the illusions of love of a thousand pretty women and even of a few ephebes who dreamed of the sweetness of marriage with the multimillionaire demon."[9] Balmori/Jurado undermined the proclaimed site for the foundation of Mexican morals, heterosexual marriage, as itself corrupting and even pathologically contagious. Cervantes Morales describes Balmori "supplanting Lucifer in the buying of souls" and working alongside his representative, Delhumeau, who was nicknamed "God." Good and evil are not reversed by the balmoreadas, they are entirely subsumed by them.

The balmoreadas performed to an extreme the battles over the "femi-

nization" of the bellas artes públicas and the meaning of nationalism during the postrevolutionary period.[10] The cathartic moment of the performance, when Jurado reveals herself as a woman, differentiates her practice from other forms of cross-dressing that existed in Mexico at the time.[11] By repeatedly unmasking masculine power at the end of each balmoreada, these performances raucously enact the threat that a woman might take over "the public thing," and reveal that doing so would alter not just the balance of power but also the defining social category of gender. They challenge the certainty of recognizing the difference between an hombre público and a mujer pública.

Like the bellas artes públicas in general, this performance has a direct impact on the status of nationalism. Balmori was not Spanish by accident, and his exaggerated accent and cries of "¡Coño!" resemble the still popular jokes in Mexico about "gachupines," in which the teller takes on an exaggerated Madrilenian accent to show how stupid the foreign colonizers really are.[12] Pinal's television episode includes one balmoreada in which Balmori brutally insults the backwardness of Mexico, and the puerquito protests in an articulate and moving defense of his country. While her version plays as an affirmation of mexicanidad, the balmoreadas that appear in Delhumeau's memoir are much less clear about the status of nationalism. As much as the Spaniard represents the corruption and economic power of the former colonizer, revolutionary soldiers are painted as foolish, greedy, and needlessly violent, and the nationalist rhetoric of the revolution is shown to be a demagogic myth used to deceive and manipulate the people. The events function as critiques of greed and consumerism, but they also demean the rhetoric and politics of the revolutionary state.

For Bustamante, this avant-garde critique of nationalism makes the balmoreadas, like Estridentismo, relevant at the end of the twentieth century. She argues that "today we are living the rupture of that idea of nation"[13] that was born in the murals and cultural nationalism of the 1920s. Bustamante proclaims that Jurado's performances contained the same spirit as the Estridentistas, which reacted against the early "institutionalization of the concept of nationality proposed by the state."[14] This historical critique, like contemporary ones, in fact "emerge[s] from Mexican popular culture and a profound, caustic sense of humor, truly revelatory of an iconoclastic Mexican human being who is fundamentally an unredeemable iconophage [icon-eater]."[15] Painting them with mouths wide open like Brazilian anthropophagists, Bustamante shows

that Jurado and the Estridentistas—all artists of the bellas artes públicas—began a century-long process of articulating the critical nationalism that was a crucial part of errant modernism.

Bustamante makes these two groups of artists the source for contemporary nonobject art. That is, they paved the way for art that values its own "dematerialization," such as performance and other ephemeral art, and which resists the circulation of objects in the art market. As part of a historical excavation of the nonobject tradition in Mexico, Bustamante traces the importance of photographic experimentation in the illustrated journals examined earlier, which she writes "can be considered in the line of that non-object spirit and discourse that has gone along propping up the form of speaking with images."[16] The revistas ilustradas take a prominent position in Bustamante's history of art, and the Estridentistas and Balmori/Jurado reach contemporary, nonobject aesthetics and its political gesture. Bustamante links them to the avant-garde group of Mexican abstract painters called La Ruptura in the 1950s, the work of experimental theater and film director Alejandro Jodorowsky in the 1960s and 1970s, and finally with feminist performance art of the 1980s and 1990s.

Bustamante's own work takes up these same challenges of performing gender, race, and class, the nexus around which the ethos of the bellas artes públicas was formulated. Her installation, "EL CORAZON COMO CEREBRO LATINOAMERICANO: La artificialidad como reflejo del cerebro-corazón" ("The Heart as the Latin American Brain: Artificiality as Reflection of the Brain-Heart"), consists of a life-size doll wearing the traditional traje de charro, which is topped by a photograph of the artist's face with her mouth agape in surprise (fig. 64). This strange figure stands beside a soft sculpture of the thorned and bleeding heart found in Mexican popular iconography. Bustamante produces a special performative power by inserting the photograph of her face. Rather than complete the doll with a sculptural head, she interrupts the three-dimensionality of the object with a two-dimensional, photographic image. The installation is both incomplete and excessive. Incomplete, for it seems as if the sculpture were not finished in time and so the artist substituted a photograph of a face for the head. Excessive, in that the precision of the smooth, flat photograph overwhelms the fuzziness—the aesthetic that in a different installation of this piece she terms "de peluche," like a stuffed animal—of the doll-like sculptural body and heart. Even in this relatively objectlike installation, Busta-

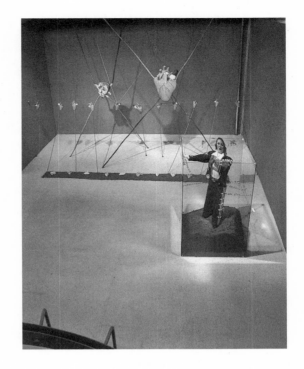

64 Maris Bustamante, "EL CORAZON COMO CEREBRO LATINOAMERICANO. La artificialidad como reflejo del cerebro-corazón" ("The Heart as the Latin American Brain. Artificiality as reflection of the brain-heart"), 2001, 6 × 6 cubic meters. *Courtesy of the artist*

mante makes icons of masculinity (the traje de charro) and femininity (the bleeding heart) performative matrices for aesthetic and ethical interventions in the classic iconography of Mexican nationalism. She places her own body at the very center of this contemporary critical nationalism; she is a female Mexican citizen, who is perhaps contorted by the mixture of two dimensional photography and three dimensional sculpture, but who refuses to be excluded from the debate about patria. Bustamante physically and photographically inserts herself in la cosa pública.

While Bustamante's fascination with Jurado/Balmori may be something of a special case in the contemporary art scene, since the 1960s Latin American artists (like other international artists) increasingly have been experimenting with photography in mixed media, performance, and installation, as well as "pure photography." The figure of the photographer as the modern form of the "scientist artist," as the tourist or ethnographer, appears frequently in work from the end of the twentieth century. Contemporary interventions take the form of fictionalized ethnographies, which replicate the status of photography

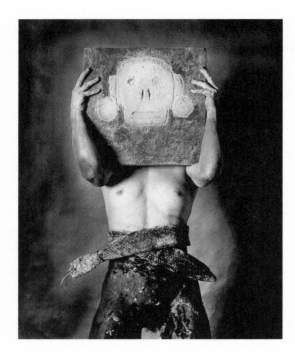

65 Gerardo Suter,
"Coatlicue," from *Códices*,
1991, 100 × 80 cm.
Courtesy of the artist

as both invention and document. In Mexico, Gerardo Suter and Silvia Gruner direct photography's fictional potential against the history of its representation of indigenous cultures and people. Both artists respond directly to Weston and Álvarez Bravo, and more generally to the dominant cultural nationalism of the twenties and thirties.

Suter, an Argentine-born photographer who has lived in Mexico since 1970, produced a series of manipulated photographs titled "The Photographic Archive of Professor Retus" (see plate 4). The artificially aged, small photographs—eerily like Mário's *O turista aprendiz*—narrate the discovery of an important archaeological ruin by the fictional explorer Retus (Suter spelled backward). The imaginary professor thus casts doubt on the veracity of nationalist historical studies grounded in the excavation of ruins. Indeed, making indigenous cultures only the subject of archaeology, and not contemporary politics for instance, was crucial to the postrevolutionary state's discourse of mestizaje. In later work, Suter has created large-scale, dramatic black-and-white photographs representing indigenous codices, as well as masked portraits of people posing as Aztec gods. Mary Schneider Enríquez argues that Suter's photographs, like the series about Professor Retus, function as

fictional tableaux by creating carefully staged spaces and characters.[17] "Coatlicue" (fig. 65) is one such portrait of the powerful goddess of life and death, the mother of the war god Huitzilopochtli, whose skirt made of snakes is tied together in the front of her waist by a large phallic snake and a skull. Suter's portrait reveals the androgyny of the goddess, as the carved stone face is held above a body with a woman's breasts and large, darkened arms and hands, which appear to be those of a man. Like Bustamante's photographed face on the sculptural mariachi, this posed figure destabilizes the construction of gender while the rough stone of the sculpture draws the viewer's eye to the glossy flat surface of the photograph. As much as Suter's invention of the alter-ego Retus resembles Mário's casting of himself as an apprentice tourist, his gods and goddesses assert the iconic presence ·of indigenous culture but do not make individual Mexicans the objects of study. His tableaux's fictive nature challenges the veracity of versions of (photographic) history that erase the history of epistemic and other violence. However, with the exception of the humorous and subtle "Archive of Professor Retus," Suter's photographs are monumental in both size and their formal composition. Imposing and grandiose, their monumentality creates a static and sepulchral aesthetic. The mixture of soft human flesh and rough stone records the undeniable destruction of indigenous peoples and cultures in over five hundred years of ongoing violence against them, and the image thus creates a space of mourning rather than a national history.[18]

Gruner's photographs and videos also take on the deployment of indigenous iconography in Mexico, but her straightforward contestation of the history of such representations contrasts with Suter's beautiful and muted works. "Don't Fuck with the Past, You Might Get Pregnant," shown both as a video and as small color stills, shows the artist's hands manipulating a pre-Columbian clay sculpture, which she repeatedly penetrates with her fingers (see plate 5). Like "The Archive of Professor Retus," it references the history of archaeological and tourist photography in Mexico as an ongoing form of conquest. Gruner's work, however, angrily and directly reveals the contemporary participation of Mexican cultural nationalism in the continuation of this violent, sexualized history. Like the ethos of Mário's apprentice tourism, she deploys a wicked sense of humor to display the indigenous past and present of Mexico as pain, as the blunt force of violence. The work forces the viewer to ponder the problem of how to deal with this colonial past—

always present in these images and in the contemporary society they address—without getting screwed or screwing someone.[19] The video screen referenced by the rounded black frame contained within the photographs—which she has called "my pornographies"—link this history of representation to what some consider the lowest form of "low" art.[20] The series fuses elite and popular culture into a critique of misogyny, racism, and the form of nationalism to which they contribute.

Gruner's work shares both formal and philosophical concerns—an ethics and an aesthetic—with modernist photographs and texts. She writes that "Don't Fuck with the Past" contests a vision of indigenous culture as always "outside us." By exploring the purportedly masculine and feminine roles of penetrator and penetrated, it rejects the protection of the self from this history of violence. The errant modernism in which photographic objects are both inside and outside the frame of the work of art—excessive—thus continues to offer an ethical mode for presenting history in photographs. Gruner, unlike the Brazilian modernists, relates this to the power of taboo rather than totem:

> I am very interested in the notion of the taboo and crossing boundaries, I do it constantly in my work. It has to do with being on both sides of one place. This work is dealing with the feminine but it is also dealing with the masculine—it is a game where I am acting both sides, the masculine and the feminine. I enter into these images with a disruptive attitude, there is this sense of prohibition, "Don't fuck with the past, you might get pregnant;" it's like a joke, something your mother, would tell you . . . ! [sic] The play with the figures, becomes an act of violation of the space, a kind of auto rape.[21]

The quick transition from a joke to a maternal admonition to a rape reveals that Gruner's contemporary practice continues to address three concerns that were central to the ethos of modernism: race, gender, and their function in the legacy of colonial violence. Like Bustamante's installation, her photographs are unfinished, broken; her work, she writes in the same essay, is always fragmentary. As Torres Bodet wrote many decades earlier, "Something of mine always remained outside of me: a foot, an arm, a desire, a lump of sugar, my heart."[22] While Erica Segre finds parallel fictional strategies of composing fragmented history in Suter and Gruner's archaeological photographs, I find that Gruner takes the project one step further.[23] She ruptures the pure interiority of photographic fictions and insists on a moving, ethical, and aesthetic

location of photographic meaning inside and outside the work. For Gruner, transgression itself is an ethical and aesthetic imperative, yet it does not dictate a moral or artistic style.

The modernist negotiation between fiction and document continues to take place at the interdiscipline between literature and photography. Bustamante writes that contemporary PIAS—an acronym she began to use in 1990 to refer to performance, installation, and "ambientation"—share Estridentismo's desire both to "drown in the possibilities of the image, toward unknown terrains," and to "cut off the logical elements that maintain an explanatory meaning, that is to say, to be against conventional narrative."[24] Imagistic fiction and invented images continue in these practices, which frequently employ photography. Brazilian artists Arthur Omar and Tunga are two prime examples of how experimental photographic practices continue to engage defining features of errant modernism through the medium's intimate relationship to the written word. These artists work in a variety of media, including photography, installation, sound, video, and drawing. Both have also chosen the artist's book as a special format that allows them to create a new work out of these diverse practices. Tunga's *Barroco de lírios* and Omar's *O esplendor dos contrários* were conceptualized by the artists themselves, and they do more than simply re-present exhibitions of their work.[25] In these books, both artists combine literary text and photographs to take up the tradition of the "scientist artist," the traveler/tourist/anthropologist who invents through his camera.

Tunga's *Barroco de lírios*, which sounds like "delirious baroque" in Portuguese, is typical of the artist's hermetic and yet engaging work.[26] While Tunga is generally considered a sculptor, this book reveals the important function that literature and photography play in his conceptualization of an interdisciplinary, contemporary art practice. The book is composed primarily of photographs, as well as some drawings, first- and third-person fictional narratives, descriptions of performances, loose inserts of text, negative images printed on plastic, and pages featuring elaborate fonts and graphic design. In Tunga's hands, writing is not only anecdotal or descriptive, and photography is not a transparent instrument used to record a performance or installation for later publication or sale. The opening piece (or chapter) in the book, "Description of an Experience of Fine Subtle Physics," most resembles the typical way in which photographs document performance art, although it ultimately undermines this use of the medium. The text is

composed of simple instructions for the performer: to use seven movable particles, as well as "equipment with photosensitive plates and an operating agent with an open program."[27] Tunga explains that the presence of this operator is necessary because "from him will come the subsidies, later *cruzados*, that will give us access to appraisals of the experience."[28] The word *cruzados* functions as a pun on the Portuguese gold coin of the colonial period, as well as on a *cheque cruzado*, or a type of check that cannot be cashed but must be deposited in an account. Tunga's language is full of double meanings that refer to financial gain: investment, speculation, waste. Thus as much as photography is the primary illustrative medium in this artist's book, from the outset it has a suspect (if pragmatic) function in the global circulation of capital that began with the cruzados of the Portuguese crown and continues today. Photographs, as the saleable object of a performance, are most corrupt for their participation in the market.

The presentation of the photographs of Tunga's performance in the streets of Manhattan produces the same rupture of inside and outside that Bustamante described above, and which photography repeatedly produced in the short novels of the Estridentistas and the Contemporáneos. The photographs of this first performance show two men dressed in white shirts and jeans as they open and close a leather suitcase and rearrange its contents to try to make them fit (fig. 66). The contents consist of a mannequin cut into pieces—head, feet, hands, and arms—the dismembered excess of modernist aesthetics. What is more, the montage of black and white images of the men struggling to fit the body parts into the suitcase are connected by white line drawings in the shape of a Möbius strip. This shape looks like a three-dimensional version of the mathematical symbol for infinity: ∞. In the accompanying text, Tunga writes that the movement of the seven mysterious particles will follow the *exterior plane* of a Möbius strip. Yet the strip, with its deceptively simple design, has only one side and one edge, and therefore no inside or outside.[29] The impossible inside/outside movement of the photographs and the grotesque, excessive, and disarticulated body thus open the way into a delirious contemporary baroque that shares much with its modernist predecessors, as well as with Gruner's problem with history.[30]

Tunga's "Capillary Siamese Among Us," a later chapter in *Barroco de lírios*, repeats the figure of the Möbius strip in the image of Siamese twins connected by long braids of hair in a mythic tale of scientific ex-

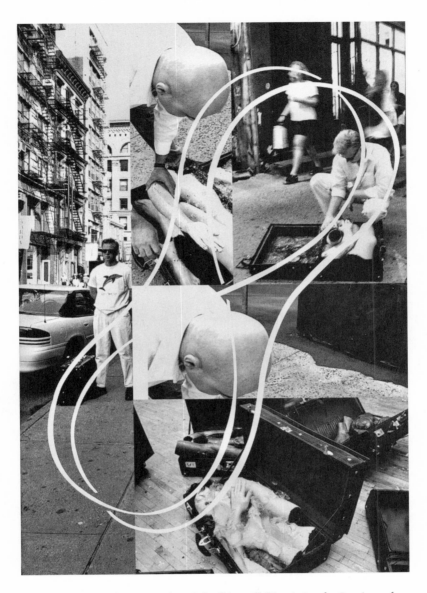

66 Tunga, "Descrição de uma experiência de fina física sutil" ("Description of an Experience of Fine and Subtle Physics"), *Barroco de lírios*, 1997. *Courtesy of the artist*

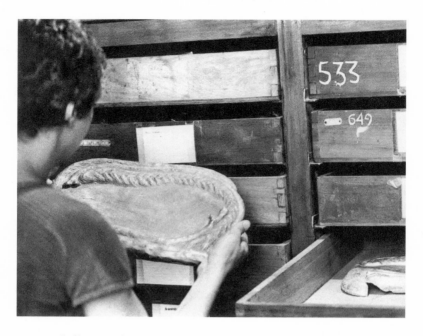

67 Tunga, "Xifópagas capilares entre nós" ("Capillary Siamese Among Us"), *Barroco de lírios*, 1997. *Courtesy of the artist*

ploration. The exotic images show two young women with hair down to their feet; they are turned inward toward one another and study the hair that binds them together, and which surrounds them in immense, braided sculptures. The text that accompanies these images weaves between Tunga's archaeology of a street tunnel in Rio de Janeiro called "Two Brothers," the story of a contemporary anthropologist, Giovana Fulvi, and a Danish paleontologist from the nineteenth century, Peter Wilhelm Lund. Tunga presents himself as an apprentice researcher into these mysterious tales; he poses in a photograph of a large room of cabinets that contain scientific collections as he examines a mysterious fossil of a braid (fig. 67). His text includes equally fantastical scientific interpretations of evidence and myth, paleontology and psychokinesis. It adeptly conjoins historical data and unbelievable coincidences in a flowing narrative that is simultaneously logical and illogical, and which makes scientific reason and mystical fantasy themselves Siamese twins joined together by the series of photographs. The twins, read as another image of the Möbius strip, repeat the embodied version of abstraction found in Mário's practice of errar. They contain the strip's core idea of

a flat plane and a pure line turned inward and outward, which is given form in phantasmatic figures.

The repeated images of Siamese twins and the Möbius strip in Tunga's work contain an ethics pictured as the bond between people and places. In "Capillary Siamese Among Us," the two lean gently against each other in a delicate balance, which threatens that if the touch were broken both would fall. This cohabitation can be separated in time, as in the story of the "Two Brothers" tunnel, in which a historical mystery is literally fossilized only to be brought back to life in the artist's work. The ethics has a darker side, both social and psychological, which appears in the concluding chapter of *Barroco de lírios*, "Sowing Sirens." Photographs and text picture Tunga's nightmarish encounter with his own decapitated head, which he cradles gently but then seeks to free himself from by swinging it from its long hair and casting it into the sea. Another photograph shows bodies dangling from ropes of hair attached to the beams of a large warehouse, reminiscent of the gory photographs of accidents and tragedies found in graphic newspapers in Brazil. The hair is attached to one body's neck in a noose, to another's genitalia, and in the center hangs Tunga's decapitated head. This grotesque side of Tunga's self-conscious exoticism places the artist, especially one working with photography, in a delicate ethical balance between creating and representing violence.

A similar focus on the "fluctuating borders" between fiction and nonfiction, document and invention, appears in the photographs and autobiographical essays included in Omar's *O esplendor dos contrários*. Like Tunga's *Barroco de lírios*, this book is more than just a catalogue of a photographic exhibit. It includes first person narratives about the artist's experience of color in a trip up the Amazon River, and it is steeped in the language of psychoanalysis and myth. Omar's textual and photographic landscapes are profoundly reminiscent of Mário's, beginning with the subtitle, *Adventures of Colour Walking on the Waters of the Amazon River*, which wanders like the titles of traveler's diaries and like Mário's "Journey through the Amazon until Peru, up the Madeira until Bolivia through Marajó until saying enough—1927." His narrative begins on a Saturday in July 2000, on the same island of Parintins where the portrait of the young Tapuio boy was taken, during the festival of Boi Bumbá, which Mário studied in the late 1920s. Rather than return to Rio de Janeiro as planned, Omar hires a boatman to take him deep into the river's heart, where they discover a place that is new even to his experi-

enced guide. The landscape is silent and absolutely still: "No wind."[31] The photographs show "a large lake, a mirror reflecting the sky, the sun and the clouds," where the artist finds a natural formation of trees that he calls a "plant phallus" that marks "the erotic heart of the Amazon." At that moment, "the whole world was outside." Later in the book, this familiar mirrored image of exteriority appears again in a place Omar calls the Angled Beach: "The halves appear to be equal. The left side could be duplicated in the right side, like the reflection of a mirror, in a photographic trick. But looking closely, we see that the halves are different . . . The trees in the background, however, are continuous, as if belonging to a single forest, and so too is the sky" (see plate 6). The photograph of the lagoon is strikingly similar to Mário's "Entry of a paraná or paranã / Madeira River / 7/5/27"; the same trompe l'oeil appears, which Omar explains "unifies the landscape, although it makes it doubly unreal." The exteriority of the photographic sublime, shown in exaggerated Freudian concepts, overwhelms Omar in the introductory story as much as it penetrated Mário like little arrows of light. Like the photographs of Mogi-Guassú with and without wind, a violent storm suddenly blows in and ruptures the perfection of photographic representation. Omar relates the punishing violence of the storm to Shakespeare's *Tempest*, which flips him upside down in the water and destroys all of the photographs he has just taken of the heart of the Amazon. While Omar produced a massive version of this photograph—almost six feet long—for exhibition, the image in *O esplendor dos contrários* must be treated separately from the photograph itself. Unlike the monumental and unwavering photographic art object hanging in a gallery, in the context of the book, the photographer is equally vulnerable in his position as explorer of the heart of Brazil—and as a modern subject—at the beginning and at the end of the twentieth century.

Omar examines portraiture and landscape as intimately related genres, an approach that abated his initial aversion to photography. He writes that he never wanted to be a photographer because he never wanted to be a portrait artist, but Omar states:

What I present in the [series] "Anthropology of the Glorious Face" are not *portraits*. They are, let's say, works affected on the first object that a human being sees in life, and that programs all his or her visual relationship with reality. The *face* (*rosto*), object par excellence, the most important object on the planet, an object of the world that represents the world itself, an object

of the world chosen as its concentrated expression, is treated therefore as landscape. I am not a portrait artist, but merely a landscape artist of the face.[32]

This aesthetic solution to the ethical problem of portraiture deploys familiar modernist strategies, first of all, a preference for *rosto* over *cara* as the word to describe the represented face. In *O esplendor dos contrários*, a book of landscapes, he also reproduces too-close portraits of several of the "People of the River" as he seeks to understand their way of thinking (see plate 7). Three separate portraits are included, all taken such that the subjects' faces exceed the frame of the photograph. They are overexposed rather than blurred like Mário's "Tapuio de Parintins," but they similarly contain subjectivity without capturing the person. Omar wonders if, rather than revealing the "Amazonian mind" through photographs, what appears instead is "only the way *I interpreted the gaze of the man* who drove me downriver toward Pará." His landscape portraits capture the gaze turned back on him: they create the modernist ethos of staring so stared-at. Omar's "landscapes of the face" do not repeat the themes of Brazilian identity associated with modernismo, yet the very aesthetic concerns of photographic modernism continue to be the fodder for his adventures of color in the Amazon.[33]

This book began with the premise that while the ethos of modernism participates in recent work on ethics in literary studies, it refuses to assume the ethical status of any "peripheral" artistic production. Instead, by focusing on modernism's photographic aesthetics—those varied cultural practices active in both elite and popular spheres—I have shown how these movements mapped an errant terrain between aesthetics and ethics. The profound differences between Pinal and Bustamante's contemporary interpretations of the ethics and aesthetics of the balmoreadas reveal that returns to the ethos of modernism, with its tricky relationship to patria, gender, and race, can have both progressive and conservative political results. We might consider the balmoreadas as the outer extreme of modernist practices; unlike the manifestos and novels by Mário de Andrade and Salvador Novo, Conchita as don Carlos Balmori could not possibly be folded into the statist forms of nationalism. They share, however, key elements of the errant modernism produced by the most canonical figures in Mexico and Brazil. To learn from Tunga, we could call photographic ethics and aesthetics "Xifópagas Capilares," twins of an expanded and renewed Latin Ameri-

can modernism. Like a Möbius strip, they join mass and popular culture with elite culture, ethics with aesthetics, photograph with word. The resulting modernism has no inside nor outside and does not stay where it ought: it exceeds the purity of the art object, the limitations of elite culture, and the European center that for so long tried to hold an exclusive claim to it.

Notes

C: Vela, Arqueles. "El café de nadie." 1926. *El Estridentismo, México, 1921–1927*. Edited by Luis Mario Schneider. Mexico City: UNAM, 1985.

D: Villaurrutia, Xavier. "Dama de corazones." 1928. *La novela lírica de los contemporáneos: antología*. Edited by Juan Coronado. Mexico City: UNAM, 1988.

E: Torres Bodet, Jaime. "Estrella de día." 1933. *Narrativa completa*, vol. 2. Mexico City: Editorial Offset, 1985.

J: Novo, Salvador. "El joven." 1928. *Narrativa vanguardista hispanoamericana*. Edited by Hugo J. Verani. Mexico City: UNAM, Ediciones del Equilibrista, 1996.

M: Torres Bodet, Jaime. *Margarita de niebla*. 1927. Mexico City: Editorial Offset, 1985.

P: Torres Bodet, Jaime. "Proserpina rescatada." 1926. *Narrativa completa*, vol. 1. Editorial Offset: Mexico, 1985.

PE: Torres Bodet, Jaime. "Primero de enero." 1935. *Narrativa completa*, vol. 2. Editorial Offset: Mexico, 1985.

RT: Novo, Salvador. "Return ticket." 1928. *La novela lírica de los Contemporáneos*. Edited by Juan Coronado. Mexico City: UNAM, 1988.

S: Vela, Arqueles. "La señorita etc." 1922. *Narrativa vanguardista hispanoamericana*. Edited by Hugo J. Verani. Mexico City: UNAM, Ediciones del Equilibrista, 1996.

1 The question of who is considered a Latin American photographer is seemingly unanswerable. Tina Modotti is treated as a Mexican photographer, while Edward Weston, who spent approximately the same amount of time in the country, is not. The rules and regulations dictating who may enter the colloquia and competitions of "Latin American photography" differ regarding the artists' citizenship and residency. For the purposes of this project, I include artists and writers who were clearly influential in the local activities of the Mexican and Brazilian modernist movements.

2 For excellent critical surveys of the Latin American avant-gardes, see Jorge Schwartz, *Las vanguardias latinoamericanas*, and Vicky Unruh, *Latin American Vanguards*.

3 In *Mexican Modernity*, Rubén Gallo's survey of early twentieth-century technologies and avant-garde culture, he stresses the importance of photography in Mexico. Gallo explores in particular the work of Tina Modotti and a current in Mexican modernism that emphasized photography as a mechanized form of vision. ,

4 Schmucler, "La fotografía y los medios masivos," 53: "La cámara no mira desde la nada"; "La Kodak, que junto con la Coca Cola y la bandera estrellada constituye uno de los símbolos más difundidos de la presencia norteamericana en el mundo."

5 Hemment, *Cannon and Camera*, 264.

6 For more on photography and U.S. expansionism in the Spanish American War, see my "'Cannon and Camera.'"

7 I borrow the phrase "mainstream modernism" from Krauss, *The Optical Unconscious*, 21.

8 Gorelik, "O moderno em debate," 59.

9 *Oxford English Dictionary*, 2nd ed., 5:426.

10 I use the masculine pronoun here because this imagined intellectual was generally male. However, as becomes clear in my discussion of Mexican modernism, changing perceptions of gender—femininity as well as "virility"—were crucial to the defining split of this intellectual subject.

11 Certeau proposes that certain narrative practices are "connected with a broader and historically less determined phenomenon, which one might designate as an *estheticization of the knowledge* implied by know-how," considered to be intuition or artistic genius of a kind, which "is supposed to be knowledge that is unaware of itself" (Certeau, *The Practice of Everyday Life*, 70, emphasis added). He terms this epistemological site as a third position between theory and practice, the kind of generative place that I examine as the ethos produced at the contact between photography, literature, and modernist theory.

12 Ramírez, *Heterotopías*, 27.

13 Bosi, "La parábola de las vanguardias latinoamericanas," 14.

14 Echevarría, *La modernidad de lo barroco*, 12–13. I thank Hortensia Calvo for this reference.

15 Echevarría, like Enrique Düssel, considers the Conquest the event that institutes modernity globally.

16 Ibid., 15.

17 See Hendrick, *Mestizo Modernism*.

18 Quijano, "Coloniality of Power, Eurocentrism, and Latin America," 533.

19 My use of the term *mediation* builds upon Jesús Martín Barbero's *De los medios a las mediaciones*; see chapter 3 for a complete discussion.

20 See Bosi, "La parábola de las vanguardias latinoamericanas," 23. On the importance of popular cultures, see Rowe and Schelling, *Memory and Modernity*, and Pratt, "Modernity and Periphery," 42–43.

21 Martín Barbero, *De los medios a las mediaciones*, 241, emphasis original. Chapter 3 engages Martín Barbero's concept of *mediation* in depth: "Entre la lógica del sistema productivo y las lógicas de los usos median *los géneros*. . . . En el sentido en que estamos trabajando un género no es algo que le pase *al texto*, sino algo que pasa *por* el texto."

22 Jara, "Afterword," 286.

23 See Greenberg, "Avant-garde and Kitsch" (1939) and "Modernist Painting" (1960).

24 See Billeter, *Canto a la realidad*.

25 Blanco Aguinaga, "El modernismo desde la periferia," 117.

26 Eder, "El concepto de modernidad en el arte de América Latina," 330, emphasis added.

27 In general, the task of translating experimental avant-garde texts is nearly impossible, for some cadence, joke, or surprising image always gets lost. The abundance of intentional errors—of breaks with grammatical as well as literary and logical conventions—that are at the heart of these works at times do not survive the transition into English. Therefore, I include the Spanish and Portuguese original texts in the endnotes of the book, including the original orthography, with the expectation that those readers dedicated to their spirit of experimentation will enjoy them. Unless otherwise noted, all translations are my own.

28 Giardinelli, "Variations on Postmodernity, or What Does the Latin American Postboom Mean?" 220; and de la Campa, "Hibridez posmoderna y transculturación," 15. One school of thought, criticized by John Beverley and José Oviedo, suggests that "postmodern seems a particularly inappropriate term for nation-states and social formations that are usually thought of as not yet having gone through the stage of modernity, in Weber's sense

of the term, or, perhaps more exactly, that display an 'uneven modernity'";
they ask, "what society does not, however?" (Beverley and Oviedo, "The
Postmodernism Debate in Latin America," 3). See also Brunner, "Notes on
Modernity and Postmodernity in Latin American Culture," 34–54.

29 Moriconi, "The Postmodern in Brazilian Literary Theory and Criti-
cism," 559.

30 For excellent histories and examples of how artists have employed
printing and other experiments with the book, see Hellion, *Libros de artista*,
and Drucker, *The Century of Artists' Books*.

31 Norman Bryson describes the maneuvers of contextualization as "a
double operation of advance and containment"; context masquerades as
"natural ground" outside the artifice of the text, yet "pass[es] its qualities to
the text" ("Art in Context," 18–20). The imagination of context as a solid base
upon which interpretation stands first seems to contain the text, locating
it in an unmoving moment of literary history and acting as "proof" of a
particular reading. Referring to Jonathan Culler's explanation of context as
"just more text," Bryson points out that this operation (of contextualization)
actually creates an unlimited complexity of narratives open to interpreta-
tion. The imagination of context as an "outside" nontext seemingly permits
the unproblematic writing of a cause-and-effect relationship between text
and context, yet in fact opens up a Pandora's box of readings of the relation-
ship between these two interpretive spaces.

32 Pollock, "Van Gogh and Holland," 104.

33 On discursive sites, see Kwon, *One Place after Another*. Mary Louise
Pratt provides an example of how to read the discursive space of European
modernity, which she argues depends on the inequality of spaces "outside"
or "behind" it, such as Latin America, for its own self-definition ("Moder-
nity and Periphery").

34 For more in-depth reading of debates over "Latin America," see Mig-
nolo, *The Idea of Latin America*; Campa, *Latin Americanism*; Moraña, *Nuevas
perspectivas desde, sobre América Latina*.

35 Eliana Bastos explains that although cosmopolitanism and nationalism
have been treated as opposing forces in the Brazilian intellectual tradition, it
is more logical to treat them as "complementary" forces given their consis-
tent history of simultaneous emergence (*Entre o escândalo e o sucesso*, 64). See
also Crespo, "Cultura e política," 187–208; and Antelo, *Literatura em revista*.

36 Ardao, *América Latina y la latinidad*, 15, 51. While Ardao does not deny
the importance of Michel Chevalier's use of the adjectival form of the term
"latin" America in 1835, he underscores the consequence of the noun (sub-
stantive) *Latin America* in the 1850s: "Este bautismo, aunque llevado a cabo en
Europa, iba a ser obra de hispanoamericanos, no de europeos . . . la idea de la

latinidad de nuestra América aperece por primera vez en la pluma de nativos de ésta."

37 Ardao points that the early determination of Latinity emerged out of nineteenth-century ethnic nationalisms, but he argues that it soon became a predominantly cultural definition.

38 The use of the term continued in the works of famous Cuban José Martí, who wrote that all of "América Latina" should be careful in trade dealings with the United States, and of "nuestra América Latina" (Ardao, *América Latina y la latinidad*, 67, 72).

39 Strand, "Photography and the New God," 254, 258.

40 Schelling, *Through the Kaleidoscope*, 3.

41 Avelar, "The Ethics of Interpretation and the International Division of Intellectual Labor," 97.

42 Borges, *Elogio de la sombra*, 60; "Se encaminó al despacho del profesor y le dijo que sabía el secreto y que había resuelto no publicarlo." While "The Ethnographer" appeared in 1969, Borges came of age as a writer in the decades of modernist avant-garde art examined here.

43 See Mitchell, *Picture Theory*, 285. See also Barthes, "Photographic Message."

44 See Brehme, *México pintoresco*.

45 Although Rio de Janeiro, the federal capital during these years, had a much larger urban population of 1,157,873 in 1920, the rate of growth had been much slower. Between 1890 and 1920, the population of Rio essentially doubled, while the population of São Paulo increased ninefold (Burns, *A History of Brazil*, 313).

46 INEGI, *Estadísticas históricas de México*, vol. 1.

47 García Canclini, *Hybrid Cultures*, 47, emphasis added.

48 Ibid., 53.

49 D. Williams, *Culture Wars in Brazil*, 36. *Automobilismo* is a topic of much debate, and I analyze its relationship to photography and gender in chapter 4.

50 Peter Bürger asserts that the (European) avant-garde's iconoclasm, its rejection of dominant bourgeois society, and its attack on the separation of art and life, was in fact made possible by the existence of an autonomous sphere of art and its market in Europe. The absence of such an established market in Mexico and Brazil in those years (and its continued anemia even today) makes that gesture of rejection impossible.

51 See Hendrick, *Mestizo Modernism*, and Coffey, "Muralism and the People."

52 Schwartz, *Las vanguardias latinoamericanas*, 42.

53 The Contemporáneos called themselves a "group without a group" but

nonetheless produced an eponymous journal and met frequently, publishing and commenting on each other's artistic and literary production. Muralism was never constituted as a movement as such.

54 The mutability of these groups can also be seen as a source of the widely proclaimed "heterogeneity" of Latin American modernism. In his anthology of avant-garde prose, Hugo Verani writes: "Quizás ningún otro escritor ejemplifique mejor que Salvador Novo la hibridez genérica que caracteriza a la literatura de vanguardia en México" [Perhaps no other writer exemplifies better than Salvador Novo the hybridity of genre that character-izes avant-garde literature in Mexico]. Novo himself explains his heteroge-neous literary practice as a result of moving freely among the different artis-tic and literary groups in Mexico. Similarly, Mário de Andrade is frequently termed the author of the most heteroclite theories of Brazilian modern-ism.

55 See Ortiz, *A moderna tradição Brasileira*, 35.

56 Buell outlines six major strands of ethics as this new paradigm for literary study: (1) a return to a "moral thematics" of literary texts, and (2) a parallel turn of philosophers to literature as a location for social values; the reevaluation of Derridean and Foucauldian theory which has led to (3) the rejection of the concept of "pure" textuality, where ethics functions as a demand for "responsible" reading practices, and (4) the employment of "a critical vocabulary of 'ethics' in rivalry to 'politics' as a way of theorizing principled social engagement." These critiques of poststructuralism have led, in postcolonial and minority studies, to (5) the insistence that "an ethical representation of subalternity must proceed in the awareness that (mutual) understanding will be limited." And finally, (6) discussions of professional ethics of pedagogy and the institutions of academia ("Introduction," 9–11). Buell concludes that, despite its broad reach, "nothing is more certain than that the question of the place of the socio-political will continue to be debated within and around contemporary ethical criticism" (15). See also Garber, Hanssen, and Walkowitz, *The Turn to Ethics*; Levinson, *Aesthetics and Ethics*; and Glowacka and Boos, *Between Ethics and Aesthetics*.

57 Rey Chow frames a related critique in what she calls a class difference between critical theory and cultural studies; briefly, racialized people and projects occupy a reduced intellectual sphere because of their imposed "ref-erentiality," which deconstruction and poststructuralism have (linguistically) superseded. Chow's remarkable argument about ethics and idealism offers both a pedagogy and a theoretical methodology that defy this class struc-ture.

58 Juan A. Martínez provides one example of this repeated tendency: "In the early 1920s Amaral, the leading painter of the movement, gave visual

expression to these ideas by *accepting the aesthetic language of the colonizer and modifying its content* to express the dual heritage of her native land" ("Early Twentieth-Century Latin American Vanguard Art," 67, emphasis added).

59 Billeter, *Canto a la realidad*, 375, emphasis added. For more on the erasure of aesthetics outside Europe, see Shohat and Stam, "Narrativizing Visual Culture."

60 The radical limitation posed by the "international" as the only modernist aesthetic becomes yet clearer when we consider the history of photography as it is generally represented in university classrooms and museums in the United States and Europe. Generally, these histories not only exclude "peripheral" practices of photography through this kind of division of labor between form and content, but also take the form of direct and precise negations of the aesthetic practice of photographers elsewhere. Simply put, Latin America most often does not appear; when it is historically impossible to ignore it, any existing aesthetic philosophy is stripped away. The collection edited by Jean-Claude Lemagny and André Rouillé, broadly titled *A History of Photography* (1987), presents a fairly representative version of this history of modernist photography. The outright exclusion of other places is quite startling: Lemagny and Colin Osmon's text about the "international" nature of photography includes only European and U.S. American examples, and no images by Latin American, African, or Asian photographers are reproduced.

61 Nesbit, "Photography, Art and Modernity (1910–1930)," 110.

62 See Huyssen, *After the Great Divide*. Huyssen revisited the question of a modernist high/low divide in productive ways in his article "High/Low in an Expanded Field" (2002), in which the titular expansion was precisely the field constituted by alternative modernities and modernisms.

63 Gilroy, *The Black Atlantic*, 39. There is a significant Afro-Mexican community on the Caribbean coast that, while excluded for centuries from national self-representation, would be an interesting addition to Gilroy's map of the black Atlantic.

64 In Brazil in 1922 and 1924, there were violent protests in São Paulo by the military, and the Liberal Alliance nominated Vargas for president and later staged a military coup that put him in power. Vargas gradually consolidated his power in the decade that followed, beginning first as chief of the provisional government (1930–34), then serving as constitutional president (1934–37) and finally as dictator (1937–45) (Burns, *A History of Brazil*, 393–400). Similarly, while the Partido Nacional Revolucionario (PNR)—the antecedent to the Partido Revolucionario Institucional—was established in Mexico in 1928, the years immediately preceding and following its foundation were still extremely unsettled. The twenties and thirties saw a be-

wildering succession of six presidents, from Álvaro Obregón to Cárdenas, many with contrasting views on essential revolutionary projects such as the redistribution of land, the role of the Catholic Church, and political and economic ties with the United States.

65 Both countries also enjoyed modernist movements outside these major urban centers, important groups that fall outside the purview of this study. See for example Bueno, *O modernismo em Belo Horizonte.*

66 Tenòrio, "A Tropical Cuauhtemoc," 126.

67 Gordon, "Modernidad y Vanguardia en la Literatura mexicana," 1083–98. Merlin Foster rightly established the dependence of the Contemporáneos on jobs and funding from the postrevolutionary government, which in fact goes against common characterizations of them as too foreign and apolitical. These accusations are addressed in this introduction, and in chapters 4 and 5.

68 Campos, "The Rule of Anthropophagy," 45.

69 To avoid confusion with Oswald de Andrade, from here on I will refer to Mário by his first name, as is done in Brazil.

70 McNulty, "The Other Jouissance," 130.

71 On the "great divide," see Huyssen's classic essay. Jean Franco addresses the multitude of valences of "lo popular" [the popular] in Latin America, pointing out that it refers to a broad spectrum of social spheres as diverse as mass culture, popular culture, folk culture, entertainment, media, communications, and the culture industry ("What's in a Name? Popular Culture Theories and Their Limitations," 5–6).

72 See Felski, *The Gender of Modernity.*

73 Bustamante, "En busca de una historia de los no objetualismos en México," n.p.: "me ha parecido más interesante tratar de encontrar las raíces de estas formas del pensamiento visual contemporáneo finisecular en la propia cultura mexicana."

Chapter 1: Landscape

1 De Andrade, *O turista aprendiz*, 201: "Minha impressão é que está tudo *errado*. Tive ímpeto de botar toda aquela gentarada no vagão, ficar na plataforma eternamente paulistana e berrar contente pros amigos partindo: — Adeus, gente! Boa viagem! Divirtam bastante . . . Boa Viagem!" Henceforth cited as TA.

2 See Schwartz, *Las vanguardias latinoamericanas*, 64.

3 Many thanks to Mary Louise Pratt for our conversation about the dual meaning of *errar.*

4 R. Williams, *The Country and the City*, 125.

5　Moraes Belluzzo, *The Voyager's Brazil*, 24. Von Humboldt was the famed German explorer who traveled throughout Latin America.

6　Mitchell, *Landscape and Power*, 14. Modern photography in particular creates this effect of fantasy and despair. Mitchell, however, insists that landscape is a medium rather than a genre. His distinction lies in the transhistorical practice of landscape representation, and the fact that it is "embedded in a tradition of cultural signification and communication, a body of symbolic forms capable of being invoked and reshaped to express meanings and values." However, I find that Mário's intervention into the practice of landscape representation—both literary and visual—treats it as a genre with certain rules that can be defied and redrawn.

7　Gombrich, "The Renaissance Theory of Art and the Rise of Landscape," 110.

8　The phrase *até dizer chega* also implies to travel a great deal. Similar rereadings of the trope of America as woman exist in earlier Brazilian nationalist literature. See, for example, José de Alencar's *Iracema*, an anagram for America. My thanks to Lúcia de Sá for this reference.

9　*TA*, 51: "As reminiscências de leitura me impulsionaram mais que a verdade, tribos selvagens, jacarés e formigões. E a minha alminha santa imaginou: canhão, revólver, bengala, canivete. E opinou pela bengala." See Mário's self-portrait with his walking stick in chapter 2.

10　*TA*, 49, emphasis added: "Mais advertência que prefácio. Durante esta viagem pela Amazônia, muito resolvido a . . . escrever um livro modernista, provavelmente mais resolvido a escrever que a viajar, tomei muitas notas como vai se ver. Notas rápidas, telegráficas muitas vezes. . . . Mas quase tudo anotado sem nenhuma intenção da obra-de-arte, reservada pra elaborações futuras, *nem com a menor intenção de dar a conhecer aos outros a terra viajada*. E a elaboração definitiva nunca realizei. Fiz algumas tentativas, fiz. Mas parava logo no princípio, nem sabia porquê, desagradado."

11　*O turista aprendiz* also responds to a long history of domestic and foreign texts that sought to represent Brazil by picturing its interior. Flora Süssekind's fascinating study of the nineteenth-century Brazilian novel presents the function of landscapes and the location of the narrator in them as key components in literary production during the century of Brazilian independence. These earlier texts share modernism's desire for a national literary and artistic aesthetic, but Süssekind explains that: "It [didn't] interest these hunters of origins to observe differences, lacunae, returns, cuts . . . [theirs was a] search for a 'nationality, essential,' of an identity without fissures, of a straight line, full, without discontinuities or erasures" (*O Brasil não é longe daqui*, 18). She explains that the foundational purpose of the Brazilian novel of the 1820s and 1830s required that their narrators close their eyes to the realities of the landscape through which they traveled. Although

literature of the period at times moved beyond this blindness, it remained marked by a paradisiacal ideal and a sense that the narrator's observations were intended for an album of curiosities. This distancing of narrator from landscape, Süssekind suggests, reproduced the foreign eye in nineteenth-century Brazilian literature. In contrast, Mário's mixed-media representations of Brazil open his eyes to the very discontinuities of the nation.

12 The literature on landscape and modernist abstraction in the European and North American tradition is vast. Perhaps most triumphantly, Clement Greenberg writes: "It has been in search of the absolute that the avant-garde has arrived at 'abstract' or 'nonobjective' art—and poetry, too. The avant-garde poet or artist tries in effect to imitate God by creating something valid solely on its own terms, in the way nature itself is valid, *in the way a landscape—not its picture—is aesthetically valid*; something given, increate, independent of meanings, similars or originals" (Greenberg, "Avant-garde and Kitsch," 5–6, emphasis added).

13 Pollock, "Van Gogh and Holland," 104.

14 Mitchell, *Landscape and Power*, 1.

15 Rey Chow contrasts the centrality of error within the idealist ethics articulated by Gayatri Spivak and Slavoj Žižek. Mário's version of intentional error, however, does not appear as a possibility in either account (Chow, *Ethics after Idealism*, 39).

16 Mondrian, *Natural Reality and Abstract Reality*, 31–2. While Mondrian cannot stand in for all approaches from the period, his essays provide some of the clearest examples of the centrality of landscape to European abstraction, and its use for universalist claims. Pablo Picasso's cubist experiments in the teens are another classic example of abstraction through the optical distortion of forms.

17 C. Armstrong, "This Photography Which Is Not One," 33, n.15.

18 Canonical exemplars of modernist photography took straight photographs that nonetheless displayed abstracted images of the medium's own tools: light, perspective, and focalization. Edward Weston, Man Ray, and Henri Cartier-Bresson produced "abstracted" images not through any manipulation of photographic negative or print, but rather in their use of close-ups, cropping, and lighting. These photographers are best known for their compositions of light and shadow, paper forms, and everyday objects made abstract. Mainstream modernist photography is thus declaredly about the use of light and lens, a "true" photography that despite its capture of an image from the world is able to present an abstract, formal essence.

19 *The American Heritage Dictionary*, Second College Edition, 518, emphasis added.

20 Unfortunately, it has been impossible to determine how Mário de-

veloped and printed his photographs, and while contemporaries have stated that he used a small, boxy 35-millimeter camera, the exact make and kind is unknown.

21 Susan Jarratt and Nedra Reynolds make use of this etymology to show the importance of ethos for feminist theory, especially the standpoint theory developed by Teresa de Lauretis (Jarratt and Reynolds, "The Splitting Image," 48).

22 McNulty, "The Other Jouissance," 130.

23 This jouissance "err[s] on the side of truth" and "offer[s] another mode of dwelling, another approach to ethics, one based in a very particular knowledge" that nonetheless wanders (ibid., 131–32).

24 This was a project he announced, but never published, a "Gramatiquinha da Fala Brasileira" ("Little Grammar of Brazilian Speech").

25 Similar linguistic play appeared in Latin American avant-garde movements from Peru to Cuba, many of which responded to the desire to write national literatures in the language of former colonial powers. This concept of error differs from Freud's study of mistakes as slips that reveal the truth; Mário's errors are consistent and directed, consciously uttered even if spoken under extended duress. Other important differences with Freud are central to chapter 2.

26 *TA*, 70: "Creio que há uma tendência muito brasileira pra botar o qualificativo depois do substantivo. Pelo menos no povo. Notar a diferença de sabor brasileiro ou português entre 'o brilho inútil das estrelas' e 'o inútil brilho das estrelas.' O exemplo não é bom. Brasileiro: 'era um campo vasto' . . . Português: 'Era um vasto campo.'" Lopez points out that both of these examples of the stars and the countryside appear in *Macunaíma*, Mário's foundational novel of *modernismo*. A precise translation into English is impossible; I have tried to alter the word order without entirely changing the meaning.

27 Gorelik, "O moderno em debate," 55.

28 There were many modernist writers and artists outside of São Paulo and Rio de Janeiro, many of whom corresponded with Mário. I briefly address this broader sphere of Brazilian modernism in chapter 3, but these movements warrant their own book-length exploration.

29 Mary Louise Pratt and Vivien Schelling have insisted that concepts of modernity in Latin America must take the rural into account, not as a minor character in the historical narrative but as a determining actor.

30 De Andrade, *Hallucinated City/Paulicéia desvairada*, 34-35. Henceforth cited as *PD*.

31 *PD*, 75. In the early 1920s, Europe began to recover from the First World War and the demand for Brazilian coffee fell precipitously. During

these decades, the rise and fall of coffee prices determined to a great degree the economic and political situation in São Paulo (the state and the city), as well as the country at large.

32 *PD*, 74: "Muito ao longe o Brasil com seus braços cruzados." My translation here.

33 Before these two major trips, Mário had made several short trips into the interior of the state of São Paulo and to Minas Gerais in 1924. He did not take photographs in the same fashion during these shorter trips (Carnicel, *O Fotógrafo Mário de Andrade*, 14).

34 "E o Interior," 3: "A preocupação pelas cidades é dominante. Procuram ellas synthetizar uma civilização e um progresso, que não correspondem á realidade nacional. Estabeleceu-se assim, e desde logo, um desequilibrio entre esses centros e o resto do país. . . . E quando nos lembramos que a fascinação das cidades é feita á custa dessa massa immensa de brasileiros . . . encontramos assunto para profundas meditações."

35 Charles Harrison explains that "the positioning of a horizon is always relative to the composition of pictorial space and to the establishment of pictorial illusion" ("The Effects of Landscape," 220).

36 Krauss, *The Optical Unconscious*, 2. It is important to note that in this text, Krauss seeks to differentiate Marcel Duchamp's modernist practice with the opticality of what she calls "mainstream modernism." Krauss's description of the sea and this self-enclosed modernism actually serves as an introduction to her analysis of what she sees as Duchamp's profound defiance of this aesthetic model. She goes on to suggest a different history visible in Duchamp's "Precision Optics," which she calls, "a counter to modernist, rationalized vision" (21). I find it important to note that this major revolution in modernist aesthetics happened, says Krauss, immediately following the year that Duchamp lived in Buenos Aires (1918–19). Krauss never makes any connection between Duchamp and the place where this tremendous reversal took place, nor mentions the presence of Argentine modernist movements. This Precision Optics is "a kind of threshold or bridge moment between a nineteenth-century psychophysiological theory of vision and a later, psychoanalytic one" (135). Indeed, many of Krauss's observations about this change resemble Latin American modernist aesthetics, as they appear both in this study and in others (see Unruh, *Latin American Vanguards*). While Duchamp denies in his letters that there is any important art being produced in Buenos Aires, current research into his time in Buenos Aires by members of the Instituto Marcel Duchamp en Buenos Aires should provide a fascinating and important contribution to the field. For a selection of letters from Buenos Aires, see Naumann and Obalk, *Affectionately, Marcel*.

37 On these decades as a neocolonial period, see Masiello, "Rethinking Neo-Colonial Aesthetics."

38 Andrade, *A escrava que não é Isaura*, 209, henceforth *Escrava*: "O que realmente existe é o subconsciente enviando á inteligéncia telegramas e mais telegramas. . . . A inteligéncia do poeta—o qual não mora mais num tôrre de marfim—recebe o telegrama no bonde. . . . Assim virgem, sinte-tico, energico, o telegrama dá-lhe fortes comoções, exaltações divinatorias, sublimações, poesia. Reproduzi-las! . . . E o poeta lança a palavra sôlta no papel." Mário's enthusiasm for modern technologies of representation brings up similar rhetoric found in Italian Futurism. For an analysis of this connec-tion and Marinetti's unpopular tour through Brazil, see Schnapp and Castro Rocha, "Brazilian Velocities."

39 *Escrava*, 203: "Seria talvez mais extacto dizer: necessidade de exteriori-zar." In chapter 2, I will explore Mário's representation of the status of the poet, the "eu profundo," in detail. For the purposes of this chapter, it is nec-essary to note the connection between modernist aesthetics and the location of the artist.

40 *Escrava*, 203: "Recriar no espectador uma comoção *análoga* a do que a sentiu primeiro."

41 *TA*, 136: "Parece que vai clarear mas logo bate um instante de escuridão intensa. Antes de qualquer prenúncio de claridade no céu, é o rio que prin-cipia a alvorada e se espreguiça num primeiro desejo de cor."

42 *TA*, 137: "O dia vem vindo lento, aguado mesmo . . . é mais luz indecisa que cor definida."

43 *TA*, 181: "O céu está branco e reflete numa água totalmente branca, um branco feroz, desesperante, luminosíssimo, absurdo, que penetra pelos olhos, pelos narizes, poros, não se resiste, sinto que vou morrer, misericórdia!"

44 *TA*, 152: "As vezes se pára, as paisagens serão codaquizadas . . . Qual a razão de todos esses mortos internacionais que renascem na bulha da loco-motiva e vêm com seus olhinhos de luz fraca me espiar pelas janelinhas do vagão?"

45 Mitchell, *Landscape and Power*, 16, emphasis added.

46 This description of travel for Ruskin's contemplation in fact forms the basis for Krauss's analysis of the modernist sea and allows for a kind of disinterested creation of knowledge. In contrast, Mary Louise Pratt critiques the illusion of passivity and examines the kind of knowledge produced by this travel. The tradition of landscape constitutes a perspective she calls the "monarch-of-all-I-survey," in which the entire landscape is frozen for the consumption of the Western traveler (*Imperial Eyes*, 204–5). Not surprisingly, Krauss's literary example for this epistemological gain is Joseph Conrad, who provides the classic articulation of the colonial "heart of darkness."

47 *TA*, 55: "Cidade do Salvador. Arre que maravilha, estou cansado. Mas o diabo é que não adianta falar 'maravilha,' 'manhã admirável,' 'invenção arquitectônica adorável,' 'moça linda.' Não adianta, não descreve. Esses quali-

ficativos só existem por que o homem é um individuo fundamentalmente invejoso: a gente fala que uma coisa é 'admirável' e ele não só acredita mas ainda aumenta na imaginação o que a gente sentiu. Mas se eu pudesse descrever sem ajuntar qualificativos . . . Bem, não seria eu."

48 Krauss, *The Optical Unconscious*, 18–19. In contrast, Krauss writes: "The frame-within-a-frame is a way of entering the figure into the pictorial field and simultaneously negating it, since it is inside the space only as an image of its outside, its limits, its frame. The figure loses its logical status as that object in a continuous field which perception happens to pick out and thereby to frame; and the frame is no longer conceived as something like the boundary of the natural or empirical limits of the perceptual field. . . . Whatever is *in* the field is there because it is already contained *by* the field, forecast, as it were, by its limits. It is thus the picture of pure immediacy and of complete self-enclosure."

49 Mitchell, *Landscape and Power*, 8.

50 *TA*, 313: "Eu já conhecia a igreja de fotografia porém fotografia ruim, péssima como todas as que tiram os fotógrafos do Brasil. De-fato: fotógrafos mais bestas que os que aparecem nessa terra é difícil. 'Praça da Sé' em S. Paulo. O que a gente vê é no fundo uma igreja em andaimes, no lado umas casas arranhaceuzadas que é um despautério e no chão duzentos automóveis alinhados de propósito, se percebe, pra fotografarem a 'Praça da Sé.' Mas, e gente? Ninguém. São Paulo tem gente muita, o Rio também, mas as fotografias, não sei que horas os fotógrafos escolhem, deserto que nem caatinga seca."

51 Mitchell, *Landscape and Power*, 9. Raymond Williams wrote that English cultured landscapes erased the hands that tamed them and were views from above, "the expression of control and of command" (*The Country and the City*, 125). Mário's painful experience of the gazes of dead railroad workers seen above contrasts strikingly with this erasure.

52 On "syntax," see Kozloff, "The Awning That Flapped in the Breeze," 59.

53 Bunn, "'Our Wattled Cot,'" 131.

54 Ades, *Photomontage*, 15.

55 On power and montage, see Matthew Teitelbaum's introduction to *Montage and Modern Life*, 8.

56 Sá, *Rainforest Literatures*, 140.

57 Clifford, "On Ethnographic Surrealism," 127. Clifford also proposes that "to write ethnographies on the model of collage would be to avoid the portrayal of cultures as organic wholes or as unified, realistic worlds subject to a continuous explanatory discourse" (146).

58 *TA*, 232: "Já afirmei que não sou folclorista. O folclore hoje é uma ciência, dizem. . . . Me interesso pela ciência porém não tenho capacidade pra

ser cientista. Minha intenção é fornecer documentação pra músico e não, passar vinte anos escrevendo três volumes sobre a expressão fisioniômica do lagarto."

59 *TA*, 56.

60 See Wagley, "Anthropology and Brazilian National Identity."

61 Cunha, *Rebellion in the Backlands*, 39–40.

62 *TA*, 295: "Pois eu garanto que *Os sertões* são um livro falso. A desgraça climática do Nordeste não se descreve. Carece ver o que ela é. É medonha. O livro de Euclides da Cunha é uma boniteza genial porém uma falsificação hedionda. Repugnante. Mas parece que nós brasileiros preferimos nos orgulhar duma literatura linda a largar da literatura duma vez pra encetarmos o nosso trabalho de homens. Euclides da Cunha transformou em brilho de frase sonora e imagens chiques o que é cegeira insuportável deste solão. . . . Deus me livre de negar resistência a este nordestino resistente. Mas chamar isso de heroísmo é desconhecer um simples fenômeno de adaptação. Os mais fortes vão-se embora."

63 This photograph is from a separate part of ieb/usp archive, from a visit to the fazenda in Sta. Tereza do Alto owned by Tarsila do Amaral.

64 Harrison, "The Effects of Landscape," 218.

65 *TA*, 40.

66 *TA*, 194: "11 de agosto—Não houve onze de agosto de 1927."

67 See Lopez's introduction to *O turista aprendiz* (40).

68 Seen in Carnicel, *O Fotógrafo Mário de Andrade*, 73; published in "Suplemento em Rotogravura," *O Estado de São Paulo*, edição 150, primeira quinzena de janeiro de 1940: "Aquilo em que a fotografia artística se eleva sobre a puramente documental, reside não na máquina ou na luz, como imaginam confusionistamente os manipuladores de truques fotográficos . . . mas na criação humana do artista. Enfim: há que ter esse dom especial de apanhar a 'poesia do real' . . . Fundamentalmente realista, amando as visões da vida, ele as interpreta, porém, captando o momento e o ângulo rico, ou compondo o ambiente em que a realidade capitula dianta da luz e se converte numa expressão sugestiva e bela."

69 Süssekind convincingly argues that in Independence period nationalism, illustration and text were intentionally redundant, locked in a continuous loop of mutual reaffirmation.

70 *Escrava*, 245: "Assim, na poesia modernista, não se dá, na maioria das vezes concatenação de idéas mas associação de imagens e principalmente: SUPERPOSIÇÃO DE IDÉAS E DE IMAGENS. / Sem perspectiva nem lógica intelectual."

71 *Escrava*, 258: "Cores, linhas, volumes numa superfície."

72 *Escrava*, 265: "Os galhos é verdade entrelaçam-se ás vezes. A árvore das artes como a das sciências não é fulcrada mas tem rama implexa. O tronco de

que partem os galhos que depois se desenvolverão livremente é um só: a vida. Varios galhos se entrelaçam no que geralmente se chama SIMULTANEI-DADE."

73 Souza, "Nacional por abstração," 131.

74 Pérez Oramas, "The Cisneros Collection," 48.

75 Ibid., 55–56.

76 Ibid., 186. Pérez Oramas sees the presence of the painter in shadows on the canvas; the profound similarity to Mário's photographic ethos appears in his photographs of his own shadow, studied in chapter 2 of this book.

77 *TA*, 166. The letter was included in part in the published version of *O turista aprendiz*, and appears in the collections of the IEB.

78 *TA*, 166: "Esta 'dor' sulamericana do indivíduo."

79 See Scarry, *The Body in Pain*. Scarry's analysis of the productive and destructive power of pain, and its relationship to language, are foreshadowed in Mário's articulation of South American pain.

80 *TA*, 237, emphasis added: "*Viveu tudo isto por aqui e viveu de verdade*, ficou tudo impresso na carne dele que é memória mais viva e menos literária."

81 *TA*, 237: "É isso: uma memória guardada nos músculos, nos nervos, no estômago, nos olhos, das coisas que viveu."

82 Facio, "Investigación de la fotografía y colonialismo cutural en América Latina," 107: "Insisto, se puede escribir sobre Buenos Aires desde Roma, componer bagualas en París, pintar la Pampa en Los Angeles, pero ¿cómo tomar fotos de obreros uruguayos en el Lago Leman?"

83 *Escrava*, 266; "—Anti-brasileiro!/—Nada disso. Sou brasileiro. Mas *além de ser brasileiro* sou um ser vivo comovido a que o telégrafo comunica a nénia dos povos ensanguentados. . . . Sou brasilero. Prova? Poderia viver na Alemanha ou na Austria. Mas vivo remendadamente no Brasil."

84 *TA*, 236: "Está claro que não se trata duma obra-de-arte perfeita como técnica, porém desde muito já que percebi o ridículo e a vacuidade da perfeição. Postas em foco inda mais, pela monotonia e vulgaridade do conjunto, surgem coisas dum valor sublime que me comovem até à exaltação."

85 *TA*, 236: "Brota um brasileirismo danado."

86 *Michaelis Dicionário Prático Inglês-Português* (São Paulo: Melhoramentos, 1987).

87 Anderson, *Imagined Communities*, 116.

88 *Escrava*, 281: "Um sorriso meio irônico dirigido á cidade de Paris."

89 *TA*, 207, emphasis added: "Um *país novo da América*, uma civilização que andam chamando de bárbara porque contrasta com a civilização européia."

90 *TA*, 248: "Não comprendo nem os pernambucanos, nem os paulistas nem ninguém que seja assim. Aliás, não comprendo nem mesmo os patriotas, já se sabe disso. Tristão de Athayde outro dia falava que apesar de eu ter

chegado a uma certa expressão de entidade nacional, tinha uma singular in-
compreensão política do Brasil. Acho que errou. Já tive compreensão política
de pátria mas a ultrapassei. Graças a Deus."

91 M. de Andrade, *Mário de Andrade—Oneyda Alvarenga: Cartas*, 71; "E
você está em Minas, está vivendo em Minas, comendo, dormindo e sofrendo
em Minas. . . . Sua pátria agora é Minas. Não no sentido vulgar, burguês e
sentimental de *pátria*. . . . Sua pátria fica sendo no momento cem-por-cento
Minas, e você fará um livro utilíssimo, que pela expansão de Minas, fica de
valor e utilidade pra todo o Brasil. E mesmo universal."

92 "Literatura Nacional" (December 3, 1939), in M. de Andrade, *O Empal-
hador de passarinho*; "Ora os países de civilização importada, os países-colônias
são, por definição, países internacionais."

93 *TA*, 232–33: "O pitoresco dela [Natal] é um encanto honesto, uma delí-
cia familiar pra nós, um ar de chacra que a torna tão brasileiramente humana
e quotidiana como nenhuma outra capital brasileira . . . Eh! ventos, ventos
de Natal, me atravessando como se eu fosse um véu. Sou véu. Não atravanco
paisagem, não tenho obrigação de ver coisas exóticas . . . Estou vivendo a
vida de meu país." This familiar picturesque appears again in chapter 5, in my
reading of the work of Mexican Salvador Novo.

94 De Campos's now canonical essay on Brazilian modernism, "The Rule
of Anthropophagy," makes it one stage in an ongoing artistic baroque, which
begins with the Conquest and continues through Concrete Poetry in the
1960s.

Chapter 2: Portraiture

1 Santiago writes: "Between sacrifice and game, between prison and
transgression, between submission to the code and aggression . . . there,
in that apparently empty place, its temple and its place of clandestineness,
there is realized the anthropophagous ritual of Latin American literature"
[Entre o sacrifício e o jogo, entre a prisão e a transgressão, entre a submissão
ao código e a agressão . . . ali, nesse lugar aparentemente vazio, seu templo e
seu lugar de clandestinidade, ali, se realiza o ritual antropófago da literatura
latinoamericana] ("O entre-lugar do discurso latino-americano," 26).

2 Jorge Schwartz argues that Tarsila and Oswald's discovery of the an-
thropophagist in their "own land" recasts European colonial images of can-
nibals that have appeared in texts from Columbus to Montaigne (Schwartz,
paper available at www.utexas.edu/cola/depts/llilas/centers/publications/
visitingpapers/jschwartz.htm). To my eye, Mário's photographs reveal less
certainty that this land is his own.

3 *PD* 5–6; the letter to Alceu Amoroso Lima is dated May 1928 and seen

in de Andrade, *Macunaíma* (henceforth cited as *M*; Goodland's English translation henceforth cited as *M* (1984)), 400: "O Oswaldo vem da Europa, se paubrasilisa."

4 Raul Antelo compares Mário to both Fernando Ortiz and José Carlos Mariátegui, all of whom produced a "proto-literary sociology," and notes that he had Ortiz's landmark study, *Los negros brujos* (*Black Witches*, 1906), in his library (Antelo, *Na ilha de Marapatá*, 43).

5 While acknowledging well-founded critiques of ethnography and anthropology, James Clifford argues that during these decades of their reinvention, "Others appeared now as serious human alternatives; modern cultural relativism became possible" ("On Ethnographic Surrealism," 120).

6 Mário's large art collection housed currently at the Instituto de Estudos Brasileiros at the University of São Paulo includes many portraits of him, mostly paintings and some sculptures, by artists such as Tarsila do Amaral and Flávio Carvalho. This collection reflects his interest in portraiture as a modernist art practice, and his frequent experience of being the subject of portraits. For his collection of art, see *Colecção Mário de Andrade*.

7 *M*, 3. See Koch-Grünberg, *Vom Roroima zum Orinoco*.

8 Prado, *O Retrato do Brasil*, 161; "falta da energia, levada ao extremo de uma profunda indolência."

9 Prado, *O retrato do Brasil*, 27: "nossas primitivas populações mestiças."

10 Jackson, "Three Glad Races," 97.

11 Letter to Prudente de Morais, neto, dated March 25, 1928, in *M*, 399: "É o livro mais imoralíssimo do mundo."

12 Lacan, *The Ethics of Psychoanalysis*, 10.

13 Eggs, "Doxa in Poetry," 417.

14 See Baumlin and Baumlin's introduction to *Ethos*, xviii.

15 Steiner, *Exact Resemblance to Exact Resemblance*, 3–4, emphasis added. Steiner is writing about Gertrude Stein's portraits.

16 Michael North compares the primitivist use of masking in Pablo Picasso's *Les Demoiselles d'Avignon* (1907), canonized as the painting that contains his transition from figuration to abstraction, with the short story "Q.E.D." by Gertrude Stein, the story of a young black woman narrated in African American "dialect" ("Modernism's African Mask," 270–71).

17 *M*, 5, 37.

18 I borrow this phrase from Schelling, "Mário de Andrade."

19 Benjamin, "A Short History of Photography," 7.

20 See Benjamin, "A Short History of Photography," 22.

21 Criminal photography, while used to identify the perpetrators of crimes, pretends to reveal a shared characteristic of antisocial behavior rather than the individual character of the man or woman who commits the crime. See Phillips, Haworth-Booth, and Squiers, *Police Pictures*.

22 During the modernist period, the extensive translation of Freud into Spanish and Portuguese was led largely by the Spanish philosopher José Ortega y Gasset, whose influence in Spanish America is well documented (see Unruh, *Latin American Vanguards*). His 1911 translation of "Psychoanalysis, the Problematic Science" was published in *La Prensa* in Buenos Aires, and he initiated Luis Lopez-Ballesteros's Spanish translation of Freud's complete works, published in Madrid between 1922 and 1934. The Brazilian Psychoanalytic Society was founded in 1927, and its members wrote Freud directly to inform him of their existence (see Benveniste, "Freud, the Spanish Language, Argentina, and Etchegoyen").

23 On bricolage, see Antelo, "Macunaíma," 261.

24 Freud, *Totem and Taboo*, v.

25 M. de Andrade, *Poesias completas*, 61: "O único grande (grande?) país civilizado tropical." Oswald similarly proclaims in the "Anthropophagist Manifesto": "Anthropophagy. Absorption of the sacred enemy. To transform him into a totem." See O. de Andrade, "Anthropophagist Manifesto," 68.

26 Freud, "The Uncanny," 368. Lacan writes that his seminar "is situated somewhere between a Freudian ethics and a Freudian aesthetics" (*The Ethics of Psychoanalysis, 1959–60*, 159).

27 Freud, *Civilization and Its Discontents*, 49, emphasis added.

28 Lacan denies that the relationship between the sublime and sublimation is so direct in Freud, arguing that the object can be brought to light as much as obscured by sublimation (*The Ethics of Psychoanalysis*, 161). Mário's repeated use of the word *sublime* in his parodic representation of civilization and savagery, however, do not reflect this interpretation of Freud. The importance of sublimation as an aesthetic concept appears in Mário's *Fichário analítico*, a catalog in his archive that seeks to organize the contents of his library using reference numbers, subject headings, and quotes that send the researcher to related texts. In the section titled "Experimental Aesthetics," subsection "Aesthetic Sensations," the word *sublimation* appears with a quote: "Explanation of artistic tendencies through the process of *Sublimation* of the love excitation—more. Freud. 'Three Essays.' page 152" (*Fichário analítico*, Serie Manuscritos Mário de Andrade, Instituto de Estudos Brasileiros, USP); "Explicação das tendências artísticas pelo processo de *Sublimação* das excitações amor (*sic*)—mais. Freud. 'Trois Essais.' pg 152." Mary Anne Doane gives psychoanalytic theory a dose of its own medicine, arguing that its central tenet of sublimation reveals the sublimated presence of colonialism in psychoanalysis.

29 *M* (1984), 36: "Nada menos de quarenta vezes quarenta milhões de bagos de cacau, a moeda tradicional."(*M*, 36)

30 *M* (1984), 32: "Porém entrando nas terras do igarapé Tietê adonde o burbom vogava e a moeda tradicional não era mais cacau, em vez, chamava

arame contos contecos milréis borós tostão duzentorréis quinhentorréis, cinquenta paus, noventa bagarotes, e pelegas cobres xencéns caraminguás" (*M*, 38).

31 *Escrava*, 266: "Confundem-se os povos. / As sub-raças pululam. / As sub-raças vencem as raças. / Reinarão talvez muito breve? / O homem contemporâneo é um ser multiplicado . . . tres raças se caldeiam na minha carne . . . / Tres?" These verses have been read as Mário's reference to his own mixed racial identity, which he complained made him a "permanent 'show'" at the center of modernist activities. The frequent attempt by scholars to make him both Afro-Brazilian and Indian reflects the degree to which Mário's racial identity continues to be the subject of much curiosity (Haberly, *Three Sad Races*, 204).

32 Kozloff, *Lone Visions, Crowded Frames*, 24.

33 Brilliant, *Portraiture*, 107, emphasis added.

34 By now, the temptation to refer to Emmanuel Levinas's theory of ethics as "facing" the other may seem almost irresistible. However, following Phillippe Crignon's excellent analysis of Levinas's iconoclasm, the photographed face of the tapuio cannot be the same ethical concept. Crignon argues that for Levinas, the work of art is "a loss . . . The work of art is a beautiful work. And, like everything that man makes, no expression, no expressivity radiates in its breast. The face has disappeared" (116). The ethical relation is not present in aesthetics for Levinas as it is for Mário, for whom the photographic image of the face produces an ethical and an aesthetic philosophy. See Philippe Crignon, "Figuration," 100–125.

35 Pratt, *Imperial Eyes*, 7.

36 *TA*, 55, emphasis added: "Uma americaninha, girl etê, com muito açúcar e fotogênica duma vez. Faz de conta que não sei absolutamente nada de inglês, tiro fotografias. Foi um encanto conversarnos *só de olhos e gestos. Nunca olhei tão olhado em minha vida e está sublime.*"

37 This intimate relationship with an other, according to Steiner, is impossible in the European avant-gardes. Steiner describes avant-garde aesthetics as essentially unethical in their refusal of any "discovery of the self in an Other" (*Venus in Exile*, 5).

38 Copjec writes: "While maintaining that it was impossible to determine whether any particular act was free, or ethical, [Kant] was certain we were free and sought to find positive evidence of our ethical nature. In his theory of the sublime, he proposed that certain ideas of reason allowed us to triumph over impasses and thus to think and act freely. In the dynamically sublime the triumphant idea is that of might, or of an absolute force, which is able to make rugged overhanging cliffs, thunderclouds, volcanoes, the boundless ocean, and all the most terrifying forces of nature sink into

puny insignificance in comparison to it. In the mathematically sublime, the idea is that of magnitude, or of an absolute all, of a measure beyond measure, a grandeur that exceeds every conceivable greatness and gives greatness itself its size. These ideas of reason are manifest in the world, however, only in the positive feeling of the sublime, in 'the *frisson* that . . . flashes through the body everywhere there is life in it,' in the feeling of an exalting satisfaction" (*Imagine There's No Woman*, 126).

41 The encounter is also strange in its embodiment of the new and overwhelming power of the United States in the region in this seemingly powerless feminine vessel. This image of the American girl contrasts strongly with a later encounter with Americans: "São dois norte-americanos do maior patriotismo peruano, que de-noite, escrevem estas coisas nas ruas, pra fazeram depressa bastante negócio e voltarem pra terra deles que é melhor" [They are two North Americans of the best Peruvian patriotism, who at night write these things in the streets, to quickly do a lot of business and return to their own land, which is better] (*TA*, 114). The written messages that appear in the streets are advertisements for gum-elastic, which was largely exploited in Peru, Brazil, and Bolivia in the first decades of the twentieth century. The exchange of gazes with the young girl interrupts the grand scale of the sublime without erasing the increasing presence of the United States as the new political and economic power in the Americas.

40 *TA*, 166: "Me lembrei de escrever pra ela uma carta amazônica, contando esta 'dor' sulamericana do indivíduo. Sim eles têm a dor teórica, social, mas ninguém não imagina o que é esta dor miúda, de incapacidade realizadora do ser moral, que me deslumbre e afete. . . . Eles não sofrem não, eles teorizam sobre o sofrimento. A dor, a imensa e sagrada dor do irreconciliável humano, sempre imaginei que ela viajara na primeira vela de Colombo e vive aqui."

41 See Simon, *The Labyrinth of the Comic*.

42 *M*, 128, my translation: "Então Macunaíma pôs reparo numa criadinha com um vestido de linho amarelo pintado com extrato de tatajuba. Ela já ia atravessando o corgo pelo pau. Depois dela passar o herói gritou pra pinguela

—Viu alguma coisa, pau?
—Vi a graça dela!
—Quá! quá! quá quaquá!

Macunaíma deu uma grande gargalhada."

43 Unruh, *Latin American Vanguards*, 133; and see also her chapter 1, on creating an audience.

44 The full title is *Orgão de Expressão das Novas Gerações Sul-Americanas*.

Revista Mensal de Arte, Litteratura, Economia e Sciencia [*Organ of Expression of the New South American Generations. Monthly Journal of Art, Literature, Economics and Science*]. Here I maintain the spelling of the original publication.

45 *Escrava*, 213: "Ninguem passa incólume pelo vácuo de Schopenhauer, pelo escalpelo de Freud, pela ironia do genial Carlito."

46 M. de Andrade, "Caras," *Espirito Novo*, January 1934, 6: "O que ha de mais admiravel na criação da cara de Carlito é que todo o efeito dela é produzido diretamente pela máquina fotografica. Carlito conseguiu lhe dar uma qualidade anticinegrafica, a que faltam enormemente as sombras e principalmente os·planos. E é por isso em principal que a cara dele é comica em si, contrastando violentamente com os outros rostos que aparecem no écran, e que a gente percebe como rostos da vida real."

47 Ibid.: "Não falo que a cara composta por Carlito não seja fotogenica, pelo contrário, é fotogeniquissima. Porém é anticinegrafica, por isso que dá a sensação dum homem real com cara de desenho."

48 Ibid.: "A inferioridade de Buster Keaton já principia na criação da cara. Ele se utiliza duma cara *d'après-nature*, o que me parece defeito grave."

49 Ibid., 7: "A gente não pode se interessar, quero dizer, não sente ao lado da sensação imediata, que atrás da personagem Carlito esteja o homem Charles Chaplin que finge de Carlito. A verdade percebida é dum ente só, Carlito ou Charles Chaplin pouco importa, que tem em si uma cara de desenho. E a cara de desenho em corpo de homem é que causa o comico (seria absurdo) extraordinariamente divertido e íntimo. E ao mesmo tempo profundamente tragico, por causa da noção de anormalidade que carrega consigo. E a prova de que o comico da cara de Carlito é sem absurdo está em que nós indentificamos intimamente com ela o homem Charles Chaplin. O retrato real de Chaplin, por mais que a gente simpatize com êle (por amarmos Carlito), nos causa sempre um certo mal-estar. Nos sentimos roubados ou mistificados, porque para nós o rosto de Chaplin é a cara de Carlito."

50 Christian Metz explains more fully that "Peirce called the indexical the process of signification (*semiosis*) in which the signifier is bound to the referent not by a social convention (= 'symbol'), not necessarily by some similarity (= 'icon'), but by an actual contiguity or connection in the world: the lightning is the index of the storm. In this sense, film and photography are close to each other, both are *prints* of real objects. . . . What is indexical is the mode of production itself, the principle of the *taking*. And at this point, after all, a film is only a series of photographs. . . . This property is very often exploited by narrative, the initially indexical power of the cinema turning frequently into a realist guarantee for the unreal. Photography, on the other hand, remains closer to the pure index, stubbornly pointing to the print of what *was*, but no longer *is*" ("Photography and Fetishism," 156).

51 Krauss, *The Optical Unconscious*, 2.

52 M. de Andrade, "Caras," 7: "É um elemento exterior, ajuntado. Não faz parte da estrutura da cara, não vem de carcassa ossea, não vem da carne, da epiderme. E não vem, muito menos, da máquina fotográfica. Não é um fenomeno plastico. É um elemento de ordem psicologica, ajuntado à estrutura da cara, para lhe dar interesse. Dá interesse, produz o comico. Mas é sempre uma superfetação."

53 M. de Andrade, *Poesias Completas*, 211: "Eu sou trezentos sou trezentos-e-cincoenta, / As sensações renascem de si mesmas sem repouso, / Oh espelhos, ôh Pirineus! Ôh caiçaras! . . . / Eu sou trezentos sou trezentos-e-cincoenta, / Mas um dia a final eu toparei comigo."

54 Ibid., 48: "O sentido exato dessas palavras, mas elas porém ficaram em mim como um refrão do significado *íntimo do meu ser.*"

55 Ibid.: "Tive um deslumbramento tamanho que até estremeci. A coisa viera enfim à consciência, o sentido de espelhos do meu verso!"

56 Ibid., emphasis added: "Se os dois outros termos parecem (não tenho certeza) exprimir valores do meu ser coletivo, brasileirismo ibérico e cultura franco-internacional, 'espelho' refletia uma atitude meramente individualista do ser, uma instintividade epidérmica, coordenada organizadamente numa constância. O 'espelho' mirado me indicava a *postura do retrato* que eu queria tornar. Se é certo que nunca estudei atitudes no espelho, não é menos certo que muitas vezes me surprendi me contemplando, me observando no espelho, e me retirava dele envergonhado. . . . 'Espelhos' no verso . . . é a externidade das minhas 'atitudes' voluntariosas, são minhas aventuras e experiências estéticas, artísticas, vitais. É o ser visto pelo espelho. *Não sou eu integralmente, mas o meu eu visível em espelhos.* Até por mim. . . . Por onde percebo agora que esse verso é terrivelmente doloroso. Já não 'sofria' propriamente com ele, mas não é que o achasse bonito ou belo: ele me deslumbra feito uma definição."

57 Mário critiques precisely the point that Mary Ann Doane observes decades later: that sublimation reveals the discursive operation of psychoanalytic theory itself. Born in the midst of nineteenth-century colonial projects and photography's epistemological promise of seeing, sublimation reveals the sublimated presence of colonialism in psychoanalysis.

58 Lacan, *The Ethics of Psychoanalysis*, 26.

59 M. de Andrade, "O Movimento Modernista," 253: "Confissão bastante cruel, de perceber em quase toda a minha obra a insuficiência do abstencionismo."

60 Ibid., 252. Although it is tempting, in light of the references to Freud, to translate this word as "castration," *desvirilização* sounds as strange in Portuguese as *devirilization* does in English: "Em nossas pesquisas e criações, nós, os

participantes do período milhoramente chamado 'modernista,' fomos, com algumas excepções nada convincentes, vítimas do nosso prazer da vida e da festança em que nos desvirilizamos."

61 Ibid., 253, 254, 238: "própria altivez sensualíssima do individualismo," "vaidade, tudo vaidade," "nossa 'orgia.'"

62 Aldrich and Woltherspoon, *Who's Who in Gay and Lesbian History*, 21; Trevissan, *Desvassos do paraíso*, 153. See also James Green, "Challenging National Heroes and Myths."

63 M. de Andrade, "Frederico Paciência," 117: "corpos enlaçados."

64 Ibid., 117-18: "[Frederico] avançou, me abraçou com ansiedade, me beijou com amargura, me beijou na cara em cheio dolorosamente. Mas logo nos assustou a sensação de condenados que explodiu, nos separamos conscientes. Nos olhamos no ôlho e saiu o riso que nos acalmou. Estávamos verdadeiros e bastantes ativos na verdade escolhida. Estávamos nos amando de amigo outra vez; estávamos nos desejando, exaltantes no ardor, mas decididos, fortísimos, sadios.

—Precisamos tomar mais cuidado.

Quem falou isso? Não sei si fui eu si foi êle, escuto a frase que jorrou de nós. Jamais fui tão grande na vida."

65 Ibid., 118: "Nos excitava físicamente demais."

66 According to editorial comments found in the table of contents for *Contos Novos*, based upon notes found in the Arquivo Mário de Andrade.

67 Ibid., 129: "Paciência me chamo eu!"

68 Ibid.: "Essa confusão como a palavra 'paciência' sempre me doeu malestarentamente. Me quiema feito uma caçoada, uma alegoria, uma assombração insatisfeita."

69 M. de Andrade, *Poesias Completas*, 148; "XXXVI: Como sempre, escondi minha paixão. / Ninguém soube do primeiro beijo que te dei. / Ninguém não é a inteira verdade . . . / Mas eu sonho que vais *agarradinha* no meu braço / Numa rua toda cheia de amigos, de soldados, conhecidos."

70 M. de Andrade, *O Empalhador de Passarinho*, 195.

71 M. de Andrade, *Poesias Completas*, 40–41, emphasis added: "Mas deixemos a beleza ao lado. *O que me deixa muito interessado por este poema é, nele, eu ter me escondido como talvez em nenhum outro dos meus poemas.* Poema 'interessado,' 'poema de circunstância' mesmo, derivado diretamente de preocupações políticas, sociais, nacionais de valor/função imediato, *O Carro da Miséria* é, no entanto, o poema mais escuro (e escuso . . .), mais aparentemente poesia pura, mais hermética que já escrevi. Mas isso . . . a meu ver constitui uma verdadeira falcatrua lírica. Eu me escondi de mil maneiras. E a mais ingênua foi essa de fazer hermetismo falso, desnecessário. E talvez às vezes forçado. Quero dizer: se o poema é bastante claro de interpretação pra mim, botei

coisas nele que estou convencido, não têm absolutamente nenhuma interpretação possivel . . . não têm sentido interpretável. Só pra *disfarçar.*"

72 Ibid., 48: "Toda a minha vida tive uma preocupação danada de combater a vaidade; que considero epidérmica e mesquinha, e convertê-la em orgulo que é fecundo, viril, capaz. O que não impede que eu tenha minhas vaidades, está claro, embora combatidas e desprezadas."

73 Freud, "On Narcissism," 75, 96.

74 Freud, *Three Essays on the Theory of Sexuality*, 5.

75 M. de Andrade, *Poesias Completas*, 47, emphasis added: "Me parece que tem visivelmente aí uma antítese: a pesquisa violenta, exacerbada, voluntária do Brasil, explodindo num brasileirismo violento 'caiçara,' é a minha mania de estudar, de me cultivar, que me fazia tão livre, tão longínquo do Brasil, fulgindo na palavra *Pirineus*. Essa angústia desnacionalizante da cultura, me deu aliás um poema inteiro, o 'Improviso do Mal da América' . . . adoro o valor achado sem querer da palavra 'Pirineus.' Está entre a península ibérica a França, com o resto da Europa . . . De forma que a palavra Pirineus, única sobre cujo sentido não tenho dúvidas (embora não procurada, nem *compreendida*, quando explodiu), me agrada muito. *É o trampolim do salto brasileiro*—e que via, nos meus estudos folclóricos—quando ele era ibérico (não só português, mas ibérico—o negrismo, o vermelhismo do ser vem no 'Improviso' citado) eram mesmo os Pirineus que me pulavam pra outras culturas e pro que fizera o meu espírito e o sentido individualista do meu ser."

76 Freud, *Totem and Taboo*, 149.

77 Ibid., 116.

78 The quotation in the section header comes from Mário's letter to Carlos Drummond de Andrade (seen in Schelling, "Mário de Andrade," 76): "Ainda é preciso distinguir entre primitivismo e primitivismo."

79 While some may dispute my designation of Mário as Creole, here I use it to describe his broad affiliation with the class of urban *letrados*. Some scholars have argued for Mário's own racial *mestiçagem* as an identity that underwrites his aesthetics. David Haberly suggests he be read as a "nonwhite writer": "Mário's skin color was the legacy of Indian ancestors; the contours of his nose and lips, so evident in photographs, portraits, and caricatures, were clearly African" (137). As such, racial determinations are deeply problematic, especially given the curious recognition of his Indian skin color from black and white photographs. The description on his state identification card reads: "Skin: White; Hair: Brown; Eyes: Brown." According to the state, in any case, Mário appears not to have lived as a mixed race person. For the reproduction of his identification card, see Lopez, *A Imagem de Mário*.

80 Prado Bellei, "Brazilian Anthropophagy Revisited," 109. See also Natalia Majluf, Sérgio Luiz Prado Bellei, George Yúdice, and Roberto Reis.

81 Majluf, "El indigenismo en México y Perú," 615: "No es ni una simple

exaltación de lo local ni un simple exotismo. Es más bien un autoctonismo cargado de angustias."

82 *M*, 356, emphasis added: "Um dos meus interesses foi *desrespeitar lendariamente a geografia e a fauna geográficas*. Assim desregionalisava o mais possível a criação do mesmo tempo que conseguía o mérito de conceber literariamente o Brasil como entidade homogenea, um concerto étnico nacional e geográfico. (Dizer também que não estou convencido . . . de ter feito obra brasileira. *Não sei si sou brasileiro*. É uma coisa que me preocupa e em que trabalho porém não tenho convicção de ter dado um passo grande prá frente não)."

83 M. de Andrade, *Poesias Completas*, 266: "Me sinto branco, fatalisadamente um ser de mundos que / nunca vi."

84 Majluf, "El indigenismo en México y Perú," 619: "El indigenismo intentó fijar al indio para poder retratarlo"; "homogeneización que facilita la dominación."

85 *M*, 398: "Macunaíma não é símbolo do brasileiro como Piaimã não é símbolo do italiano. Eles evocam 'sem continuidade' valores étnicos ou puramente circunstanciais de raça."

86 See Schwartz, *Las vanguardias latinoamericanas*, 16.

87 Campos, "The Rule of Anthropophagy," 45.

88 On filmic recreations of anthropophagy throughout the twentieth century, see Xavier, *Allegories of Underdevelopment*.

89 M. de Andrade, *Será o Benedito!*, 82: "Os objetos, os desenhos, as fotografias que pertenceram a minha existência de algum dia passado, guardam sempre para mim uma força enorme de reconstitução de vida. Vendo-os, não me recordo apenas, mas revivo com a mesma sensação e o mesmo estado antigo, o dia que já vivi."

90 Letter to Newton Freitas, 1944, seen in Carnicel, *O Fotógrafo Mário de Andrade*, 69: "Lhe mando o meu retrato que mais gosto . . . porque marca no meu rosto os caminhos do sofrimento, você repare, cara vincada, não de rugas ainda, mas de caminhos, de ruas, praças, como uma cidade. Às vezes, quando espio esse retrato, eu me perdôo e até me vem um vago assomo de chorar. De dó. Porque ele denuncia todo o sofrimento dum homem feliz . . . [as derrotas] eram pra mim motivo de tanta, não alegria, mas dinâmica do ser e superação até física, que me esqueci que sofria. Até que me tiraram essa fotografia. E fiquei horrorizada de tudo o que sofri."

91 Freud, *Civilization and Its Discontents*, 18.

92 Ibid., 19.

93 Buchloh, "Residual Resemblance," 56.

94 They also can be read as a satire of the conservative political projects of *branqueamento*, or whitening, that sought to increase European immigration to Brazil.

95 M. de Andrade, "Toada": "Busquei São Paulo no mapa, / Mas tudo,

com cara nova, / Duma tristeza de viagem, / Tirava fotografia . . . / Fiquei tão pobre, tão triste, / Que até o olhar se fechou. / No outro lado da cidade / O vento me dispersou." See also M. de Andrade, *Poesias Completas*, 309.

Chapter 3: Mediation

1 Editorial, *S. Paulo* 1, no. 1 (1936): "Este mensario, orgão documental das realizações paulistas, nasce da propria logica deste instante, como um espelho necessario a fixar nossa pujante vitalidade. Seu valor residirá apenas nas imagens que nelle se reflectem, si bem que tudo seja pequeno para poder reproduzir a acção e o pensamento de uma 'raça de gigantes.'"

2 *Base* 1, no. 2 (September 1933): 25.

3 *Escrava*, 265: "Pelo jornal somos omnipresentes."

4 For a description of the journal as political propaganda and more details about its graphic design innovations, see Mendes, "A revista S. PAULO."

5 Jorge Schwartz emphasizes the importance of the entire range of publications. Borges, perhaps the most-read Latin American writer inside and outside the region, began publishing during the period of the modernist avant-garde and also contributed for many years to the popular illustrated magazine *El Hogar* (*Home*). While several books containing these texts have been published, they tend to downplay his investment in them and do not analyze them as serious sites for literary experimentation. Enrique Sacerio-Garí and Emir Rodríguez Monegal state from the beginning that they will ignore the question whether the housewives who were the readers of *El Hogar* appreciated the texts. María Kodama reveals that Borges published in the magazine between 1925 and 1962 and even reproduces images of the mixed-media photographic design that filled the pages, but does not analyze their impact on his avant-garde aesthetic. See Borges, *Textos cautivos*, and Kodama, *Borges en* El Hogar.

6 Ehrenberg, "La desobedencia como método de trabajo," 94: "[el] medio popular por excelencia."

7 The *Manifesto da poesia Pau-Brasil* was published in the *Correio da Manhã*, on March 18, 1924. English translation by Stella M. de Sá Rego, *Latin American Review* 14, no. 27 (1986): 184–87.

8 Editorial, *S. Paulo* 1, no. 9 (1936): n.p. Johnson describes him as an "Estado Novo ideologue" ("The Institutionalization of Brazilian Modernism," 8).

9 Ricardo, "Moça tomando café": "Derrubou sósinho a floresta brutal."

10 Ricardo, "Moça tomando café": "Quedê o lavrador? / Está plantando café. / Quedê o café? / Moça bebeu. / Mas a moça onde está? / está em Pariz (*sic*). / Moça feliz."

11 The material interaction between photographic image and word is discussed in detail in chapter 4.

12 Telê Porto Ancona Lopez, introduction to M. de Andrade, *Táxi e Crônicas no Diário Nacional*, 39.

13 Ibid., 15, 16.

14 Hansen, "The Mass Production of the Senses," 60.

15 The translations that follow are my own. Readers can also see the translation by Elizabeth Fox and Robert A. White: *Communication, Culture and Hegemony*.

16 Martín Barbero, *De los medios a las mediaciones*, 189: "El gesto negro se hace popular-masivo."

17 Ibid., 135.

18 Sérgio Miceli calls this "the nonunification of the material and symbolic markets . . . [and] the subsistence in the massive of cultural matrices in conflict" (*Intelectuais e classe dirigente no Brasil*, 249). On primitivism and the popular, as well as more on the middle class in São Paulo, see Gelado, *Poéticas da transgressão*.

19 Martín Barbero, *De los medios a las mediaciones*, 50–51, emphasis original: "*atrofia de la actividad del espectador*"; "pesimismo cultural."

20 This definition of aesthetics also brings in Michel de Certeau's strategies, tactics, and *uses* or practice of everyday life (ibid., 24).

21 Martín Barbero, *De los medios a las mediaciones*, 178–79: "vivencia, en sentimiento y cotinianidad."

22 Amaral, *Artes Plásticas na Semana de 22*, 97.

23 Rama, *La ciudad letrada*, 162–63: "Ya sea por razones económicas o intelectuales, la Universidad deja entonces de ser la forzosa vía del letrado como lo fuera omnímodamente en el XIX y aún en la modernización. Con inédita dignidad aparece la categoría autodidacta."

24 Graciela Montaldo clarifies this point further, writing about the writer in the 1920s in Argentina: "El escritor profesional es para Viñas, aquel que comienza a tener conciencia de su tarea intelectual en tanto tal y que ve a la literatura no como mero pasatiempo para los momentos de ocio sino como una ocupación disciplinada; de ningún modo la profesionalización incipiente se refiere a la posibilidad del escritor de vivir de su trabajo" [The professional writer is for Viñas, one who begins to have a consciousness of his intellectual work such that he sees literature not as a mere pastime for moments of laziness, but rather as a disciplined occupation; in no way does the incipient professionalization refer to the possibility of the writer making a living from his work] (Montaldo 137n16). Nevertheless, this professionalization also signified the entry into the literary sphere of writers who did not emerge from the oligarchical families of Argentina.

25 Miceli, *Intelectuais e classe dirigente no Brasil*, 27: "home[ns] sem profissão."

26 Letter to Alceu Amoroso Lima, *M*, 400.

27 Miceli, *Intelectuais e classe dirigente no Brasil*, 28.

28 See Barrera, *Salvador Novo*.

29 Monsiváis, *Salvador Novo*, 108: "¿Es posible en nuestro tiempo, en México, vivir de escribir?"

30 Novo's attraction to truck drivers, however, was not purely professional. There is more on his queer aesthetics in chapter 5.

31 D. Williams, *Culture Wars in Brazil*, 98.

32 Seen in D. Williams, *Culture Wars in Brazil*, 100.

33 "Esboço"; "indumentaria regional"; "o cavaleiro, o vaqueiro, a baiana"; "Outro processo ainda, e utilissimo, pra por em prática esta parte móvel do programa social seria o lançamento duma Revista da Moda Nacional, ou criação duma seção dirigida pela Sociedade, numa revista já lançada (*Vanitas*, *Cigarra*), de combinação com os directores dela." See "Esboço dum *Programa Geral de Cultura Artistica Nacional*," Manuscritos Mário de Andrade, MA-MMA-59, Arquivo Mário de Andrade, Instituto de Estudos Brasileiros, USP.

34 The importance of this change in name might be considered in comparison to the famous Museo Nacional de Antropología e Historia in Mexico City, which similarly makes the implicit argument that the diverse indigenous groups belong to the country's past rather than its present. Given the fact that according to the 1990 census more than 5 million Mexicans over the age of five speak indigenous languages—a number more likely to err on the low rather than the high side—the insertion of the word *history* in these titles is quite powerful.

35 D. Williams, *Culture Wars in Brazil*, 101.

36 Kaz, "A Revista no Brasil," 25.

37 Ibid., 22: "Esporte, política, artes e espectáculos, consumo, modos de vida."

38 Ibid., 158: "Se 'feminizaram.'"

39 Ibid., 162.

40 *PD*, 63–65: "Mulher mais longa / que os pasmos alucinados /das tôrres de São Bento! / Mulher feita de asfalto e de lamas de várzea, / toda insultos nos olhos / toda convites nessa boca louca de rubores! . . . meio fidalga, meio barregã, /as alucionações crucificantes / de todas as auroras de meu jardim!"

41 Tenorio, "A Tropical Cuauhtemoc," 117.

42 Ibid., 119.

43 For a trenchant critique of representations of mestizaje in Mexico, see Lund, "They Were Not a Barbarous Tribe."

44 Martín Barbero, *De los medios a las mediaciones*, 10, emphasis original: "La *verdad cultural* de estos países: al mestizaje que no es sólo aquel hecho racial del que venimos, sino la trama hoy de modernidad y discontinuidades culturales, de formaciones sociales y estructuras del sentimiento, de memorias e imaginarios que revuelven lo indígena con lo rural, lo rural con lo urbano, el folklore con lo popular y lo popular con lo masivo. Fue así como la comunicación se nos tornó cuestión de *mediaciones* más que de medios, cuestión de cultura y, por tanto, no sólo de conocimientos sino de re-conocimiento."

45 The bibliography about the discursivity of race is extensive, notably by the group of scholars examining the "coloniality of power," including Aníbal Quijano, Walter Mignolo, and Immanuel Wallerstein.

46 This prologue is to a later edition of *The Cosmic Race* (Vasconcelos, *La raza cósmica*, 43): "Las comunicaciones modernas tienden a suprimir las barreras geográficas . . . lentamente irán desapareciendo los obstáculos para la fusión acelerada de las estirpes." The editors of *S. Paulo* reflect the continued influence of Vasconcelos's cultural theory more than a decade after his visit to Brazil, writing about "the miracle of the 'Cosmic Race,'" that begins with the Indian and come to a halt in the immigrant who brings, in his clothing, in variegated patches, the map of all countries (1, no. 6 [1936]): "O milagre da 'raça cosmica,' que começa do indio e vem parar no immigrante que traz, na roupa, em remendos variegados, o mapa de todas as patrias."

47 Corral Corral, *La ciencia de la comunicación en México*, 57. Corral Corral points that during Manuel Ávila Camacho's presidency (1940–46), nationalism and revolutionary ideals became disentangled, fundamentally changing the context and content of Mexican mass media.

48 Ibid., 56.

49 Ortiz Gaitán, *Imágenes del deseo*, 180.

50 Rubenstein, *Bad Language, Naked Ladies, and Other Threats to the Nation*, 3, 5.

51 See essays by Blanca Aguilar Platas and Javier Gariadiega D. in Cano Andaluz, *Las publicaciones periódicas y la historia de México (ciclo de conferencias)*.

52 González Marín, "La prensa y el poder político en el gobierno del general Lázaro Cárdenas," 159, Aguilar Platas, "1917–1934," 134.

53 On letterhead from the Secretaría de Hacienda y Crédito Público to the Departamento de Pago: "Con referencia al atento oficio de esa Secretaría No. 5836, girado el 8 del actual por su Sección 1/a., tengo la honra de manifestar a Ud. que hoy ordeno a la Tesorería General de la Nación, abone a la cuenta de esa propia Secretaría, la suma de $3,247.00 (tres mil doscientos cuarenta y siete pesos oro nacional), que importó la operación de la venta hecha a la Empresa Editorial de 'El Universal,'—de cincuenta rollos de papel, con peso de 9.550 kilos, al precio actual de plaza de $0.34 kilo." Signed on March 12, 1917, by order of "El Oficial Mayor en funciones de Subsecretario"

(Archivo General de la Nación, Período Revolucionario, Gobernación, Caja 206, Exp. 12, Fs. 2).

54 Palavicini, *Mi vida revolucionaria*, 353–54: "Me dediqué a organizar una empresa privada para editar un diario, pues mi propósito era dedicarme al periodismo político, creando una gran empresa para hacer un diario revolucionario independiente. . . . Es oportuno declarar que el Gobierno del señor Carranza no proporcionó un solo peso para la fundación de este periódico."

55 Castro Ruiz and Maya Nava, *Historia de* El Universal, 4; and Loyo, "Lectura para el pueblo, 1921–1940," 299.

56 Palavicini, *Mi vida revolucionaria*, 363: "El Estado puramente político decae en nuestra época. . . . El industrialismo, en cambio, es dueño del mundo moderno: difunde el bienestar, consolida la democracia." Palavicini's liberal economic model in no way precluded racism, which appears in his hispanophilia and proclamation that "autochthonous elements" had not sufficiently developed the country, thus Mexico needed new immigration.

57 Aurrecoechea and Bartra, *Puros cuentos*, 200, emphasis added: "Desde las vanguardias *más o menos elitistas*, hasta las aún irredentes masas populares."

58 Gonzáles de Mendoza, "Carlos Noriega Hope," 34: "El ideal de esta revista es un [foro] . . . frívolo y moderno, donde las cosas trascendentales se ocultan bajo una agradable superficialidad. Porque es indudable que todos los periódicos tienen su fisonomía y su espíritu, exactamente como los hombres. . . . Los hay frívolos y aparentemente vacíos, pero que guardan, en el fondo, idea originales y una humana percepción de la vida. Quizás este semanario, dentro de su espíritu frívolo, guarda el perfume de una idea."

59 Ibid., 33: "Quiso hacer del *Universal Ilustrado* una publicación hogareña e insertó retratos de damas y de niños; estableció secciones de recetas útiles, consejos a la mamás, lecciones de bordado; publicó artículos sobre la hora del té, los abanicos, las arrugas y su triunfal aversaria: la cirugía estética."

60 Castro Ruiz and Maya Nava, *Historia de* El Universal, 21: "Era una anárquica plana ilustrativa de las diferentes corrientes artísticas; no llevaba en realidad coherencia alguna ya que sus temas eran tan disímbolos que una plana era insuficiente para darles orden."

61 Crow, "Modernism and Mass Culture in the Visual Arts," 3.

62 Ibid., 27.

63 Ibid., 4.

Chapter 4: Essay

1 Despite his proclamation of the unique mixture of "high" and "low" as characteristic of Latin American modernism, García Canclini does not examine the revistas ilustradas, excluding both the important space of mass

media and the crucial category of gender from his analysis of the region's avant-garde movements. While Guillermo Sheridan, Salvador Albiñana, and Horacio Fernández repeatedly cite weeklies such as *El Universal Ilustrado* and *Revista de Revistas* as major sources of support for the avant-garde literary movements and as key resources for the study of modernist photography in Mexico, they do not analyze them as mass media or as women's publications. As a result, the content and the address—the women who are the pictured subjects and the imagined audience of these publications—of the vast majority of pages in the journal is lost.

2 See Irwin, *Mexican Masculinities*, especially chapter 3, "Virile Literature and Effeminate Literature." Irwin writes compellingly about homoeroticism and sexual politics in postrevolutionary Mexico and considers the problematic categories of masculinity and femininity in elite and popular literature.

3 See Díaz Arciriega, *Querella por la cultura "revolucionaria,"* 55, emphasis added: "Falta quien elabore las frases que consagran, las que el público—*la masa*—se encarga de repetir, creando así la popularidad, ya que no está capacitado para formarse, por sí mismo, opinión definida sobre las obras nuevas."

4 See Balderston, "Poetry, Revolution, Homophobia"; Irwin, *Mexican Masculinities*; and Monsiváis, *Salvador Novo*. See chapter 5 of this book for further discussion of queer aesthetics in these groups.

5 Díaz Arciriega, *Querella por la cultura "revolucionaria,"* 85, emphasis added: "Ahí conviven, *promiscuamente*, un muy extenso muestrario de temas reveladores de una dirección editorial que tiene dificultades para discriminar." Another example of the sexualized language of early mass media appears in Aurrecoechea and Barta's history of *historietas*: "Millones de compatriotas, que aún no habían experimentado los placeres de la letra impresa, perdieron su virginidad literaria sumergiéndose en las seductoras páginas de las revistas de monitos" [millions of compatriots, who had still not experienced the pleasures of the printed word, lost their literary virginity by submerging themselves in the seductive pages of comic books] (Aurrecoechea and Bartra, *Puros cuentos*, 2.13). For a useful survey of the debate about femininity, see Hernández Rodríguez. Hernández Rodríguez, however, concludes that "the avant-garde in Mexico for the most part excluded women and everything feminine was often considered fragile, unstable, and undesirable, therefore being effeminate, a woman or a homosexual—it did not matter which one—was to be *weak*." This chapter argues that it did matter.

6 Castillo, *Easy Women*, 13; here she cites Monsiváis's formulation of the mujer pública and develops it broadly.

7 Castañón, "La ausencia ubicua de Montaigne," 35.

8 Corominas, *Diccionario crítico etimológico castellano e hispánico*: "obra literaria didáctica ligera y provisional."

9 Castañon, "La ausencia ubicua de Montaigne," 37.

10 García Canclini, *Hybrid Cultures*, 47.

11 Ibid., 2.

12 For more on this, see my "Recycled Photographs."

13 I thank Bruno Bosteels for pointing out the importance of this contradiction in reading these photo-essays.

14 Mitchell, *Picture Theory*, 281.

15 Ibid., 285.

16 The repeated exclusion of women's writing and the importance of gender from the study of the essay is addressed in D. Meyer, *Reinterpreting the Spanish American Essay*. Mary Louise Pratt notes that this period saw an almost obsessive essayistic response—by men and women—to the escalation of activity in women's organizations, especially suffragist movements ("'Don't Interrupt Me'").

17 See Masiello, *Between Civilization and Barbarism*, 28–31.

18 Debra Castillo describes Mexico's national culture as one "in which presumed gender boundaries for women and the transgression of these boundaries are deeply imbedded features of the social fabric. . . . Women who infringe upon the public space remain scandalous, and this continuing scandal, I believe, resides initially in the impact of a female-gendered human being in an unexpected public space" (*Easy Women*, 4).

19 Maples Arce, List Arzubide, Gallardo, et al., "Manifiesto Estridentista Num. 2," 170: "la posibilidad de un arte nuevo, juvenil entusiasta y palpitante."

20 See Reyes Palma, "Arte funcional y vanguardia (1921–1952)."

21 Pratt, "Women, Literature, and National Brotherhood," 52.

22 Sierra, "Aspectos sociales de las mujeres de México," 4, emphasis added.

23 Ibid.

24 See Debroise, *Fuga mexicana*, 38: "En efecto, si hay ocupación para la mujer, es la fotografía."

25 Novo, "El arte de la fotografía," 169: "La hija pródiga de las bellas artes"; "Nuestra pobre fotografía [está] relegada al último rincón del valor artístico. Como un traje sucio, recoge humildemente la misión que ha dejado la pintura, y se la viste. Pero, criatura nueva, se marcha alegremente por los caminos, va a las excursiones, se ejercita, curiosea. Es la hija pródiga del arte: ha nacido y se ha desarrollado, máquina ella misma, en la edad de los instrumentos mecánicos. Pero, exiliada y todo, sigue con sus propios recursos los pasos que ahora da su madre cruel. Y si la pintura ha dejado de copiar, ¿no podrá la fotografía intentar la creación por su cuenta? ¿No podrá llegar a producir un conjunto de líneas, de formas significativas relacionadas de un modo tal que a propio tiempo que no nos recuerden nada visto nos susciten,

sin embargo, la emoción estética?" This essay was first presented as a lecture at the opening of an exhibition by experimental photographer Agustín Jiménez on April 20, 1931, at the Sala de Arte, a gallery run by Francisco Díaz de León and Gabriel Fernández Ledesma but owned by the Ministry of Public Education (Albiñana and Fernández, *Mexicana*, 267). It was soon published in *Contemporáneos*, the high-quality journal edited by this avant-garde group.

26 Novo, "El arte de la fotografía," 171: "Una oposición absoluta entre lo artístico y lo útil."

27 Ibid.: 169. "En manos de millones de jóvenes, la humilde kódak es deporte y expresión. . . . ¡Cuántos pequeños trozos de arte puro!"

28 The tendency to fit Mexican photographic aesthetics into an already existing canon appears even in the impressive and important exhibit organized by Salvador Albiñana and Horacio Fernández. The organizing principle of the exhibit fit Mexican photography into the "international style of the New Vision," and the catalogue explains that they selected work "with techniques and themes similar to those which then characterised modern photography—urban life, mechanisation, formalism, compositions close to abstraction, and so on" (236). These categories leave out techniques and themes that were central to modernity in Mexico: the rural, popular culture, mass media itself, and modern women, as well as a diverse aesthetic mixing the formal characteristics they mention with photomontage, documentary, and even melodrama.

29 Editorial, *Imagen* 1, no. 1 (1933): 3: "Será la cámara, el espejo o la antena, que por su condición mecánica proyectará la imagen o la palabra, el gesto o la voz tal como son en el modelo, sin que nadie altere la visión o el acento en perjuicio de la verdad que se le debe al público."

30 Waldemar George, "Fotografía, Magia Moderna": "Una traducción, una interpretación, libre, arbitraria de un espectáculo existente. Es una creación que utiliza las propiedades de la placa, receptáculo de la luz, para un fin que no es la copia, sino un arreglo fantástico de las sombras y de las luces"; "atacan su esencia corpórea. Objetos que se hacen desconocidos. . . . Transgresión, violación de las leyes de la vista."

31 Becerra González, "La mujer, la moda y el modisto", n. pag., emphasis added: "Veamos ahora cómo se desarrolla *la magia* del vestido, su concepción, su metamorfosis, su realización y su éxito como *obra* acabada."

32 Psique Hadaly, "Como tú me deseas," *Imagen*, June 23, 1933, 6: "Mis queridas lectorcitas de IMAGEN," "frivolidades exquisitas y deliciosas que constituyen la atmósfera y el ambiente nuestro."

33 Ibid.: "Precisamente, en conocer esta imagen y apropiársela."

34 *Rotográfico*, September 22, 1926, 4: "Un tocado masculino . . . y algo más; las mujercitas que fuman Murad y quieren ser hombres."

35 "Flappers," *El Universal Ilustrado*, March 25, 1926, 24: "Con el pelo tan corto que muestra toda la nuca . . . es algo más que la muchacha 'tomboy' o marimacha, excepción que escandalizó a nuestras abuelas. La 'flapper' lo es voluntaria y deliberadamente y sin vestido, sus ademanes, su especial caló exteriorizan una arraigada y lamentable filosofía que va desde el nefando crimen de la que mató a su propia madre porque le impedía ir a danzar al cabaret noche con noche, hasta las que contraen tisis galopante por pasar las veladas bailando y los días trabajando bajo el dictáfono y frente a la maquinilla." *Caló* refers to a Spanish mixed with English, taken up as a point of pride by Chicano/a writers such as Gloria Anzaldúa. For more on Tablada and modernity as a frightening femininity, see Hernández Rodríguez, "El poeta en la quinta avenida."

36 Monsiváis, *Celia Montalván*, 27.

37 Ibid., 23–24: "La *vamp*, la hembra que vampiriza con su hermosura excéntrica"; "cuyo sustrato cultural mezcla a Scott Fitzgeralds, Freud y las vanguardias europeas." For an analysis of Rivas Mercado's role in this generation, see Franco, *Plotting Women*.

38 Monsiváis, *Celia Montalván*, 31: "'Intranscendente' teatro frívolo."

39 Ibid.: "Una suerte de medio masivo de difusión, en una ciudad dominada todavía por la cultura oral."

40 Ibid.: "Las vanguardias transcurren sin mayor registro público, los *Estridentistas* le cantan a la máquina sin provocar conmoción fuera de los círculos literarios, y Tablada, Pellicer y Novo son apenas advertidos." For an excellent treatment of Agustín Jiménez's avant-garde photography in illustrated journals, see Córdova, *Agustín Jiménez*.

41 "Silvestre Paradox," "El café de nadie," *El Universal Ilustrado*, June 3, 1926, 43: "Ahora hay que buscar a los escritores, a los poetas, a los pintores y a los músicos, en el café más próximo a la vida ajetreada y tumultuosa . . . los escritores, pintores y poetas invadir los restoranes automáticos, sentarse a lo largo de ese perenne banquete que son los 'Quick-Lunchs' y charlar rápidamente, sintetizando los conceptos para estar al día de las emociones sincrónicas que sugiere el aceleramiento de la vida. . . . Todas las noches se reunen alrededor de unos 'hot-cakes,' Salvador Novo, Xavier Villaurrutia, José Gorostiza, Bernardo Ortiz de Montellano, Roberto Montenegro y se sirven rápidamente sus emociones, sujetándose al lema de café. . . . sintetizan las escenas de la vida y las visualizan para una futura escena."

42 "Silvestre Paradox," "El café de nadie," 43: "Sin lo ficticio de la bohemia."

43 Monsiváis adds, "Illicitly, or thus I observe it now, Celia Montalván transmits a complex and risky code of signals, directed not at the buyer nor the specific public but at her performance as a *vedette*" (Monsiváis, *Celia Montalván*, 59–60, emphasis added): "De contrabando, o así lo observo ahora,

Celia Montalván transmite un complicado y arriesgado código de señales, no dirigido al comprador ni a un público específico sino a su desempeño de vedette."

44 Arqueles Vela, "Un cuento espantable," *El Universal Ilustrado*, March 11, 1926, n.p.: "Cuando ella había apagado todos sus pensamientos, sumiéndose en una deslumbrante preocupación, comenzó a repasar los nombres innumerables que usara durante los pocos años que llevaba de mujer elegante, sin decidirse por ninguno.

"Betty Reynolds.

"Stenilda Steinberg.

"Charlotte Ellis.

"Varenka Karinec.

"Asunción González.

"Etcétera.

"Etcétera.

"Guardó su carnet, desechándolos alfabéticamente, convencida de que ninguno de ellos serviría para interpretar la mujer que tuviera que ser en esta aventura, en la que todo iba a depender del nombre que la presentara en la suntuosidad de aquella fiesta llena de presunciones.

"Tenía que caracterizarse como la mujer que no conoce a nadie, con la que se equivocan todos. De ahí que se le viera desconcertando la prestidigitación de los espejos, aguzándose y arqueándose las cejas, como para dar a sus miradas cierta desviación malévola, despistando su ingenuísmo."

45 The female narrator is an exception in avant-garde prose fiction. The more common first-person male narrator is addressed in my discussion of the genre of prose fiction in chapter 5.

46 Monsiváis, *Salvador Novo*, 34, emphasis added: "El 'travestismo verbal' es obligatorio porque lo más próximo a la esencia de los 'raritos' es *la identidad femenina por contagio*." The translation of "raritos" as "queers" is based upon his article in *Debate Feminista* in 1997.

47 Felski, *The Gender of Modernity*, 111.

48 Luis de Hoz, "La Mujer Moderna y el Flapperismo," *Rotográfico*, October 2, 1926, 6–7, emphasis added: "¿Toda mujer 'moderna' tiene que ser precisamente una 'flapper' en el sentido un tanto pecaminoso que se da en Latinoamerica a esta palabra inglesa? . . . *No* respondemos. . . . La aparenca exterior de estas dos modalidades femeninas es, sin embargo, exactamente igual. La misma silueta alargada y quebradiza . . . las mismas diez uñas escarlatas como otras tantas amenazas de araño y sangre . . . Idénticas cabelleras recortadas hombrunamente . . . Los mismos toques azules, rojos y negros en las caras hasta darles cierta expresión lucerfina"; "muchas de nuestras damitas modernizadas llevan detrás de ese continente de vampirenas todos los escrúpulos de la provincia."

49 Luis de Hoz, "El arte en la fotografía," *Rotográfico*, November 10, 1926, 9: "los fotógrafos actuales tienen a su disposición todo un arsenal de lámparas, cortinas y fondos para buscar los 'efectos' de luz, que tanto realzan la hermosura femenina, y después un catálogo completo de diversos papeles, de ácidos, de sales, etc. para complementar por medio de los retoques el parecido físico y comunicar a la tarjeta impresionada 'ese algo' que viene a constituir, en último análisis, la verdadera fisonomía de una persona."

50 De Hoz, "El arte en la fotografía," 9: "Tiene una serenidad y una harmonía de expresión que concuerdan a maravilla con las altas morales que adornan a esta dama. Este es el secreto de la éstetica de la fotografía moderna."

51 The canonical text on the woman as object of the gaze, initially about cinema but quickly part of feminist debates about photography, is Laura Mulvey's article "Visual Pleasure and Narrative Cinema," originally published in *Screen* and widely reproduced. Also see Berger, *Ways of Seeing*.

52 The comics included in the back section of many illustrated journals repeat the theme of the danger that the "prodigal daughter" poses to photographers. They reproduced recurrent jokes about what "really" happened when a woman went to have her portrait taken: she always ended up in a sexual encounter with the photographer. The message of the comics was, however, just as conflicted as the photographs of modern women. At times, the woman was portrayed as an innocent at the mercy of a lecherous photographer. Just as often, she was a vamp who used the intimacy of the photographic studio to entrap the naive photographer. In both cases, photography was clearly identified with a dangerous new feminine sexuality.

53 The magazine *Mexican Folkways* employed Álvarez Bravo as a photographer, and the book *Idol behind Altars* employed Weston and Modotti.

54 MacDonald Escobedo, *Turismo, una recapitulación*, 97–121.

55 The phenomenon of domestic tourism has been largely ignored by histories of tourism, which tend to analyze the experiences and desires of foreign travelers. Since this topic has received so little attention, I briefly introduce it here, in order to be able to better discuss photography and the circulation of a hybrid femininity in this period. However, the relationship of this domestic tourism to international tourism is complicated, and the parallels and differences between the two merit further investigation.

56 "Nos Presentamos," *El Mapa*, April 1934, 5–6, emphasis added; "En fin, es necesario que defendamos nuestra verdad artística, nuestra 'realidad nacional' (*para apelar a la frase en boga*). . . . Creemos, por esto, que el turismo nacional, es decir, el que dará a conocer México a los mexicanos, debe crearse y fomentarse de toda preferencia, sin por ello descuidar naturalmente la vista extranjera que es, en estos momentos, una realidad indiscutible. Enseñarnos a ser turistas en nuestro proprio país, es el primer paso para un acercamiento

que sólo el turismo podrá conseguir efectivamente; es el primer paso, también, para poder entender, valorizar y respetar nuestras riquezas de todo orden, nuestra tradición y nuestra nacionalidad, valores que, conservados celosamente, serán, además, la mayor atracción para el turismo extranjero." Domestic tourism, therefore, was also linked to international tourism, and after more than a year in publication, *El Mapa* began to include translations into English of certain articles.

57 "Viajes/Turismo," *El Mapa*, May 1935, 33: "Nuestro tiempo es la época del transporte."

58 Ibid., 33: "Hay que practicar el turismo. El turismo es benéfico aun en la propia casa. El panorama urbano que se contempla desde la azotea es distinto al que puede verse desde la ventana. Este ejercicio agudiza el sentido de la visión."

59 "Técnica fotográfica," *El Mapa*, May 1935, 51: "No basta ya, para el aficionado, dedicarse a tomar fotos documentarias; quiere ahora escenas animadas, efectos de luz, motivos de naturaleza muerta; en suma, trata de producir asuntos que despierten una emoción estética."

60 Xavier Villaurrutia, "Los frescos de Diego Rivera," *El Mapa*, February 1935, 39: "Comenzamos a publicar con este artículo lo que pudiera llamarse en términos turísticos 'Circuito de Diego Rivera.'"

61 Alonso Alejandro Nuñez, "Nuestra Capital," *El Mapa*, August 1934, 36, emphasis added; "¡Oriente! Esto es Oriente!": "Pasear por el centro de México es hacer el más extraño de los itinerarios viajeros. . . . *El Occidente está en el centro de México, y México, nuestra capital, está diseminada, por extrañas alusiones, en todo mundo occidental.*"

62 "La anarquía arquitectónica en México," *El Mapa*, March 1936, 5: "convierten esta ciudad, que era única, en un horrible mosaico de todos los estilos."

63 See Costa and Rodrigues, *A Fotografía Moderna no Brasil*.

64 The connection between sexualized women and touristic travel appears in "high art" publications as well. *México moderno*, supposedly an intellectual journal, published "Un flirt a bordo" (May 10, 1921, 187–89), by Bartolomé Galindez, about a flirtation during a journey by boat.

65 Salvador Novo, "Elogio del Automóvil," *El Universal Ilustrado*, January 28, 1926, 19: "Ven en el automóvil el resumen más completo de su ambición y la realización perfecta del progreso."

66 Novo, "Elogio del Automóvil," 19, emphasis added: "Fuera de lo que significan con relación al progreso, considerados como cosas en sí, es grato observar que en su aspecto se van acercando cada vez más a una realización perfecta de aquella línea pura, limpia y sintética que todos queremos expresar . . . fuera de toda duda, una ponjola girl se ve más en su casa en un Paige, en

un Packard, en un Buick." "Ponjola" may be a reference to the 1923 silent film directed by Donald Crisp, which told the story of a deceived young wife, a journey to Africa, and a gold mine. The word *ponjola* means "whisky" in Kaffir, but Novo's meaning here is obscure.

67 Abella Caprile was an Argentine poet, famous enough in her day to be considered among the ranks of Alfonsina Storní, Delmira Agustini, Juana de Ibarbourou, and Gabriela Mistral.

68 Margarita Abella Caprile, "La Mujer que Viaja Sola," *El Mapa*, May 1934, 52: "La exclusividad del 'atelier' individual y silencioso, el derecho a que no le distraigan durante muchas horas del día, a que no interruman [sic] su vagar caviloso por los caminos del campo o por las calles de la ciudad."

69 On feminist organization and citizenship, see Olcott, *Revolutionary Women in Post-Revolutionary Mexico*.

70 Gabriela Medina, "La Mujer y el Auto," *El Mapa*, January 1935, 90: "El auto ha creado una actitud mental, por así decirlo, en el hombre moderno, pero mientras para éste, el automovilismo se ha resuelto en una mecanización del espíritu, para la mujer ha resultado ser una liberación y una conquista. . . . ¿por qué el automovilismo es una conquista para la mujer si es una merma intelectual para el hombre?"

71 Abella Caprile, "La Mujer que Viaja Sola," 52, emphasis added: "Ahora las cosas han empezado a mejorar bastante, principalmente en los países del otro hemisferio. Entre nosotros, que conservamos todavía la suspicacia *primitiva* de la 'viveza,' no se ha establecido aún la diferencia que existe entre el noble concepto de 'libertad' y la idea inferior de 'libertinaje.' Y tratándose de la mujer, peor que peor. No se la concibe buscando su independencia, sino con la maliciosa intención de emplearla en forma indebida. . . . La que tiene el sentido de la propia responsabilidad, viajando o sin viajar, será siempre equilibrada y formal; la que es irresponsable cometerá errores *aunque no salga de las cuatro paredes de su casa.*"

72 Arqueles Vela, "Cohetes luminosos," *El Universal Ilustrado*, March 4, 1926: "Las luces en los estribos de los coches [que] nos presentan las pantorrillas como en un 'close-up.' Parece que se han puesto de moda estas luces, precisamente ahora que las faldas cortas triunfan de los comentarios . . . [las] luces alucinadoras . . . Las que se van apagando y encendiendo, según su automatismo, que es idéntico al guiño de ciertas mujeres que encontramos en las calles prohibidas. Luces que tergiversan el sentido de las calles, que nos cambian de dirección, como si hubiesen movido el 'switch' de las perspectivas."

73 Arqueles Vela, "Las mujeres y el automóvil," *El Universal Ilustrado*, March 4, 1926, 37: "En el automovilismo, las mujeres pueden ensayar todas las coquetarías y todos los flirts."

74 Novo, "Elogio del Automóvil," 19: "Me interesaban las cosas en relación con las personas. Si el hombre hizo máquinas, éstas le volvieron chofer, como las bicicletas le desarrollaron las piernas, como los trenes rápidos, a los que tenían que trepar los garroteros, les han dado una forma peculiar de sombrero contra los vientos y un modo cabeceante de ambular."

75 "Influencia Social del Auto," *El Mapa*, January 1935, 46: "No se dan cuenta generalmente de que el automóvil está cambiando el pensamiento y aún el cuerpo humanos."

76 "Autos y artistas," *El Universal Ilustrado*, January 28, 1926, 20: "Apasionadas del volante . . ."

77 "Gráficas de las Carreras," *El Universal Ilustrado*, April 19, 1923, 19: "El momento más emocionante de la carrera de coches piloteados por damas. Los autos fueron sorprendidos en plena carrera en esta admirable fotografía"; "Georgina Henderson y su mecánico, momentos antes de iniciar la carrera que costara la vida del segundo. La señorita Henderson quedará terriblemente desfigurada."

78 Ruiz Martínez, "Nación y género en el México revolucionario," 71.

79 *El Universal*, August 2, 1921 (see Reyes, "Los Contemporáneos y el cine," 120): "Todas las características de la raza: color moreno, cabello lacio y negro, etcétera. Pertenece desde el punto de vista racial a la raza azteca, que está extendida por diversas partes de la República; su idioma es mexicano."

80 See Ruiz Martínez, "Nación y género en el México revolucionario."

81 *El Universal Ilustrado*, August 4, 1921, 11: "Una india pura raza 'Meshica' que no habla español."

82 *El Universal Ilustrado*, August 11, 1921, 35: "En amena charla con gentiles señoritas de nuestra mejor sociedad, en la casa del señor Secretario de Relaciones Exteriores, don Alberto J. Pani."

83 Manuel Gamio, "La Venus India," *El Universal Ilustrado*, August 17, 1921, 19: "¿Es en verdad una bella mujer, Bibiana Uribe la 'India Bonita'? ¿Es representativa del tipo de hermosura femenina? Estas preguntas aparentemente sencillas entrañan, sin embargo, complejos problemas de estética bien difíciles de resolver."

84 Blanca de Montalbán, "La[s] Mujeres no quieren ser morenas," *El Universal Ilustrado*, August 4, 1921, 34: "Estoy con vosotras, lectorcitas, en que no debe ser muy cómodo tener la piel de un moreno tostado." Again, the address is to women readers. However, Malinche was Cortés's indigenous wife, proclaimed mother of the first mestizo in Mexican nationalist narratives; Xóchitl was an Aztec princess. Neither was racially mixed.

85 Jerónimo Coignard [Francisco Zamora], "Del Pequeño Mundo," *El Universal Ilustrado*, August 17, 1921, 21, emphasis added.

86 The *traje de charro* is the black suit worn by mariachi musicians; the *china poblana* outfit consists of a cloth skirt with red and green sequins and

a large Mexican eagle in the front, matched with an embroidered white blouse and a shawl.

87 See Martín Lozano, *Del istmo y sus mujeres.*

88 Muñiz, "*Garçonnes, flappers* y pelonas," 7.

89 Viviane Mahieux argues that Cube Bonifant in fact was a predecessor for much of Novo's experimental chronicles ("Cube Bonifant: La cronista olvidada del *Universal Ilustrado*," presented at the Latin American Studies Association annual conference, Puerto Rico, 2006.

90 Ortiz Gaitán, *Imágenes del deseo,* 349.

91 "El Caballero Puck," "Las máscaras," *El Universal Ilustrado,* March 4, 1926, 28–29. "El Caballero Puck" was a pseudonym for Manuel Horta (Ruiz Castañeda and Márquez Acevedo, *Diccionario de seudónomos,* 396).

92 "Nuestras artistas en antifaz," *El Universal Ilustrado,* March 4, 1926, 29–30, emphasis added: "Artistas. Mujeres que tienen la celebridad pasajera del éxito, que exhiben su belleza en el frívolo tablado de la farsa. Almas incógnitas que hacen gráfico el símbolo de 'La Señorita Etcétera': UNA, DOS, TRES, CUATRO, CINCO, SEIS, SIETE, OCHO." Here the author is referring to a novella by Arqueles Vela, first published in 1922 as the *novela semanal* of *El Universal Ilustrado.* I will examine this text in greater detail in chapter 5.

93 Xavier Villaurrutia, "La máscara," *El Universal Ilustrado,* March 4, 1926, 35, 66: "Tan semejante a ella . . . se le destina a la vez que a mostrar algo, a ocultar algo también, es como ella un modo de puente tendido hacia un reino puro." "La máscara" faces a page with an article titled "Las mujeres y el automóvil" ("Women and Cars").

94 Villaurrutia, "La máscara" 36: "Senda medianera entre la representación mecánica del rostro y la pura misión artística."

95 Although figures vary from source to source, in 1921 approximately 70 percent of Mexico was illiterate, and by 1940 that number had fallen to 45 percent. It is important to note that the illiteracy rate for the capital city in the same year was by contrast only 25 percent, in comparison to states such as Chiapas (80 percent), Querétaro (78 percent), and Guerrero (82 percent). Moreno y García surveys data from the other Latin American countries and compares it to the United States. In 1920, 75 percent of Brazil was illiterate, while in 1930, the United States had a rate of only 4.3 percent. He notes, however, that blacks and immigrants in the United States suffer from much worse access to education and higher rates of illiteracy (Moreno y García, *Analfabetismo y cultural popular en América,* 40–41).

96 The published version of his theory of artistic education, *Método de dibujo* (1923), was a tremendous success soon published in English as *A Method for Creative Design* (1926).

97 Best Maugard, *A Method for Creative Design,* 76.

98 Aquino Casas, "Graphic Design in Mexico: A Critical History," 101.

Aquino Casas idealizes the freedom associated with a competitive market of images and stories but is one of the few scholars to examine the difference between state-funded and commercial culture.

99 "Un Viernes de Dolores con La Niña Lupe," *El Universal Ilustrado*, April 1, 1926, 22–23: "No *sentimos* el fluir del tiempo: agua irretenible, Lupe Vélez seduce, encanta, domina"; "Lupita Vélez, en Santa Anita, sorprendida el Viernes de Dolores, por nuestro fotógrafo, quien la siguió a todo lo largo de su excursión místico-pagana."

100 Arqueles Vela, "La dama encerrada," *Rotográfico*, March 3, 1926, 5: "La Dama Encerrada . . . Desargumentada y Desdirigida por Arqueles Vela . . . la película que no existe."

101 Ibid., 5: "La mirada de aquella mujer que jamás pudo identificar, tan vista por todos . . . Viene de lejanas tierras inaugurando todas las ciudades y conquistándolas."

102 The woman in the photograph appears to be actress Lilian Gish. The relationship between film and still photography is discussed at length in chapter 5.

103 Martín Barbero, *De los medios a las mediaciones*, 192–93; Martín Barbero examines the case of Chile, where he finds a popular press beginning in the 1920s, and a popular illustrated press in *Las Noticias Gráficas* in 1944. On (middle-class) women's relationship to melodrama, see Tania Modleski, *Loving with a Vengeance*, especially chapter 4. Melodrama taken seriously—the disorienting, enchanting effects of the fictional photo-essays—even poisons the foundational Enlightenment concept of objectivity (Martín Barbero, *De los medios a las mediaciones*, 193).

104 *Horizonte*, June 1926, 1, emphasis added: "Porque el ambiente que se han creado las revistas en México . . . es el de una flojedad en los conceptos y una cobardía en las manifestaciones, que malamente ha dado en llamar eclecticismo, caos que satisface el gusto *ondulante* de las mujeres."

105 Ibid.: "La mujer mexicana se incorpore a las falanges que van a emprender la batalla del pensamiento nuevo."

106 Germán List Arzubide, "Así se hizo *Horizonte*," *Horizonte*, April–May 1927, 12: "Las revistas hebdomadarias de México, son tan cursis y tan fútiles, tan ñoñas y tan frívolas, obligadas a publicar lo que hay, cuando lo hay"; "enternecer a las niñas bien." "Niñas bien" is difficult to translate; it operates like the phrace "nice girls," along with a clear upper-class marker.

107 "Cómo se hace *El Universal Ilustrado*," *El Universal Ilustrado*, May 10, 1923, 13.

108 "¿Por qué se anuncian Uds. en *El Universal Ilustrado*?" *El Universal Ilustrado*, May 10, 1923, 14: "Por ser un periódico serio y de amplia circulación. Gracias a su escogido material literario, llega a los hogares, lo leen las mujeres

y el anuncio de las preparaciones para la belleza. . . . no sólo en la capital de la República sino en varios Estados."

109　Ibid., 14. Unlike *El Universal Ilustrado*, recall that most of the canonically avant-garde publications such as *Forma* were entirely funded by the state, through the Secretaría de Educación Pública.

110　"¿Por qué se anuncian Uds. en *El Universal Ilustrado*?" 14: "EL UNIVERSAL ILUSTRADO es independiente y no tiene ligas políticas y puede atender cuidadosamente la parte gráfica, publicando bellos anuncios que se graban en la mente de los lectores."

111　Appadurai, *Modernity at Large*, 7.

112　Luis G. Pinal, "Hombres-Mujeres," *El Universal Ilustrado*, April 8, 1926, 34, all bold and capitals original; "la mujer debe figurar en la **'Cosa Pública'**"; "Ya quedan nombradas tres MUJERES que ahora ocupan puestos públicos, los cuales fueron creados para HOMBRES."

113　Manuel Maples Arce, "El Movimiento Estridentista de 1922," *El Universal Ilustrado*, December 28, 1922, 25.

114　Oscar LeBlanc, "¿Cuál debe ser la fuente del arte pictórico nacional?" *El Universal Ilustrado*, March 8, 1923, 22–23.

115　See Sheridan, "México, Los 'Contemporáneos' y el nacionalismo."

Chapter 5: Fiction

1　See the appendix for abbreviations of the novels cited in this chapter.

2　Villaurrutia, "Manuel Álvarez Bravo," 20–21: "Al servicio de la ciencia, de la actualidad, de la moda o del periodismo"; "uno de los medios que más incitan a la desconfianza."

3　Schelling, *Through the Kaleidoscope*, 3.

4　Given the shared aesthetic developed in the bellas artes públicas, the animosity expressed in terms of virility and effeminacy no longer need divert scholarly opinion from the artistic similarities between Estridentistas and Contemporáneos. María del Mar Paúl Arranz writes, "Contemporáneos and Estridentistas found themselves narratively closer than their mutual contempt permitted them to reveal" ("Contemporáneos," 260). Novo actively resisted proclaiming any affiliation with either of these two avant-garde movements while participating in the activities of both: "I have been a little heterodox and I have not belonged to this group or the other, I haven't liked to stick to anything" (Barrera, *Salvador Novo*, 127). His *New Mexican Greatness* [*Nueva grandeza mexicana*, 1946], a reflection about cultural life in postrevolutionary Mexico City, shows the close ties between both avant-garde groups and popular arts in the city.

5 Paúl Arranz, "Contemporáneos," 256. The classic novels of the Revolution include Mariano Azuela's *Los de abajo* (1913) and Martín Luís Guzmán's *El águila y la seripiente* (1928).

6 See Irwin, *Mexican Masculinities*, 165–75, for a discussion of Villaurrutia and Novo's queer nationalism as a homosexual coupling that is not too distant from Vasconcelos's "cosmic race."

7 Coronado, prologue to *La novela lírica de los Contemporáneos*, 14: "Un erotismo brumoso . . . Entre estas dos aguas vaga y naufraga el narrador de los textos. Al final nada queda en las manos, más que la sensación de que donde hay cenizas hubo humo."

8 On this relationship between women, realism, and photography in Anglophone modernism, see N. Armstrong, "Modernism's Iconophobia and What It Did to Gender."

9 Tagg, *The Burden of Representation*, 12.

10 The Works Progress Administration (WPA) was a federal relief program established during the Depression in the United States to provide jobs; it included the Federal Arts Program (FAP) and the Farm Security Administration (FSA), which sent photographers including Walker Evans and Dorothea Lange to document the work and the lives of poor communities.

11 Pérez Firmat, *Idle Fictions*, 37. Pérez Firmat flirts with the function of the photographic and cinematic in the structure of these texts but fails to draw the connection between the kinds of fictions created in the texts and the media they engage.

12 Cohn, *The Distinction of Fiction*, vii, emphasis added. Michael Riffaterre concurs: "Fictional truth spurns referentiality that raises the specter of whether or not the reader acknowledges its accuracy. Instead, fictional truth relies entirely on the text itself as if the latter were self-sufficient. Truth is a modality of text generation" (*Fictional Truth*, 84). Despite the apparent rigidity of her theoretical model, Cohn's nuanced readings of novels in fact permit a surprising amount of flexibility. The insights of her book balance between her introductory demands for the purity of the idea of fiction, and the way in which fictions operate when she analyzes them.

13 Cohn, *The Distinction of Fiction*, 13.

14 González, "'Press Clippings' and Cortázar's Ethics of Writing," 254.

15 For instance, a group of theorists led by Lubomír Dolezel proposes the idea of fiction as "possible worlds." Dolezel distinguishes between high and popular culture: high culture invents "new" stories that can be considered fictions, while popular culture simply rewrites "stock tales." Further, he bases his model of fictional worlds on Daniel Defoe's *Robinson Crusoe*; the imperial text becomes the ideal fiction. In conclusion, Dolezel dismisses all postcolonial rewritings of such canonical texts, saying: "The rewrite enriches, expands, the universe of fiction, without deleting the extant world; it takes its

place alongside the canonical protoworld, and, hopefully, itself will enter the canon. . . . I can imagine Coetzee having a drink with Defoe, Charlotte Brontë having tea with Jean Rhys, Plenzdorf going on a pilgrimage to visit Goethe in Weimar. This fictional symposium of fiction writers might seem naive in a time that stresses radical ruptures. But why would a writer engage in rewriting if he or she were not aware of the continuity of poetic activity?" (223). Dolezel's tea party—the ultimate anglophone colonial social event— denies any popular or postcolonial texts the status of fiction unless they bend to the model of *Robinson Crusoe*, and it does not permit Rhys the option of throwing her cup of tea in the face of its literary history. Finally, Dolezel allows no contamination of "possible worlds"; they are hermetically sealed off from the world of politics, exploitation, and revolt. He writes: "As non-actualized possibles, all fictional entities are of the same ontological nature. . . . A view which presents fictional persons as a mixed bag of 'real people' and 'purely fictitious characters' leads to serious theoretical difficulties, ana-lytical confusions, and naive critical practice. The principle of ontological homogeneity is a necessary condition for the coexistence, interaction, and communication of fictional persons. It epitomizes the sovereignty of fic-tional worlds." The hermeticism of fiction here appears to be intimately related to an indifference to colonial history (Dolezel, "Possible Worlds of Fiction and History," 788). For a somewhat different picture of "possible worlds," see Eco, "Small Worlds."

16 *Oxford English Dictionary*, 2nd ed.

17 Baumlin and Baumlin, *Ethos*, xvi.

18 The fiction of art will be addressed only in relation to photography in this chapter; I expand it greatly in new work in process on a variety of con-temporary artistic disciplines, including painting, installation, and video.

19 A. Horseley Hinton, *Practical Pictorial Photography*. Amateur Photogra-pher's Library, no. 17 (London: Hazell, Watson and Viney, Ltd., 1898), 24.

20 See Thomas, *"From today painting is dead,"* 9.

21 See Solomon-Godeau, *Photography at the Dock*. Jennifer Green addresses the narrativity of the exhibition of photographs, asserting that it is necessary to approach photography via the lens of narrative theory. She suggests that by focusing on the narrative arrangement of the exhibition, one "resurrects" the narrator of the photograph and the act of its making. Narrative strate-gies provide the context for a discussion of exhibition semantics in a new context of readership: the audience is mobile and can to a certain degree chose the narrative order, even as the author (whose function in this case is split between photographer and curator) maintains the power of selection. Green states that narrative theory "makes visible the invisible walls" of the photographic exhibition.

22 Paúl Arranz, "Contemporáneos," 257: "Entregarse a la imagen."

23 Coronado, *La novela lírica de los Contemporáneos*, 21–22: "La novela, la nube y la mujer son lo inasible por excelencia."

24 Rimmon-Kenan, *Narrative Fiction*, 43, 60.

25 *S*, 191: "Para asirme más a la absurda realidad de mi ensueño, volvía a verla de vez en cuando. . . . Era inevitable y hasta indispensable que siguiésemos juntos."

26 There are so many examples of the characterization of avant-garde fiction by these women—by Gilberto Owen, Villaurrutia, and others—that all cannot be analyzed in the space of this chapter.

27 *M*, 27: "La firmeza de los tobillos y . . . la solidez de los hombros;" *M*, 53: "En contra con lo que esperaba, es más alta que Margarita. Sus cabellos, cortados a la Bob, no tienen esa facilidad sentimental que deshace . . . las trenzas de su amiga."

28 *D*, 195–96: "Miente naturalmente, como si no mintiera. . . . Escribirá con rapidez, sin ortografía, en párrafos interminables que habrían de estar llenos de punto y coma, si cuidara de la puntuación."

29 *D*, 196: "Pertenece a la flora punto menos que extinta de mujeres que escriben con lentitud, en párrafos largos, repintando la letra dos o tres veces, cuidando de la ortografía."

30 *D*, 197, emphasis added: "Decidadamente me equivoco. Susana no es tan diferente de Aurora. . . . Así Susana en Aurora, así Aurora en Susana. . . . *Ahora se sobreponen en mi memoria como dos películas destinadas a formar una sola fotografía.* Diversas, parecen estar unidas por un mismo cuerpo, como la dama de corazones de la baraja."

31 *C*, 26: "Mi sensualismo . . . es puramente intelectual. Las mujeres no me interesan, sino a través de las que hojeo en los magazines. La ropa interior me inquieta más en un magazín que en una mujer."

32 Mabelina is clearly a reference to the new popularity of makeup. The Maybelline Company was founded in 1915 by T. L. Williams and began to sell Maybelline Cake Mascara through the mail in 1917 (company Web site). Recall too the scarlet fingernails of de Hoz's flapper.

33 *C*, 23: "Bajo la neblina del tiempo"; "irrealidad retrospectiva."

34 *C*, 20: "Con cada uno de ellos se había sentido una mujer diferente, según su psicología, su manera, sus gustos, sus pasiones, y ahora apenas si era un 'sketch' de sí misma. Le parecía que la habían falsificado, que la habían moldeado. . . . Le habían ido arrancando una mirada, un beso, una sonrisa, una caricia hasta dejarla exhausta, extinguida, lánguida, derrotada, destartalada, insomne. De tanto sentir se encontraba insensible. . . . Después de ser todas las mujeres ya no era nadie."

35 *C*, 222, emphasis added: "[Mabelina] Balbucea lo que él le dijera aquella noche que se conocieron y sonríe, parentizando sus pensamientos con ese murmullo interior que se emulsiona después de la risa, enumerando

los subterfugios en que escudaba disimulando su timidez, disfrazándola en una serie de frases y de situaciones que casi siempre lo hacían aparecer como un hombre despreocupado, insolente, intrépido y hasta cínico."

36 *C*, 20: "Queriéndose adaptar al *irrealismo* de la mujer que evocaba." The image of photomontage appears in Vela's "El café de nadie" as well; the café tables hold "napkins stained by *flirt* and incongruous sentences intersecting with smiles" ["las servilletas manchadas de flirt y las frases incongruentes, interseccionadas de sonrisas"] (*C*, 24).

37 List Arzubide, "El movimiento estridentista," 271, 273: "Mujeres de los estridentistas . . . niñas cinemáticas, superpelonas . . . las amadas de todos, las novias unánimes, colgadas de nuestros afanes, ante la infecunda protesta de los fifíes"; "Con estas mujeres representa Arqueles Vela los dramas y las novelas que luego aparecen en los diarios." Despite the overwhelming repetition of these references, Luis Mario Schneider explains this text as "a book of anecdotes, of happenings, that is difficult to appreciate in its totality if one does not already have knowledge about what the movement was . . . in reality, we lack the secret 'keys' that all poetic society presupposes, and for that reason many of its elements are inaccessible to us" (Schneider, *El Estridentismo*, 31). Like Coronado earlier in this chapter, Schneider protects the elite status of these texts from the hybrid mass-media characters that populate them.

38 List Arzubide, "El movimiento estridentista," 272: "Estas mujeres . . . son las que le dictan sus novelas. . . . La Señorita Etcétera, es la más real de sus muñecas, a veces hasta creemos que va a fracasar convirtiéndose en una flapper."

39 Ibid., 273: "La avenida salpicada de pedazos de todas las mujeres."

40 *M*, 34: "Si no fuera por el ángulo de cielo anaranjado que flota en el cristal de sus ojos líquidos, quisiera despedirme, pero hay en su actitud uno de esos ademanes que recuerdan, en la tipografía, el trazo en que principia un paréntesis."

41 *E*, 13: "El más grande concurso de cejas de la República" "vedette de la pantalla." This competition is a reference to actual announcements from the time, such as one in *El Universal Ilustrado* on January 14, 1926, which called for a "young Mexican girl" to study cinema with Cecil B. DeMille.

42 *E*, 45: "En el hermético mundo de la cultura que Enrique mismo se había forjado, como una brisa candente—quién sabe por qué puerta, por qué ventana—estaba entrando la vida."

43 *E*, 45: "Recortar a una mujer, desarticular sus fragmentos. Luego, pieza por pieza, sobre una página en blanco, irlos pegando con goma."

44 *PE*, 90: "¡Impecable Sara! Estaba allí, a catorce años, a catorce centímetros de distancia, con ese mudo semblante que necesitó corregir el fotógrafo, adelgazando las facciones más personales—la dedicatoria de la boca, de la

nariz; la fecha de los ojos —todo lo que no se escribe con tinta, que no se borra, pero en cuyos párrafos sin palabras el marido más optimista descubre, como en la postdata de una carta póstuma, una dramática confesión."

45 *PE*, 91: "No podía explicarse a sí mismo el origen de aquel adjetivo. Pero le bastaba mirar el retrato de su consorte, tocarlo, para comprender que tenía razon."

46 *PE*, 93–94: "Todo, en la fotografía de una esposa culpable, está de acuerdo con ella. Todo la absuelve: los ojos, los muebles, la dimensión de la boca, la perezosa curva de las sortijas. Todo, al contrario, en la fotografía de Sara, prueba de inocencia, se le oponía con frialdad. . . . Una esposa que traiciona . . . escoge mejor a sus cómplices. Pero esas perlas, esas cejas, esas zapatillas desobedientes. . . . Sólo una mujer sin reproche podía permitirse el lujo de retratarse así."

47 *PE*, 135: "Hacía tiempo que nadie había conseguido de él una *pose* tan perfecta."

48 *PE*, 140: "A tener hijos, amigo, muchos hijos. La patria los necesita."

49 Rimmon-Kenan, *Narrative Fiction*, 43.

50 Unruh, *Latin American Vanguards*, 83.

51 *P*, 160: "Siempre algo mío se queda fuera de mí: un pie, un brazo, un deseo, un terrón de azúcar, el corazón. . . . Envidio a Jano. Lo compadezco. Dos semblantes valen menos que uno cuando ambos deben reír o llorar a término fijo."

52 *M*, 77: "Tengo la extraña sensación de que, al descender del coche, voy a encontrar junto a la puerta la silueta de mi cuerpo de entonces, esperando mi regreso. ¿Coincidirá conmigo?"

53 *M*, 37. The status of the fictional text here can be contrasted to the modernism that Lisa Siraganian finds in Gertrude Stein, in which the art object maintains a total independence from the viewer. See Siraganian, "Out of Air."

54 W. J. T. Mitchell sees a similar textual strategy in Borges, which he describes as typically "postmodern" ("Representation," 17). Borges, a member of the Argentine avant-garde from the twenties, fits more comfortably into the kind of Latin American modernism that I have been describing. My choice of *fiction* as the simple term for the genre I examine in this chapter also, of course, plays on his collection of *Ficciones*.

55 *P*, 163, emphasis added: "Pensando siempre en esa teoría que no puede contener una sola frase. . . . *Propietaria de una mirada más grande que los ojos*."

56 See Bryson, *Word and Image*.

57 *P*, 179, 181: "La ciudad la atraía visiblemente"; "aquella lúcida curiosidad."

58 There is a great deal of literature on this particularly unscientific side of photography; for example, Coates, *Photographing the Invisible*.

59 "El espíritu del cine," *Revista de revistas*, June 18, 1922, 43.

60 *P*, 163–64: "De otras mujeres, la memoria nos devuelve por grados la instantánea de cierta imagen silenciosa, el escorzo de cierta actitud amable, la presión de una mano delicada, tibia. . . . De Proserpina, en cambio, el recuerdo me asalta por todas partes, me envuelve, me cubre, me perfora con flechas imperceptibles, me destruye como una plaga."

61 Barthes, *Camera Lucida*, 28.

62 Ibid., 53.

63 *P*, 161: "De cada ventanilla asomaba un semblante que decía, en voz alta: 'No olvide usted.'"

64 Breton, *Nadja*, 6. This explanation comes from Breton's 1962 introduction to his 1927 text: "L'abondante illustration photographique a pour objet d'éliminer toute description."

65 Torres Bodet, "Nadja," 195: "Ha intercalado, en las páginas de *Nadja*, varias fotografías de sus amigos . . . y varias tarjetas postales que representan los sitios en París en que desarrolla lo que, con cierta benevolencia de la imaginación, podríamos llamar su argumento."

66 Torres Bodet accuses the surrealists' mixed media experiment of falling into what he terms "the monotony of the extraordinary" (ibid., 195). The boredom that the Mexican avant-garde writer feels with the "exotic" is discussed in greater detail at the conclusion of this chapter.

67 Rubén Gallo reads "Primero de enero" as a cosmopolitan rejection of literary nationalism, against the novel of the Revolution, but does so through formal comparisons to James Joyce and Marcel Proust, emphasizing Torres Bodet's similarities to Breton's *Nadja*.

68 Cohn's tautology of fiction is limited to the formal patterns of fiction as narrative, which has an ability to distort time and operates as a crucial marker of the "unnatural discourse" of fiction (Cohn, *The Distinction of Fiction*, 25).

69 See García Canclini, "Estética e Imagen Fotográfica," on pluralist histories; George Baker argues that both stasis and narrativity have been celebrated as liberatory and accused of repression.

70 Chatman, *Coming to Terms*, 7–8, emphasis added.

71 Rimmon-Kenan, *Narrative Fiction*, 43–44.

72 One example of the collapse of the photographic and the cinematic in avant-garde prose occurs in Unruh's survey of the Latin American avant-gardes. She refers to criticism of Peruvian poet Martín Adán's novel *La casa de cartón* (1928) that describes its "cinematographic and 'kaleidoscopic' imagery." Immediately before this description, however, Unruh mentions that one section of the novella is called "Poemas Underwood" (*Latin American Vanguards*, 106). However, Underwood and Underwood was also one of the largest companies producing photographic views and postcards in Latin

America beginning in the 1880s. What is more, one edition of *La casa de cartón* (Lima: Ediciones PEISA, 1989) was published with anonymous photographs.

73 Coronado, *La novela lírica de los Contemporáneos*, 20: "[Gilberto] Owen enhebra un discurso visual en vez de seguir el transcurso de un verdadero tiempo narrativo. *Novela como nube* es cine moderno, ese que niega su esencia de movimiento y se congela en la composición de imágenes."

74 Aurelio de los Reyes investigates many of these same novels as manifestations of the cinematic in the fiction of the Contemporáneos. He argues that only cinema served as the inspiration for the experimental narrative of the avant-garde. The cinema as a cultural phenomenon undoubtedly had an impact on the fiction of both the Contemporáneos and the Estridentistas. However, given this contrast between still and moving pictures, and the repeated references between photographic still and the texts examined in chapter 4, such a claim seems overstated ("Los Contemporáneos y el cine," 181).

75 Novo, "El arte de la fotografía," 189: "Se marcha alegremente por los caminos, va a la excursiones, se ejercita, curiosea." On the mobility of photography in Europe, see Buchloh, "From Faktura to Factography."

76 *P*, 232: "No consigo ya unir los fragmentos, todas las páginas sueltas del libro desencuadernado del almanaque en desorden que esparce sobre mi memoria los recuerdos de nuestra vida de Nueva York."

77 *P*, 160: "Soy, como una frase perfecta, una sucesión de sílabas que nadie podría cambiar de orden. Por ejemplo: *Dábale arroz a la zorra el abad*. Me leo a mí mismo, varias veces, en uno y otro sentido de la línea. Me complazco no tener revés ni derecho." This palindrome is the equivalent of "Devil never even lived"; the translation of the phrase is not itself important [The abbot gave rice to the fox].

78 *PE*, 82: "El que acababa de penetrar en el cuarto, por la ventana del parque, silencioso Fantomas, ni siquiera bisiesto, tenía el estilo más femenino de romper con la tradición. Encubría, intrepidez aparente, con una audacia de hombre, una tenacidad subterránea, pasiva, resignación de mujer."

79 *PE*, 81: "La alcoba estaba inundada de niebla, con incrustaciones de nácar, de plata pálida. Nada negro ni blanco. Gris sobre gris."

80 *Manuel Álvarez Bravo: Fotografías*, 15; "Como expresión de las inquietudes y progresos del hombre y del mundo actual, como lenguaje contemporáneo que ha alcanzado rico vocabulario y gran literatura."

81 Elena Poniatowska remarks on the fogginess of Álvarez Bravo's images: "For this reason a discreet and profound poetry, desperate and fine irony, emanate from the photos by Manuel Álvarez Bravo in the manner of particles suspended in air, which make visible a ray of light penetrating a dark

room. The emotive particles arrive to us in a continuous and slow flight. Not a spark nor lightning strike, little by little they saturate us. It does not have to do with an instantaneous and violent electronic discharge. . . . the photo-poetry of Manuel . . . knows to give the image produced by the camera the precise value of a dream" (Poniatowska, *Manuel Álvarez Bravo*, 41).

82 See Kismaric, *Manuel Álvarez Bravo*, 37.

83 Abigail Solomon-Godeau emphasizes the importance of the Russian concept of *ostranenue*, of defamiliarization in literature, for thinking about photography. She refers in particular to Jakobson's concept of "laying bare of the device" from 1924.

84 Waldemar George, "Fotografía, Magia Moderna," *Imagen*, June 30, 1933, n.p.: "Naturalezas muertas de objetos dispersos o aislados, objetos de uso, accesorios de la vida. . . . *Separados de su ambiente*, estos compañeros nuestros de todos los días adquieren una vida nueva y entablan entre ellos interminables diálogos." The managing director of *Imagen* was Alejandro Núñez Alonso, who also contributed to the catalogue for Álvarez Bravo's show.

85 *El Nacional*, March 7, 1935, cited in Albiñana and Fernández, *Mexicana*, 65, emphasis added: "Documento revelador de la más extrordinaria *realidad*"; "obscenidad[es]"; "Cartier Bresson interrumpe la vida, Álvarez Bravo anima las naturalezas muertas."

86 Albiñana and Fernández, *Mexicana*, 254.

87 Debroise, *Lola Álvarez Bravo*, 19.

88 Villaurrutia, "Manuel Álvarez Bravo," 22: "Manuel Álvarez Bravo hace posible que ante sus mejores fotografías nos encontremos frente a verdaderas representaciones de lo irrepresentable, frente a verdaderas evidencias de lo invisible."

89 See Sontag, *On Photography*, 193.

90 Related experiments such as the New Biography and documentary novels also use these devices to bridge the textual and the actual worlds, and they share a structure of heroic self-discovery by the narrator. See Cohn, *Distinction of Fiction*, and Foley, *Telling the Truth*.

91 *D*, 226, emphasis added: "Hago mi equipaje con lentitud, procurando arrancarle a cada cosa el placer doloroso *de un indicio*, aunque sea pequeño, que me ayude a fijar un momento de mi estancia en esta casa. Ahora cada cosa es como una de esas fotografías que conservamos sin querer y que, con el tiempo, al encontrarlas casualmente un día cualquiera, nos asombran porque han adquirido un valor preciso, histórico, que hace daño. Dentro de mí empieza a nacer, hasta hoy, el pasado que no quise, que no pensé siquiera tener jamás."

92 *D*, 226: "Tomo el espejo pequeño y lo encierro rápidamente en la maleta con la esperanza de que en otra parte, al verlo otra vez, conserve

todavía la última imagen, el trozo de tapiz color de tabaco que ha copiado diariamente, durante tres meses."

93 *D*, 226: "También yo tengo ahora algo que contar a los amigos con las mismas palabras que suenan a mentira, algo que no será la anécdota que más tardaba en inventar que en olvidar."

94 *D*, 227: "Con ojos muy abiertos que llevan ya, desde ahora, el paisaje del lugar de su destino. Ésta lleva el mar de Veracruz en sus ojos; ése, las casas de madera de Laredo."

95 *D*, 189: "Hace tiempo que estoy despierto. No atrevo ningún movimiento. Temo abrir los sentidos a una vida casi olvidada, casi nueva para mí. Tengo abiertos los ojos, pero la oscuridad de la pieza se empeña en demostrarme que ello es completamente inútil; al contrario, cerrándolos, apretándolos, se encienden pequeñas lámparas vivas, regadas, húmedas, pequeñas estrías coloridas que me reviven las luces del puerto lejano, en la noche, a bordo."

96 Approximately 95 percent of "Return ticket" was published first in the modernist little magazine, *Ulises*. The first edition of the entire book was printed by Cultura in September 1928. An edition of five hundred copies was published, 490 in cardboard cases in the form of a suitcase, and ten in leather cases containing a travel document inside (Barrera, *Salvador Novo*, 146). Clearly, Novo was interested in the book as an art object itself, as much as a text.

97 *RT*, 233: "Quizá de esto pueda hacerse un libro, mi primer libro."

98 *RT*, 233: "Va el tren por la ruta *tan conocida* de San Juan del Río, Querétero, Irapuato. . . . A toda esta gente ya la conozco. Estos tipos desconocidos, oscuros, pintorescos, buenos para los cuadros de caballete, son de lo más vulgar que pueda encontrarse. No hay realmente nada que apuntar en el diario."

99 *RT*, 296: "¡También hay papaias aquí como en México! Y, como en la Casa de los Azulejos, se las almuerza uno con limón y cuchara . . . Se ofrecen también mangos en el menú, lo que parece bastante natural." The House of Tiles is a house in the historical Center of Mexico City, belonging to the Sanborne's restaurant chain since Novo's time, that is entirely covered in baroque Mexican tiles.

100 *E*, 16; "Ansiosos de sumergirla [a Piedad Santelmo] en ese baño de 'color local'—mexicano al ciento por ciento—, la privaban de todas las delicias, de todas las costumbres que habían constituido para ella su patriotismo: su ambiente propio, la religiosidad de su madre, el clima de su provincia discreta, la canción de su México indescriptible. Le daban un rebozo, una jícara. ¡A ella, que pedía siempre en las tiendas los sombreros más europeos! ¡A ella, que servía siempre las frutas—aunque fuesen piñas, mangos, naranjas—en bandejas anónimas de cristal!"

101 *E*, 17: "La vena mexicana corría por otros sitios, sutiles, donde los norteamericanos no la buscaban."

102 See the English translation, Salvador Novo, "Memoir," 37. Novo describes his lifelong desire to write a memoir in the tell-all about his youth in Mexico City during the twenties and thirties, *La estatua de sal* (*The Statue of Salt*), which was completed in 1945 but not published in Mexico until 1998. His wish to publish it was frustrated by the unanimous opposition of both friends and enemies to the detailed description of his (and their) sexual lives. In fact, Novo's earliest autobiography, titled *Yo* (*I*), was destroyed by his friend Villaurrutia, who "was alarmed by its crudeness and directness, by my use of actual names instead of pseudonyms" (Novo, "Memoir," 37).

103 On sexuality and knowledge, see my "*La ciudad loca.*"

104 Salvador Novo, "Memoir," 41.

105 See Monsiváis, *La nueva grandeza mexicana*, 11, emphasis added: "No desconozco el hecho de que antes de mí, y después, los escritores hayan compartido la elaboración lenta, oculta y heroica de su verdadera obra, con el periodismo: la maternidad clandestina con la prostitución pública. Simplemente confieso, relativamente arrepentido, que a mí me arrastró la prostitución, circunstancia de la que me consuela la esparanza de haberla un poco ennoblecido."

106 See http://redescolar.ilce.edu.mx/redescolar/publicaciones/publi_quepaso/salvadornovo.htm: "Se inspiraba a menudo en temas autobiográficos, y mostraba las emociones del autor mediante el recurso de la ironía, y el empleo de variadas formas expresivas." Much already has been written on Novo's use of irony as a literary strategy to achieve this end. See Roster, *La ironía como método de análisis literario.*

107 Brooks, *The Melodramatic Imagination*, ix, 15. Brooks's preface to the new edition of his classic study of melodrama explains that interest in the mode had blossomed "because it pointed to—as no other term quite could—a certain complex of obsessions and aesthetic choices central to *our modernity*" (vii, emphasis added). While he does not mention who constitutes this "we," he does suggest that melodrama emerges as ethics in a secular modern era (15).

108 *RT*, 310: "¡Oh, mi primer contacto con el océano! Yo avanzaba, de la mano de mi instructor. Lenta me embiste—su dulce lengua de templado fuego. Ya soy todo suyo. Entra en mi boca, estruja mi cabeza, llena mi oído de rumores profundos. Me levanta en sus manos múltiples y mis brazos en vano buscan asirlo. Me abandono a flotar o a hundirme. ¡No estoy nadando! Yo no estoy aquí para los demás, ni quiero lucirme, ni tengo ningunos propósitos, ni deseo aprender a nadar, ni a ninguna otra cosa. En vano es que me digas, oh sabio instructor, que accione con los brazos. No quiero ir a ninguna parte. . . . Renuncia a enseñarme y conversamos dentro del agua, trozos de conversación, mientras yo floto como una botella y él hace piruetas en el

agua. . . . Está tostado por el sol; pero cuando se quita el bathing suit azul, le queda otro bathing suit blanco, de su propia carne."

109 *RT*, 311: "Siempre he preferido la imaginación a la realidad. En este elevador que baja a la playa hay unos avisos: UNDER NO CIRCUMSTANCES WHATSOEVER WILL BEACH BOYS BE ALLOWED INTO GUEST-ROOMS."

110 *D*, 220: "En el *hall* encuentro al doctor Batista, el médico de la casa, ocupado en consumir más que en fumar un cigarro enorme. En un instante recuerdo, por la primera vez, en una súbita iluminación de la infancia, el modo extraño que tenía de acariciarme cuando era niño."

111 *D*, 213: "Recuerda nuestras pláticas sobre literatura, y las frases de novela moderna que jugábamos a inventar con un arte próximo al vicio, con un arte perfecto . . . y termina con una frase perfecta por lo breve, ofrecida en movimiento lento como si su inteligencia la hubiese obtenido fotografián- dola con la cámara ultrarrápida."

112 *P*, 160: "Algo mío se queda fuera de mí: un pie, un brazo, un deseo, un terrón de azúcar, el corazón."

113 Verani, "La narrativa hispanoamericana de vanguardia," 56, empha- sis added; "trae un cambio radical de perspectiva: pretende ser un cronista objectivo que aplica recursos de las ciencias sociales, cita sus fuentes de in- formación y acumula datos . . . pero los hechos que observa estimulan un desplazamiento de la realidad documentada a la interioridad y a la autorrefle- xión . . . [crea] una nueva forma literaria, la narrativa sin ficción, género intermedio entre la novela y el documento que constituye una línea central de la narrativa latinoamericana actual."

114 Long, "Salvador Novo's *Continente vacío*," 106.

115 Barrera, *Salvador Novo*, 175.

116 *J*, 228–30: "¿Existe en México una literatura que sintetice el espíritu popular? ¿Hay slang, argot? . . . ¿Cuándo será que pueda haber literatura mexicana, teatro, novela, canción, música? . . . ¿Cuándo debieron las hijas de Europa empezar a huirse de su casa?"

117 Throughout Novo's work, and most especially in *La estatua de sal*, English appears to have a special function. The manuscript pages reproduced as an appendix to the memoir reveal that he wrote the outline for it mostly in English, and his dramatic encounter with his mentor uses English for a key exchange. When Novo admits his sexual proclivities, Henríquez Ureña asks him whether he would "do it" with him also. After he reluctantly agrees, the older writer describes a previous student in the United States who had tried to seduce him. The text switches between English and Spanish: "Y un día: *I feel like kissing you*—me dijo. Y yo: *Go ahead*. Y me besó aquí, en la me- jilla. Pero está mal. No debe ser" ("And one day: *I feel like kissing you*—he said to me. And I: *Go ahead*. And he kissed me here, on the cheek. But it is bad. It shouldn't be," 116).

118 Salvador Novo, "La última exposición pictórica juvenil," *El Universal Ilustrado*, June 19, 1924, 41: "Sus figuras son perfectas y significativamente deformes. Cumplen, sin conocerlos, los postulados de la estética más reciente: por medio de colores y líneas combinadas de una manera significativa, entonan una música que no cuenta cuentos ni reproduce fisonomías reconocibles; que únicamente conecta al artista que 'crea' con el artista que admira."

119 Novo, "El arte de la fotografía," 171: "Una oposición absoluta entre lo artístico y lo útil"; "He dicho al principio que estamos dispuestos al engaño; a que la realidad se tergiversase en provecho de nuestros más altos sentidos; digámoslo ya: queremos que el artista ilustre la frase de Goethe: que use *lo contrario de la realidad para dar el colmo de la verdad*."

Epilogue

1 "El hombre que desnudaba almas," *El Universal Ilustrado*, December 4, 1931, 43–44: "Una de las mujercitas más humildes y más inteligentes de México." For a full discussion of the balmoreadas, see my: "I Swear She is a Woman: Balmoreadas and Ethics in Drag," forthcoming in *TDR: The Drama Review*.

2 Even Jurado's real name sounds like a joke to the Spanish speaker. *Conchita* literally translated means "little shell," and is used as slang for female genitals. *Jurado* means sworn, from the verb *jurar*, to promise. Thus her name literally promises that she is a woman, despite her performance as Balmori. It is impossible to know if this had anything to do with Jurado's invention of the Spaniard or her gender-bending experiments.

3 Delhumeau, *Don Carlos Balmori*, 9: "Banda de los Burladores."

4 Ibid., 4: "Farsa," "extraordinarias andanzas," "Lo falso y lo real se confunden."

5 See "Las Bromas de don Carlos," *Mujer: Casos de la vida real*, January 29, 2000; prod. Silvia Pinal, original idea Jorge Lozano Soriano, screenplay Rosa Sabugal.

6 Bustamante, "En busca de una historia": "Todo empezaba cuando ella se disfrazaba de hombre y cortejaba a jóvenes de sociedad para después burlarse de ellas."

7 Several of these photographs were reproduced in Cervantes Morales's memoir.

8 Cervantes Morales, *Memorias de Don Carlos Balmori*, 11: "Edad de oro del 'MAREO' . . . cuando la varonil figura de 'DON CARLOS BALMORI' brilló en la Ciudad de México, cincelando la época de maravillosa bohemia."

9 Ibid., 296: "Sedujo hermosas jóvenes y casó con ellas; varias veces se unió con el vínculo matrimonial con respetables matronas, casándose al

mismo tiempo con sus hijas; fue polígamo por excelencia, a todas las bellas las apapachó y las besó en la boca, quizá les haya pasado la tuberculosis pulmonar; encarnó ilusiones de amor en mil mujeres bonitas y hasta en algunos efebos que soñaron con las mieles del matrimonio con el demonio archimillionario." The Spanish original avoids the awkward "he/she."

10 It is important to note that another character performed by Jurado was La India. Cervantes Morales remembers her description of tricking her own mother into taking La India in as her comadre, and insisting that she be baptized by the priest to counter her pagan religious beliefs (ibid., 34). Race as much as gender was a target of the Jurado's performances.

11 See Gabriela Cano on the history of Amélio Robles, a transgendered person who was born female but began to live (and fight) as a man during the Mexican Revolution. Robles had a wife and children, and lived as a man until his death.

12 *Gachupín* is the equivalent of *gringo*, referring insultingly to Spaniards.

13 Bustamante, "En busca de una historia": "Hoy vivimos una ruptura de esa idea de nación."

14 Bustamante, "En busca de una historia": "Institucionalización del concepto de nacionalidad propuesto desde el Estado."

15 Bustamante, "En busca de una historia": "Parten de la cultura popular mexicana y de un profundo sentido humorístico, cáustico, verdaderamente revelador de un ser humano mexicano iconoclasta que es en el fondo un iconófago irredento."

16 Ibid., "Pueden ser considerados en la línea de ese espíritu y discurso no objetual que ha ido apuntalando la forma para decir con las imágenes." See Lippard, *Six Years*.

17 Schneider Enríquez, "Rites of Memory."

18 I have written more extensively on the question of monumentality in photography elsewhere ("Recycled Photographs").

19 Any remaining doubt about the presentness of this history is erased by Gruner's photographed installation, "Half the Trip" ("La mitad del camino," 1994), erected on the border fence between San Diego and Tijuana. Made of a long series of pre-Columbian figures seated on stools attached directly to the fence, this work translates the violence of colonialism into the violence against Mexican migrants to the United States. This translation insists that the painful migration is suffered most by mestizo and indigenous Mexicans, who survive poverty, violence, and the lack of political representation in Mexico, only to experience discrimination, poor work conditions, and legal persecution once they arrive on the U.S. side of the border.

20 Medina, "La prohibición como incitación," 11.

21 Gruner, "Don't Fuck with the Past."

22 *P*, 160: "Siempre algo mío se queda fuera de mí: un pie, un brazo, un deseo, un terrón de azúcar, el corazón."

23 See Segre, "Relics and Disject in Mexican Modernism and Post-Modernism."

24 Bustamante, "En busca de una historia": "Ahondar en las posibilidades de la imagen, hacia terrenos inéditos"; "prescindir de los elementos lógicos que mantienen el sentido explicativo, es decir, estar contra la narración convencional."

25 On the artist's book as a medium, see Drucker, *The Century of Artists' Books*, and Carrión, *Libros de artista*. Tunga produced the "sculptures and concepts" for Omar's film *Nervo de prata* (*Nerves of Silver*, 1987). (Laddaga, "Tunga," 50). The catalogue, *Tunga, 1977–1997*, contains excellent essays on the artist; Carlos Basualdo's "A Viperine Avant-garde" performs a beautiful analysis of the intersection between the literary and the visual in his work.

26 Like all neobaroque literature and art, Tunga's work is full of expanding and infinite references, fantastic images, and bizarre stories. The reader unfamiliar with his work may be overwhelmed by the extravagance of the following descriptions, and I have limited my analyses to the points most relevant here. Its baroque aesthetic, however, tempts the viewer and reader to follow its uncentered path until she is lost.

27 Tunga, *Barroco de lírios*, 11: "Um equipamento com lâminas fotosensíveis e um agente operador com programa aberto."

28 Ibid., 12: "Dele virão os subsídios que, posteriormente cruzados, nos darão acesso a avaliações da experiência."

29 The Möbius strip was the inspiration for Lygia Clark's piece "Caminhando" (1964), which asked the viewer to make a strip out of paper and keep cutting around it until the paper became too thin to cut into two. To make one, cut a strip of paper, twist it once, and tape the two ends together. Trace your finger around the flat surface, and you will see that there is no inside or outside. My description of Tunga's piece reveals how successful it is in maintaining a sculptural and performative function, for I translated it from a two-dimensional drawing and photograph into a three-dimensional Möbius strip in my own two-dimensional representation of it.

30 As I argued in the introduction, this baroque modernism has everything to do with the history of colonialism in Latin America.

31 Omar, *O esplendor dos contrários*. All of the following quotes are from Omar's text in the unpaginated book.

32 See the page on Omar at www.museuvirtual.com.br: "O que apresento na Antropologia da Face Gloriosa não são *retratos*. São, digamos, trabalhos efetuados sobre o primeiro objeto que o ser humano vê na vida, e que programa toda a sua relação visual com a realidade. O *rosto*, o objeto por

excelência, o objeto mais importante do planeta, um objeto do mundo que representa o próprio mundo, um objeto do mundo eleito como a sua expressão concentrada, e tratado, portanto, como paisagem. Não sou um retratista, mas apenas um paisagista do rosto."

33 Omar had not looked at Mário's photographs or *O turista aprendiz* before his trip to the Amazon; he states, however, that Mário's writings generally provided an important epistemological foundation for him (personal communication with the author).

Bibliography

Acha, Juan. "El despertar latinoamericanista, 1920–1950." In *Las culturas estéticas de América Latina. Reflexiones*, 117–46. Mexico City: UNAM, 1993.

Ades, Dawn. *Photomontage*. Rev. and enlarged edition. London: Thames and Hudson, 1986.

Aguilar, Nelson, ed. *Bienal Brasil Século XX*. São Paulo: Fundação Bienal São Paulo, 1994.

Aguilar Platas, Blanca. "1917–1934: Los caudillos." In *Las publicaciones periódicas y la historia de México (ciclo de conferencias)*, edited by Aurora Cano Andaluz, 129–38. Mexico City: UNAM, 1995.

Albiñana, Salvador, and Horacio Fernández, eds. *Mexicana: Fotografía moderna en México, 1923–1940*. IVAM Centre Julio González. Catalog. Valencia: Generalitat Valenciana, 1998.

Aldrich, Robert, and Garry Woltherspoon, eds. *Who's Who in Gay and Lesbian History: From Antiquity to World War II*. London: Routledge, 2001.

Alloula, Malek. *The Colonial Harem*. Translated by Myrna Godzich and Wlad Godzich. Minneapolis: University of Minnesota Press, 1986.

Alonso, Carlos, ed. *Julio Cortázar: New Readings*. Cambridge: Cambridge University Press, 1998.

————. *The Burden of Modernity: The Rhetoric of Cultural Discourse in Spanish America*. New York: Oxford University Press, 1998.

Álvarez Bravo, Manuel. *Manuel Álvarez Bravo: Fotografías*. Catalog. Third exhibition of the Sociedad de Arte Moderno, Mexico City, July 1945. Collection of the Museum of Modern Art, New York.

Amaral, Aracy. *Artes plásticas na Semana de 22*. Edição revista e ampliada. São Paulo: BOVESPA, Bolsa de Mercadorias & Futuros, 1992.

Amor, Mónica. "Manuel Álvarez Bravo: The Impossibility of the Archive." *Art Nexus* 25 (1992): 80–83.

Anderson, Benedict. *Imagined Communities: Reflections on the Origins and Spread of Nationalism*. Rev. ed. London: Verso, 1991.

Andrade, Mário de. *Amar, verbo intransitivo: Idilio*. 1927. São Paulo: Livraria Martins Editora, 1955.

—. *Balança, Trombeta e Battleship: Ou o descobrimento da alma*. Edited by Têle Ancona Lopez. São Paulo: Instituto Moreira Salles/IEB/USP, 1994.

—. *O Empalhador de passarinho*. 3rd ed. São Paulo: Livraria Martins Editora, 1972.

—. "A escrava que não é Isaura." 1925. *Obra Imatura*. 3rd ed. Belo Horizonte: Livraria Martins Editora, 1980.

—. "Frederico Paciência." 1922–42. *Contos Novos*. São Paulo: Livraria Martins Editora, 1973.

—. *Fotógrafo e turista aprendiz*. Edited by Telê Ancona Lopez. São Paulo: Instituto de Estudos Brasileiros/USP, 1993.

—. *A imagem de Mário: Textos extraídos da obra de Mário de Andrade*. Introduction by Telê Ancona Lopez. Rio de Janeiro: Edições Alumbramento, 1984.

—. "E o Interior," *Movimento* 1, no. 2 (1929): 3.

—. *Macunaíma: O héroi sem nenhum caráter*. 1928. Edited by Telê Ancona Lopez. Florianópolis: Coleção Arquivos, 1988.

—. *Macunaíma*. Translated by E. A. Goodland. New York: Random House, 1984.

—. *Mário de Andrade—Oneyda Alvarenga: Cartas*. São Paulo: Duas Cidades, 1983.

—. "O movimento modernista." *Aspectos da literatura brasileira*. São Paulo: Livraria Martins Editora, 1941.

—. *Paulicea desvairada/Hallucinated City: A Bilingual Edition*. 1922. Translated by Jack E. Tomlins. Kingsport, Tenn.: Vanderbilt University Press, 1968.

—. *Poesias completas*. Edited by Diléa Zanotto Manfio. Belo Horizonte: Editora Itatiaia Limitada, 1987.

—. *Será o Benedito! Artigos publicados no suplemento em rotogravura de O Estado de S. Paulo*. Apresentação de Telê Porto Ancona Lopez. São Paulo: Editora da PUC-SP, 1992.

—. *Táxi e Crônicas no Diário Nacional*. São Paulo: Livraria Duas Cidades, 1976.

—. *O turista aprendiz*. Edited by Telê Ancona Lopez. São Paulo: Livraria Duas Cidades, 1978.

———. "Toada." *S. Paulo* 1, no. 8 (August 1936): n.pag.

Andrade, Oswald de. "Anthropophagist Manifesto." 1928. Translated by Alfred MacAdam. *Review* 51 (1995): 65–70.

———. "Manifesto of Pau-Brasil Poetry." 1924. Translated by Stella M. de Sá Rego. *Latin American Review* 14, no. 27 (1986): 184–87.

Andrade, Rodrigo Melo Franco de. *Rodrigo e o SPAHN. Coletânea de textos sobre patrimônio cultural*. Rio de Janeiro: Ministério da Cultura, Secretaria do Patrimônio Histórico e Artístico Nacional, Fundação Nacional Pro-Memória, 1987.

Antelo, Raúl. *Literatura em revista*. São Paulo: Editorial Atica, 1984.

———. *Na ilha de Marapatá. Mário de Andrade lê os hispano-americanos*. São Paulo: Editora HUCITEC, 1986.

———. "Macunaíma: Apropriação e originalidade." *Macunaíma*. Edited by Telê Ancona Lopez. Florianópolis: Coleção Arquivos, 1988.

Appadurai, Arjun. *Modernity at Large: Cultural Dimensions of Globalization*. Minneapolis: University of Minnesota Press, 1996.

Aquino Casas, Arnaldo. "Graphic Design in Mexico City: A Critical History." *Print*, January–February 1997, 98–105, 134–35.

Ardao, Arturo. *América Latina y la latinidad: Quinientos años después*. Mexico City: UNAM, Centro coordinador y difusor de estudios latinoamericanos, 1993.

Argudín, Yolanda. *Historia del periodismo en México desde el Virreinato hasta nuestros días*. Mexico City: Panorama Editorial, 1987.

Armstrong, Carol. "This Photography Which is Not One: In the Gray Zone with Tina Modotti." *October* 101 (2002): 19–52.

Armstrong, Nancy. "Image and Empire: A Brief Genealogy of Visual Culture." Unpublished manuscript, April 2003. Available at www.duke.edu/literature.

———. "Modernism's Iconophobia and What It Did to Gender." *Modernism/Modernity* 5 (1998): 47–75.

Aurrecoechea, Juan Manuel, and Armando Bartra. *Puros cuentos: Historia de la historieta en México*. Vol. 1–3. Mexico City: Grijalbo, 1994.

Avelar, Idelber. "The Ethics of Interpretation and the International Division of Intellectual Labor." *SubStance* 91 (2000): 80–103.

Baciu, Stefan. "Los estridentistas de Jalapa." *La Palabra y el hombre*. Nueva época 40 (Oct.- Dec. 1981): 9–15.

Bahia, Juarez. *Jornal, história e técnica: História da imprensa brasileira*. 4th ed. São Paulo: Editora Atica, 1990.

Baker, George. "Photography between Narrativity and Stasis: August Sander, Degeneration, and the Decay of the Portrait." *October* 76 (1996): 73–113.

Balderston, Daniel. "Poetry, Revolution, Homophobia: Polemics from the

Mexican Revolution." In *Hispanisms and Homosexualities*. Edited by Sylvia Molloy and Robert McKee Irwin, 57–75. Durham, N.C.: Duke University Press, 1998.

Barrera, Reyna. *Salvador Novo: Navaja de la inteligencia*. Mexico City: Plaza y Valdés, 1990.

Barthes, Roland. *Camera Lucida: Reflections on Photography*. Translated by Richard Howard. New York: Hill and Wang, 1981.

———. "The Photographic Message." In *Image—Music—Text*, 15–31. New York: Hill and Wang, 1977.

———. "The Third Meaning: Research Notes on Some Eisenstein Stills." In *Image—Music—Text*, 52–68. New York: Hill and Wang, 1977.

———. *Roland Barthes*. New York: Noonday, 1977.

Bastos, Eliana. *Entre o escândalo e o sucesso: A semana de 22 e o Armory Show*. Campinas: Universidad Estadual de Campinas/UNICAMP, 1991.

Baumlin, James S., and Tita French Baumlin, eds. *Ethos: New Essays in Rhetorical and Critical Theory*. Dallas: Southern Methodist University Press, 1994.

Becerra González, María. "La mujer, la moda y el modisto." *Imagen* 1, no. 6 (1933): n.pag.

Benjamin, Walter. "Art in the Age of Mechanical Reproduction." In *Illuminations*, 217–52. New York: Shocken Books, 1968.

———. "A Short History of Photography." 1931. *Screen* 13 (1972): 5–26.

———. "Surrealism: The Last Snapshot of the European Intelligentsia." *Reflections: Essays, Aphorisms, Autobiographical Writings*. Translated by Edmund Jephcott. New York: Harcourt Brace Jovanovich, 1978.

Benveniste, Daniel. "Freud, the Spanish Language, Argentina, and Etchegoyen." *Fort-Da* 4, no. 2 (1998): n. pag.

Bergmann, Emilie, Janet Greenberg, Gwen Kirkpatrick, Francine Masiello, Francesca Miller, Marta Morello-Frosch, Kathleen Newman, and Mary Louise Pratt. *Women, Culture, and Politics in Latin America: Seminar on Feminism and Culture in Latin America*. Berkeley: University of California Press, 1990.

Berger, John. *Ways of Seeing*. London: BBC and Penguin Books, 1972.

Best Maugard, Adolfo. *A Method for Creative Design*. New York: Alfred A. Knopf, 1926.

———. *Método de dibujo. Tradición resurgimiento y evolución del arte mexicano*. Mexico City: Departmento Editorial de la Secretaría de Educación, 1923.

Beverley, John, José Oviedo, and Michael Aronna, eds. *The Postmodernism Debate in Latin America*. Durham, N.C.: Duke University Press, 1995.

Beverley, John and José Oviedo, "Introduction." In Beverley et. al., *The Postmodernism Debate in Latin America*, 1–17.

Bhabha, Homi K. *The Location of Culture*. New York: Routledge, 1994.

Billeter, Erika. *Canto a la realidad: Fotografía latinoamericana, 1860–1993*. Barcelona: Casa de América, 1993.

———. "Photographers Who Documented History." In *Images of Mexico: The Contribution of Mexico to Twentieth-Century Art*, edited by Erika Billeter and Alicia Azuela, 372–421. Dallas: Dallas Museum of Art, 1987.

Blanco Aguinaga, Carlos. "El modernismo desde la periferia." *Filología y Lingüística* 1 (1995): 115–23.

Bolton, Richard. Introduction to *The Contest of Meaning: Critical Histories of Photography*. Edited by Richard Bolton, ix–xix. Cambridge: MIT Press, 1989.

Borges, Jorge Luis. *Elogio de la sombra*. Buenos Aires: Emecé, 1969.

———. *Textos cautivos: Ensayos y reseñas en "El Hogar" (1926–1939)*. Edited by Enrique Sacerio-Garí and Emir Rodríguez Monegal. Barcelona: Marginales Tuquets Editores, 1986.

Bosi, Alfredo. "La parábola de las vanguardias latinoamericanas." In Schwartz, *Las vanguardias latinoamericanas*, 13–24.

Brehme, Hugo. *México pintoresco*. Hugo Brehme: Mexico City, 1924.

Brenner, Anita. *Idols behind Altars*. New York: Harcourt, Brace and Co., 1929.

Breton, André. *Nadja*. Paris: Editions Gallimard, 1964.

———. "Souvenir de Mexique." *Minotaure* 12–13 (1939): 30–52.

Brilliant, Richard. *Portraiture*. London: Reaktion Books, 1991.

Brooks, Peter. *The Melodramatic Imagination: Balzac, Henry James, Melodrama, and the Mode of Excess*. New Haven, Conn.: Yale University Press, 1976.

Brunner, José Joaquin. "Notes on Modernity and Postmodernity in Latin American Culture." In Beverley, et. al., *The Postmodernism Debate in Latin America*, 34–54.

Bryson, Norman. "Art in Context." In *Studies in Historical Change*, edited by Ralph Cohen, 18–42. Charlottesville: University Press of Virginia, 1992.

———. *Word and Image: French Painting of the Ancien Régime*. Cambridge: Cambridge University Press, 1980.

Buchloh, Benjamin H. D. "From Faktura to Factography." In *The Contest of Meaning: Critical Histories of Photography*, edited by Richard Bolton, 49–85. Cambridge: MIT Press, 1989.

———. "Residual Resemblance: Three Notes on the Ends of Portraiture." In *Face-Off: The Portrait in Recent Art*. Catalog. Edited by Melissa E. Feldman, 53–69. Philadephia: Institute of Contemporary Art, University of Pennsylvania, 1994.

Buell, Lawrence. "Introduction: In Pursuit of Ethics." *PMLA* 114 (1999): 7–19.

Bueno, Antônio Sérgio. *O modernismo em Belo Horizonte: Década de vinte*. Belo Horizonte: Universidade Federal de Minas Gerais, 1982.

Bunn, David. "'Our Wattled Cot': Mercantile and Domestic Space in Thomas Pringle's Landscapes." In *Landscape and Power*, edited by W. J. T. Mitchell, 127–73. Chicago: University of Chicago Press, 1994.

Bürger, Peter. *Theory of the Avant-garde*. Translated by Michael Shaw. Minneapolis: University of Minnesota Press, 1984.

Burns, E. Bradford. *A History of Brazil*. 2nd ed. New York: Columbia University Press, 1980.

Bustamante, Maris. "En busca de una historia de los no objetualismos en México." 1996. Available at www.altamiracave.com/MARIS.htm.

Camargo, Susan, ed. *A revista no Brasil*. São Paulo: Editora Abril, 2000.

Campa, Román de la. "Hibridez posmoderna y transculturación: Políticas de montaje en torno a Latinoamérica." *Hispamérica* 22, no. 69 (1994): 3–22.

———. *Latin Americanism*. Minneapolis: University of Minnesota Press, 1999.

Campos, Haroldo de. "The Rule of Anthropophagy: Europe under the Sign of Devoration." Translated by María Tai Wolff. *Latin American Literary Review* 14, no. 27 (1986): 42–60.

Cano Andaluz, Aurora, ed. *Las publicaciones periódicas y la historia de México (ciclo de conferencias)*. Mexico City: UNAM, 1995.

Cano, Gabriela. "Amélio Robles, andar de soldado velho: Fotografia e masculinidade na Revolução Mexicana." *Cadernas Pagu* 22 (2004): 115–50.

Carnicel, Amarildo Batista. *O Fotógrafo Mário de Andrade*. 2nd ed. Campinas: Unicamp, 1993.

Carrión, Ulises. *Libros de artista*. Vols. 1 and 2. Edited by Martha Hellion. New York: Turner, 2003.

Castañón, Adolfo. "La ausencia ubicua de Montaigne. Ideas para una historia del ensayo hispanoamericano." *Vuelta* 16, no. 184 (1992): 35–38.

Castellanos, Alejandro. "Las herencias del mito: Fotografía e identidad en México, 1920–1940." In Curiel, et. al., *Arte, historia e identidad en América: Visiones comparativas*, 2: 647–54.

Castillo, Debra. *Easy Women: Sex and Gender in Modern Mexican Fiction*. Minneapolis: University of Minnesota Press, 1998.

Castillo Ledon, Luis. *El Museo Nacional de Arqueología, Historia y Etnografía, 1825–1925. Reseña histórica escrita para la celebración de su primer centenario*. Mexico City: Talleres Gráficos del Museo Nacional de Arqueología, Historia y Etnografía, 1924.

Castro Ruiz, Miguel, and Alfonso Maya Nava, dir. *Historia de El Universal: El Gran Diario de México*. Mexico City: El Universal Compañía Periodística Nacional S.A. de C.V., 1991.

Certeau, Michel de. *The Practice of Everyday Life*. Translated by Steven F. Rendall. Berkeley: University of California Press, 1984.

Cervantes Morales, Luis. *Memorias de Don Carlos Balmori: Escritas por su secretario particular, 23 de junio de 1926 a 27 de noviembre de 1931*. Mexico City: B. Costa-Amic, 1969.

Chamberlain, Bobby J. and Ronald M. Harmon. *A Dictionary of Informal Brazilian Portuguese: With English Index*. Washington, D.C.: Georgetown University Press, 1983.

Chatman, Seymour. *Coming to Terms: The Rhetoric of Narrative in Fiction and Film*. Ithaca, N.Y.: Cornell University Press, 1990.

Chow, Rey. *Ethics after Idealism: Theory, Culture, Ethnicity, Reading*. Bloomington: Indiana University Press, 1998.

Clifford, James. "On Ethnographic Surrealism." In *The Predicament of Culture: Twentieth Century Ethnography, Literature, and Art*, 117–51. Cambridge, Mass.: Harvard University Press, 1988.

———. "Spatial Practices: Fieldwork, Travel and the Disciplining of Anthropology." In *Routes: Travel and Translation in the Late Twentieth Century*, 52–91. Cambridge, Mass.: Harvard University Press, 1997.

Coates, James. *Photographing the Invisible: Practical Studies in Spirit Photography, Spirit Portraiture, and other Rare but Allied Phenomena*. Chicago: Advanced Thought Pub., 1911.

Coffey, Mary Katherine. "Muralism and the People: Culture, Popular Citizenship, and Government in Post-Revolutionary Mexico." *Communication Review* 5 (2002): 7–38.

Colecção Mário de Andrade: Artes Plásticas. São Paulo: Instituto de Estudos Brasileiros/USP, 1984.

Collins, Jane, and Catherine Lutz. "Becoming America's Lens on the World: *National Geographic* in the Twentieth Century." *South Atlantic Quarterly* 91 (1992): 161–91.

Cohn, Doritt. *The Distinction of Fiction*. Baltimore: Johns Hopkins University Press, 1999.

Conger, Amy, and Elena Poniatowska. *Compañeras de México: Women Photograph Women*. Riverside: University Art Gallery, University of California, Riverside, 1990.

Conor, Liz. *The Spectacular Modern Woman: Feminine Visibility in the 1920s*. Bloomington: Indiana University Press, 2004.

Copjec, Joan. *Imagine There's No Woman: Ethics and Sublimation*. Cambridge, Mass.: MIT Press, 2003.

Cordero Reiman, Karen. "Ensueños artísticos: Tres estrategias plásticas para configurar la modernidad en México, 1920–1930." In *Modernidad y modernización en el arte mexicano, 1920–1950*, 52–65. Mexico City: Museo Nacional de Arte, INBA, 1991.

Córdova, Carlos A. *Agustín Jiménez y la vanguardia fotográfica mexicana*. Mexico: Editorial RM, 2005.

Corominas, Joan, ed. *Diccionario crítico etimológico castellano e hispánico*. Madrid: Editorial Gredos, 1992.

Coronado, Juan, editor and prologue. *La novela lírica de los Contemporáneos*. Mexico City: UNAM, 1988.

Corral Corral, Manuel. *La ciencia de la comunicación en México: Orígen, desarrollo y situación actual*. Mexico City: Editorial Trillas, 1986.

Costa, Heloise, and Renato Rodrigues. *A fotografia moderna no Brasil*. Rio de Janeiro: FUNARTE-IPHAN, Ministério da Cultura, Editora UFRJ, 1995.

Craven, David. "The Latin American Origins of 'Alternative Modernism.'" *Third Text* 36 (1996): 29–44.

Crespo, Regina Aída. "Cultura e política: José Vasconcelos e Alfonso Reyes no Brasil (1922–1938)." *Revista Brasileira de História* 23, no. 45 (2003): 187–208.

Crignon, Philippe. "Figuration: Emmanuel Levinas and the Image." Translated by Nicole Simek and Zahi Zalloua. *Yale French Studies* 104 (2004): 100–125.

Crow, Thomas. "Modernism and Mass Culture in the Visual Arts." In *Modern Art in the Common Culture*, 3–38. New Haven, Conn.: Yale University Press, 1996.

Cuesta, Jorge. *Antología de la poesía mexicana moderna*. Presentation by Guillermo Sheridan. Mexico City: Letras mexicanas/Fondo de Cultura Económica, 1985.

Cunha, Euclides da. *Rebellion in the backlands (Os sertões)*. Translated by Samuel Putnam. Chicago: University of Chicago Press, 1964, c1944.

Curiel, Gustavo, Renato González Mello, and Juana Gutiérrez Haces, eds. *Arte, historia e identidad en América: Visiones comparativas*. Vol. 2–3. Mexico City: UNAM, 1994.

Dawson, Alexander Scott. "México Indígena: Indigenismo and the Paradox of Nation, 1915–1940." PhD diss. SUNY Stony Brook, 1997.

Debroise, Olivier. *Fuga mexicana: Un recorrido por la fotografía en México*. Mexico City: Cultura Contemporánea de México, 1994.

———. *Lola Álvarez Bravo: In Her Own Light*. Arizona: Center for Creative Photography, University of Arizona, 1994.

Debroise, Olivier, et al. *Modernidad y modernización en el arte mexicano, 1920–1960*. Mexico City: CONACULTA, 1991.

Delhumeau, Eduardo. *Don Carlos Balmori: Su extraordinaria vida y hazañas*. Mexico City: Omega, 1938.

"Del Tercer Coloquio Latinoamericano de Fotografía." *Casa de Las Américas*, no. 149 (1985): 3–33.

Díaz Arciriega, Victor. *Querella por la cultura "revolucionaria" (1925)*. Mexico City: Fondo de Cultura Económica, 1989.

Doane, Mary Ann. *Femmes Fatales: Feminism, Film Theory, Psychoanalysis*. New York: Routledge, 1991.

Dolezel, Lubomír. *Heterocosmica: Fictional and Possible Worlds*. Baltimore: Johns Hopkins University Press, 1998.

———. "Possible Worlds of Fiction and History," *New Literary History* 29, no. 4 (1998): 785–809.

Drucker, Johanna. *The Century of Artists' Books*. New York: Granary Books, 1995.

———. *Theorizing Modernism: Visual Art and the Critical Tradition*. New York: Columbia University Press, 1994.

Dussel, Enrique. *Ética de la liberación en la edad de la globalización y de la exclusión*. Mexico City: Editorial Trotta/Universidad Autónoma Metropolitana-Iztapalapa/Universidad Nacional Autónoma de México, 1998.

Eagleton, Terry. "Aesthetics and Politics." In *Between Ethics and Aesthetics: Crossing the Boundaries*, edited by Dorota Glowacka and Stephen Boos, 187–94. Albany: SUNY University Press, 2002.

———. "Deconstruction and Human Rights." In *Freedom and Interpretation: The Oxford Amnesty Lectures*, edited by Barbara Johnson, 121–45. New York: Basic Books, 1992.

Echevarría, Bolívar. *La modernidad de lo barroco*. 2nd ed. Mexico City: Ediciones Era, 2000.

Eco, Umberto. "Small Worlds." *Versus* 52–53 (1989): 53–70.

Eder, Rita. "El concepto de modernidad en el arte de América Latina." In *Simpatías y diferencias: Relaciones del arte mexicano con el de América Latina*, 319–35. Mexico City: IIE, UNAM, 1988.

———. "Modernismo, modernidad, modernización: Piezas para armar una historiografía del nacionalismo cultural mexicano." In *El arte en México: Autores, temas, problemas*, edited by Rita Eder, 341–71. Mexico City: Consejo Nacional para la Cultura y las Artes, Lotería Nacional, Fondo de Cultura Económica, 2001.

Edwards, Elizabeth E. *Anthropology and Photography, 1860–1920*. New Haven, Conn.: Yale University Press, 1992.

Eggs, Ekkehard. "Doxa in Poetry: A Study of Aristotle's Poetics." *Poetics Today* 23 (2002): 395–426.

Ehrenberg, Felipe. "La desobediencia como método de trabajo." In *Aspectos de la fotografía en México*, edited by Rogelio Villarreal, 93–106. Mexico City: Editorial Mexicana, 1981.

Eisenstein, Sergei. "Principios de la forma fílmica." *Contemporáneos*, April–June 1931, 116–35.

———. *¡Qué viva México!* London: Vision, 1952.

Espinosa, Aurelio M. "América Española o Hispano América," *Biblios* 2 (1920): 65–69.

Facio, Sara. "Investigación de la fotografía y colonialismo cutural en América Latina." In *Hecho en Latinamerica 2: Segundo coloquio latinoamericano de fotografía*, 103–7. Mexico City: Palacio de Bellas Artes, 1981.

Faucherau, Serge. "The Stridentist." *Artforum* 24, no. 2 (1986): 84–89.

Felski, Rita. *The Gender of Modernity*. Cambridge, Mass.: Harvard University Press, 1995.

———. "Modernist Studies and Cultural Studies: Reflections on Method." *Modernism/Modernity* 10 (2003): 501–17.

Fer, Briony. *On Abstract Art*. New Haven, Conn.: Yale University Press, 1997.

Fernández, Justino. *El arte moderno en México. Breve historia-siglos XIX-XX*. Mexico City: Porrúa, 1937.

Fernández, Miguel Angel. *Historia de los museos de México*. Mexico City: Promotora de Comercialización Directa, S.A., 1988.

Foley, Barbara. *Telling the Truth: The Theory and Practice of Documentary Fiction*. Ithaca, N.Y.: Cornell University Press, 1986.

Folgarait, Leonard. *Mural Painting and Social Revolution in Mexico, 1920–1940: Art of the New Order*. Cambridge: Cambridge University Press, 1998.

Foster, Merlin H. *Los Contemporáneos: 1920–1932. Pérfil de un experimento vanguardista mexicano*. Mexico City: Ediciones de Andres, 1964.

Franco, Jean. "Comic Stripping: Cortázar in the Age of Mechanical Reproduction." In *Julio Cortázar: New Readings*, edited by Carlos Alonso, 36–56. Cambridge: Cambridge University Press, 1998.

———. *Plotting Women: Gender and Representation in Mexico*. New York: Columbia University Press, 1989.

———. "What's in a Name? Popular Culture Theories and Their Limitations." *Studies in Latin American Popular Culture* 1 (1982): 5–15.

Freud, Sigmund. *Civilization and Its Discontents*. 1930. Translated by James Strachey. New York: W. W. Norton & Co., 1961.

———. "On Narcissism: An Introduction." 1914. In *The Standard Edition of the Complete Psychological Works of Sigmund Freud*, edited by James Strachey, 73–102. Vol. 14. London: Hogarth, 1953.

———. *Three Essays on the Theory of Sexuality*. 1905. Translated and revised by James Strachey. New York: Harper Collins, 1962.

———. *Totem and Taboo. Resemblances between the Psychic Lives of Savages and Neurotics*, translated and introduction by A. A. Brill. New York: Moffat, Yard, 1919.

———. "The Uncanny." 1919. In *Collected Papers*, 4:367–407. New York: Basic Books, 1959.

Gabara, Esther. "'Cannon and Camera': Photography and Colonialism in the Américas." *ELN* 44, no. 2 (2006): 45–64.

———. "*La ciudad loca*: An Epistemological Plan." *Journal of Latin American Cultural Studies* 9 no. 2 (2000): 119–135.

———. "Recycled Photographs: Moving Still Images of Mexico City, 1950–2000." In *Double Exposure: Photography and Writing in Latin America*, ed. Marcy Schwartz and Mary Beth Tierney-Tello, 139–72. Albuquerque: University of New Mexico Press, 2006.

Gallagher, Catherine. "Formalism and Time." *Modern Language Quarterly* 61, no. 1 (2000): 229–51.

Gallo, Rubén. "Jaime Torres Bodet's *Primero de enero*: The anti-novel of the Mexican Revolution." *Hispanic Review* 74 (2006): 181–207.

———. *Mexican Modernity: The Avant-Garde and the Technological Revolution*. Cambridge: MIT Press, 2005.

Garber, Marjorie, Beatrice Hanssen, and Rebecca L. Walkowitz, eds. *The Turn to Ethics*. New York: Routledge, 2000.

Garciadiego D., Javier. "La prensa durante la Revolución Mexicana." In Cano Andaluz, *Las publicaciones periódicas y la historia de México (ciclo de conferencias)*, 71–88.

García Canclini, Nestor. "Estética e imagen fotográfica." *Casa de las Américas* 149 (1985): 7–14.

———. *Hybrid Cultures: Strategies for Entering and Leaving Modernity*. Translated by Christopher L. Chiappari and Silvia L. López. Minneapolis: University of Minnesota Press, 1995.

García Canclini, Nestor, Alejandro Castellanos, and Ana Rosas Mantecón. *La ciudad de los viajeros. Travesías e imaginarios urbanos: México, 1940–2000*. Mexico City: Editorial Grijalbo, 1996.

Gelado, Viviana. *Poéticas da transgressão: Vanguarda e cultura popular nos anos 20 na América Latina*. Rio de Janeiro: Editora 7Letras, 2006.

George, Waldemar. "Fotografía, Magia Moderna." *Imagen* 1 (1933): n. pag.

Genocchio, Ben. "The Discourse of Difference: Writing 'Latin American' Art." *Third Text* 43 (1998): 3–12.

Giardinelli, Mempo. "Variations on Postmodernity, or What Does the Latin American Postboom Mean?" In *Latin America Writes Back: Postmodernity in the Periphery*, edited by Emil Volek, 217–24. New York: Routledge, 2002.

Gilroy, Paul. *The Black Atlantic: Modernity and Double Consciousness*. Cambridge, Mass.: Harvard University Press, 1993.

Glowacka, Dorota, and Stephen Boos. *Between Ethics and Aesthetics: Crossing the Boundaries*. Albany: State University of New York Press, 2002.

Goldman, Shifra. "Nationalist and Anti-Nationalist Modernisms: Vanguard Mexican Art." *Art Nexus* 23 (1997): 76–81.

Gombrich, E. H. "Image and Code: Scope and Limits of Conventionalism

in Pictorial Representation." In *Image and Code*, edited by Wendy Steiner, 11–36. Ann Arbor: Michigan Studies in the Humanities, 1991.

———. "The Renaissance Theory of Art and the Rise of Landscape." In *Norm and Form: Studies in the Art of the Renaissance*, 107–21. London: Phaidon, 1966.

Gonzáles de Mendoza, J. M. "Carlos Noriega Hope y 'El Universal Ilustrado.'" In *Carlos Noriega Hope, 1896–1934*, 33–48. Mexico City: INBA, 1959.

González, Aníbal. "'Press Clippings' and Cortázar's Ethics of Writing." In *Julio Cortázar: New Readings*, edited by Carlos Alonso, 237–57. Cambridge: Cambridge University Press, 1998.

González Marín, Silvia. "La prensa y el poder político en el gobierno del general Lázaro Cárdenas." In Cano Andaluz, *Las publicaciones periódicas y la historia de México (ciclo de conferencias)*, 157–68.

Gordon, Samuel. "Modernidad y vanguardia en la literatura mexicana: Estridentistas y Contemporáneos." *Revista Iberoamericana* 40 (1989): 1083–98.

Gorelik, Adrián. "O moderno em debate: cidade, modernidade, modernização." In Melo Miranda, *Narrativas da modernidade*, 55–80.

Green, James N. "Challenging National Heroes and Myths: Male Homosexuality and Brazilian History." *Estudios Interdisciplinarios de América Latina y el Caribe* 12, no. 1 (2001). Available at www.tau.ac.il.

Green, Jennifer. "Stories in an Exhibition: Narrative and Nineteenth-Century Photographic Documentary." *Journal of Narrative Technique* 20, no. 2 (1990): 147–66.

Greenberg, Clement. "Avant-garde and Kitsch." 1939. In *Art and Culture: Critical Essays*, 3–21. Boston: Beacon, 1989.

———. "Modernist Painting." In *The Collected Essays and Criticism, vol. 4 Modernism with a Vengeance, 1957–1969*, 85–93. Chicago: University of Chicago Press, 1995.

Gretton, Thomas. "Interpretando los grabados de Posada: La modernidad y sus opuestos en imágenes populares fotomecánicas." In Curiel et. al., *Arte, historia e identidad en América: Visiones comparativas*, 3: 755–70.

Gruner, Silvia. "Don't Fuck with the Past, You Might Get Pregnant," December 1994, available at www.zonezero.com/magazine/essays/distant/ygruner2.html.

Gullar, Ferreira. *Vanguarda e subdesenvolvimento: Ensaios sobre arte*. Rio de Janeiro: Civilização Brasileira, 1969.

Haberly, David T. "The Search for a National Language: A Problem in the Comparative History of Post-Colonial Literatures." *Comparative Literature Studies* 11, no. 1 (1974): 85–97.

———. *Three Sad Races: Racial Identity and National Consciousness Brazilian Literature*. Cambridge: Cambridge University Press, 1983.

Hancock de Sandoval, Judith. "Cien años de fotografía en México (Norte-americanos, europeos y japoneses)." *Artes Visuales* 12 (1976): i–x.

Hansen, Miriam. "The Mass Production of the Senses: Classical Cinema as Vernacular Modernism." *Modernism/Modernity* 6 (1999): 59–77.

Hanssen, Beatrice. "Portrait of Melancholy (Benjamin, Warburg, Panofsky)." *MLN* 114 (1999): 991–1009.

Harrison, Charles. "The Effects of Landscape." In Mitchell, *Landscape and Power*, 203–22.

Hecho en América. Vol. 1. Mexico City: Consejo Mexicano de Fotografía, 1978.

Hecho en América. Vol. 2. Mexico City: Instituto Nacional de Bellas Artes, 1989.

Hecho en Latinoamérica 2: Segundo coloquio latinoamericano de fotografía. Mexico City: Palacio de Bellas Artes, 1981.

Hellion, Martha, ed. *Libros de artista/Artist's Books*. Madrid: Turner Books, 2003.

Hemment, J. C. *Cannon and Camera: Sea and Land Battles of the Spanish-American War in Cuba Camp Life, and the Return of the Soldiers*. New York: D. Appleton and Co., 1898.

Hendrick, Tace. *Mestizo Modernism: Race, Nation and Identity in Latin American Culture, 1900–1940*. New Brunswick, N.J.: Rutgers University Press, 2003.

Hernández Rodríguez, Rafael. "El poeta en la quinta avenida: Modernidad o el tropiezo con el cuerpo femenino." *Latin American Literary Review* 25, no. 49 (1997): 43–61.

———. "Whose Sweaty Men Are They? Avant-garde and Revolution in Mexico." *Ciberletras*, December 2002. Available at www.lehman.cuny.edu/ciberletras.

Hinton, A. Horseley. *Practical Pictorial Photography*. Amateur Photographer's Library, no. 17. London: Hazell, Watson and Viney, Ltd., 1898.

Huyssen, Andreas. *After the Great Divide: Modernism, Mass Culture, Postmodernism*. Bloomington: Indiana University Press, 1986.

———. "High/Low in an Expanded Field." *Modernism/Modernity* 9 (2002): 363–74.

INEGI. *Estadísticas históricas de México*. Vol. 1. Mexico City: INEGI, 1986.

Irwin, Robert McKee. *Mexican Masculinities*. Minneapolis: University of Minnesota Press, 2003.

Jackson, K. David. "Three Glad Races: Primitivism and Ethnicity in Brazilian Modernist Literature." *Modernism/Modernity* 1 (1994): 89–112.

Jaffee, Barbra. "In the Name of Peirce: Art Criticism and the October Circle." *Art Criticism* 11, no. 2 (1996): 92–114.

Jakobson, Roman. "Two Aspects of Language and Two Types of Aphasic Dis-

turbances." In *Language in Literature*, edited by Krystyna Pomorska and Stephen Rudy, 95–114. Cambridge, Mass.: Belknap, 1987.

Jara, René. "Afterword. A Design for Modernity in the Margins." In *Modernism and Its Margins: Reinscribing Cultural Modernity from Spain and Latin America*, edited by Anthony L. Geist and José B. Monleón, 277–96. New York: Garland, 1999.

Jarratt, Susan, and Nedra Reynolds. "The Splitting Image: Contemporary Feminisms and the Ethics of Ethos." In *Ethos: New Essays in Rhetorical and Critical Theory*, edited by James S. Baumlin and Tita French Baumlin. Dallas: Southern Methodist University Press, 1994.

Johnson, Randal. "The Institutionalization of Brazilian Modernism." *Brasil/Brazil* 3, no. 4 (1990): 5–24.

Kismaric, Susan. *Manuel Álvarez Bravo*. New York: Museum of Modern Art, 1997.

Klein, Alexander, ed. *Grand Deception: The World's Most Spectacular and Successful Hoaxes, Impostures, Ruses and Frauds*. Philadelphia: J. B. Lippincott, 1955.

Knight, Alan. "Popular Culture and the Revolutionary State in Mexico, 1910–1940." *Hispanic American Historical Review* 74 (1994): 393–444.

Koch-Grünberg, Theodor. *Vom Roroima zum Orinoco: Mythen und Legenden der Taulipang un Arekuná Indianern*. Vol. 2. Stuttgart: Ströcker and Ströcker, 1924.

Kodama, María. *Borges en El Hogar, 1935–1958*. Buenos Aires: Emecé Editores, 2000.

Kozloff, Max. "The Awning That Flapped in the Breeze and the Bodies That Littered the Field: Painting and the Invention of Photography." *Artforum* 20, no. 1 (1980): 53–60.

―――. *Lone Visions, Crowded Frames: Essays on Photography*. Albuquerque: University of New Mexico Press, 1994.

Kracauer, Siegfried. "Photography." Translated by Thomas Y. Levin. *Critical Inquiry* 19 (1993): 421–34.

Krauss, Rosalind E. "A Note on Photography and the Simulacral." In *The Critical Image: Essays on Contemporary Photography*, 15–27. Edited by Carol S. Squiers. Seattle: Bay Press, 1990.

―――. *The Optical Unconscious*. Cambridge, Mass.: MIT Press, 1993.

―――. *The Originality of the Avant-garde and Other Modernist Myths*. Cambridge, Mass.: MIT Press, 1986.

Krauze, Enrique. *Mexico: Biography of Power: A History of Modern Mexico, 1810–1996*. Translated by Hank Heifetz. New York: Harper Collins, 1997.

Kwon, Miwon. *One Place after Another: Site Specific Art and Locational Identity*. Cambridge: MIT Press, 2004.

Lacan, Jacques. *The Ethics of Psychoanalysis, 1959–1960*. New York: W. W. Norton & Co., 1997.

Laddaga, Reinaldo. "Tunga." *Art Nexus* 27 (1998): 48–55.

Lafetá, João Luiz. *1930: A crítica e o modernismo*. São Paulo: Livraria Duas Cidades, 1974.

Lara, Cecília de. *Klaxon e Terra Roxa e outras terras: dois periódicos modernistas de São Paulo*. São Paulo: Instituto de Estudos Brasileiros/USP, 1972.

Lauer, Mirko. *Introducción a la pintura peruana del siglo XX*. Lima: Mosca Azul Editores, 1976.

Lemagny, Jean-Claude, and André Rouillé, eds. *A History of Photography: Social and Cultural Perspectives*. Translated by Janet Lloyd. Cambridge: Cambridge University Press, 1987.

Levinson, Jerrold, ed. *Aesthetics and Ethics: Essays at the Intersection*. Cambridge: Cambridge University Press, 1998.

Lima, Jorge de. *A pintura em pânico*. Rio de Janeiro: Tipografia Luso-Brasileira, 1943.

Lima, Yvone Soares de. *A ilustração na produção literaria*. São Paulo: Instituto de Estudos Brasileiros/USP, 1985.

Lippard, Lucy. *Six Years: The Dematerialization of the Art Object, 1962–1972*. Berkeley: University of California Press, 1997.

List Arzubide, Germán. "El movimiento estridentista." In Schneider *El Estridentismo, México, 1921–1927*, 261–73.

Long, Mary Kendall. "Salvador Novo: 1920–1940. Between the Avant-garde and the Nation." PhD diss. Princeton University, 1995.

———. "Salvador Novo's *Continente vacío*." *Latin American Literary Review* 24, no. 47 (1996): 91–114.

Lopez, Telê Ancona. "As viagens e o fotógrafo." In *Mário de Andrade: Fotógrafo e turista aprendiz*, 109–119. São Paulo: IEB/USP, 1993.

———. "Viagens etnográficas de Mário de Andrade: Itinerário fotográfico." *Revista do Instituto de Estudos Brasileiros* 11 (1972).

Lowe, Sarah M. *Tina Modotti: Photographs*. New York: Harry N. Abrams, Inc., 1995.

Loyo, Engracia. "Lectura para el pueblo, 1921–1940." *Historia mexicana* 33 (1984): 298–345.

Lovibond, Sabina. "'Gendering' as an Ethical Concept." *Feminist Theory* 2: 151–58.

Lund, Joshua. "They Were Not a Barbarous Tribe." *Journal of Latin American Cultural Studies* 12 (2003): 171–89.

MacDonald Escobedo, Eugenio. *Turismo, una recapitulación: Historiografía de conceptos pronunciados por gobernantes mexicanos desde 1823*. Mixcoac: Editorial Bodoni, 1981.

Majluf, Natalia. "El indigenismo en México y Perú: Hacia una visión comparativa." In Curiel, et. al., *Arte, historia e identidad en América: Visiones comparativas*, 610–28.

Maples Arce, Manuel. *Urbe: super-poema bolchevique en 5 cantos*. Mexico City: Andres Botas e Hijo, Sucr., 1924.

Maples Arce, Manuel, Germán List Arzubide, Salvador Gallardo, et al., "Manifiesto Estridentista Num. 2." In Schwartz, *Las vanguardias latinoamericanas: Textos programáticos y críticos*, 170–71.

Martín Barbero, Jesús. *De los medios a las mediaciones: Comunicación, cultura y hegemonía*. Barcelona: Editorial Gustavo Gili, 1987.

———. *Communication, Culture and Hegemony: From the Media to Mediations*. Translated by Elizabeth Fox and Robert A. White. Introduction by Philip Schlesinger. London: Sage, 1993.

Martín Lozano, Luis, coord. *Del istmo y sus mujeres: Tehuanas en el arte mexicano*. Mexico City: Museo Nacional de Arte, 1992.

Martínez, Juan A. "Early Twentieth Century Latin American Vanguard Art: The Invisible Modernism." *Art Nexus* 24 (1997): 64–68.

Masiello, Francine. *Between Civilization and Barbarism: Women, Nation and Literary Culture in Modern Argentina*. Lincoln: University of Nebraska Press, 1992.

———. "Rethinking Neocolonial Esthetics: Literature, Politics, and Intellectual Community in Cuba's *Revista de Avance*." *Latin American Research Review* 28, no. 2 (1993): 3–32.

———. "Women, State, and Family in Latin American Literature of the 1920s." In Bergmann et al., *Women, Culture, and Politics in Latin America Seminar on Feminism and Culture in Latin America*, 27–47.

McNulty, Tracy. "The Other Jouissance, A Gay Sçavoir." *Qui Parle* 9 (1996): 126–59.

Medina, Cuahtémoc. *Diseño antes del diseño: Diseño gráfico en México, 1920–1960*. Catalog. Mexico City: Museo de Arte Carrillo Gil/INBA, 1991.

———. "¿Identidad o identificación? La fotografía y la distinción de las personas. Un caso oaxaqueño." In Curiel et. al., *Arte, historia e identidad en América: Visiones comparativas*, 577–98.

———. "La prohibición como incitación." In *Silvia Gruner: Reliquias. Collares*. Catalog with Osvaldo Sánchez and Kellie Jones, 6–39; 66–75. Mexico City: CONCACULTA/Centro de la Imagen/FONCA, 1998.

Melo Miranda, Wander, ed. *Narrativas da modernidade*. Belo Horizonte: Autêntica, 1999.

Mendes, Ricardo. "A revista S. PAULO: A cidade nas bancas." *Imagens* 3 (December 1994): 91–97.

Metz, Christian. "Photography and Fetishism." *The Critical Image: Essays on

Contemporary Photography, edited by Carol Squiers, 155–64. Seattle: Bay Press, 1990.

Meyer, Doris, ed. *Reinterpreting the Spanish American Essay: Women Writers of the Nineteenth and Twentieth Centuries*. Austin: University of Texas Press, 1995.

Meyer, Jean. "Revolution and Reconstruction in the 1920s." *Mexico since Independence*, edited by Leslie Bethell, 201–40. Cambridge: Cambridge University Press, 1991.

Miceli, Sérgio. *Intelectuais e classe dirigente no Brasil, 1920–1945*. São Paulo: DIFEL, 1979.

Mignolo, Walter. *The Idea of Latin America*. Oxford: Blackwell, 2005.

Mitchell, W. J. T., ed. *Landscape and Power*. Chicago: University of Chicago Press, 1994.

———. *Picture Theory: Essays on Verbal and Visual Representation*. Chicago: University of Chicago Press, 1994.

———. "Representation." In *Critical Terms for Literary Study*, ed. Frank Lentricchia and Thomas McLaughlin, 11–22 Chicago: University of Chicago Press, 1990.

Modleski, Tania. *Loving with a Vengeance: Mass-produced Fantasies for Women*. London: Routledge, 1990.

Mondrian, Piet. *Natural Reality and Abstract Reality: An Essay in Trialogue Form*. 1919–1920. Translated by Martin S. James. New York: George Braziller, 1995.

Monsiváis, Carlos. *Celia Montalván (te brindas, voluptuosa e impudente)*. Serie Memoria y Olvido: Imágenes de México, no. XIV. Mexico City: Martín Casillas Editores/Cultura/SEP, 1982.

———. *Escenas de pudor y liviandad*. Mexico City: Grijalbo, 1981.

———. *La nueva grandeza mexicana*. Mexico City: CONCACULTA, 1992.

———. "Los que tenemos unas manos que no nos pertenecen." *Debate Feminista* 8, no. 16 (1997): 11–33.

———. *Salvador Novo: Lo marginal en el centro*. Mexico City: Ediciones Era, 2000.

Montaldo, Graciela. "Los años veinte: Un problema de historia literaria." *Filología* 22, no. 2 (1987): 129–44.

Moraes Belluzzo, Ana Maria de, ed. *Modernidade: Vanguardas artísticas na América Latina*. São Paulo: UNESP/Fundação Memorial da América Latina, 1990.

———. "A modernidade como paradoxo: Modernidade estética no Brasil." In Melo Miranda, *Narrativas da modernidade*, 167–74.

———. *The Voyager's Brazil: A Place in the Universe*. Vol. 2. Translated by H. Sabrina Gledhill. São Paulo: Metalivros/Odebrecht, 1995.

Morais Silva, Antonio de. *Grande diccionário da língua portuguesa*. Vol. 7. 10th ed. Lisbon: Editorial Confluência.

Morales-Moreno, Luis Gerardo. "History and Patriotism in the National Museum of Mexico." In *Museums and the Making of "Ourselves": The Role of Objects in National Identity*, edited by Flora E. S. Kaplan. London: Leicester University Press, 1994: 171–91.

Moraña, Mabel, ed. *Nuevas perspectivas desde, sobre América Latina: El desafío de los estudios culturales*. Providencia, Santiago: Editorial Cuarto Propio, Instituto Internacional de Literatura Iberoamericana, 2000.

Moreno y García, Roberto. *Analfabetismo y cultural popular en América*. Mexico City: Editorial Atlante, 1941.

Moriconi, Italo. "The Postmodern in Brazilian Literary Theory and Criticism." In *Literary Cultures of Latin America: A Comparative History*, edited by Mario J. Valdés and Djelal Kadir, 555–61. New York: Oxford University Press, 2004.

Mosquera, Gerardo. "Africa in the Art of Latin America." *Art Journal* 51 (1992): 30–68.

———, ed. *Beyond the Fantastic: Contemporary Art Criticism from Latin America*. Cambridge: MIT Press, 1995.

Mulvey, Laura. "Some Thoughts on Theories of Fetishism in the Context of Contemporary Culture." *October* 65 (1993): 3–20.

———. "Visual Pleasure and Narrative Cinema." *Screen* 16, no. 3 (1975): 6–18.

Muñiz, Elsa. "*Garçonnes, flappers* y pelonas: En la década fabulosa ¿de qué modernidad hablamos?" *Revista Fuentes Humanísticas* 21–22 (2001): 3–15.

Naumann, Francis M., and Hector Obalk, eds. *Affectionately, Marcel: The Selected Correspondence of Marcel Duchamp*. Translated by Jill Taylor. Ghent: Ludion Press, 2000.

Nesbit, Molly. "Photography, Art and Modernity (1910–1930)." In Lemagny and Reouillé, *A History of Photography*, 103–23.

North, Michael. *The Dialect of Modernism: Race, Language, and Twentieth Century Literature*. Oxford: Oxford University Press, 1994.

———. "Modernism's African Mask: The Stein-Picasso Collaboration." In *Prehistories of the Future: The Primitivist Project and the Culture of Modernism*, edited by Elazar Barkan and Ronald Bush, 270–92. Stanford, Calif.: Stanford University Press, 1995.

———. *Reading 1922: A Return to the Scene of the Modern*. Oxford: Oxford University Press, 1999.

Noyola Rocha, Jaime. "La visión integral de la sociedad nacional, 1920–1934." In *La antropología en México: Panorama histórico*, vol. 2, *Los hechos y los dichos, 1880–1986*, edited by Carlos García Mora, 133–222. Mexico City: INAH, 1987.

Novo, Salvador. "El arte de la fotografía." *Contemporáneos* 9 (1931): 165–72.

———. *Continente vacío. Viaje a Sudamérica.* Madrid: 1935.

———. *La estatua de sal.* Prologue by Carlos Monsiváis. Mexico City: Consejo Nacional para la Cultura y las Artes, 1998.

———. "El joven." 1928. In *Narrativa vanguardista hispanoamericana.* Edited by Hugo J. Verani, 213–36. Mexico City: UNAM, Ediciones del Equilibrista, 1996.

———. "Memoir." In *Now the Volcano: An Anthology of Latin American Gay Literature,* translated by Erskine Lane, Franklin D. Blanton, and Simon Karlinsky, edited by Winston Leyland, 11–47. San Francisco: Gay Sunshine, 1979.

———. *La nueva grandeza mexicana.* 1945. Mexico City: Editorial Hermes, 1992.

———. "Return ticket." 1928. In Coronado, *La novela lírica de los Contemporáneos,* 229–321.

Nunes, Zita. "Anthropology and Race in Brazilian Modernism." In *Colonial Discourse/Postcolonial Theory,* edited by Francis Barker, Peter Hulme, and Margaret Iversen, 115–25. Manchester: Manchester University Press, 1994.

Olcott, Jocelyn. *Revolutionary Women in Post-Revolutionary Mexico.* Durham, N.C.: Duke University Press, 2005.

Omar, Arthur. *O esplendor dos contrários: Aventuras da cor caminhando sobre as águas do rio Amazonas.* São Paulo: Cosac & Naify, 2002.

Ortiz, Renato. *A moderna tradição Brasileira: Cultura Brasileira e insústria cultural.* São Paulo: Editora Brasiliense, 1988.

Ortiz Gaitán, Julieta. *Imágenes del deseo: Arte y publicidad en la prensa ilustrada mexicana (1894–1939).* Mexico City: UNAM, 2003.

Osorio, Nelson T. *El futurismo y la vanguardia literaria en América Latina.* Caracas: Centro de Estudios Latinoamericanos Romulo Gallegos, 1982.

———. *Manifiestos, proclamas y polémicas de la vanguardia literaria hispanoamericana.* Caracas: Biblioteca Ayacucho, 1988.

Owen, Gilberto. "Novela como nube." 1928. In Coronado, *La novela lírica de los Contemporáneos,* 39–94.

Palavicini, Félix F. *Mi vida revolucionaria.* Mexico City: Ediciones Botas, 1937.

Parkinson Zamora, Lois. "Quetzalcóatl's Mirror: Reflections on the Photographic Image in Latin America." In *Image and Memory: Photography from Latin America, 1866–1994,* 293–375. Edited by Wendy Watriss and Lois Parkinson Zamora. Austin: University of Texas Press, 1998.

Paúl Arranz, María del Mar. "Contemporáneos: La narrativa de un grupo de poetas." *Cuadernos Hispanoamericanos* 553–54 (1996): 255–69.

Pérez Firmat, Gustavo. *Idle Fictions*. Expanded ed. Durham, N.C.: Duke University Press, 1993.

Pérez Oramas, Luis Enrique. "Armando Reverón: Anthropophagy of Light and Melancholy of Landscape." In *XXIV Bienal de São Paulo: Núcleo histórico: Antropafagía e histórias de canibalismos*, 1:183–86. Edited by Paulo Herkenhoff. São Paulo: Fundação Bienal de São Paulo, 1998.

———. "The Cisneros Collection: From Landscape to Location." In *Geometric Abstraction: Latin American Art from the Patricia Phelps de Cisneros Collection*, 38–57. With Yves-Alain Bois, Paulo Herkenhoff, and Ariel Jiménez. New Haven, Conn.: Yale University Press, 2001.

Phillips, Sandra S., Mark Haworth-Booth, and Carol Squiers. *Police Pictures: The Photograph as Evidence*. San Francisco: San Francisco Museum of Modern Art, Chronicle Books, 1997.

Podestá, Guido A. "An Ethnographic Reproach to the Theory of the Avant-garde: Modernity and Modernism in Latin America and the Harlem Renaissance." *MLN* 106 (1991): 395–422.

Pollock, Griselda. "Van Gogh and Holland: Nationalism and Modernism." In *Avant-gardes and Partisans Reviewed*, edited by Fred Orton and Griselda Pollock, 103–14. Manchester: Manchester University Press, 1996.

Poniatowska, Elena. *Manuel Álvarez Bravo: El artista, su obra, sus tiempos*. Mexico City: Banamex, 1991.

Poole, Deborah. *Vision, Race and Modernity: A Visual Economy of the Andean World*. Princeton, N.J.: Princeton University Press, 1997.

Prado, Paulo. *O retrato do Brasil: Ensaio sôbre a tristeza brasileira*. Rio de Janeiro: Livraria José Olympio, 1962.

Prado Bellei, Sérgio Luiz. "Brazilian Anthropophagy Revisited." In *Cannibalism and the Colonial World*, edited by Francis Barker, Peter Hulme, and Margaret Iverson, 87–109. Cambridge: Cambridge University Press, 1998.

Pratt, Mary Louise. "'Don't Interrupt Me': The Gender Essay as Conversation and Countercanon." In *Reinterpreting the Spanish American Essay: Women Writers of the Nineteenth and Twentieth Centuries*, edited by Doris Meyer, 10–26. Austin: University of Texas Press, 1995.

———. *Imperial Eyes: Travel Writing and Transculturation*. New York: Routledge, 1992.

———. "Modernity and Periphery: Toward a Global and Relational Analysis." In *Beyond Dichotomies: Histories, Identities, Cultures, and the Challenge of Globalization*, edited by Elisabeth Mudimbe-Boyi, 21–46. Albany: SUNY University Press, 2002.

———. "Repensar la modernidad." Unpublished manuscript, 2000.

———. "Women, Literature, and National Brotherhood." In Bergmann

et al., *Women, Culture, and Politics in Latin America Seminar on Feminism and Culture in Latin America*, 48–73.

Quijano, Aníbal. "Coloniality of Power, Eurocentrism, and Latin America." *Nepantla: Views from South* 1 (2000): 533–80.

Rama, Angel. *La ciudad letrada*. Hanover, N.H.: Ediciones del Norte, 1984.

———. "Los contestarios del poder." *Quimera*, no. 9–10 (1981): 44–52.

Ramírez, Mari Carmen, and Héctor Olea. *Heterotopías. Medio siglo sin-lugar: 1918–1968*. Madrid: Museo Nacional, Centro de Arte Reina Sofia, 2000.

———. *Inverted Utopias: Avant-garde Art in Latin America*. New Haven, Conn.: Yale University Press and the Museum of Fine Arts, Houston, 2004.

Ramírez Leyva, Edelmira. "Negativos de fotografía: Una aproximación a la descripción en la narrativa de Jaime Torres Bodet." In *Los contemporáneos en el laberinto de la crítica*, edited by Rafael Olea Franco and Anthony Stanton, 67–76. Mexico City: El Colegio de México, 1994.

Reflecciones: The Art of Manuel Álvarez Bravo. San Diego, Calif.: Museum of Photographic Arts, 1990.

Reyes, Aurelio de los. *Cine y sociedad en México 1896–1930: Bajo el cielo de México*. Vol. 2, *1920–1924*. Mexico City: IIE/UNAM, 1993.

———. "Los Contemporáneos y el cine." *Anales del Instituto de Investigaciones Estéticas* 13, no. 52 (1983): 167–86.

Reyes Palma, Francisco. "Arte funcional y vanguardia (1921–1952)." In Debroise, et al., *Modernidad y modernización en el arte mexicano, 1920–1960*, 83–95.

Ricardo, Cassiano. "Moça tomando café." *S. Paulo* 1, no. 9 (1936).

Richard, Nelly. "La condición fotográfica." Special issue of *Art and Text* 21 (1986): 129–32.

———. "Latin America and Postmodernity." In *Latin America Writes Back: Postmodernity in the Periphery*, edited by Emil Volek, 225–33. New York: Routledge, 2002.

Riffaterre, Michael. *Fictional Truth*. Baltimore: Johns Hopkins University Press, 1990.

Rimmon-Kenan, Shlomith. *Narrative Fiction: Contemporary Poetics*. New York: Routledge, 1983.

Rodríguez, Omar. *Etnias, imperios y antropología*. Caracas: Universidad Central de Venezuela, Facultad de Ciencias Económicas y Sociales, 1991.

Rosenberg, Fernando J. *Avant-garde and Geopolitics in Latin America*. Pittsburgh: University of Pittsburgh Press, 2006.

Rosenblum, Naomi. *A World History of Photography*. New York: Abbeville, 1984.

Roster, Peter J. *La ironía como método de análisis literario*. Madrid: Gredos, 1978.

Rowe, William, and Vivian Schelling. *Memory and Modernity: Popular Culture in Latin America*. London: Verso, 1991.

Rubenstein, Anne. *Bad Language, Naked Ladies, and Other Threats to the Nation: A Political History of Comic Books in Mexico.* Durham, N.C.: Duke University Press, 1998.

Ruiz Castañeda, María de Carmen, and Sergio Márquez Acevedo. *Diccionario de seudónomos, anagramas, iniciales y otros alias usados por escritores mexicanos y extranjeros que han publicado en México.* Mexico City: UNAM, 2000.

Ruiz Martínez, Apen. "Nación y género en el México revolucionario: La India Bonita y Manuel Gamio." *Signos históricos* 5 (2001): 55–86.

Sá, Lúcia Regina de. *Rainforest Literatures: Amazonian Texts and Latin American Culture.* Minneapolis: University of Minnesota Press, 2004.

Santiago, Silviano. "O entre-lugar do discurso latino-americano." 1971. In *Uma literatura nos trópicos,* 9–26. Rio de Janeiro: Rocco, 2000.

———. "Reading and Discursive Intensities: On the Situation of Postmodern Reception in Brazil." *Boundary 2* 20 (1993): 194–202.

Sarlo, Beatriz. *Una modernidad periférica: Buenos Aires 1920 y 1930.* Buenos Aires: Nueva Visión, 1988.

Scarry, Elaine. *The Body in Pain: The Making and Unmaking of the World.* New York: Oxford University Press, 1985.

Schelling, Vivian. "Mário de Andrade: A Primitive Intellectual." *Bulletin of Hispanic Studies* 65, no. 1 (1988): 73–86.

———. *A presença do povo na cultura brasileira.* Translated by Federico Carotti. Campinas: Editora da UNICAMP, 1991.

———, ed. *Through the Kaleidoscope: The Experience of Modernity in Latin America.* Translated by Lorraine Leu. London: Verso, 2000.

Schmucler, Héctor. "La fotografía y los medios masivos de información en América Latina." In *Hecho en Latinoamérica: Memorias del Primer Coloquio Latinoamericano del Fotografía,* 51–54. Mexico City: Consejo Mexicano de Fotografía, A.C., 1978.

Schnapp, Jeffrey T., and João César de Castro Rocha. "Brazilian Velocities: On Marinetti's 1926 Trip to South America." *South Central Review* 13.2–3 (1996): 105–56.

Schneider, Luis Mario, ed. *El Estridentismo, México, 1921–1927.* Mexico City: UNAM, 1985.

———. *México y el surrealismo, 1925–1950.* Mexico City: Arte y Libros, 1978.

Schneider Enríquez, Mary. "Rites of Memory: The Photographs and Video Installations of Gerardo Suter." In *Gerardo Suter: Labyrinth of Memory,* 10–21. New York: Americas Society Art Gallery, 1999.

Schwartz, Jorge. "Literature and the Visual Arts: The Brazilian Roaring Twenties." Translated by Adria Frizzi. N.d. Available at lanic.utexas.edu/project/etext/llilas/vrp/jschwartz.htm.

———. *Las vanguardias latinoamericanas: Textos programáticos y críticos.* Portuguese translated by Estela dos Santos. Madrid: Catedra, 1991.

Schwarz, Roberto. *Misplaced Ideas: Essays on Brazilian Culture*. New York: Verso, 1992.

Segre, Erica. "Relics and Disject in Mexican Modernism and Post-Modernism: A Comparative Study of Archaeology in Contemporary Photography and Multi-Media Art." *Journal of Latin American Cultural Studies* 14 (2005): 25–51.

Sheridan, Guillermo. *Los Contemporáneos ayer*. Mexico City: Fondo de Cultura Económico, 1988.

———. "México, Los 'Contemporáneos' y el nacionalismo." *Vuelta* 8, no. 87 (1984): 29–37.

Shohat, Ella and Robert Stam. "Narrativizing Visual Culture: Towards a Polycentric Aesthetics." In *The Visual Culture Reader*, edited by Nicholas Mirzoeff, 27–49. London: Routledge, 1998.

Sierra, Silveria. "Aspectos sociales de las mujeres de México." *El Machete*, no. 1 (1924): 4.

Silvo Brito, Mário da. *História do modernismo brasileiro. Antecedentes da Semana de Arte Moderna*. Rio de Janeiro: Civilização Brasileira, 1978.

Siraganian, Lisa. "Out of Air: Theorizing the Art Object in Gertrude Stein and Wyndam Lewis." *Modernism/Modenity* 10 (2003): 657–76.

Simon, Richard Keller. *The Labyrinth of the Comic: Theory and Practice from Fielding to Freud*. Tallahassee: Florida State University Press, 1985.

Solomon-Godeau, Abigail. *Photography at the Dock: Essays on Photographic History, Institutions, and Practices*. Minneapolis: University of Minnesota Press, 1991.

Sommer, Doris. *Foundational Fictions: The National Romances of Latin America*. Berkeley: University of California Press, 1991.

Sontag, Susan. *On Photography*. New York: Farrar, Straus and Giroux, 1973.

Souza, Eneida Maria de. "Nacional por abstração." In Melo Miranda, *Narrativas da modernidade*, 129–41.

Steiner, Wendy. *Exact Resemblance to Exact Resemblance: The Literary Portraiture of Gertrude Stein*. New Haven, Conn.: Yale University Press, 1978.

———. *Venus in Exile: The Rejection of Beauty in Twentieth-Century Art*. Chicago: University of Chicago Press, 2001.

Strand, Paul. "Photography and the New God." *Broome* 3, no. 1 (1922): 252–58.

Süssekind, Flora. *O Brasil não é longe daqui: O narrador, a viagem*. São Paulo: Editora Schwarcz, 1990.

———. *Cinematograph of Words: Literature, Technique, and Modernization in Brazil*. Translated by Paulo Henriques Britto. Stanford, Calif.: Stanford University Press, 1997.

Tagg, John. *The Burden of Representation: Essays on Photographies and Histories*. Amherst: University of Massachussetts Press, 1988.

Tashijian, Dickran. *Skyscraper Primitives: Dada and the American Avant-garde, 1910–1925*. Middletown, Conn.: Wesleyan University Press, 1975.

Tausk, Peter. *Historia de la fotografía en el siglo XX, de la fotografía artística al periodismo gráfico*. Barcelona: Gustavo Gili, 1978.

Taussig, Michael. *Mimesis and Alterity: A Particular History of the Senses*. New York: Routledge, 1993.

Teitelbaum, Matthew, ed. *Montage and Modern Life: 1919–1942*. Cambridge, Mass.: MIT Press, 1992.

Tenorio, Mauricio. "A Tropical Cuauhtemoc: Celebrating the Cosmic Race at the Guanabara Bay." *Anales del Instituto de Investigaciones Estéticas* 65 (1994): 93–137.

Thomas, David. B. *"From today painting is dead": The Beginnings of Photography*. London: Arts Council of Great Britain and the Victoria and Albert Museum, 1972.

Thompson, Krista A. "The Tropicalization of the Anglophone Caribbean: The Picturesque and the Aesthetics and Politics of Space in Jamaica and the Bahamas." PhD diss., Emory University, 2002.

Torres Bodet, Jaime. "Estrella de día." 1933. In *Narrativa completa*, vol. 2, 9–70. Mexico City: Editorial Offset, 1985.

———. *"El Juglar y la Domadora" y otros relatos desconocidos*. Edited by Luis Mario Schneider. Mexico City: El Colegio de México, 1992.

———. *Margarita de niebla*. 1927. Mexico City: Editorial Offset, 1985.

———. "Nadja, de Andre Breton." *Contemporáneos* 11 (1931): 194–99.

———. "Primero de enero." 1935. In *Narrativa completa*, vol. 2, 79–168. Mexico City: Editorial Offset, 1985.

———. "Proserpina rescatada." 1926. In *Narrativa completa*, vol. 1, 155–248. Mexico City: Editorial Offset, 1985.

Trevissan, João Silvénio. *Desvassos do paraíso*. N.p.: Editora Max Limonad, 1986.

Tunga. *Barroco de lírios*. São Paulo: Cosac & Naify Edições, 1997.

Tunga, 1977–1997. Catalog. Annandale-on-Hudson: Center for Curatorial Studies, Bard College, 1997.

Unruh, Vicky. *Latin American Vanguards: The Art of Contentious Encounters*. Berkeley: University of California Press, 1994.

Valle Gagern, Carlos. *El renacimiento de las artes gráficas en México*. Mexico City: n.p., 1926.

Van Damme, Wilfried. *Beauty in Context: Towards an Anthropological Approach to Aesthetics*. Leiden: E. J. Brill, 1996.

Vasconcelos, José. *The Cosmic Race/ La raza cósmica*. 1925. Translated by Didier T. Jaén. Mexico City: Centro de Publicaciones Bilingües, 1988.

Vela, Arqueles. "El café de nadie." 1926. In Schneider, *El Estridentismo, México, 1921–1927*, 213–34.

———. "La señorita etcétera." 1922. In Verani, *Narrativa vanguardista hispano-americana*, 189–204.

Verani, Hugo J. "La narrativa hispanoamericana de vanguardia." In *Narrativa hispanoamericana de vanguardia*, 41–73. Mexico City: UNAM, 1996.

———. *Las vanguardias literarias en hispanoamérica. Manifiestos, proclamas y otros escritos*. Mexico City: Fondo de Cultura Económica, 1986.

Villaurrutia, Xavier. "Dama de corazones." 1928. In Coronado, *La novela lírica de los Contemporáneos*, 187–228.

———. "Manuel Álvarez Bravo." In Álvarez Bravo, *Manuel Álvarez Bravo: Fotografías*, 20–21.

Wagley, Charles. "Anthropology and Brazilian National Identity." In *Brazil: Anthropological Perspectives. Essays in Honor of Charles Wagley*, edited by Maxine L. Margolis and William E. Carter, 1–18. New York: Columbia University Press, 1979.

Walz, Robin. *Pulp Surrealism: Insolent Popular Culture in Early Twentieth-Century Paris*. Berkeley: University of California Press, 2000.

Weissberg, Liliane. "Circulating Images: Notes on the Photographic Exchange." In *Writing the Image after Roland Barthes*, edited by Jean-Michel Rabaté, 109–31. Philadelphia: University of Pennsylvania Press, 1997.

Williams, Darryle. *Culture Wars in Brazil: The First Vargas Regime, 1930–1945*. Durham, N.C.: Duke University Press, 2001.

Williams, Raymond. *The Country and the City*. New York: Oxford University Press, 1973.

———. *The Politics of Modernism: Against the New Conformists*. London: Verso, 1989.

Xavier, Ismail. *Allegories of Underdevelopment: Aesthetics and Politics in Modern Brazilian Cinema*. Minneapolis: University of Minnesota Press, 1997.

Yúdice, George. "Marginality and the Ethics of Survival." In *Universal Abandon? The Politics of Postmodernism*, 214–36. Minneapolis: University of Minnesota Press, 1988.

Index

Page numbers in italics refer to illustrations.

Abella Caprile, Margarita, 172, 173, 193

abstraction: contemplative, 18, 57, 98; errancy and, 10, 40–41, 52, 65, 69; landscapes and, 33, 40–41, 46, 50, 61–62, 65, 68–71, 82; Mário de Andrade on, 68–71, 226; modernism and, 10, 53, 70; primitivism and, 82; progression toward, 7, 74; race and, 81–82

Adorno, Theodor, 128–29

aesthetics, modernist: errancy in, 42, 259; ethics and, 2, 6, 7, 10, 22, 32, 80, 126, 259; excess and, 148, 191, 193–94, 213–16; geopolitics of, 28–29; heroic phase and, 27; landscapes and, 41–42, 55–56; as local, 32; mediation and, 128–29, 181–83; opacity and, 11; portraiture and, 81, 259. See also ethos of modernism

Alonso, Carlos, 17

Alvarenga, Oneyda, 72

Álvarez Bravo, Lola, 159

Álvarez Bravo, Manuel: "Arena y pinitos," 23; compared to Edward Weston, 28, 225; exhibitions, 153; fictional photographs, 224–26; "Four Little Horses," 155; on geopolitics of aesthetic value, 29; "Historic Plot," 222–24; illustrated magazines and, 166, 168, 221; photographic style, 11, 20–21, 35, 116, 221, 224; "Sand and Little Pines," 23, 222; "Striking Worker Murdered," 221–22; "Urinating Boy," 226–27; use of invisible, 116, 225; Villaurrutia on, 169; "Washerwomen Implied, The," 225, 226

Amaral, Aracy, 27

Amaral, Tarsila do, 29, 66, 68

Americanness, 18

Anderson, Benedict, 71

Andrade, Mário de, 3, 4, *104*; "Abrol-hos," 57–58; on abstraction, 68–71, 226; "Alagoas—Maceió," 51; "Alva-rengas," 52, *54*; "Aposta do ridículo em Tefé," 93–94; on apprentice tourism, 17, 126; as autoethnog-raphy, 93; on avant-garde poetry, 106–7; "Bom Passar," 86–87; on Brazilian photography, 59; Bra-zilian primitivism and, 33, 78, 82; Brazilian travels, 36–45, 49, 82; on city as feminine, 133–34; on collo-quialisms, 46–47, 60; connection to artists/writers, 27; on critical nationalism, 5; on cultural nation-alism, 71–74, 78; "Desvairismo por acaso," 42, *43*; on documentary practices, 20, 65; "Dolur na Sta. Tereza do Alto," *64*, 65; "Dolur na vista Marajoara," 60–61; "Entrada dum paraná ou paranã," 44; on epidermic portraits, 22, 107; on errancy/errar, 36–37, 40, 41, 43, 65, 68; *Escrava que não é Isaura*, 55, 71, 86, 95, 122; on ethos, 70, 78, 83; on Euclides da Cunha, 63–64; fictive photographs, 221–24; on folklore, 33, 37, 62, 65, 73, 109; "Foto futurista de Mag e Dolur," 114–15; "Frederico Paciência," 103–6; homosexuality of, 102–8; on horizons, 50–59; on humor, 93–99; images of invisible, 225–26; "Improviso do mal da América," 110; "Jangadas de mogno," 52, *54*; "Lago Ararí, Marajó," 117–18; landscapes and texts, 36–74; on Latin American intellectuals, 49; on locale, 46; *Macunaíma*, 33, 79–81, 84–85, 93, 111–12, 118; on modernist artists, 79; "Modernist Movement, The," 12, 102–3, 107; "Mogi-Guassu," 52, *53*; "Mogi-Guassu (com vento)," 52, *53*; on place, 33; on poetic simultaneity, 129; poetry of, 42, 120; portrai-ture, 75–119; on primitivism, 102; on race, 78, 87; "Rio Madeira," 75, 77; "Roupas freudianas," 115–16; "Sombra minha," 75, *76*; split with Oswald de Andrade, 103; "staring so stared at," 91, 101, 119, 259; on sublime, 75, 81, 85–86; "Tapuio de Parintins," 88–89, 211, 259; "Toada," 120, 123, 124; on true rep-resentation, 196. See also *Turista aprendiz, O*

Andrade, Oswald de: "Anthropo-phagist Manifesto," 29, 35, 48, 279 n. 25; background, 78, 130; lin-guistic jokes, 37; "Manifesto Pau Brasil," 123–24, 130–31; photo-graph of, 66; split with Mário de Andrade, 103

Ángel, Abraham, 145

Antelo, Raul, 78, 278 n. 4

anthropophagy, Brazilian, 2, 78

anticolonialism, 17, 20, 26, 62, 72, 119, 238

Appadurai, Arjun, 193

apprentice tourism: clothing and, 132; domestic tourism and, 18; García Canclini on, 78; Mário de Andrade on, 17, 73, 126, 133, 141, 251; modernist art and, 113; para-dox and, 40; Salvador Novo on, 230

Apprentice Tourist, The. See *Turista aprendiz, O*

Arce, Maples, 194

Ardao, Arturo, 19

Aristotle, 6, 45, 80, 200

Athayde, Tristão de, 72

Aurrecoechea, Juan Manuel, 139

authorship, 20

autoethnography, 90, 93

automovilismo, 25, 171–77, 186, 265

avant-garde movements, modernist: aspects, 2; circulation and, 172; femininity and, 140; high modernism vs., 26; imitation and, 13; Latin American, 2–3, 13; mass culture and, 34; mass media and, 34, 131; mestizaje and, 183; *modernismo*, 14; political vs. artistic, 26–27, 102; popular culture and, 9, 141, 203, 221; *vanguardia*, 14, 136, 140

Avelar, Idelber, 21

balmoreadas, 242–47

Balmori, don Carlos. *See* Jurado, Concepción (Conchita)

Bandeira, Manuel, 111

Bandeirantes, Paulista, 121

Band of Jokesters, 240, 246

baroque, 8, 11, 31, 74, 242, 254

Barreto, Lima: *Sad End of Policarpo Quaresma, The*, 46

Barthes, Roland, 22, 97, 148, 216–17

Bartra, Armando, 139

Bastos, Eliana, 73, 264 n. 35

Bataille, Georges, 61

Baumlin, James, 200–201

Baumlin, Tita, 200–201

beauty: of the feminine in photography, 163–64; graphic design and, 177–86; Mário de Andrade on 62, 71, 98, 106–07. *See also* India Bonita, La

Becerra González, María, 155–57

bellas artes públicas, 34–35; critical nationalism and, 248; ethos and, 145–47, 207; femininity and, 161–62, 206, 246; gender and, 166; mass culture and, 147; mestiza aesthetic and, 180, 183; political impact of, 186

Benjamin, Walter, 82–83, 128–29

Best Maugard, Adolfo, 187, 238

Bibiana Uribe, María, 178, 180, 181–82

bilingualism, 71–72

Billeter, Erika, 28

Black Atlantic, 30

Blanco Aguinaga, Carlos, 14

Bonifant, Cube, 181

Borges, Jorge Luis, 21, 287 n. 5, 308 n. 54

Bosi, Alfredo, 7, 13

Brazil: cosmopolitanism in, 27; iconic modernism in, 1–3; landscape photography of, 4, 36–74; national character of, 79; rural, 49, 60; São Paulo, 24–25, 29–30, 48–49

Brehme, Hugo: "Peak of Orizaba," 23, *24*, 168

Brenner, Anita, 165–66

Breton, André, 216–17

Brilliant, Richard, 87–88

Brunner, José Joaquín, 15

Bryson, Norman, 214, 264 n. 31

Buchloh, Benjamin, 117, 118

Buell, Lawrence, 27

Buñuel, Luis, 245

Bürger, Peter, 265 n. 50

Bustamante, Maris, 242, 245–46, 248–49, 253, 254, 259

camera obscura, 13

Campa, Román de la, 15

Campos, Haroldo de, 31, 74, 111

cannibalism, 63, 78. *See also* anthropophagy

Capanema, Gustavo, 132

captions, 5, 66–67

Carranza, Venustiano, 138

Cartier Bresson, Henri, 224

Casebere, James, 22

Castillo, Debra, 145, 293 n. 28

Castro, Jorge de, 66, 67

categorical imperative, 84

Cavalcanti, Emiliano de, 133

Cendrars, Blaise, 37

Certeau, Michel de, 7

Cervantes Morales, Luis, 243, 244, 246

Césaire, Aimé, 61

Chaplin, Charles (Charlie), 95–96, 102, 150

characterization, 202–6

Chow, Rey, 266 n. 57

circulation, 146, 147–48, 155, 164–65, 167, 171–74, 177, 186, 193

citizenship, 193

city: anonymity and, 106; change and, 125; ciudad letrada, 24–26, 34, 47, 129–34, 191, 194, 207; Creole dwellers of, 110; defined, 25; futurism and, 46; growth of, 121; hybrid, 147, 169; landmarks and, 48; modern, 34, 174, 183, 207; of pain, 113; the rural and, 3, 24, 46, 48–49, 60, 76, 127, 135, 146, 169, 205; as woman, 133. See also urban

ciudad letrada, 24–26, 34, 47, 129–34, 191, 194, 207. See also letrados

class: critical theory and, 266 n. 57; femininity and, 151; race and, 25; writers and, 130

Clifford, James, 62, 278 n. 5

Cohn, Doritt, 199–200, 213

collage, 15, 60, 61–62, 65, 207

colloquialisms, Brazilian, 46–47, 60

colonialism: critique of, 5; history of modernity and, 3; history of photography and, 3; landscapes and, 37–38, 41, 57, 60–61; Latin American modernism and, 7–8; race and, 8; violence and, 111

Conchita. See Jurado, Concepción

Concrete Poetry, 31

Conesa, María, 181

Constructivism, 3

Contemporáneos, 2, 27, 31, 34, 143, 150, 160, 166, 202, 303 n. 4

context, 16–17

Copjec, Joan, 280 n. 38

copyright, 20

Coronado, Juan, 203, 219

cosa pública. See public thing

Cosmic Race, 180–81

cosmopolitanism, 7, 27

criminal photography, 83; in Primero de enero, 209–10

critical nationalism, 109–12; as bridge, 50; cultural nationalism and, 26, 30, 71–74, 127; cultural referents, 111–12; emergence of, 26–32; errancy and, 242, 248–49; femininity and, 195; mass media and, 126–27, 248; photo-essays and, 146; popular and, 132; primitivism and, 109; Salvador Novo on, 239; sexuality and, 233

Crow, Thomas, 140–41

Cuesta, Jorge, 31, 141

Cueto, Germán, 183

cultural nationalism: critical nationalism and, 26, 30, 71–74, 127; identity and, 118; illustrated magazines and, 127; as monolithic, 146; in 1920s, 247, 251; photo-essays and, 187–88; post-revolutionary, 149; state and, 134, 144, 167, 193

culture: ethos vs., 26–32; high/low, 140–41, 159, 234; mass media and 123; peripheral, 40; state funding and, 131. See also mass culture; popular culture

Cunha, Euclides da, 63–64

daguerreotype, 13

danado, 71, 109, 124

dance, 71

Delhumeau, Eduardo, 244, 247

desire, 230–37

Díaz, Porfirio, 149, 188

Díaz Arciriega, Víctor, 145, 174

difference: errant modernism and, 52; ethnic, 63; proximity and, 77

diffusionism, 63
Doane, Mary Ann, 283 n. 57
Dolezel, Lubomír, 304 n. 15
double-exposure, 44

Eastlake, Lady, 201
Echevarria, Bolívar, 8
Eder, Rita, 14
Ehrenberg, Felipe, 123
Eisenstein, Sergei, 219
Enciso, Jorge, 178
episteme, 21–22
errancy: in aesthetics, 42, 259; in circulation, 146; defined, 13; in ethos, 33, 45, 64; in ground and figure, 59–65; in landscapes, 56, 69; in language, 46–47; in Latin Americanism, 20; Mário de Andrade on, 36–37, 40, 41, 43, 65, 68; in modernism, 10, 14, 26, 41–42, 52, 123; as modernist abstraction, 10, 41; in photography, 13–14, 17, 61, 72, 252; in urbanism, 48
errar, 37, 40–41, 45, 46–50, 62, 65, 68, 256. See also errancy
Escola Paulista de Belas-Artes, 130
essays, 147–48; design and, 186–93; effeminate, 148; genre limits, 146–47. See also photo-essays
Estado Novo revolution (1930), 30
Estrada, Genero, 186
Estridentistas, 2, 27, 31, 34, 35, 143, 150, 161, 166, 183, 202, 303 n. 4
ethics: aesthetics and, 2, 6, 10, 22, 32, 80, 126, 259; femenino, lo (the feminine) and, 149; knowledge and, 21; lies and, 43, 79, 98, 197, 209, 230; major strands, 266 n. 56; national, 151, 237–39; photography and, 20–25; of place, 40; of psychoanalysis, 45, 80; recent theory, 27; space and, 6. See also ethos of modernism
ethnography: autoethnography, 90,

93; collage and, 62; knowledge and, 21; other and, 28; photography and, 9, 32, 36–37, 62–63, 78, 83, 87, 154; popular culture and, 132; portraiture and, 87–94
ethos of modernism, 6–9, 32–35; bellas artes públicas and, 145–47, 207; character and, 79–81; culture/politics vs., 26–32; defined, 2, 6–7, 80–81; duality of, 134; dual meaning, 33, 70; episteme and, 21–22; errancy in, 33, 45, 47, 64; ethical responsibility and, 9; ethics/politics and, 30; fiction and, 197, 199–202; frames and, 59; gender and, 149–52; landscapes and, 41, 43, 65; as locale, 45–46, 73; mass media and, 123; mediatory function, 8–9, 137, 140; photography and, 153; popular and, 9, 191; portraiture and, 83; problems in, 12; professionalization and, 130–31; race and, 149–52; vanguardist, 7
excess, 148, 186–93, 213–16; melodrama and, 234
exoticism, 18, 88, 110, 118, 142, 232, 242, 257
exteriority, 99–102, 113, 116, 165, 258
externalization, 55

faciality, 95–99, 259
Facio, Sara, 70
fake photography, 22–23
Fanon, Franz, 101
Farrington, Wallace Rider, 235
Felski, Rita, 162
femininity: avant-garde and, 140; bellas artes públicas and, 161–62; codes of, 161; in illustrated magazines, 137, 145, 149, 164, 186; images of, 133, 137, 160–61, 216–17; in El Mapa, 168; mass media and, 144; mediation and, 144, 157, 195; modernist fiction and, 198, 236–

femininity (*continued*)
37; myth of, 8–9; regulating, 150;
roles and, 252

feminization: identity and, 162; of
mass media publications, 133, 136,
143–47, 247; mediation and, 144;
of photo-essays, 10–11

Fernandes, Jorge, 70, 74

fiction, 196–239; documentary, 11, 35,
197, 222, 228–30, 236, 239; ethos
and, 197, 199–202; as genderless,
199; hermeticism and, 211–13, 239,
305 n. 15; imagistic, 202; narrative,
202–3, 218–21; photographic, 11,
197, 202, 221–28; photographic
time and, 218–21; popular culture
and, 203, 305 n. 15

figuration, 68

figure: errancy and, 59–65

flappers, 157–58, 162, 180, 193

Florence, Antoine Hercules, 13

focalization, 211–18, 230

folklore: Mário de Andrade on, 33,
37, 62, 65, 73, 109; photography
and, 123; popular, 9, 32, 123, 127,
135, 168

frame, photographic, 11, 59

Freud, Sigmund: aesthetics and,
85–86; basic proposition, 101;
character and, 81; ethos and, 80; on
homosexuality, 108, 113–15; on hu-
mor, 93; primitivism and, 102–3,
108–9; on Rome as model, 113; on
simultaneity, 114–15; on taboo, 84

Fulvi, Giovana, 256

futurism, 114–15

Gamio, Manuel, 178, 180

García Canclini, Nestor, 18, 25, 78,
141, 147

gaze: acquisitive, 17, 58; all-powerful,
57; bidirectional, 213; of ethnog-
raphy, 88; of Hollywood, 231;
human, 70; inquisitive, 107; land-

scapes and, 57; literary women
and, 192; of Narcissus, 214; object
of, 33, 79, 97; photographic, 65,
182, 213; power of, 164; return, 91

gender: bellas artes públicas and, 166;
ethos and, 149–52; fiction and,
199; imaging, 12; mediation and,
183; of modernity, 34; as philo-
sophical category, 25; photography
and, 164; popular culture and, 127.
See also women

genres, modernist, 9–20; uses and,
10. *See also* specific genres

George, Waldemar, 155, *156*

Giardinelli, Mempo, 15

Gilroy, Paul, 30

Girondo, Oliverio, 2

globalization: local impact, 16; of
mass media, 136; modernity and,
15

Goethe, Johann Wolfgang von, 82–
83, 239

Gombrich, E. H., 38

Gómez Mayorga, Ana, 192

González, Anibal, 200, 230

González Carrasco, Aurelio, 178

Gonzáles de Mendoza, J. M., 140

Gorelik, Adrián, 6, 12, 47, 150

Gorostiza, José, 31

Gramsci, Antonio, 137–38

graphic design: effect on photogra-
phy, 5; essays and, 186–93; media-
tion and, 181–82; race/beauty and,
177–86

Green, Jennifer, 305 n. 21

Greenberg, Clement, 11, 42, 67, 270
n. 12

ground, errancy in, 59–65

Gruner, Silvia, 250, 251–54

Guedes Penteado, Olivia, 126

Haberly, David, 285 n. 79

Hadaly, Psique, 157, 161

Harrison, Charles, 272 n. 35

Hegel, G. W. F., 7, 63
Heliodoro Valle, Rafael, 246
Hendrick, Tace, 17
Henríquez Ureña, Pedro, 233, 238
Herkenhoff, Paulo, 35
hermeticism: abstract, 11, 83; as disguise, 107, 109; fiction and, 211–13, 239, 305 n. 15; modernist sublime and, 81; poeticism and, 26; politics and, 110; portraiture and, 112; primitive, 112, 118; sexuality and, 103
heroes, 79–81, 84, 87–99, 101–2, 111, 119
Herschel, John, 14
heterogeneity, 78, 87, 100, 266 n. 54
hija pródiga, la. See prodigal daughter
Holden, Dr., 192
homophobia, 145, 206
homosexuality, 103–8, 145, 232–37
horizons: errant, 55; identity and, 71; as localizing, 52; shifting, 50–59
Horkheimer, Max, 128
Hoz, Luis de, 162, 165
Humboldt, Alexander von, 37
humor, 37, 79, 93–99, 111, 115, 119
hybridity: in bellas artes públicas, 186, 233; class, 151, 181; identity and, 194; theory, 147; of Turista aprendiz, 65–66; urban, 169

ideas out of place, 13–15, 40
identity: biologistic concepts, 117–18; femininity and, 162; horizons and, 71; national, 63, 77–79, 119, 166, 193; philosophy of, 63; regional, 19, 77; sexuality and, 232; truth of, 96
illustrated magazines, 3; cultural nationalism and, 127, 134; femininity in, 137, 145, 149, 164, 189–90; growth of, 133–34, 136; legs in, 174, 175; literacy and, 129; mediation and, 137–39, 181; Mexican

modernism and, 32; photo-essays and, 34–35; photography and, 152–57, 248; readership, 151; Salvador Novo and, 237; shift in, 194; women and, 133, 144, 203
Imagen (journal), 155–57, 160
images/words, 65–68, 186–93
imitation, 13
indexicality, 22, 97–98, 116, 118, 213, 229
India Bonita, La, 177–81. See also Bibiana Uribe, María
indigenism, 12, 78, 111. See also primitivism
indigenous cultures: as feminine, 177–81; fifth race and, 135; hispanization, 135; integration of, 118; national identity and, 12, 77, 150–51; nationalist ideology and, 110; as outside, 252; patrimony and, 133; representation of, 87–93, 168, 250; in São Paulo, 48; Tupi, 29, 46–47, 62–63, 78; violence against, 251
interiority, 81, 116, 213, 215, 217, 252–53
invention, photographic, 197
irony/ironic, 72, 73, 95, 125, 167, 234, 235, 237, 239
Izquierdo, María, 159

Jackson, K. David, 80
Jara, René, 11
Jardim, Eduardo, 27
Jodorowsky, Alejandro, 248
jokes. See humor
journals. See illustrated magazines; mass media; specific journals
Jurado, Concepción (Conchita), 240–46, 249

Kahlo, Frida, 159
Kant, Immanuel, 84
Kaz, Leonel 133
Keaton, Buster, 95, 97, 99, 110–11

knowledge: institutions of 21, 130; queer, 233; truth and, 20–25; visual 168

Koch-Grünberg, Theodor, 79

Kodama, María, 287 n. 5

Krauss, Rosalind, 18, 51, 98

Lacan, Jacques, 45, 80, 101

Lam, Wifredo, 61

landscapes, 9, 33, 36–74; abstraction and, 33, 40–41, 46, 50, 61–62, 65, 68–71, 82; aesthetics and, 41–42, 55–56; colonial, 37–38, 41, 57, 60–61; errancy in, 56, 69; ethos and, 41, 43, 65; of the face, 259; history and theory, 37–38; literary, 58–59; locale and, 10; pure, 60

language: bilingualism, 71–72; images vs., 3, 65–68; Latin Americanism and, 18; Tupi, 46–47

Latin Americanism, 19–20

Leal, Fernando, 224

letrados, 24, 131, 160, 192, 202, 207–8, 217

lettered city. See ciudad letrada

Lévi-Strauss, Claude, 62

Lévi-Strauss, Dina, 62, 69, 72, 74, 77, 91–92, 101

List Arzubide, Germán, 143, 174, 183, 197

literacy, 129, 301 n. 95. See also visual literacy

locale: aesthetics and, 33; ethics and, 6–7, 45; experience and, 70; modernity and, 10; photography and, 43; portraiture and, 10

Lopez, Telê Ancona, 61, 66, 83

Lund, Peter Wilhelm, 256

magazines. See illustrated magazines; mass media; specific journals

Majluf, Natalia, 110

Malinche, 180

manifestos, 2, 26, 35

Mapa, El (journal), 166–72

Marín, Lupe, 159

Martín Barbero, Jesús, 9–10, 34, 126, 132, 144, 164, 190–91, 198–99; De los medios a las mediaciones, 127–29

Marinetti, Filippo, 37

Martínez, Juan A., 266 n. 58

Masiello, Francine, 149

masks, 184–85

mass culture: aesthetics and, 186, 233; avant-garde and, 34; bellas artes públicas and, 147; elite culture vs., 33; mass market and, 128; mediation and, 32, 136; modernists and, 141, 172; women and, 162. See also popular culture

mass media: avant-garde in, 34, 131; ethos and, 123; feminization of, 133, 136, 143–47; globalization of, 136; growth of, 122, 126, 134; photography in, 9

Mauss, Marcel, 61

McNulty, Tracy, 45

mediation: aesthetics and, 181–83; ethos and, 8–9, 137, 140; femininity and, 144, 157, 195; gendered, 183; graphic design and, 181–82; mass culture and, 32, 136; mestizaje and, 135–36, 169, 181; photoessays and, 148, 164–65; popular culture and, 9, 128, 157; theory, 32, 34, 127–29, 144, 263 n. 21; women and, 146

Medina, Gabriela, 172–73, 174

medium specificity, 42, 59, 67

melodrama, 188, 191, 198, 234–36, 302 n. 103

mestizaje, 8, 110, 126, 135–36, 144, 169, 177–78, 180, 250

Metz, Christian, 282 n. 50

Mexico: iconic modernism in, 1–3, 29; national iconography, 248–49, 251; renaissance, 134–35

Miceli, Sergio, 130
Miguel, Francisco, 224
mimeticism, 42, 50, 52, 117, 197, 214
mirrors, 99–102
Mitchell, W. J. T., 148, 308 n. 54
Mobius strip, 254, 256–57, 260
modernism: avant-garde vs., 26;
 characteristics, 7–8; defined, 16;
 errancy in, 10, 14, 26, 41–42, 52,
 123; geopolitics of, 11, 29; locale
 and, 46; mainstream, 5, 11, 15,
 28–29, 40–41, 76, 98, 117, 140, 186,
 198; mass, 140–42; modernity vs.,
 16, 17, 29; nationalism and, 13, 49;
 phases of, 27; postmodernism vs.,
 14–15; race and, 34; theory of, 42.
 See also ethos of modernism
modernismo, 14, 102, 130
modernist aesthetics. See aesthetics,
 modernist
modernist avant-garde movements.
 See avant-garde movements, mod-
 ernist
modernist genres. See genres, mod-
 ernist
modernity: characteristics, 1–2, 10;
 colonialism and, 3; defined, 16;
 ethics/aesthetics and, 10; global-
 ization and, 15; modernism vs., 16,
 17, 29; rejection of, 17
modernization: centralization and,
 31; visions of, 17; women's bodies
 and, 176
Modotti, Tina, 153, 159
Mondrian, Piet, 41
Monsiváis, Carlos, 131, 145, 157–59,
 232
montages. See photomontages
Montaigne, Michel de, 147
Montaldo, Graciela, 288 n. 24
Montalván, Celia, 159
Montenegro, Roberto, 145
Monterde, Francisco, 144

monumentalism, 3, 203, 251
morality: ethos vs., 6; in modernist
 studies, 27–28; modernity and,
 10; moralism of postrevolutionary
 state, 233; sexuality 145; of women,
 149, 162
Mujer Nueva. See New Woman
Muñiz, Elsa, 180
muralism, Mexican, 29, 34, 135, 136

narcissism, 84, 102, 107–9, 113
narrative. See under fiction
national character, 79, 111–12
nationalism: knowledge of country
 and, 40; during Mexican Renais-
 sance, 134–35; modernism/post-
 modernism and, 13; ontological,
 111; photo-essays and, 40; tourist
 propaganda and, 18. See also critical
 nationalism; cultural nationalism
Nesbit, Molly, 28, 29
New Objectivity, 3, 224
New Vision, 3
New Woman, 146, 157–65, 168–69,
 177, 180–81, 203, 204, 207
noble savage, 28
Noriega Hope, Carlos, 139, 140, 240
Novo, Salvador, 3, 27, 31, 131, 141,
 143, 145, 152–53, 172, 174, 197,
 230–39; "Arte de la fotografía,
 El," 172, 219, 239; Continente vacío,
 230; Estatua de sal, 233; "Joven, El",
 230; "Return Ticket", 20, 230, 232,
 237–38

Omar, Arthur, 253, 257–59
Ortega, Carlos M., 178, 188
Ortiz, Fernando, 15
Ortiz Gaitán, Julieta, 137, 181
other, ethnographic, 28
Owen, Gilberto, 31, 219

Padilla, Chela, 159
pain, 92–93, 98, 99, 113, 115, 119
Palavicini, Félix, 138–39

Pani, Alberto J., 178
Paradox, Sylvestre. *See* Vela, Arqueles
pátria, 72–73
patrimony, 132–33, 133
Paúl Arranz, María del Mar, 202
Paulistas, 29–30, 36, 49, 121
Pellicer, Carlos, 145
Pérez Firmat, Gustavo, 199
Pérez Oramas, Luis, 68
Pérez Taylor, Rafael, 178
performance: aesthetic of, 81; art, 35, 241, 242, 244–45, 248, 253; of femininity, 34, 151, 160, 195; feminist, 8; image of desire and, 232; language of, 80; of otherness, 94; of race, 111; sexuality and, 103, 232, 237
periodicals. *See* illustrated magazines; mass media; specific journals
photo-essays, 9, 121; circulation and, 177, 187; feminization, 10–11, 189–90, 198; mediation and, 148, 164–65; nationalism and, 186. *See also* essays
photogenicity, 98, 165
photography: colloquium on, 4; as effeminate, 152–57; ethics and, 20–25; historical accounts, 267 n. 69; modernist intellectuals on, 21, 123; origins of, 13–14; status as art, 3, 9, 20, 65, 123, 128–29, 221–22; technologies of representation, 15–16. *See also* prodigal daughter; specific genres; specific types
photomontages, 15, 61, 120, 125, 205
Picasso, Pablo, 81–82
Picchia, Menotti del, 123
picturesque, 73, 74, 166, 168, 230, 231
Pierce, C. S., 97
Pinal, Luis G., 193
Pinal, Silvia, 245–47, 259
Pirandello, Luigi, 157

plastic vision, 41
poetry: avant-garde, 106–7; modernist, 55–56
politics: avant-garde and, 26–27, 102; ethos vs., 26–32; hermeticism and, 110
Pollock, Griselda, 16
Poniatowska, Elena, 310 n. 81
popular culture: avant-garde and, 9, 203, 221; elite culture vs., 33, 128, 136, 141, 145, 157, 180, 252, 259–60; errant modernism and, 15; ethnography and, 132; ethos and, 32, 123, 134; fiction and, 203, 304 n. 15; gender and, 127; graphic arts and, 192–93; immersion in, 10–11; letrados and, 160, 189, 207–8; mediation and, 9, 128, 157; Mexican civil society and, 137, 166; modernists and, 9, 25, 124, 142, 198; patrimony and, 133; race and, 127; revolutionary, 144–45; studies of, 127. *See also* mass culture
Portinari, Cândido, 18
portraiture, 9, 75–119; aesthetics and, 81, 259; biologistic, 117–18; epidermic, 22; ethnography and, 87–94; locale and, 10; photography and, 82–83; possessions and, 100; primitivist, 82; race and, 10, 81–82, 88; representation and, 87–99
postcolonialism: Latin Americanism and, 19
postmodernism: modernism and, 14–15, 242; nationalism and, 13
postmodernismo, 14
Prado, Paulo, 79–80
Prado Bellei, Sérgio Luiz, 18, 110
Pratt, Mary Louise, 90, 271 n. 29, 273 n. 46
primitivism, 108–12; abstraction and, 82, 116–18; Brazilian, 33, 77–78, 93, 99, 101, 109, 111, 118, 136; Euro-

pean, 76, 118; modernist, 80; narcissism and, 109; race and, 12, 108, 136; sexuality and, 82, 102, 233
prodigal daughter, 3, 34, 143, 152–53, 157–65, 168, 186, 194, 199, 217, 219, 234, 297
Promonument Committee, 244
prose fiction. *See* fiction
public thing, 193–95, 205, 206

Quijano, Aníbal, 8

race: abstraction and, 81–82; class and, 25; colonialism and, 8; "ethnic values" and, 111; ethos and, 149–52; graphic design and, 177–86; imaging, 12; modernism and, 34, 81; performance of, 111; as philosophical category, 25; popular culture and, 127; portraiture and, 10, 81–82, 88, 91–92; as primitivism/indigenism, 12; proximity and, 77; stereotypes, 28. *See also* heterogeneity; indigenous cultures; mestizaje
radio, invention of, 16
Rama, Angel, 15, 24, 130, 131, 148, 191
Ramírez, Mari Carmen, 7
Ramos, Samuel, 141
realism, 28
reflective surfaces, 51–52
representation: figurative, 42, 83; mimetic, 42, 117; photography and, 1, 66, 164; portraiture and, 87–99; subjectivity and, 83–84; technologies of, 15–16; theories, 2; truth and, 196–97
Reverón, Armando, 68
revistas ilustradas, 152, 191, 193–94, 248, 291 n. 1
Reyes, Aurelio de los, 310 n. 74
Ricardo, Cassiano, 123; "Girl Drinking Coffee," 124–25
Riffaterre, Michael, 304 n. 12

Rimmon-Kenan, Shlomith, 201–2, 211, 218
Rivas Cacho, Lupe, 182–83
Rivas Mercado, Antonieta, 159
Rivera, Diego, 27, 135, 168–69
Rodin, Auguste, 78
Rodríguez Lozano, Manuel, 145
Rodríguez Monegal, Emir, 287 n. 5
Rosenberg, Fernando, 11
Ross, María Luisa, 140
rotogravure technology, 2, 121
Rubenstein, Anne, 30, 137
Ruiz Martínez, Apen, 178
rural: city and, 3, 24, 46, 48–49, 60, 76, 127, 135, 146, 169, 205; urban and, 3, 24–25, 46, 111, 127, 135, 169, 205
Ruskin, John, 18, 57

Sá, Lúcia de, 61
Sacerio-Garí, Enrique, 287 n. 5
Santelmo, Piedad, 207, 231
Santiago, Silviano, 15, 76
São Paulo, 24–25, 29–30, 48–49
Sarlo, Beatriz, 15
Schelling, Vivien, 271 n. 29
Schneider Enríquez, Mary, 250–51
Schwartz, Jorge, 26, 277 n. 2, 287 n. 5
Schwarz, Roberto, 12, 13, 40
scopophilia, 57
Secretaría de Educación Pública (SEP), 234
Segre, Erica, 252
self-referentiality, 41, 75, 201, 236. *See also* medium specificity
SEP. See Secretaría de Educación Pública (SEP)
Serviço do Patrimônio Histórico e Artístico Nacional (SPAHN), 132–33
sexuality, 81, 102–9; hermeticism and, 103; identity and, 232; popular literature and, 145; primitivism and, 84; of women, 159–61, 173,

sexuality (*continued*)
177. *See also* femininity; homo-
sexuality; virility
Sherman, Cindy, 22
Sierra, Silveria, 150
simultaneity, 67, 112, 115, 129
space. *See* locale
S. Paulo (journal), 120–24, *125*, 129,
136, 139, 290 n. 46
staged photography, 22–23
Stein, Gertrude, 81–82
Steiner, Wendy, 81
Stieglitz, Alfred, 29
Stradano, Giovanni: "Vespucci Dis-
covering America," *39*
Strand, Paul, 20
Stridentists. *See* Estridentistas
subjectivity: ethics and, 6–7; exteri-
ority and, 99–102, 116; modernity
and, 10; representation and, 83–84
sublimation, 83–87, 108, 115–16
sublime, 75, 81, 83–87, 90, 102, 119
suffering, 92. *See also* pain
surrealism, 41
Süssekind, Flora, 269 n. 11, 275 n. 69
Suter, Gerardo, 250–51

Tablada, José Juan, 158
Tagg, John, 198–99
Tenorio, Mauricio, 135
texts: effect on photography, 5, 70
time, photographic, 218–21
Torres Bodet, Jaime, 7, 131, 141, 197,
216–17, 230, 252; "Estrella de día,"
207, 231–32; *Margarita de niebla*,
204, 207, 213; "Primero de enero,"
207–8, 220–21; "Proserpina resca-
tada," 212–16
Torres Caicedo, María, 19
Torres García, Joaquín, 49, 68
tourism: aesthetics and, 142; auto-
mobiles and, 25; desire and, 231;
domestic, 18, 141, 146, 165–71, 172,
197, 297 n. 55, 298 n. 56; interna-

tional, 167, 297 n. 55, 298 n. 56;
women and, 177. *See also* appren-
tice tourism; picturesque
Toussaint, Manuel, 141
tradition: women and, 12, 150, 177
transculturation theory, 15
travel: modernist aesthetics and, 18;
writing, 17–18, 38–40
truth: abstract, 41; cultural, 135; elas-
ticity of, 66; of ethnography, 63;
fiction and, 196; knowledge and,
21; modernity and, 10; photog-
raphy and, 21–23, 66–67, 96, 98,
196–97; seeing, 24; universal, 41
Tunga, 253–57
Tupi, 29, 46–47, 62–63, 78
Turista aprendiz, O, 36, 39, 65–66,
69, 75, 83, 91. *See also* apprentice
tourist

Universal Ilustrado, El (journal): ad-
vertising/readership, 191–92; his-
tory of, 138–40. *See also* illustrated
magazines
urban: avant-garde fiction and, 212;
Creoles, 24; culture, 141; exteri-
ority and, 102; growth, 17, 125;
hybridity, 169; landscape, 125, 168;
odes to, 2; photography and, 123,
152; popular, 128, 134, 138; popular
culture, 133; renewable, 149; rural
and, 3, 24–25, 46, 111, 127, 135, 169,
205; subject, 228; urbanism, 127;
urbanization, 15, 47–48. *See also*
city

Vampré, Leven, 123
vamps, 159
vanguardia (vanguards), 14, 136, 140.
See also avant-garde movements,
modernist
vanity, 102–3, 108, 144
Vargas, Getúlio, 73, 124, 126, 132–33,
267 n. 74

Vasconcelos, José, 18, 134–35, 238
vedettes, 159, 162, 205
Vela, Arqueles, 8, 159–62, 173, 174,
 175, 189, 192, 197, 198, 203–4, 221;
 "Café de nadie, El," 159, 205–6;
 "Señorita etcetera, La," 183, 198,
 203–4, 206, 220, 221
Vélez, Lupe, 159, 188–89
Verani, Hugo, 237
Villaurrutia, Xavier, 7, 31, 131, 141,
 145, 183, 185, 196, 197, 225; "Dama
 de corazones," 204, 212, 221, 228–
 30, 235–36
violence: mediation of, 177; moder-
 nity as, 15, 16; performances
 against, 242; representing, 257;
 vedettes and, 205
virility, 8, 102–3, 144–45, 206, 246
visual literacy, 187
voyeurism, 57

Wall, Jeff, 22
Week of Modern Art (São Paulo), 2,
 25, 29, 31, 42, 133

Weston, Edward, 28–29, 153–54, 156,
 225–26; "Excusado," 224–28
Williams, Darryl, 25, 30
Williams, Raymond, 60
women: automobiles and, 171–77;
 characterizations, 203–6; circula-
 tion and, 193; images of, 157–65,
 171; journals for, 133; liberation
 of, 172; literary, 143; mediation
 and, 146; in public thing, 193–95;
 sexuality of, 159–61, 173, 177;
 suffrage, 193–94; tourism and, 177;
 tradition and, 12, 150, 177. See also
 femininity; feminization
Woolf, Virginia, 172
words. See images/words; language;
 writing
writing: and class, 25; travel, 17–18;
 See also ciudad letrada

Xóchitl, 180

ESTHER GABARA

IS AN ASSISTANT PROFESSOR

OF ROMANCE STUDIES AND ART,

ART HISTORY, AND VISUAL STUDIES

AT DUKE UNIVERSITY.

*Library of Congress Cataloging-
in-Publication Data*

Gabara, Esther, 1972–
Errant modernism : the ethos of photography
in Mexico and Brazil / Esther Gabara.
p. cm.
"A John Hope Franklin Center Book."
Includes bibliographical references and index.
ISBN 978-0-8223-4340-0 (cloth : alk. paper)
ISBN 978-0-8223-4323-3 (pbk. : alk. paper)
1. Photography—Social aspects—Mexico.
2. Photography—Social aspects—Brazil.
3. Literature and photography—Mexico.
4. Literature and photography—Brazil.
5. Modernism (Aesthetics) —Mexico.
6. Modernism (Aesthetics)—Brazil.
I. Title.
TR28.G33 2008
770.981—dc22 2008023164

EXACTLY OPPOSITE
THE GOLDEN GATE

*In clear and quiet weather each
dwelling enjoyed an unobstructed view
of the Bay, and the opening into the
Pacific seemed so wide and ample that
every resident, from Temescal to San
Pablo, claimed for his own house the
distinction of being "exactly opposite
the Golden Gate."*
Edward B. Payne (1898)

EXACTLY OPPOSITE THE GOLDEN GATE

Essays on Berkeley's History
1 8 4 5 • 1 9 4 5

Edited by Phil McArdle

THE BERKELEY HISTORICAL SOCIETY

Published by
The Berkeley Historical Society
P.O. Box 1190
Berkeley, California 94701

This book is dedicated to the memory of
Edward Staniford
by his friends on the Research Committee of the
Berkeley Historical Society

THE RESEARCH COMMITTEE OF THE
BERKELEY HISTORICAL SOCIETY

Bois Burk

Florence Jury

Phil McArdle

Charles Marinovich

Ken Pettitt

T. Robert Yamada

Foreword

In 1966 Berkeley embarked on the West Berkeley Industrial Park project, a redevelopment effort which destroyed much of what was left of Ocean View, the City's original American settlement. More than any other event, this planned destruction of an important part of Berkeley's living heritage symbolized the City's ignorance of and disinterest in its history.

Fortunately, this situation changed in the 1970s. The U.S. bicentennial and Berkeley's own hundredth birthday in 1978 stimulated new interest in the local past. More important, many residents sought a strong identification with their neighborhoods and community. Not only were the Berkeley Architectural Heritage Association and the Berkeley Historical Society founded in the seventies, but voters approved the Neighborhood Preservation Ordinance, and the City Council established a Landmarks Commission.

This book is very much a product of that new mood of the 1970s. Many of the contributors to this volume were active in the establishment of the Architectural Heritage Association and the Historical Society, and some campaigned for neighborhood preservation and the Landmarks Commission. The book is quite properly dedicated to the late Edward Staniford, who did so much to promote the serious study of Berkeley's past.

The volume is not, however, intended as a systematic or complete history of the City. Rather it is a diverse collection of articles, originally published in the Historical Society's *Gazette* series. The articles differ widely—from carefully researched studies by Staniford and Karen Jorgensen-Esmaili, to informative, personal recollections

by Florence Jury and Bois Burk. Some important events, such as the 1923 fire, are covered in great detail; others, such as the World War II black migration to the Bay Area, are not covered at all. But the book's variety is an indication of the richness of the City's history, and the volume's omissions simply show how much research still needs to be done.

This is a fine introduction to much of Berkeley's history, and a work whose spirit is consistent with the proposition that Berkeley's heritage is worth preserving.

Charles Wollenberg

Preface

The earliest study of our City which attempted to portray all its facets was *A Berkeley Year*, a slender, graceful volume of essays edited by Eva Carlin in 1898.

This little book contains descriptions of the City's landscape and its people.

It was informal, unsystematic, unscholarly and, from today's perspective, rather naive. Even so, its concern with what we call "environmental issues" was prophetic.

None of the contributors to *A Berkeley Year* felt a conflict between the interests of the University and the interests of the City. On the contrary, they believed that the town and the gown shared the same purposes.

Today one of the important problems in the life of the City is the loss of that sense of common purpose.

Three years before *A Berkeley Year* appeared, Professor William Carey Jones (who wrote an essay for it) published his *Illustrated History of the University of California*. This work is indispensable to an understanding of the early days of the University. It provides a clear contemporary account of important events in the early life of the University, and vivid sketches of some of its leading personalities.

In Joseph Le Conte's *Autobiography*, Edward Rowland Sill's poetry, and Josiah Royce's letters we have other documents giving the flavor of that period.

Impressions of Berkeley and its people at the turn of the century can be found in some of the short stories of Frank Norris, as well as in several episodes in his novels. Some of his characters are based loosely on people he knew here.

Although Oakland claims Jack London, he spent a surprisingly large amount of time in Berkeley. Unlike Norris, who felt at ease socially in Berkeley, London resentfully considered himself an outsider, and in *Martin Eden* he produced a hostile picture of the City's cultural life.

The years from 1910 to 1923 are enchantingly chronicled in Leonard Bacon's *Semi-Centennial*.

The first full scale history of Berkeley was W. W. Ferrier's *Berkeley: The Story of the Evolution of a Hamlet into a City of Culture and Commerce*. Published in 1933, it contains most of the essential facts about the City's development up to that time. Ferrier was very thorough, and later writers have added only incidental details to our knowledge of the period he covered. One of his major concerns was to increase the mutual understanding of Berkeley's Catholics and Protestants. Subsequent writers have reinterpreted the early history of the City from more secular perspectives. Appearing as it did at the onset of the Depression, Ferrier's book cast an anxious eye on the future.

We are given a sense of what life was like here during the Depression years by Anthony Boucher in *The Seven of Calvary*, and by John Kenneth Galbraith in his essay, "Berkeley in the Thirties."

Resuming the formal chronicle of Berkeley's history begun by Ferrier, in 1941 Willis Foster edited *Berkeley: The First Seventy-Five Years*. This is a somewhat disappointing book, even though it was sponsored by the Works Progress Administration. It leaves no clear impression in the mind.

In the 1950s, George Elliott's *Parktilden Village* gave us glimpses of the town and the gown, and the tensions between them. This fine novel raises issues which are still pertinent.

As the centennials of the University and the City approached, new efforts were made to sum up their respective histories.

In *The University of California: 1868–1968*, Verne E. Stadtman produced an amazingly detailed history of the University. (*The University of California Centennial Record, 1868–1968*, an indispensable gold mine of raw information, was also published in 1968.) Five years later came George A. Pettitt's landmark *Berkeley: The Town and Gown of It*.

Because Stadtman focused so intensely on the University, his

reader has little sense of the surrounding community except as an obstacle dimly seen.

Pettitt's book goes to the other extreme: from it the reader might never guess that the University is a place of international importance, or why. Nevertheless, it is the best study of the City since Ferrier.

In terms of the big picture (whatever that may be), no doubt the City of Berkeley is less important than the Berkeley campus of the University of California. Yet it can be shown that each depends upon the other, and someday we hope they will recover a sense of common purpose.

<div align="center">* * *</div>

The Berkeley Historical Society was formed to help the residents of our unique City understand their heritage. The Society presents public programs on important historical events, such as the Berkeley Fire of 1923, the reclamation of the Berkeley beaches, and the evacuation of Japanese-Americans in 1942. It also sponsors projects such as the preparation of curricula for use in the Berkeley schools and an oral history of the City.

This book contains a selection of essays written for one of the Society's longest ongoing projects, "Berkeley's History," a weekly series of articles published in the *Berkeley Gazette*. It reflects the interests and enthusiasms of our members. Therefore, while it contains much original research and writing about the City, it is not intended as a comprehensive history. If it were, it would treat in detail matters which are only touched in passing—the evolution of City government, the story of our minorities, the City's missed opportunities for economic development, the fate of the young men who served in our country's wars, and many other subjects. We hope to deal with these more fully in future publications.

We have found (as have others before us) that an event has continuing consequences, just as when a pebble is tossed into a pool of water, ripples flow out from the point of impact. When the Kellogg School opened in 1880, for example, it set in motion a series of consequences for the education of our children which still continue. Our essay on schools in the nineteenth century follows educational events down through the years. So, within our generally chronological framework, there is a constant weaving back and forth which shows the various meanings of what occurred in the past. The end

result is to clarify how certain aspects of Berkeley came to be what they are today.

"Berkeley's History" began appearing in the *Gazette* when Stephanie Manning and the late Edward Staniford persuaded members of the Society to commit their research to paper. But this book would not have been possible without the members of the Society's Research Committee—Florence Jury, Ken Pettitt, Bois Burk, Bob Yamada, and Charles Marinovich—who have given so much of their time for the past two years to the multitude of tasks involved in editing this book. The members of the Committee drew generously on their special knowledge and skills at every step of the way in our long journey from the beginning to the completion of this project. *Exactly Opposite the Golden Gate* has been a truly cooperative effort. It has been a pleasure to work with them. We owe a special debt to my wife, Karen, for her help in the final stages of the work.

<div style="text-align: right">Phil McArdle</div>

Table of Contents

FOREWORD ix
PREFACE xi

PROLOGUE: BERKELEY'S NAMESAKE 1

THE LAND 5

 Berkeley's Hills 7
 Trees and Flowers 10
 The Beach 13
 The Creeks 15
 The Hayward Fault 18

THE INDIANS AND THE SPANISH 21

 The Costanoan Indians 23
 The Indian Earthquake Legend 26
 Mortar Rock Park 28
 The Peralta Land Grant 30
 Domingo Peralta 33

THE AMERICANS ARRIVE 37

 The Story of the Hanging Oak 39
 Julius Kellersberger: Mapping the Land 42
 The Growth of Ocean View 44
 The Irish-American Farming Community 46
 The Lumber Mills 48

J. Ross Browne 50

Ocean View's Social and Ethnic Diversity 52

The Asylum for the Deaf, Dumb, and Blind 55

Claremont Canyon 58

THE UNIVERSITY ARRIVES 61

Henry Durant 63

Durant on Life 66

Early Days at the University 68

Founders Rock 70

The Le Contes 72

E. R. Sill 74

Josiah Royce 77

Military Training 80

Football 83

BUILDING THE CITY 135

Incorporation 137

Sam Heywood 140

Volunteer Fire Departments 142

Public and Private Schools 144

The Ferries 148

Joseph Mason 151

Lincoln Steffens 155

Mathilde Wilkes 159

Cookbooks 161

Frank Norris 164

Maurice Curtis and Peralta Park 166

Stiles Hall 169

The Piano Club 171

The Public Library 173

Benjamin Ide Wheeler and Phoebe Hearst 178

Shattuck's Evolution as "Downtown" 180

Cutter Laboratory 183

The Little Building that Led Three Lives 185

Spring's Time in Berkeley 188

Douglas Tilden 191
August Vollmer 195

THE 1906 EARTHQUAKE AND ITS AFTERMATH 199

An Eyewitness Remembers 201
The Damage in Berkeley 205
Almost the State Capital 208
The Northbrae Subdivision 212
The Tennis Club: Home of Champions 214
Arthur Ryder 217
Leonard Bacon 220
Promotional Booklets 224
J. Stitt Wilson 226
G. Sydney Rose 228

THE 1920s 279

The Great Berkeley Fire 280
Chief Rose's Report 283
The Community's Response 285
Bohemian Dinners and Fine Music 291
Campus Traditions 293
The Poets' Dinner 296
The Veterans' Memorial Building 299

THE DEPRESSION 301

Student Rooming Houses 303
How the City Weathered the Cruelest Depression Year 305
The Lighter Side of the Depression 316
Ella Young 319
George R. Stewart 321
Walter Gordon 324
Robert Gordon Sproul 327
Ernest O. Lawrence 330
J. Robert Oppenheimer 333
The Horrors of War 337

WORLD WAR II 343

 Home Front Alarms 345
 The Longest Blackout 348
 Pettittania Revisited 351
 Camp Ashby 354
 Japanese Internment 357
 Atom Spies in Berkeley 361

EPILOGUE: THE CITY SINCE WORLD WAR II 365

BERKELEY HISTORY SERIES—INDEPENDENT AND
 GAZETTE 366

GENERAL INDEX 375

AUTHOR INDEX 385

LIST OF ILLUSTRATIONS 389

EXACTLY OPPOSITE
THE GOLDEN GATE

Prologue:

Berkeley's Namesake

It is a nice piece of good luck that our City bears George Berkeley's name. Like him, it is visionary and impractical, genial and enthusiastic. Like him, too, our City has its unintentionally comic side.

Born at Kilkenney, Ireland, in 1685, Berkeley was a student and later a professor at Trinity College, Dublin. He took holy orders in the Church of Ireland and was by eighteenth century standards a saintly minister. All his writings—he became famous for the beauty of his prose—were intended to stem the rise of atheism in England and Ireland. The same purpose shaped his philosophical work at Trinity, including *The Principles of Human Knowledge*, the great and subtle book for which he is best known today. In it he attempted to show that "matter" has no reality apart from "mind," and that things we think of as physical actually exist only as ideas. If this be true, he argued, atheism is false, since the existence of things when we are not thinking of them must be due to the thoughts of an all encompassing Mind; i.e., the Absolute, or God. Ronald Knox wrote a pair of limericks which make Berkeley's theory clear:

There was a young man who said, "God
Must think it exceedingly odd
 If he finds that this tree
 Continues to be
When there's no one about in the
 Quad."

 REPLY
Dear Sir: Your astonishment's odd:
I am always about in the Quad,
 And that's why the tree
 Will continue to be,
Since observed by,
 Yours faithfully,
 God.

Berkeley offered his theory as mere common sense, but many of his contemporaries thought it as misty as Irish moonlight. His academic colleagues agreed that he was "either the greatest genius or the greatest dunce" at Trinity.

When Berkeley moved to London in 1713 while still in his twenties, his talents were quickly recognized by the great men of the age—Addison, Steele, Pope, Arbuthnot, and that glowering genius, Swift. But even as they made him their friend, they teased him and joked among themselves about his theory. Once, when Berkeley had a cold, Dr. Arbuthnot wrote to Dean Swift that "poor philosopher Berkeley" had "the idea of a strange fever" and was struggling hard to get "the idea of health." The time came, though, when Berkeley's philosophy influenced thinkers throughout the Western world.

Berkeley lived in Italy from 1715 to 1720 returning to London just in time to witness the debacle caused by the collapse of the South Sea Bubble—the first big stock market crash. The suffering he saw during the ensuing depression led him to write *An Essay Towards Preventing the Ruin of Great-Britain,* in which he recommended laws to prevent extravagance, encourage simple pleasures, and aid the arts. When he resumed his pastoral duties in Ireland, the South Sea Bubble remained in his thoughts.

As Berkeley's career in the Church progressed, he was raised to the rank of Dean and given a rich salary to go with it. But seeing that

Ireland and England were not going to adopt the simple life he advocated, he became excited about a missionary enterprise, apparently as a moral substitute. He resigned his Deanery and devoted himself to establishing a college in the Bermudas which he hoped would supply ministers to strengthen Protestantism in America, slow the spread of Catholicism, and save the souls of Indians and slaves. While fund raising for the college he wrote the poem which contains the line, "Westward the course of empire takes its way."

It is to this line that we owe the name of our City. More than a hundred years after it was written, when one of the University of California's founders stood on a rock in a barren field and looked toward the Golden Gate, those words leapt spontaneously into his mind. Under their spell the founders were able to feel that in a sense they were achieving Berkeley's vision and thus they named the City in his honor.

Of course Berkeley never did reach the Bermudas. He set sail from England in 1728 cheered by the promise of a subsidy from Sir Robert Walpole, the prime minister we know today as "Mack the Knife" in "The Three Penny Opera." On reaching mainland America Berkeley came ashore for a visit in the colony of Rhode Island. He spent the next three years near Provincetown waiting in vain for the subsidy. Preaching, farming, meditating on philosophical problems, he passed the time. Finally, despairing of the funds without which he could not proceed, he had friends approach Walpole on his behalf. Walpole told them confidentially that as a minister of the crown he stood by the promise, but as a friend he advised Berkeley to give it up. On learning this Berkeley returned to England. The college in Bermuda, which had been a happy dream, came to an end.

But before sailing away, Berkeley made a fine contribution to the future of education in America. He deeded his farm to Yale College for use in providing scholarships to needy students, and he donated almost 1,000 books, gathered for the Bermudas, to the Yale library. He also gave a collection of books to Harvard College. For these gifts he was long remembered by American educators, including Henry Durant.

Three years after his return from America Berkeley became Bishop of Cloyne, a small town some fifteen miles from Cork. For eighteen years he ministered faithfully to the needs of the people in his care.

He was not a stranger to anyone—Catholic or Protestant—afflicted by sickness or poverty.

Like every other Anglo-Irishman who came to understand the relationship between Irish poverty and English policy, he was moved to protest. But Berkeley's writings on Irish problems did not have any more impact than Swift's "Modest Proposal."

Berkeley's last great enthusiasm was for the use of tar-water as an all-purpose remedy for sickness. He had become enamored of it while at Provincetown, and experiment led him to see it as a cure for everything from hangnails to cancer. Tar-water was prepared by mixing water with the wood tar distilled from charcoal. The treatment was simple. When the nauseating mixture had settled enough to be kept on the stomach, the sufferer drank it. Berkeley described it as "the cup that cheers but does not inebriate." (William Cowper later borrowed this phrase to describe tea.) The book he wrote to urge the use of tar-water became a best seller in England and Europe. Alas, tar-water was not a panacea. Nowadays it has limited, residual use as a topical treatment for psoriasis and eczema.

As old age crept up on Berkeley he withdrew from public life. In 1752 he signified his desire once again to resign his ecclesiastical post, this time to go to Oxford and live in retirement. King George II gave him permission to leave Cloyne but gracefully refused his resignation, saying that Berkeley "might live where he chose, but he would die a bishop." In January 1753, at the age of sixty-eight this remarkable and much loved man died quietly at Oxford in the midst of his family.

The choice of Berkeley's name for our City was a combination of good luck and happy symbolism. If the philosopher had not been shocked by the South Sea Bubble, our City might have been named for a less interesting person or for a bush or a tree. And he was—though the men who founded our City were probably not fully aware of it—a most fitting choice as our patron.

Phil McArdle

4

THE LAND

Berkeley's Hills

From time to time the Historical Society reprints significant documents which bear on Berkeley's history. The following essay, which was written for *A Berkeley Year*, is one such reprint. A sketch of its author by Stephanie Manning can be found later in this book.

Phil McArdle

Among the many phases of outdoor Berkeley, I am asked to give a brief account of that one which interests me most.

Some, doubtless, would talk of the beautiful flowers which mantle the hills like an exquisitely varied carpet; some of the birds, their habits, their color, their song; some would talk of the early history of Berkeley and would give reminiscences of the Golden Age of youthful Berkeley.

But underlying all these, and forming the condition of their existence—without which there never would have been any Berkeley—are the Hills with their rounded and infinitely varied forms, their noble outlook over fertile plain and glistening Bay shut in beyond by glorious mountain ranges through which the Golden Gate opens out on the boundless Pacific. It was this that decided the choice of the site of the university, and determined the existence of Berkeley.

I have thus given in few words the prominent geographical features of Berkeley. But how came they to be what they are? How were they made and when?

These, our beloved Berkeley Hills, were born of the Pacific Ocean

7

about the end of the Miocene or mid-Tertiary times. They took on a vigorous second growth about the end of the Pliocene epoch.

As soon as these Hills raised their heads above the ocean, the sculpturing agencies of sun and air, of rain and rivers, commenced their work of modeling them into forms of beauty. Slowly but steadily, unhasting yet unresting, the sculpturing has gone on from that time till now. The final results are the exquisitely modeled forms, so familiar, and yet so charming.

These Hills, therefore, like all mountains, were formed by upheaval, or by igneous forces at the time mentioned; but all the details of their scenery—every peak or rounded knob, every deep canyon or gentle swale, is the result of subsequent sculpturing by water. If the greater masses were determined by interior forces, all the lesser outlines—all that constitutes scenery—were due to exterior forces. If the one kind of force rough-hewed, the other shaped into forms of beauty.

In those golden Miocene days, with their abundant rain, their warm climate and luxuriant forest-vegetation, life was even more abundant than now. The sea swarmed with animals of many kinds, but nearly all different from those we now find. The remains of these are still found abundantly in the rocks, and a rich harvest rewards the geological rambler over the hills, with hammer in hand.

The land, too, was overrun by beasts of many kinds characteristic of the times. Some of these extinct animals, both of sea and land, I think, we must sorely regret; for example: little, three-toed horses, much smaller than the smallest Shetland pony, roamed in herds over our new-born hills. We have not, indeed, yet found them in Berkeley rocks, but abundantly in rocks of the same age not very far away. They probably visited our hills.

Again: Oysters, such as would astonish a latter-day Californian, existed in such numbers that they formed great oyster-banks. Their agglomerated shells, each shell five to six inches long, and three to four inches wide, form masses three feet thick, and extending for miles. These are found in the Berkeley Hills; but elsewhere in California, Miocene and Pliocene oysters are found, thirteen inches long, eight inches wide, and six inches thick. Alas for the degeneracy of their descendants, the modern California oyster. And yet, upon second thought, there may be nothing to regret. It may well be that

in the gradual decrease in size the flavor has been correspondingly intensified. It may be that what was then diffused through a great mass of flesh and therefore greatly diluted, was all conserved and concentrated into the exquisite piquancy characteristic of the little California oyster of the present day. If so, we are consoled.

But the character of the Berkeley Hills was not yet fully formed. Still later there came hard times for Berkeley. But hard times are often necessary for the perfecting of character, and therefore we do not regret the next age. There was for Berkeley, as for other places, an ice age. An arctic rigor of climate succeeded the genial warmth of Tertiary times. Our hills were completely mantled with an ice-sheet moving seaward, ploughing, raking and harrowing their surfaces; smoothing, rounding and beautifying their outlines. The materials thus gathered were mixed and kneaded and spread over the plains, enriching the soil, and preparing it for the occupancy of man—not yet come.

Last of all—last stage of this eventful history—came man. When did he come? Was there a Pliocene man, and was his skull really found in Calaveras? If anyone is interested in this famous controversy, let him consult Professor Whitney on the one side, and Bret Harte on the other.*

But certainly, evidences of Prehistoric man are abundant all over California, and nowhere more so than in and about Berkeley. Those interested in this subject will find abundant material.

Joseph Le Conte

*See George R. Stewart, *Bret Harte: Argonaut and Exile* for the background of Harte's "To the Pliocene Skull."

Trees and Flowers

"Scattered over the place are many of the old oak trees which alone in the early days broke the drear monotony of the plains and hills."

This quote from the *Berkeley Daily Advocate* in 1892 paints a picture of the early East Bay as anything but a natural flower garden. But Nature had provided the favorable climate and fertile soil needed to sustain one. The many kinds of rock supplied a variety of soils. The prevailing ocean breezes gave mild temperatures and adequate rainfalls. This combination created a colorful array of native wild flowers and weed plants along with the "old oak trees."

The East Bay remained for many centuries as Nature made it, even after the Indians arrived. They lived without cultivating the soil. Wild game, fish, roots, acorns, and berries were enough for their simple needs.

The Spanish explorers recorded a few of the native plants while describing Indian ways. Poison oak, for example, was used by the Indians for curing warts and for making the coloring baskets. The "wild bastard onion" was used uncooked for soap and cooked for food. Another native plant that caught the Spanish eye was a wild rose. This pink flower was recorded as the "Rose of Castile" by Fr. Crespi. The Indian name for it was Teczuma.

In 1816 a Russian ship sailed into the San Francisco Bay with the German poet and naturalist Adalbert von Chamisso on board. For about a month Chamisso collected and recorded our native flowers and plants. He added the red rhododendrons, the multi-pink fuchsias (later to be named Berkeley's flower), the spotted tiger lily,

and the California poppy to the list of "natives" in the East Bay garden.

In 1831, a Scotsman named David Douglas, a member of the London Horticultural Society, recorded many native plants and flowers which had never been seen before by naturalists. Among the native wild berries he saw growing in the East Bay were the " . . . huckleberry, rasberry and the common blackberries."

The Spanish were the first to introduce plants from other areas to the Bay Garden: from Spain, they brought lemon seeds; from the South American Andes, the seeds of the trumpet-shaped petunia, the nasturtium and the Andean begonia; from Mexico, the marigold and the Mexican cherry tree.

Rapid changes in the domestication of our Bay Area garden began in 1853. Colonel James Warren published the first nursery catalog in California. It announced that the belladonna lily, Easter lily, sweet pea, lupine, coreopsis, and the ice plant were readily available to the new arrivals, the American pioneers.

Three years later, the Australian eucalyptus tree was imported. Stephan Nolan, an Oakland nurseryman, sold them for $5 and $10 apiece. By 1871, their price had dropped to 10 cents and 25 cents each, which probably explains why so many eucalyptus trees were planted in the 1870s.

" . . . Much has been done in the way of planting other trees to supplement the charming effect of these old pioneers (the live oak and the tan oak) . . . ", according to the *Daily Advocate*, which only hints at the variety of fruit and ornamental trees planted by the American pioneers.

The Berkeley Floral Society, in an attempt to organize the "proper planting of trees," encouraged residents to plant deciduous trees on streets running east and west—the silver leaf maple and the American white elm were suggested. On streets running north and south, the society encouraged the planting of evergreen trees, especially recommending the acacia.

Around 1900, many new flowers and trees arrived from Australia, China and Japan. Among the most popular was the wisteria.

The natural garden of the East Bay was cultivated. Water was piped in where it was needed. Flowers, plants and trees from many

other parts of the world were planted and took root. Buildings and houses were constructed. But in between, around, and through this abundant garden grow the colorful living records of Berkeley's "early days."

Gloria Cooper

The Beach

Before technology came to Berkeley in the mid-nineteenth century, a fine beach stretched in a smooth arc from the mouth of Strawberry Creek to the rock known as Fleming's Point, nearly a mile north (where Golden Gate Fields is now).

Just to the east of the beach, and following the sand dune northward from Virginia Street, was an interesting salt marsh teeming with crawdads and crabs, as local historian Louis Stein testifies. The balance of natural forces that placed the sand there sealed off Virginia and Codornices creeks from direct access to the Bay and they flowed slowly into the Bay northeast of Fleming's Point.

The tidal action coming through the Golden Gate and the northwesterly winds formed a natural bowl along the coast between University Avenue and Fleming's Point where sand collected. Tidal action cleaned the sand; lighter material was washed away in the flow of the Bay.

There was a lot of sand, so much sand that in 1874 Captain James Jacobs, of the Heywood and Jacobs Lumber Mill, thought there was an unlimited supply. According to the late Paul Spenger, Sam Heywood sold sand for fifty cents a load, whether it was a wheelbarrow or a wagon load.

Although buildings began to encroach on the tidelands, the beach nevertheless remained pleasureable for many years and was used as a weekend picnic spot by San Franciscans who wanted relief from their cold summers.

Paul Spenger remembered hauling in good catches of fish from the beach when a boat was not available. Sometimes he left his nets piled on the sand.

Gertrude Wilkes Burdick, who grew up on Sixth Street, remembers Berkeley Beach fondly and remembers taking walks up the beach and over to McKeever Hill (which is now called Albany Hill). Other oldtimers remember swimming from the Berkeley Pier to Fleming's Point.

At that time, West Berkeley was a sprawling town and an active center for trade. As it became important as an industrial center, things which were merely nice were converted into moneymaking enterprises. Thus, the town which was at first very close to its beach grew more distant. Willow Grove Park gave way to the El Dorado Oil Works and Spenger's Fish Market. Sand was sold and eventually the seashore became a highway. Fleming's Point became a racetrack.

Today sand still accumulates on the Bay floor and in a couple of places south of Berkeley's landfill, but the harsh angular projections of modern landfills have created many places where only mud and plastic debris collect. Perhaps in a hundred years a stable beach could form.

A hint of what the old beach was like can be seen at the southwest corner of University and Frontage Road near where vegetables are sold on weekends. Walking west through the weeds, one can see where Strawberry Creek empties into the Bay. To the left is a beach perhaps twenty meters across the ten meters deep. Due to the enclosed nature of this spot, it is also very clogged by debris. One wonders whether it would be possible to reshape the landfill there to enable the forces of nature to restore this one beautiful beach.

Curt Manning

14

The Creeks

Some of the anecdotes and data that follow may be old hat to people who grew up in Berkeley and Albany in the 1920s, but for others of us, people who grew up later or elsewhere, the glimpses we get of the bits and pieces of open creek that remain, such as Blackberry Creek in John Hinkel Park, Codornices Creek in Live Oak Park, or the footbridge over a creek to the front door of someone's house, are great finds.

In *The Ohlone Way*, Malcolm Margolin writes of the Bay Area creek deltas and wildlife as they were in the 1700s upon the arrival of the Spaniards:

> Nowadays, especially during the summer months, we consider most of the Bay Area to be a semi-arid country. But from diaries of early explorers the picture we get is of a moist, even swampy land. In the days of the Ohlone Indians, the water table was much closer to the surface, and indeed the first settlers who dug wells here regularly struck clear, fresh water within a few feet.

Along the creek canyons leading into the hills grew buckeye, laurel, wild plum and manzanita trees, forming a habitat for orioles, linnets, wrens, wild canaries and warblers.

In "The Story of Albany Hill," Neil Havlik writes that

> . . . the coming of the Spaniards was marked with few changes (to the creeks and wetlands). Cattle, horses and sheep were grazed on the fertile grasslands, and their main effect was the partial replacement of the native perennial grasses by annual grasses and

15

weeds from the Old World via Mexico. It was with the coming of
the Americans that large-scale changes in the landscape began.

But in the early 1900s many of the Berkeley-Albany creeks were
still places of beauty, play and investigation. Gerald Browne and
Robert Hansen tell tales of minnows, water cress, water snakes,
blackberries, owls, linnets, and hundreds of robins in creek willows.

Albany boys engaged in a business enterprise in the creeks.
Besides running paper routes and raising guinea pigs for the Univer-
sity laboratory, boys would walk Cerrito and Codornices Creeks
setting wire cages to trap "red-heads," the male linnets, which
besides being colorful, sang like canaries. The linnets fed on seeds
along the creeks. They were sold as songbirds, but this was later
halted by the law.

Browne also remembers a place called the Willows near the
junction of Middle Creek and Cerrito Creek at the foot of Albany Hill
where much, much earlier an Indian camp had been. In any event,
by about 1910 this creek junction was a stop-off home for hobos.
Browne says that the hobos, their belongings in blankets roped over
the shoulder, traveled on Southern Pacific cars, and had their own
code. Some might have worked as migratory fruit pickers, others
were just knights of the road.

Today most of the Berkeley-Albany creeks are in culverts under
streets or under private homes.

Cerrito Creek forms the boundary between Alameda and Contra
Costa counties. Until the 1940s, Blackberry Creek ran open through
the Thousand Oaks Elementary School yard. Marin Creek runs just
about exactly under Marin Avenue between Colusa and San Pablo
Avenues. At one time it was dammed near today's Ordway Street to
form a watering hole for cows (and a swimming hole for kids on Curtis
Street).

Jose Domingo Peralta used to hunt quail along one of the creeks,
and so he named it Codornices (which is Spanish for Quail) Creek in
1818.

Strawberry Creek, besides running through the University of
California, runs in a culvert under Civic Center Park, the Berkeley
City Hall and Spenger's Restaurant.

Interest in the preservation or revitalization of those portions of the

creeks that still run free and open is growing. Berkeley has an ordinance which states that the alteration of any area that receives rain runoff requires a permit from the city engineer, and that removal of unauthorized alterations can be required at the property owner's expense.

People building or buying a home over a culverted creek should be aware that the culvert may collapse should the house settle. The storm drain system is integrated with the creeks. Thus, a street catch basin may drop directly or indirectly into a creek. People parking their cars over storm drains, or dumping oil, chemicals, or dog droppings into storm drains are, in effect, polluting the creeks. Pollution also occurs when City or private sanitary sewer pipes leak and leach into the creeks.

Barbara Luce-Richey

The Hayward Fault

All too often the 1906 earthquake stands out in our minds as the only earthquake, and we give little attention to the frequent seismic activity that takes place along the nearby fault zones. (Recent U. S. Geological Survey studies show that there were over 1,000 earthquakes of varying magnitudes between 1962 and 1970 in the Bay Area.)

In an excellent article in the April 11, 1979 issue of *The Montclarion*, Beth Bagwell discussed the effects of the 1906 quake on the growth of Oakland. From 1900 to 1910, the population of Oakland soared from 67,000 to 150,000. But until recently, little has been written about the earthquakes originating in the East Bay, and particularly about Berkeley's seismic fault, the Hayward fault.

The Hayward fault, which runs through the Berkeley Hills on its way from San Pablo to San Jose, could produce an earthquake of 8.2 magnitude on the Richter scale. A history of the quakes along this fault was compiled in 1972 by the Hayward Planning Commission, and summarized by Ignacio San Martin in his recent and well-written study, "Social Alternatives for Mitigation of Seismic Hazards."

The resort indicates a surprising number of earthquakes along the Hayward fault from as far back as 1836 when considerable shaking occurred, especially in Monterey and Santa Clara, with aftershocks that lasted at least a month.

The first major earthquake on record in Berkeley and its vicinity occurred on October 21, 1868, with the greatest damage occuring in Hayward and some damage in San Francisco. Every building in Hayward was damaged, and many were destroyed. Thirty people were killed, mostly from falling debris. According to the *Oakland*

18

Daily News of October 22, 1868, the quake began at 8:00 in the morning and "about 25 different shocks were felt, the last being about 12:00 midnight." Although in later issues the *News* said that the quake was felt "all over the state," it also referred to earlier earthquakes in Peru and Equador of much greater severity. The *San Francisco Chronicle* reported, "Never in the history of San Francisco has so great a calamity befallen it as we have met today . . . the people were crazed with terror."

One must remember that Berkeley in 1868 was largely made up of open farmland, with a small scattering of homes and business in Ocean View. The *Oakland Daily News* reported that at Jacob's Wharf in Ocean View a large pile of lumber was thrown into the Bay, but the wharf itself was not damaged. The Asylum for the Deaf, Dumb and Blind suffered eleven toppled chimneys, but the original stone structure of the school withstood the shaking. Modern scientists have estimated that this earthquake had a magnitude no greater than seven, but it was probably remembered as the great quake until 1906.

There was also a minor quake on April 14, 1880 (an event which did not even bear mentioning in the recent studies). It is interesting to note, however, that the *Oakland Times* of April 15, 1880, referred to the shock as "rather violent" and the cause of great excitement. It lasted only five seconds and the *San Francisco Post* reported that in San Francisco it was felt as "a pretty lively shock." *The Bulletin* described it as two shocks, the first had "verticle or rotary motion;" the second had "oscillating motion from northeast to southwest." *The Oakland Tribune* barely mentioned the earthquake several days later in a story on an explosion at the Giant Powder Works northwest of Berkeley. It is possible that the earthquake's shaking had cracked gas lines leading into the factory and caused the ignition of several thousand barrels of gun powder.

Later earthquakes occurred in 1891 centered at Mt. Hamilton, 1898 at Mare Island and 1915 at Piedmont. The Mare Island quake was particularly damaging and its shock, lasting 40 seconds, was felt as far away as Carson City, Nevada.

More recently, Berkeley-centered earthquakes happened in 1937 and 1951, although these were relatively minor.

Stephanie Manning

THE INDIANS AND THE SPANISH

The Costanoan Indians

Students of the Costanoan Indians,* the tribe who lived here before the Spanish arrived, agree that they lived in remarkable harmony with their environment.

Acorns, fish and game supplied them with ample food. Reeds supplied the material for their huts. Their myths assured them that they lived at the center of the universe and that the gods meant well.

As Henry Pancoast wrote,

> They were able to live in the Bay Area for more than 3,500 years without overwhelming and destroying the environment that sustained them . . . apparently without rendering any other species extinct (and) . . . without destroying each other.

This view of the Indians has a tremendous nostalgic appeal nowadays.

In the eighteenth century it is estimated that there were 1,000 Indians living in the area between North Oakland and Martinez. They were stone age men, essentially, and their way of life was static. It had not changed for over a millennium. Berkeley currently has a population of more than 106,000 people, and we lead complicated, endlessly changing lives.

The Costanoans may have been perfectly integrated with their environment but, tragically for them, the environment changed.

In 1772, when the expedition led by Lt. Pedro Fages (a future

*The name of this tribe has become a minor bone of contention. Current activists name them the Ohlones, but anyone seeking information about them in archeological literature must look for references to the Costanoans.

governor of California) and Fr. Juan Crespi reached the East Bay and Fr. Crespi saw them for the first time, he wrote, "We found a village of heathen, very fair and bearded, who did not know what to do, they were so happy to see us . . . "

In the 1790s the Spanish cleared the East Bay of Indians, moving them to Mission Dolores in San Francisco. Then what Theodore White calls "the law of unintended consequences" began to operate.

The Indians were stricken by epidemics of measles in 1806 and 1827, smallpox in 1833, and cholera in 1834. (The cholera epidemic of 1834 killed one of every five residents of San Francisco.) The survivors drifted south after the missions were broken up by the Mexican government.

In 1915 the anthropologist Alfred Kroeber studied the last of them, a few women who had married into the Mexican-American population of Monterey. He recorded their language and some of their stories about Coyote, the major figure of California Indian myth.

"In all the legends," according to Robert Pearsall, "Coyote is quick and alert, his metier being the contest of wits, his great goal pleasure and easy living."

Here are two of the legendary stories told by a people who themselves have become legendary.

"Coyote and His Children"

Coyote killed salmon and put them into the ashes to roast. He did not want his children to eat them. Therefore he pretended that they were only ashes. Once in awhile he reached into the ashes, took a piece and ate it. Then his children cried out that he was eating fire and would be burned. When they wanted to take some, he did not let them. He said, "You will be burned."

"Coyote and His Wife"

Makewiks is an animal that lives in the ocean and sometimes comes to the surface. Coyote went to the ocean with his wife. He told her not to be afraid. He told her about the sea lion, about the mussels, about the crabs, and the octopus. He told her that all these were relatives; so when she saw them she was not afraid. But he did not tell her about the makewiks. Then when this rose before her it frightened her so that she fell dead.

Coyote took her on his back, carried her off, built a fire, and laid her by the side of it. He began to sing and dance and jump. Soon she began to come to life. He jumped three times and brought her to life.

Phil McArdle

The Indian Earthquake Legend

While sifting through perhaps hundreds of books, from time to time I have found reference to an apparently forgotten local Indian legend that the Golden Gate was formed in an earthquake.

William Heath Davis wrote in *Sixty Years in California* (1889):

> A curious tradition was current in regard to the bay of San Francisco, which greatly interested Mofras, as well as myself and others who heard it. Captain Richardson, who has been mentioned before in this narrative, had in his employ at the time an Indian by the name of Monica. He was about eighty years of age, but still active and vigorous, and was employed by Captain Richardson as a boatman on the bay, in launches which were used to run between the shipping and different points to convey goods back and forth. This old Indian told Captain Richardson that the story had been handed down from his remote ancestors, that a long way back there was no Golden Gate; that between Fort Point and right across to the north it was all closed by a mountain range and there was no access to the ocean there, but the natural outlet of the bay was through the Santa Clara Valley, across the Salinas plains, to the bay of Monterey; that in a tremendous convulsion of nature the mountain barrier between the bay and the ocean was thrown down and a passage made where the Golden Gate now is. That became the entrance to the bay. In the course of time the Santa Clara Valley and the other land between the lower end of the bay of San Francisco and the bay of Monterey became drained and elevated.

The legend is mentioned in a few other places, most notably in Dr.

26

Platon Vallejo's *Memoirs of the Vallejos* (1914–15). Here he states that the Suisun Indians had a persistent legend that the Central Valley was an immense deep fresh water sea which was divided from the ocean by a narrow barrier of hills and mountains. Then he goes on to relate a romantic tale of how the Bay came into existence when the Sun stole an Indian princess:

> As he rose in the sky, the Sun stumbled and his arm pushed through the barrier and created the Straits of Yulupa, which we call the Golden Gate. She rests where she fell, the legendary sleeping princess of Mount Tamalpais.

Charles Marinovich

Mortar Rock Park

There are few reminders in Berkeley today of the area's first inhabitants. Although the Costanoan Indians lived here for several thousand years, they lived lightly on the land, and most traces of their presence have vanished.

One piece of evidence that Berkeley was the location of Indian settlements can be seen easily today. Mortar Rock Park, a City park located on Indian Rock Avenue in North Berkeley, is less well-known than its larger neighbor, Indian Rock park, but equally interesting. A sheltered corner with large trees and massive rock outcroppings, it is a good place to experience prehistoric Berkeley first-hand.

In small rock outcroppings close to the ground are several smooth, cylindrical holes. These are the mortars made by generations of Indian women as they ground the acorns which were the basis of their diet.

We don't have any Indian records to tell us how they treated and used the acorns, but we do have a description of the process written by Pedro Fages. His careful and detailed observations provide one of the earliest descriptions of Northern California.

The Indians encountered here by Fages and Fr. Crespi were friendly to the Spanish visitors. Fages described their manner, dress, and customs in some detail and wrote of their treatment of the acorns:

> After they (the acorns) have been skinned and dried in the sun, they are beaten in stone mortars until they are reduced to powder or flour. This is mixed with a suitable quantity of water in close-woven baskets, washed repeatedly, and the

sediment or coarse flour allowed to settle. This done, it is now put on the sand and sprinkled with more water until the mass begins to harden or break up. It is now ready to eat, uncooked. A part may be boiled in a quantity of water, when it is like a gruel.

This may not sound delicious to us, but the acorns, treated in this way, were a major part of the Indian diet. They were so plentiful that it was not necessary for the Indians to grow crops. Harvested in the fall before the winter rains, the acorns were readily available in most years. Fages also says that the Indians gathered wild onions, laurel berries and grass seeds. They hunted deer and found fish and shellfish in the Bay and many local streams.

According to Malcolm Margolin, an Indian family ate from 1,000 to 2,000 pounds of acorns each year. It is not surprising then that the mortars at Mortar Rock Park are so deep. They represent many years of grinding all those acorns, a task that occupied a great deal of time in the life of an Indian woman.

When acorns were not plentiful, the Indians gathered buckeyes and used them for food. Mortar Rock Park contains several beautiful, large buckeye trees, perhaps grown from some buckeyes carelessly scattered by the Indians long ago.

The buckeye and bay trees, the large, irregular rock outcroppings, and the mortars themselves, all combine to provide a beautiful glimpse of Berkeley's past. A climb to the top of the larger rocks, where there is a sweeping view of both hills and Bay, makes it easy to imagine what the land we now call Berkeley might have been like 200 years ago.

Trish Hawthorne

The Peralta Land Grant

The Costanoan Indians lived in a pre-literate society. They did not have written records—only a few legends and some archaeological remains, the meanings of which are often enigmatic. The pages from which we might have learned of their triumphs and failures, their virtues and vices, are blank. We are free to think as we wish of them, even that they lived in Eden.

In the sense that history begins with written records, it can be said that Berkeley entered history in 1820, when the King of Spain, through his duly appointed representatives, granted Rancho San Antonio to his trusted servant, Don Luis Maria Peralta. A truly royal gift, the Rancho consisted of the land lying between present day San Leandro and El Cerrito, bounded on the west by the bay and on the east by the tops of the Contra Costa hills. Don Luis held the land under three flags: those of Spain, the Republic of Mexico, and the United States.

How the Peraltas came to own so much of the East Bay is a story combining imperial policy and personal adventure.

In the sixteenth century the Indians of the Southwest assured the Spanish explorers that the Strait of Anian was in the far, far north Ships, they said, could sail through the Strait from the Atlantic to the Pacific, and en route they could visit the seven golden cities along its shores. Many Spaniards perished in the attempt to find that mythical Northwest Passage. In the end, they gave it up, feeling that Upper California was a barren land.

They began to develop trade with Spain's rich colony in the Philippines.

When the authorities at Mexico City realized winter storms were driving homeward-bound Manila Galleons into the upper latitudes, they decided safe northern harbors were a necessity. But pushing north was risky and expensive. The Indians rose up from time to time and massacred Spanish settlers (200 killed in 1616, 400 in 1680, 100 in 1751). The rancheros and the missionaries needed military protection. The army's presidios were an expensive, permanent obligation for the colonial government.

The harbors established at San Diego, Los Angeles, and Monterey saved many ships. But, the Viceroys found, to secure the ports from the Russians (who were moving south from Alaska) and the English (who were established firmly in Canada), still more resources had to be committed to Upper California.

When Viceroys turned their eyes to the north, some saw only a burden: a province where the costs exceeded the income. But some, like Francisco de Crois and Antonio Maria Bucareli, saw a strategic opportunity. Realizing the land could be secured by a loyal population, they gave land grants to soldiers of good character: they created the California ranchos to protect an imperial domain.

Their policy was so successful that it was continued by the Republic of Mexico (which, in a desultory fashion, sought to protect California from the United States). More than 20,000 square miles of the best land in California was parceled out in land grants.

The de Anza expedition of 1775–76 came to the Bay Area to explore the land and to establish settlements. Its most lasting achievement was the founding of San Francisco. By order of Viceroy Bucareli, it consisted only of married soldiers and their families. Corporal Gabriel Peralta was picked as one of its members, and he brought with him his son, Luis Maria Peralta.

After the de Anza expedition dispersed, Gabriel Peralta remained with the army in Upper California. He died at Santa Clara in 1807 at 70 years of age.

Luis Maria Peralta enlisted in the King's service in 1781. He was stationed at the presidios of Monterey, San Francisco, and San Jose during his forty-five year military career. He lived to be 93, and died in 1851.

On the whole, it appears that while the Peraltas, father and son, did not fight in any major battles, they did do the usual peace-keeping

chores of the Spanish frontier troops—chasing Indians who stole horses or fled from the Missions. They were, in fact, part of the standing army the Viceroys had established to control the Indians and to deter Russian or English encroachment on Spanish territory.

By the time Don Luis received Rancho San Antonio other land grants had been given in the East Bay: the ranchos at San Pablo, El Sobrante, San Lorenzo, and San Leandro. Don Luis was still on the frontier of the empire, but not at the forward edge.

Rancho San Antonio was one of the last land grants issued by Spanish colonial authorities. Shortly after Don Luis obtained the land, the Mexican revolution took place. The Peraltas held the land for about fifty years. When they lost it, the ranchos were gone because of changes caused by the Gold Rush.

Phil McArdle

Domingo Peralta

Jose Domingo Peralta was born at Mission Santa Clara near San Jose in 1794, the second son of Luis Peralta. We know little of his early years.

He was married around 1824 to Maria Guadalupe Pacheco, by whom he had four children. In 1833 he received title to a large rancho near Santa Clara (Canada del Corte de Madera), where he probably lived for several years as a ranchero.

Contemporaries described him as being like his father—short, stocky, and dark in appearance, a courteous and friendly person with an impulsive nature.

Domingo moved his family to the East Bay in 1836 to begin a new phase in his life. His father persuaded him to join his brothers on Rancho San Antonio in a move to offset squatters encroaching on the land. At about this time, Domingo's first wife died and he married Maria Eubiges Garcia, a woman 27 years his junior, by whom he had six more children. Domingo lived several years with Vicente at Temescal, then moved his family to the adobe casa he built on Codornices Creek in 1841. The one-story house was 30 by 18 feet in size with a tile roof and dirt floor. A plaque marks its site at 1302 Albina Street.

On a March day in 1842 Luis, the 82-years old patriarch, rode with his sons along the ridge of the East Bay hills and allocated to each son a share of the rancho. Domingo received the northern portion, including modern-day Berkeley.

In 1851 Domingo moved his growing family into a two-story wood frame house at what is now 1505 Hopkins Street. Domingo lived a

modest but comfortable rancho life before the coming of the Americans.

In July 1852 Domingo sold a 50-acre parcel on the waterfront (the site of today's Golden Gate Fields) for $2,200 to John Fleming, who brought cattle there from all the East Bay ranchos for shipment to his meat-packing operations in San Francisco. A month later Domingo sold the bulk of his ranch, except for the 30-acre reservation he kept as a homestead, to a prominent group of San Francisco capitalists for $82,000. Domingo profited well from his dealings with these fair-minded men.

But for the remainder of his life, Domingo was not so fortunate. He was caught in the legal manipulations and fraudulent shenanigans of wily lawyers and speculators. The most notorious of these rascals was the legendary Horace Carpentier, who ingratiated himself into Domingo's confidence, became his agent, and then proceeded to defraud the naive ranchero of his lands in Alameda, Santa Clara and Contra Costa counties.

Domingo was also duped by other lawyers and speculators who competed with each other for his land. One of their tricks was to persuade Domingo to sign papers which would supposedly pay off property taxes, mortgages or other debts, using his land as collateral for payment of personal services and legal fees. They even succeeded in carving up Domingo's 30-acre homestead among themselves, eventually depriving Domingo's heirs of their inheritance.

Domingo and his family also had troubles with the American judicial system. Domingo had his first brush with the law in 1852 when two squatters brought a complaint against him for assault and battery with intent to kill. Domingo, with a friend, had accosted the squatters while riding horseback on his land, and with his sword "struck, beat, and bruised" the interlopers. The grand jury indicted Domingo for inflicting bodily harm with a deadly weapon. A trial jury found him guilty and fined him $700. The fine was calculated by the jury foreman, who had each juror recommend the fine, added up their figures, then divided by 12 (for the total jurors). The fine was paid by a sheriff's sale of a 428-acre tract of Domingo's share of the Rancho San Ramon in Contra Costa County.

Domingo's sons also had brushes with the law. Juan and Ramon Peralta were involved with a group convicted in 1853 of grand larceny

for the theft and slaughter of beef cattle. Miguel Peralta and a friend were indicted in 1864 for the theft of thirty-five sacks of barley valued at $110, but the outcome of the case cannot be found in court records, which are incomplete. Ramon Peralta was convicted in 1865 of horse theft and was sentenced to state prison, but he was apparently pardoned by the Governor in 1867. The Peraltas' altercations with the law cost Domingo dearly in fees for bondsmen and lawyers, added immeasurably to his debts, and undoubtedly contributed to the impoverishment of his family.

Domingo—an ailing and broken man in his last year—died at his home on April 3, 1865. In his will, witnessed by his three brothers, he gave a lengthy testament, saying in part:

> My God, you that have in your hands the concealed keys of my life, death and eternity, you know in what year, day and hour I ought to die—I know that I have to die . . . I will not refuse death. I shall die to see you and live eternally with you . . . In the name of the Father, the Son and the Holy Ghost, I, most miserable sinner redeemed with the most precious blood of my Lord Jesus Christ, do protest before you most omnipotent God, and before heaven and earth, that I wish to die in the Catholic faith . . . with my spirit animated with a firm hope in the piety and love of my God and Lord . . .

He commanded his wife and sons to bury his body beside the graves of his parents at the Mission Santa Clara and humbly asked for a performance of the Mass. He left his wife and ten children his interest in San Antonio and the other two ranchos mentioned above, denying the rights of Horace Carpentier, who had failed to perform his contracts for thirteen years. He ended his will with a charge:

> Lastly, I command all my sons to be maintained and live in fear of God and obedience to their mother and all the elder brothers; that God may bless them, as I bless them, in the name of the Father, the Son and the Holy Ghost. Amen.

Domingo's story ends with a sad epilogue. He was buried in an unmarked pauper's grave in St. Mary's Cemetery in Oakland. His wife and children were evicted from the family home by the sheriff in 1872, and little is known of their whereabouts thereafter. They

received a pittance from Domingo's estate, which the courts finally disposed of in 1878 by partitioning it among the lawyers and speculators who had filed claims against it. So it was that the Peralta family lost the Rancho San Antonio.

Edward Staniford

THE AMERICANS ARRIVE

The Story of the Hanging Oak

Berkeley was once a grass-covered plain dotted with oak trees, particularly along the creeks. The grasslands have been obliterated and the creeks diverted into underground culverts. But some of the oak trees still survive in parks and on the UC campus.

Several of these trees have gained more than casual notoriety. The list includes Annie's Oak, situated near the intersection of Le Roy and Le Conte Avenues: as well as the Wheeler Oak, Le Conte Oak, and another in Faculty Glade—all three on the UC Berkeley campus. Certainly, though, the Gibbet, Vigilante—or Hanging—Oak is the least known of them.

The article reproduced here was written by John Boyd in 1902 when someone proposed to cut down the Hanging Oak. And it was reprinted subsequently in the January 14, 1908, *Berkeley Gazette* and the January 18, 1908, *Berkeley Sun & Letter* when the tree was finally cut down.

<div align="right">Charles Marinovich</div>

One night in the spring of '51 a man named Charles Baldwin, whose ranch was near the town of San Pablo, heard some disturbance in his horse corral, and on proceeding to investigate discovered the lock broken and bars down, and a valuable mare missing. The alarm was at once given and as there was nothing the neighboring ranchers were more willing to help at than to pursue a horse or cattle thief, a crowd was soon collected.

Piloted by an Indian in the employ of one of the Alvarado family, the trail was soon taken. The tracks led toward what was then known

as Ocean View (now West Berkeley). At Captain Bowen's Trading Post, which stood on what is now San Pablo Avenue and Delaware Street, it was learned that a man riding one horse and leading another had stopped in the early hours of the morning and purchased a flask of liquor and passed on.

Tracks were found leading to what is now Peralta Park,* and about five o'clock the horse thief was found in a gully and on investigation the fugitive was discovered with some hot irons trying to change the brand on the stolen animal.

Surrounded on all sides by brave and determined men with leveled shotguns, the robber was soon a prisoner. Mounted on another horse (they would not trust him on his own animal), with feet tied under the horse's belly and a lariat around his neck, the crowd and prisoner started. It was determined to take him to Judge Blake's ranch and there await the sheriff, one of the party being sent ahead into Oakland to request Sheriff Harry Morse to meet them at the ranch and take charge of the prisoner.

The capturing party reached the ranch, and after tying the prisoner securely to a tree, seated themselves on the ground to await the sheriff, though some grumbled at the time wasted when they ought to be at home attending to other duties. At length the messenger returned and not only brought a demijohn of whiskey from Oakland, but also the news that Sheriff Morse had been called away to San Leandro and would probably not return until one or two o'clock when they would send him out at once. Great discontent was at once manifested among the assembled ranchers and various discussions took place as to the best mode of procedure. Some were for pulling straws to decide who should guard the prisoner and journey with him to Oakland. Other plans were discussed and no agreement was reached until one rancher, in whose brain the whiskey was working, yelled out, "Let's hang the horse thief and he will steal no more horses."

The suggestion took at once, and a lariat was at once thrown over the long limb which reaches out into what is now Allston Way. But some of the more conservative now demanded that the man should have some sort of a trial. A judge was selected and a jury sworn, and the trial took place. The prisoner refused to plead and would make no answers to any questions except to give his name as Cloromeda Mendoza.

In about 15 minutes the jury found him guilty and gave him five minutes to say his prayers, all of which time the prisoner occupied in cursing his captors in English and Spanish, and ending by threatening that "his gang" would make bonfires of his captors' houses and barns in return for his death. At the expiration of the five minutes, the crowd took hold of the rope and the prisoner (as an old pioneer said who told me this story) was "hoisted." The body had hung about 15 minutes and the crowd were taking the last drink out of the demijohn and preparing for home when some horsemen were seen coming up the Temescal Road (now Shattuck Avenue), and in a few minutes Sheriff Morse, accompanied by two deputies, rode up.

Springing from his horse the sheriff drew a bowie knife and at once cut down the body but too late, the life was extinct. The sheriff inquired who the lynchers were, but, strange to say, no one in the crowd knew anything about them. They just happened to be riding by, etc., and knew nothing.

In those days of law, the empowered sheriff forthwith proceeded to empanel a jury out of the crowd of lynchers, and the very men who hanged him quickly returned a verdict "that the deceased had met his death at the hands of parties unknown."

John Boyd

*In North Berkeley.

Julius Kellersberger:

Mapping the Land

Julius Kellersberger surveyed the Berkeley area in 1856 and recorded the results on a map filed at the Alameda County Courthouse in 1857. The purpose of his survey, which was paid for by Colonel Jack Hayes, the former U. S. Surveyor General for California, was to aid in subdividing the land sold by Domingo Peralta so that each of the new owners would know the precise shape of his property.

Kellersberger's map makes it possible to trace the history of land ownership and development in Berkeley between 1850 and 1906.

The most interesting feature of the map to a historian of early Berkeley is the boundary it shows for Domingo Peralta's reservation (the land he kept for a homestead after selling most of the rancho in 1852). Its triangular shape explains the irregular street patterns we have in North Berkeley today. Look at any current map of Berkeley and you will see, in the diagonal streets paralleling Peralta Avenue from Hopkins to Sonoma, traces of Domingo's homestead.

An immigrant from Switzerland, Julius Kellersberger was trained as a surveyor in Vienna, and practiced his profession in New York City. He joined the Gold Rush to California in 1851, and after an unsuccessful fling in the Sierra mines, he settled down in San Francisco.

He became involved in the East Bay as a pioneer surveyor and city planner, when, in 1852, he was employed by a trio of squatters

headed by Horace Carpentier to lay out the town of Oakland. The next year he plotted the county road from Oakland to San Pablo for the Board of Supervisors of Contra Costa County. When Oakland was incorporated in 1852, Kellersberger served as town surveyor. When the town was reincorporated as a city in 1854, he served as city engineer under the first mayor, Horace Carpentier. Apparently Kellersberger and Carpentier had a falling out, for shortly afterwards Kellersberger's loss of a close election for the city engineer's post was attributed to Carpentier's influence.

In any event, Colonel Hays appointed Kellersberger as deputy surveyor. He served in that post until 1857 when he was removed by President Buchanan, who followed the "rules" of patronage politics. It was at this time that Hays, who had also been returned to private life, employed Kellersberger to survey the former ranchos of Vicente and Domingo Peralta. Kellersberger was also involved in other important surveys in Northern California and acquired a reputation for professional accuracy and integrity.

Edward Staniford

The Growth of Ocean View

Among the Historical Society's long term projects is the preparation of curricula for the Berkeley public schools. The following essay and "Ocean View's Social and Ethnic Diversity" are extracts from the first curriculum to be completed and published, *Victorian Berkeley: The Community of Ocean View.*

Phil McArdle

Captain James Jacobs, who built the wharf known as Jacobs' Landing in 1853, was the first notable American pioneer to settle on the Peralta rancho lands. Jacobs came to the Bay Area via the gold fields. Like most other mid-nineteenth century Californians, he had been attracted to the West by the prospect of striking it rich. Jacobs' modest success as an Argonaut allowed him to purchase a small sloop in 1851, which he used to transport freight back and forth from San Francisco to the smaller communities surrounding the Bay.

Within a year, Jacobs' Landing was connected by a footpath to an inn and grocery store. Captain William Bowen was the proprietor of the inn. Bowen had also achieved a modicum of success during the fifties prospecting for gold. Coming to Ocean View in 1854, Bowen located his inn on Contra Costa Road. When the road was made a stage line, the inn became a stage stop. The stop was soon known as Ocean View.

From 1855 to 1860, some fifty to sixty people migrated to this small community. The new arrivals were predominantly foreign-born. A quarter of them were Irish. Their families had been driven from their farms in Ireland by the crop failures of the 1840s. Some of these early pioneers had temporarily settled in the East and Middle

44

West before moving on to California. They continued as farmers after arriving in Ocean View. A few of them were skilled craftsmen and others worked in the mills. The remainder earned their living as day laborers and as cooks in the houses of the richer residents of the settlement.

Second-generation Americans, born in the East and Middle West, were the second largest group to settle in Ocean View from 1844 to 1860. Coming to the East Bay with more resources than their foreign-born counterparts, most of these pioneers became land-owning farmers and skilled artisans. Also arriving during Ocean View's early years were a scattering of Chileans, Canadians, Danes, Germans, English, French, Mexicans and Scots.

Despite the relative stability of the population and the lack of dramatic economic growth, some important institutions were established during the sixties. In 1866, Heywood and Jacobs joined forces to build a small wooden wharf on the site of Jacobs' old landing. Outside of the settlement, the opening of the Asylum for Deaf, Dumb and Blind in East Berkeley created a new market for the skills of Ocean View's trained artisans and the products of her young shops and industries.

In 1873, the University of California had established its new campus a few miles north of the Asylum. The arrival of the University created a second market for Ocean View's industries. It also created a source of political and ideological conflict which would plague the community of Ocean View throughout the remainder of the nineteenth century.

Karen Jorgensen-Esmaili

The Irish-American Farming Community

"Farms in Berkeley?"

This catchy advertising slogan belies the historical fact that at one time the flatlands of Berkeley were covered by farms. As Berkeley grew, the farms became fewer and smaller to the point where now, none of them remain.

Probably the first European-born American to farm in Berkeley was Michael Curtis. Curtis Street today runs through what was once his property and what is known today on official maps as the "Curtis tract."

Michael Curtis was born in Ireland, as were many other early local farmers such as Michael Higgins, John Tierney, James McGee, Peter Mathews, and John Kearney—all of whom bought farmland north of Oakland in what is now Berkeley. Curtis came to California by way of Boston in 1852 in search of gold. Meeting little success in the mines, he turned instead to farming. He acquired 150 acres lying roughly between what is now University Avenue and Hopkins Street, and San Pablo Avenue and Curtis Street. Although other farms, such as that of James McGee, were larger, and others, such as that of Peter Mathews, survived longer, the farm of Michael Curtis was the oldest in Berkeley.

The Irish farming community of the East Bay was close-knit, a quality enhanced by the intermarriage of large families. For example, Patrick Dunnigan's four daughters all married local farmers. Mrs. Michael O'Neil, Mrs. Peter Mathews, and Mrs. John Kearney were

all Dunnigans. His fourth daughter, Anne Dunnigan became the wife of Michael Curtis.

Anne and Michael Curtis had ten children, among whom were Josephine (who married Edward Brennan), Anne (who married John Brennan), and Teresa (who also married John Brennan after Anne's death.)

The Curtis-Brennan family is still a part of the life of Berkeley, most visibly through Brennan's Marina and Brennan's Restaurant in West Berkeley.

The Irish farming community of Berkeley was held together not only by family relationships but also by religion and politics. In the 1870s, the Catholics of Berkeley met for religious services at Michael Curtis's farm. This Catholic community eventually developed into St. Joseph's Church, which was built on land donated by another Irish farmer, James McGee.

Nineteenth century Irish-Americans were usually as loyal to the Democratic Party as to their religion. But by the late 1870s, as Berkeley edged toward incorporation, Bay Area Irish and others formed the Workingman's Party to oppose the anti-labor practices of the railroad barons, who seemed to have both the Republican and Democratic establishments in their grip. Though the Workingman's Party was short-lived, it was thriving at the time Berkeley was incorporated as a town and carried the ticket in Berkeley's first municipal election.

Rev. Harry B. Morrison

The Lumber Mills

A study of the historic resources of West Berkeley prepared for the City by architectural historian Sally Woodbridge states that, "among the most enduring of the West Berkeley industries were the lumber mills."

Indeed, industry in West Berkeley has always taken place alongside a substantial residential neighborhood. As early as 1860 Ocean View sported a trading post, a freight wharf, a grist mill and a lumber yard.

The West Berkeley Planing Mill began in 1874 as a cabinet shop behind John Everding's grist mill at Second and Hearst. The location was choice. It was next door to Heywood's Lumber Yard and adjacent to Captain Jacobs' freight wharf. The founders of the shop were two immigrant German carpenters—Edward F. Niehaus and Gustavus A. Schuster.

The idea for the shop was to provide "sashes, doors, mouldings, turned and scroll-sawed wood, and other purely decorative adjuncts and furbelows, which every American citizen of the 1870s thought essential," according to George Pettitt in *Berkeley: The Town and Gown of It*. Within the next twenty years, West Berkeley used these products as it grew from a small farming village into a densely settled community, thick with well-adorned Victorian houses.

By 1881 the mill reached its peak of operation. The business changed names from Niehaus & Schuster to Niehaus Bros. and Co. The Niehaus family built several magnificent homes in West Berkeley, the best of which still exists at Channing and Seventh, and is a designated City landmark.

48

In 1901, tragedy struck the mill in the form of fire. The fire was disastrous and resulted in a suit in which G. Schuster contended that the fire could have been extinguished if the fire department had been better organized.

After the Niehaus fire, the City began to seriously search for a good source of water.

Stephanie Manning

J. Ross Browne

Several notable characters passed through the village of Ocean View in the years between 1853 and 1870. One such was the writer, traveler, and Government secret agent, J. Ross Browne (1821–1875).

Although Browne risked his life by exposing corruption in the San Francisco Customs House and other Governmental agencies, he is best remembered for his literary accomplishments.

In *J. Ross Browne: Confidential Agent in Old California*, Richard H. Dillon placed him with Mark Twain as a member of the "Western frontier school" of American writing. His books include *Indians of California, Etchings of a Whaling Cruise, Yusef, The Coast Rangers, Adventures in the Apache Country, Exploration in Lower California, A Dangerous Journey, A Tour Through Arizona, Washoe Re-visited*, and *Crusoe's Island*. They have been looked upon not only as absorbing adventure stories but also as important historical records of the West's pre-Civil War days.

Browne became linked to the history of the East Bay after making his home in the Claremont district in the 1850s. His palatial residence, Pagoda Hill (built 1868), remained a Bay Area landmark for many years after his death in 1875. It resembled the ornate Peralta Hotel and could be seen for miles from any direction.

Berkeley is indebted to Browne because in 1870, after being recalled to the United States from his post as Minister to China, he accepted a commission from a group of Oakland investors to do a study of "Lower Berkeley."

This study resulted in a most important resource guide to the physical conditions of early West Berkeley (Ocean View) entitled

"Letter from the Hon. J. Ross Browne, Late U.S. Minister to China, in relation to the proposed Town Site of Lower Berkeley, and the Value of Property and Growth of Population in and around Oakland."

Despite the lengthy title, the "Letter" gave a concise and vivid picture of the beautiful farming village and its advantages as a potential city. Its purpose was to encourage increased investment in this land which "has an absolute value, in itself, of at least 50 percent beyond the purchase money" according to Browne.

He went on to paint a rosy picture of the farmland with "rich black loam . . . unsurpassed in fertility by any in the State," producing a myriad of vegetables, fruits, flowers, and grains.

His "Letter" enumerated all the potential for transit development, stressing the concept of a ferry connection with San Francisco and a rail connection with Oakland.

With Browne's "Letter," Berkeley's forefathers were able to convince men of means to invest in developing Berkeley. This capitalist drive succeeded in attracting businesses, jobs, and a population which joined with the University community in 1878 as an incorporated town.

Although Browne figured only slightly in the history of Berkeley, his influence as a nationally known figure, a man of honor and accomplishment, helped Berkeley immensely to become what it is today.

<div align="right">Stephanie Manning,
with special thanks to Rev. Harry B. Morrison.</div>

Ocean View's Social and Ethnic Diversity

There was little opposition in Ocean View to the incorporation of the City in 1878. Disputes between the University and Ocean View settlements were subordinated to the desire to solve common problems and to increase public services and funds.

Despite incorporation and the fact that Ocean View was referred to as West Berkeley after 1878, the community continued to assert its special identity from 1878 to 1910. During this period, East and West Berkeley bickered over the location of the town hall and the high school.

West Berkeleyans resented the tax-exempt status of the University which allowed it to use City services while sharing none of the costs. West Berkeleyans felt they suffered a severe indignity when sewage from the University contaminated the streams and underground water supplies of the western part of the City.

Population growth in West Berkeley intensified water problems. From 1880 to 1900, West Berkeley's population jumped from 668 to 1,544.

Second-generation Americans born in the community contributed to a large part of the increase. At the same time another large group of foreign-born people migrated into the area.

The Germans were the largest in numbers and, for the first time since the establishment of the community, they outnumbered the Irish. A sizeable new influx of Scandinavians, Italians, Portuguese, Irish, English and French also helped to expand West Berkeley's population.

While the immigrants often worked together and lived in mixed neighborhoods, they kept their social lives distinct. Increasing affluence allowed some groups to build ethnic halls for social and cultural gatherings.

The larger population also increased the need for community services. Improvements, in turn, encouraged more settlers to live in West Berkeley. A local post office was established in 1878, gas lights were installed in 1879, a volunteer fire department and a telephone exchange were started in 1882 and electricity was introduced in the 1890s.

Individuals of European descent dominated the ranks of those attracted to West Berkeley during the last two decades of the nineteenth century. In 1900, there were still few blacks. The black families residing in the settlement were homeowners and skilled artisans from Southern border states.

The Hispanic community consisted of scattered Chilean, Mexican, Columbian, Central American and Brazilian families.

The largest non-European group in the community in 1900 was the Chinese. Although some factories employed them, the intense anti-Chinese feelings which surfaced in West Berkeley from time to time after the 1870s kept most of them working as cooks, servants and laundry helpers. By the 1890s, however, there were two medium-sized West Berkeley vegetable farms owned and worked by Chinese men.

Despite restrictions on the non-European population, job opportunities for the expanded West Berkeley population had broadened by the turn of the century.

Many new factories had been built: the Giant Powder Works, the Judson-Shephard Chemical Works and the O'Neil Glass Works were among the largest. For the first time, second generation Americans outnumbered foreign-born workers at the work benches of these factories. Native-born workers were also the backbone of the new class of clerks, bookkeepers and other white-collar workers who were seen in increasing numbers by 1900.

The community's occupational base expanded in other ways. More single, male factory workers without local relatives created a need for boarding house keepers and other service industry employees. Affluence stimulated a demand for such luxury goods as candy and flowers.

In the 1890s, women in moderate numbers began to work outside the home. Many were young, unmarried offspring of foreign-born parents. They worked as seamstresses in the shirt factory, bookkeepers, teachers and salesgirls. Another important shift in the community's occupational base occurred between 1880 and 1900: the number of farmers declined for the first time.

The decline in farming, the increase in the employment of women outside the home, and the general growth of the West Berkeley population continued after 1900.

By 1910, the immigrant farming settlement of Ocean View had been transformed into a city of factory workers and service industry employees. In 57 years, the community had grown to encompass a strip of land that was bounded by the Bay on the west, present day San Pablo Avenue on the east, Emeryville on the south and the city of Albany on the north. Within this territory, buildings had been constructed by the hundreds and much of the open space had been filled by the factories, houses, schools and shops of the growing community of West Berkeley.

<div style="text-align: right">Karen Jorgensen-Esmaili</div>

The Asylum For the Deaf, Dumb and Blind

In 1980 the California Schools for the Deaf and Blind moved from Berkeley to Fremont. Its Berkeley campus has been acquired by the University for student and faculty housing. Thus an old Berkeley landmark—home of one of the oldest and most esteemed of our State institutions—has passed from one role to another.

Originally founded in San Francisco in 1860 as the Asylum for the Deaf, Dumb and Blind, it was supported by private subscription and legislative appropriation. The Legislature reorganized it in 1866 by providing full state support and authorizing a commission to select a new site. The commission considered forty, and unanimously agreed on Berkeley because of its natural scenic beauty and its proximity to San Francisco and the new University of California.

In 1867 the commission purchased 131 acres from John Kearney (the Kearney Farm) for $12,000. The first building constructed was a large, handsome Victorian-Gothic edifice resembling a cathedral. It was designed by the architectual firm of Wright and Saunders, and built at a cost of approximately $149,000. The stone for the building was shipped to Berkeley by Captain James Jacobs of Ocean View. In 1875, after the building was destroyed by a fire, some of the stone was used for the stone wall along one side of the school property.

The school was rebuilt to accommodate a larger student body. By 1887, twelve buildings had been constructed for the education and housing of over 100 deaf and blind students from all parts of the state. The Education Building, designed in the Romanesque style, was the central edifice of the reorganized campus.

The school underwent another physical transformation in 1929 after the Legislature authorized another long-range rebuilding program. The older brick buildings were replaced by new ones in the Mission style. Credit for the architectural style of the modern buildings has been attributed to Alfred Eichler, the long time State supervising architect.

The moving spirit in the early development of the school was Warring Wilkinson, its superintendent for forty-four years (1865–1909). A charming man completely dedicated to the cause of his handicapped students, he was a popular figure on the Berkeley scene.

On the basis of his reputation as a teacher of deaf-mute children in New York, he was selected in 1865 to head the Asylum for the Deaf, Dumb and Blind. He was instrumental in persuading the Legislature to move the institution from San Francisco to Berkeley. He supervised its growth and development as it won universal acclaim for its successful work with the handicapped children. In 1905, after many years of effort, Wilkinson persuaded the Legislature to change the name of the Asylum to the California Institution for the Deaf and Blind in order to emphasize the educational, rather than the custodial, nature of the school.

Several graduates of the school went on to notable careers. Theophilus Hope d'Estrella, a homeless orphan in 1860, was the first deaf-mute admitted to the Asylum. He grew up to study at the University of California and teach at the Asylum for many years. Douglas Tilden was perhaps the school's most famous student. He became an accomplished sculptor, studied in Paris (thanks to the bequest of a local farmer), and won world acclaim for his works. Other graduates became prominent educators, lawyers and public officials.

The school underwent several major changes after 1921. The Legislature divided it into the California School for the Deaf and the California School for the Blind, each operating with separate administrations, but on the same campus. It also transferred governance from the independent board of directors to the State Director of Education at Sacramento. In 1929, the completion of new buildings for the blind students marked the final separation of the two schools.

The California Schools for the Deaf and Blind made an outstanding contribution to the life and cultural history of the City, and will be missed.

Lynn Laird and Stephanie Manning

Claremont Canyon

Claremont Canyon is the last relatively undeveloped area in the Berkeley Hills. This is remarkable because it was once the main overland route between the booming cities of Berkeley and Oakland and the East. This steep-sided, 619-acre canyon runs from the Berkeley Hills at its northeastern end to the Claremont Hotel and the flatlands of Berkeley and Oakland at the southwestern end.

Within a period of seventy years, Claremont Canyon changed from Indian land to Mexican pasture to an early American communications corridor.

American development of the area began on July 4, 1858, when crews began stringing the first transcontinental telegraph cable between Oakland and the East Coast. Oakland, the first and fastest growing city in the East Bay, was selected as terminus for the telegraph line and, later, the transcontinental railway.

Claremont Canyon was chosen as a cable route over the hills because it was the lowest pass in the central portion of the Contra Costa Hills. The road that grew up along this cable route became known as the Telegraph Road.

Telegraph Road extended from Broadway in downtown Oakland, along the present alignment of Telegraph Avenue to the intersection of Telegraph and Claremont Avenues. At that point it angled eastward following present day Claremont Avenue and climbed up through Telegraph Canyon (now Claremont Canyon) on its way over the Hills toward Mount Diablo, and then north to the Sacramento River at Martinez. Settlers began to take up land adjoining the road, and eventually Orinda, Lafayette, Walnut Creek and other towns came into existence.

Later when Oakland's Telegraph Avenue was extended into Berkeley, its name displaced Choate, the name originally chosen for this Berkeley street by the Trustees of the College of California.

In 1860, after the Alameda County Board of Supervisors declared Telegraph Road a public highway, a stage route began to operate between Park street in Oakland and the Morgan House in Martinez. Its service was coordinated with the ferry boats that travelled from San Francisco to Oakland and from Benicia across the Sacramento River to Martinez.

The Pony Express riders galloped along Telegraph Road and through Claremont Canyon during 1861 whenever their westbound trips failed to connect with the Sacramento-San Francisco riverboat. They crossed the Sacramento on the Benicia-Martinez Ferry, and made the trip from Martinez to Oakland in about two hours.

But it was more difficult for a loaded wagon. In *New Pictures from California*, Bayard Taylor described a frustrating three-hour trip over Telegraph Road through Claremont Canyon in 1859.

The road through the canyon was so steep, narrow, and difficult that there were many accidents and a call soon went out for a new route that would be easier and safer—perhaps by means of a tunnel through the hills. But for more than forty years this difficult route was the main overland road to Contra Costa County and the points further east.

For a time the portion of the road going through the canyon was called Summit Road and a hotel, a saloon and a staging station by the name of Summit House (elevation 1,315 feet) were built at the top of the divide. Summit House operated from 1860 to 1903. Stages, including those bound for Mount Diablo, often changed horses there.

In 1893 a pledge of financial support and a concerted effort by the Merchants' Exchange Club of Oakland (a forerunner of the Oakland Chamber of Commerce) finally persuaded the supervisors of Alameda and Contra Costa Counties to construct a tunnel through the hills.

Years of planning, fund-raising and construction were capped on November 4, 1903 by the formal opening of the 1,100-foot-long tunnel, some 320 feet lower than the old summit. Located above the present Caldecott Tunnel, it gave Tunnel Road its name and reason for being.

Once this new route opened, traffic in Claremont Canyon dropped off sharply and soon the old road was closed completely.

The upper part of the canyon became a quiet, remote area used only for cattle grazing, some minor quarrying and the development of water from hillside springs. The Alameda Water Company and William Glassock purchased the 174 acres at the upper end of the canyon. This land became part of East Bay Municipal Utility District watershed lands in 1923, and then in 1961 was taken over by the University of California which has kept it as undeveloped open space.

During the years the Schools for the Deaf and the Blind were in Berkeley only the fifty acres in the western portion of their 130-acre site were developed. The eighty acres to the east were undeveloped open space and have been used by Berkeleyans as hiking and sightseeing parkland for more than 100 years.

At the end of the century, the Claremont-Elmwood district was a place where the mansions had large private grounds. After 1905 a new stage of development occurred when Duncan McDuffie hired Frederick Law Olmsted, Jr., son of the designer of New York's Central Park, to design the subdivisions being laid out on the Edson Adams ranch. Drawing on Olmsted's skills, Mason-McDuffie pioneered in landscape planning, street tree planting, contoured roads and parkways.

Development of the Claremont-Elmwood district was given another boost by the construction of the Hotel Claremont in 1914 (part of the region–wide speculation brought about by the Panama-Pacific International Exposition in San Francisco). The Key System rail lines also helped by providing the new residents of the district with cheap, fast transportation to downtown Oakland and to San Francisco.

The canyon, however, largely remained an out of the way cul-de-sac given over primarily to cattle grazing and dairying.

Henry Pancoast

THE UNIVERSITY ARRIVES

Henry Durant

Henry Durant was a scholarly clergyman in the New England tradition established by the Puritans. Born in Massachusetts in 1802, graduated from Yale in 1827, he was variously a teacher of Greek, the pastor of a Congregational Church, and the principal of a highly respected college preparatory school.

As a minister he supported the work being done by Protestant missionaries from the West. As an educator he saw the need for schools on the frontier, including schools of higher education. These interests led him, in his mid-40's, to go West in order to start an academy which he hoped would grow into a college similar to Yale or Harvard. Durant reached Oakland in 1854. "I came," he told Daniel Coit Gilman many years later, "with a college on the brain."

He began by renting the Washington Pavilion, a thirteen-room building at Broadway and Fifth Street (where the Oakland Police Department now has its parking lot) for $150 a month. The Pavilion had previously been used as a dance hall; it must also have been a saloon (and possibly a brothel, though Durant's biographers did not discuss such matters). He rechristened the Pavilion as The Contra Costa Academy and advertised it as a boarding school offering college-prep training. Two years later he moved his school to Twelfth and Harrison Streets (near where the Tribune Tower was built), a location at which he had purchased land for larger facilities.

During the first 15 years of his work in California, Durant was plagued by money problems. He did not have many students, and their parents did not always pay tuition promptly.

Once, while at Fifth and Broadway, Durant fell behind in the

63

payment of wages to a Mr. Quinn and his wife, whom he had hired as housekeepers. To get the money due him, Quinn claimed squatters rights to the first floor of the school and put out a sign announcing rooms for rent and liquor for sale. They almost came to blows before patching up the problem.

Later, at the Twelfth and Harrison campus, Durant owed money to his building contractor, who also brought in squatters to take possession of the property. Durant, alone, faced them down.

The Contra Costa Academy survived despite its troubles, and Durant obtained a charter from the Legislature for it—and renamed it the College of California. As a nondenominational Christian college, by 1860 it was offering college-level instruction.

But Durant and the men he gathered around him as trustees felt their efforts to build a first-class institution were not progressing rapidly enough, and they concluded by 1865 that downtown Oakland was no place for a college.

They chose a new site for the college near Strawberry Creek and began purchasing the land. They hoped to resell parts of it to home builders and use the income thus derived to construct their campus. But the resale of their Berkeley holdings went slowly.

Meanwhile, they watched helplessly as their competitors made headway. Several colleges opened under Catholic auspices, and in 1867 the University of Santa Clara awarded the first bachelor's degree given in California. At the same time, agitation was building for the Legislature to organize the State university mandated by the Constitution of 1849, a promise long unfulfilled.

With things at this pass, Durant and his board of trustees offered the Oakland facilities and the Berkeley land of the College of California to the State. The Governor accepted, with the Legislature's blessing, and on March 23, 1868, under a new charter, the College of California became the University of California.

But teaching continued in Oakland until the Berkeley campus was ready for use. According to Joseph Le Conte, the student body of the University during the Oakland interval consisted of 11 students inherited from the College of California, 25 freshmen, and one or two special students, "a total of about thirty-eight." Durant was officially designated president of the University in 1870, and was succeeded in 1872 by Daniel Coit Gilman.

Before Henry Durant died in 1875 he had made the great dream of his life a reality, and had seen his college so securely established that it could face the future confidently. He is a somewhat neglected figure in Berkeley history, but it is evident that without his dedication and his tenacity, Berkeley as we know it would not exist.

Phil McArdle

Durant on Life

Excerpts from a speech by Henry Durant welcoming Daniel Gilman to Berkeley on November 7, 1872.

A more welcome service could not have been assigned to me for this occasion than that of bidding you, Sir, in behalf of myself and the several faculties of the University, welcome to that office from which I retire . . .

It is with some sadness I take leave of a work which has been at once the burden and the joy of my life, for which I longed as I dimly saw it in imagination while I was yet a boy, of which I dreamed by day as well as by night till it became as the revelation of my destiny—a bright and charming vision in the far-off prospect, nearing and brightening and alluring more and more, as step by step, year after year, I trod the long and rugged way of preparation till the goal was reached and the work of my life profession was begun. And now I am to leave it . . .

If it be with sad regret that I drop my work, and so, the feeling is compensated, and more than compensated: it is overpaid in the reflection that these beginnings of the University in the past, with which I have been so humbly connected with others more worthy than I, will be taken up (as we leave them) and carried on and elaborated towards their ends more fully and more perfectly by those who are coming after us. I say more fully and perfectly, for it is not possible that those who begin a work, if it be a work of any consequence, should bring it to perfection. That were a

poor life work indeed which one lifetime should suffice to finish. "We labor—other men enter into our labors . . . " He shall increase, I shall decrease; these are the terms of all human progress . . .

Early Days at the University

The March 23, 1868, charter of the University was prepared, it would seem, almost wholly by John Dwinelle. It provided for twenty–two Regents, divided into three types—ex-officio, appointed, and honorary. When the distinction between appointed and honorary Regents was found to be meaningless, it was abolished by an amendment to the charter.

Although approved in March 1868, the University did not open the following September. Even in those wide open days it took more than six months to organize a University! The winter found the Regents still enmeshed in the complications arising from the University's "inheritance" of its predecessor, the College of California. The disincorporation of the College of California moved slowly, and the Board of Regents did not actually complete this process until May, 1870.

The founders believed that, given sufficient endowment from land revenues, taxes, and philanthropy, the University could go into perpetual motion, marching down through the years without further assistance from the public treasury.

The Regents devoted ten months to selecting the first ten faculty members. A few of their choices turned out to be unwise, but four of them were giving distinguished service to the University 20 years later. Two of them, John Le Conte and Martin Kellogg, served so well that they were later chosen as presidents of the University.

When University instruction began at the temporary Oakland campus in September, 1869, there were 10 faculty members and about 40 students. The student-teacher ratio has probably never been so low since.

From the beginning there were disagreements between the Regents and the faculty. The Regents, for example, wanted the faculty to conduct college preparatory classes in addition to the regular University-level classes. The faculty felt that this task should be performed by the high schools. The Regents' desires prevailed at first, and college-prep classes were offered until 1872. At that time, when there were only twelve houses in Berkeley, 500 students were attending the college-prep classes offered by the University in San Francisco, and another hundred were on the waiting list. Some of the lecture titles have been preserved. Professor Carr talked on "What We Breathe," "What We Drink," and "What We Eat." Professor John Le Conte discoursed on "The Distances and Activities of the Stars." Professor Kellogg, the classicist, communed with his students on "Homer and the True Homeric Poems."

The faculty soon organized an Academic Senate, and even though it met infrequently, it gave the faculty strong powers over questions involving instruction, curriculum, and student discipline. The Regents developed their role, assuming control of faculty working conditions, hiring and firing, and general policy decisions.

The early days of the University were exciting but unsettled. In that atmosphere the faculty had little time for research—and of course, virtually no facilities. The surprise is not that research was so meager, but rather that such men as Eugene Hilgard and Frederik Hesse were able to do anything at all. Talent will out.

Bois Burk

Founders Rock

Where Gayley Road and Hearst Avenue meet at the northeast corner of the University campus, eucalyptus trees and a variety of shrubs provide a parklike setting for Founders Rock.

This dramatic outcropping was torn from the Hayward Fault geologic ages ago. Since there is no rock of similar composition within 25 miles, geologists conclude that it was carried to its present site and thrust upward through the earth's crust by movement of the fault itself.

Today from Founders Rock, one looks out on a busy intersection full of moving cars and hurrying people, a parking garage and a massive complex of campus buildings, relieved by the delicate spire of the Campanile.

By contrast, the view from the rock a century and more ago was a vast meadow, dotted here and there with ancient oaks, and sloping from the Hills to the Bay. Such was the scene in 1860 that met the eyes of a small group of men, trustees of the new College of California, who had chosen the rock as a suitable place from which to dedicate a portion of this land to the cause of learning. So Founders Rock symbolizes the beginning of a great University, now one of the most famous in the world.

In 1866 the selection of a name for the town that would grow up around the college was a matter of great concern. In May of that year the founders of the new college met again at the rock.

Standing on its summit, trustee Frederick Billings, moved by his view of ships at sea beyond the Golden Gate, was inspired to quote poetry.

"Westward the course of empire takes its way," he declaimed.

"Who wrote that?" someone asked.

"Why, Berkeley, the Bishop of Cloyne," Billings answered. "Berkeley! We'll name the town Berkeley."

Not every one agreed at first. But the name Berkeley persisted and eventually became the name of the town and the university.

On Charter Day, March 23, 1896, the senior class commemorated the dedication of the University by attaching a marble plaque to the face of the rock, where students, professors and townsfolk can still see it today.

Again, on April 18, 1910, the *Daily Californian* reported that students, alumni and faculty met at Founders Rock to commemorate the 50th anniversary of the college. That day the main speaker was the Rev. Samuel Willey. Of the board of trustees who had selected the site in 1860, he alone was still alive. Wiley was, at this time, past 90.

Fifty years later, on April 22, 1960, a ceremony celebrating the centennial birthday of the College of California was held at Founders Rock. Among the speakers were Chancellor Clark Kerr, Regent Donald McLaughlin and Governor Edmund Brown, Sr.

Today, the Greek Theater, Wheeler Hall, and the Zellerbach buildings meet many of the ceremonial needs of students and faculty. But Founders Rock remains the uniquely significant landmark it had been when all the rest was barely a dream.

On the 50th anniversary of the founding of the college, Willey had said, "The rock is no longer a stone, but a witness." We agree. Founders Rock has been and is a witness to the history of a great University.

Lillian Davies

The Le Contes

One of the first tasks of the new Regents was to search for distinguished scholars to serve as teachers. It should be recalled that those were the days shortly following the Civil War, when many Southern intellectuals were ostracized for fighting for the South. As a consequence, the Regents were able to draw on a pool of talented Southerners who were eager to move West, where the feeling against them was much less intense than in the East.

The first two scholars found and appointed were the brothers John and Joseph Le Conte. They were born and bred in Georgia on a plantation that included a chemistry laboratory and a lush garden of regional renown.

Both attended the University of Georgia and went on to medical school in New York. John became a chemistry teacher and Joseph worked with Louis Agassiz in Cambridge. Joseph later taught physics, chemistry, geology, and natural history at Oglethorpe University.

The brothers volunteered to fight for the Confederacy during the Civil War, and oversaw the production of gun powder at a plant in South Carolina. By the end of the war, they were ruined financially and had difficulty finding work.

Thus, the University of California was able to recruit the two Le Contes and benefit from their broad experience and knowledge. John Le Conte taught and served as president (1876–1881) and Joseph taught until 1896.

In addition to his teaching on the Berkeley campus, Joseph Le Conte paid many visits to Yosemite, especially in his early years as a Californian. The Sierra Club placed a memorial to him in Yosemite in commemoration of his work there as a naturalist.

At Joseph Le Conte's death in 1901, Benjamin Ide Wheeler described him as "so immeasurably much more than professor, or geologist, or philosopher, that his connection with us and his life among us shine out as brilliant revelation . . . "

The City honors the Le Contes through the street that bears their name and the Le Conte School. The University followed suit with Le Conte Hall. But perhaps the Le Contes' finest memorials were their influence on their students and their effect on the reputation and establishment of one of the world's great universities.

Stephanie Manning

E. R. Sill

In 1874 Edward Rowland Sill was appointed to the University faculty as professor of English. Sill, then 34 years old, was the first prominent writer to live and work in Berkeley.

Sill was a romantic figure, tall and slender, with "cameo-like features only half concealed by a full beard." He had a rich and flexible voice, and some people believed that he might have made a good actor. Instead, his dramatic flair helped to make him an inspiring teacher. He was, as George Stewart wrote of him, "a loved and conspicious figure."

In the beginning his life in Berkeley was an idyll. He and his wife lived in a little cottage covered by flowers. He enjoyed climbing in the hills behind campus, and he liked to ride around town on a handsome black horse. He soon became addicted to camping. And, perhaps to his surprise, he found University teaching engrossing, and even began to describe himself as a "a professor who writes verses." Taking part in the social and literary life of the area, he knew the California writers of the time—Stoddard, Harte, and the others. His poems and essays in *The University of California Magazine*, *The Californian* and *The Overland Monthly* were much admired.

In his writings Sill was not a political activist. His best work has a personal, meditative tone. Congruently, as a teacher he was notable for the personal influence he exerted on his students. William Carey Jones described Sill's teaching career as remarkably successful.

Though he was a success as a teacher, he did not always get along with other faculty members. With Josiah Royce, his assistant, he irritated some faculty members by campaigning to increase the

library's holdings so that poor students would be relieved of the need to buy all their own textbooks.

Sill also advocated women's suffrage and supported the new and controversial idea that women should have full access to higher education. (At the time the University admitted women into programs which satisfied their desire to attend college, but which directed them away from degrees.) Sill wanted coeducation to be, as he wrote, "a complete success." He not only urged full acceptance for women at the University, but also searched for areas of employment for educated women outside teaching.

In 1880 Sill was attacked for spreading atheism through his teaching. Since he had at one time studied conscientiously for the ministry, this attack must have wounded him deeply. Excessively scrupulous in religious matters, he would never have set out to undermine anyone's religious beliefs. (In point of fact, some of his verses can still be found in Unitarian hymnals.)

When President Le Conte was fired by the Regents in 1881, an acrimonious dispute developed on campus as to who would be his successor. The charges and countercharges which followed became so nasty that Sill apparently found them intolerable and resigned from the faculty.

But Sill remained in Berkeley some six months after his resignation. During that time he decided to devote himself to writing on a full-time basis. He collected the best poems he had written during his years on the faculty and published them as *The Venus of Milo and Other Poems*. This privately printed book was the first volume of poetry written in Berkeley. He also helped one of his students, Millicent Shinn, to revive *The Overland Monthly*.

Then Sill returned to his family home in Ohio and became, as he had planned, a "full-time writer." He worked industriously, producing enough poetry and prose to lead some critics to see him as a sort of Matthew Arnold. But in 1887, only five years after leaving Berkeley, he died in the aftermath of supposedly minor surgery. He was only 46 years old.

Sill had kept in touch by letter with his friends in Berkeley—"It is evidence of the irrational attachment one gets (as cats do) to places," he wrote to one of them, "that the Berkeley postmark gives me always a pleasant twinge of homesickness"—and there was grief here at his

passing. The Berkeley Club held a memorial meeting to honor his memory and published its proceedings in a volume which contains tributes by Daniel Coit Gilman, Josiah Royce, Martin Kellogg, Ina Coolbrith, and others. Sill's reputation as a writer grew for some years after his death, and then faded away.

<div align="right">Phil McArdle</div>

Josiah Royce

The philosopher Josiah Royce (1855–1916) was the greatest man connected with Berkeley as a student or teacher in the nineteenth century.

He learned much from Sill, Kellogg, Le Conte, and others on the University faculty—but they were talented, and he was a genius. Frank Norris was the only other Berkeleyan of the time whose accomplishments rival those of Royce. Norris has a permanent place in American literature, but Royce has had a worldwide influence as a thinker.

Royce came to the University from a poor home and needed financial aid. But the University he entered was not the splendid place we know today. It was a small, struggling clapboard school in Oakland—to dignify what it was then with the word "institution" verges on hyperbole. In the 1870s the University was less important in the general scheme of things than a junior college in the Oklahoma panhandle is today.

The University moved out of Oakland into the barren hills which later became Berkeley when Royce was a junior. By the time he graduated in 1875 it had become clear to his teachers that something had to be done to give Royce further schooling, lest his gifts be wasted. President D.C. Gilman raised money from a group of anonymous local businessmen—whose names are still unknown—to send the 19-year old student to Germany where he could study philosophy (a discipline missing from the University's formal curriculum in those days). Before leaving for Germany, Royce wrote to Gilman, "Your influence in getting me this assistance is going to be the making of my whole life."

Royce flourished in Germany. From there he followed Gilman to Johns Hopkins, where he participated in one of the great experiments in American education, met his lifelong friend William James, and completed his doctoral degree.

Then, his career came to a sudden halt. Where, he wondered, could he teach? There were no philosophy departments in those days. Royce had prepared himself for a career which did not yet exist!

While he was wondering what to do, E.R. Sill offered him a position teaching English at Berkeley.

Royce's reaction shows what a difference six years can make in a young man's life: his initial impulse was to refuse. He was afraid that a teaching position at Berkeley, the school which had opened his eyes to the possibilities of life, would become a trap, that once buried in obscurity here he would never again find his way East where he could do the great work his heart was set on. It was a realistic fear. After he swallowed his doubts and accepted the job, his mentor, Sill, wrote to Gilman, saying "He will do excellently well here . . . only, he must not stay too long in this wilderness for his own good . . . "

What a transformation! The University which was the boy's road to freedom suddenly appeared to the young man as a dangerous trap.

Royce, it must seem to us now, was never in any danger of staying "too long in this wilderness for his own good." He had hardly arrived before he began writing letters to Gilman, James, and others imploring them to help him find a job in the East.

These letters are important for the unguarded insight they give into Royce's character. They are also primary documents in the history of Berkeley: they provide a picture of the academic life as it existed here in the early days which is unvarnished by hindsight, sentimental recollection, or the ruddy self-congratulation some of the pioneers indulged in after their struggles were over.

Here are extracts from the letters:

> "After all I doubt whether I can endure the (metaphysical) climate of California for more than some two years, I shall grow consumptive (spiritually) and shall come East for my health." (July, 1878)

> "The classes are attentive and at moments quite bright; but their wants are very elementary, and the supplying of the same more

of a strain on the patience than on the intellect." (September, 1878)

"At Berkeley, as you doubtless know, we live on in a very quiet way, without much to make us afraid, and also without much encouragement, kept alive by our own enthusiasm when we have it, and allowed to come as near death as we choose if we find enthusiasm irksome. The public says very little about us and knows, I fear, even less." (September, 1880)

"Our regents, a miscellaneous and comparatively ignorant body, are by fits and starts meddlesome, always stupid, not always friendly, and never competent or anxious to discover the nature of our work or of our ability." (May 1882)

". . . Californians generally, and on the whole with very good reason, regard one another with profound suspicion and contempt." (May, 1882)

When William James was finally able to arrange for Royce to teach temporarily at Harvard, Royce leapt at the chance:

"In answer to your very kind letter, I telegraphed an affirmative last night, and now await hopefully something official. I am very willing to run risks and to make sacrifices to get a permanent foothold East. Even if they offered me something definite here, I should regard an egg in Cambridge as worth more than a brood of chickens here." (May, 1882)

Out of the provinces and on to glory! Royce's "temporary appointment" led to a permanent appointment and lasted 34 years.

It is only fair to us to add that Royce came back to Berkeley periodically, and his returns eventually became reunions. He grew to love Berkeley, once his ambitions had been achieved, much the way he loved the memory of his own youth.

Phil McArdle

Military Training

The military training program at the University of California, popularly known as ROTC (Reserve Officers Training Corps) has a long tradition and has been the subject of periodic controversy.

University military training had its inception in the Morrill Land Grant Act signed by President Lincoln in 1862. The act stipulated that colleges and universities accepting Federal land donations provide for military training. Specifically, it stated that such land-grant institutions include in their curricula training in military science and tactics, but did not make courses mandatory for all students. Eventually, some 68 colleges and universities, including the University of California, were established under provisions of the act.

The University of California created a strong program. The Organic Act of 1868 provided for compulsory military training. The Regents established the policy that every able-bodied male student was required to take four years of military classes and drills.

When the Spanish-American War began, thirty-five students and two faculty members entered the armed forces as volunteers. University records indicate that, in addition, forty-one alumni, many of them professional soldiers who had earned ROTC commissions, also served.

The ROTC program continued without change until 1904, when the requirement was reduced to two years for freshmen and sophomores. During World War I, one hundred and twenty-one faculty members and more than four thousand students entered the services. When the U.S. Army and Navy underwent a major reorganization between 1917 and 1920, the ROTC for both services (Army and Navy)

acquired its modern form. An amendment to the California Constitution in 1918 affirmed State policy for compulsory military training at the University.

Alumni have vivid memories of the University's military program. Military uniforms were issued during the first week of each semester, which was also freshmen initiation week. Students had to carry their uniforms around campus at this time. Some freshmen were compelled to wear the coat inside out during initiation by the sophomores in order to make them look foolish. Especially when the sophs made the frosh roll peanuts down Telegraph Avenue!

The military uniforms were not comfortable. The coat had a stiff collar and a detachable white collar attached to the inside of the coat collar. Both collars often pressed or rubbed against the neck. The pants were wrapped around by leggings, called puttees, which took the wearer much time to roll and reroll around the legs. Occasionally a cadet's leggings would unwind and slip down during drill. Naval ROTC cadets were better off because their uniforms had no leggings. The uniforms were especially hot on warm days.

After drill at noon, students often changed into civilian clothes at the Men's Gym, leaving their uniforms in lockers. Students who had to hash at fraternities, sororities and boarding houses had no time to change. At least that was better than many high schools in the Bay Area which had compulsory military programs. Those students usually wore their uniforms all day long, being too far from home to change clothes.

Over the years, students protested and rebelled periodically against compulsory military training. Student rallies against the program occurred in the 1870s, 1880s, 1930s and 1960s. Peace-loving students, particularly resented hard-boiled instructors from the U.S. Army teaching them the art of killing. Student protests may have contributed to the University's reducing the military training required from four to two years in 1904.

The student protest in later years was linked to the anti-war movement that spread among university campuses at home and abroad. As Verne Stadtman pointed out in his scholarly history of our University, compulsory ROTC was "an immediate and highly visible manifestation of militarism," a prominent target for pacifists. In 1934, two students at UCLA were suspended for refusing to participate in

ROTC drill. Sons of Methodist ministers, they gave conscience as their reason. They appealed their case to the U.S. Supreme Court on grounds that compulsory military training was contrary to the Fourth Amendment of the U.S. Constitution and in violation of the 1929 Kellogg-Briand Pact outlawing war. The high court denied their argument. Nevertheless, their cause continued to be a live issue for years afterwards.

The spark for an international student anti-war movement was struck by students at Oxford University in England who pledged in 1933 that under no circumstances would they "fight for king and country." Many American students also took the Oxford Pledge and refused to support any war undertaken by the U.S. government.

In the Spring of 1935, an Anti-War Committee at the University of California issued bulletins which included a call for local support of a national student anti-war strike in April. The Berkeley police arrested 18 students for distributing leaflets in violation of a City ordinance. After a showdown involving students groups, and University and City officials, the City revised the ordinance and charges against the arrested students were dropped. The national strike was held in Berkeley in April, as scheduled. An estimated 2,000 students attended the rally—including spectators and demonstrators—outside the University entrance at Sather Gate. The calm and orderly meeting resulted in resolutions condemning both military training and the arrest of activist students.

Thereafter the issue flared up periodically. In February 1936, the Berkeley students voted by ballot 1,281 against and 537 for compulsory ROTC. In the following month, however, the Regents reaffirmed existing policy, which they maintained was required by law and was academically sound. Public debate continued on the issue down to the beginning of World War II.

The debate stopped, of course, after Pearl Harbor, and was not revived again until after the end of World War II.

Bois Burk

Football

Cal football has come a long way since its inception on November 3, 1877. On that day the contest was between the freshman class and the sophomore class.

There were no uniforms and no stadium in the early days—in fact there was no intercollegiate opposition. Although Eastern schools such as Rutgers and Princeton had been playing since 1869, the West had yet to develop a formal intercollegiate athletic program.

From 1877 to 1885 the Cal team resorted to playing the Phoenix Rugby Club of San Francisco, the Merions, the Allies, the Wanderers and the Wasps, all private rugby football clubs. The games were played at the old Recreation grounds in San Francisco and were attended by an average crowd of 350 enthusiasts.

American football was not played on the West Coast until 1886, when Oscar Shafter Howard arrived and began training the various teams. On January 16, 1886, the first game was played between Cal and the Wasps. Cal won 20–2. Thereafter the Bears' arch rivals were the Orions, a private club from Oakland, and three other teams that together formed the California Football League.

The attendance at two of the early 1886 games with the Orions surpassed 3,000, a figure that would not again be reached until the first Big Game with Stanford in 1892. By this time Cal had developed quite a reputation and eventually ended the season with 6 wins and 2 losses.

From 1887 to 1890 Cal lost only one out of 15 games and this was to a team called the "Posens" (named after Sam'l O'Posen, a popular stage character portrayed by Berkeley actor Maurice Curtis). How-

ever in 1891 the Bears played only one game and lost miserably to a San Francisco club 36–0.

It was not until 1892 that Cal got its first crack at playing a college team. In 1891 Roy Gallagher, the team manager, decided to challenge Stanford University. Stanford accepted but had one big problem—no football team. It rushed to put one together and by March 19, 1982, the two teams were ready for the first Big Game. A total of 9,500 people showed up to watch Stanford win 10–1.

Cal could not wait for revenge and quickly challenged Stanford to another game on December 17, 1892. The schools entered into a contract to play every year on Thanksgiving Day. The December 17 game drew a record crowd of 18,753 and it ended in a 10–10 tie. The game had great significance because it established collegiate football as a major athletic event in the West.

The story of the Big Game would not be complete without mentioning the Axe. The Axe is traditionally passed to the winner of the Big Game—Stanford or Cal. This tradition began in 1899 when Stanford brought the Axe to a Cal-Stanford baseball game and flourished it at Cal supporters.

At first everyone took it all in good fun. But as Cal (the underdog team) proceeded to trounce Stanford, the Cal supporters became irritated by the Stanford crowd and its Axe. The Axe changed hands, a fight ensued, and much chasing through the streets took place as each side tried to get hold of the Axe. The Axe's handle was sawed off during the hubbub and the head smuggled by Clinton Miller to Berkeley.

Stanford rooters attempted many times to recover it but failed until 1930 when they nabbed it in transit to a bank where it was kept. In 1933, after much discussion, the Axe became the trophy of the Big Game and has remained a tradition ever since.

From 1905 to 1914, due to the urging of UC President Benjamin Ide Wheeler and others, American football was once again forsaken for rugby. Despite this period away from American football, Cal went on in later years to develop its greatest team, "The Wonder Team."

Coach Andy Smith was lucky to have many greats on this team in 1920, including Brick Muller, Brodie Stephens, Bob Berkey, Archie Nisbet, Stan Barnes, Dan McMillan, Fat Latham, Cort Majors, Lee Crammer, Charley Erb, Pesky Sprott, Crip Toomey and Duke

Morrison. Their very nicknames struck fear in the hearts of opposing teams. Cal went on to win all nine games that season and attracted a crowd of 42,000 at the Rose Bowl.

Football's rich folklore helps to make Cal's team one of the most beloved subjects in the life of Berkeley, and an integral part of our heritage.

Stephanie Manning

Mens agitat molem

BERKELEY.

FROM AN ORIGINAL OIL PAINTING.

George Berkeley

Berkeley Historical Society

The shaded area shows the Costanoan Indian territory in the
mid-18th century.

Adapted from the University of
California Map Series No. 11

Mortar Rock.

Curt Manning, Photographer
Berkeley Historical Society

Berkeley Creeks (1975).

Courtesy of the Berkeley Planning
Department

The intersection of San Pablo Road and the road to the hills.
Domingo Peralta lived in this house (now the site of 1505
Hopkins Street) in 1851.

Courtesy of the Bancroft Library

Bowen's Inn, Ocean View (1880).

Mathilde Wilkes

93

J. Ross Browne.

Sam Heywood.

North of Campus, looking East from what is now known as "Holy Hill." Euclid Avenue will run north-south just below the hill in the immediate foreground. The trees on the right grow along the north fork of Strawberry Creek. The present intersection of La Loma and Le Conte Avenues will lie beyond the barn and to the right (c. 1880).

Berkeley Historical Society

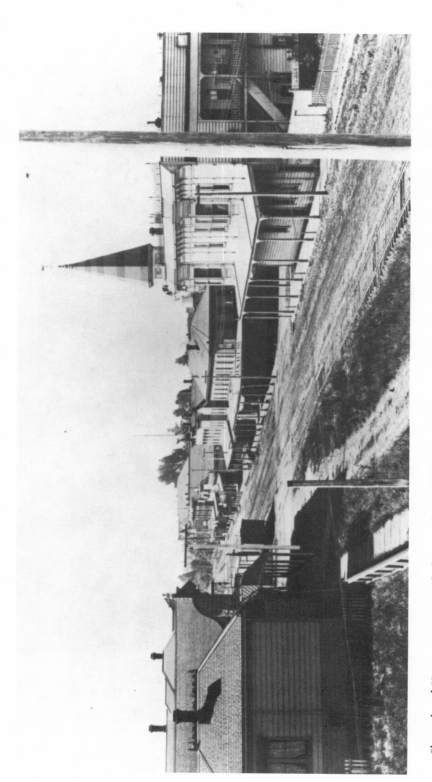

Shattuck and University Avenues, looking south on Shattuck (c. 1892).

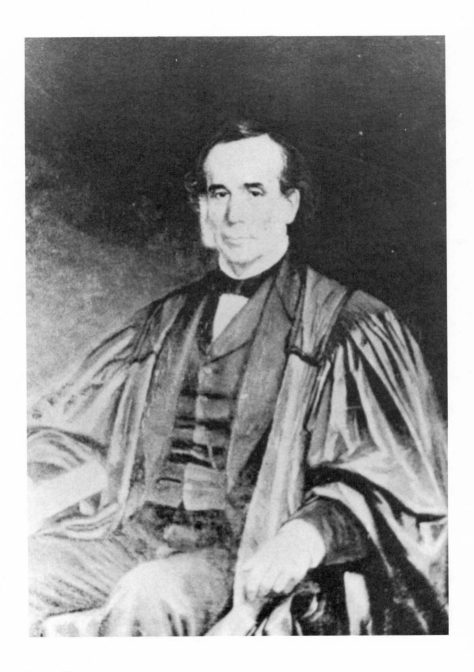

Henry Durant.

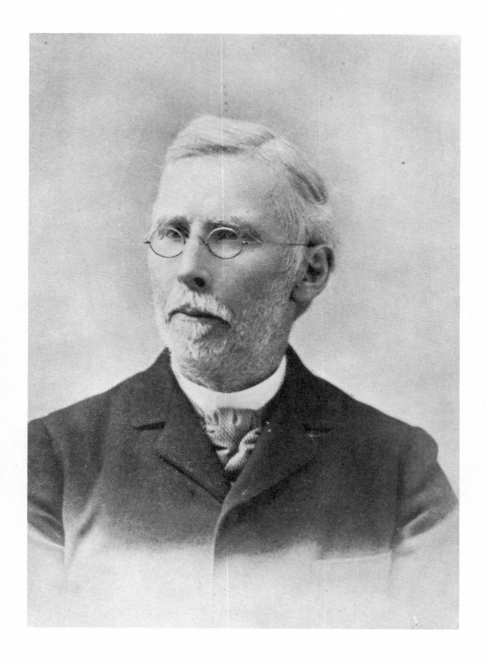

Martin Kellogg.

99

Kellogg School on Oxford Street between Center Street and
Allston Way (c. 1880).

Courtesy of Louis Stein

General Merchandise Store, Shattuck and Dwight Way
(1885).

John and Joseph Le Conte.

102

Berkeley's waterfront in 1885, with the Standard Soap
Company and the ferry landing in the foreground. The
University community is represented at the foot of the hills
to the far left and West Berkeley (Ocean View), on the shore
to the right. A Central Pacific train is arriving from Oakland.

Berkeley Historical Society

· OAKLAND TERMINAL DEPOT PIER · A VIEW LOOKING WEST ·

The western, terminal station of the Central Pacific Railroad, shown above, is situate near Oakland, upon a pier of earthwork and rock running out into San Francisco Bay from its eastern shore a distance of 1¼ miles, having a wharf and ferry slip at its western extremity.

The building is constructed in three main divisions longitudinally. The central part is 120 feet wide and 60 feet high, and accommodates overland trains, and the divisions on either side of this are 60 feet wide and 40 feet high, being exclusively for suburban trains running to and from Oakland, Alameda and Berkeley, connecting with the San Francisco ferry steamers.

At the west end of the main or central division are two commodious waiting-rooms for passengers. The upper or main waiting-room, 120 x 120 feet, connecting by side aprons with the saloon deck of ferry steamers, and the lower waiting-room, connecting by end apron with the main deck of steamers, give quick and easy passage to and from the boats.

The building also contains a restaurant and various offices and apartments for railroad employees.

The structure, 1000 feet total length, covers an area of over four acres, and is constructed mainly of wood and iron, the supports resting on concrete and pile foundations. The roof, covered with corrugated iron and glass, gives abundant light during the day, and at night the building is illuminated with electric lights generated by machinery on the premises.

In the grandest 19th century railroad cathedral style, and the largest edifice in the State of California, the western terminus of the Central Pacific Railroad in Oakland, where Berkeley passengers made the train-to-ferry transfer on their way to San Francisco (1885).

Berkeley Historical Society

View of Berkeley, with San Francisco to the left of the Golden Gate. Berkeleyans frolic in the hills in the foreground, and the Bay is covered with ships and ferryboats (c. 1885).

Berkeley Historical Society

The Advocate office and the drug store at Shattuck and
University Avenues (1885).

106

Edward Rowland Sill.

Josiah Royce

Cattle on the Hills (1889).

O.V. Lange, Photographer
Berkeley Historical Society

On Shattuck Avenue, looking east toward Oxford Street. Strawberry Creek to the left now flows under Allston Way. The church is on the corner of Allston and Oxford (1889).

O.V. Lange, Photographer
Berkeley Historical Society

Looking north on Fulton-Oxford. The electric light pole is at Durant, and the church is at Allston Way (1889).

O.V. Lange, Photographer
Berkeley Historical Society

A view of the northwest corner of the Campus. Oxford Steet lies beyond the buildings in the foreground and intersects with Hearst Avenue on the left (c. 1902).

Courtesy of the Oakland Historical Room, Oakland Public Library

A view of the Campus. Berkeley Way is in the foreground and intersects with Oxford Street to the left. The House is on the southwest corner (c. 1902).

Courtesy of the Oakland History Room, Oakland Public Library

Vine Street to the left intersecting Shattuck Avenue at the railroad track. Schoolhouse Creek, just beyond the cow, is now filled land. The trees on the peak are a landmark, known as King's Crown (c. 1885).

Lincoln Steffens.

115

Frank Norris.

Douglas Tilden.

Phoebe Apperson Hearst.

Benjamin Ide Wheeler.

119

SHATTUCK AVENUE.—BERKELEY.

2156　　　2154　　　SHATTUCK BLOCK　　2148　　　2144　　　2142　　　2140　　　CENTER ST.

2156. BERKELEY PUBLIC LI-BRARY.

2154. WOMEN'S EXCHANGE,
Telephone 223 Red. Orders Taken for All Kinds of Work. Ladies Supplied with Help.

2152. THE OAKLAND SHOE HOUSE.

2148. BERKELEY BAZAAR,
H. R. Sorensen, Prop. Crockery, Glass, China, Silverware, Cutlery, Ornaments, Lamps and Household Goods.

2144. SCHMITT & ZEHNER,
General Hardware, Tin and Agateware.

2140. JOS. J. MASON,
Real Estate and Insurance.

2142. COMMERCIAL BANK,
F. K. Shattuck, Pres.; A. W. Saylor, Cashier

MRS. J. DOW.
2171 Center St. Dressmaker. Cutting and Fitting a Specialty.

F. V. BAER, Druggist

POPULAR RESTAURANT
and Oyster House. H. Mattison, Prop.

MRS. M. ASHWORTH, Variety Store.

Shattuck Avenue (1896).

Berkeley Historical Society

UNIVERSITY AVE.

2038 2036 2034 2032 2020 2010 2000

SHATTUCK AVENUE.—BERKELEY.

2038. LANCASTER BLOCK,
Joseph Lancaster, owner.

2038. H. D. KELSEY,
Druggist. Prescription Pharmacy.

2052. DR. G. B. HOAGLAND,
Rooms 3 and 4. Hours 1 to 4 and 7 to 9 p. m.
Telephone 75 Main.

2036. J. M. McNAMARA,
Stove, Ranges and Household Goods, Plumbing, Tinning and Gas Fitting.

2034. MERCER & GRAHAM,
"Two Friends" Barbers

2020. A. EARLANDSEN,
Berkeley Hardware and Repairing Shop. General Hardware, Tinware and Household Goods.

2010. W. G. CLARK & CO.
Interior Decorating and Paper Hanging Fresco Painting, House Painting, Tinting and Kalsomining.

2000. C. DEMETRAK,
Groceries, Fruits and Provisions, Whole-ale and Retail.

S. FISCHEL & CO.
Liberty Meat Market. All kinds of Fresh and Salt Meats. California Hotel Building.

Shattuck Avenue (1896).

Cannon practice on Campus. The ROTC cadets are wearing
Union Civil War uniforms (1890s).

Bayonet practice on Campus (1899).

123

The Berkeley (1898–1958) was thought to be one of the
"great white ladies" of the Bay.

Courtesy of the Southern Pacific

The Faculty, Columbus School (c. 1901).

Hugo Weitz, Photographer
Berkeley Historical Society

Berkeley public school boys (c. 1901).

Hugo Weitz, Photographer
Berkeley Historical Society

126

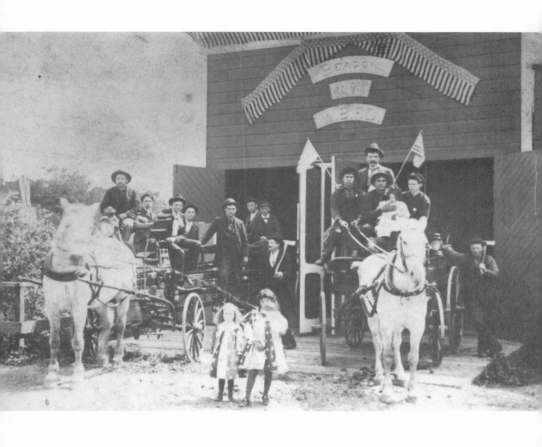

Volunteer Fire Department, Beacon Station, Fifth Street,
north of University Avenue (1903).

Courtesy of the Berkeley
Firefighters Historical Committee

127

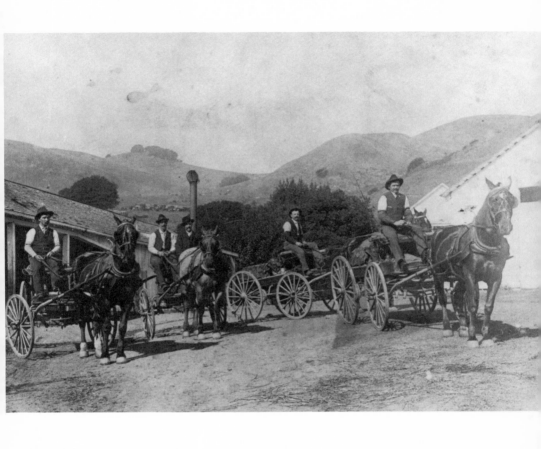

Berkeley Farm Dairy in Strawberry Canyon (c. 1905).

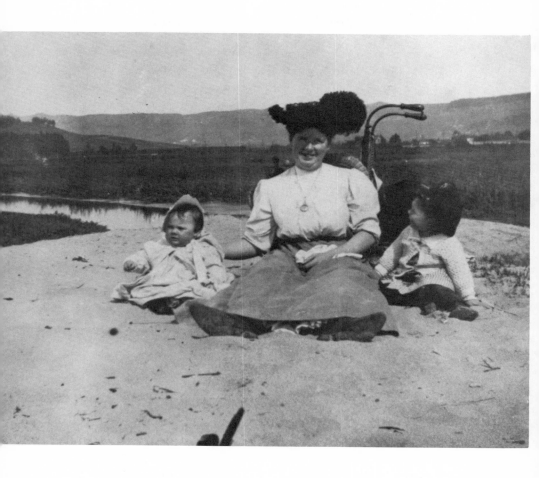

On Berkeley's Beach (1908).

Courtesy of the Charles Moisan
family

Earthquake, April 18, 1906: early in the morning, the chimneys fell through the roof of Berkeley High School.

The cornice of the Barker Block at Shattuck Avenue and Dwight Way fell to the sidewalk (1906).

San Francisco caught fire. The fire from Adeline and Oregon Streets (1906).

Courtesy of Bethany Westenberg and the Berkeley Architectural Heritage
Association

Refugees from San Francisco at California Field, University of California campus (1906).

San Francisco burned for three days. The fire from North Berkeley (1906).

BUILDING THE CITY

Incorporation

In the 1860s and early 1870s Berkeley was part of a large area governed by the Alameda County Board of Supervisors. Its future—whether it was to continue in that status, or be annexed by Oakland, or incorporated as an independent city—became an issue in June, 1874, owing to various problems arising in Ocean View, the most developed section of Berkeley, and East Berkeley, the campus area.

Ocean View was largely a farming community, but it was beginning to develop an industrial base. The East Berkeley community was also in the middle of a farming area, but the interests of the two areas were obviously dissimilar.

The dusty, muddy roads, the large number of cows, horses, goats and chickens wandering around, and the lack of local authority to license and control saloons were among the reasons Henry Durant called a town meeting to discuss the future of the area. Although Durant was Mayor of Oakland at the time, he felt that Berkeley should be incorporated as an independent town. Horace Carpentier, the richest man in Oakland, owned property in Berkeley, and it was his position that the Berkeley area should be annexed by Oakland.

The 1874 town meeting was attended by University men like Professors Rising and Dwinelle and other leading citizens of Ocean View and East Berkeley, such as Captain Jacobs, Francis Shattuck, James Edgar, James McGee and William Ashby.

According to George Pettitt, most citizens of what became Berkeley opposed both ideas for change—annexation and incorporation. John Dwinelle warned that Oakland was heavily in debt, and that if Berkeley was annexed by Oakland, residents would share

responsibility for Oakland's debts. This led to a rejection of Carpentier's hopes.

But Berkeley's farmers, who were still in the majority, were fearful that land values would increase if the town was incorporated and that taxes would rise to pay for the improvements new residents would deem essential. This would lead, they saw, to the end of their farms. The opposition of the farmers was decisive, and the first move to incorporate the City failed.

With ferry service to San Francisco from the wharf at the foot of University Avenue, Ocean View continued to grow faster than East Berkeley. For example, gas mains were installed in Ocean View four years before the same service was available in the campus area.

In December, 1877, Martin Kellogg, the University's Professor of Latin and Greek, revived the issue by calling another town meeting to discuss incorporation. Again there was opposition, this time on the grounds that the proposed district had a population of only 2,000 residents—one person for every four acres. According to William Ferrier, it was argued that,

> The centers of population are so remote from each other and have so little in common that it would be impossible to have a system of police or improvements. This would lead our councils to intrigue, bargaining, corruption and a big debt.

But the Kellogg committee went to the Legislature with a petition for incorporation. The petition contained the names of Professors Hilgard, Kellogg, William C. Jones, E. R. Sill, Joseph Le Conte and George Edwards. Farmers like Woolsey and Carleton also signed it. In fact, nine-tenths of the property owners in the area of the proposed town signed the petition. It passed both houses of the Legislature and was signed by the Governor on April 1, 1878.

The first Berkeley election was held on May 13, 1878, to select the following officers for the new City government: a Board of Trustees (who would choose one of their own members as president), six school directors, a town clerk, an assessor, a constable, and two justices of the peace.

Two parties formed: the Citizens Party, which was backed by farmers, merchants, and East Berkeley residents; and the Working-

man's Party, which had its strength in Ocean View. The Workingman's ticket was a misnomer in a sense, since grocers, saloonkeepers and clerks were on its slate, but it also represented unemployed and underpaid workers. (The Workingman's Party was part of a larger movement formed in response to a state-wide depression then causing economic problems.)

The *Advocate* (forerunner of the *Gazette*) supported the Citizens' ticket. The Workingman's Party swept the election.

Early city government was relatively informal. During 1879 the town hall was located for six months at 6th and Delaware. For the other six months of the year, the City's headquarters were in an office on Shattuck Avenue. This political and sectional compromise continued until a permanent city hall was built at Sacramento and University in 1884.

Berkeley is a charter city, which means that its governmental structure, powers, limitations, and procedures are set forth formally. The charter of 1878 has been amended from time to time—in 1895, 1909, 1915, and 1923—by vote of the people. It is the source of local authority in all municipal affairs, limited only by the State Constitution.

The current Charter provides for a city manager form of government. This consists of an elected council and a hired executive—the City Manager and his staff. He is directly responsible to the Council and can be removed by majority vote. The Council may not interfere with any department or individual civil servant but, of course, may inform the Manager of its opinions.

The Manager appoints department heads, chief officials, and other employees, subject to civil service regulations. He attends all Council meetings and is supposed to have answers to everything immediately. John N. Edy, City Manager in 1928, said that the city manager form of government is not merely "another administration. It is another *kind* of administration—more responsible, more business-like, more definite."

Bois Burk and Florence Jury

Sam Heywood

Samuel Heywood, who served on the Board of Town Trustees in the 1880s and 1890s, was born on November 16, 1833 in New Brunswick, Canada. He was the fourth of ten sons born to Zimri Brewer Heywood, who came to California to seek his fortune. When Z.B. came around the Horn in 1850 aboard the ship Ida with seven of his children, he was rather poor; but by the time he settled in the Bay Area, around 1860, he had amassed a considerable fortune in the lumber trade.

The exact date of Z. B. Heywood's arrival in Ocean View is uncertain; however, we do know that his son, Charles, a rancher, had arrived by 1860. By 1870 Z. B. Heywood had joined with Capt. James Jacobs to establish the Heywood & Jacobs Lumber Yard and Wharf, which was one of Ocean View's first industries.

Sam Heywood and his brother William ran the lumber business for many years. In 1874 he built a home for himself at 812 Delaware, and he and his family became identified with the west end of town.

During the 1870s, West Berkeley grew into a fully operational village with homes, churches, schools, shops and factories. When East and West Berkeley incorporated in 1878, the west end was anxious to be well-represented on the new governing Board of Town Trustees (which evolved into the City Council in the early 1900s). Thus, Sam Heywood, a well-liked, experienced businessman from a pioneering family, was not only elected to the board in 1882, he also served as president of the board, a position equivalent to that of mayor, until 1884.

In 1885 he was elected to the School Board and again in 1890 to the Board of Town Trustees.

140

Sam Heywood epitomized West Berkeley. He held many social functions in his elegant home on Delaware Street and he helped organize and raise money for the Church of the Good Shepherd, built in 1878.

He was best loved for helping his neighbors after the great fire of 1893 that burned down several dwellings and shops at Sixth and Delaware. He helped finance the rebuilding of these structures and the laying in of pipes and water mains to prevent future fire disasters.

Sam died in May, 1903. He left a wife, Emma, two sons, three daughters and many grandchildren, several of whom still reside in Berkeley.

Stephanie Manning

Based in part on research of
Lt. Col. Samuel Heywood Oakley

Volunteer Fire Departments

In the early days Berkeley depended on the volunteer efforts of its people in handling local disasters like fire and floods. It was commonly understood that each person assumed responsibility for protecting his property, whether it be his homestead, a store or factory.

As the community grew, local citizens formed volunteer fire departments which obligated their members to appear at any fire armed with buckets, hoses, and ladders to fight the conflagration. Fire-fighting equipment, such as hose carts, hook–and–ladder wagons and other specialized apparatus, was acquired with funds raised through public subscription or special events like banquets, picnics and exhibitions. In time, the volunteer firemen formed into exclusive clubs with a strong esprit de corps centered on the neighborhood companies and brigades which often competed against each other to see which was the best in town. Membership in such clubs was by invitation and almost obligatory for ambitious politicians vying for public office.

The first volunteer fire company was organized in July 1882 in West Berkeley after three buildings had burned to the ground in the three previous months. The first equipment comprised a new hose cart and a second-hand "pumper" engine which were housed in a small barn on 5th Street near University. Later the fire station was dubbed Beacon Number One and in 1883 the Town Trustees appropriated $75 for a hose "without leaks."

Other volunteer companies were organized during the course of the decade. In East Berkeley, a hotel on Telegraph and a union hall with two other buildings on Shattuck went up in flames before local

citizens took action. The Columbia Company was formed with volunteers from the business and University communities and was headquartered on Addison near Shattuck. A third company, Posen Chemical Number One, was organized in 1887 with an imposing station on 6th Street near Bancroft. The fourth company was the Peralta Hook–and–Ladder Number One, organized after 1890 and located on Russell near Shattuck.

The Depression years of the 1890s spelled hard times for the organization of the volunteer firemen. Columbia Company disbanded in 1894, leaving the East Berkeley area without adequate fire protection until 1897 when students organized the University Fire Company. The pioneer company, Beacon Number One, narrowly avoided dissolution in 1895.

Nevertheless, by the end of the decade, Berkeley had a substantial volunteer fire department of seven companies, including the addition of three auxilliary stations, Berkeley Hose on Vine and Shattuck, Alert Hose on Shattuck near Haste, and the Lorin Hook–and–Ladder Number Two on Alcatraz.

The volunteer fire department reached its zenith at the turn of the century. The volunteers served without compensation. Each company received $5 a month for the care of each horse. Two companies, Beacon and Columbia (before dissolution), occupied good buildings owned by the town but the other companies were housed in rented quarters. All companies were fairly well equipped with the necessary fire-fighting apparatus. In 1902, the department established the "callmen" who were paid $5 a month to sleep at the station ready to go out on call.

In 1904 the City replaced the volunteer organizations with a full-time, paid fire department. James Kenney, who had served as the volunteer chief since 1896, was appointed the first paid chief in 1904. The disbanded volunteer firemen, a close-knit group tied by years of strong friendship, formed an association to sustain their tradition with a historical museum and annual banquets. It survives today as the Veteran Volunteer Firemen's Association of Berkeley and maintains a close relationship with the Berkeley Fire Department.

Edward Staniford

Public and Private Schools

What was the Kellogg School and for whom it was named? Therein lies a tale worth telling, for in it we can see the interplay of elements in the creation of a University town.

The Kellogg Primary School opened for classes in January 1880. It was the first public school built after the formation of the City. The need for schools was one of the principal reasons for incorporation, and a grateful community named it in honor of Martin Kellogg, Professor of Latin Languages and Literature at the University of California. He was the man-of-the-hour, having chaired the successful meeting which led to the union of Ocean View and Berkeley.

The school was located between Center Street and Allston Way just below the entrance to the University grounds on Oxford Street. Because there was no money available, businessmen F.K. Shattuck, J.L. Barker, George Dornin and A. Bartlett advanced $2,800 to secure five lots. Money for the building, the sum of $3,365, was lent by George D. Metcalf, J.H. Haste, J.L. Barker and Professor W.B. Rising. There were separate entrances for boys and girls in the three-classroom building designed by architects Samuel and J.C. Newsom.

In this school building one day in 1884, the pupils were asked to write on "A View From the School House Door." One boy eleven years old wrote:

> Just a little west and back of the public school house is a picturesque group of oak trees. Nearly all of them are wide-spreading and tall and furnish fine seats for the school-boys to eat their luncheon. In spring when the leaves are green and the

144

luxuriant grass is like a velvet carpet, groups of artists come to sketch this beautiful scene. A brook runs through the center of the grove and the water bubbling over the rocks with the soft murmuring of the leaves makes the delightful music so pleasant to hear. Just outside the group is a dilapidated barn, under the eaves of which the swallows build their nests in summer . . . On a clear summer day you may see west of the school a creek the banks of which are covered with old oak trees—so old that the trunks are as hollow as bottles. The banks of the creek are very straight and the creek is as wide at the level of the water as it is at the top. The water flows placidly along under the bridges and jumps over the rocks . . . The creek has been called Strawberry Creek on account of its banks being almost lined with strawberry vines.

The first high school classes were held there. In 1884, with four graduates, it became the first accredited high school in California. Music and art were introduced and the school boasted an orchestra and mandolin club.

Essentially a preparatory school for the University, it alienated the working class people in West Berkeley who felt that if parents wanted to prepare their children for college, they should pay for it themselves.

Bond issues to build a new high school failed in 1896 and 1898, but finally bonds were approved in 1900. The cornerstone of Berkeley High School was laid in 1901.

The Berkeley High School annual began in 1895 as the Crimson and Gold. Later the name was changed to Olla Podrida. The 1909 Olla Podrida mentioned performances of noon concerts. In fact many who played the violin and sang in the concerts were UC students. A glee club and debating team were going strong in 1909 which was also the first year the senior class succeeded in winning the annual baseball game with the faculty.

In 1911 the old Kellogg School building was rented to the California College of Arts and Crafts. It was used until the college moved to Oakland in 1926.

The first public school in the Berkeley Area was an elementary school established in Ocean View in 1856. It was on San Pablo Avenue at Virginia Street, near the current Franklin School.

145

Mary Hyde started the first Berkeley private school in 1877 on the banks of Strawberry Creek, near Faculty Glade. A year later she combined her classes with the Berkeley Gym, a newer private school on Dana Street near Allston Way. The principal of the Berkeley Gym was John F. Buris, and the combined schools offered primary and secondary classes.

In 1877, Ella Bynon also started a Select School for Boys in a vacant store on 6th Street near Delaware in West Berkeley.

The third Berkeley private school was started by A.W. McArthur on Shattuck Avenue at Berkeley Way. Later McArthur's school became the public high school when it was taken over by the Trustees and moved into the newly constructed Kellogg School building on Center Street.

Subsequently, there have been many schools, private and public, in Berkeley serving the different educational needs of the community.

One of the best known of Berkeley's private schools was Boone's Academy, one building of which is still standing at 2029 Durant Avenue. Established in 1881, it lasted until 1915.

The A-Zed School began its career at 2401 Channing Way, and later moved to 2038 Telegraph Avenue.

The Beaulieu Boarding and Day School for Girls was at 2207 Dwight Way in the 1890s. The rules at this school allowed only one visitor a month, no cake or candy, and fruit was the only snack allowed between meals. Young ladies were permitted off the campus only once a month if escorted by a parent.

The Harmon Seminary for Girls on Atherton Street ceased in 1887. Its building was later used as a new location for the Berkeley Gym. "Some students were expelled from this school when found in saloons," according to the May 1880 *Berkeley Advocate*. Later public school classes were held there and after that it was used as a temporary home for the Pacific School of Religion. It was razed in 1931 to make room for Edwards' track.

The Pacific Kindergarten Normal School under Froebel Educational Associates was established in 1879 on Dana near Allston.

When the Peralta Park Hotel venture failed, it became a ladies seminary. Later it became the Dunn School for Boys. In 1930, it became St. Joseph's Academy and lastly St. Mary's High School.

146

In 1907, Adelaide Smith, Wellesley '93, was a teacher at Emerson School and in 1914 was principal of Snell Seminary at 2337 Piedmont Avenue. In 1923 she started the Wellesley School at 2429 Channing and it was mainly a tutoring school up to the 1950s.

The Cora Williams School on Arlington Avenue began in 1918. The students progressed at their own pace jumping from one subject to another as soon as the first subject was assimilated.

Many other schools might be mentioned, but we will close this sketch with one of the most illustrious, and longest standing—the Anna Head School. It opened at 2538 Channing Way in 1887, and operated in Berkeley until 1964, when the University took over the property on which it was located. It began as a co-educational school, became a school for girls, and then became co-educational again in 1964, when it merged with the Royce School for Boys in Oakland.

Bois Burk and Ellen Drori

The Ferries

Today San Francisco Bay, ringed by its three great bridges, is a world apart from the days of the ferry boats. In *San Francisco Bay Ferry Boats*, H. George Harlan has described those early days vividly:

> Dotted among ships from the seven seas . . . the ferries offered contrast. Most were white, some were orange, others yellow, a few red or even olive green. Life and movement they brought, as well as color, for they were always on the go, converging on San Francisco from various points to the North and East, followed by seagulls whose white markings matched the broad mile-long wakes behind the moving boats.

John Marshall, by discovering gold on the American River in 1848, unknowingly created the need for the ferry boats. Throngs were leaving the East by land and by sea to seek wealth in California. The Bay Area became their point of departure for the gold fields, and for many it was also the point of return, empty-handed. The ferries met the need for transportation.

The first ferry was Captain Thomas Grey's small river boat, the Kangaroo, put in service in 1850 between San Francisco and the Oakland Estuary. Two years later Charles Minturn received from the town of Oakland the first ferry franchise. Minturn's boat, the Antelope, had the honor of carrying mail for the Pony Express on its first run between Sacramento and San Francisco.

Ferries were, at first, single-ended river boats. These were soon replaced by double-ended vessels which did not have to turn around

148

at the end of each trip. Captain and crew simply moved from one end of the vessel to the other.

The Southern Pacific Railroad, in 1893, was the first company to establish a continuous land-bay operation, with its big red trains carrying passengers from Thousand Oaks in Berkeley to the Oakland Mole. There the "great white ladies," as the Southern Pacific ferries were lovingly called, took over for the trip across the bay to the Ferry Building, the central terminal for all lines. Hurrying crowds dispersed up Market Street to do business or to go on shopping sprees.

In 1903 the Key System, a combination of small independent lines, began regular passenger service with handsome orange trains and boats. The Southern Pacific and the Key System were not the only lines, but they were the giants.

Elegant design and superb construction typified the ferries, especially the early ones. Wooden hulls, expertly crafted, were later replaced by hulls built of steel. Steam engines, in the course of time, were replaced by electric turbines. Steering was by sight and sound. The low melodic warnings of the fog horns are part of an unforgettable past.

In the early days the lower decks were rough hewn, carrying horses, and even cattle. On one occasion a herd of cows broke loose, some climbing to the upper deck and startling stylish passengers en route to dinner and the theater in San Francisco. Upper decks were often luxurious, with stained glass partitions, red velvet seats, and potted palms. The topmost or hurricane deck with its two pilot houses was reserved for officers and infrequently invited guests.

The mechanics of the ferries fascinated children. With noses pressed against the glass on the cabin deck, they spent whole trips gazing at the magical workings and constant movement of rods, beams and other engine parts. Lucky was the child who on clear days might be invited up to the hurricane deck by the captain to blow the whistle. Travel by ferry represented a leisurely way of life which set the pace for cities by the Bay. One might enjoy a ferry breakfast, a reading of the morning paper, a game of cards with cronies, or simply a chance to feed the gulls from bags of bread crumbs brought from home. And for regular commuters to San Francisco there was always the delight of the approaching skyline, ever changing in the morning

light; and on the return to the East Bay at evening, the lights of the towns sparkling below the Hills.

The great bridges, by satisfying the public's hunger for speed, brought an end to the ferries and to their pleasant mode of travel. The Key System wharf was demolished after the trains were rerouted over the Bay Bridge. But the ferries will always be remembered for giving the best in service, for making each trip a joyous adventure, and for influencing the progress of the Bay Area.

Lillian Davies

Joseph Mason

Berkeley in the 1880s presented good business opportunities to those with the foresight to understand the needs of a growing community. One of the most pressing needs was for homes to house the ever-increasing population.

Joseph J. Mason was one of the first in Berkeley to make it his vocation to supply this need. In 1887 he opened a modest real estate and insurance business on Shattuck Avenue at the Dwight Way Station. Shattuck Avenue was then an unpaved dirt road, delineated by the narrow gauge tracks of the Southern Pacific Railroad. Mason chose Shattuck Avenue and Dwight Way because it was one of the stops of the S.P. steam trains that rattled past, carrying passengers to and from Oakland. The area around the station was a lively one. Mason rented a small wooden storefront on the southeast corner of the intersection and had "J. J. Mason, Real Estate and Insurance" painted across the front. His name was highlighted by a large red diamond.

The proprietor of this new business was a newcomer to Berkeley. Mason had arrived in San Francisco almost 20 years earlier, in 1869, from his native London. According to his grandson, George Emanuels of Walnut Creek, who has done extensive research on Mason's life, Mason left England because he could not find work there. In search of work so that he could marry, he arrived in San Francisco at age 24. There he did find a job as a porter on the docks, and by 1872 his financial position was secure enough that he could send for his future bride.

George Emanuels writes that during the time they lived in San

Francisco, the Mason family liked to take picnics in the East Bay. They would ride over from San Francisco on the ferry, and then board the steam train which took them out to Berkeley. Mrs. Mason was especially attracted to Berkeley because, in the springtime, its open, green hills reminded her of her native Scotland.

While he was working as a porter, Mason was constantly on the lookout for a way to improve his financial positions. He wanted to start a business, but had no capital. Finally he decided to open an insurance business. He borrowed a little money from a friend and moved his family across the bay. The Masons rented a small house not far from where the new insurance and real estate business was located.

Why had Joseph Mason chosen Berkeley as the place to start his business? And, perhaps more importantly, why did this business prosper?

The answer to these questions lies in the nature of the man and in the nature of the town he had chosen. Mason recognized that the presence of the University was creating a demand for housing and that this demand could only increase. When Mason and his family moved to Berkeley, they found a country town. The population of Berkeley in 1890 was 5,000, while the population of neighboring Oakland was already 48,000. The country town had a University campus with five buildings, no paved streets, few street lights, and plenty of open, undeveloped land. There were small settlements around the campus, along Shattuck Avenue, and down by the bay in Ocean View. The rest was ranch land and truck gardens. Joseph Mason realized that this would change, and that with this change would come his opportunity to succeed.

He began to buy small parcels, which he split into building lots and offered for sale. They sold quickly, sometimes for a price of $300 with monthly payments of $10 per month. At the start, this business was a one-man concern. He drove prospective customers around town in his own surrey, drawn by a grey mare.

Mason also began to build houses on the land he purchased, and to offer both house and lot for sale. Along Grove Street, between Russell and Ashby, is a row of houses that are actually two-family dwellings. These flats were constructed by Mason around the turn of the century. In fact, Ashby Avenue below Adeline was once known as Mason Street.

As his business flourished, he was able to buy larger parcels of land. This was land that had been ranches or truck gardens when Mason came to Berkeley, and later became desirable as home sites. One such plot was the 40-acre barley field that Mason turned into Fairview Park. This development borders on Alcatraz Avenue above Telegraph on the southern edge of Berkeley. Another large area developed by Mason was the Kellogg Ranch, north of the campus, extending from Hearst to Cedar, and from Oxford to Arch. He also turned the Hopkins Tract, below Euclid Avenue, into Hopkins Terrace.

These developments were straightforward, with streets basically laid out on a grid pattern and with few extra amenities, but the property sold quickly. The reason for this is clear: the population of Berkeley grew from 5,000 in 1890 to 23,000 in 1905. The clusters of settlements in West Berkeley, along Shattuck Avenue and around the campus began to be encircled by more and more development. The country town was becoming a city, just as Joseph Mason had envisoned years earlier.

By 1900 Mason had moved his office to downtown Berkeley, which was becoming the commercial center. Again he located close to a train station, this time at the corner of Shattuck Avenue and Center Street.

His reputation for fair treatment of his customers was deserved, as demonstrated by this advertisement in the *Berkeley Advocate*:

> To whom it May Concern:
>
> Twelve months ago, in advertising the Berry and Bangs Tract for sale, I made the offer to anyone that I would take the land (back) from any dissatisfied purchaser at the end of the year, at the price paid with 6% added. I am ready to do so now.
>
> <div align="right">J. J. Mason</div>

Apparently no one came forward to accept this offer.

As Mason became more successful, he found time to serve the community he had adopted. He helped establish the first water company, he was a director of the Berkeley Board of Trade, and he was a director of the University Savings Bank, as well as a deacon of the Congregational Church.

But by 1905, Mason felt the need of a business partner. He was now 60 years old and wanted a more leisurely pace after a life filled with hard work. He was able to convince a young man named Duncan McDuffie to join him in business and the firm became known as Mason-McDuffie. Now both names were highlighted by the bright red diamond that Joseph Mason had originally selected to mark his place of business.

With McDuffie in the office, Mason was able to ease himself out of the business. He continued to handle the insurance accounts, while the younger man handled the large development projects. In 1908, Mason hired Julia Morgan to design a new home for himself and his family. The result was a grand Tudor-style home which graced the corner of Telegraph and Ward Street. He had come a long way from the streets of London.

When Joseph Mason died in 1927, he was eulogized by Supreme Court Justice William Waste as "a sort of institution in Berkeley." He was not only an upright businessman, but also "a part of the city." Berkeley was lucky to attract such a man at a key phase in her development, and we have, as his legacy to us, the many areas of the City that he developed between 1890 and 1905.

Trish Hawthorne

Lincoln Steffens

In novels and stories Henry James wrote about the disastrous intellectual and moral misadventures of American innocents abroad. Lincoln Steffens, the first of Berkeley's famous leftists, was in real life a naif who could have stepped out of the pages of James's fiction. But *The Autobiography of Lincoln Steffens* is a minor classic of American literature, and we owe its author some familiar phrases—"the shame of the cities," "the system," and, of course, "I have seen the future and it works."

Steffens grew up in Sacramento, and came down to Berkeley in 1884. When he applied to the University of California he failed his entrance examinations in Greek and Latin. But a year of study in San Francisco with an Oxford graduate as tutor remedied his deficiencies. Forty-five years later he wrote,

> The University of California was a young, comparatively small institution when I entered there in 1885 as a freshman. Berkeley, the beautiful, was not the developed villa community it is now; I used to shoot quail in the brush under the oaks along the edges of the college grounds. The quail and the brush are gone now, but the oaks are there and the same prospect down the hill over San Francisco Bay . . .

His tutor introduced him to several other Oxford graduates, and he joined in their discussions of intellectual and religious matters with zest. Steffens thought that their poise and sophistication was a foretaste of what he would find on the Berkeley campus, an expectation in which he was mistaken.

155

His introduction to undergraduate life was disconcerting. One of his earliest experiences at the University occurred late one evening when he

> . . . was taken out by some upper classmen to teach the president a lesson . . . Fetching a long ladder, the upper classmen thrust it through a front window of Prexy's house and, to the chant of obscene songs, swung it back and forth, up and down, round and round, til everything breakable within sounded broken and the drunken indignation outside was satisfied or tired.

Steffens learned to drink and gamble, but he was uncomfortable with this kind of rowdyism, and tended to see his fellow students as a crude lot. "Their motives," he wrote, "were foreign to me: to beat the other fellows, stand high, represent the honor of the school."

He was not really happy at the University until he came under the influence of Professor William Carey Jones, with whom he studied American constitutional history. Steffens thought Jones was

> dull lecturer, but I noticed that, after telling us what pages of what books we must be prepared in, he mumbled off some other reference "for those who may care to dig deeper."

Steffens looked up some of the references, found that they disagreed with each other, and asked Jones for more. He was amazed at the result:

> The historian did not know! History was not a science, but a field of research, a field for me, for any young man to explore, to make discoveries and write a scientific report about. I was fascinated.

The course had a life-long impact on his thinking; it fired his imagination, but it also led him to a curiously blunt conclusion—that because everything is not known, nothing is known.

This skepticism was confirmed by his years of investigative reporting—his dedicated effort to promote reform, which Theodore Roosevelt eventually attacked as "muckraking." Steffens spent so much time preoccupied with graft and corruption that he lost faith in the idea of reform. He came to think nothing was what it seemed to be, and he "saw through" conventional appearances so completely

that he began to assume automatically that "bad men" were actually good and "good men" were really bad. Steffens was an incorrigible moralist.

By the time he wrote *The Shame of the Cities*, he was well on his way to losing confidence in the democratic idea, too. It was at this era in his life, as noted by Russell Horton, that Steffens coined a term which has become an idiom in the American language. Speaking of the interrelation and interdependence of local, state and federal governments with business, crime and corruption, he established the label "the System."

World War I completed his disillusionment with reform as a method for improving life.

In the aftermath of the war he made a trip to Russia during which he observed the euphoria that followed the overthrow of the Czar, and met Lenin, who made a tremendous impression on him. On returning to France he told Bernard Baruch, "I have been over into the future, and it works."

His lost faith in reform was replaced by a new faith in revolution. In Lenin and Mussolini he saw men who had a quality that liberals lacked, the ability to act ruthlessly without letting ideas or scruples immobilize them. Steffens mistook this for strength.

Mussolini appeared to him as a demigod. It is embarrassing today to read his praise of the Fascist dictator;

> . . . no mere intellectual, he could change his mind, deep down,
> to the depths where it would change his acts, his every impulse
> . . . As bold as Einstein, Mussolini, the willful man of action . . .

But as a liberal converted to faith in revolution, he eventually came down on the side of revolution from the left. To him, Woodrow Wilson was a "mere sailor," Lenin a "navigator." In 1930, while writing his Autobiography, he could find nothing to say for Herbert Hoover as compared with Joseph Stalin, and he viewed the liquidation of the kulaks with equanimity. Red terror did not terrify him.

Steffens is such an appealing character that it is distressing to find him writing, and believing, such humbug as,

> The Russian Revolution consciously abolished the middle class
> . . . Revolution has the advantage in that it clears the ground. It

swept away in Russia one detected cause of what we call evil; it opened the door to such human intelligence as a few thoughtful, feeling individuals had developed to lay out consicously and carry through ruthlessly a plan . . . Russia is the land of conscious, willful hope.

Life carried Steffens a long way from the delights of his undergraduate days in Berkeley. Reading his *Autobiography* is rather like living in the mind of some shrewd, gullible Yankee created by Henry James, but without having the meaning of the tale lit up by the Master's formal ironies. To find the significant form in this case, one must look outside the story.

<div align="right">Phil McArdle</div>

Mathilde Wilkes

In examining the early life of the pioneering Wilkes family, one gets a feel for the sublime nature of Victorian West Berkeley: dirt paths where roads are now, open creeks with willow trees, fields and a beach along the Bay. There was also the workaday side: the factories that made soap, gun powder, watches, shoes, starch and feed; the lumber yard and wharf. The social aspects included beautiful large homes surrounded by small workers' cottages, schools, churches, meeting halls, and shops.

To understand Mathilde Wilkes' position in West Berkeley, we must go back to four years before she arrived in America. Fred Wilkes and his brother Richard and sister Annie had come from England in 1885, almost like scouts, to smooth the way for the rest of their family, including Mathilde. This was a common practice among European immigrants. Wilkes, a carpenter, had little money. For $200 he bought half of a lot on Sixth Street from C.W. Davis, an important West Berkeley settler and Town Trustee. He set about building a little house and by November 1889, Wilkes brought the rest of the family to West Berkeley from England. This included five brothers and two sisters (besides the brother and sister already in America) and their parents, George and Alice Wilkes, and all the children—quite a shipload of English immigrants to settle in this small community.

Mathilde Wilkes was the wife of Fred's brother Samuel. Mathilde, born in 1869, married Samuel when she was 19. In the spring of 1889 she left her homeland and family to come to America with her husband, his family, and her infant, Gertrude, who had been born in

159

February. The voyage aboard ship was stormy and very rough around Cape Horn.

She later recounted to Gertrude how the sea was so rough that dishes would not stay on the table and everyone was seasick, how she had a baby to nurse and she was pregnant again. It was a difficult time for this brave pioneer.

The Wilkes family finally arrived in November, 1889, and came directly to Fred's house in West Berkeley. Samuel got a job in the soap factory, where he made $9 a week. With this he was able to support Mathilde and their children. As his family grew, he worked very hard to make life comfortable. He and Mathilde had a huge garden with cherry, apple, and apricot trees. They built a tennis court between their house and the yard of the corner saloon. And Samuel built a slide for his children. He also had a "dog-wheel" which pumped water out of the well. In the early 1900s he raised his house to make two stories and added a fancy porch and dormer. (This old house exists today.)

Mathilde's immigrant family had little money. Her children can remember the precious new outfits that they had on the first day of school. They remember that at Christmas time they felt lucky if they received a doll or a little candy. They appreciated everything they had. As very young children, they were taught to work hard and they helped their mother pick potatoes. The oldest daughter, Gertrude, had a job as a bookbinder in San Francisco in 1903 at the age of 14.

In 1907 Mathilde contracted Bright's Disease, a form of kidney degeneration, and died. She was only 38. She was not famous or esteemed (like her contemporary, Phoebe Hearst), but she gave so much to the survival of her family that this simple woman surely deserves a place in the rich history of West Berkeley.

Stephanie Manning

Cookbooks

A survey of four historic Berkeley cookbooks published by groups of women between the years 1884 and 1933 yields not only a cornucopia of fine, original recipes, but also a fund of data about the quality of life in times past, especially the lives of women.

These books were published privately with the financial aid of advertisements placed by local merchants. The ads themselves are period pieces of graphic design in elegant letters and picturesque styles of handset type. The names and addresses of such places as Sill's Market and the Varsity Creamery will be familiar to Berkeley's old-timers.

There are several ads for the wood and coal which heated the stoves of the women who compiled *The Ladies of Berkeley, California, A Collection of Choice and Tested Recipes* in 1884. This book was edited by the women of the First Congregational Church, the first church built in East Berkeley. The recipes abound in fresh eggs, milk, cream, and butter for custards, puddings and cakes like Charlotte Russe, a small sponge cake topped with whipped cream. A peck of tomatoes was sliced for Mrs. Hall's piccalilli. Mrs. Dornin's chocolate caramels were made with one cup of molasses and they had a zesty taste, much less sweet than those we eat today.

Mrs. Kellogg, the wife of Martin Kellogg, provided many suggestions for cleaning. Her directions for washing luncheon cloths by "soaking in suds and salt then starching, drying and ironing," suggest a great deal about arduous "women's work." We are reminded that there were no dishwashers or detergents or convenient no-iron fabrics, the modern labor saving devices that have liberated women.

161

The Twentieth Century Cookbook was published in 1914 by the ladies of the Twentieth Century Club, one of the earliest social and civic clubs in Berkeley. This hardcover book is a compendium of choice recipes which, while it runs the gamut from soups to sauces and salads, contains a variety of party fare with elegant desserts, punch and sophisticated dishes: Raspberry Mousse, Mint Punch, Beauregard Eggs, Souffles.

These early cookbooks are written in a conversational style. Directions for preparation and cooking times are rarely included. Cooking was taught at home to girls and the basic rules were assumed to be known by those who used the books.

One lady of clearly scientific bent listed no less than twenty uses for the lemon, including, "Taken with tea it will cure a nervous headache, with black coffee it will cure a bilious headache." (Aspirin phobics take note.) "It also removed unsightly stains from the hands."

The women were witty and wise. Under Conserves and Jams, the following recipe reads:

> A Good Appetizer is 1 pound good temper, 1 pound patience, 3 pounds of usefulness, 2 pounds of cheerfulness, 2 pounds of forebearance, 1½ pounds of contentment, 1 pound of fun. Mix well with 2 quarts of human kindness. One wine glass full the first thing every morning. To be repeated as soon as effectiveness wears off.
>
> E.W.C.

The advertisements reflect the changing times. Victor Talking Machines were sold in Reid's Drugs at Telegraph and Durant. We note that women's corsets have changed their shape from the hourglass of Freud's Corset House (1884) to a less constricting style in 1914.

Conservation Recipes compiled by the Mobilized Women's Organization of Berkeley in 1918 boasts a cover designed by Bernard Maybeck, the legendary Berkeley architect. Mrs. Maybeck was a member of the editorial committee that compiled this collection of recipes gathered during World War I. With food being shipped to the soldiers and allies abroad, there were food shortages locally. This highly organized book was written with the hope of changing people's cooking and eating habits to conform to the tenor of the times. "Eat

Plenty—Eat Wisely—But Without Waste" is the admonishment of the Foreword.

There is a section on Meat Substitutes—dried beans, lentils and peanuts are suggested. The Consumer Bread Company at 2029 Channing Way advertised, "Why not have your bread delivered directly from our ovens to your home? By Buying Your Bread You Prevent Waste of Flour."

The many uses for stale breads remind us that there were no preservatives and no plastic "skin" to wrap fresh bread in. The recipes come from a broad spectrum of the community and include a recipe for Cioppino, a fresh seafood stew created by Italian fishermen from Monterey.

The Household Science Department of the Berkeley Schools contributed a section on Butter and Fat Substitutes. This cookbook could be used by diet conscious consumers.

In 1933, the Berkeley Women's City Club, now the Berkeley City Club, published *Recipes* "to give an opportunity to its members to exchange their favorite and tried recipes." The frontispiece is a drawing of the City Club by its designer and member, Julia Morgan.

Inside the back cover is an ad by the PG&E for an electric stove which is touted as "Economical and Scientifically Certain." This appeal to women gave tacit recognition to the complex abilities needed to provide "three squares" daily, not to mention the cleaning chores. (Is there any householder today who can do without Easyoff for oven cleaning?)

The recipes in this cookbook are international in flavor: Italian stew, French salad dressing (six recipes), Russian borscht and English chess pie. There are thirteen recipes for gingerbread, a perennial favorite. The recipe for Club Woman's Cake, which appealed to the many business and professional women who were in the club, reads like the forerunner of today's quiche mixes for the busy woman.

Collectively, the books contain contributions by more than 300 women, who, through good times and bad, used their inventive skills to provide nourishment with style for their families and friends. In publishing these books, they gave expression to their talents and left a storehouse of clues to the eager researcher.

Ellen Drori

Frank Norris

The relationship between the artist and the scholar often founders on a difference of temperment that amounts to antipathy. This was wonderfully illustrated by an exchange between Frank Norris and Charles Mills Gayley some 90 years ago.

When he was 18, Frank Norris went to Paris thinking he wanted to be a painter, but Paris tempted him away from his easel. He became an enthusiastic opera buff, took fencing lessons, and made a passionate study of medieval armor. He ignored Zola, Maupassant, and Flaubert, and read deeply in the literature of the French middle ages. He adopted the high Parisian style—wearing sideburns, a silk hat, a frock coat, spats, and sporting a walking stick. By the time he was 20, he had acquired the Old World manner. But while he spent his days drifting pleasantly, Norris was learning about himself. When he knew he wanted above all to be a novelist, he came home.

Frank Norris entered the University of California at a unique moment in academic history: in 1890 English departments across the country were just taking their modern form. Under Charles Mills Gayley's leadership, the English Department at Berkeley quickly came to be recognized as among the most progressive.

Gayley was a prominent figure in Berkeley for over three decades. (Gayley Road above the UC campus is named for him.) He possessed strong beliefs and great personal charm. He could count as friends such brilliant personalities as Charles Stewart Parnell, John Dewey and Henry James. He was a compelling preacher on behalf of his own ideas. For an 1894 symposium on the function of the English department he wrote an article saying that it had two purposes: to educate students and to expand knowledge by professional research.

As a distant third, he gave grudging recognition to courses for the "encouragement of literary production." The lofty altitude from which he viewed creative writing classes is worth quoting:

> We have as yet none such in the University of California, unless one denominated Special Study . . . may be construed as sufficient for the emergency. Academic scholarship does not look with favor upon the attempt to stimulate or foster creative production. But . . . there is, nowadays, no reason why genuis should be untutored or its early productions unkempt.

Into Gayley's English department marched Frank Norris, freshman, complete with sideburns, spats, and walking stick. He did not like what he found.

After four years as an undergraduate, and after having written the first draft of *McTeague*, Norris vented his accumulated resentments by writing a response to Gayley's article. In "The English Courses of the University of California," Norris argued that the University smothered creativity and stifled literary instincts among the students. He also made a snide personal attack on Gayley, insinuating that the department chairman was about to profit illicitly by preparing textbooks for use in California schools. This was a complete falsehood.

It would be interesting to know how Gayley felt about Norris's attack, but if he deigned to reply to it, the reply has been lost.

In this exchange, each man made himself look silly. When Norris wrote his essay, he had almost completed a novel that is likely to last as long as people continue to read. Clearly, the University had not destroyed his creativity or his literary instincts. On the other hand, Gayley had made an indefensible pronouncement: without the creative production on which literary scholarship frowns, there would be no need for literary scholarship.

Were there hard feelings between Norris and Gayley? We do not know with certainty.

We do know that, before his tragically premature death, Frank Norris became a loyal UC alumnus. He left his mark on American literature with his masterpiece, *The Octopus*. We also know that sometimes Charles Mills Gayley quoted Norris with approval. But we have no evidence to show that they became friends.

Phil McArdle

Maurice Curtis and Peralta Park

Berkeley entered the 1890s with a population of around 5,000 and plenty of open, underdeveloped land. The City was growing and many people felt that boom times were on the way and there was money to be made in real estate.

The construction of an imposing hotel was one man's idea of how to attract potential buyers to the wilds of North Berkeley. Maurice B. Curtis, a flamboyant and successful actor best known for his role as Sam'l O'Posen, began buying up tracts of land in North Berkeley in the 1880s. He intended to establish a summer resort, with a grand hotel and gardens, and to sell off the surrounding property as residential lots in what would become a fashionable neighborhood.

Curtis named his development Peralta Park, in honor of Domingo Peralta, who had built a home near the hotel site when he settled on the banks of Codornices Creek in the 1840s.

The Peralta Park Hotel, located just north of Hopkins Street at the end of Albina Street, was a far cry from Peralta's simple adobe. A palatial structure which cost $125,000 to construct, it contained 60 bedrooms and 20 bathrooms. The newspapers described it as "a very imposing and capacious caravansary on a beautiful elevation" when it opened in 1891. The exterior was decorated with Moorish arches, arcades and balconies. An exuberant collection of gables and towers, complete with finials, capped the roofline.

To insure that potential customers could find their way to Peralta Park, which was located some distance from the then-developed area of Berkeley, Curtis arranged to have the Claremont, Branch and Ferries Railroad run a branch horsecar line to his development. The

branch traveled from University Avenue out Sacramento Street to Hopkins, and connected the property with Ocean View and downtown Berkeley.

With good transportation available and the lure of the stunning Peralta Park Hotel at the end of the line, Curtis's project seemed sure to succeed.

Thirteen houses were built near the hotel in the 1880s and early 1890s, several of which were quite imposing. Curtis and his wife, Albina de Mer (who also happened to be his leading lady), built their own home near the intersection of Sacramento and Hopkins Streets.

But success as a real estate developer eluded Curtis. A few months before the hotel opened in 1891, he was accused of murdering a man on a San Francisco street. Although after three trials he was cleared of the charges, he was never able to regain the public's confidence as a developer or an actor.

Curtis eventually sold Peralta Park to pay his debts, and the grand summer resort he had planned for North Berkeley never really had a chance to become fashionable. Curtis died in 1920, his fortune and his plans ruined.

The Peralta Park Hotel and grounds became the site of various private schools and was taken over by the Christian Brothers in 1903. The hotel building was used as a school for many years, although it was badly damaged by fire in 1946. It was demolished in 1959. Only the palm trees still standing on the St. Mary's High School campus remind us that something existed there before the current building.

Much of the Peralta Park residential property was later resubdivided by Roy O. Long, a Berkeley developer of a later time who had more success than Maurice Curtis. Long, who is reputed to have built more houses in Berkeley than anyone else, worked in the area through the 1920s. By then North Berkeley was no longer wild, and the once open hillsides were covered with houses.

In addition to the palm trees, we do have other legacies from Maurice Curtis' grand scheme. Albina Street, named after Curtis' wife, leads from Hopkins to St. Mary's High School, and Posen Street, named by Curtis after his favorite stage role, still winds its way west from Albany into Berkeley.

The careful observer will notice a few Victorian houses close to the

intersection of Hopkins and Sacramento, one on Albina, and still another farther east on Hopkins across from the tennis courts of King Junior High School. These are what remain of the thirteen houses built in the heyday of Peralta Park.

Maurice Curtis' plans didn't work out exactly as he had hoped, but they nevertheless had an effect on the Berkeley we know today.

Trish Hawthorne

Stiles Hall

One question heard these days as newcomers enter Stiles Hall is, "What is this place?" That question would never have been asked in the late 1890s or the early part of this century because Stiles Hall was the student center—the headquarters for social life and clubs, the campus reading room, the employment office, the source of student housing lists, the meeting place for foreign students and the general information center for the entire student body. It has been the role of Stiles Hall over the years to perceive needs peculiar to University students living away from their family homes and to develop programmatic answers to them which have eventually been institutionalized by the University itself.

The very name "Stiles Hall" may be a bit confusing to the current generation of students, suggesting, as it does, a dormitory or classroom. Few, if any, know of the Hall's long history at UC—how it was for many years located in a capacious brick building facing Strawberry Creek at the site of the present Harmon Gym.

Mrs. Anson Gales Stiles had had the building constructed in 1892, in memory of her husband, as a non-denominational student center providing rooms for meetings and reading (including religious study which was a prime focus at that time), a cafeteria, and a large auditorium. The building was open to all students and there was a busy schedule of lectures and get-togethers.

After the 1906 earthquake, Stiles Hall, whose fallen brick chimneys were dramatic physical evidence of the event, became a central location for relief work and temporary housing for "refugees" from San Francisco. During World War I, soldiers by the hundreds came to Stiles for their "R and R".

In 1931 the original Stiles Hall was sold to the University and then torn down so that the men's gymnasium could be constructed. The association settled into a small, white wooden residence (usually referred to as "the Old Shack") on Union Street at about where the lower Sproul Plaza now is. The basic facilities for student needs having been absorbed by the University administration, the nature of Stiles Hall's work focused more on individuals, especially the orientation of young men to University life, the development of leadership, and an emphasis on civil liberties and free speech.

Highlights of this period were Stiles's participation in the development of the University Students Co-ops and, later, its aid to Japanese-Americans when they were abruptly re-settled following Pearl Harbor.

The cramped quarters on Union Street were always thought of as "temporary" and when the University absorbed the land, the Directors of Stiles Hall sought a permanent location. After an extensive fund-raising effort, the current building was erected on the corner of Dana and Bancroft. The undecorated cement exterior of the new Stiles Hall, the square lines, the use of glass bricks, and the light wood and stucco interior were the latest modern look in 1949.

Over the years ivy has covered parts of the building, softening its outline, and inside remodeling goes on as projects change. The program these days concentrates on community service, with students volunteering to work with less-advantaged segments of the community and gaining valuable personal and vocational experience for themselves.

In the case of Stiles Hall, the design or period of architecture, although always esthetically or historically interesting, is not of major significance. The "Hall" is the people involved in it at any given time.

Fran Linsley

The Piano Club

Of all the clubs in Berkeley, one of the oldest is The Piano Club at 2724 Haste Street.

It was formed by a group of women interested in piano music and, for a while, they met at various members' houses to play duets. Eventually the members began to play the scores of other music, including operas, and then they began to play music for several instruments. The club ultimately became involved with all phases of music.

Nowadays the piano club gives a yearly prize to a young person of exceptional ability in any field of performance. The prize winner must give a concert for the membership and guests.

The club was founded in 1893 and its first permanent home was a barn lent by Mrs. Thomas Rickard in 1901 (probably at the corner of Dwight Way and Warring Street). Churches were used for more ambitious concerts.

The present property on Haste Street was bought in 1912. The club house was designed by Woolett and Woolett. Its interior is very simple—wood walls and ceiling—with marvelous accoustics.

After the building of the clubhouse, the membership became busy with matters not especially concerned with serious music. A yearly "jinx" was established, which took various forms. The first important one was a "Chauve Souris," a take-off of a Russian musical in 1923. For that event a mural was painted on the east wall in the style of Leon Bakst, first on paper and later copied on canvas. It was the work of Mrs. Richardson and her daughter.

In 1926 Mrs. John Galen Howard brought back a mystery play

which she had seen in Provence. It was presented at the clubhouse and elsewhere to help raise money for the club.

During World War II, members provided musical entertainment at Oak Knoll hospital. The club continues its musical work today— enriching our lives in Berkeley.

Fillmore Eisenmayer

The Public Library

Berkeleyans have long held a special affection for their libraries and have maintained them through difficult times. In 1882, four years after Berkeley's incorporation, private citizens opened the first voluntary library. This "Free Reading Room" at Shattuck and University served the small town of 2,000 residents for just six months. The time for a library was not yet right. But as community spirit grew, a new attempt was made to establish a library for Berkeley.

In September 1889, the local paper printed an editorial on the pressing need for a library and reading room. This was the beginning of a long tradition of strong editorial support for the Berkeley library. Thus it was fitting that the successful attempt to create the Holmes Library in 1893 was launched by a letter to the *Advocate* (later the *Berkeley Gazette*) in November 1892. Two young UC graduates, J.E. Kelsey, a Berkeley druggist, and W.H. Waste (later the Chief Justice of California's Supreme Court) united to start the campaign for a Berkeley library. The *Advocate* reinforced Kelsey's letter with its own strong editorial support:

> A public library is universally conceded to be indispensable and towns are few equal in size and material development to Berkeley that are not well provided in this respect. It is a . . . stigma on our name as the literary center of the state that we have no place where the current literature is accessible, except by purchase, to the general public . . . There is a public duty which . . . we cannot neglect without great injury to the town . . . If we all unite in this movement there need be no great hardship . . . imposed on any of us.

The effort to establish the library quickly succeeded. F.K. Shattuck donated two rooms in his Shattuck block. Within three months the founders had raised $1,600, hired a librarian, Lucy Wheeler, and opened the library on February 10, 1893.

This new library, the "Holmes Public Library," was privately funded and not a "free public library" as we think of it today. Use of books, newspapers, and periodicals at the library was free to all: those who wanted to borrow materials had to pay one dollar a year in advance. Nevertheless, the library proved an immediate success.

The requirement of payment for the privilege of borrowing was an obstacle preventing everyone in the community from making full use of the library. So within a few months efforts were made to make the library a city responsibility, thus assuring adequate support and ability to make it a truly "free public library." This fight took several years.

While the majority of Berkeleyans have long had a special affection for their public library, there was resistance to its creation. There were opponents and objections. Berkeley's historians, in telling the story of the fight to create the library, have given those opponents of the library a kind of notorious immortality. In *Berkeley: The Story of the Evolution of a Hamlet into a City of Culture and Commerce*, W.W. Ferrier reports on the August 1893 public meeting which discussed the question of making the library a publicly supported institution. Ferrier describes an influential citizen who

> rose and moved it as the sense of the meeting that no money be appropriated by the Trustees for the formation of a public library. Times were hard, he said, wait a few years . . . Thought went out then, it has been said, to that man's beautiful and somewhat luxurious home in which the children were provided with all that many others would lack if the library were not placed on a substantial basis.

Reverend Ferrier mercifully omits the man's name from this account. The movement for the free public library proceeded over this man's objections.

In August 1895, a proposition that the town of Berkeley take over the library and maintain it was made to the Board of Town Trustees (as the City Council was then called). The Town Trustees made an appropriation for the library but were soon halted by the City

Attorney's opinion that the Town Trustees didn't have the power to appoint a library board. Another objection was whether they had the legal power to create an institution, the library, not mentioned in the City Charter. Professor William Carey Jones of the University Law School met with the Town Trustees to discuss these points of law and, as George Pettitt puts it in *Berkeley: The Town and Gown of It*, "tore (the legal) objections into such small pieces that the Trustees were left to decide only whether they were mice or men." As a result, funds were voted and a Board of Library Trustees was created with Francis Kittredge Shattuck as president.

Once created, the Berkeley Public Library was strongly supported through the years by the City Council members when they were elected by wards and later when elected at large and by all the various groups that have at different times controlled the City Council. The Republicans supported the library, the Socialist mayor did, the Democrats did and the nonpartisans did.

When the library became both free and public, the Board of Town Trustees was elected by district, one each from seven wards. One concern that had been raised was that a main library in central Berkeley would not adequately serve West Berkeley, and the Town Trustee from West Berkeley had pointed this out. Thus when the first meeting of the Board of Trustees of the now truly public library was held on December 11, 1895, arrangements were made to establish branch libraries in Lorin (South Berkeley) and West Berkeley. Thus, a strong commitment to providing conveniently located branch libraries was made from the start. This politically astute policy built public support for the library throughout the City, made libraries far more accessible for children, and ensured support from the city councils that were elected by ward during the period from 1895 to 1909.

In the early years the main library and the branches were located in buildings originally built for other purposes. In 1903, however, the Town Trustees succeeded in getting a $40,000 Carnegie grant to build a new main library at Shattuck and Kittredge on land donated by Francis Kittredge Shattuck's widow, Rosa. The new building opened in 1905.

Use of the main library was already heavy when the 1906 earthquake and fire led to the greatest population and building boom in the

history of Berkeley. Thousands fled devasted San Francisco, resettled in Berkeley, and tripled the population from 13,214 in 1900 to 40,434 by 1910. The new library was soon overwhelmed.

The population boom led to other changes. The City Charter was revised in 1909 to replace the district election system with at-large elections used in the commission form of government. Although elected at-large, the new commissioners remained committed to branch libraries and used them to relieve pressure on the main library. By 1916, Berkeley had six branch libraries: two branches in South Berkeley (South and Ashby); two in West Berkeley (West and Hawthorne); a North branch; and a Claremont branch. These were still not enough to satisfy everyone's needs, and efforts were soon made to raise funds to build a new, larger main library.

The commissioners levied a tax to set up a library building fund, but the rate was too low. When the voters approved increasing the building fund tax, the new Council immediately implemented it and started rapidly to accumulate the money to build the new main library.

The library building fund tax meant there were now two library tax rates collected in Berkeley: the building fund for capital improvements, and the library tax for operating expenses. By the end of the 1920s, the operating tax had reached 9 cents per $100 assessed value.

The building fund tax generated enough money to start construction of the new main library. Then the Great Depression struck.

Faced by the greatest economic depression in American history, the City Council had tough decisions to make on whether to go ahead and build a new main library and, if they did so, how to maintain it. This group of community-minded, fiscal conservatives had enough confidence in the future to proceed with the construction of the new main library. This new building—the present main library—opened in 1931.

The next questions in the face of severe economic hardship, was whether to maintain the special library tax. The answer of the Council can be seen in the record of the library tax rate during the decade of the Great Depression, which although it fluctuated, remained close to 9 cents per $100 throughout the 1930s.

This showed the City could rely on a separate tax for the library during great economic crisis.

176

The library and its staff did suffer during the Depression. But library service was maintained. Later, when Federal anti-Depression funds were available, the community put up matching funds to build a new North branch at Hopkins and The Alameda, which still serves Berkeley today.

<div align="right">

Henry Pancoast and
Sayre Van Young

</div>

Benjamin Ide Wheeler
and
Phoebe Hearst

Every two years a distinguished Berkeley citizen receives the Benjamin Ide Wheeler Service Medal. This award was created by the Service Club Council of Berkeley, which was formed in the 1920s to coordinate the activities of clubs working on community problems. Its first recipient was William H. Waste, the Chief Justice of the California State Supreme Court, and a respected local civic leader.

Since 1929 the award has gone to such notables as August Vollmer, Robert Gordon Sproul, Lester W. Hink, Claude B. Hutchinson, Wallace Johnson, Wilmont Sweeney, and Carol Sibley, to name only a few.

But who was Benjamin Ide Wheeler?

He was one of the most important presidents of the University. Born in Massachusetts in 1854, he studied the classics at Brown University. After graduating in 1875 he taught for several years and then, from 1881 to 1885, he studied at the major universities in Germany and earned his Ph.D. at Heidelberg. Upon returning to this country he became a professor of philology at Harvard (1885–86) and at Cornell (1887–98).

In 1899 he became president of the University, a post he held for 20 years. Had he not become a university president, Wheeler might have gone on to become one of America's foremost philologists. In his youth he produced numerous treatises and articles on the subject.

During his time at the University, Wheeler was known for his

178

strong leadership. He became a familiar figure to everyone during his horseback tours of the growing campus.

Wheeler's name is indissolubly linked in the history of the University with the great building programs made possible by the philanthropy of Phoebe Apperson Hearst.

Mrs. Hearst was the University's first female regent, and one of its greatest benefactors. Together, she and Wheeler saw the University grow from a provincial outpost into a majestic campus.

In 1896 she sponsored an international competition to find the architect who could provide the best overall design for the campus. As a result of this competition, many of the most beautiful buildings on the campus were constructed under the guidance of John Galen Howard.

Mrs. Hearst sought to upgrade education for women by having Bernard Maybeck design the Hearst Hall for Women (destroyed by fire in 1922). She paid for archeological expeditions and sponsored numerous education programs.

Wheeler saw to it that many of her initiatives were brought to completion.

In 1909–10 Wheeler was the Theodore Roosevelt professor at the University of Berlin, an experience that increased his admiration for German scholarship. It was perhaps his observation of progressive German city governments which helped Berkeley eventually to adopt the city manager form of government. When he returned to Berkeley he summed up his impressions by stating that democracy depends on the availability of "expert service."

Wheeler's unabashed boosterism spread the University's reputation for academic excellence. He was known to have refused more lucrative presidencies in favor of his position at the University. He also attracted prestigious scholars to the faculty (including Alfred Kroeber and Joel Hildebrand). Wheeler transformed the campus from a small, local institution into one of the greatest universities in the country.

Stephanie Manning

Shattuck's Evolution as "Downtown"

Shattuck Avenue, once the widest street in America, has changed a lot since the first trains ran along it in 1876. For more than 100 years this broad avenue has been known as central Berkeley, and has been popular for its many shops and meeting places.

In 1876 Francis K. Shattuck and J. L. Barker persuaded the stockholders of the Central Pacific Railroad to invest in the Berkeley Branch Line which was being constructed along present-day Shattuck Avenue. At first the line ended at University Avenue, but by 1890 it had been extended to Berryman Street for the benefit of businessmen and residents there. Later in the 1890s, when it was fully operational, it had powerful steam trains and a large station on Shattuck at Center Street, the area now known as Berkeley Square.

By 1900 Shattuck Avenue was well established as "downtown" Berkeley. The post office in the 2100 block was the only postal facility for miles, the other being at Bowen's Inn in West Berkeley. The Shattuck post office became a center for East Berkeley residents and wayfarers using the Branch Line Railroad.

Three businesses had been established near the post office at the turn of the century. Joseph J. Mason was operating his real estate and insurance office there as early as 1895 at the northwest corner of Shattuck and Dwight Way. He moved to 2103 Shattuck in 1898 and stayed there until 1905, when he formed the famous partnership of Mason-McDuffie with offices at 2100 Center Street.

Foss & Company was established at Shattuck and Center by Fred Foss in 1897. Foss's major merchandise was wood, coal, hay, grain, lime, cement, and plaster. In 1917 Foss became the county supervisor from the 4th District.

The Wilcox Photo Company occupied the floor above the post office in the early 1890s, but George L. Wilcox, the proprietor, moved his shop around the downtown area. In the early 1900s, his studio in the 2100 block of Shattuck was used by various Berkeley photographers including J. C. Clark from 1902 to 1905, Pollock Studios and Needham Brothers Photo Supplies in 1906, and Arriola & Company in 1907. Berkeley seemed (and seems even to this day) to attract photographers, perhaps because of the nearby Studio Building (northeast corner of Shattuck and Addison) in which artists worked and exhibitions were frequently held.

When the Key System came to Berkeley in 1903, Shattuck Avenue received another increase in mercantile traffic. San Franciscans were now able to travel to Berkeley by ferry and up to Shattuck Avenue to shop.

Berkeley's population grew, and after the 1906 earthquake a flood of displaced persons came to the East Bay. The newcomers included French-American shopkeepers, some of whom had helped to found the French laundry business in San Francisco. Among them were Jack Jaymot and Pauline Mirandette, who promptly set about establishing the Berkeley French Laundry at 2578 Shattuck Avenue. In the style of early commercial construction, their building consisted of a shop on the ground floor and dwelling space upstairs. Such an arrangement is still an American tradition among small shopkeepers. Berkeley artists and home craftsmen continue to cut expesnses by operating in this manner today.

When Jaymot and Mirandette arrived in Berkeley they, like other immigrant Frenchmen, sought shelter with their countrymen who were already settled here. In this case, they joined Jean Bernadou and his family who had been operating a laundry on Shattuck Avenue since 1895.

Like other businesses on Shattuck Avenue the laundry flourished. It was taken over by Simon Bidalot and Germaine Ducasse, who ran it until 1922. Thereafter it changed hands periodically, usually remaining in the hands of French proprietors with names such as Birsinger, Lafon, Longtine, and Coudures. The French-operated laundry once had as much a place in Berkeley's downtown and other neighborhoods as the bakery, grocery, shoe shop, and saloon.

Berkeley's downtown is particularly well endowed with remnants

of a more prosperous era such as the elegant Shattuck Hotel (formerly the Whitecotton), the Studio Building and the Golden Sheaf Bakery. But Berkeleyans also take pride in the less grand, but equally important, establishments that represent the early ethnic diversity and spirit of enterprise of the community.

Stephanie Manning

Cutter Laboratory

As Berkeley entered the twentieth century, many changes signalled the end of the Victorian era. Not only did architectural design and taste in fashion change, but many San Francisco entrepreneurs began to have faith in Berkeley's future as a commercial center.

West Berkeley's old neighborhood also began to change. Primarily built up in the 1870s, 1880s and 1890s, West Berkeley always had its share of merchants and commercial flow. Its easy access to the railroad and wharf had made it a prime candidate for industrial development.

But the area south of Dwight Way had not yet been developed, and existed as a rather rural residential neighborhood. There were creeks and trees and one needed to go as far as San Pablo Avenue to purchase supplies and provisions.

In 1904 Edward A. Cutter decided to move his "analytic laboratory" to West Berkeley from its location in the Rialto Building in downtown San Francisco.

Cutter was probably attracted by the University as well as by the excellent location in West Berkeley. The number of highly trained students available as potential employees was increasing every year.

Cutter was able to call upon the skills of two Berkeleyans, John Raholl and a bacteriologist named Charles Twining. Together, the three set up the business along Berkeley's shoreline. The main activity of their laboratory was the analysis and manufacture of vaccines and serums. The demand for these items was enormous in the early 1900s.

By the 1930s, the area around the Cutter Laboratory had changed.

The creeks were built over. The Works Progress Administration had begun to construct Aquatic Park by running a breakwater along the Bay (on top of which now sits Interstate 80). Bay water fills the lake at the park and adds to a pleasant setting.

But Cutter Laboratory's front yard had become choked with industrial buildings and factories. It is hard to believe that the lab began in an open field in windmill country.

<div align="right">Stephanie Manning</div>

The Little University Building
That Led Three Lives

On the University campus, hidden away among oak trees and about a hundred yards from Sather Gate, is a gem of a little building which, since its construction in 1904, has led three lives.

It was built to be a power plant, to furnish light, heat, and power for the fast growing campus. The architect was John Galen Howard, and the power plant was the fourth in a series of buildings he designed, all of which add style and grace to the campus.

The little building was constructed of brick and steel. A long slender skylight along the red tile roof furnished light to the interior. In the early days fuel oil was delivered in tank cars to the Berkeley Station and from there to the plant by horse and wagon. *The Daily Californian* for August 29, 1904 called the plant "an innovation in heating systems," adding enthusiastically, "the four enormous boilers are now on the grounds and part of the piping system is already laid."

The power plant operated for nearly 30 years. Then, again because of campus expansion, it was supplanted by the present central heating plant near Harmon Gymnasium.

And now we come to the second life of the little building. There was no adequate place on campus to exhibit works of art. A few small displays hung in some buildings but they were scarcely noticed.

Professor Stephen Pepper believed that students learn just by being in the company of creative works of art. "If the least endowed of us have our creative capacity stirred even to a little production it will unite us to a common understanding with the greatest creative artists and their achievements," he said. Pepper was one of a group

who wanted some space on campus which would be used to inspire young artists. This group began to look seriously for a museum.

Not everyone agreed a museum was needed, but Professor Eugen Neuhaus sided strongly with the museum group. He looked at the old powerhouse being dismantled, and came up with the idea of using it as a small gallery. His idea caught on and became official when adopted by Regents and officers of the University. Work to convert the powerhouse into a gallery began. The huge power pole outside and the transformers inside were removed. Landscaping began around the building and flower boxes appeared. The handsome mosaics flanking the east entrances were designed by the Bruton sisters, Helen and Esther, and were executed in 1936 as a WPA project.

On either side of the east entrances and a few yards in front of the mosaics, two large stone "dog-lions" sit on squat but ornate stone pedestals in beds of jasmine. Given to the University in 1934 by Albert Bender, San Francisco benefactor of colleges and collector of Oriental art, they have aroused curiosity and given enjoyment through the years. In the Orient some charming myths have been woven around the creatures represented by these statues. The males are said to play with large colored balls, and to leave milk in them for people who climb the hills to collect it. The females are usually shown playing with their cubs. Albert Bender's gift is a pair, male and female. One has his paw placed arrogantly on a large ball, and if one looks closely at the other, one can see, peeking out from its mother's paw, a small cub. Dog-lions are said to have a close relationship with the Buddha, and are placed in front of official buildings to scare away demons. Perhaps they are performing the same function for this campus.

To return to Neuhaus's idea for the little gallery, the interior walls of the little building were cleaned and painted white as a background for exhibitions. Throughout the gallery's life, the displays had a distinction the campus had never seen before. Treasures were brought out into the light of day from the vaults where they had been carefully stored. Winfield Scott Wellington, who followed Neuhaus as curator, was responsible for some of the gallery's best displays, and later presented to the Bancroft Library Archives handsome photographs of many of the exhibits.

Displays from China, Egypt and Africa, as well as an exciting collection of artifacts by California Indians, were interspersed with exhibits of student work. Receptions were often held at openings, accompanied by refreshments and music. A special reception was held to celebrate Lutze's colossal painting of Washington at Monmouth.

A display of Jugendstyl posters was the occasion for another memorable reception, when German tunes were played by accordian and violin. Such jovial occasions were part of the little gallery's life.

From the beginning the enthusiasm created by the gallery intensified the drive toward an objective many of its sponsors had held from the beginning—a University of California Museum, large, distinguished, suited to a variety of artistic endeavors. In the 1960s work began on the big museum on Bancroft Way, and as it came to completion the little gallery was closed.

The third and current life of John Galen Howard's building is less distinguished, less inspiring, less beautiful than the gallery era, or even the rugged years of its use as a power plant. The exterior, with its mosaics and its splendid dog-lions, remains. But the interior has been divided and appropriated for two functions. The west half has been cut into box-like rooms where young women spend their days sorting cards from the student loan files. The east half is now a department of the University Police—the Bicycle Bureau. Racks of bicycles share space with the dog-lions now.

Necessary functions, both, but perhaps someday this little building with its strong beautiful lines, standing among ancient oaks, may live still another life more worthy of its past.

Lillian B. Davies

Spring's Time in Berkeley

Every so often a figure appears on the historial stage, performs a brilliant role, and then disappears. Only fleeting memories remain of a spectacular performance. Such a figure was John Spring, a daring capitalist with imaginative vision and business acumen. He was such a dramatic figure on the Berkeley stage at the beginning of the century that Hal Johnson of the old *Gazette* was prompted to remark it was Spring all year round in Berkeley in those days.

Spring was a born gambler who took the good and bad in life with equanimity. A contemporary described him as an exuberant personality with a congenial, if somewhat brash, personality and a flair for spectacular, risky business deals.

He is remembered for land deals that brought him enormous profits, a once magnificent estate in Berkeley where only an aged mansion now remains, the game of dominoes in which he lost ownership of the Claremont Hotel, and the sensational divorce that relegated him to obscurity.

Forgotten today is his importance as a pioneer of large-scale residential subdivisions, as a major builder of local streets, and as a significant contributor to the beautification of the Berkeley landscape.

John Hophius Spring was born in 1862. His grandfather and namesake was a New England sea captain who came to California in 1852 on his own ship with two sons and settled in San Francisco. In his youth, Spring was an outstanding athlete, excelling in bike racing and swimming. His father and uncle were partners of a thriving real estate firm, where the youth presumably learned the business. In 1888 he married Celina Dusperry Warfield, a divorcee with two children (Frances and Katherine).

From their union came five more children (Anne, Dorothy, Gertrude, Marjorie and Francis). After his father died in 1897, Spring moved his family to Oakland. He built a lovely home along Sausal Creek amidst giant redwoods and big ferns that made his estate a great showplace of the Fruitvale area. It was his residence until 1912.

The Spring family was already involved in East Bay land ventures before John's move to Oakland. Spring inherited from his father a sizeable fortune which he evidently used to pay $35,000 for the land holdings of his uncle, who withdrew from the real estate business. He soon acquired substantial holdings in the East Bay—farm lands in the Decoto area, real estate in Oakland, and the Galpin Ranch in present-day El Cerrito. These land holdings provided the broad base for his spectacular real estate ventures.

Spring joined an enterprising Berkeley group that included real estate developer Duncan McDuffie, and local capitalists Louis Titus and W. E. Creed (later PG&E president). All were partners and/or officers of the Berkeley Development Company and the North Berkeley Land Company which figured so conspicuously in local subdivision development in those years. Spring was also a business associate of Francis "Borax" Smith and Frank Havens, especially in the East Bay real estate ventures of their Realty Syndicate.

Spring's first venture in Berkeley real estate was in the Claremont District. In 1903, he paid the Glasscock Estate $63,000 for land between Panoramic Way and Fish Ranch Road, including University Terrace and the Claremont Tract. Before long Frank Havens and W. P. Mortimer became Spring's partners in the Claremont Tract. The three of them financed the grand Hotel Claremont. Spring planned the lovely garden terraces around the hotel that became known as the "Jewel of the East Bay."

Construction was slowed by the financial stringencies resulting from the 1907 panic, and in 1910, Spring approached his partners with a proposal to play a game of dominoes with the hotel property as the stake. Spring first played Mortimer and beat him. Later he played Havens and lost—announcing gleefully to his wife that he had finally gotten rid of that "white elephant."

Next Spring turned his attention to North Berkeley. In 1904–1905, for $100,000 he acquired the Dunn Estate in the Hopkins Terrace subdivision, including the quarry Dunn had operated from 1879 until

the time of his death in 1900. He formed the Spring Construction Company with Creed and Titus as partners in order to build streets and other projects in the North Berkeley. The company quarried rock at its Spruce Street facility (La Loma Park and Codornices Park area) and later at The Arlington facility (Cerrito Canyon). Construction vehicles and equipment were maintained at a depot on the old Boswell Ranch (Solano and Peralta junction).

Spring's best known venture was the Thousand Oaks subdivision in the northeast corner of present-day Berkeley. In developing this huge tract after 1909, Spring may have been inspired by McDuffie who had begun laying out the adjacent Northbrae subdivision four years earlier. Both converted hilly cattle land into beautiful residential subdivisions, marked by winding streets and attractive homes with prominent boulders and green landscape enhancing the scenic view.

Spring's lasting monument was his magnificent estate on The Arlington, which he completed for his family in 1914 and which was considered among Berkeley's most beautiful landmarks.

But within two years of its completion the public world of John Spring fell apart. At Christmas, 1915, he left his wife for another woman. The lovers divorced their respective spouses and were married a "year and a day" after the dissolution of his marriage. Celina Spring married the brother of her first husband and then sold the Spring family estate to a private academy.

The story that Berkeley expressed its displeasure with the flamboyant capitalist by changing the name of Spring Street to Scenic Avenue is not true. Actually the original street name antedated his arrival in the area by several years.

Spring spent the rest of his life in relative obscurity. He lived in San Francisco and then in Los Gatos, where he died in 1933, shortly after divorcing his second wife. By that time he had gambled away his wealth after the 1929 stock market crash. A journalist reported in those later years that Spring still had his old spunk and spirit.

Spring had said of himself in an earlier and happier time that he was just a "plaything of the winds of fortune."

<div style="text-align: right">Edward Staniford</div>

Douglas Tilden

Douglas Tilden's statue of "The Football Players" was dedicated on the University campus at 11:45 A.M. on Class Day, May 10, 1900. The dedication of the statue has been overshadowed by what took place at 11:15 that same morning—the official groundbreaking for the greater University, presided over by Mrs. Phoebe Hearst. Nonetheless, it was the statue's dedication which concluded the day's events, and it is that with which we shall concern ourselves here.

The statue was in fact a prize presented to the University by San Francisco Mayor James Phelan (later Senator Phelan) for having won a contest which Phelan himself had devised: whichever football team won the Big Game two years in a row would also win the statue—and UC won, handily defeating Stanford, first in 1898 (22–0) and again in 1899 (30–0). Since the beginning of the Big Game tradition in 1891, although Cal had tied three games, it had never beaten its rival prior to the Phelan contest. The two victories were attributed, in large measure, to the efforts of Cal's new coach, Gary Cochran—"a young man of marvelous skill in football and a great leader among students."

In Brick Morse's chronicle of the 1899 Big Game we learn that,

> With Pringle and Whipple tearing holes ahead of them, the California backs went through for gain after gain until 24 points had been rolled up in the first half. Chet Murphy, one of the two Stanford veterans, tried to stop the whole California team single-handed, but was finally forced out of the game with a couple of broken ribs. It was the finish of a great and worthy opponent, and the California rooters stood up and cheered him as he limped from the field. That meant something in those days of

intense rivalry. Neither California nor Stanford ever gave meaningless cheers for a fallen enemy.

And so Cal won a statue. It is a statue of heroic strength and dignity, and of an equally heroic compassion and tenderness—attributes of the period, and perhaps even more, of the sculptor himself.

Although he was unquestionably one of California's finest sculptors, it has rightfully been said that Douglas Tilden was a man who lived and worked and died alone. His family was prominent in California's early history—Tilden's grandfather Adna Hecox and Hecox's young daughter Catherine (later to be Tilden's mother), crossed the plains with the ill-fated Donner party in 1846, "but separated from them before the catastrophe in the mountains." Hecox was the last alcalde (Spanish mayor) of Santa Cruz under the Mexican government, and Tilden's father, Dr. W. F. Tilden, was twice a member of the State Legislature.

Douglas Tilden was born in Chico. (He is no relation to Charles Lee Tilden, after whom Tilden Park was named). As a young child, Tilden lost his hearing due to scarlet fever, and he entered the Asylum for the Deaf, Dumb and Blind in 1866.

Coincidentally, Tilden's birthday (May 1, 1860) was also the day that the Asylum opened its doors in San Francisco.

Tilden graduated in 1879, intending to enter the University of California to prepare for a literary career. Instead, he accepted a position teaching at the Deaf School, where he remained from 1879 to 1887. During this time, he contributed numerous articles to California magazines on the subject of deafness.

Tilden discovered sculpture when he was 23. Until that time, he wrote, "I knew nothing about sculpture." After his awakening, he taught for four more years, while he studied sculpture in his spare time. The trustees of the school were so impressed by his self-taught early work that they provided him with a scholarship to further his studies in New York and Paris. In Paris, he studied for a year under the great sculptor Paul Chopin, who was also deaf.

Tilden's first work in Paris, "The Ball Player," won immediate acceptance at the famed Salon. This work is now in Golden Gate Park, as are his "Father Junipero Serra" and "The California Volun-

teers." Tilden's "The Football Players" was completed in Paris in 1893, where it won a medal at the Paris Exposition.

In 1894 Tilden returned to San Francisco, where he taught sculpture at the University's Mark Hopkins Institute of Art. He communicated with his students "with a pad of paper and a pencil that he always carried with him."

Tilden's work for and with the deaf was a lifelong concern. While in Paris he inaugurated the first International Congress of the Deaf, of which he became vice president, and he was a member of the program committee of the second International Congress, held under the auspices of the World's Columbian Exposition at Chicago in 1893, where he also served on the jury judging sculpture.

In 1896, Tilden married Elizabeth Delano Cole, a ravishing beauty, and moved his studio to Oakland, where for many years he continued to create outstanding public statues and monuments. His best known works include the "The Mechanics Statue" and "The Native Sons" fountain on Market Street in San Francisco; "The Bear Hunt," on the grounds of his Alma Mater; and "U. S. Senator Stephen M. White," in Los Angeles. It was Tilden who first suggested that sculptural art be used to beautify Golden Gate Park.

During Tilden's days of affluence and renown, his greatest patron was Senator James Phelan. According to a biography of Tilden included in a 1960 history of the California School for the Deaf, Tilden, "genius that he was, regarded competition as beneath him, and would not submit entries in competition with others . . . This resulted in a breach between Tilden and Phelan which gradually widened and proved to be catastrophic for Tilden. His commissions dwindled."

Around 1915 Tilden suffered from what he termed "a spell of inertia." He laid aside his chisel and mallet and lost all interest in his art. Until 1925 he worked for a manufacturing concern in the East Bay. Then he began work on "The Bridge," which has been called "a poem in bronze," and is considered by some to be his masterpiece.

In 1926, he was divorced by his wife and thereafter "lived the life of a recluse, being rather embittered against the whole world."

As a companion to "The Bridge," Tilden had planned a frieze for the 1939 San Francisco Exposition, and although "he strove night and

day to finish what he regarded as his masterpiece," it was a work he would not live to complete.

The California School for the Deaf biography says, "his last days were not happy ones," and goes on to cite an article from the *Digest of the Deaf* that appeared in 1940:

> Estranged from his wife, patrons, and friends, embittered by the failure of his dreams for an artistic and educational Utopia on the West Coast, and in straightened circumstances, the unhappy, proud, and lonely old man was found dead in his studio from heart failure on August 6, 1935.

At the time, Tilden's home and studio were at 834 Channing Way in Berkeley, where he had moved in the late 1920s. The day after Tilden's death, the *Gazette* reported that neighbors told of how

> at one time he came to borrow water and it was discovered that his water and lights had been shut off because he had no money to pay for them. For several nights he had been using candles and cooking on a small oil stove. Friends secured for him a state old age pension of $35 a month. He seemed indignant and hastily wrote on a piece of paper, "I'm no pauper." Later it was learned that he had not eaten for several days.

In the end then, there were no California rooters to stand up and cheer for Douglas Tilden "as he limped from the field." He was buried in Mountain View Cemetery, and his funeral services were conducted in sign language.

Ken Stein

194

August Vollmer

Berkeley's .most famous police officer—August "Gus" Vollmer—was the Chief of Police from 1905 to 1932. During this time, he not only developed Berkeley's police force into a professional, well-equipped and innovative department, but he became a nationally renowned figure in the field of criminal justice.

Vollmer was born on March 7, 1876, in New Orleans to German parents. His father, a grocer, had a heart attack and died when August was only eight.

After two years of living in Germany, Mrs. Vollmer brought her children back to New Orleans in 1886 and August enrolled at the New Orleans Academy, where he learned bookkeeping, typing and shorthand. This was the extent of his schooling.

Vollmer's family shortly after moved to San Francisco because his mother considered New Orleans too violent a city. They lived at 721 O'Farrell Street until 1891, when they moved to 1627 Louisa (present day Bonita Street) in Berkeley.

One of Vollmer's first accomplishments was his role in organizing the North Berkeley Volunteer Fire Department in 1896. His efforts must have been considerable, for in 1897 he was awarded the Berkeley Fireman medal. At the time, he was also running a wood and coal supply shop with H. R. Patterson at 1504 Shattuck and supporting his whole family.

The Spanish-American War pulled him away from his business. In 1898 he enlisted in the Marines and fought in 25 battles while stationed in the Philippines. This experience weighed heavily in Vollmer's decision to pursue a career in law enforcement. He was deeply impressed by the organization found in the military.

Upon returning to Berkeley in 1900, Vollmer acquired a letter-carrier job with the post office and held it until he was elected town marshal in 1905.

Prior to his election, he became well-known throughout town for his congenial personality, and he was considered a war hero by many.

He became a different kind of hero in 1904 when he spotted a runaway railroad car loaded with bricks about to crash into a car full of passengers from San Francisco who were arriving at the Southern Pacific station in downtown Berkeley. He jumped onto the runaway car and jammed on the brakes "with all his might," thus saving the day. The Berkeley newspapers ran his picture and a story on the event. The *Gazette* mentioned this story several times during Vollmer's campaign for town marshal, which may have contributed to his election.

As marshal, Vollmer brought order to a rather disorganized police force, and by 1906 he had established the bicycle patrol and the first centralized police records, including modus operandi files. In 1907 he was re-elected and became the president of the California Association of Police Chiefs. He was not actually referred to as "police chief" until 1909. During the years that Vollmer was Chief, the Berkeley Police Department became a model for the nation, using one of the first lie detectors and pioneering other modern police techniques.

Vollmer had an advanced theory of criminology. He believed all policemen should be college graduates and should go through a police training program. He also believed in social programs to help disadvantaged children. He was often criticized for his lenient treatment of lesser offenders such as loiterers and public drunks.

He opposed capital punishment, but he believed in the enforcement of all laws.

Vollmer married Millicent Gardner Fell in 1932 after his eye sight began to deteriorate. He continued to teach and write, and left several dozen articles, books, and reports. He was responsible for police department surveys in over eight major American cities including San Diego, Portland, and Dallas. He also did important work in the Los Angeles and Chicago departments.

In 1951 Vollmer saw the fruition of his work at the University in the

establishment of a criminology school. By that time, however, he had Parkinson's disease and eventually developed cancer. Determined never to become a bed patient, he committed suicide at the age of 79 in 1955.

Stephanie Manning

THE 1906 EARTHQUAKE
AND ITS AFTERMATH

An Eyewitness Remembers

On the 18th of April, 1906, the San Francisco Bay Area and other sections of coastal Northern California were jolted awake at 5:18 a.m. by an earthquake registering close to 8 on the Richter Scale—a quake so severe that it damaged and even wrecked buildings in a wide area of downtown San Francisco, broke water mains, and was the direct cause of the holocaust which left much of San Francisco east of Van Ness Avenue a barren waste land. Other communities north and south of San Francisco, along the great San Andreas Fault, also suffered serious damage. Of the East Bay communities, Berkeley was probably hardest hit.

On that fatal day, I was exactly one month short of my fourteenth birthday, a lofty senior in the old Whittier School, and the happy possessor of a well paid—for then—*Chronicle* morning paper route in hilly North Berkeley.

My usual rising hour was 5:15, but on that particular morning I must have overslept, for at 5:18 my bed shook so violently that I was almost tossed out onto the floor. While I was coming alive, wondering what had hit me, my mother appeared in the doorway looking scared half to death. "It's an earthquake," she said, "and I don't know what's going to happen to us. You'd better get up right away." Which I did, wondering if our house was to be shaken down.

Our home was a modest two-story frame house on the northeast corner of Hearst and Oxford, with a picket fence on the Hearst Avenue front and half way along the Oxford Street side, and an old-fashioned board fence the rest of the way around. (The lot was on the Kellogg Property, so-called because it was owned, we were told, by University President Emeritus Martin Kellogg and his wife.)

201

We *Chronicle* carriers picked up our papers at the corner of University Avenue and the branch of Shattuck then known as Stanford Place. The papers came across the Bay by a freight ferry which landed them somewhere near today's Jack London Square at around 4:30 a.m.

There they were picked up by our boss, a Berkeleyan named Hill, who was a pleasant, cheerful, fair-minded man. He brought the papers to his allotted territory in North Berkeley in a specially designed, one-horse rig faintly reminiscent of the ancient Roman chariots. And when I say "one-horse", I mean "one-horse"—not one horse-power. It was a ten-mile trek, out Telegraph, Grove, Adeline, and, finally, Shattuck and Stanford Place, and Hill's horse came at a trot all the way.

On that particular morning, Hilly, as we kids called him, was later than usual, and as he drove up he was not smiling. One of the kids said, "What's the matter, Hilly? Did the earthquake hit you?" Hilly shook his head. "I didn't feel any earthquake in my cart, but as I came along I wondered why so many people were out on the streets so early, so I stopped at Alcatraz to find out. They told me there had been a pretty hard earthquake, but that was all they knew. It worries me, somehow." (Remember: there were no radios then, and many people in Berkeley didn't yet have telephones in their homes, so news got around very slowly.)

By 6:30 we had our papers counted out and were on our several ways, leaving Hilly still with a puzzled frown on his face. My route took me back up Oxford past my house, where my mother was still standing in our front yard. "I guess the house is all right," she said, "but I'm going to stay out here for awhile. I'll have your breakfast ready by the time you get home."

My route took me up Hearst to Euclid, then north, along that street, with incursions into side streets, and, until I got to somewhere around Le Conte, I saw nothing unusual. Then I saw the first of the great quake's calling cards: bricks that had once been outside chimneys scattered across a front lawn, with people clustered around looking dazed and worried, chatting in subdued tones. As I went up the hill I saw more of the same, many more. I believe the *Gazette* later published the total number of fallen brick chimneys in Berkeley.

My last "serve" was on Arch Street near Hilgard. From there I cut

202

across a vacant lot—North Berkeley was full of them!—to Spruce; then, at Virginia Street, diagonally across another lot toward Oxford.

It was a clear, warm morning—"earthquake weather," people later called it—and as I looked across the Bay, I realized that a cloud of black smoke was rising over San Francisco. I still didn't connect it with the earthquake, and I kept on home for breakfast and a change into school clothes.

School didn't start until 9 o'clock, but I always went earlier to play games in the schoolyard, so by 8:30 I was on my way up Oxford. I didn't get far, however, for halfway up the block I sighted a kid I knew running toward me. "No school!" he yelled. "They gotta see if the building's safe before we go back. But they say somethin's happened to Berkeley High. Let's go down and see."

The high school building was almost brand new; three or four years old, at the most, and it was Berkeley's pride and joy. An impressive, two-story brick structure, with two fairly tall brick chimneys rising above its handsome slate roof. But when we got down Milvia Street to where we could see the building, the chimneys were gone. Where the chimney had stood at the southern end of the building, there was only a great gaping hole in the roof. Where the other chimney had stood there was also a hole, but it was oblong and even, so I suspect that chimney may have been a "falsie," not a real brick chimney, and of no practical use.

My friend said, "Gee! Good thing the kids weren't in school early this morning. Some of 'em mighta been killed."

Berkeley schools, undamaged except for the high school, reopened following the usual spring vacation and I became absorbed with the final weeks of my grammar school career. The community as a whole, however, became very active, extending a helping hand to dispossessed and displaced citizens of their stricken sister city across the Bay.

There were hundreds, perhaps thousands, of persons who had lost all of their worldly possessions in the fire, and the problem of housing and feeding them until order could be restored in San Francisco was monumental. Berkeley not only opened its arms to these unfortunates, it did so in a well-planned, efficient manner.

The first problem, of course, was to get the refugees out of San Francisco to places where care could be provided. The Ferry

Building itself had not been damaged by the quake or the fire, but all ferry service to East Bay and Marin County points had been discontinued. This meant moving the refugees by rail. Automobiles? In 1906, the "horseless carriage" was a new-fangled contraption and highways were a thing of the future. The Southern Pacific provided full and willing cooperation.

Refugee trains were run as frequently as equipment and personnel allowed from the Third and Townsend Street terminal to San Jose, thence up the East Bay tracks to the Oakland Mole, and finally to Berkeley Station. There an efficient refugee operation had been set up with the full cooperation of several churches, the Masonic Lodge, the City administration, and many concerned private citizens.

I have no idea how many refugees were cared for by our friendly community, but the number surely ran well into the hundreds, and the operation continued until some order had been restored in San Francisco, and the monumental task of cleaning up and rebuilding was well underway.

Early in June, after school was out for the summer and ferry service had been restored, I went to San Francisco with my mother to see what the earthquake and fire had done to the City by the Golden Gate. The sights that greeted us that summer day in 1906 remain indelibly etched on my memory to this day.

We walked up Market Street—no street cars were running, of course—but didn't get the full effect of the devastation until we had turned up the hill on Geary Street, I believe it was. Five or six blocks up that street we could see everything: complete destruction, desolation, blocks and blocks with nothing standing but broken walls. And silence: complete, eerie silence; the only sounds were the occasional muffled clang of bits of torn metal swaying in the breeze.

Harold Yost

The Damage in Berkeley

Describing the earthquake in the May, 1906, issue of the *Architect and Engineer of California*, William B. Gester wrote:

> . . . to all to whom it was an experience it was one of awe, compelling a peculiar profound consciousness of infinite human insignificance and helplessness. In the house in question, those of us who could hold ourselves to the side or head or foot of our beds did so. But one of the occupants, an active athletic young fellow weighing about 170 pounds, was thrown by the shock from his bed to the floor. Scrambling to his feet to reach the door of his room, he was immediately landed upon his hands and knees, and thence flung in a huddled heap into the angle formed by floor and wall. Pictures, furniture, the chain-hung electroliers, everything not fastened to floor or wall, was put into instantaneous motion, the commotion and the din being indescribable.

Yet the damage here in Berkeley was comparatively trivial and insignificant.

About 5,000 chimneys collapsed—almost every chimney in town was damaged—the most important being the tall smokestack at the Standard Soap Factory. The goods in many stores spilled from the shelves and bricks fell from buildings on a number of business blocks, most seriously from the Barker Building which still stands at Shattuck and Dwight. John Galen Howard's recently completed Carnegie Library had some cracked walls and plaster. Charles Dickey's West Berkeley Bank, which is still at San Pablo and University, required

extensive repairs. And William Wharff's Masonic Temple (still standing at Shattuck and Bancroft) experienced some damage to one of the walls.

The Asylum for the Deaf, Dumb, and Blind weathered the quake safely, except for several of the towers. But the high school had the most serious damage—the front wall was badly cracked. The building was eventually repaired and the second floor rebuilt of wood, but only after extensive debate and some accusations of graft. Too often it is overlooked that, except for the Barker Building, these were all buildings situated near or virtually atop the many creeks in this area which had been diverted into underground culverts.

Damage to University buildings amounted only to about $200 according to John Galen Howard. Interestingly, these buildings included South Hall, California Hall, Hearst Mining Building (then under construction), University House, and the Greek Theatre, all structures presently considered to have very poor earthquake resistance!

Perhaps because it was one of the few cities or towns around the East Bay which experienced almost no damage, Berkeley was inundated with refugees. And perhaps because it was a mere village and a University community, it responded in a manner no longer possible. A model Relief Committee was organized to supervise relief measures in both the town and the University. Needless to say, the exact number of refugees who came was probably never known, but was estimated variously at 10 to 20,000, proportionately perhaps one of the heaviest influxes of refugees to any Bay city. (In 1906 Berkeley was the fourth largest city in the State after San Francisco, Los Angeles, and Oakland, and had a population of 26,000 according to the 1906 school census.)

As elsewhere, churches and lodge halls were opened to provide temporary shelter. Frank McAllister, the Recording Secretary of the Native Sons of the Golden West, wrote, on May 10, 1906, "Owing to our having our Hall open at the time of the quake and fire and feeding or at least serving almost 16,000 meals, our treasury has diminished until we are overdrawn in the Bank." But, perhaps more than elsewhere, private homes housed many refugees.

Hearst Hall and the old Odd Fellows Hall were turned into temporary hospitals. Two camps were organized on the campus, one

at California Field for families—now the site of Hearst Gym—and another for men at the baseball field—now the site of Life Sciences Building. Harmon Gym, which stood where Dwinelle Hall is now, provided toilet and washing facilities for men. Hearst Hall, at that time located on Channing above College, served for women. One of the several kitchens organized and run by the coeds was located near Douglas Tilden's "The Football Players".

For a week after the fire the *Gazette* devoted an entire section of each issue to listing the names of local refugees. The *Daily Cal* suspended publication and all campus activities came to a close and did not resume until Summer Session. For three days, April 18 to April 21, U.C. Cadets patrolled a part of the Western Addition in San Francisco, until they were recalled to Berkeley at the request of the citizenry.

Because of the large number of footpads who descended upon Berkeley, Town Marshal August Vollmer pressed into service an auxiliary force of constables composed mostly of Civil War and Spanish-American War veterans. All refugees with weapons were ordered to leave town and a 10 p.m. curfew was imposed. All able-bodied male refugees who refused to work were also ordered to leave town, which many did. By May 11 the Relief Committee estimated only about 3,000 refugees were left in Berkeley, mostly in private homes. On May 17 Sarah Bernhardt presented "Phaedre" at the Greek Theatre. By June 1, at least on the surface, everything was back to normal.

Charles Marinovich

Almost the State Capital

Imagine a Berkeley that is not only the home of the University of California, but the site of the State capital as well. That's just what a group of Berkeley citizens hoped would happen when they launched an ambitious effort to move the State capital from Sacramento to Berkeley in 1907.

Berkeleyans who opened their *Gazettes* on March 2, 1907 found this headline in the center of the front page: "Berkeley Wins Battle for Capital in Assembly."

But the announcement of victory was premature. In the election of 1908, Berkeley missed becoming the State capital by only 33,000 votes state wide, and the capital remained in Sacramento. The land that had been set aside for the capitol buildings was subdivided and sold as residential lots. Most traces of the scheme vanished from the City.

But the best part of the story isn't the defeat of what became known as the Capital Removal Measure, but rather the boldness of the proposal itself.

Berkeley in 1907 was at the peak of a boom period. The City was growing rapidly. Between 1900 and 1905, Berkeley's population had grown from 13,000 to 20,000. After the great earthquake its growth was even more dramatic; by 1907 more than 38,000 people lived in Berkeley. The impetus for this sudden jump was, of course, the influx of people fleeing from earthquake stricken San Francisco.

Berkeley was ready to receive the refugees: the new subdivisions like Claremont Park, which had been developed shortly before the earthquake, offered building lots for new homes, and there was much

open, undeveloped land. Most of this land was north of the City, beyond the town line at Eunice Street.

Almost 1,000 acres of this prime land was owned by the Berkeley Development Company, whose president was Louis Titus, and whose vice president was Duncan McDuffie, a partner in Mason-McDuffie Company, which had developed Claremont in 1905.

On February 18, 1907, Louis Titus stood up before a mass meeting of the Chamber of Commerce and proposed that the State capital be moved from Sacramento to Berkeley. He offered a 40-acre site north of town, valued at $240,000, as the location for the new capitol. The forty acres were to be a gift of the Berkeley Development Company.

According to the *Berkeley Gazette*:

> A bombshell exploded in Town Hall last night, the echo of which is today resounding throughout the entire State, when the proposition to move the State capital from Sacramento to Berkeley was proposed amid a scene of the greatest enthusiasm Berkeley ever witnessed . . .

At the meeting Louis Titus, who was soon chosen as the chairman of the Executive Committee to Move the Capital to Berkeley, enumerated the advantages of Berkeley. He referred to the deplorable and unsightly condition of the capitol in Sacramento, to the fact that Sacramento was far removed from the center of population and thus inconvenient, and stated that the general welfare of the people of the State and the economical administration of the business of the State demanded that the capital be moved nearer the center of population and business. He reasoned that Berkeley was within a 10-cent fare of more than 50 percent of the State's population. Resolutions were approved to adopt the removal measure, and a committee appointed to go to Sacramento to invite the legislators to visit Berkeley to view the proposed capitol grounds.

Many Berkeleyans had visions of stately buildings arising north of the town. The proposed site, one mile north of the campus, was on a line with Grove Street. The Northbrae Community Church now occupies some of the land where the capitol would have been. The 40-acre area was bounded by what later became Los Angeles Avenue, The Alameda and Arlington Avenue. On an upslope, it commanded an excellent view of the Bay. One supporter of the plan observed,

"Such a view will surely make a legislator do anything right, even his duty."

Events moved with amazing speed and on February 23, only six days after the original proposal, the members of the Senate and Assembly visited Berkeley. They arrived by train and were escorted by private automobile to a sumptuous five course banquet at the Elks Hall on Shattuck Avenue.

The visitors heard speeches following the banquet about how they could avoid the climatic discomforts of Sacramento, center administrative work in the Bay Area, and create architecture and landscape which, when combined with the University campus, would gain a worldwide reputation. Moreover, since Berkeley had outlawed saloons in January of 1907, the City would provide a moral atmosphere for the proper conduct of legislative business.

Apparently the legislators' excursion to Berkeley had the desired effect. On March 1 the State Senate approved the proposal by a vote of 30 to 9. The following day the Assembly endorsed the plan, 59 to 18. On March 6, Governor Gillett affixed his signature to the Capital Removal Measure, thereby giving the people of the entire State the opportunity to decide the question of the capital's location at the next statewide election, in November of 1908.

With the measure on the ballot and the vote 22 months away, Berkeley residents settled down and returned to business as usual. And business was good. New subdivisions opened almost weekly that spring and lots near the proposed capital were heavily advertised. The paving of Shattuck Avenue had begun and the Chamber of Commerce undertook a plan to work with University architect John Galen Howard on a "City Beautiful Plan for Berkeley." The Regents approved the plans for the Doe Library, and Bakewell and Brown's design for the new town hall was approved by the trustees. Berkeley building was booming.

But by the fall of 1907 the picture had changed. A banking crisis had occurred and San Francisco banks had closed briefly. In the midst of this money panic, caused in part by the overly-ambitious rebuilding of San Francisco after the earthquake, the campaign for the State capital received little attention.

Before the election of November, 1908, there was a major push to convince voters that Berkeley was indeed the place for the capital.

210

The arguments that had been used to convince the legislators to endorse the plan were printed in brochures and distributed up and down California.

But Sacramento and the saloon interests worked against the measure, and there were those who felt that under all the noble rhetoric there was really nothing but a real estate deal engineered by Louis Titus.

Whatever the reason for the launching of the capital plan, it was more than a coincidence that on April 17, 1907, a large Mason-McDuffie Company subdivision named Northbrae was opened on land adjoining the proposed capitol.

We'll never know if the major purpose of the scheme was to promote a real estate deal, but we do know that it did not receive voter approval. The measure passed only in San Francisco and Alameda counties.

Although the City lost its chance to become the home of both the University and the State government, we still have a few reminders of that long ago scheme. The names of Marin, Napa, Fresno, Colusa and Monterey avenues were not randomly chosen. All the streets in Northbrae were named after California counties (with the exceptions of Milvia, Hopkins and Shattuck, which were extensions of existing streets.) Perhaps the fact that Los Angeles Avenue adjoins the capitol site was an attempt to woo the voters of Southern California.

We also still have The Circle, connecting Marin, Arlington, Los Angeles and Del Norte. This was John Galen Howard's grand design for what was to have been the entrance to the capitol grounds.

If the City today is feeling the pressure of the presence of the University and all the tax-free land it occupies, it's interesting to wonder what would have happened if the capital were located here as well. Perhaps it's just as well that the Capital Removal Measure failed. Maybe the voters from Los Angeles and the Sacramento and San Joaquin Valleys, who defeated the measure, knew best after all.

Trish Hawthorne

The Northbrae Subdivision

Located in the foothills north of the town line at Eunice Street, Northbrae was a typical subdivision of the period when it opened in April of 1907. The developers laid out a system of streets and lots and were ready for business. Street improvements meant gravel or macadam paving (which consisted of oiled crushed rock). Improvements also eventually included sidewalks, and Northbrae streets can be easily identified today by the rose-pink sidewalks put in by the developers. Northbrae was the first tract in the City to offer cement sidewalks, more up to date than the boardwalks of earlier tracts.

The demand for housing in the East Bay accelerated after the San Francisco earthquake and fire of 1906. Thomas Rickard, President of the Town Board of Trustees, a forerunner of the City Council, pointed out, "the effect of the disaster to our sister city." There was room to build and the advent of the new electric railway systems made new areas accessible which had previously been left undeveloped because they were too far from the center of things.

It's hard to say whether electric transportation produced the city or it was the other way around, but the transformation of Berkeley from a town into a city dates from the introduction of the electric railway system after the turn of the century. Linked to the Key System electric railway, a "dinky" streetcar took Northbrae passengers to downtown Berkeley via Grove Street. There they could transfer to the Oakland Traction Company's larger electric trains and ride to the ferries at the Oakland Mole, on which they completed the journey to San Francisco. It took ten minutes to get to downtown Berkeley and another thirty minutes for the trip from Berkeley to San Francisco. The price for the whole trip was five cents.'

Land Speculation and traction development were also linked in another way. The "dinky" stopped close to the Mason-McDuffie Tract Office. Here salesmen waited to greet potential customers and to show them first hand the desirable features of the area, both as a place to live and a place to invest.

The Northbrae tract office, with its pergola and palm trees, was removed after the majority of the lots were sold, and the wedge of land between Marin and Monterey where it had stood became a park. Today we know the site as the location of the round North Berkeley Fire Station.

A shingle bungalow stood alone on the open hillside near the realty office. This particular house was closely connected with the development of Northbrae. When the subdivision opened to buyers in April of 1907, Mason-McDuffie offered $500 to the builder of the first house in the new tract. In April of 1908, that $500 was claimed by P.M. Raymond of Milvia Street, who had constructed Northbrae's first house, that shingle craftsman bungalow. Although it has been altered, the house still stands at 1919 Marin Avenue. Because developers at this time usually sold only building lots, the buyer was free to construct a house according to his own choice of design. This allowed a remarkable variety of architecture within the area, a contrast to the more recent subdivisions where the developer constructs all the houses according to a limited number of models.

Another development device was the construction of elaborate entry gates of street markers, an attempt to give the then open area some identity of its own. Stone pillars marked streets in Northbrae. Many of these ornamental pillars still exist, and the street names are stamped into the concrete above the stonework.

Trish Hawthorne

The Tennis Club: Home of Champions

The Berkeley Tennis Club produced a remarkable list of champions.

Helen Wills—once a name known wherever in the world tennis was played. At fifteen she won her first girls' championship, and at seventeen her first women's. She won the United States championship seven times. In 1927 she was Wimbledon champion for the first time and repeated seven more times. In addition, she added four United States championships, three women's doubles titles, two United States and one Wimbledon mixed doubles, four French singles and two doubles titles. In Paris in 1924 she won two Olympic gold medals. Until 1932, when she was forced to default on account of a bad back, she had never lost a single set in the United States, not to mention a match or a tournament.

Helen Jacobs—born a little too close to Helen Wills, nevertheless persisted and eventually she too became a champion. In 1927 Helen Jacobs was selected for the Wightman Cup team and participated 12 times, a record.

Hazel Hotchkiss Wightman—the first Cal student to win national recognition—won forty-three championships. She gave the Wightman Cup as a goal for women's team matches between the United States and Great Britain.

A bit later, but while the two Helens were still playing, came Don Budge and Frank Kovacs. Budge had an extraordinary tennis career. In 1935 he was named to the Davis Cup team and in 1937 won all of

his Cup singles and doubles matches, thereby regaining the Cup for the United States for the first time in ten years. He won his first senior title in 1936 in doubles, and in 1937, too, the United States, Wimbledon and Australian singles championships. It was said that his five-set singles victory over the German champion, Baron Gottfried von Cramm, was one of the most exciting in tennis history. In 1938 he won the "grand slam" of tennis—United States, Wimbledon, Australia, and France—a record not to be duplicated in twenty-four years.

The skills of all these young champions were acquired on the courts of the Berkeley Tennis Club, that celedon shingled structure on the corner of Tunnel Road and Domingo Avenue in the shadow of the Claremont Hotel.

The club was created on January 8, 1908 by a small group of Berkeley residents at the home of R. B Daggett on Hillegass Avenue. A site was leased from Dr. Hillegass and a Mr. Meyer extending between Hillegass and Regent near the intersection of Parker Street. Meyer agreed to build a clubhouse for $2000 and lease it and the land to the club for $85 a month. Walter Ratcliff was the architect. The building still stands at 2624 Hillegass and is now a small rental unit.

Play began on two courts of rolled earth and another was added later for $150. Then the board decided to surface the courts with crushed sea shells, which had a tendency to blow away. By 1909 there were five courts with oiled surfaces. In 1917 the club moved to facilities it rented from the Claremont Hotel. In 1945 the club purchased the facilities from the hotel by issuing $35,000 worth of twenty year bonds.

Roland Stringham designed the clubhouse, which was built in 1917. It has a massive stone chimney on the south side and a spectators' terrace on the north. There are ten courts and a swimming pool.

The longtime tennis pro was Tom Stow, a great promotor of the sport. From the very beginning of the club in 1908, junior players were encouraged to join and practice. The results, as we have seen, have been champions and an ever increasing number of tennis buffs from Berkeley.

"Although I have seen many tennis clubs in different parts of the

United States and abroad, I believe that the little Berkeley Tennis Club can be said to be as nicely situated and attractive as any of them," wrote Helen Wills in her 1937 book, *Fifteen-Thirty*.

<div align="right">

Fillmore Eisenmayer
and
Florence Jury

</div>

Arthur Ryder

Arthur William Ryder (1877–1938), the University's great translator of Sanskrit, the ancient classical language of India, was born in Oberlin, Ohio, graduated from Harvard in 1897, and did postgraduate work in Germany.

He began teaching at Harvard in 1906, and, arriving in Berkeley in 1910, remained here for the rest of his life.

Ryder was raised in the Puritan religious tradition and acquired its habits of mind even while repudiating its theology.

"I began to consider what goodness meant," he wrote, "and at last hit upon a definition which has ever since given me tolerable satisfaction. To be good, I thought, meant to do good work and to add as much as possible to the happiness of others."

In this he was, intellectually, the descendant of Emerson and the New England Transcendentalists: not formally religious, but morally earnest and upright. He lived frugally, giving much to charity.

He reacted against the excesses of philology by publishing translations which were so faithful to the author's intent that they required no footnotes. And, though one of the great scholars of his age, he published only two scholarly papers.

But while Emerson found Indian mysticism rewarding, Ryder found the genius of India best expressed in its lyric poetry and drama. Kalidasa and other Sanskrit poets are to India what Shakespeare and Homer are to us, the standards of poetic achievement, and Ryder translated all the major secular Sanskrit writings.

"Taken as a whole," G. R. Noyes wrote, "Ryder's work as a translator is probably the finest ever accomplished by an American. It

is probably also the finest body of translation from the Sanskrit ever accomplished by one man . . ."

Ryder's translations are not now as widely available as one could wish. The following short poems provide a glimpse of his achievement:

When Woman Wills

When loving woman wants her way,
God hesitates to say her nay.

Poverty

A beggar to the graveyard hied
And there "Friend corpse, arise," he cried:
"One moment lift my heavy weight
Of poverty; for I of late
Grow weary, and desire instead
Your comfort; you are good and dead."
The corpse was silent. He was sure
'Twas better to be dead than poor.

Beasts

Men void of learning, character and worth
Religion, kindness, wisdom, piety,
Are but a mortal burden on the earth;
Such men are beasts allowed to wander free.

Hospitality

A mat of straw upon the floor,
Water, and kindly words as well;
These things at least, if nothing more,
Are always found where good men dwell.

Women's Eyes

The world is full of women's eyes,
Defiant, filled with shy surprise,
Demure, a little overfree,
Or simply sparkling roughishly;

It seems a gorgeous lily-bed,
Whichever way I turn my head.

The Thief of Hearts

You practice theft by strangest arts
Once and again;
In broad daylight you steal the hearts
Of waking men.

Hindrances

'Twould not be hard,
Through life's gray sea
To find the track;
But fawn-eyed women hinder me,
And hold me back.

After Life's Fitful Fever

My mind no longer loves philosophy,
No longer seeks delight in poetry,
Contemns the paths of doubt so often trod,
And yearns to be united with its God.

Ryder's version of Kalidasa, *Shakuntala and Other Writings*, has been available in a Dutton paperback, and his *The Panchatantra* is in print in a University of Chicago paperback.

Some of his other translations can be found in the Berkeley Public Library. Ryder became a Berkeley legend when Anthony Boucher portrayed him as Dr. Ashwin, the detective in *The Case of the Seven of Calvary*.

Phil McArdle

Leonard Bacon

Three poets closely associated with Berkeley have won major literary awards. Leonard Bacon, the first of them, received the Pulitzer Prize in 1941. Louis Simpson achieved the same distinction in 1964. In 1981, to our delight, Czeslaw Milosz was presented with the Nobel Prize. Bacon would have shared our pleasure in the recognition given to Milosz. One of his most treasured memories was a youthful meeting with another Nobel laureate, the Provencal poet Frederic Mistral.

Bacon's Pulitzer marked the apex of a writing career which began before World War I and lasted into the 1950s. Though largely forgotten today, in his time he was praised for the technical skill, lyric richness, and satiric wit of his poetry. He wrote in standard meters, creating verse with a polished and precise surface. But the type of verse he wrote was passing out of fashion even at the time he received the Pulitzer. Randall Jarrell, for example, dismissed him as a poet who did a pretty good job of writing in second rate forms.

Leonard Bacon lived in Berkeley and taught at the University from 1910 to 1923. He was appointed to the faculty by Charles Mills Gayley, who recognized the promise of his early verse. Gayley, having instructed Bacon not to seek a doctorate, allowed him to teach the first creative writing class for undergraduates ever offered by the University. And what a class it was! Sidney Howard and Genevieve Taggard were in it, along with Frederick Faust ("Max Brand," the

inventor of Destry and Dr. Kildare), who became one of Bacon's life-long friends.

Bacon wrote steadily throughout his years in Berkeley, but without much success at first. When his own poetry was slow in finding an audience he turned to translation. His work on a volume of Serbian ballads and two epics, the French "Song of Roland"and the Spanish "El Cid," taught him to write verse smoothly and colloquially, so that the art conceals itself. The translations also accustomed him to composing long narrative poems. Bacon's ambition, however, was not to be a professor or a translator, but to be a poet, and he was not fully satisfied by these three books.

When the U.S. went to war in 1917, Bacon enlisted in the Army Air Corps. Though he spent the entire war on active service, he was not sent overseas. Shuttled from one part of the country to another, and thrown in with people of all sorts, Bacon learned much that he would have remained ignorant of in Berkeley. He returned to teaching after the war, but he could not adjust to academic routine. When he picked up his pen again, he wrote satire.

He began with a little narrative called "The Banquet of the Poets," a spoof of Amy Lowell and her circle, which was circulated anonymously in Berkeley and Boston. He enjoyed the speculation as to the author's identity, and she enjoyed the joke. Several years later, when she published her own "Critical Fable" anonymously, she let it be known that Bacon was the author. He tells us that he was startled when "the morning mail began to bring me epistles whose tenor was in general: 'My dear fellow: Let me congratulate you on your writing a good book at last.'" He denied the author-ship, she insisted it was his, and "the flood of congratulatory letters came pouring on unchecked." When the dust settled he complimented her for "mendacity which ran the whole gamut from disingenuous innuendo to naked and shameless perversion of the fact." "I like lying on that great imaginative scale," he wrote, "because it takes personality, which she had over-whelmingly."

In 1921 Bacon read a newspaper article about "the first six months of Bolshevism in Central Asia . . . In ten seconds I was on fire with what became the mock-epic of *Ulug Beg*." The idea obsessed him.

Teaching kept him from making progress on it, so he applied for a sabbatical. The leave granted, he completed the poem within a year.

Almost three hundred pages longs, *Ulug Beg* has the Byronesque jauntiness which is one of the attractive characteristics of the 1920s:

> Here is my Epic. Epic, Macaulay said, is a product of the childhood of the race, Of a simplicity and truth that fled Long since. I think not, but in any case I should be glad to know what reason led A clear mind to express that commonplace, For it is clear to the most casual eye That the race's infancy has not gone by.

A loosely plotted adventure story, full of digressions, it is highly accomplished in parts. Its strongest feature is its shrewd analysis of fanaticism. Its weakest is the portrayal of some characters in a vein which may strike readers today as anti-Semitic. "For better or worse," Bacon wrote, "it . . . got me more of what a man really desires than most of my other works." He meant friendships, recognition as a poet, and clarity about his future. Publication of the poem made it clear to him that he could no longer continue as a professor, and he resigned to devote himself to writing. It is well that he did, for our literature would be poorer without his masterpieces—*Ph.D.'s*, *Anima Vagula*, and *The Furioso*, and *The Lusiad* (his translation of Portugal's national epic).

Once done with teaching, he realized that he had always had a small, secret hatred of the idea of himself as a teacher. He ignored it for many years, at cost to himself, because he found Berkeley entrancing. In those days, he tells us in *Semi-Centennial*, his autobiography, Berkeley "had the quality of a small New England town, in spite of the fact that it was already a considerable city." He described in as "a Concord in Brobdingnag." He had deep affection and respect for such Berkeley luminaries as Gayley, Arthur Ryder, and Gilbert Lewis. "On the whole," he wrote, "it is my considered opinion that I have never been in a place where people were more genuine and attractive . . . What America may yet be, a country of

uncompromising and uncompromised intelligences, was, it seems to me, foreshadowed in the unpretentious town. We have drifted very far from all that. But we could return."

Phil McArdle

Promotional Booklets

"Berkeley is worthwhile," boast many of the articles in *Berkeley: A Journal of a City's Progress*, a series of booklets the Chamber of Commerce began to publish in January, 1911.

H.S. Howard of the Courier Publishing Company volunteered to print 1000 copies of each booklet once a month for a year without compensation in order to help "sell" Berkeley to the outside world.

Although Berkeley's population had been increasing, the Chamber continued to plead for more "good people" to come to Berkeley.

One promotional point about the City was centered around its favorable climate: "The weather is neither too warm nor too cool. It is just right for the highest endeavor, mental and physical."

Berkeley was also portrayed as a desirable summer resort for babies:

> . . . That is why so many little ones are seen on our streets during the season of warm weather in the interior of the State . . . Dr. Snow, Secretary of the State Board of Health, says that if babies could travel alone, there would be a regular July and August hegira of infants from the scorching East to California every year. And if they were allowed to designate their local habitation they would choose Berkeley.

The homes in Berkeley were also used as a selling point. Favorable lumber rates and low prices for building material encouraged the community to build new bungalows, cottages, and other buildings. This unusual activity in the "building operations of Berkeley" proved that people came for "the purpose of making homes." They were here

to stay, and no rival city could ever expect to lure them from their allegiance.

The City's freedom from crime, its "safe theaters offering acceptable entertainments," its low tax rate (79 cents a year per $100.00 in 1911), its immunity from fire, and its "boulevards as smooth and hard as iron" were just a few reasons why "good people" were looking our way.

If there was any doubt that such a city could exist, the Chamber of Commerce reprinted in several issues the following "pure fact law":

> Every statement contained in promotion literature issued by the Berkeley Chamber of Commerce is backed by a guaranty under the pure fact law. All of our statistics are conservative . . . the strong points of Berkeley are so apparent that it is not necessary to go beyond the plain truth.

Gloria Cooper

J. Stitt Wilson

Over the last two decades Berkeley has acquired a reputation for political radicalism. But relatively few people know that almost 70 years ago the City was among the first in the United States to elect an avowed Socialist as its mayor.

J. Stitt Wilson, elected in April 1911, was born in Canada in 1868. He came to the United States where he studied history, sociology and religion, and was ordained a minister in the Methodist Church. He resigned his Chicago pulpit, however, to devote his full time efforts to what was known at the time as "social evangelism."

Coming to the Bay Area on a speaking tour, he fell in love with our region and settled here. Later he wrote that "any kind of a day in Berkeley seems sweeter than the best day anywhere else."

In 1911 Wilson ran as the candidate of the Socialist Party for Governor of California and garnered 50,000 votes, which was considered a reputable showing. He gained even more recognition for conducting part of his campaign in an automobile—dubbed the "Red Special"—still enough of a novelty to attract attention. The next year, he was the unanimous choice of Berkeley Socialists for the mayoralty race.

The scene for the Socialist victory in Berkeley was set by a split within the old parties of the City. In 1901, Beverly Hodghead, a Democrat, had been elected as a reform mayor. During his administration, Hodghead drew the animosity of the *Berkeley Gazette* which, although conservative in its editorial policy, endorsed his Socialist opponent in 1911. At that time, Berkeley had two daily newspapers. The other paper, the *Independent*, although pro-labor,

pro-woman's suffrage, and generally progressive in its sympathies, endorsed Hodghead rather than the Socialist.

Stitt Wilson spoke at well-attended meetings virtually every night during the campaign. In contrast, the incumbent mayor waged a rather low profile campaign. Of handsome features and great oratorical skill, Wilson clearly had the edge in the "image" category.

The Socialist election platform called for:

- Municipal ownership of utilities.
- Immediate regulation of utility rates.
- Additional taxation of vacant land and the issuance of bonds to support public enterprises and improvements.
- A municipal lighting plant, reduced telephone rates and water rates, commuter fares on streetcars, free textbooks, kindergartens and playgrounds.

In the vote cast on Saturday, April 1, 1911, Stitt Wilson was elected mayor by a vote of 2,749 to Hodghead's 2,468.

As one went west in Berkeley in 1911, neighborhoods became, generally speaking, more working class and more populated by minority ethnic groups (which at that time meant primarily Finns). Wilson carried every precinct west of Shattuck Avenue.

In a statement to the citizens of Berkeley the day after his election Wilson proclaimed, "I stood as a Socialist, on a Socialist platform, and from night to night proclaimed my principles and our program in harmony with our new charter." In the next election, on April 22, Socialists were elected to the City Council and the school board.

Wilson declined to run for re-election in 1913, preferring to return to a career of writing and speaking. He later had a falling out with his Socialist comrades, but retained a keen interest in progressive causes. He supported Upton Sinclair for governor in 1934. J. Stitt Wilson remained a resident of Berkeley and concerned with local political and civic affairs until his death in 1942.

James T. Burnett

G. Sydney Rose—Fire Chief

A bronze plaque in honor of G. Sydney Rose (1878–1927) still hangs in the old Berkeley City Hall on Grove Street. It pays tribute to him as "for thirty-three years a faithful member of the Berkeley Fire Department and for eleven years its competent chief, a good and kindly man, a courageous loyal public servant."

John Rose, a carpenter of Portuguese descent, came to West Berkeley in the second half of the nineteenth century. He married Mary MacDonald, one of nine Scottish sisters who had emigrated to Berkeley from Nova Scotia. Their son, G. Sydney, was born on November 28, 1878.

G. Sydney Rose was, according to his daughter-in-law Elma Rose, in his early thirties when his father died. As the oldest son he felt an obligation to help raise all of his brothers and sisters—Mary, Mabel, Jessie, Donald, John and Amelia. Laden by this responsibility, it was not until Rose was forty-two that he married Annabelle Jones, a vivacious twenty-seven year old redhead, a gifted singer and musician from San Francisco. (Later in life, after her husband died, she sang with Meredith Willson's radio show on KGO in San Francisco.) They had two children who survived infancy.

G. Sidney Rose joined the old Beacon Company of Volunteers in 1894 when he was only sixteen years old. In 1904, when the department became professional, he was appointed to drive one of the horse drawn trucks. He was promoted to captain in 1906, Battalion Chief in 1908, and Deputy Chief in 1912. In December of that year Rose was badly injured when, while racing to a fire, his vehicle collided with a Southern Pacific train at Ashby Avenue and

Ellsworth Street. In that accident he suffered injuries to hand and leg from which he never fully recovered.

Despite his injuries, when Chief James Kenney died tragically in a West Berkeley fire, Rose was chosen as his successor. Thus it happened that in 1916 he became the youngest fire chief in the country.

During his eleven years as chief Rose brought the Berkeley Fire Department national recognition for efficiency. He originated the two platoon (or two shift) system for firemen, a system subsequently adopted by many departments throughout the country. He initiated a number of other improvements, including the systematic drilling of departmental personnel, a merit system, and an inspection bureau. Rose increased the number of firemen to 95, the number of fire stations to ten, and the number of fire companies to twelve.

In his work at fire prevention, Rose became State Vice President of the International Association of Fire Chiefs in 1923, and was appointed Deputy State Fire Marshal under State Fire Marshal Jay W. Stephens. Elma Rose recalls that he and a New York fire chief were instrumental in starting fire prevention week on a national scale.

During his tenure as fire chief, he earned a reputation for bravery and character. A local newspaper item of the time said of him, "Chief Rose is to the front in every fire, for, being himself an experienced and courageous fireman, he will take the same risks as his men."

Therese Pipe

Comic postcard (c. 1910).

Courtesy of Ken Pettitt

785 Berkeley, California — A busy street scene.

Berkeley Station on Shattuck Avenue,
looking north (c. 1908).

Berkeley Historical Society

Berkeley Station, Shattuck Avenue, looking
west on Addison Street (c. 1909).

John Hopkins Spring.

234

Berkeley City Council with J. Stitt Wilson
seated at the far left (1912).

235

Bancroft Way, looking south on Telegraph Avenue (c. 1909).

University Avenue and Walnut Street, the Acheson Building to the left (c. 1912).

Berkeley Historical Society

Jack Jaymot's Berkeley French Laundry, 2578
Shattuck Avenue (c. 1915).

238

A good picnic spot: the west end of the Campus
near Oxford Street (c. 1916).

Berkeley public school girls (c. 1916).

McCullagh Photographers
Berkeley Historical Society

240

G. Sydney Rose (c. 1916).

Mobilized Women's cookbook (1918).

Douglas Tilden's "The Bear Hunt" (c. 1891) was
on view at the Berkeley campus of the California
School for the Deaf from 1895 to 1980.

Courtesy of the California School for
the Deaf

243

The Berkeley High School faculty (1909).

244

For decades the University's stage productions have
entertained Berkeley audiences, town and gown alike. In
"Suppressed Desires," Mabel, the heroine, dreams of a
walking hen. Her sister Henrietta, a radical disciple of
psychoanalysis, takes her to Dr. Russell, the master
psychoanalyist, who interprets the dream to mean that Mabel
has a suppressed desire for Step-hen, her sister's husband.
There was a happy ending (1920).

Courtesy of the Blue and Gold

University students guarding the Axe at a rally (1920).

Courtesy of the Blue and Gold

Cal's Wonder Team (1920).

University aviators receive domestic help (1920).

Courtesy of the Blue and Gold

The Muses Quartet at 2134 Oxford Street.
Antonia Brico is seated at the piano (1921).

George Gibson, Photographer
Courtesy of Frances Cheney Lozier

Arthur W. Ryder.

250

Office girls at the International Distributing Company in the
Acheson Building on University Avenue near Oxford Street.
The photos were taken in March, 1923, when the boss was
away. Miss Hymer's is the kind of provocative behavior that,
in the movies of the 1920's, was always followed by
Earthquake, Fire, or Huns.

Courtesy of Ken Pettitt

251

Fire: September 17, 1923. The Berkeley fire from University and Oxford.

Wind driven debris at Euclid and Virginia as the fire approaches the Campus (1923).

The 1700 block of Shattuck Avenue goes up in flames (1923).

Ed ("Doc") Rogers, Photographer
Courtesy of the Berkeley Firefighers
Historical Committee

Extent of the Berkeley fire (1923).

Courtesy of the Berkeley
Firefighters Historical Committee

255

A Sunday stroll on Euclid Avenue after the fire (1923).

Courtesy of the Berkeley
Firefighters Historical Committee

256

City Hall, at Grove Street and Allston Way (c. 1934).

The Chamber of Commerce Building under construction at
Shattuck Avenue and Center Street. Berkeley's only
skyscraper until 1970, it was also called the American Trust
Company building, and now houses a Wells Fargo Bank
(1926).

The Berkeley in the 1930s.

Courtesy of the Southern Pacific

Helen Wills.

August Vollmer.

2428 Channing Way, Miss Talbert's rooming house
in the early 1930s (1965).

In the roof garden of the Whitecotton (now
Shattuck) Hotel: Charles E. Dunscomb, owner and
publisher of the Berkeley Daily Gazette, with
his wife (c. 1936).

Courtesy of Florence Jury

The living-dining room in a Maybeck family home.
The Maybecks pushed a table on wheels into the
middle of the room for formal dinners, and had
the room wired for radio music. After dinner,
there was dancing. The table was wheeled aside;
the waltzes and foxtrots broadcast by KRE seemed
to come from all corners (c. 1933).

Courtesy of Jacomena Maybeck

In the 1930s the University converted its old
power house into an art gallery (1965).

Courtesy of Benjamin B. Ehrich

265

Ella Young

Courtesy of Florence Jury

George R. Stewart

Mr. and Mrs. Walter Gordon

Ernest O. Lawrence

Robert Gordon Sproul.

The original Radiation Laboratory, University of California
campus (c. 1930s).

Courtesy of the Lawrence Berkeley
Laboratory

271

74 ton 27½ inch cyclotron, University of California (1933).

Courtesy of the Lawrence Berkeley
Laboratory

In Berkeley, between the two World Wars, there was the
question of whether toy guns should be given to boys; they
might develop war-like tendencies (1936).

Berkeley Historical Society

Berkeley's "College Cops," 1941

Berkeley's police officers were called "College Cops"
because they had attended college, not because they were
assigned to patrol campus neighborhoods (1941).

Berkeley Historical Society

The internment of Berkeley's Japanese-Americans, at the
corner of Channing Way and Dana Street (1942).

Courtesy of the First Congregational
Church

275

At Camp Ashby: Mrs. Lucile M. Lane and four members of
the Camp Ashby Choir (c. 1944).

Courtesy of Mrs. Lane

Learning the intricacies of the machine gun on Campus
(1944).

Courtesy of the Blue and Gold

World War II cigarette line. Tuesday was cigarette day;
there would be a two-pack limit.

278

THE 1920s

The Great Berkeley Fire

The worst disaster that the community of Berkeley ever suffered was the terrible fire of September 17, 1923. Today, the fire is a distant memory. To recapture the essence of that event we have drawn excerpts from two contemporary sources which provide interesting perspectives on the conflagration.

An unidentified witness gave this personal account:

> Propelled by the strong draft that whipped down Codornices Canyon, the flames raced through the grass and by one-thirty the uninhabited hillside at the head of the canyon was ablaze. Newspaper reporters in downtown Berkeley saw the smoke, which by this time was forming a menacing cloud over the city . . . It was not until 2:05 that the fire department received an urgent call about a grass fire from the resident of an isolated house high on the hill. Fire companies were still busy with a number of small blazes, however, and by the time the trucks had chugged up the narrow, winding streets to the scene, the conflaguration had descended to the edge of the hillside residential areas and about 2:20 ignited several houses . . . The firemen immediately went to work, too busy to notice that the grass fire was spreading into a large eucalyptus grove along the crest above them. The fire raced through the trees and suddenly burst out into the residential area on La Loma Street several hundred yards away from the fire fighters. Within a few minutes, before additional fire fighters could be summoned, the blaze was advancing into the fringe residential areas on a quarter-mile front . . . Within forty minutes after the first house was on fire, burning shingles were sailing over the rooftops throughout an area a half-mile square. As the firemen fought the blaze at one house,

its flying shingles would touch off another house several doors down the street

The Berkeley fire chief, watching his men fall back before the advance of the flames, put in an emergency call for help from Oakland, but at that moment thirteen Oakland fire companies were fighting fires of their own and could not be spared. He tried to phone San Francisco for help, but the phone lines were jammed. University students had been mobilized for the emergency by the more ancient means of communication—the bell of alarm. The elderly elevator operator at the Campanile had gone to the top of the tower and frantically pushed a big wooden bell handle, sending the tocsin over the campus and the city. Classes were dismissed, and students and faculty ran to the base of the tower. There university authorities told the men to report to the fire area and the women to organize relief centers for the refugees, who were already gathering on the campus.

Throughout the area north of the campus, most residents gave up battling the rooftop flames and concentrated on hauling furniture and valuables from the lower floors of the buildings to the street. In the confusion they grabbed whatever was on hand, and one dazed housewife wandered down the street clutching a telephone book. From the darkened sky fell a hot hail of ashes and blazing fragments of wood. Ambulances raced through the area. Intersections were jammed with cars escaping the flames.

Then came the decisive moment. Fire fighters and refugees alike felt instinctively that a major change had occurred, paused, and looked at each other wonderingly. Someone pointed up at the cloud of smoke. It was no longer billowing southwest over Berkeley but seemed to be heading back toward the hills. Gradually everyone realized what had happened. The wind had changed. The battle front in the upper air had turned. The northeast gale had blown itself out, and was now a gentle breeze. Though it brought the salt tang of the ocean, it was sweet and cool in the hot lungs of the weary fire fighters. The turning point had been reached.

From the National Board of Fire Underwriters, which submitted its report three weeks after the fire, can this terse description:

A grass fire, which originated about noon in Wild Cat Canyon at a point along the Pacific Gas and Electric Company's high tension

line, about three miles from the city, swept over the range of hills to the northeast of Berkeley and within two hours was attacking houses within the city limits. As it came into the more closely-built part of the city, at about 2:20 p.m., it travelled by two paths, presenting a total front about 1,600 feet wide . . . Several houses on Keith Avenue and Tallac and Tamalpais Streets were quickly involved and were soon followed by others on Buena Vista Way. In the next forty minutes burning brands carried by the high wind had spread the fire over an area extending 1,400 feet with a maximum width of 2,400 feet further; the concentration of fire apparatus along the northwestern flank of the fire and open spaces to the southeast steadily narrowed the path until it was only 800 feet wide when finally stopped.

The area of the built-up territory burned over was 130 acres. A total of 584 buildings were wholly destroyed and about 30 others seriously damaged. By far the greatest proportion was single-family dwellings, but among the number were 63 apartment and flat buildings, 13 fraternity, sorority and student house clubs, six hotels and boarding houses, four studios and libraries, two schools, one fire station and one church. There were also 218 small structures of minor importance, such as detached private garages, stables and sheds . . . The total loss is roughly estimated at $10,000,000 and the insurance loss at $4,500.000. At about 4,000 persons were rendered homeless.

<div align="right">Edward Staniford</div>

Chief Rose's Report

When the great fire of September 17, 1923 razed a sizable portion of North Berkeley, Chief G. Sydney Rose of the Berkeley Fire Department used his entire force to fight the fire.

Fearing that the hill district would be razed completely, Rose called for outside assistance. Oakland, San Francisco, Richmond, Piedmont and Emeryville came to the rescue. Two thousand firefighters eventually arrived and, at UC President Campbell's request, the University was closed down and 4,000 students volunteered to help put out the blaze. It is believed that additional firemen and equipment were on their way from San Jose before the direction of the wind suddenly changed and made it possible to bring the conflaguration under control.

Considered to be the worst California fire since San Francisco's in 1906, it lasted from noon through part of the night. Battalion Chief Kearns of San Francisco's fire department (who brought 200 firemen across the Bay by ferry) said that in his opinion the Berkeley fire burned faster and hotter than the San Francisco fire. (Massed at University and Shattuck Avenues ninety minutes after being called, the San Francisco apparatus is said to have saved Berkeley's business district.)

Chief Rose estimated the loss at between eight and nine million dollars and said the value of several of the homes destroyed, together with their contents, ran upwards of $250,000 each.

In his report Chief Rose wrote that due to high wind and a warm sultry atmosphere.

. . . during the entire morning the demand on the Department was such that at one time the entire Department was engaged in fighting fires in various sections of the City . . . At 1:25 p.m. all companies were again in service and 40 minutes later our first alarm was received from Mill Road and East Euclid Avenue for a grass fire . . . the first alarm received on the fire that eventually caused the inevitable conflagaration.

Burning shingles were falling more than one and a half miles from the scene of the conflagration. Two story houses were completely obliterated in the short space of five or ten minutes time and many of the smaller homes and garages were wiped off as if by magic . . . orders were given to abandon positions only when men and apparatus were in danger . . . and to work toward the narrowing of the fire into a wedge shaped area if possible with Shattuck and University Avenues as its apex.

Rose praised his men for their conduct and wrote that he considered the help given his department by the University students and many other citizens "a great factor in the ultimate control of the fire."

For the future, Rose asked for "nonflammable roof coverings and adequate water and fire protection" in the rebuilding of the burned area "so as to lessen the danger as much as possible for a recurrence of the terrible holocaust." (At least 90 percent of the buildings destroyed in the fire were of shingle construction.) And he stressed that adequate fire breaks on hill property must be made mandatory with protective agencies put in charge of this for future fire prevention.

At least some of his recommendations were acted on. Soon after the fire, a fire tower, built on the highest point in the Berkeley hills at 1800 feet elevation, helped the department to detect grass fires in the City and the outlying district behind the hills. As soon as the grass became dry each year, crews would begin burning operations under the supervision of the department—with all vacant lots cleared at the earliest possible time. This was only one part of the active fire prevention program that Berkeley became known for from that time on.

Therese Pipe

The Community's Response

When a community has suffered a catastrophe, its people in later years may remember the event well but not the aftermath. Yet the aftermath of disaster—whether from fire, flood or earthquake—may have the greater significance. For in the aftermath of the catastrophe comes the critical work of providing relief for the victims and rebuilding the destroyed area so that community life may return to normal. It is a test of the community's spirit how well its people recover from the tribulations of disaster. How the damaged area is restored as a healthy functioning part of the community is a measure of its character.

So it was with the Berkeley Fire of 1923.

The aftermatch of the fire is the remarkable story of how effectively and rapidly the community recovered.

Berkeley in the 1920s was an orderly community with an efficient municipal government. Two months before the fire the City had instituted the office of City Manager, a relatively new idea adopted by progressive-minded communities to ensure professional management of municipal affairs. Berkeley had a national reputation for pioneering the city planning commission idea and for its innovations in public education, including the primary and secondary schools as well as the State University. Its police department was nationally famous for its modern crime detection methods and traffic control procedures. In 1915 its fire department had made its mark as the first city in the State to convert completely from horse-drawn wagons to motorized vehicles. Fire Chiefs James Kenney and G. Sydney Rose were well-known for their involvement in fire prevention work at the state and national levels.

Berkeley had at the time a strong tradition of group organization and volunteer cooperation. Among the familiar list of local civic, business and professional associations, several had outstanding leaders. One was Charles Keeler, an important literary figure and cultural leader who headed the Chamber of Commerce. Of the neighborhood groups, the Berkeley Hillside Club was perhaps best known for its ambitious plans for city beautification and for its talented membership, which included such figures as Bernard Maybeck.

At the University of California was a host of administrators, professors and students who played significant roles. While the fire was still raging on the afternoon of September 17, top administrators greatly facilitated the work of the American Red Cross in establishng a headquarters on campus and providing facilities for refugee care centers and depot areas for household and personal goods rescued from the fire. Under the leadership of the Associated Students (a pioneer student body government and the nation's largest at the time), students fanned out in the fire area and systematically warned the occupants of endangered homes to leave and assisted in transporting their possessions to the campus. Some 800 students signed up for volunteer patrol duty on the evening of and the morning after the fire. Several professors, notably Stuart Daggett, Samuel May and Horace Weeks, who were active in municipal affairs, participated in important ways in the City's reconstruction efforts. Rare is the community that is so fortunate as to have such diverse resources in organization and manpower for dealing with a catastrophe.

The immediate problems resulting from the fire were handled with dispatch and speed. The extent of destruction was quickly estimated by public officials and publicized through the newspapers the day after the fire. Within three weeks, reports from the City Manager and the National Board of Fire Underwriters provided accurate data. The total property loss was estimated at $10 million, of which $4.6 million was covered by insurance.

The fire also had its human costs. Some 4,000 persons were rendered homeless. An unknown number of people visited local infirmaries and hospitals for minor treatment. But the only serious injury was to a freshman who suffered a broken leg. The remarkable fact is that not a single person lost his life during the fire.

Of great concern to victims of the fire was financial compensation

for their losses in homes and property. The National Board of Fire Underwriters announced in the newspapers the day after the fire that fire insurance to the amount of $3 million would be paid to victims within a week—and the first insurance payment was made that day. Some 45 insurance companies were involved in compensating victims for financial losses and they completed most of their task within six weeks.

Relief activities were organized immediately by the Berkeley Chapter of the American Red Cross. While the fire was still raging in the late afternoon, the Red Cross set up a canteen on the campus of the University to provide lunches, soup, and hot and cold drinks for some hundreds of fire fighters and guards. It also set up temporary tents in staging areas for immediate care of the fire victims.

By evening, the Red Cross had established headquarters and a communication post in the chamber room of the City Council at City Hall. The Berkeley Chapter of the Red Cross was in contact with the Oakland chapter and the San Francisco regional headquarters which was coordinating the flow of emergency food and clothing from a variety of local organizations. Assignments were given to the multitude of volunteers who appeared at City Hall to offer their services. Fire victims were helped to locate their families and friends. Calls came in from people throughout the community who offered their homes as temporary shelter for the fire victims—387 Berkeley, 40 in Oakland and others in the East Bay and San Francisco accommodating 3,522 persons in all.

Rehabilitation of the burned area and assistance to fire victims in returning to a normal life was also undertaken under the auspices of the City Council and the Red Cross. The City Council, on recommendation of the ARC's Berkeley Chapter, established the Berkeley Red Cross Disaster Rehabilitation Committee to plan the relief of victims and rehabilitation of the burned area. The University assumed responsibility for the care of its own—the 1,084 homeless students and 103 professors, administrators and other employees. Here again, the Red Cross and the University cooperated closely. Through the Pacific Division headquarters of the Red Cross in San Francisco, arrangements were made with the national headquarters in Washington, D.C. to insure the flow of funds for financing relief and rehabilitation. Money was allocated to fire victims according to

basic needs rather than the value of property losses. The Red Cross completed its work before the year was out.

Several issues arose from the fire that evoked considerable public feeling and controversy—some of which even continues today. Attention focused almost immediately on the origins of the fire. In a report made at the request of Berkeley's City Manager, the U.S. Forest Service advised that the fire began along the PG&E high tension lines, but there was no evidence it started due to a fallen wire. The most probable cause: a careless smoker along the power-pole line frequented by hikers.

Fire prevention measures were taken almost immediately. The East Bay Municipal Utility District held two public hearings to obtain information on fire protection provided by the East Bay Water Company. Berkeley's City Manager employed a private consultant to undertake a separate investigation. As a result of recommendation from both agencies, the U.S. Forest Service appointed two rangers to patrol the hills back of the City during the hot, dry weather until the arrival of the rainy season.

Redevelopment of the burned area aroused unexpected public passion. The City planning commission held a public meeting four days after the fire, ostensibly to provide an occasion for City officials to announce proposed plans for rebuilding the area. Individual residents and representatives of community groups, however, immediately took the floor to voice their demands, converting the public meeting into a mass demonstration. Leaders of the community offered some interesting perspectives. Bernard Maybeck, the prominent local architect, proposed that neighborhood groups form block committees to work out their own plans. William Barber saw the fire as providing a great opportunity for beautifying the area. Out of the public meeting came several recommendations from the audience: temporary and permanent fire protection in the hill region, telephone and electric wires underground, and the burned area rebuilt primarily for single-dwelling homes. It became apparent that residents were most concerned about zoning regulations and property values.

The disastrous lesson of the City's inadequate water supply once again promoted public demand for immediate action. The City Manager prepared a plan and negotiated a contract with the East Bay Water Company for constructing more and larger water mains. The

288

City auditor, however, refused to countersign the contract, raising the issue of who was to pay the costs of the project—property owners or the company. The issue dragged on for months as interested parties debated the matter in the public press. The City Council procrastinated, but in February, 1924, it was forced to act. The result was a compromise by which the company would build the water mains without contract and would be compensated by water hydrant charges paid by the cities of the area.

Perhaps the most significant issue raised by the fire was the matter of shingle roofs. It was apparent that the fire was greatly intensified and extended by burning embers from wood-shingled roofs which not only set nearby houses on fire but set off small fires as far as two miles away. A day after the fire, lumber companies, notably the California Redwood Association and the California Retail Lumber Association, began their campaign with newspaper ads discounting the fire hazards of the wood-shingle roof. Before long a "war of words" erupted between them and community organizations as to the merits and demerits of wood-shingle roofs. The Affiliate Clubs of Berkeley took form as an umbrella organization to coordinate the campaign against wood-shingle roofs. In October, 1923, the City Council unanimously adopted an ordinance requiring fire-retarding materials for roofs. The City Council's action only intensified public debate and spurred the affected groups to further action. One group sponsored a referendum while the other group pressed for an initiative. The outcome was decided in the City election held in May 1924 as a victory for the lumber companies and their supporters. The vote determined the character of home-building in Berkeley that we see today. With that, the aftermath of the fire may be said to have come substantially to a close.

An unexpected tragedy occured many years later to remind us that the final consequences of an event can rarely be assigned a clear and definite date. On December 3, 1931, the Fire Department was called to handle an emergency at 2600 Cedar St. In the basement of the house two 18-year-old boys had found a capped pipe—a remnant from the 1923 fire—protruding through the foundation. When they sought to tighten the pipe cap, it suddenly broke and gas flowed into the basement. As firemen worked to put out a small blaze at the scene, a huge explosion took place. Two firemen and a young man

were killed. Seventy other people were injured. Chief Haggerty and two firemen were literally blown through one wall and sustained injuries which probably contributed to their early deaths.

Florence Jury
and
Edward Staniford

Bohemian Dinners and Fine Music

When Antonia Brico and her colleagues in the Muses Quartet posed for their portrait at the Gibson Photography Studio at 2134 Oxford Street in the 1920s, not long before Brico set out with her UC music degree to seek her fortune in Europe, they left the spirit of music in the picture—or perhaps it was already there.

The piano around which they posed belonged, and still belongs, to Gibson's niece, Frances Lozier of Albany, who was majoring in music at the University then.

In any case, in the next decade while Antonia Brico made her mark in the musical world, the Gibson Photography Studio became an important local institution, the Berkeley Music Center.

Antonia you know about; the story of the Berkeley Music Center and Charles Dutton is a bit of Berkeley history becoming old enough to deserve retelling.

From 1924 to 1946 pianist Charles Mallory Dutton presided over weekly candlelit bohemian dinner concerts at the Berkeley Music Center—150 or so of the finest evening-dressed guests, paying a dollar each to eat at rough trestle tables in the poster-covered rooms, and hear exquisite performances by leading local musicians in a familiar, club-like atmosphere.

"Hundreds of candles, all over the house, cracking plaster, red-haired and red-faced women seeing their reflections in brilliant mirrors," a feature writer found in 1936. "Rachmaninoff's Second Concerto played in duet . . . One hour and 30 minutes of Heaven."

This was the second career of Charles Dutton: he had studied music around the turn of the century, married well, lived and

performed in Europe, and in 1914 had a grand house on Tunnel Road designed by Henry Gutterson especially for home concert-giving. But when he separated from his wife, the house and the money went too.

What happened next shows Berkeley as a small town looking after its own—the local cultural patronesses came to the rescue. As one of our informants put it in fine period terms, "Sadie Gregory and some other women felt very badly for Charles Dutton, because he's never earned his living—except by teaching some music. So they set him up in the Berkeley Music Center, down on Oxford Street."

The musicians donated their services—charity at first, but it soon became prestige. University music students earned their admission, lessons, or room and board by serving at the dinners. Dutton himself did the cooking.

What began as an aristocratic relief project became a lively institution filling a real need in the community. To the Berkeley Music Center once every week came teachers, students, businessmen, people who found comfort in the greatest of all the arts—music!

The story's end and its sequel tell something about Berkeley history too. Early in 1946, given notice to vacate the house, Dutton went across the street to the University campus and shot himself. His suicide note said that at 68 he couldn't start over again.

Betty Marvin

Campus Traditions

Student life on campus in the years 1925 to 1929 was quite different from that of today, owing primarily to the fact that many traditions that existed then are no longer around.

Intense campus spirit was aroused by the *Daily Cal*, which was a large-size paper and full of feature columnists and a big "ice box" section (letters to the editor). This spirit was enhanced by the emphasis on class loyalty.

When enrollment was highest during this four-year stretch there were only 11,044 students and 509 faculty members. This made for more informality between the professors and the students. The joy of a long, sixteen week semester system allowed for more time to study and for activities to get fully under way. The competition for grades was less keen, and so many more students were able to enjoy extracurricular activities.

There were more playboys.

The freshman in his blue hat was initiated by jean-clad sophomores and, especially during the first week of college, lived in fear of being made to roll a peanut or a cigarette down Telegraph Avenue with his nose. Some freshmen were forced to direct traffic at "Telly" and Bancroft while standing on an ashcan with a wooden barrel around their middle. Still others were forced to pose in dress shop windows along side the mannequins, receiving stares from passers-by.

Physical education and military training were required and despised.

To choose the P.E. course he wanted, a freshmen had to pass an agility test which included climbing a 12-foot backboard with the help

of a rope. In the second semester he had to pass a swimming test, and in the third a boxing match. If he failed the tests, the poor frosh had to take calisthenics instead.The big event of the year was the Frosh-Soph brawl, which took place in the third week of the fall semester and consisted of a number of different contests. Each participant painted his class numerals on his chest. The "tie-up" involved tying up your opponent's legs with rope. In the "joust," painted, stuffed sacks were tied at the end of poles and each attacker carried one while riding on the shoulders of a classmate. The frosh had to try to knock the sophomores to the ground—and vice versa.

The main event was the tug-of-war. Some years the people nearest the center of the rope would be pulled into a muddy hole. In other years a stream of water from a hose greeted the losers of the battle.

Women students also enjoyed extracurricular activities, but they were less rowdy, and cleaner. Their sports were many and varied— tennis, basketball, swimming, canoeing, hockey, crew, even fencing. The competition was both interclass and with Mills and Stanford.

There was widespread participation in dramatics involving both men and women, and producing outstanding productions in serious drama and hilarious farces and extravaganzas. The men were inclined to be amused at the Springtime Partheneia which was always written, produced and acted in by the women. It was a colorful spectacle in Faculty Glade, and everything about these annual performances was professional.

The Little Theatre founded in 1922 immediately set a standard of excellence in every phase of its work. Through the years many of its graduates went into successful professional work.

Stephens Hall was the student union then. The bookstore was on the ground floor, the men's club rooms were on the second floor, and the women's were on the third.

Chess games were played on many afternoons at the student union, and Professor Branch of the Chemistry Department would come down once a year and challenge the whole chess club to simultaneous play.

The Social Problems Club attacked the ASUC as "a refined racket . . . controlled by alumni and faculty." Political speakers spoke outside Sather Gate, which was off campus then, since Telegraph Avenue still reached that far.

There were three Greek Theatre rallies in the fall. The third was called the "pajamarino rally" because the students wore pajamas and sat close to the diazoma where an enormous bonfire burned.

After finals came senior week, in which there were the men's and women's banquets, the Greek Theater Extravaganza, the baccalaureate sermon, and the Senior Ball. The senior pilgrimage consisted of a last farewell visit to hallowed spots on campus with speeches by class leaders. Women dressed in white and carried parasols. The men wore duck pants and dark coats.

At graduation in the Greek Theater, seniors were able to get their real diplomas, since grades were sent in and posted during senior week.

<div align="right">Bois Burk and Florence Jury</div>

The Poets' Dinner

Year after year in the spring they arrive, friend and stranger, to attend the Poets' Dinner. They come from all around the East Bay, San Francisco, the North Bay, Sacramento, Monterey.

In years past they have come from Eureka and from San Diego (once from Reno, and even Utah), and they have numbered, these writers of verse, as many as 400 on occasion to hear the reading of poems judged winners in the Poets' Dinner contests.

For the past 55 years they have arrived at the appointed restaurant—seasoned poets who are old hands at winning and those who have penned their first poem—to learn whether their works have been declared winners.

They are young; they are old. One can only guess as to their daily work and other concerns, but they are alike in one area—their interest in poetry. Some have companions, others come alone sustained by the hope, the dare, even, that the poems they have sent in are good enough.

Their credentials have preceded them—the eight and one-half by eleven inch sheet of words carved out of the mind and submitted anonymously.

The winning poems are read at these dinners, and it is only when the winner claims the prize that the author is revealed. The author must be present to win. The suspense can be excruciating to those who've "got a poem in."

The nail-biting is intensified by the inclusion of a speaker in that part of the program preceding the awards.

Some years the poets wait hours to learn whether they have written a prize poem. The dinners start at 6:20 p.m. and have been known to last until 1:30 a.m.

"Wake up, you're a winner," a knowing spouse was heard to say one year.

The Poets' Dinner began in 1927, when a few souls who'd had poems published in Ad Schuster's *Tribune* column decided to hold a poetry contest.

The rules were printed and distributed. No names were to show on the poems entered; poets had to be present to win.

About 60 hopefuls attended the first Poets' Dinner held on March 15, 1927. They were hardly moon-gazing wraiths. Indeed, they dispelled the myth about poets existing on euphoria and a whiff of rose by wolfing down a hearty dinner in the restaurant at the Varsity Candy Shop on Bancroft Way in Berkeley.

A menu from the second Poets' Dinner remains to testify that they put away orange fruit cocktail and asparagus-and-tomato salad, followed by roast leg of spring lamb with mint jelly, creamed mashed potatoes, buttered green peas, and hot home-made biscuits.

They topped it all off with strawberry sundae and small cakes and coffee. the cost, $1. Actually, the restaurant charged 65 cents; 35 cents went to pay contest expenses.

The first chairman was John Brayton, who conceived the idea of a poetry contest and dinner.

Minnie Faegre Knox, who saw its plausibility, attended the first event and gave her enthusiastic and uninterrupted presence to every dinner for 50 years. She received an award for endurance and a standing ovation at the dinner's Golden Anniversary in 1976.

Despite her failing health Minnie Knox's interest in the occasion continued until her death in 1980 at age 94.

What could a poet expect to win?

In the early years the prizes were rich in variety: a lamp, a painting, a clock, candle holders, all donated by merchants, poets, and other supporters.

And, since the authors were unknown until the poems were read publicly, the prizes were sometimes surprising.

One year the contest committee, figuring the grand-prize poem bore every sign of feminine authorship, allocated a basket of flowers to the winner, who turned out to be a burly 6-footer. He accepted it with good humor.

Another year a woman who won a lamp simply refused it.

If a winning author did not show up to claim the prize, the absent winner forfeited the prize, and the next-best poem moved up.

In recent years the prizes have been cash; the honorable mentions are books of poetry donated usually by poets familiar with the Poets' Dinner.

The judges are chosen by the current committee and are usually poets of stature, college professors, and newspaper people.

The names of the judges are not released until the night of the dinner to prevent those entering the contest from writing to suit a judge's suspected predilection or from pestering those deciding the merits of the poems. It's simpler this way.

The poems in the anthology, *The Singing East Bay and Beyond* reflect the times, and they bring to verse such diverse concerns as flying saucers, World War II, the Watts riots, and the investiture of Prince Charles. More than 300 poets and other aficionados gathered at Spenger's on March 20, 1976 and paid $6 for the 50th anniversary dinner of roast beef or salmon.

Those honored for their affiliation with the Poets' Dinner in its formative years, in addition to Minnie Knox, were Dorothy Tyrrel and Mrs. Raoul Dorsay of Oakland, Mrs. Addison B. Schuster of San Rafael, Rosalie Moore Brown of Fairfax, and LoVerne Wilson of San Diego. The dinner chairman that year was Dr. Wesley Dexter Gordon of Hayward, whose participation in the event included reading many of the poems that had won over 40 years.

Interestingly, the Poets' Dinner has no on-file organization.

Each year those who have had a job on the most recent event get together and pick over the bones of the last dinner. They suggest what needs to be done to strengthen the event and what modification of the rules seems to be in order.

The next chairman is picked, and that individual finds a contest chairman and others to take responsibility for the following year's dinner.

So it is that the Poets' Dinner, like the swallows and the wild flowers, reappears every spring.

Dorothy V. Benson

The Veterans Memorial Building

Situated downtown on Center Street near Grove, the Veterans Memorial building is one of the few County buildings in Berkeley. It was built to serve the City as a major community center, but for years it was a forgotten and rarely used facility.

Located on a side street, the site was chosen because of its proximity to the former National Guard Armory on Addison Street. With the open floor space of the adjacent Armory available for meetings and displays, it gave Berkeley the facilities needed for large conventions.

Begun early 1928, the Veterans Memorial Building was one of the first units of the proposed Civic Center Complex. A plan created in 1914 by architect Charles H. Cheney suggested a library for the site. No doubt the Veterans Memorial classical facade represents the proposed library classical colonnade. But pilasters have replaced columns. The groundbreaking ceremony for the construction of the new building took place in early 1928. Guests of honor at the ceremony were Sheriff John Driver, John Honer and Guy Hassle. They were veterans of World War I, the Civil War and the Spanish American War respectively.

Dedicated formally on Sunday, November 11, 1928, to the memory of the young men of the City and the University who had given their lives in the country's wars, the building was the scene of an elaborate celebration. On Sunday there were speeches, including one by Lt. Gov. Buron R. Fitts. On Monday, in the afternoon there was an open house with entertainment and a banquet in the evening, at which local architect William H. Wharff, a ninety-two year old survivor of the Grand Army of the Republic, recited Lincoln's Gettysburg Address. A Grand Ball ended the festivities.

Lauded as one of the finest buildings of its kind in the State, one of the architectural triumphs of the Bay, and one of the finest buildings in the City, it may well have been. It was among the earliest such memorials constructed following the passage of the State law which authorized them, and it preceded the Veterans Memorial Complex in San Francisco by four years.

Constructed to house veteran, auxiliary and service groups, it is a building that appeals to men. Somewhat austere within, the tile floors provide a Spanish touch. Somewhat severe without, the facade commemorates three wars: the Civil, Spanish-American, and First World wars. Medallions depict a soldier, a sailor, an aviator, and the seals of California and the United States.

Designed to accommodate a number of activities, it has an auditorium that measures 64 feet by 66 feet. With the balcony it seats about 600. The large stage can handle theatrical performances. The flat maple wood floor serves also as a ballroom dance floor. Furnished with a projection booth and screen, the auditorium can also be used as a movie theatre.

Equipped fully, it has a complete heating and ventilating system. The basement has a banquet room with kitchen for 250, a pool room, and an apartment for the custodian. Two club rooms and two lodge rooms, one of each for the men and for women, and a second small banquet room on the upper floor end the list of facilities which this memorial offers.

Attributed to Henry H. Meyers, the County Architect for twenty-two years until his retirement in 1936, it was one of ten war memorials for which his office was responsible. Meyers was the architect for many public buildings (including Highland Hospital in Oakland), and this may be one of his best works.

Isolated in the midst of the City, the Veterans Building remains a showcase of 1930s design. The lighting fixtures, furniture and equipment are modern styling period pieces. The pool room, fashioned from a former bowling alley, features an Art Deco style bar and chairs. Preservation of these qualities and the purpose memorialized herein merits consideration.

Charles Marinovich

THE DEPRESSION

Student Rooming Houses

Student life and life in Berkeley were quite different during the Depression, especially in the early thirties when room rent began at $10 and board ran from $30 to $40 per month.

Many widows and spinsters ran rooming and boarding houses or a combination of the two in the large wood-frame houses located where the current dormitories, People's Park, and Edwards Field are now. These women worked hard to earn their livelihood while providing cheap places for the foreign student or the poor domestic student to live.

One such well known house that offered a combination of room and board was run by Miss Lillian Talbert at 2401 Durant. Her roomers, and anyone who lived elsewhere and needed board only, could come there for meals. Dinners were served to ninety people, ninety-nine percent of whom were students. This landlady attracted this large turnout owing to her low prices. She had four other houses. Three of them were located at 2428, 2430 and 2434 Channing Way (now a parking lot).

In 1895 Miss Talbert had come from San Jose to be a freshman on the Berkeley campus. After graduation she became a supervisor and lecturer in education at the San Francisco State Teachers College. In 1913 she bagan a private primary school, called Miss Talbert's School, at 2430-2434 Channing Way. In the early 1930s she began her career as a proprietor of rooming and boarding houses.

Miss Talbert worked very hard and some of the renters called her "Tillie the Toiler," after the popular comic strip character of those glorious days.

One tradition of the establishment was to invite members of the International House down to dinner on Saturday nights. Such selected students would entertain with stories of life in their native countries.

From the thirties through the fifties Miss Talbert left the front door unlocked. This gave students the freedom of not having to carry keys around. In fact, many students left their own rooms unlocked. The fear of theft was not the problem then that it is today.

The alumni of the House of Talbert can be found all over the world as doctors, lawyers, judges and in many other occupations.

Bois Burk

How the City Weathered
the Cruelest Depression Year

At the beginning of 1932 I returned to Berkeley from a job as a research assistant and librarian within a consulting engineering firm. It had been a fascinating job except for the fact that, although companies needed consulting services, they were seldom able to pay for them. As the firm's bank account seeped away, so did its employees.

Having worked at the *Berkeley Gazette* twice before, I now wrote to Charles E. Dunscomb, the publisher, asking for a job. He replied by wire—briefly, and to the point, "Yes, damn it, for the last time. Check in mail."

Dunscomb was quite imposing. He had a straight thin nose, and high cheek bones, rather like an Indian's. His face was tanned nut brown, as was the bald part of his head. His spare circle of hair was gray. He was very slender, which made him seem taller than he actually was, probably just under six feet.

He was always immaculately dressed and groomed, a joy to look at. His arrival at work each morning at 9 o'clock through the back door of the old composing room was announced by the sudden fragrance of a Havana cigar and its trail of blue smoke.

There was something in his face that made him seem formidable. Yet with his employees he was approachable and kindly. Though he did not exactly pay high wages, he was generous with loans which he sometimes forgot about.

His political stance was conservative. The paper was conservative.

But he was a fair man, and he had that old-fashioned virtue—his word was his bond.

My job at the *Gazette* was to begin immediately when I arrived in Berkeley or, at the latest, the next morning. I stayed at the Carlton Hotel while I looked for an apartment, which I found within a few days, at the top of Virginia Street for $25 a month. It was spacious and furnished: a large living room, a dining room with a red brick corner fireplace, a large kitchen opening onto the lawn and clothes line, a dressing room and bath, and a large sleeping porch with a view of the Bay! After a few months I wrote to the landlady, whom I never saw, that I thought it would be helpful if she reduced the rent to $22.50 a month. She did, without resistance. While I was at the hotel I found I had no means of doing my laundry. (There were no landromats in those days.) I looked at ads in the *Gazette* and found a woman willing to take my things to her home, wash and iron them, and bring them back. But Miss Dodge couldn't come the first day I wanted her because she was going to the campus to hear a lecture on Irish poetry. I thought this an unusual laundry woman, so I attended the lecture too. There I first heard Ella Young, the Irish poet and story teller. After I moved into the apartment, Miss Dodge came each week, did all the laundry and cleaned the apartment for—$1.25 a week. I learned she had been the principal of a school in Sacramento and had retired with a pension which was not adequate even for those days.

Perhaps the Depression was slow in being realized in Berkeley. I was amused recently when I read the *Gazette's* 1932 New Year's headline: "Berkeley Looks to 1932 For Increased Business." The article accompanying this remarkable statement announced that Berkeley had written off its losses from the Depression of 1931. It went on to list the City's plans for spending $200,00 on municipal work, including the paving of Spruce Street.

Early in January, Hink's announced its "Greatest Dollar Day.' The ad stated that the 1932 dollar would buy more and better merchandise than for the past 20 years: all-wool blankets were $3.95, $15 dresses were reduced to $5 and $18.50 dresses to $10.00. The Lincoln Market was selling turkeys for 30 cents a pound, prime rib roast for 22½ cents, and shoulder lamb roast at 10 cents. The Blue and Gold Market had butter for 28 cents a pound, eggs at 25 cents a dozen, and bacon for 21 cents a pound.

But the hardships of the Depression did reach Berkeley. A man was found unconscious on the sidewalk at Solano and Peralta. he had an unused meal ticket from a charitable organization in his pocket, apparently just issued. His condition was diagnosed as starvation.

The City Council received a letter from the Workers International Relief and Unemployment Council requesting food, shelter and permission for 200 of its delegates to stage a "Hunger March" parade on San Pablo Avenue. The City decided to grant only the parade permit. The *Gazette* editorialized that the hunger marchers knew their demands were utterly absurd and impossible. That no doubt the leaders were Communists exploiting the misfortunes of the unemployed to spread dissatisfaction and the spirit of revolution among the people:

> The very nature of their demands . . . brands these agitators as Reds! There is but one real cure for this brand of disturber and that is hard work, preferably making little rocks out of big ones. They have repeatedly scorned work along their line of march to San Francisco. Doubtless some of the rank and file would willingly have worked for a meal, but their Communist leaders would not permit it.

Perhaps and perhaps not.

Sometime during the mid-thirties Dunscomb told all of the women on the paper that he'd gone through his closet and decided to get rid of some of his suits. He asked whether we would like them. We all knew their quality, and we said yes. Suddenly by way of some ingenious tailoring, many old suits were transformed and made new again, with the jackets looking feminine, and the trousers turned into skirts.

Nineteen thirty-two was the year Frederick Lewis Allen called the cruelest of the Depression, and the Berkeley City government was trying bravely to be optimistic.

Almost defiantly, it announced that 1931 had seen much building. The University Christian Church was built for $120,000; the public library was completed at a cost of $250,000; a $40,000 addition to the

YMCA was virtually finished; $289,000 worth of municipal improvements were made; and the University had spent $3 million on its building program.

And 1932 was to see continued progress. The United Artists Theater, when finished in the summer, would represent an investment of $300,000, and the Federal government had awarded a $105,000 contract for an addition to the local post office.

But the uncomfortable truth was that Alameda County had to order the charitable organizations disbursing county funds to cease issuing grocery orders because the county treasury faced a deficit. Only four months into 1932, it had spent $1,139,630 on relief—$129,630 more than budgeted. Berkeley itself had raised $50,000 in the fall of 1931 and spent $80,000, all gone early in 1932.

City Manager Hollis Thompson told a conference of City officials and unemployed men that Berkeley's ideal was that no family should be without food or shelter during the economic crisis, and that the City must go forward with new plans to meet a situation which "grows more difficult than any of us had a right to expect."

The new money was raised, and 500 destitute families received grocery orders and orders for the payment of rent, lights, and heat. With each order came an assignment to a definite City or public works job. This allowed the recipient to work out the amount of the order at fifty cents an hour.

All of us in Berkeley knew the dismal situation in our town and all over the country—all over the world, as a matter of fact. We had the radio and the newsreels at the movies. (And the movies were cheap.) Neither I nor my friends, who had jobs, could do more than contribute an occasional dollar or two to the continuing drives to build up the City's relief funds. My $25-a-week job kept me solvent, but little more.

It was laughter that kept people sane. The country read *Oh, yeah?*, a collection of hilarious prophecies by people who didn't know what was going on. The new *Ballyhoo* magazine, which pilloried the sacred cows of business, politics, and advertising, reached a circulation of more than a million almost immediately.

The 1932 Pulitzer Prize for Drama was a first—it was given for a musical comedy—"Of Thee I Sing" by George Kaufman and Morrie Ryskind. It was a glorious satire on American politics and politicians.

It concerned a presidential campaign whose platform was "Love." Alexander Throttlebottom, the vice-presidential candidate, became a household name.

The more serious-minded were delighted that Pearl Buck won the Pulitzer at the same time for *The Good Earth*. Rudy Vallee was keeping up our spirits with "Life is Just a Bowl of Cherries."

Meanwhile, poor President Hoover, by early training and his own good fortune, unable to conceive of Government programs to help the jobless and the poor directly, presented the sorry picture of a man doing too little too late, and the wrong thing.

If any of us had been seers in early 1932, we would all have been both happy and horrified. For the names of two new men began to appear in the press, and now and then we saw pictures of them in the newsreels.

Franklin Delano Roosevelt and his friends had begun to plan his strategy for election to the Presidency, months before the Democratic National Convention in June.

Thousands of miles away, Adolph Hitler was challenging the re-election of President Paul von Hindenburg. The latter beat Hitler by six million votes and ordered the suppression of Hitler's Fascist army. However, the Fascist power continued to grow. The Nazis increased the number of seats they held in the Prussian Diet from nine in 1928 to 162 out of a total of 418.

Thus, while no relief seemed in sight for the plight of the country, two men were in the wings preparing for the days when they would change our world.

Democrats were hard to find in Berkeley in 1932. There were only 10,885 of them then, and 31,073 Republicans.

As the May 3 State primary neared, the Republicans were astonished to learn that, statewide, they had lost 243,395 registered voters, while the Democrats had gained 391,386 new ones. Straws in the wind, but not in Berkeley.

Franklin D. Roosevelt was the favored Democrat, and his organization was busy getting a substantial number of delegates lined up for the June Democratic Convention. In our State primary there were

three Democratic candidates—Roosevelt, Speaker John Nance Garner, and Alfred E. Smith. On the Republican side, President Herbert Hoover was unopposed. The Democratic race ended in an upset: Garner got the State's 44 Democratic delegates. Berkeley, of course, gave Hoover a big majority.

In those primitive, pre-television days, the *Gazette* flashed the election figures on a board on the front of the building across the street from its office. People who wanted the returns but who did not want to go downtown could stay home and listen to the radio.

A battle of another kind, but actually a part of the nation's malaise, was that of the Wets vs. the Drys. The *Literary Digest* poll discovered a 3 to 1 vote for the Wets. It also found the clergy the driest, to no one's surprise, and lawyers the wettest.

The Allied Forces of Prohibition, touring the country to muster support for the Eighteenth Amendment, came to Berkeley. Dr. Daniel A. Poling, editor of the *Christian Herald*, told an audience at the Whitecotton Hotel (now the Shattuck Hotel) that not only had the young of the nation not been corrupted by Prohibition, had not created the speakeasy; instead, Prohibition had uncovered it! The executive counselor of Allied Youth, speaking at Stephens Hall (then the student union), said that young men carrying flasks were in the minority. Neither group, wet or dry, thought legalized beer could bring back prosperity.

1932 was an unfortunate year for two men who had created financial empires of such magnitude their names were everywhere spoken with awe—even in Berkeley. Samuel Insull, once Thomas Edison's private secretary, put together a mammoth structure of utility holding companies. It crashed with the stock market, and Insull fled to Europe.

In Paris, Ivar Kreuger, known worldwide as the Swedish match king, failed to appear at a business meeting. They found his body on his bed—a suicide. He was a handsome charmer whose career was a tissue of fraud, false figures, and lies. *Fortune Magazine* ran the story of his life and death under the heading "Overture on a Browning."

During the twenties women, apparently weary after the bitter struggle for suffrage, were gathering their forces quietly. But they were on the march—not the sort of march we are accustomed to nowadays. They were still asking instead of demanding. But more

310

and more they were going to college and into professions and businesses.

One of Cal's most distinguished alumni, Lillian Gilbreth, Class of 1900, visited her alma mater in 1932.

She was an engineer specializing in plant efficiency. In her home town in New Jersey she conducted engineering classes for representatives of corporations interested in modernizing their plants. She was the mother in the famous book *Cheaper by the Dozen*. Written by one of the Dozen, it presents the true story of Mrs. Gilbreth's family, and might be said to offer an interesting solution for women today who are struggling with the problem of home vs. career.

The National Council of Women was seeking one million signatures to impress foreign governments with the importance of a proposed International Congress of Women to be held in connection with the Chicago Century of Progress Exposition in 1933.

Thousands of veterans of World War I marched on Washington, D.C. in the spring of 1932 to urge Congress to give them the bonus it had promised. They brought their families and camped in makeshift huts. Congress adjourned without granting the bonus. They remained—a problem for President Hoover.

When he ordered them to be dispersed by troops he shocked the nation, and this probably contributed as much to his defeat as any other of his attempts to heal the economy.

The Republicans went to Chicago in the middle of June 1932 to nominate President Herbert Hoover for a second term.

The keynote speaker told delegates that the President had saved the nation from panic, and reminded them that the Republican Party was still the party of "sound money," a statement that rang hollow to those who had none, sound or otherwise. The only fight at the convention concerned the party's stand on Prohibition. It finally adopted a resolution favoring a modified Eighteenth Amendment which would permit wet states to legalize liquor and dry states to retain Prohibition. Of course, it condemned the saloon.

There was a slight flurry when an attempt was made to dump Charles Curtis as vice-presidential candidate. He and Hoover dis-

liked each other. He had been unwelcome but politically necessary in 1928. But it was still expedient to put him on the ticket, and the Republicans nominated them both again.

The debris left from the Republican convention had scarcely been swept away and the smoke-filled rooms aired out, before the Democrats began pouring into Chicago. They convened on June 27.

Franklin Delano Roosevelt had the largest number of delegates already pledged. Senator Alben W. Barkley, the keynote speaker, made a caustic attack on Republican policies during the Depression. He promised that a solution of the Prohibition question would be found by submitting a repeal proposal to the state conventions. On the third ballot Roosevelt and John Nance Garner were nominated. Contrary to all precedent, Roosevelt flew to Chicago to make his acceptance speech. Twenty-five thousand people greeted him at the municipal airport.

Here in Berkeley, as everywhere else in the country, a thrill of hope ran through us as we heard for the first time those two words— New Deal—which would be a beacon to a better future, or to some cynics, a signal for the beginning of Armageddon. Feelings ran high in those days after years of deprivation and desperation for millions.

He stood to make his speech, his eldest son James beside him. Nearly everyone knew Roosevelt had had polio, but no one ever saw him in a wheelchair, nor struggling in and out of cars. The photographers of those days carefully refrained from picturing him as a man handicapped. Nor, indeed, did anyone ever think of him as handicapped as we saw him year after year standing to speak to the American people, his strong torso showing him a man of vigor and purpose.

We also saw Eleanor for the first time beside her husband—the woman who was destined to become the most beloved, admired, visible, controversial, and vilified First Lady in history.

As the summer progressed toward that fateful autumn election day, that thrill of hope grew stronger. The candidates were heard throughout the land. We saw them on the movie newsreels, we listened on radio. What a difference between the cold, impersonal tones of Hoover's pedestrian speeches, and the warm, buoyant Roosevelt voice. We felt he was speaking to each of us directly. Other voices were heard, too. At Cambridge University in England,

Lord Rutherford, the renowned British Scientist, was asked about the atom splitting by two young physicists there. He said that, while this was important to scientists, it was difficult to say to where the discovery might lead.

General Charles C. Dawes, retiring as president of the Reconstruction Finance Corporation, said the country had reached the "turning point" in the Depression. This was true, but not in the way he meant.

An interesting woman came to Berkeley that summer of 1932. A writer of books for adolescents—stories and biographies of some of the early writers of New England. She came "trailing clouds of glory" for she was Hildegarde Hawthorne, the granddaughter of Nathaniel Hawthorne! She moved into Normandy Village, a place well suited to her piquant charm. And there above her fireplace hung the very painting of her grandmother which later appeared in the biography, *The Peabody Sisters of Salem*. She was an excellent cook—her roast lamb with plenty of garlic was notable. And so was the conversation at her small dinner parties.

The Olympics were held in Los Angeles that summer. There was an interpreter there who spoke twenty languages. The Cal Crew won the gold. At Wimbledon, Berkeley's Helen Wills won her fifth Women's Singles victory. In five years she hadn't lost a single set!

More than 2000 people saw the completion of Grizzly Peak Road one Sunday afternoon when the ribbon was cut, lengthening the old road from Little Grizzly to its present meeting with Fish Ranch Road.

But the most exciting event of the summer was the opening of the brand new $300,000 United Artists Theater—the very latest of innovations in movie theaters, a fantasy in Art Deco design and furnishings.

On opening night the 1,800 seats were filled as fast as people—including all the City officials—could get in.

On September 22, 1932, Franklin Roosevelt arrived for his first campaign visit to California. He told the Commonwealth Club that the "protection of the citizenry comes first." A *Literary Digest* poll in

eleven states showed that he was gaining slightly over Hoover. The significant aspect of his lead: nearly 40 percent of it was coming from former Republicans.

Joseph W. Harris, local clothier, on his return from the East, told the *Gazette* that the Depression was over on the East Coast—that business conditions there were good. In one column of the paper on that same day was a quote from a director of the Reconstruction Finance Corporation to the effect that business had improved. An adjoining column carried the news that Alameda County relief funds were again near depletion.

While the local unemployed were demanding an increase in aid allowances because the year's relief funds were not enough to feed, clothe and house the destitute, a University physician announced that students could live well on a thirty-cent-a-day balanced diet. But many students were in need, some trying to live on fifteen cents a day. Many men students had no place to sleep at night, and many women students needed warm clothing. All were applying for non-existent jobs at the University.

Norman Thomas, slim and elegant, also came to the Bay Area and Berkeley. Long before he had exchanged the Presbyterian pulpit for a faith as strong—the Socialist Party. On a late afternoon he spoke at International House to an audience that overflowed the auditorium to Piedmont Avenue, where he had to speak again from the steps of I House. His message was always that we had a choice between sheer catastrophe, immense civil revolt and Fascism—the choice being Socialism. There were thousands who believed that what Roosevelt was espousing was also Socialism.

Voting registration was breaking all records. Berkeley had never had so many voters—52,741. Although the polls continued to raise the expectations of the Democrats, the Republicans apparently ignored them.

Life did not stand still even in the heat of that campaign. The Reconstruction Finance Corporation announced that the $62 million loan to help finance the Bay Bridge would be forthcoming when the State agreed to build proper approaches and pledge enough income to cover the loan with interest.

Election Day must have been eagerly awaited, for by afternoon a record vote had already been cast in Berkeley. Better than 85 percent

314

of the voters had gone to the polling places. Berkeley, of course, was one of the few cities of any size in the State to go for Hoover. He had a lead of 6,057 over Roosevelt.

Florence Jury

The Lighter Side of the Depression

The Depression was a miserable time, but people did find some periods of relaxation. For many, it was the movies with their cheap admissions and the prizes given away—mostly dishes. There were those who complained that the recipients of welfare ought not to spend that money going to the movies.

My friends and I were young then, and for the most part we made our own fun, proving what can be done without money. We gathered at the Maybeck Studio, the pink sack building which replaced the family home that burned to the ground in the 1923 fire. It was a wonderful place for parties and dancing, with a huge fireplace and a smooth concrete floor which needed only a sprinkling of flake wax to make it perfect for the turns and swirls of the waltz and fox trot.

But early in 1933, the house Mr. Maybeck built for Wallen and Jacomena, his son and daughter-in-law, was finished. (This was one of the two houses he built at this time to keep workmen employed.)

The idea of a housewarming came up. Jacomena wanted it to be elegant. The new house had a big living room and Wallen, who was an electrical engineer, had wired it so that the radio music seemed to come from every side of the room. We danced to the music of Anson Weeks, Guy Lombardo, Meredith Willson and the other big bands. Berkeley's own station KRE played music every evening.

Eight was the right number for a sit-down dinner. There was still Prohibition (a law "more honored in the breach than the observance" by otherwise perfectly law-abiding people) and for a proper dinner party, we needed liquor. We knew a young man who could get us drinking alcohol which we cut and flavored. One of our sorority

sisters in her first year of medical practice in Petaluma came to Berkeley as many weekends as she could, bringing her precious allotment of whiskey. And I made a very respectable black fig wine.

I remember the tall green tulip glasses and the many colored plates from Chinatown, but I don't remember what we ate from those plates.

The eight of us were our host and hostess, Wallen's sister Kerna and a charming young man she did not marry, our doctor friend Kay, another doctor named Hunt, a friend of Jacomena's from high school days, and I with a handsome young German who danced like a dream. The men wore their tuxedos and we our long dresses, back in style after the up and down hemlines of the Twenties.

There were in those years quite a lot of young German men in San Francisco, here from South America to learn our business practices. Somehow we met some of them. They were very social and always available for parties. We also became acquainted with Katia, a White Russian girl who lived in Berkeley, and through her, some extremely interesting refugees. Many of them had long since established themselves in various vocations—painting, music, dancing. Katia herself had been a ballet dancer in Russia before the Revolution. She became a close friend of our group.

Through her, we had another of our more memorable parties. She wanted to pay off some of her social obligations, but she lived in a small apartment. So she borrowed the new house and sent out her invitations, instructing each guest to bring a sheet and pillowcase. Wallen and I were stationed at the front door and as each guest arrived, we directed them into the bedrooms where we helped them get wrapped into the sheets and cut eye holes in the pillow slips. At the top of the stairs in the living room was a large sign forbidding talking there. On the doors to the back porch, the balcony and the deck were signs stating what WAS to be talked about in each place— philosophy, art, love. Refreshments were punch and crackers and cheese. At midnight, we unmasked and the dancing went on. If one hasn't waltzed with a Russian, one simply has not danced.

Another party which left a lasting impression on the guests was one that Katia, Aimee and I gave. Katia knew a real estate agent who had for rent a big, empty (haunted?) "cobwebby" house. He loaned it to us for Halloween. It was dusty, of course, but we did remove some of

the cobwebs. We brought in some chairs, a table and Wallen's radio. The invitations baffled everyone since no one knew anyone on that street, but they all showed up.

Those parties were highlights, but we had casual ones nearly every weekend, mostly at the new house which was so perfect for them. Now and then, there would be a small and inexpensive dinner at someone's house or apartment. We were all hikers and on the Friday or Saturday night of a full moon, we set off to walk in the hills, still wild and for the most part without houses. Wildcat Canyon was a good place to meet other nocturnal walkers like skunks and raccoons.

Every Sunday morning, we had breakfast at someone's place. There were several specialties. Wallen made wonderful pancakes, someone else turned out potato pancakes. My best effort was rice waffles.

Looking back at those years, I think none of us who are left would deny that it was a period of wonderful friendship and fun.

<div style="text-align: right">Florence Jury</div>

Ella Young

The Irish storyteller, writer, and folklorist Ella Young gracefully touched many lives in Berkeley during the 1930s.

A figure out of romance, she was the friend and contemporary of the writers, poets, playwrights, and patriots who brought about the literary and cultural revival of Ireland which began in the last years of the nineteenth century. During the Irish Rebellion she lived in houses where ammunition and rifles and mausers were hidden. She rode horseback at night, carrying messages to hidden units of revolutionary soldiers. She earned a place on the English blacklist.

But she herself needed no such background to fascinate her listeners. When she spoke, her voice made music.

A beautiful woman, she had gray, rather fluffy, hair. She was not tall and she seemed fragile.

In the autumn of 1931 she accepted an appointment at the University as James D. Phelan Lecturer in Celtic lore. Before beginning public lectures, she gave a series of lectures for students and faculty only, because she wanted to outline certain possible fields of investigation and to create an interest in Celtic studies.

In the early spring of 1932, she began her public lectures in Wheeler Hall. They were an instant success with the townspeople and even with the students—who received no credit for attendance.

By 1936 the Phelan money ran out, and it was announced that her lectures would be no more. Then an extraordinary thing happened.

Letters of protest accompanied by money flowed in from the public and the students alike—more than $900. In that Depression year, $900 was a large amount, and it provided a last, thrilling series of

evening lectures at the Life Sciences Building: The Art of Storytelling, Craftsmanship in Poetry, Halloween Among the Celts, Dublin Salons, Dublin Wits, The Poet's Fee. For Ella Young, the best part of her poet's fee was bringing her hearers to share her passionate love for Ireland's legends and beauty.

She lived in a big old house on Elmwood Court. There was a garden at the back with tall trees. She tamed a California jay to sit on her hand and eat walnuts. She believed in the "little people," and in her stories she could convince you that there were indeed little people.

For those fortunate enough to become her friends, there were evenings by her fire which were pure delight. She entertained only when she must have felt some happy stirring of her Irish memories. Then the royal command would go out to one or two of us. We would immediately set aside any other engagement or task.

It was a rare, sweet pleasure to sit with her before her fire— she in a long flowing gown, a ring set with a precious gem on each finger of her hands.

Once, long before, she had stayed in a farmhouse in a part of Ireland where she had gone to collect the local legends. As she was leaving, the woman of the house bade her good-bye, saying that she and her family would never forget that a great saint had once stopped beneath their roof.

Derrick Lehmer, himself a poet, as well as playwright, composer and professor of mathematics, summed her up for all who heard and knew her in Berkeley when he said, "She is a strange and very wonderful woman and her influence in molding literary taste in this community is powerful and stimulating."

Ella Young died in 1956. Her works included *Celtic Wonder Tales*, *The Wonder Smith and his Son*, *The Tangle-Coated Horse*, *The Unicorn With Silver Shoes*, and an autobiography, *Flowering Dusk*.

Florence Jury

George R. Stewart

When the late George R. Stewart was 80, the University's Bancroft Library honored him with a retrospective exhibition of his writings. I visited the exhibition, as did many other Berkeleyans, and found myself dazzled both by the number of his books and by the number of languages into which they had been translated.

The display made it clear that Stewart had a worldwide audience, one that transcended cultural differences, class lines, and ideological barriers. On a very large scale it confirmed my own experience—I have met people in all walks of life who have read Stewart's books and retained them in memory as vital parts of their experience. Writers yearn to have such an impact on their readers.

I met George Stewart a year or so after the exhibition, and found him to be a tall, slender gentleman with white hair and a white moustache. I thought his observant blue eyes were his most interesting feature. He wore his years with elegance, and he spoke carefully, with a great concern for accuracy. He was clearly a man not given to verbal extravagance.

Perhaps we took George Stewart for granted: he was such a permanent part of our Berkeley landscape, as solid a presence as a California Oak. But he was a very unusual man.

Many people dream of making teaching and writing their careers, but few achieve Stewart's productivity or his extraordinary success. It is more usual for an assistant professor to write a critical study or a novel, store the remainder copies in the garage for a few years, and then lapse into literary silence for the rest of his or her career.

Stewart began as a professor of English in the 1920s and kept

teaching on into the 1960s, mostly on the University campus here in Berkeley. His first book, a noncommercial item entitled *The Techniques of English Verse*, appeared in 1930; his last, *American Given Names*, in 1975. In the years between he published many solid volumes of historical and biographic work, and best selling fiction— *Storm, Fire,* and *Earth Abides*.

Storm is probably still his most famous novel. Pitting man against nature in a classic plot, the novel shows the birth of a storm in the mountains of Asia, its growth as it travels across the Pacific, its power as it inundates the Bay Area with rain and wind, and the beginnings of its death as it disappears into the Midwest. The storm is opposed by man as a social being, not man the isolated figure found in the work, for example, of Robinson Jeffers, another western writer who watched the storms sweep over the coast from Asia.

Storm was an unlikely novel to become a best-seller and a Book of the Month Club selection. Perhaps its popularity stemmed from its being the right story at the right time: storms are traditionally symbolic of turbulence in human affairs. By 1941, when Stewart's novel came out, a storm had broken over Europe and was rapidly approaching our own shores. It may be that Stewart's novel, which shows how men work together to conquer adversity, struck a symbolic note many people responded to spontaneously in those last troubled days before Pearl Harbor.

But to suggest the novel's symbolic value may be misleading to anyone who has not read it; the novel presents details of daily life with superb clarity, and the narrative is compelling. It is a book that is hard to put down before you finish it.

In an introduction for the Modern Library edition of *Storm* Stewart told how he did the research for it:

> When a bad storm broke, I took to the road—up to the Pass, out with the Highway Patrol, through the flooded Sacramento Valley. I talked with the men and saw what they were doing, and I was sometimes cold and wet and hungry along with them. Not the least among my later pleasures was to get comments and letters from men who . . . knew the book to be genuine.

I asked George Stewart whether, at any time, he had considered leaving the University to devote himself to writing on a full-time

basis, his answer was, "No. I do not consider myself a good money writer." He added that he was glad he had not done so because he enjoyed teaching for its own sake and valued the freedom it gave him to write as he pleased.

When I think of his seven novels (leaving aside his enormous output of non-fiction), I cannot help concluding that he made a wonderful use of his freedom. Faithfully dramatizing the lives of ordinary men and women, and beautifully written, his novels ring true. I suspect that long after literary reputations now blooming have withered, Stewart's books will still be with us.

Phil McArdle

Walter Gordon

Walter Gordon, one of Berkeley's most outstanding, beloved, and memorable citizens, was born in Atlanta, Georgia in 1894. When his family moved to Riverside, California in 1914, his father said to him, "You're going to a new experience. You're going to a school where there are Whites and Negroes, and I don't want you to come home and say you are suffering prejudice, that you are not getting a fair deal. It's up to you to get a fair deal, and you can't ever use color as an excuse, remember that!"

Later, Walter came up to Northern California to attend the University here. He was interested in sports, especially football. Andy Smith was coach at Cal at that time and it was he who was responsible for putting Walter on the football team. Thus, he became the first Black football player at Cal and was chosen the first All-American football player west of the Rockies.

He was a champion boxer as well as an outstanding football player. While at the University he won the Pacific Coast heavyweight boxing championship.

After graduation in 1918 he became assistant football coach under Andy Smith and he was still coaching when his son, Walter Gordon Jr., was at Cal and on the team.

One day, August Vollmer, Berkeley's police chief, approached Walter about becoming a member of the police force. Gordon said, "I'm sorry, but I'm going to law school." Vollmer responded, "Maybe we can arrange for you to attend law school and work on the force at the same time. You could work the midnight shift."

When Vollmer announced to the force that he was hiring Gordon,

he added, "If anyone has any objection he can leave his badge on the table when he leaves the room." No one left his badge.

In 1920 Walter married Mary Elizabeth Fisher, an attractive, gracious and charming young lady from a pioneer California family. He worked on the police force from midnight until eight. He went from there to Boalt Hall until twelve, then home for lunch. He went to bed until three-thirty, and to football practice at four. At seven it was home for dinner and to bed from seven-thirty until eleven-thirty when he got up to go to work. His wife does not remember that he ever complained about being tired in spite of that tight schedule.

He received his J.D. degree in 1922, was admitted to the California Bar in 1923, and opened his law practice. He continued as assistant football coach and scout for Cal. He served as assistant coach for over two decades, working under Andy Smith, Nibs Price, Brutus Hamilton, and Stub Allison. He was also a member of the Executive Board of the Stiles Hall Y.M.C.A., and president of the Alameda County N.A.A.C.P. In his work as an attorney, Gordon contributed a great deal to better race relations and earned the admiration and respect of many people.

In 1945 Governor Earl Warren appointed Gordon to the Board of Paroles and Prison Terms (which later became the California Adult Authority). In 1955 President Eisenhower appointed him Governor of the Virgin Islands, and in 1958 he was named Federal District Court judge in the Islands.

In 1968 Gordon retired and returned to Berkeley with his wife. He always spoke of her in the most endearing terms, and referred often to her loving support throughout their marriage of more than fifty years. He felt that her devotion and encouragement and love helped to make his achievements possible. He said that she was the most self-sacrificing person in his life. They had two sons, Walter, Jr., and Edwin, and a daughter, Betty Gordon Jackson.

During his retirement he served on the Alameda County Grand Jury and on the Housing Development Committee. He died in 1976.

The following is a partial list of his awards.

- Benjamin Ide Wheeler Award—from the City of Berkeley as the most distinguished citizen of 1955. Order of the Coif—1969—for his contributions to law. National Football Foundation Hall of Fame—1976 Berkeley Fellow—one of the original

members of this group of one hundred distinguished friends of the University of California.

There were many more acknowledgments of his outstanding contributions.

He was once quoted as saying, "Human courage, abilities, and achievements have no racial boundaries, and intelligent people know it."

This man of great strength and humility proved it by his life.

Ruth Acty

Robert Gordon Sproul

Robert Gordon Sproul served as president of the University from 1930 to 1958.

Sproul was born in San Francisco in 1891. He came to the University in 1909 and graduated with an engineering degree in 1913. But, rather than pursue a career in his field, he sought employment with his alma mater and in 1914 became a cashier. From then on he climbed the ladder of success—from cashier to assistant secretary to the Regents and assistant comptroller in 1918, to secretary and comptroller in 1920, to vice-president in 1925, and president in 1930.

According to William Warren Ferrier's 1930 account, Sproul's presidency "met with widespread approval among the members of the faculty, the students, the alumni, and the citizens of the State in general."

Indeed, he must have been very popular, for in 1939 students demonstrated outside of the President's House to urge Sproul not to leave the University for a more lucrative position with a bank.

Picket signs read "We Want Sproul," "Bobby is Our Hobby," "Greetings Sproul—We Raise a Howl," and "RGS Stay!"

One must remember the times when Sproul ascended to the presidency.

He had given a stirring speech seven years earlier at the dedication of Memorial Stadium in 1923 when he was comptroller. He depicted the stadium as standing

> to help the life of men to higher physical, spiritual, and moral
> values, to teach character and rugged purpose, courage and

self-sacrifice to youth . . . it will build into itself the richest and warmest blood of generations and seek its fruitage in the young life of all the days to come.

Sproul went on to deliver many, many speeches. Several were included in George Pettitt's biography of Sproul, *Twenty-eight years in the Life of a University President.*

Sproul was devoted to education and spiritual values. His 1933 commencement address was a truly moving reflection of the Depression years and perhaps one of the main reasons for his receiving the Wheeler Award that year:

The greatest danger you face in the world you are about to enter is the fallacy that things are more important than man. Your greatest peril is that the idealism of youth may be dwarfed and twisted, and the mysticism of the spirit cramped into a materialistic mold The supreme goal of any life consists of three things: first, a trained and useful mind; second, a cultured and serene spirit; and third, an empowered personality. That is the end of true education—personal completeness.

He warned of a world where "social wrongs and economic injustice are still rampant," where knowledge and change must be fought for. It was a truly heartfelt plea for the spiritual values of higher education.

Sproul was also a devoted patriot and spoke against the influence of Communists, Fascists, and other revolutionaries whenever possible.

In 1934 he warned the students, "Noisiest among those who will claim your attention are the impetuous and headstrong adherents of revolutionary doctrines." In 1936 he said,

Revolution destroys more than it creates. The bombs of revolutionists are not dangerous because they may start a conflagration, but because they will call out the fire department of reaction. And with the smoke of propaganda, the water of suppression and the axes of terrorism, the damage will be done . . .

In 1940 he warned,

Unless our loyalty and devotion of this free community is more powerful than the fanaticism of the Communist for the class war,

or the bigotry of the Nazi for the Nordic race, then they and not we will shape the future of the world.

In truth, there was much more to Sproul than expressed here, as many are alive to testify.

Student housing was almost as scarce during Sproul's presidency as it is today.

Following World War II, the student enrollment rose from 11,028 in 1945 to 25,272 in 1946 thanks to GI benefits and a flood of young men returning home eager to complete their educations.

Sproul requested that the Regents build a residence complex to help house these students and consequently Fernwald Hall was built at the top of Dwight Way adjacent to the School for the Deaf and Blind. In addition, about 300 apartments in north-west Berkeley and Albany were converted to student use.

As land was developed by the University and it became apparent that the City was losing its property tax base, Sproul made an effort to study the problem and its long-range consequences.

During his presidency the University's enrollment more than doubled. Liberal arts colleges were opened at Santa Barbara, Davis and Riverside. The faculty had six Nobel Prize winners. Sproul played a vital role making the University a symbol of quality education for the entire country.

With Sproul's retirement in 1958 came the end of an era.

Stephanie Manning

Ernest O. Lawrence

Ernest O. Lawrence arrived in Berkeley in 1928. He came from Yale, where a promotion had been denied him, to set up shop in Le Conte Hall as an associate professor of physics. With his arrival, which was followed within a year or so by that of J. Robert Oppenheimer, a great period of scientific research began in Berkeley.

These two men—Lawrence, the atom smasher, and Oppenheimer, the father of the atom bomb—had temperaments as different as their specialties, but they became close friends and collaborators.

Lawrence was an experimental physicist. He believed in testing the limits of theoretical knowledge, and going full tilt to do it. When he set a task for himself, he put all of his boundless physical energy into it, letting nothing stand in his way. He was, at times, willing to ignore the known laws of nature in order to achieve his objectives. Oppenheimer, on the other hand, found in theoretical physics an unearthly beauty, and was not preoccupied by a need to produce practical results. No man in his time, by common agreement among those who knew, had a better grasp of the possibilities of physics. It appears that in contemplating the structure of nature as revealed by physics, he found a satisfaction at least equivalent to what Lawrence found in assaulting it.

By the time Lawrence came to Berkeley, physicists had carried the analysis of the atom a long way beyond the discovery of radioactivity. The quantum theory and the theory of relativity had shown how much energy might be released by atoms—if a way could be found to do it. Hence, the importance of experimental physicists. Rutherford,

Bohr, and many others had worked on this problem. In 1932 Cockcroft and Walton, in England, invented the first atom smasher—a linear particle accelerator. Since it moved particles in a straight line, an enormous and impractical length of tubing was required before the particles could get up the speed needed to crack a nucleus. In fact, since there were practical limits on the lengths of linear accelerators, experimental possibilities were also limited. Lawrence's great invention, the cyclotron, broke through these limits by providing a method for moving protons in a circular, rather than linear, direction, and abolishing the limits on the speed to which they could be accelerated.

Lawrence was still single when he came to Berkeley, and as an unmarried professor he decided to live at the Faculty Club. He developed the habit of strolling to the library in the evenings and spending several hours there, thinking through experimental problems and reviewing the physics journals in order to keep abreast of new developments. One evening in February, 1929, as he looked at a diagram in an article which suggested a possible use for positive and negative electronic charges, he had his great moment of intuition: he spent the evening entranced by the possibility of spinning ions around and around with a magnet, pushing them to greater and greater speeds with alternating jolts of positive and negative electricity, even by charges as great as a million volts! He went back to the Faculty Club without even finishing the article. Before going to bed he translated his vision into a formula: MRO = eRH. In the morning, the formula still looked good.

Then in fits and starts (but not soon enough to anticipate the work of Cockcroft and Walton), his epoch-making work began, first in Le Conte Hall (until the accumulation of apparatus required larger space) and then in the first Radiation Laboratory—which Nuel Pharr Davis has called "the enchanted laboratory." Under Lawrence's guidance, a series of cyclotrons were constructed, each larger than the last, firmly establishing Berkeley's tradition of "big machine" physics. And the discoveries rolled forth in breath-taking abundance. Collaborating with the laboratory, the chemist Gilbert Lewis produced the first samples of heavy water, which the cyclotron transformed into helium. This alchemy was repeated with aluminum, nitrogen, and other elements. And new elements were created, beginning with Nitrogen 13, and reaching one climax among many

with Carbon 14. In 1935 Lawrence and his brother John, a doctor, began to apply the cyclotron to cancer therapy by curing their own mother's pelvic cancer with high energy x-rays and the cyclotron's neutron beam. The range of work done at the Radiation Laboratory defies superlatives.

Lawrence became famous within his profession, and he was even known to the general public. *Time Magazine* called him "the cyclotron man, foremost U.S. destroyer and creator of atoms." In November, 1939, he was awarded the Nobel Prize. His standing was so great that the Nobel Academy agreed, for the first time, to allow a recipient to accept the prize without going to Sweden. On February 29, 1940, the award was presented to Lawrence in the auditorium at Wheeler Hall on the Berkeley campus. This was the joyful public climax of an astounding decade of achievement.

But in Germany, in 1938, Otto Hahn and Lise Meitner had discovered the secret of the fission of uranium. The possibility of making atom bombs had become a reality. Lawrence's thinking was far removed from such terrifying uses of atoms. His thoughts had been concentrated on how to use the atom for peaceful purposes. It was with the greatest reluctance that he began to consider its sinister possibilities. While working in Lawrence's laboratory, Edwin McMillan discovered plutonium, and published his findings. The British sent an attache from their embassy to plead with Lawrence to withhold the publication of research which might help the German atomic weapons project.

<div align="right">Phil McArdle</div>

J. Robert Oppenheimer

J. Robert Oppenheimer was an independently wealthy young man, absolutely free to choose to do what he wanted with his life. He chose to do physics.

In 1928 he accepted appointments to the faculties of Cal Tech and U.C. Berkeley. A somewhat unworldly youth at twenty-six and not at all career minded, he did not realize he had done anything unusual. So it was thoroughly in character when, before teaching for even a single day at either institution, he asked for a year off in order to take some additional courses in Germany and Switzerland.

Oppenheimer was regarded as such a promising physicist that both schools agreed to wait for him, and each kept his place open on its faculty.

When Oppenheimer returned from Europe in the spring of 1929, he went to his family's ranch in New Mexico to recover from a touch of tuberculosis. Oppenheimer was not daunted by this frightening disease. he enjoyed his convalescence, and he found the desert awesomely beautiful. That summer in New Mexico became one of the high points of his life. In later years, he often said, "I have two loves, physics and the desert. It troubles me that I don't see any way of bringing them together."

When Oppenheimer came to Berkeley in September to begin teaching, he and Ernest O. Lawrence soon became close friends. They formed the habit of taking long walks together and discussing interesting problems in physics, casually bridging the gap that separated many theoretical and experimental physicists. (This was important for reasons they could not foresee. One of the problems

that delayed the German atom bomb program was the inability of German physicists with different specialties to work together.)

As eligible bachelors, they were sought after by Berkeley's hostesses, and they often attended the same parties. Lawrence liked to take his dates to the movies; Oppenheimer was more likely to quote Sanskrit verse to his. (In any event, both married women from outside Berkeley.)

Oppenheimer did not read newspapers or listen to the radio, and was sometimes uniformed about current events. Lawrence (and others) would obligingly bring him up to date. For example, in the spring of 1930 Lawrence told him about the great stock market crash—six or seven months after it happened. Oppenheimer had simply not noticed it in the headlines.

Oppenheimer was reading the *Eternities*, not the *Times*, the *Gazette*, or the *Chronicle*. He was deeply interested in the principles of Ahimsa, the Hindu principle of "doing no hurt" or "not injuring animal life." In order to read Indian philosophy in the original language, he studied Sanskrit with Arthur Ryder. Some of his colleagues in the physics department thought this a little strange, but during the war these religious and philosophical studies helped him bear the pressures of his work.

Lawrence relied on Oppenheimer for theoretical guidance in his projects; from Lawrence, Oppenheimer learned much about applied physics. In fact, due to Lawrence's influence, Oppenheimer spent much more time in the laboratory than did most theoretical physicists of the time. Oppenheimer did not claim to have an aptitude for dealing with machinery, but David Sloan, one of Lawrence's researchers, said of him, "He learned to see the apparatus and to get a feeling for its experimental limitations . . . When you couldn't carry it any farther, you could count on him to understand and to be thinking about the next thing you might want to try."

Oppenheimer's own studies concerned collapsing suns, cosmic ray showers, and other recondite matters. His work did not startle the public the way Lawrence's invention of the cyclotron did. But he did achieve a measure of fame when he collaborated in developing the Oppenheimer-Phillips process, a method making isotopes to treat leukemia and other types of cancer.

Oppenheimer rose steadily within the ranks of his department, and

within a few years, he had made it the major American center for the study of theoretical physics. His students idolized him, and many adopted his physical mannerisms. Some even followed him to Cal Tech where he taught in the summers.

In the mid-thirties Oppenheimer's social isolation gradually came to an end. One factor in this (of which not much is known) was the end of his love affair with a woman he had known in Europe. Another was the lack of jobs for his graduate students—in the Depression, there was not much work available for theoretical physicists. Never worried about employment himself, he was concerned for their welfare.

In 1936 he became acquainted with Jean Tatlock, the daughter of a University professor, who apparently was a member of the Communist Party, and Haakon Chevalier, a professor of French. They introduced him to the Berkeley left. He began to make regular contributions to such leftist causes as Spanish War Relief.

Chevalier's two books on his friendship with Oppenheimer suggest that it was the Berkeley left which made Oppenheimer "politically aware." It seems more likely that this resulted from the Nazi persecution of his relatives in Germany. His left-wing associations gave Oppenheimer a means of expressing his anger at what Hitler stood for. Looking back on this period of his life many years later, Oppenheimer said, "I liked the new sense of companionship, and at the same time felt I was coming to be part of the life of my time and country."

In 1939 he had already begun to make rough calculations of critical mass (the amount of uranium necessary to cause an atomic explosion).

Oppenheimer's first official connection with the atomic energy program occurred in 1941 when Arthur Compton invited him to attend a special committee meeting of the National Academy of Sciences to discuss the military applications of atomic energy.

Compton asked Oppenheimer to direct a small group of scientists at Berkeley in planning, for the first time as a practical problem, how to produce an atom bomb. This meeting occurred in 1942 at Le Conte Hall on the Berkeley campus, and was one of the critical events of modern history.

Oppenheimer's involvement in the American atom bomb project gradually increased, and, when production was ready to begin, he

suggested Los Alamos, New Mexico, as the site for the atomic bomb laboratory.

He was officially appointed director of Los Alamos in 1943. Thus, he brought his love of physics and his love of the desert together, with dire consequences for the rest of us.

Phil McArdle

The Horrors of War

When I was an elementary school kid in Berkeley in the thirties, I picked up bits and pieces of information about war.

Fortunately for Berkeley (and all of us) the battlefields were, and remained, distant: newsreels, headlines and twice-told tales.

In those days a peace-time draft was as unthinkable as tuition at Cal, the people's free university. The World War (1914–1918) had been a war fought to end War and to make the world safe for Democracy. It was not called "World War I." By the mid-thirties Americans could see the possibility of another European conflict. However, no one thought of any foreign nation as a military threat to the United States as nearly everyone does the Soviet Union today.

Getting and keeping a job, paying the bills (it was the time of the Depression), and raising one's children were of far more concern than the rise of Hitler 6,000 miles away. But when the subject of war came up, Berkeley people were outspoken in their dislike of it, especially of European squabbling, referring to Europeans as krauts, frogs, limeys and so on—no worse than what Europeans were calling each other. War was "over there"— what we had to do to ensure peace for ourselves was to avoid "foreign entanglements," as recommended by George Washington.

My father had enlisted in the Navy during the War, as the First World War was called then. It wasn't until he was in his 70s, and thought I was old enought to deal with the truth, that he told me he had not been a heroic volunteer. He had enlisted in the Navy to avoid being drafted into the Army. In the Army your life wasn't worth two bits.

Born in 1893, he was of the generation that believed munition-makers caused wars for profit, and that generals, safe far from the Front, ordered thousands of soldiers over the top into deadly machine-gun fire to conquer an inch of France. There was useless slaughter because of the incompetence, stubbornness, vanity and cowardice of generals. When father was really angry at generals, they had Mata Haris on their laps, drank champagne, and spilled the beans.

However, when we lived in 1721 Grove Street in the 1930s, father, who was born and raised in Idaho, would sing "How're you going to keep 'em down on the farm (after they've seen Paree)?" and "Mademoiselle from Armentieres":

> Mademoiselle from Armentieres,
> Parlay voo.
> Mademoiselle from Armentieres,
> Parlay voo.
> Mademoiselle from Armentieres
> Hasn't been kissed in 40 years.
> Hinky, dinky, parlay voo."

He would always grin when he sang that. It was a mystery.

We were living at Grove Street when I found his box of war souvenirs. I was five or so and could reach the top secrets on the shelves in the huge, windowless closet. The box contained post-cards that showed the horrors of trench warfare in France and many photographs of life aboard ship. There were some of the Rheims Cathedral, ruined in the snow, that father had taken himself when on leave. A photo of him in the Place de l'Opera in Paris had been taken as far away as possible to get the whole Opera facade in the picture. There was no traffic, and his was the only figure in that vast, empty, foreign-looking place. It was difficult to believe that he had been alive before I was born, but not only that—he hadn't met Mother. "Souvenirs" was a funny sort of word. They played a song on the big, wind-up phonograph: "Among My Souvenirs."

At Whittier Elementary School, I saw my native land in the middle of the Mercator map that the teacher pulled down from a roll hung on the wall. We were protected by two big oceans from the quarreling

nations in Europe and Asia. I learned that we were a peaceful, democratic people even though we hadn't joined the League of Nations (a "foreign entanglement"). The proof was that there were no fortifications on our Canadian and Mexican borders and that we had no peace-time draft. In photo magazines I saw pictures of little boys like me in uniforms saluting and marching around. They didn't look very happy. I was glad America wasn't militaristic. Alphabetical seating in the classroom was bad enough.

Mother was concerned about guns. There was a question of whether toy guns should be given to boys; they might develop warlike tendencies. Nevertheless, I was a cowboy and was permitted a cap gun. It was forbidden to point it at anyone, even accidentally. I learned to be polite, but the constant explosions got on everyone's nerves. The red cap rolls contained little bumps of real explosives that could be scraped off to make a larger amount. Perhaps because I had ignited a whole box of kitchen matches to see what would happen (whoosh!), my parents thought there was no sense in taking chances. It was the end of my cowboy career.

In the 1930s, November 11, Armistice Day, was a holiday celebrating the end of the War. You probably can't imagine a veterans' parade in downtown Oakland or that Berkeley people would go to see one.

During the parade I remember, Latham Square was so filled with spectators that they spilled off the sidewalks into the street. Marching were men in their thirties and forties who had fought in the war to end War.

There were old veterans of the Spanish-American War marching, too. People still said "Remember the Maine," though not very often.

The Civil War veterans were nearly all dead, but men in the parade knew grandfathers who had fought against each other in that awful conflict.

Not a show of military power, the parade was held in honor of free Americans who had made sacrifices for their country. Father took his hat off and put it over his heart when the American Flag went by.

At the store on the southeast corner of Virginia and Grant in

Berkeley, you could buy a wide selection of penny candy and gum. I preferred the red to the black whips.

The flat bubblegum contained picture cards you could collect and trade with other kids of Japanese war atrocities. I remember two of them: the Japanese attack on the Panay and the rape of Nanking. In the newspapers of the 1930s, rape was something that happened to cities. There were German and Italian cards too, but the Japanese had the best atrocities in those days.

For a while, father belonged to the Veterans of Foreign Wars. One night my parents and I attended a meeting of the VFW at its headquarters on Center Street in Berkeley. Issues of some kind were discussed.

My parents finally let me go into the lobby, where I looked at a photo magazine. There was an article in it depicting how the world might end by an Act of God. Mankind might destroy itself in War, but His powers were of greater magnitude: a giant meteor, a new Ice Age, the melting of the polar icecaps, the death of the sun, the moon (mysterious before it was recently stepped on) drawn too close by Earth's gravity. I worried about all this a lot.

One day I was exploring the Grove Street neighborhood when an old lady, finding me in her backyard, invited me in for lemonade. I visited her every so often after that, arriving over the Hobson's back fence until the Morrison's dog bit me.

She gave me an old scrap album, a copy of a magazine with photos of a Spanish Civil War firing squad execution, and some maple sugar candy. I was unused to candy without chocolate in it, and the maple sugar cakes made me queasy. The execution photos made me queasy, too. But all three gifts were somehow significant loot from the world of adults.

I had wanted to see the movie cartoon "Peace on Earth" for a long time before I got to. Movies would play for weeks in San Francisco or downtown Oakland (where there used to be many movie palaces) before reaching Berkeley.

"Peace on Earth" was a 1939 Harman and Ising cartoon recommended by *Parents' Magazine*, but it was not the sort of movie Mother or Aunt May would take me all the way to the City to see. So different from "Snow White" and "Pinocchio,' it was a movie a boy should see with his father; the human race squared off as vegetarians

and meat-eaters and fought to the death over which was the proper diet. After all us people had been killed, men gassed in trench warfare, women and children bombed at home in air-raids, rabbits and such like came out of their burrows and wept at our fate. It was scary and sad for a cartoon; I cried too. But soon the little animals went to work to clean up the mess the human race had made. They converted helmets into nests, and began to dance about merrily. When the movie ended, they were having a Thanksgiving dinner. Such was my introduction to ideological warfare at the UC Theatre.

Believe me, I was in over my head. I thought the Hobsons were vegetarians; we Pettitts were meat-eaters. If a war occurred, would we have to fight the Hobsons? I didn't want to have to fight the Hobson boys; there were three of them. My parents did not have comforting answers to my questions. They thought by that time, I guess, that another European war for America was inevitable and that if it lasted long enough, I might be killed in it.

Ken Pettitt

WORLD WAR II

Home Front Alarms

Even by those who experienced it, many details of life on the home front during World War II have been forgotten.

Yet, California was a veritable armed camp by 1945. With more than 300 military installations, the State was ready to repel any invader, not one of whom came, however. A few bunkers still stand silent guard around the Golden Gate, reminders of those years when an invasion seemed imminent.

For purposes practical, life was conducted under martial law. All food was rationed as was almost everything else—when it was available.

Because of air raid fears, there were the drills and there were the alerts. At least along the West Coast, a strict blackout prevailed.

As the war approached its end, rumors were rampant that new, exotic weapons would turn the tide against us. Not the least of these were the Kamikaze Air Balloons which were to bring an army of Japanese soldiers.

But only the balloon bombs came. News of them was officially suppressed but through the schools the public learned of their danger.

The following article appeared in the November 2, 1945 issue of the *Berkeley Gazette*. It revives memories of the anxious days after the attack on Pearl Harbor when for a few months an enemy submarine lurked beneath every floating log and a Japanese landing craft behind every wave.

Charles Marinovich

345

Air defenses of the Pacific Coast were in an almost continual state of alert for more than three months early in 1942 following official warnings that a "coordinated Japanese offensive" might be directed against American areas, the Fourth Air Force reported today.

It was also disclosed that an undisclosed number of fighter planes and three lumbering B-18s were sent to attack a Japanese submarine which shelled an oil refinery near Santa Barbara.

Full power of the Coast's defense was not sent against the submarine because Maj. Gen. Jacob E. Flekel, commanding general of the Fourth, believed the attack was "a diversion meant to attract attention from something else that might happen."

Numerous Reports

Releasing further details of its wartime history, the Fourth Air Force said that "reports of attacks, sabotage and enemy planes were numerous in (its) various units" during the period.

These reports chiefly concerned unidentified ships, submarines and planes but also enumerated wire cutting, flares and minor enemy operations on or near the coast, an announcement said.

Officials said they had been informed "early in 1942" that Fleet Admiral Ernest J. King had warned that there were "signs which appear to be definite of a widespread and coordinated Japanese offensive in American, British, Dutch, Australian and New Zealand areas."

Stations Alerted

The Fourth Air Force immediately alerted all stations and units "against sabotage and surprise attacks," the announcement said. It pointed out that the warning "was the prelude" to shelling of an oil refinery at Elwood by a Japanese submarine "and the appearance of mysterious, still unidentified planes over Los Angeles during the early morning hours of December 25."

The announcement also disclosed that reports of the presence of Japanese planes during the week after December 7, 1941 "were of such a nature as to convince the highest military authorities that they actually were in the vicinity (of the West Coast)."

Between the Japanese attack on Pearl Harbor and December 31, 1941, there were 18 blackouts, 30 radio silences and 25 alerts, none of which were attributed to enemy action. However, four alerts, six radio silences and 10 blackouts were laid to "unidentified causes," the report said.

The Longest Blackout

The blackouts, air raid shelters, civilian evacuations and other precautions of World War II civil defense seem quaint today, but they were a practical response to the threat of air raids forty years ago. In the dark old days when a miss was as good as a mile, hiding could save your life.

On the evening of December 12, 1941, a Friday, at about 7:30 p.m., the citizens of Berkeley heard the distant wailing of air raid sirens. The sound of the old fashioned sirens seemed to predict disaster.

I was 12 years old at the time and I remember our uncertainty as to whether it was a real alert, but not the sequence of events that proved it real. My parents and I heard the sirens faintly. There were people in the streets, probably Cal students, shouting "Air raid" and "Blackout". (Big kids have all the fun). Was it an air raid warning? A student prank?

The street light by our house went out. Radio stations were off the air or signing off. We turned out our lights and hurried downstairs to keep my grandmother, who lived in the lower flat, company.

Did Mother tidy up before we left? She wouldn't have wanted her house destroyed when it was in a mess.

We sat in Grandma's living room in the dark, waiting for whatever might happen next.

We knew what had happened in Europe: London and other cities bombed and in flames. That had been so far away. But with Pearl Harbor fresh in our minds that night, it seemed possible to us that the Japanese could really be coming to destroy our two new bridges.

The living room where we waited (once known as the front parlor) was the ceremonial room in the house: there I had recited "The Night Before Christmas" in 1934, my parents had been married in 1926, and my mother's father's wake had been held in 1916. Children were not permitted to eat or drink in the living room and had to be especially clean and well-behaved there. It was the room in which I had been taught to shake the very big hands of great uncles with Edwardian moustaches—luxuriant, not the little clipped things on the faces of Hitler and movie stars.

We did not go to the basement, which the adults must have known was supposed to be safer than the first floor if a bomb fell. Perhaps this was because they thought it would be better, if we were to be killed, for us to die like ladies and gentlemen in the parlor and not like rats in a hole.

We had never sat like that in the dark before. As usual, though, I was supposed to sit still. We turned on Grandma's powerful radio and heard very distant stations (which were unaffected by the alert) and static.

The all-clear sounded at 10 p.m., two and a half hours later. I must have been restless sitting there. Father was, and he went upstairs to the attic to look out over Berkeley and the Bay to check on the effectiveness of the blackout. When he came back down he was angry because lights were still on everywhere. Also, he had bumped into a door in the dark and thought he might have a black eye in the morning.

I wanted to go up and look, too, and was finally permitted to because no one could stand my squirming around. It was always fun to be in the attic, which was full of shadowy furniture, trunks and stuff, although you could never be sure that you'd like what you found. In one trunk there was a little bag containing a set of false teeth. I wasn't afraid of the Japanese; I was afraid of *them*.

So that was the first alert and blackout I remember. There were, I have read since, earlier ones we slept through because the warning system was not yet fully in operation. There was a longer alert later in the war, but the one on December 12 was the longest blackout.

Our thinking about blackouts changed later. We became more accustomed to voluntary darkness. The more blackouts there were without an attack, the more confident we became, and the more fun

349

they were. I enjoyed the excitement. There was a blackout one time when I was taking a bath. By then, we had blackout curtains and blue bulbs, so I finished my bath in blue light.

Sometimes, we thought, the blackouts were initiated to conceal troop movements. At least once during the darkness we heard an army truck convoy on Ashby, then the major route between the Caldecott Tunnel and the Bay Bridge.

There were more than 20 alerts in the Bay Area, but only a few resulted in blackouts, and only during the first years of the war. What was all-pervasive later was the brownout of windows, street lights and outdoor advertising. Brownouts were supposed to prevent approaching enemy planes from locating cities. The streets were very dark and we no longer went window-shopping at night in downtown Oakland. The Flying Horse over San Francisco, my favorite neon sign, was turned off. Even the street lamps were painted to prevent full illumination. The paint did not wear off them until several years after the end of the war.

We were lucky, and the Japanese never did find Berkeley or our house on Hillegass.

Ken Pettitt

Pettittania Revisited

You don't hear much about incendiary bombs these days; thousands of them were scattered over London, Hamburg, Tokyo and other cities during World War II. Wooden Berkeley was a built-to-order target for such a weapon.

After the Japanese attack on Pearl Harbor, we were advised to empty our attics to reduce the amount of fuel there for incendiary bomb fires and, at the beginning of the war, at least, we were told not to hose down the bombs with water. Incendiary bombs were supposed to be smothered with sand, foam, or something.

It could have been in the spring of 1942 that my parents and I went up to the Safeway parking lot on the northeast corner of College and Russell to witness an incendiary bomb demonstration. The parking lot had been the site of a Methodist Church where, on Easter Sunday, April 23, 1916, mother's sister Maybelle, Florence Thaxter and Taye Shima, had sung "Resurrection Joy."

A large group of neighbors had gathered to witness the after-dinner bomb demonstration, which may have been put on by the firemen across the street. The demonstrator ignited an incendiary "bomb" (the devices contained magnesium), and then to show us why we shouldn't put water on it, demonstrated what would happen if we did. When the water hit it, burning matter shot up 50 feet into the air, higher than the apartment building across the street. As if that weren't enough to make these bombs fiendish, they could also contain an auxiliary explosive that would send metal junk whizzing around when you were attempting to put out the fire. My parents must have decided that we might as well kiss the house goodbye. In any case, we didn't clean out our attic.

Under the influence of Roger Welty, a military genius I met at Willard Junior High, I had founded a city in the attic, and it occupied my time for about two years. Roger had a city he called Nineveh. Mine was called Kenniveh, after Nineveh of course, and it was the capital of Pettittania. Ted Warren had a city, too; I forget its name. It was the capital of Warrenia.

Kenniveh was a good deal more like the Berkeley of today than the Berkeley of forty years ago. Donna XXVII and Boris XXX fled the terraces of their doomed palace with revolutionaries in hot pursuit. The lifestyle and experiences of the Empress and Emperor were much the same as those of their predecessors, Donnas I through XXVI and Borises I through XXIX; however, this time his Highness didn't make it. There was an earthquake during the revolution and he was killed by a toppling column.

I used animal figurines to act out dramas of war, revolution and intrigue. Empress Donna was a white Japanese dachshund from a box of Haas candy Aunt May had given me. Emperor Boris was a blue elephant with a hole in his howdah, originally for kitchen matches, I guess. There were a dozen or so lesser figures.

Kenniveh was made out of cardboard boxes, which were easy to get in those days. The palace, which dominated the town, had distinctive architectural features . . . balconied towers originally used to display vitamins at Beretta's Elmwood Pharmacy were (I see it now) an Art Deco plus, and a good setting for suicides and elopements. Black, gold, turquoise and magenta construction paper and colonnades of Alka-Seltzer bottles filled with colored water were arranged around the thrones.

At first it was a small town, but later developed a skyline of towering 'scrapers. Nineveh and Warrenia's capital were one-horse towns in comparison.

Ted was always interested in finance, and the solvency of Warrenia was based on the value of an "emerald" from the Tower of Jewels at the Panama Pacific International Exposition (1915). He very begrudgingly consented that the strings of several thousand yellow beads I had from a beaded lampshade were amethysts and equal in value to the Warrenian emerald. Everything went okay financially for Pettittania until I decided that the strings had no place in my Fort Knox. Eventually all the amethysts fell through the cracks

in the attic floor, and they are there still, awaiting some enterprising treasure hunter.

Pettittania was neutral during the World War II, like Switzerland, Sweden, and the Republic of Ireland, but the war had an important effect on Pettittanian civilization. Tinfoil, which came in many colors on candy and in plain silver on gum, was used as material for clothing; Kenniveh was the Paris of Berkeley. Gradually the colored foil became unavailable, and the quality of the silver foil deteriorated until it was impossible to peel it off gum wrappers; then it disappeared altogether. The Pettittanians had been used to dressing in the foil and throwing the candy and gum away; however, they had no garbage disposal problems. They made terrific coronation robes out of tin foil, and a good thing, too! There had to be many coronations in their lifestyle.

What little foil there was left was soon worn to shreds and dress in the Capital became shabby-genteel. Finally it became the style to go without any clothes at all. The Empress herself initiated the new fashion, so I guess it was all right.

With the shortage of foil, what little you could find was supposed to be rolled up into balls and donated to the U.S. War Effort. Needless to say, rolling tinfoil into balls never caught on in Kenniveh. In fact, the Pettittanians thought rolling tinfoil into balls was a very eccentric thing to do.

Meanwhile, a Red Cross casualty station had been set up in our basement for victims of enemy attack. The lady who owned the house in back of us on Benvenue was in charge and a gate of ours was put in her fence to facilitate her access. Our basement was painted white, and stocked with medicine—iodine, mentholatum, and later some of the new sulfa salve. There were gauze, splints, hot water bottles and the like, and cots. Hot and cold running water were available at the 1910 washtubs.

It must have been the best basement on the block, but it's hard to believe that it would have provided much shelter for the injured in an incendiary bomb raid. Ours was the tallest wooden house on the block, and there was plenty of fuel in the attic for a fire. But then, the real war—in Berkeley at least—was in our attic.

Ken Pettitt

Camp Ashby

Perhaps because of the effectiveness of wartime secrecy, forty years after the war there was only a rumor that a "Camp Ashby" had existed in Berkeley. No one seemed to know where it had been located, or they were not telling.

On February 3, 1942, Berkeley City Council president, Frank S. Gaines, said in a statement to the council, "Berkeley is located in an area which has been designated as a target area and both the Army and Navy are deadly serious in believing that we must prepare for air raids and other acts of war."

But there was no mention of Camp Ashby in the City Council minutes. In those first few days of World War II the City Council was kept busy issuing orders to protect the health and safety of Berkeley's citizens. It dealt with such matters as the proper distribution of gasoline, tires and used cars, the proper stamping of vegetables and fruit as "Japanese grown" or "not Japanese grown," and the proper increase of salaries for City workers to make their pay competitive with that offered by the rapidly expanding war industries in the area.

Recently Stephanie Manning of the Berkeley Historical Society found the probable location of Camp Ashby in the Berkeley tax map records which show the United State Government owned a large plot of land bordered by Ashby Avenue, 7th Street, Anthony Street and Front Street.

The Government established Camp Ashby to help protect our "target-area" City and to quarter and train the 779th military police, which was composed entirely of black troops. They had white

officers—as required by the Army's then traditionally segregated framework.

Because of the potential for racial problems connected with the establishment of Negro bases in small towns, the War Department retained Truman Gibson, a civilian agent, to visit base areas to determine how the black troops were getting along.

Later in the war Attorney Walter Gordon introduced Gibson to the City Council. Gibson stated that "The Army of the United States is a people's army and a democratic army for the reason that Negroes are now accepted . . . and I find that the attitude in this community as good as anywhere and better than in most places."

Actually blacks have been accepted in the armed forces since the Revolutionary War, when several thousand blacks served side by side with white soldiers in the Continental Army; and black regiments also served in the Union Army during the Civil War. During World War I, black divisions under white officers were sent to France, and segregated forces under white leadership continued during World War II.

Because of the failure of traditional historical sources to document the history of Berkeley's Camp Ashby, community individuals were sought who could provide oral or written information about it.

Walter Dix, who was stationed at the camp, still lives in the area. While many of his memories of that time have become fuzzy, he remembers the special kindness of the residents of Berkeley to those lonely young soldiers.

Dix specifically recalled Byron Rumford's willingness just to talk to him, and a Mr. King, owner of King's Liquors on Sacramento Street, who loaned him $300 to purchase a printing press used at the camp.

Mrs. E. A. Sykes of Berkeley, who was responsible for providing entertainment for the Camp Ashby troops, said her "work was made easy by the large highly respected 'colored' population in Berkeley, who were property owners and family people always willing to help."

Most of the young troops came from Philadelphia, Pennsylvania, and a large contingent came from the South. Mrs. Lucille Lane shared a letter dated 11 March 1948 from Lt. Col. Reinhold C. Dedi, who had been the commanding officer at Camp Ashby: "My thoughts

frequently return to those days, when your Red Cross Sewing Group took such a keen interest in my troops. They were good men and good soldiers . . . We often play the recordings they made for us."

<div align="right">Careth B. Reid</div>

Japanese Internment

From early morning till dusk, from Tuesday, April 28th through Friday, May 1, 1942, Dana Street between Channing Way and Durant was blocked off and the sidewalks were lined with boxes, suitcases and duffle bags. Big moving vans and chartered buses moved in and out in a steady procession. Inside the First Congregational Church, hundreds of men, women, and children were collected in Pilgrim Hall, and assigned to groups, tagged, and given time slots for departure from Berkeley. The ladies of the church hovered about serving coffee, tea, and sandwiches. What at any other time would have appeared to be nothing more than the members of the congregation going on a recreational retreat was at this time of a more serious import, for there were armed guards at the door, inside the building, and on the buses.

The war had dramatically come to Berkeley. The U.S. Military had ordered the removal and detention of all Berkeley residents of Japanese ancestry, and on those days some 1,200 men, women and children were forcibly removed from the City of Berkeley and transported to the detention center at Tanforan. The basis for this action was declared to be "military necessity" by the Commander of the Western Defense Command. These people were not charged with any crime, and without a hearing or trial were ordered from their homes and livelihood to be incarcerated in American concentrations camps and exiled from Berkeley for the duration of the war.

Though there had been a few students from Japan attending the

357

University of California in the early 1880s and 1890s, the beginning of the resident Japanese community in Berkeley did not occur until late in the 1890s, when the big wave of immigration from Japan to this country began. By 1900, there was a small Japanese colony living in the Telegraph-Dwight Way area. By 1910, the main Japanese community had moved to the Shattuck-Channing Way area with a smattering of small shops catering to this new immigrant group: a small hotel, grocery stores, laundries, a shoe repair shop, an employment office, a tailor shop, a barbershop, a bath house, and even a pool hall. By this time, there were over 500 Japanese living in Berkeley. In 1924, all immigration from Japan was prohibited and all Japanese residing in the United States were classified as permanent resident aliens, ineligible for U.S. citizenship on the basis of race and national origin. Though there was no new immigration from Japan there was much internal migration to Berkeley of Japanese from other parts of California. Among the Japanese, Berkeley was recognized as a congenial place to live with a mild climate, an attractive educational environment and less overt racial prejudice.

Most of the early immigrants settled for menial jobs, serving as domestics, laborers, gardeners and small shopkeepers, but there were notable exceptions. Nobutoro Akagi started the California Mission Furniture Company at Fourth Street and Bancroft Way in 1911, and at its peak it employed nearly 50 Japanese workers. George Shima made his fortune in agriculture and moved to Berkeley in 1909, where he resided until his death in 1926, leaving a private fortune of over $15 million. Chiura Obata immigrated to this country in 1911, achieved international fame as an artist, and moved to Berkeley in 1931 to teach at the University of California.

By today's standards Berkeley, in the period from the turn of the century to the beginning of World War II, can be called a racist town. Housing discrimination was sanctioned by restrictive covenants, which prohibited the sale or rental of property to non-whites in many of the neighborhoods of Berkeley, and the Japanese were primarily restricted to south central Berkeley: south of University, north of Ashby, west of Shattuck and east of Sacramento.

Employment opportunities in Berkeley for Japanese were limited mainly to blue collar and menial low-level white collar positions. College graduates with degrees in engineering, in the physical

sciences, in education, in accounting and business could not find work in their fields and had to settle for lesser jobs. Professionals such as doctors, dentists, lawyers, and others could make a living only by serving the needs of other Japanese Americans. Life in pre-war years for the Japanese residents of Berkeley involved knowing one's place, and learning to live and survive in a segregated world. There was practically no intermingling socially among the various ethnic groups in Berkeley.

<p style="text-align:center">***</p>

When the war broke out, there were approximately 1,300 persons of Japanese descent in Berkeley out of a total population of 85,000. Though they had lived here most of their lives, to the majority of Berkeley's population they were an unknown entity.

There was much fear, apprehension, and lack of understanding. Events moved quickly, and when orders came from Washington imposing war-time regulations, only a few took the time to question their consequences.

From the beginning of hostilities, a few brave souls spoke out fervently for the fair treatment of Americans of Japanese descent. Leading Berkeleyans, such as Galen Fisher, Eric Bellquist, Harry and Ruth Kingman, and President Robert Sproul of the University of California, worked diligently in the early months of 1942 to oppose those who were calling for harsh action against all Japanese on the West Coast.

When war broke out, all permanent resident aliens from Japan, Germany, and Italy were classified as enemy aliens.

The orders came, beginning with a round-up of dangerous enemy aliens on December 7th and 8th. Next came curfew and travel restrictions for enemy aliens, then confiscation of radios, weapons, and cameras of enemy aliens followed by the designation of prohibited zones where enemy aliens could not reside or work. On February 19, 1942, President Roosevelt issued Executive Order No. 9066, which dramatically changed the whole focus. Executive Order No. 9066 gave the military commander the right to prescribe military zones from which any or all persons could be excluded. Thereafter a series of orders from the military placed curfew and travel restrictions

on American citizens of Japanese descent and provided for the confiscation of cameras, radios and weapons of Americans citizens of Japanese descent, and finally culminated in the exclusion orders for the removal of "all persons of Japanese ancestry: aliens and non-aliens."

On April 21, 1942, Exclusion Order No. 19 was issued calling for the evacuation of persons of Japanese ancestry from the City of Berkeley. All Japanese Americans were ordered to report to the Civil Control Station on April 25th and 26th for registration and instructions, to return again between April 28th and May 1, 1942, for transportation to the detention camp.

In Berkeley the Civil Control Station was organized in the hospitable quarters of Pilgrim Hall at the First Congregational Church, and Reverend Loper, Eleanor Breed and Mrs. Ruth Kingman of the Church worked tirelessly organizing other Berkeleyans to provide aid and comfort to the Japanese Americans during this trying ordeal.

By the evening of May 1, 1942 there were no residents of Japanese descent left in Berkeley. Empty houses and boarded-up churches stood as silent witnesses to their absence. The houses soon filled with incoming war workers, and the plight of the Japanese Americans was soon erased from Berkeley's consciousness as everyone became busy winning the war and making the world safe for democracy.

T. Robert Yamada

Atom Spies in Berkeley

In 1938 the German physicists Otto Hahn and Lise Meitner discovered nuclear fission. When they published their discovery, it was quickly confirmed by French physicists. By the spring of 1939 the possibility that a chain reaction could be used to explode an atomic bomb had been established to the satisfaction of theoretical physicists around the world. In Berkeley, Dr. Robert Oppenheimer made rough calculations of critical mass. Dr. Yoshio Nishina did the same in Tokyo.

"The country which first makes use of it has an unsurpassable advantage over others," Professor Paul Hartack, who had the ability to supervise the building of one, wrote to the Reich War Office in April 1939. Einstein wrote a similar letter to President Roosevelt about six months later. The race to build an atom bomb had begun with the Germans off to a solid head start. By the time the war reached its full fury, every major power except Italy had begun some kind of a nuclear weapons program.

From 1939 on, the secrecy and censorship surrounding nuclear research stopped the publication of new discoveries. But knowledgeable people in each of the belligerent countries were anxious to know how their rivals were doing. To find out, they turned to their secret services.

So it was that the Radiation Laboratory in Berkeley, a center of theoretical and applied physics, became an important target for spies. The U.S. government made a serious efort to protect it from penetration by foreign agents.

We know now that the Axis was able to estimate the size and intensity of the American atomic program, but not to crack it. However, major successes against American security at Los Alamos and elsewhere were scored by the Russians.

Insofar as is known, Germany and Japan were unable to place operatives in Berkeley. It is possible that the evacuation of Japanese residents from the Bay Area contributed to this, even though injustices were done to many loyal citizens. The Russians did have spies here who succeeded in penetrating the Radiation Laboratory. That they did not do much damage was due more to good luck than good management.

The U.S. was poorly prepared to resist espionage. "Gentlemen do not read each other's mail," Secretary of State Stimson had said in 1929, and that remained the American attitude almost until Pearl Harbor. Many of the security officers sent to Berkeley early in the war by the FBI and the Army were so inexperienced that ordinary citizens spotted them. Others alienated scientists by behaving like B-movie private eyes.

The Russians had three assets in their attempt to penetrate the Radiation Laboratory: their Consulate in San Francisco, their agents in place, and the sympathy of many Americans for their brave fight against the Germans.

According to Nuel Pharr Davis in *Lawrence and Oppenheimer*, the principal Russian agents in the Bay Area were Steve Nelson— a regular Communist Party organizer—and George Eltenton—an official of the Federation of Architects, Engineers, Chemists, and Technicians.

Eltenton used his social contacts to make at least one major attempt to place a spy in the American nuclear program. We will get to that later. Nelson actually managed to conduct Communist party meetings at the Radiation Laboratory. He also subverted an employee named Joseph Weinberg.

Fortunately not all of the American security officers were bunglers. They discovered Weinberg. "We proved to our satisfaction," John Lansdale, the best of them, said flatly, "that he gave information to Steve Nelson for money." Security observed and recorded the transaction and then watched as Nelson turned the data over to the Third Secretary of the Russian Consulate.

Weinberg was not arrested, apparently because the information he had access to concerned the Calutron, a machine which produced minute quantities of fissionable material at an astounding cost. The Calutron has been described as Lawrence's "historic mistake." The Government spent five hundred million dollars on it before Oppenheimer shifted U.S. production to a faster, less expensive method. Davis speculates that General Groves, the military chief of the nuclear physics program, allowed Weinberg to steal Calutron data in the hope that if the Russians relied on it, it would exhaust their post-war economy before they could build a bomb. If this was his game, he played for high stakes. Of course, he could not win because Klaus Fuchs—the Russians' deep cover agent—went undetected at Los Alamos.

The boldest of the Russian ploys was what is known as "the Chevalier incident." This was the approach made by George Eltenton to Robert Oppenheimer, in which he tried to use Haakon Chevalier as an intermediary. Eltenton probably looked on it as a long shot. The possibility that Oppenheimer, the civilian director of the Los Alamos Laboratory, might be corruptible was too glittering to resist.

For some years Chevalier had ben a friend of both Eltenton and Oppenheimer. He was the type of person described in those days as a "fellow-traveller." When Eltenton decided to sound out Oppenheimer in 1943 (less than a year after the Soviets began their atom bomb program), he took a more sophisticated tack than Nelson's with Weinberg. Money was not mentioned. He appealed to Oppenheimer's idealism, stressing the need for Soviet-American friendship. Eltenton merely asked Chevalier to pass a message to Oppenheimer. Since he (Eltenton) and Oppenheimer shared the same beliefs, they must both feel it was wrong of the U.S. to withhold research from its ally. If so, he would be willing to help Oppenheimer correct the situation. If Oppenheimer wanted to give the Russians current research, Eltenton would see that it reached them.

Chevalier has written that he refused to carry the message as an accomplice, but that he did report it to Oppenheimer. Oppenheimer, in turn, reported it to security, as he was obligated to do. But he behaved equivocally by trying not to reveal Chevalier as the contact. When he lied to protect Chevalier, even considering that friendship and personal loyalty were his motives, he was culpable. We were in

a war that cost millions of lives, and Oppenheimer was building the most hideous weapon yet invented by mankind. Many years later "the Chevalier incident" was used by Oppenheimer's political enemies to deprive him of his security clearance and drive him out of Government service. This long delayed and unfortunate result was probably the only success the Russian spies achieved in Berkeley.

Chevalier has always maintained that he carried Eltenton's message only to alert Oppenheimer to a potential danger. That may be true. But security agents believed that if Oppenheimer had responded by saying, "Gosh, Haakon, why didn't I think of such a great idea," Chevalier would have carried the affirmative message back to Eltenton. Both Chevalier's and Oppenheimer's versions of the incident make it easy to see why the security agents concluded that he was indeed offering Oppenheimer, very carefully and noncommittally, an opportunity to commit treason.

<div style="text-align: right">Phil McArdle</div>

Epilogue:

The City Since World War II

During the years chronicled in these pages Berkeley became a city with qualities which set it apart from San Francisco, Oakland, and other Northern California communities. Its size was an important factor in this: it was neither too large nor too small for the development of a unique identity. Berkeley became home to settled neighborhoods of permanent residents devoted to their families and their callings, and this gave the City some of the characteristics of a small town; but it also became home to a University with a cosmopolitan faculty and a changing population of students. The townspeople built well, constructing beautiful homes and fine, spacious streets, and planting trees and flowers in such profusion as to make the City truly a garden spot. The studies pursued by the University faculty gave the City an international significance, and the enthusiasms of the students often gave the surface of daily life an extra lilt. Together the townspeople and the academics cooperated to build an exemplary local government.

Throughout most of this period the City government reflected the nature of the people, which was optimistic and conservative; even the vigorous measures taken to achieve incorporation followed well established precedents. Together, the people and the government learned the lessons of experience and applied them to their future with considerable courage—as we have shown in the stories of the public library and the fire department.

Acceptance of civic responsibility for the unfortunate—one of the City's deeply ingrained characteristics—first showed itself when the community welcomed the arrival of the Asylum for the Deaf, Dumb, and Blind. The same humane personal and civic concern showed itself splendidly in the City's responses to the earthquake of 1906, the fire of 1923, and the terrible Depression of the 1930s.

Outstanding scientists from the University played key roles in one of the most astonishing developments of World War II—the invention of nuclear weapons.

Since World War II Berkeley has continued to be the home of a settled community of permanent residents and of what is now a world famous University. But a lot has happened since 1945. Some of the major developments include:

- large growth in the population, with many of our fellow citizens being members of racial minorities;
- an unprecedented growth in the size of the public school system and the number of private schools;
- important initiatives to desegregate the public schools;
- steady growth in the size of the University and a concomitant increase in its impact on the City;
- the era of loyalty oaths;
- the increasing social and political impact of the student community (of which the famous Free Speech Movement was only one sign);
- the rise of the neighborhood preservation movement; and
- a shift from Republican to Democratic political majorities

These changes and their ramifications offer a fertile field of inquiry, even though many of them are still so recent that they are only as "historical" as yesterday's newspapers, and cannot yet be seen in full perspective.

In years to come, we hope that the Berkeley Historical Society will be able to aid in deepening our understanding of these events.

Phil McArdle

Berkeley History Series

A comprehensive listing of all articles that appeared in our Berkeley History Series in the *Berkeley Gazette*. 1978–1983.

Stephanie Manning; West Berkeley Was a Place For Determined Pioneers (16 November 78).

Stephanie Manning; West Berkeley Also Known for Its Industrialists (24 November 78).

Curt Manning; When North Campus Was Just a Farm (1 December 78).

Frances Starn; The '99 Prohibition (8 December 78).

Careth B. Reid; Camp Ashby—Providing for the City Defense During World War II (21 December 78).

Stephanie Manning & Anthony Bruce; Celebrating the New Year Back in the Gay 90s (28 December 78).

Rev. Harry B. Morrison; Yes, the City Really Did Have Farms (4 January 79).

Ellen Droiri; The City's First Public School (15 January 79).

Ken Stein; International Airport? (25 January 79).

Trish Hawthorne; North to Thousand Oaks—A Forerunner of BART (1 February 79).

Henry Pancoast; Claremont Canyon: Telegraph Lines, Pony Express (8 February 79).

Lillian Davies; Founders Rock—A Witness to UC's History (22 February 79).

Gloria Cooper; Garden Record of Early Days (1 March 79).

Fillmore Eisenmayer; Lawn Bowling Oasis in City (8 March 79).

Betty Marvin; Bohemian Dinners and Fine Music (15 March 79).

Stephanie Manning; One of the City's Earliest Politicos (24 March 79).

Unsigned; A Time To Search Out Roots (29 March 79).

Stephanie Manning; The City's One-Man Library (5 April 79).

L. Hoppe-Glosser; The Ohlone Way of Spring (12 April 79).

Stephanie Manning; April: A Time for Remembering Past Quakes (20 April 79).

Stephanie Manning; One of the City's Women Pioneers (26 April 79).

Stephanie Manning; Durant: College Founder, Ferry Backer (3 May 79).

Fillmore Eisenmayer; The Piano Club: Meeting for Music Since 1893 (10 May 79).

Stephanie Manning; The Mill: One of the City's Enduring Industries (17 May 79).

Stephanie Manning; French Laundry: A Mercantile Tradition (24 May 79).

Stephanie Manning; Speculation: When Real Estate Replaced Gold (31 May 79).

Stephanie Manning; The Era of the Bay Ferry—And of the Good Life (7 June 79).

Stephanie Manning; Wagon Wheels Mark Past Commerce Center (14 June 79).

Fillmore Eisenmayer; Tennis Club Helped Pioneer Sport (21 June 79).

Stephanie Manning; J. Ross Browne: A Colorful Character and An Early Booster (28 June 79).

Stephanie Manning; UC's First Scholars: Two Confederate Brothers (5 July 79).

Stephanie Manning; Stories Found In Musty Documents (12 July 79).

Stephanie Manning; Cutter Laboratory: An Early Berkeley Resident (19 July 79).

Stephanie Manning; August Vollmer: The City's Most Famous Cop (26 July 79).

Stephanie Manning; Shattuck's Evolution Into City's Downtown (2 August 79).

Stephanie Manning; From Spanish Trail to City Street (9 August 79).

Stephanie Manning; Tracing Downtown Changes (16 August 79).

Fillmore Eisenmayer; Garden Club Lives Up to Its Credo (23 August 79).

Fran Linsley; Stiles Hall: It's People, and Not a Single Building (30 August 79).

Curt Manning; City's Own Beach Disappeared in Building the Growing New Town (6 September 79).

B. Luce-Richey; The Local Creeks Have a Story All Their Own (16 September 79).

Charles Marinovich; A Lot of History, But No Museum (23 September 79).

Stephanie Manning; UC's Wheeler: The Man Behind the Award (30 September 79).

Stephanie Manning; The City, As Chronicled By The Magazines (7 October 79).

Stephanie Manning; Give 'Em The Axe: 102 Years of Cal Football (14 October 79).

George Collier; Societies Working Together (21 October 79).

Gloria Cooper; The Booklets Guaranteed by the "Pure Fact Law" (28 October 79).

Fillmore Eisenmayer; The Sign of the Elk (4 November 79).

Stephanie Manning; The Earliest Days of the City's Waterfront Area (11 November 79).

Lillian B. Davies; The Little University Building that Led Three Lives (18 November 79).

Bois Burk; The Days of Cheap Student Rent (21 November 79).

Stephen Warshaw; Free Speech movement—The Resurrection of Idealism (2 December 79).

Trish Hawthorne; Peralta Park: One Man's Dream of a Resort (9 December 79).

Trish Hawthorne; A Rock-Reminder of the Area's First Inhabitants (16 December 79).

Stephanie Manning; Neighborhood Shoppers Used Bruns Block in West Berkeley (23 December 79).

Edward Staniford; How to Go About Doing "Your Own Historical Thing" (30 December 79).

Edward Staniford; Tracking Down Rail War (6 January 80).

Edward Staniford & Therese Pipe; The Tunnel: Southern Pacific Dug Its Way to Supremacy (13 January 80).

Therese Pipe; G. Sydney Rose (20 January 80).

Edward Staniford; There's More to a Picture—North Berkeley (27 January 80).

Edward Staniford; Berkeley Fire Was Second Only to San Francisco's (3 February 80).

Ken Stein; Sculptor Doug Tilden Was California's Finest (10 February 80).

Edward Staniford; Peralta Park—An Elegant Berkeley Development (17 February 80).

Trish Hawthorne; How Berkeley Almost Became the State Capital (2 March 80).

Edward Staniford; Spring's Time in Berkeley: A Gambler's Legacy. (9 March 80).

Bois Burk; The Rise and Fall of Berkeley's Schools (16 March 80).

Edward Staniford; Domingo Peralta: Berkeley's First Homesteader (6 April 80).

Trish Hawthorne; Subdivisions Helped the City Grow (13 April 80).

James T. Burnett; J. Stitt Wilson: City's Socialist Mayor (20 April 80).

Edward Staniford & Bob Tapia; Herrick Is the Result of a Widower's Dream (27 April 80).

Bois Burk; Military Training was Part of UC (4 May 80).

Henry Pancoast & Sayre Van Young; How the City Got Its First Free Public Library (11 May 80).

Henry Pancoast & S. Van Young; How the Libraries Survived Hard Times (18 May 80).

Stephanie Manning & Lynn Laird; Deaf and Blind Schools (25 May 80).

Charles Marinovich; How the Community Theater Came About (1 June 80).

Phil McArdle; Berkeley Follows Its Namesake's Footsteps (9 June 80).

Edward Staniford; Horace W. Carpentier: The King of Controversy (15 June 80).

Edward Staniford; Horace Carpentier: The Lord of the Legal Land Grabbers (22 June 80).

Edward Staniford; The City's Volunteer Firefighters—A Red Hot Lot (30 June 80).

Edward Staniford; Mapping the City's Geographical History (4 July 80).

Phil McArdle; Frank Norris: Champion of Creativity (13 June 80).

Elizabeth Fahey; Public Health Agency Turns 100 This Year (3 August 80).

Stephanie Manning; Old Photo Collection Found in U.C.'s Bancroft Library (10 August 80).

Elizabeth Fahey; Berkeley Tennis Club—An Anonymous Survivor (17 August 80).

Charles Marinovich; The Veterans Memorial: A Tribute to the Past (7 September 80).

Edward Staniford & Florence Jury; The Fire of '23: Two Accounts by Observers (14 September 80).

Edward Staniford & Florence Jury; The Fire of '23: How the City Pulled Together (21 September 80).

Edward Staniford & Florence Jury; The Great Fire of '23: Picking Up the Pieces. (28 September 80).

Ellen Drori; Old Cookbooks Reveal More Than Their Recipes (5 October 80).

Glen Turner; 58 Years of Girl Scouts (12 October 80).

Trish Hawthorne; Realtor Joseph Mason: He Saw a Need and Sold It (19 October 80).

Phil McArdle; Philosopher Josiah Royce (26 October 80).

Therese Pipe; League of Women Voters: Berkeley Leads Again (2 November 80).

Phil McArdle; Lincoln Steffens: The Moralist Who Labeled the System (9 November 80).

370

Sisters Beus & Johnson; Beginnings of the City's Mormon Church (16 November 80).

Karen Jorgensen-Esmaili; How Immigrants Settled Ocean View District (30 November 80).

Phil McArdle; Leonard Bacon: A Pulitzer Poet of Polish and Precision (14 December 80).

Elizabeth Fahey; City's First Presbyterian Church Turns 50 (21 December 80).

Phil McArdle; Henry Durant: True Patriarch of the City (11 January 81).

Phil McArdle; The Costanoan Indians of the East Bay (6 February 81).

Charles Marinovich; Old Article Describes Wild West Days of Berkeley (11 February 81).

Therese Pipe; Interviewing Observers of the Past (13 February 81).

Florence Jury; The Story of the Story Teller (23 February 81).

Bois Burk; Early Days at the University (9 March 81).

Gloria Cooper; Past and Present in Pictures (20 March 81).

Charles Marinovich; Remembering the Shock of the '06 Earthquake (I) (5 April 81).

Charles Marinovich; The Destructive Fire that Followed the 1906 Big One (II) (14 April 81).

Harold Yost; The Day the City Trembled: An Eyewitness Remembers (19 April 81).

Charles Marinovich; The Quake: Yes, It Happened Here, Too (III) (26 April 81).

Charles Marinovich; The Indians' Legend of the Great Quake (IV) (3 May 81).

Florence Jury; Weathering the Depression Years (10 May 81).

Phil McArdle; George R. Stewart's Audience (24 May 81).

Florence Jury; How the City Weathered the Cruelest Depression Year (7 June 81).

Phil McArdle; Edward Rowland Sill: The City's First Prominent Writer (14 June 81).

Phil McArdle; A Look at Some of the City's More Notable Scribblers (5 July 81).

Florence Jury; Roosevelt Would Have Gotten a Chilly Reception in '32 (19 July 81).

Phil McArdle; Sanskrit Translator Arthur Ryder (9 August 81).

Joseph Le Conte; Hills Evoked Purple Prose (23 August 81).

Florence Jury; "New Deal" Stirred City (6 September 81).

Stephanie Manning; Sproul: The Epitomy of the Wheeler Award (13 September 81).

Therese Pipe; Photo Exhibit Offers a Special Link to City's Rich Past (27 September 81).

Phil McArdle; Program to Give Young a Peek Into City's Past (11 October 81).

Dorothy V. Benson; The Decades Fail to Erode Tradition of Poets' Dinner (18 October 81).

W. C. Jones; They Looked Through the Golden Gate (25 October 81).

Phil McArdle; Slim Pieces of the Past (1 November 81).

C. B. Bradley; The Secret Nooks of Local Hills (8 November 81).

Ken Mahaffey; Our Changing Shore (15 November 81).

Jacomena Maybeck; How Spanish Lost Region (29 November 81).

Charles Marinovich; WWII Fears Turn State Into Armed Camp (6 December 81).

E. Greene; City's Parks and Trees, The Way They Were (13 December 81).

Charles Marinovich; Some Bay Area Churches Stand Steeples Above the Rest (20 December 81).

Charles Marinovich; The Anatomy of Architecture (3 January 82).

Phil McArdle; Test Classes at Hillside School on History of North Berkeley (17 January 82).

Bois Burk; Berkeley Begins: An Incorporation Fight (24 January 82).

Florence Jury; Dog Days for Democrats (31 January 82).

Phil McArdle; Berkeley's Burdick: His Books Are Already History (14 February 82).

Phil McArdle; The Last Will and Testament of Don Luis Maria Peralta (21 February 82).

Karen Jorgensen-Esmaili; A Long-Lost Bit of Berkeley (28 February 82).

Karen Jorgensen-Esmaili; Berkeley, A Town of Ethnic Diversity (7 March 82).

Bois Burk; A Nostalgic Look at Cal's Traditions (14 March 82).

Florence Jury; Lighter Side of the Depression (18 March 82).

Florence Jury; The Bright Side of Life in the Great Depression (26 March 82).

Karen Jorgensen-Esmaili; Our Two Towns Grow and Grudgingly Incorporate (4 Apil 82).

Trish Hawthorne; Local History Project Brings the Past to Life (11 April 82).

Ken Pettitt; The Longest Blackout of the War (25 April 82).

Stephanie Manning; A Look at the Not-Too Distant Past (8 June 82).

Stephanie Manning; The Days of No Car Jams (13 June 82).

Stephanie and Curt Manning; The City's Waterfront (20 June 82).

Betty Marvin; Continuing Beauty of Tunnel Road (27 June 82).

Karen Jorgensen-Esmaili; Ocean View's Social and Ethnic Diversity (11 July 82).

Bois Burk; South Berkeley's Pre-1900 Decades (18 July 82).

Betty Marvin; Chronicling the City's Hard Times (25 July 82).

Betty Marvin; Cellophane Bucks, Free Trips and Other Depression Tidbits (1 August 82).

Phil McArdle; City's Spanish Roots Stem from Imperial Policy (8 August 82).

Unsigned; 90 Years of Mass Transit (15 August 82).

Boris Burk; In 1873 only 2 Buildings on U. C. campus (29 August 82)

Therese Pipe; California Writers Club (I) (3 September 82).

Therese Pipe; California Writers Club (II) (19 September 82).

Brick Morse; UC Fields Its First Team in 1882 (26 September 82).

Ken Pettitt; Merry Rides to the Ferry (10 October 82).

Brick Morse; UC Teaches Britons a Lesson (17 August 82).

Brick Morse; Cal Adopts "New" Football Rules in 1886 (24 October 82).

Florence Jury; A Look Back at the Great Depression (7 November 82).

Ken Pettitt; Hitler's Rumblings in Europe Seemed So Far Away (21 November 82)

Ken Pettitt; A Youth Learns About War and Peace (28 November 82)

Phil McArdle; Lawrence's Years at U.C. (12 December 82)

Phil McArdle; Oppenheimer in Berkeley: Physicist Meets the Left (26 December 82)

Ken Pettitt; WW II: Incendiary Times for Berkeley (2 January 83)

Phil McArdle; Atomic Age Spies in Berkeley (23 January 83)

Bob Yamada; Berkeley: Peace, War and Executive Order 9066 (13 February 83)

Charles Marinovich; Fear of Japanese Fed Area Hysteria (29 May 83)

Ruth Acty; Walter Gordon: In the Forefront of Change (5 June 83)

Ken Pettitt; Pot Luck (16 July 83)

Therese Pipe; UC Campus' Towering Treasures (23 July 83)

Florence Jury; Memories of St. Margaret's House (13 August 83)

General Index

Academic Senate, 69
Adventures in the Apache Country, 50
Affiliate Clubs of Berkeley, 289
Agassiz, Louis, 72
Akagi, Nobutoro 358
Alameda-Contra Costa Boundary, 16
Alameda County, 137, 308, 314
Alameda County Grand Jury, 325
Alameda Water Company, 60
Albany 15, 54
Albany Hill, 14, 15, 16
Allen, Frederick Lewis, 307
Allied Youth, 310
Allison, Stub, 325
Alvarado Family, 39
American Given Names, 322
American River, 148
Anima Vagula, 222
Anna Head School, 147
Annie's Oak, 39
Anson Weeks Band, 316
Antelope, 148
Aquatic Park, 184
Architect and Engineer of California, 205
Arlington Facility, 190
Arriola and Company, 181
Ashby, William, 137
Associated Students, U.C. 286, 294
Asylum for the Deaf, Dumb and Blind, 19, 45, 55–57, 192, 206
Autobiography of Lincoln Steffens, 155, 158
Axe (UC), 84
A-Zed School, 146

Bacon, Leonard, xii, 220–223
Bagwell, Beth, 18
Bakewell & Brown 210
Bakst, Leon, 171
Baldwin, Charles 39
The Ball Player, 192

Ballyhoo Magazine, 308
Barber, William, 288
Barker Building, 205, 206
Barker, J. L., 144, 180
Barkley, Alben W., 312
Bartlett, A., 144
Baruch, Bernard, 157
Bay Bridge, 314, 350
The Bear Hunt, 193
Beaulieu Boarding and Day School for Girls, 146
Bellquist, Eric, 359
Bender, Albert, 186
Benicia-Martinez Ferry, 59
Berkeley:
 Board of Town Trustees, 138, 140 174, 175, 212
 Charter, 139, 176
 City Council, 139, 140, 174–176, 287, 289, 307, 354
 City Hall, 16, 228
 City Manager, 139, 179, 285, 286, 288
 Commission Government, 176
 Fire Department, 143, 195
 Incorporation, 137–139
 Library, 173–177, 307
 Name, 3, 4, 71
 Planning Commission, 288
 Police Department, 195, 196, 285, 324, 325
 Population, 23, 52–54, 138, 152, 153, 166, 206, 208;
 Schools, 140, 144–147
 Tax Rate, 225
 Town Line, 209, 212
 Town Marshal, 234
 Volunteer Firemen, 142, 143, 195, 228
Berkeley Beach, 13, 14
Berkeley Board of Trade, 153
Berkeley Branch Line, 180

Berkeley Chamber of Commerce, 210, 224, 225, 286
Berkeley Club, 76
Berkeley City Club, 163
Berkeley Creeks, 184
Berkeley Daily Advocate, 11, 139, 147, 153, 173
Berkeley Democrats and Republicans, 309–312, 314
Berkeley Development Company, 189, 209
Berkeley Fellow, 325
Berkeley Fire, 280–290
Berkeley, First Seventy-Five Years, xii
Berkeley Floral Society, 11
Berkeley Flowers, 10–12
Berkeley French Laundry, 181
Berkeley Gazette, xiii, xiv, 39, 139, 188, 194, 196, 202, 208, 209, 226, 305, 306, 307, 310, 314, 345
Berkeley, George, 1–4
Berkeley Gym, 146
Berkeley High School, 145, 203
Berkeley Hills, 7–9, 14, 58
Berkeley Historical Society, xii, 366
Berkeley Independent, 266
Berkeley in the Thirties, xii
Berkeley, Journal of a City's Progress, 224
Berkeley Music Center, 291, 292
Berkeley Pier, 14
Berkeley Promotional Booklets 224, 225
Berkeley Square, 180
Berkeley School Board, 140
Berkeley, Story of the Evolution of a Hamlet into a City of Culture and Commerce, xii, 174
Berkeley Sun and Letter, 39
Berkeley Tennis Club, 214–216
Berkeley: The Town and Gown of It, xii, 175
Berkeley Trees, 10–12
Berkeley Year, xi, 7
Bernadou, Jean, 181
Bernhardt, Sarah, 207
Berry and Bangs Tract, 153
Bidalot, Simon, 181
Big Game, 84, 191
Billings, Frederick, 70
Bishop Berkeley, 1–4
Blue and Gold Market, 306
Bonus March, 311

Boone's Academy, 146
Boswell Ranch, 190
Boucher, Anthony, xii, 219
Bowen, Captain William, 40, 44
Bowen's Inn, 44, 180
Bowen's Trading Post, 40
Branch Line Railroad, 180
Brand, Max, 220
Brayton, John, 297
Breed, Eleanor, 360
Brennan, Edward, 47
Brennan, John, 47
Brennan's Marina, 47
Brennan's Restaurant, 47
Brico, Antonia, 291
The Bridge, 193
Brown, Edmund, Sr., 71
Brown, Rosalie Moore, 298
Browne, Gerald, 16
Browne, J. Ross, 50–51
Bruton Sisters, 186
Bucareli, Antonio Maria, 31
Buck, Pearl, 309
Budge, Don, 214, 215
Burdick, Gertrude Wilkes, 14
Buris, John F., 146
Bynon, Ella, 146

Caldecott Tunnel, 59, 350
California Adult Authority, 325
California Association of Police Chiefs, 196
California College of Arts & Crafts, 145
California Field, 207
California Hall, 206
California Institution for the Deaf and Blind, 56, 57, 192, 193
California Mission Furniture Co., 358
California Redwood Association, 289
California Retail Lumber Association, 289
The California Volunteers, 192
Californian, 74
Camp Ashby, 354–356
Campbell, William W., 283
Capital Removal Measure, 251–257
Captain Bowen's Trading Post, 40
Carlin, Eva, xi
Carlton, Henry Erskine, 138
Carlton Hotel, 306
Carnegie Library, 175, 205
Carpentier, Horace, 34, 35, 43, 137
Carson City, 19

Central Pacific Railroad, 180
Central Valley, 27
Chamber of Commerce, 209, 210, 224, 286
Charter Day, 71
Cheaper By the Dozen, 311
Cheney, Charles, 299
Chevalier, Haakon, 335, 363, 364
Chicago Century of Progress Exposition, 311
Choate Street, 59
Christian Brothers, 167
Christian Herald, 310
Church of the Good Shepherd, 141
The Circle, 211
Citizens Party, 138
Civil Control Station, 360
Civic Center Complex, 299
Civic Center Park, 16
Claremont Avenue, 58
Claremont, Branch and Ferries Railroad, 166
Claremont Canyon, 58–60
Claremont District, 50, 189
Claremont-Elmwood District, 60
Claremont Hotel, 58, 60, 188, 189, 215
Claremont Park, 208
Claremont Tract, 189
Clark, J. C., 181
Coast Rangers, 50
Codornices Park Area, 190
College of California, 59, 64, 68, 70
Commonwealth Club, 313
Communists, 307, 335, 362
Compton, Arthur, 335
Confidential Agent in Old California, 50
Consumer Bread Company, 163
Contra Costa Academy, 63, 64
Contra Costa County, 59
Contra Costa Hills, 30, 58
Contra Costa Supervisors, 43, 59
Cookbooks, 161–163
Coolbrith, Ina, 76
Cora Williams School, 147
Costanoan Indians, 23, 28, 30
Courier Publishing Company, 224
Cowper, William, 4
Coyote, 24, 25
Creed, W. E., 189, 190
Creeks:
 Blackberry, 15–16
 Cerrito, 16
 Codornices, 15, 16, 33, 166

Marin, 16
Middle, 16
Strawberry, 14, 16, 64, 169
Virginia, 13
Crespi. Father, Juan, 10, 24, 28
Critical Fable, 221
Crusoe's Island, 50
Curtis, Charles, 311
Curtis, Maurice, 83, 166–168
Curtis, Michael, 46, 47
Cutter Laboratory, 183, 184
Cutter, Edward A., 183

Daggett, R. B., 215
Daggett, Stuart, 286
Dangerous Journey, 50
Davis Cup, 214, 215
Davis, Nuel Pharr, 331, 362
Davis, William Heath, 26
Dawes, General Charles E., 313
de Anza Expedition, 31
de Crois, Francisco, 31
de Mer, Albina, 167
Dedi, Lt. Col. Reinhold, 355
Democratic National Convention, 309, 312
Democrats, 309, 310, 312, 314
Depression, 176, 177, 303, 306, 307, 313, 316, 319, 337
d'Estrella, Theophilus Hope, 56
Destry, 221
Dewey, John, 164
Dickey, Charles, 205
Digest of the Deaf, 194
Dillon, Richard H., 50
Dix, Walter, 355
Doe Library, 210
Dornin, George, 144
Dorsay, Mrs. Raoul, 298
Douglas, David, 11
Driver, Sheriff John, 299
Ducasse, Germaine, 181
Dunn Estate, 189
Dunn School for Boys, 146
Dunnigan, Patrick, 46
Dunscomb, Charles E., 305, 307
Durant, Henry, 63–67, 137
Dutton, Charles Mallory, 291, 292
Dwinelle Hall, 207
Dwinelle, John, 68, 137

Earth Abides, 322
Earthquakes, 18, 19, 26, 27, 181, 201–207

East Bay Municipal Utility District, 60, 288
East Bay Water Company, 288
Edgar, James, 137
Edson Adams Ranch, 60
Edwards Field, 303
Edwards, George, 138
Edwards' Track, 146
Edy, John N., 139
Eichler, Alfred, 56
Einstein, Albert, 157, 361
Eisenhower, President, 325
El Cid, 221
El Dorado Oil Works, 14
Elks Hall, 210
Elliott, George, xii
El Sobrante Rancho, 32
Eltenton, George, 362–364
Emanuels, George, 151
Emerson School, 147
Emeryville, 54
Essay Towards Preventing the Ruin of Great Britain, 2
Etchings of a Whaling Cruise, 50
Eucalyptus Trees, 11
Eunice Street, 209, 212
Everding, John, 48
Exclusion Order No. 19, 360
Executive Order No. 9066, 359
Exploration in Lower California, 50

Faculty Glade, 39, 294
Fages, Lt. Pedro, 23, 28, 29
Fairview Park, 53
Farms, 46, 47
Father Junipero Serra, 192
Faust, Frederick, 220
Fernwald Hall, 329
Ferrier, W. W., xii, xiii, 138, 174, 329
Ferries, 59, 138, 148–150
Ferry Building, 149, 203, 204
Fire, 322
Fisher, Galen, 359
Fitts, Lt. Gov. Buron R., 299
Flekel, Major-General Jacob E., 346
Fleming, John, 34
Fleming's Point, 13, 14
Flowers, 10–12
Football, 83–85 191, 192, 324, 325
Football Players 191, 192, 193, 207
Fortune Magazine, 310
Foss, Fred, 180
Foss and Company, 180

Foster, Willis, xii
Founders Rock, 70, 71
Fourth Air Force, 346
Franklin School, 145
Froebel Educational Associates, 146
Fuchs, Klaus, 363
The Furioso, 222

Gaines, Mayor Frank S., 354
Galbraith, John Kenneth, xii
Galpin Ranch, 189
Garner, John Nance, 310, 312
Gayley, Charles Mills, 164, 165, 220, 222
George II, 4
Gester, William B., 205
Giant Powder Works, 19, 53
Gibson Photography Studio, 291
Gibson, Truman, 355
Gilbreth, Lillian, 311
Gillett, James N., Gov., 210
Gilman, Daniel Coit, 64, 66, 76–78
Glasscock Estate, 189
Glasscock, William, 60
Golden Gate, 3, 7, 13, 26, 27, 70
Golden Gate Fields, 13, 34
Golden Gate Park, 192, 193
Golden Sheaf Bakery, 182
The Good Earth, 309
Gordon, Walter, 324–326, 355
Gordon, Dr. Wesley Dexter, 298
Greek Theater, 71, 206, 207, 295
Gregory, Sadie, 292
Grey, Captain Thomas, 148
Grist Mill, 48
Grizzly Peak Road, 313
Groves, General, 363
Gutterson, Henry, 292

Haggerty, Fire Chief, 290
Hahn, Otto, 332, 361
Hamilton, Brutus, 325
Hanging Oak, 39
Hansen, Robert, 16
Harlan, H. George, 148
Harmon Gymnasium, 169, 185, 207
Harmon Seminary for Girls, 146
Harris, Joseph W., 314
Hartack, Paul, 361
Harte, Bret: Argonaut & Exile, 9
Hassle, Guy, 299
Haste, J. H., 144
Harvard College, 3

Havens, Frank, 189
Havlik, Neil, 15
Hawthorne, Hildegarde, 313
Hayes, Col. Jack, 42, 43
Hayward, 29
Hayward Fault, 18, 19
Hayward Planning Commission, 18
Hearst Gym, 207
Hearts Hall, 179, 206
Hearst Mining Building, 206
Hearst, Phoebe Apperson, 60, 178, 179, 191
Hecox, Adna, 192
Hesse, Frederick, 69
Heywood, Charles, 140
Heywood and Jacobs Lumber Mill, 13, 48, 140
Heywood, Samuel, 13, 45, 140–141
Heywood, William, 141
Heywood, Z. B., 140
Higgins, Michael, 46
Highland Hospital, 300
Hildebrand, Joel, 179
Hilgard, Eugene, 69, 138
Hillside Club, 286
Hink, Lester W., 178
Hinks, 306
Hitler, Adolph 309
Hodghead, Beverly, 226, 227
Holmes Library, 173–174
Home Front Alarms. 345–347
Honer, John, 299
Hoover, President, 157, 309, 310–312, 315
Hopkins Terrace, 153, 189
Howard, H. S., 224
Howard, John Galen, 205, 206, 210, 211
Howard, Mrs. John Galen, 171
Howard, Sidney, 220
Hutchinson, Claude B., 178
Hyde, Mary, 146

Illustrated History of the University of California, xi
Independent, 226
Indian Rock Park, 28
Indians, 23–30
Indians of California, 50
Indians, Costanoan, 23–30
Indians, Legends, 24–27
Indians, Ohlone Way, 15
Indians, Ohlones, 23
Indians, Suisun, 27

Insull, Samuel, 310
International Association of Fire Chiefs, 229
International House, 304, 314

Jack London Square, 202
Jacobs, Captain James, 13, 44, 45, 55, 137, 140
Jacobs, Helen, 214
Jacob's Landing, 44, 45
Jacob's Wharf, 19, 48, 140
James, Henry, 155, 158, 164
James, William, 78, 79
Japanese Internment, 190, 357–360, 423
Japanese Residents, 190, 357–360
Jarrell, Randall, 220
Jaymot, Jack, 181
Jeffers, Robinson, 322
John Hinkel Park, 15
Johns Hopkins, 78
Johnson, Hal, 188
Johnson, Wallace, 178
Jones, William Carey, xi, 74, 138, 156, 175
Judson-Shepard Chemical Works, 53

Kangaroo, 148
Kaufman, George, 308
Kearney, John, 46, 55
Keeler, Charles, 286
Kellersberger, Julius, 42, 43
Kellogg, Martin, 68, 69, 76, 77, 138, 144, 161, 201
Kellogg Ranch, 153
Kellogg School, xiii, 144–146
Kelsey, J.E., 175
Kenney, James, 143, 229, 285
Kerr, Clark, 71
Key System, 60, 149, 150, 181, 212
Kildare, Dr., 221
King, Fleet Admiral Ernest J., 346
King Junior High School, 168
Kingman, Ruth and Harry, 359, 360
King's Liquors, 355
Knox, Minnie Faegre, 297, 298
Knox, Ronald, 1
Kovacs, Frank, 214
KRE, 316
Kreuger, Ivar, 310
Kroeber, Alfred, 24, 179

Lafayette, 58
La Loma Park, 190

Land Grant Act, 80
Lane, Mrs. Lucille, 355
Lansdale, John, 362
Laundry Business, 180–181
Lawrence, Ernest O., 330–332, 380
Lawrence, John, 332
Le Conte Hall, 73, 330, 331
Le Conte, John, 68, 72, 73, 75
Le Conte, Joseph, xi, 7–9, 64, 72, 73, 138
Le Conte Oak, 39
Le Conte School, 73
Lehmer, Derrick, 320
Lenin, 157
Lewis, Gilbert, 222, 331
Life Sciences Building, 207, 320
Lincoln Market, 306
Literary Digest, 310, 313
Little Theater, 294
Lombardo, Guy, Band, 316
London Horticultural Society, 11
London, Jack, xii
Long, Roy O. 167
Loper, Rev. Vere, 360
Lorin, 175
Los Alamos, 336, 362, 363
Lowell, Amy, 221
Lozier, Frances, 291
Lumber Mills, 48, 49
Lusiad, 222

Mack the Knife, 3
Mare Island, 19
Margolin, Malcolm, 15, 29
Mark Hopkins Institute of Art, 193
Marshall, John, 148
Martin Eden, xii
Martinez, 58, 59,
Mason, Joseph J., 180, 151–154
Mason-McDuffie, 60, 154, 180, 209, 211, 213
Masonic Lodge, 204
Masonic Temple, 206
Mathews, Peter, 46
May, Samuel, 286
Maybeck, Bernard, 162, 179, 286, 288, 316
Maybeck Studio, 316
Mechanics Statue, 193
Meitner, Lise, 332, 361
Mendoza, Cloromeda, 40
Merchants Exchange Club of Oakland, 59

Metcalf, George D., 144
Meyers, Henry H., 300
Miller, Clinton, 84
Milosz, Czeslaw, 220
Minturn, Charles, 148
Mirandette, Pauline, 181
Miss Talbert's School, 303
Mission Santa Clara, 33, 35
Mistral, Frederic, 220
Mobilized Women's Organization, 162
Monterey Bay, 26
Montclarion, 18
Morgan House, 59
Morgan, Julia, 154, 163
Morrill Land Grant Act, 80
Morse, Brick, 191
Morse, Sheriff Harry, 40, 41
Mortimer, W. P., 189
Mt. Diablo, 58
Mt. Hamilton, 19
Muses Quartet, 291
Museums, 185–187
Mussolini, 157
McAllister, Frank, 206
McArthur, A.W., 146
McDuffie, Duncan, 60, 154, 189, 190, 209
McGee, James, 46, 47, 137
McKeever Hill, 14
McLaughlin, Donald, 71
McMillan, Edwin, 332
McTeague, 165

NAACP, 325
National Academy of Sciences, 335
National Board of Fire Underwriters, 281, 286, 287
National Council of Women, 311
National Football Foundation of Fame, 325
National Guard Armory, 299
Native Sons of the Golden West, 206
Needham Brothers Photo Supplies, 181
Nelson, Steve, 362
Neuhaus, Eugen, 186
New Pictures From California, 59
Newsom, Samuel and J.C., 144
Niehaus Bros. and Co., 48
Niehaus, Edward F., 48
Niehaus and Schuster, 48
Nobel Prize, 220, 329, 332
Nolan, Stephen, 11
Normandy Village, 313

Norris, Frank, xi, 77, 164, 165
North Berkeley Fire Station, 213
North Berkeley Land Company, 189
Northbrae Community Church, 209
Noyes, G.R., 217

Oak Knoll Hospital, 172
Oakland, xii, 18, 40, 43, 57, 58–60, 63, 64, 137, 138
Oakland Chamber of Commerce, 59
Oakland Daily News, 18, 19
Oakland Mole, 149, 204, 212
Oakland, Population, 18
Oakland Times, 19
Oakland Traction Company, 212
Oakland Tribune, 19, 297
Obata, Chiura, 358
Ocean View, 44, 45, 48, 50, 52–54, 137, 139, 140 144, 145, 152 167
Octopus, 165
Odd Fellows Hall, 206
Of Thee I Sing, 308
Oglethorpe University, 72
Ohlone Indians, 15, 23
Ohlone Way, 15
Oh, Yeah?, 308
Olla Podrida, 145
Olmsted, Frederick Law, Jr., 60
Olympics, 214, 313
O'Neil Glass Works, 53
O'Neil, Michael, 46
O'Posen, Sam'l, 83, 166
Oppenheimer, J. Robert, 330, 333–336
Order of the Coif, 325
Orinda, 58
Overland Monthly, 74, 75
Oxford Pledge, 82

Pacific Kindergarten Normal School, 146
Pacific School of Religion, 146
Pagoda Hill, 50
Panama-Pacific International Exposition, 60, 352
Parent Magazine, 340
Parktilden Village, xii
Parks: Aquatic, 184;
 Civic Center, 16;
 Indian Rock, 28;
 John Hinkel, 15;
 Live Oak, 15;
 Mortar Rock, 28, 29;

 Peralta, 40
 Willow Grove, 14
Parnell, Charles Stewart, 164
Partheneia, 294
Patterson, H.R., 195
Pearl Harbor, 82, 170, 347, 349, 362
Pearsall, Robert, 24
People's Park, 303
Pepper, Stephen, 185
Peralta, Domingo, 16, 33–36, 42, 43, 166
Peralta, Gabriel, 31
Peralta, Juan, 34
Peralta, Luis Maria, 30, 31
Peralta, Miguel, 35
Peralta, Ramon, 34
Peralta, Vicente, 33, 43
Peralta Park Development, 166–168
Peralta Park Hotel, 50, 146, 166, 167
Peralta Ranch Lands, 44
Pettitt, George A., xii, 48, 137, 175, 328
Pettittania, 351–353
P.G. & E., 163, 189, 281, 288
Phaedre, 207
Ph.D's, 222
Phelan, James, 191, 193
Phelan, James D. Lectureship, 319
Piano Club, 171
Piedmont, 19
Poets' Dinner, 296–298
Poling, Dr. Daniel A., 310
Pollock Studios, 181
Pony Express, 59, 148
Post Office, 308
Presidios, 31
Price, Nibs, 325
Principles of Human Knowledge, 1
Prohibition, 310, 311, 316
Pulitzer Prize, 220, 308

Radiation Laboratory, 331, 361, 362
Raholl, John, 183
Rallies, 295
Ranchos, 30–32
Rancho San Antonio, 30, 32, 33, 36
Railroads, 149, 150, 152, 180, 181, 212
Ratcliff, Walter, 215
Raymond, P.M., 213
Realty Syndicate, 189
Reconstruction Finance Corporation, 313, 314
Reid's Drugs, 162

Relief Funds, 337–338
Richardson, Captain, 26
Rickard, Thomas, 212
Rickard, Mrs. Thomas, 171
Rising, Willard Bradley, 137, 144
Rooming Houses, 303
Roosevelt, Eleanor, 312
Roosevelt, Franklin Delano, 309, 312, 313, 315
Roosevelt, Theodore, 156
Rose Bowl, 85
Rose, G. Sydney, 228, 229, 283, 284, 285
ROTC, 80–82
Royce, Josiah, xi, 74, 76–79
Royce School for Boys, 147
Rumford, Byron, 355
Russia, 157, 158
Rutherford, Lord, 313, 330
Ryder, Arthur, 217–219, 222,
Ryskind, Morrie, 308

Sacramento-San Francisco Riverboat, 59
St. Joseph's Academy, 147
St. Joseph's Church, 47
St. Mary's Cemetery, 35
St. Mary's High School, 146, 167
Salinas Plains, 26
Saloons, 210
San Andreas Fault, 201
San Francisco, 18, 19, 60
San Francisco Bay, 13, 14, 26, 27, 29, 30, 148, 155
San Francisco Bay Ferry Boats, 148
San Francisco Bulletin, 19
San Francisco Chronicle, 19, 201, 202
San Francisco Post, 19
San Martin, Ignacio, 18
San Pablo, 43
Santa Clara Valley, 26
Sather Gate, 185, 294
Schools, 144–147
Schuster, Ad, 297
Schuster, Mrs. Addison 298
Schuster, Gustavus A., 48, 49
Semi Centennial, xii, 222
Service Club Council, 178
Seven of Calvary, xii, 219
Shame of the Cities, 157
Shattuck Avenue, 41, 151, 153, 180–182
Shattuck, Francis R., 137, 144, 174, 175, 180

Shattuck Hotel, 182, 310
Shima, George, 358
Shinn, Millicent, 75
Sibley, Carol, 178
Sierra Club, 72
Sill, Edward Rowland, xi, 74–78, 138
Sill's Market, 161
Simpson, Louis, 220
Sinclair, Upton, 227
Singing East Bay and Beyond, 298
Sixty Years in California, 26
Sloan, David, 334
Smith, Adelaide, 147
Smith, Alfred E., 310
Smith, Andy, 84, 324, 325
Smith, Francis "Borax", 189
Snell Seminary, 147
Social Alternatives for Mitigation of Seismic Hazards, 18
Social Problems Club, 294
Socialism, 314
Socialist Party, 226, 227, 314
Song of Roland, 221
South Berkeley, 176
South Hall, 206
South Sea Bubble, 2, 4
Southern Pacific Company, 149, 151
Spanish American War, 195
Spanish War Relief, 335
Speakeasy, 310
Spenger, Paul, 13
Spenger's 16, 298
Spenger's Fish Market, 14
Spring Construction Company, 190
Spring, John, 188–190
Sproul Plaza, 170
Sproul, Robert Gordon, 178, 327–329, 359
Stadium, 327
Stadtman, Verne E., xii, 81
Stalin, Joseph, 157
Standard Soap Factory, 205
Stanford Place, 202
Stanford University, 83, 84, 191
State Capital, 208–211
Steffens, Lincoln, 155–158
Stein, Louis, 13
Stephens Hall, 294, 310
Stewart, George R., 9, 74, 321–323
Stiles Hall, 169, 170, 325
Stiles, Mrs. Anson Gales, 169
Storm, 322
Stow, Tom, 215

Stringham, Roland, 215
Studio Building, 181, 182
Suisun Indians, 27
Summit House, 59
Summit Road, 59
Sweeney, Wilmont, 178
Sykes, Mrs. E. A., 355

Taggard, Genevieve, 220
Talbert, Lillian, 303, 304
Tamalpais, 27
Tanforan, 357
Tatlock, Jean, 335
Taylor, Bayard, 59
Techniques of English Verse, 322
Telegraph Avenue, 59
Telegraph Canyon, 58
Telegraph Road, 58, 59
Temescal, 33
Temescal Road, 41
Thomas, Norman, 314
Thompson, Hollis, 308
Thousand Oaks Subdivision, 190
Three Penny Opera, 3
Throttlebottom, Alexander, 309
Tierney, John, 46
Tilden, Douglas, 56, 191–194,
 207
Tilden, Dr. W. F., 192
Time Magazine, 332
Titus, Louis, 189, 190, 209, 211
To the Pliocene Skull, 9
Tour Through Arizona, 50
Town and Gown of It, xii, 48, 175,
Trees, 10–12, 39
Tunnel Road, 59
Twentieth Century Cookbook, 162
Twentieth Century Club, 162
Twenty-eight years in the Life of a
 University President, 328
Twining, Charles, 183
Tyrrel, Dorothy, 298

Ulug Beg, 221, 222
United Artists Theater, 313
University of California, xi, xiii, 3, 45,
 51, 52, 56, 60, 64, 164, 165, 287,
 365, 366
 Atomic Energy Program, 335
 Bancroft Library, 186, 321
 Berkeley Fellow, 325
 Building Program, 308
 California Hall, 206

Charter, 68
Early Days, 68, 69
Earthquake (1906), 205–207
Enrollment, 329
Founders Rock, 70, 71
Fernwald Hall, 329
Football, 83–85, 191, 324, 325
Hearst Mining Building, 206
Housing, 303
Le Conte Hall, 73
Little Theater, 294
Magazine, 74
Military Training, 80–82, 293
Museums, 185–187
Nobel Prize Winners, 220, 329, 336
Police 187
Radiation Laboratory, 331, 361, 362
Regents, 68, 69, 210
Sather Gate, 185
South Hall, 206
Stadium, 327
Stiles Hall, 169–170
Traditions, 293–295
University of California: 1868–1968,
 xii
University of California Centennial
 Record, 1868–1968, xii
University of California Crew, 313
University of California Magazine, 74
University Christian Church, 307
University House, 206
University of Santa Clara, 64
University Savings Bank, 153
University Terrace, 189
U.S. Forest Service, 288
U.S. Geological Survey, 18
U.S. Senator Stephen M. White, 193

Vallee, Rudy, 309
Vallejo, Dr. Platon, 27
Vallejos, Memoirs, 27
Varsity Candy Shop, 297
Varsity Creamery, 161
Venus of Milo and Other Poems, 75
Veterans Bonus March, 311
Veterans Memorial Building, 299, 300
Victorian Berkeley: The Community of
 Ocean View, 44
Virgin Islands, 325
Vollmer, August, 178 195–97, 207, 325
von Chamisso, Adalbert, 10
von Cramm, Baron Gottfried, 215
von Hindenburg, Paul, 309

Walnut Creek, 58
Walpole, Sir Robert, 3
War, Horrors of, 337–341
Warren, Earl, 325
Warren, James, 11
Washington Pavilion, 63
Washoe Re-visited, 50
Waste, Chief Justice William H., 154, 173, 178
Weeks, Anson, 316
Weeks, Horace, 286
Weinberg, Joseph, 362
Wellesley School, 147
Wellington, Winfield Scott, 186
West Berkeley, 14, 47, 48–50, 52–54, 145, 146, 159, 160, 180, 183, 228
West Berkeley Bank, 205
West Berkeley Planing Mill, 48, 49
Wharff, William H., 206, 299
Wheeler Award, 178, 325
Wheeler, Benjamin Ide, 73, 178, 179
Wheeler Hall, 71, 319, 332
Wheeler Oak, 39
Wheeler, Lucy, 174
Whitecotton Hotel, 182, 310
Whittier School, 338
Wilcox, George L., 181
Wilcox Photo Company, 181
Wildcat Canyon, 281, 318
Wightman, Hazel Hotchkiss, 214
Wilkes, Mathilde, 159, 160
Wilkinson, Warring, 56

Willey, Samuel, 71
Willow Grove Park, 14
Willows, 16
Wills, Helen, 214, 216, 313
Willson, Meredith, 228, 316
Wilson, LaVerne, 298
Wilson J. Stitt, 226, 227
Wilson, Woodrow, 167
Wimbledon, 214, 215
Woman Suffrage, 75
Women, 83, 343
Wonder Team, 84
Woodbridge, Sally, 48
Woolett and Woolett, 171
Woolsey, James Bradshaw, 138
Workers International Relief and Unemployment Council, 307
Workingman's Party, 47, 138, 139
Works Progress Administration, xii, 184, 186
World War I, 169, 311, 355
World War II, 82, 172, 329, 351, 353, 354, 358
Wright and Saunders, 55

Yale, College, 3, 63
YMCA, 308
Young, Ella, 306, 319, 320
Yulupa Straits, 27
Yusef, 50

Zellerbach, 71

384

Author Index

Acty, Ruth
 Walter Gordon, 324

Benson, Dorothy V.
 The Poets' Dinner, 296

Burk, Bois
 Early Days at the University, 68
 Military Training, 80
 Incorporation (with Florence Jury) 137
 Public and Private Schools (with Ellen Drori) 144
 Campus Traditions (with Florence Jury) 293
 Student Rooming Houses, 303

Burnett, James T.
 J. Stitt Wilson, 226

Cooper, Gloria
 Trees and Flowers, 10
 Promotional Booklets, 224

Davies, Lillian B.
 Founders Rock, 70
 The Ferries, 148
 The Little University Building That Led Three Lives, 185

Drori, Ellen
 Public and Private Schools (with Bois Burk) 144
 Cookbooks, 161

Eisenmayer, Fillmore
 The Piano Club, 171
 The Tennis Club: Home of Champions (with Florence Jury) 214

Hawthorne, Trish
 Mortar Rock Park, 28
 Joseph Mason, 151
 Maurice Curtis and Peralta Park, 166
 Almost the State Capital, 208
 The Northbrae Subdivision, 212

Jorgensen-Esmaili, Karen,
 The Growth of Ocean View, 44
 Ocean View's Social and Ethnic Diversity, 52

Jury, Florence
 Incorporation (with Bois Burk) 137
 The Tennis Club (with Fillmore Eisenmayer) 214
 The Community's Response (with Edward Staniford) 285
 Campus Traditions (with Bois Burk) 293
 How the City Weathered the Cruelest Depression Year, 305
 The Lighter Side of the Depression, 316
 Ella Young, 319

Laird, Lynn
 The Asylum for the Deaf, Dumb and Blind (with Stephanie Manning) 55

Linsley, Fran
 Stiles Hall, 169

McArdle, Phil
 Preface, xi
 The Costanoan Indians, 23
 The Peralta Land Grant, 30
 Henry Durant, 63
 E.R. Sill, 74
 Josiah Royce, 77
 Lincoln Steffens, 155
 Frank Norris, 164
 Arthur Ryder, 217
 Leonard Bacon, 220
 George Stewart, 321
 Ernest O. Lawrence, 330
 J. Robert Oppenheimer, 333
 Atom Spies in Berkeley, 361
 Epilogue: The City Since World War II, 365

Marinovich, Charles
 The Indian Earthquake Legend, 26
 The Story of the Hanging Oak, 39
 The Damage in Berkeley, 205
 The Veterans Memorial Building, 299
 Home Front Alarms, 345

Le Conte, Joseph
 Berkeley's Hills, 7

Luce-Richey, Barbara
 The Creeks, 15

Manning, Curt
 The Beach, 13

Manning, Stephanie
 The Hayward Fault, 18
 The Lumber Mills, 48
 J. Ross Browne (with Rev. Harry B. Morrison) 50
 Asylum for the Deaf, Dumb and Blind (with Lynn Laird) 55
 The Le Contes, 72
 Football, 83
 Sam Heywood, 140

Mathilde Wilkes, 159
Benjamin Ide Wheeler and Pheobe Hearst, 178
Shattuck's Evolution as "Downtown", 180
Cutter Laboratory, 183
August Vollmer, 195
Robert Gordon Sproul, 327

Marvin, Betty
Bohemian Dinners and Fine Music, 291

Morrison, Rev. Harry B.
The Irish-American Farming Community, 46
J. Ross Browne (with Stephanie Manning), 50

Pancoast, Henry
Claremont Canyon, 58
The Public Library (with Sayre Van Young) 173

Pettitt, Ken
The Horrors of War, 337
The Longest Blackout, 348
Pettittania Revisited, 351

Pipe, Therese
G. Sydney Rose—Fire Chief, 228
Chief Rose's Report, 283

Reid, Careth B.
Camp Ashby, 354

Staniford, Edward
Domingo Peralta, 33
Julius Kellersberger, Mapping the Land, 42
Volunteer Fire Departments, 142
Spring's Time in Berkeley, 188
The Great Berkeley Fire, 280
The Community's Response (with Florence Jury) 285

Stein, Ken
Douglas Tilden, 191

Van Young, Sayre
The Public Library (with Henry Pancoast) 173

Yamada, T. Robert
Japanese Internment, 357

Yost, Harold
An Eyewitness Remembers, 201

List of Illustrations

	Page
George Berkeley	87
Costanoan Indian Territory	88
Mortar Rock	89
Berkeley Creeks	90
Domingo Peralta House	91
Bowen's Inn, Ocean View	92
Mathilde Wilkes	93
J. Ross Browne	94
Sam Heywood	95
North of Campus, East of "Holy Hill"	96
Shattuck and University, looking South	97
Henry Durant	98
Martin Kellogg	99
Kellogg School	100
General Merchandise Store, 1885	101
John and Joseph Le Conte	102
Berkeley's Waterfront, 1885	103
Central Pacific Railroad Oakland Terminus, covering more than four acres	104
Berkeley with San Francisco in distance, c. 1885	105
Advocate Office, Shattuck and University, 1885	106
Edward Rowland Sill	107
Josiah Royce	108
Cattle on the Hills, 1889	109
Allston looking East from Shattuck, 1889	110
Fulton-Oxford, looking North, 1889	111
Northwest Corner of Campus, Hearst and Oxford, c. 1902	112
Campus, Berkeley Way and Oxford, c. 1902	113
Vine and Shattuck Intersection, c. 1885	114
Lincoln Steffens	115
Frank Norris	116
Douglas Tilden	117
Phoebe Apperson Hearst	118
Benjamin Ide Wheeler	119
Shattuck Avenue, 1896	120, 121
ROTC Cannon Practice	122
Bayonet Practice on Campus, 1899	123
Ferry "Berkeley", 1898–1958	124
Columbus School Faculty, 1901	125
Berkeley Public Schools Boys, c. 1901	126
Berkeley Dairy in Strawberry Canyon, c. 1905	128
On Berkeley's Beach, 1908	129
Earthquake Damage at Berkeley High, 1906	130
Barker Block Cornice Fell in 1906 Earthquake	131

San Francisco Fire Seen from Berkeley 132
Fire Refugees in California Field, 1906 133
San Francisco Fire from North Berkeley, 1906 134

Comic Postcard, c. 1910 231
Berkeley Station on Shattuck Avenue, 1908 232
Berkeley Station on Shattuck Avenue looking West on Addison, c. 1909 233
John Hopkins Spring 234
Berkeley City Council with J. Stitt Wilson seated at far left, 1912 235
Bancroft Way looking South on Telegraph Avenue, 1909 236
Acheson Building on University at Walnut, c. 1912 237
Jack Jaymot's Berkeley French Laundry, c. 1915 238
West End of Campus near Oxford Street, c. 1916 239
Berkeley Public School Girls, c. 1916 240
G. Sydney Rose, c. 1916 241
Mobilized Women's Cookbook, 1918 242
Douglas Tilden's "The Bear Hunt", c. 1891 243
Berkeley High School Faculty, 1909 244
University Little Theater Play, 1920 245
University Students Guarding the Axe, 1920 246
Cal's Wonder Team, 1920 247
University Aviators Receive Domestic Help, 1920 248
Muses Quartet, Antonia Brico at Piano, 1921 249
Arthur W. Ryder 250
Office Girls in Acheson Building when the Boss was Away, March 1923 251
Fire, September 17, 1923 from University and Oxford 252
Fire at Euclid and Virginia, 1923 253
1700 Block of Shattuck Goes up in Flames 254
Extent of the Berkeley Fire, 1923 255
A Sunday Stroll on Euclid Avenue after the Fire, 1923 256
City Hall at Grove and Allston Way, c. 1934 257
The Chamber of Commerce Building under construction at
 Shattuck and Center, 1926 258
The Berkeley in the 1930s 259
Helen Wills 260
August Vollmer 261
Miss Talbert's Rooming House in the Early 1930s 262
Charles E. Dunscomb and His Wife, c. 1936 263
A Maybeck Living-dining room, 1933 264
University Early Museum, 1965 265
Ella Young 266
George R. Stewart 267
Mr. and Mrs. Walter Gordon 268
Ernest O. Lawrence 269
Robert Gordon Sproul 270
The Original Radiation Laboratory, c. 1930s 271
The 74 Ton 27½ inch Cyclotron, 1933 272
Between the Two World Wars, Should Boys be Given Guns, 1936 273
Berkeley's "College Cops", 1941 274
Japanese Internment, 1942 275
At Camp Ashby, 1944 276
Learning the Intricacies of the Machine Gun on Campus, 1944 277
World War II Cigarette Line 278